Words of Praise for *Baking in the*

"You won't need encouragement to bake like mad from this book—the collection of recipes is truly stunning: I could spend days delighting in the chapter on cornbread with all its variations and all of Anne Byrn's stories. So many fascinating stories about so many inspiring people in so many corners of the south. Bake, bake, bake, but be sure to give yourself the pleasure of reading this book. There's as much to savor in Anne's words as there is in her glorious recipes.

—Dorie Greenspan, *New York Times* bestselling cookbook author

"With *Baking in the American South*, Anne Byrn is an informative and enjoyable guide. Byrn makes you feel like she's at your side, soothing any baking anxiety you may have by helping you through these comprehensive and classic recipes. This is a 'must have' cookbook for any baker interested in regional American baking specialties."

—Adrian Miller, James Beard award-winning author of *Soul Food* and *Black Smoke*

"Anne Byrn is one of the country's most prolific and passionate chroniclers of American baking traditions, and now she has turned her attention to her native South to tell the stories of the inventive bakers, both famous and unsung, to help us better understand and appreciate the wondrous complexity behind even the simplest biscuit. *Baking in the American South* is a *tour de force* and destined to be a classic."

—Susan Puckett, author of *Eat Drink Delta* and former food editor of the *Atlanta Journal Constitution*.

"If I'm searching for a classic recipe anywhere in the genre of southern baking, I turn to Anne Byrn. Her credentials are impeccable: accomplished journalist and former food editor, author, raised in Tennessee, studied in Georgia (and Paris). Anne is a keeper of the knowledge of the best women bakers in her multigenerational southern family, and now the region's best home cooks, professional bakers, culinary entrepreneurs, growers, millers, and makers brought together in the ever-evolving community that is *Baking in the American South*."

—Marcie Cohen Ferris, Professor Emeritus, UNC-Chapel Hill

"Impeccably researched and written with affection and humor—this is a love letter to the Southern cooks of past and present—and finally we have the definitive book on Southern baking."

—Nathalie Dupree, preeminent food writer, cooking teacher, and television personality

"*Baking in the American South* celebrates Southern baking's history, as well as the heirloom recipes that are part of our country's food culture."

—Carrie Morey, founder, Callie's Hot Little Biscuit

"Anne Byrn is a gifted Southern storyteller and culinary sleuth. She has coaxed iconic Southern recipes from White House chefs, home cooks, farmers, Appalachian grandmothers, civil rights leaders, and bakers from Eureka Springs, Arkansas, to Key West. Just what the doctor ordered!"

—John Martin Taylor, author of *Hoppin' John's Lowcountry Cooking*

BAKING IN THE
AMERICAN SOUTH

200 Recipes *and Their* Untold Stories

ANNE BYRN

PHOTOGRAPHY BY RINNE ALLEN

HARPER
Celebrate

Published by Harper Celebrate, an imprint of HarperCollins Focus LLC.

Any internet addresses (websites, blogs, etc.) in this book are offered as a resource. They are not intended in any way to be or imply an endorsement by HarperCollins Focus LLC, nor does HarperCollins Focus LLC vouch for the content of these sites for the life of this book.

Photography: Rinne Allen
Food stylist: Tami Hardeman
Assistant food stylist: Angela Hinkel
Interior design: Emily Ghattas
Cover design: Katie Jennings
Art direction: Jennifer Showalter Greenwalt

ISBN 978-0-7852-9133-6 (HC)
ISBN 978-0-7852-9134-3 (eBook)

Printed in Malaysia

24 25 26 27 28 VIV 6 5 4 3 2

Kentucky's Shaker Village
of Pleasant Hill

For the bakers of the South,
past and present,
near and far,
seen and unseen.

Ella Beesley's Refrigerator Rolls (pages 153–154)

CONTENTS

INTRODUCTION

Food has been perhaps the most positive element of our collective character,
an inspiring symbol of reconciliation, healing, and union.

—JOHN EGERTON, *SOUTHERN FOOD: AT HOME, ON THE ROAD, IN HISTORY* (1993)

n the fall of 2021, traveling on a book tour through North Carolina, I stopped at the Country Bookshop in Southern Pines, where a woman from Ohio asked me, "What makes Southern baking so special?"

As a fifth-generation Southerner, I was at a loss for words. I naively wondered why the aroma of pound cake or the taste of soft, buttered yeast rolls needed explaining.

I looked to the audience for help. Hands were raised. It's your mama's cooking. It's the biscuits. It's the flour. It's the people. In short, everyone from the South had an answer, but there was no definitive answer.

As I drove home to Nashville, through the Nantahalas and into the Great Smoky Mountains, driving past Knoxville, over the Cumberland Plateau, and back into the middle of Tennessee, the question stayed in my mind.

I have spent most of my life writing for and about Southerners. I recall after a stint in France studying pastry in Paris that I was homesick for Southern baking and would trade a fancy génoise for a warm slice of my mother's pound cake any day.

But not until I dove into this book did I truly appreciate the deep baking legacy Southerners take for granted. It is quite possibly the first and finest style of baking America has ever known.

Baking Out of Necessity

While other pockets of the country—New England, the Midwest, and California—have their own regional baking styles, the South, which is about the size of Western Europe, has created more than its share of America's best-loved recipes. Our cornbreads, biscuits, rolls, puddings, pies, cakes, and cookies with unique names, flavors, and stories create a deeply textured mosaic.

Without the number of commercial bakeries found in the urban Northeast, home baking in the South was out of necessity and used what the land provided. Take peach cobbler. If you've traveled to the South, you've witnessed the romantic affection we have for it and how it is a sacred rite of summer. You choose fragrant peaches to peel while juices run down your wrist and onto your arm, and you toss the slices with sugar, layer them in pastry, and bake a panful to feed a family, with scoops of vanilla ice cream, all season until next summer, when you do it all over again.

Peach cobbler was born from the profusion of ripe peaches that fell from the trees. The soft wheat ground into pastry flour had been planted in the fall and was harvested in spring before the heat and bugs set in. It had flavors of honeysuckle, vanilla, and faint black pepper. And in the years when wheat didn't grow, you simply didn't have wheat flour or peach cobbler.

Land and climate in the South differ from the rest of America. Sandy Gulf coastlines, snaky bayous, black-soiled farmland, lush river deltas, family farms where fig trees grow as tall as houses, and mountains encircled in a smoky blue haze define our land. The South is different even in the way it smells: the honeysuckle that weaves around a picket fence post and the fat blackberries or dewberries, full of chiggers and rattlers, growing wild along a hot and dusty Mississippi road. Here grand Georgia pecan trees on family land outlive their owners. satsuma, hickory, or pear trees dot backyards. It's as if the trees, fields, flowers, fruits, and vegetables etched into the Southern psyche have crept into everything we bake.

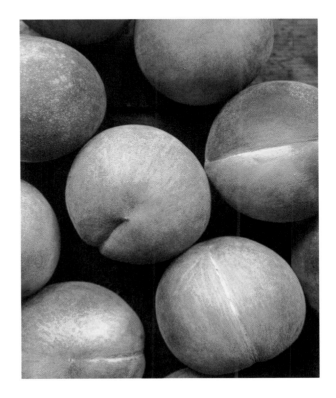

In comparison to other regions of the country, the South was an agrarian society where cooks lived far apart but were close to the land and fed those who worked it. The region was prone to storms and used to drought and all the vagaries of weather over which people had no control. It's all the more reason Southerners have baked for others at quiltings, barn raisings,

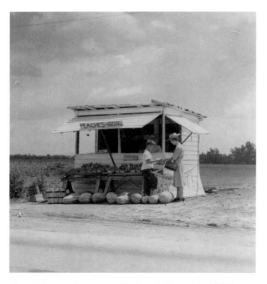

Roadside produce stand in South Carolina, 1936

church dinners, political rallies, funerals, and celebrations of farm planting and harvest.

A ready supply of trees to fell for wood to stoke woodstoves not only allowed cheap fuel but introduced the South to a biscuit we can never forget. Daufuskie Island author Sallie Ann Robinson recalled in her 2003 book, *Gullah Home Cooking the Daufuskie Way*, that, as a girl growing up off the coast of South Carolina, she would head home and light the woodstove so it would be nice and hot for her mother to bake biscuits. "Momma made it look so easy as she made the dough and rolled it out on the table. . . . She'd reach for one of the jelly jars that we drank from, then let me press it down into the quarter-inch dough to cut out the biscuits."

A Story of Preservation and Art

Learning to bake a layer cake, ice it neatly, and sell it out of your home kitchen or at the beauty parlor paid some bills. When times were hard, cooks took in boarders in upstairs bedrooms and rolled out buttermilk biscuits each morning for the breakfast table. Struggling Southerners again looked to the land and the recipes they knew, and baking proved to be a currency outlasting Confederate money.

When Mother Nature didn't cooperate, the South became an inventive no-waste region, baking pies of oats instead of pecans and flavoring with vinegar in lieu of lemon juice. Grandmothers baked layer cakes by measuring flour with a chipped teacup. Mothers taught their daughters how to bake cornbread with yellow cornmeal or white, with or without sugar, and these methods became as sacred as the Bible.

"Virtually everyone in the rural area where I was from would have had a milk cow. We milked that cow every day and churned our own butter. It was like life on *Little House on the Prairie*. You had to be self-sufficient," says country ham king Allan Benton.

At the same time that baking in the North was influenced by factory innovation and commercial baking, Southern recipes became preserved in memory, written in diaries, or simply ripped off the box of baking powder. Cookbooks were published by charitable groups such as the Ladies' Southern Relief Association, whose members fed, clothed, and sent money to the needy and wrote down recipes for fundraising cookbooks, in the process preserving the classic recipes of the nineteenth-century South that we still use today.

Recipes became hyper-regional because their people were.

But what we bake isn't always defined by state lines. It might be geography—the flow of the Cumberland, Chattahoochee, or Apalachicola Rivers; the plateaus and valleys; the Tidewater; the

Bluegrass; or the stark isolation of the mountains—that informs the cake we bake. If you drive from western Georgia into eastern Alabama, you gain an hour in time, but the Lane Cake and the "lemon cheese" layer cake recipes, beloved in both states one hundred years after they were first created, know no time zones and are still baked each Christmas.

A Complicated South

Outsiders may imagine the South as a white-columned Tara from *Gone with the Wind*, but, in truth, the South was largely poor. The people of Florida's turpentine camps, sawmills, and citrus groves existed on cornbread smothered in molasses. We have sweetened our food with sorghum molasses, cane syrup, the elusive sourwood honey found in higher elevations, maple syrup tapped from trees in West Virginia, or coveted white sugar, which was locked up in colonial kitchens and later blockaded and inaccessible during the Civil War.

Sugar, essential to Southern baking, is complicated. So is the South. Along with cotton and rice, sugarcane created an economy dependent on slavery, and the enslaved cooks provided the labor that made the biscuits, cornbread, pies, and cakes we still bake today.

From West Africa, enslaved Black cooks brought their knowledge of frying, preparing grains, stewing greens, and integrating heat and spice. And while buttermilk pound cake, rice pudding, and sweet potato pie might evoke nostalgic memories for some, for others who did not bake out of joy, they may mean something else altogether.

Pound cakes—fixtures at church suppers, funerals, and christenings—have built churches and funded schools. They also had a close relationship with the Civil Rights Movement. Georgia Gilmore and other Black women baked golden loaves of pound cake to raise money for alternative transportation as part of the 1956 bus boycott in Montgomery, Alabama.

Pecan pie was the specialty of President Lyndon Johnson's longtime cook, Zephyr Wright, of Marshall, Texas, who followed him from the ranch to the White House. She couldn't board the same flights as the First Family because of Jim Crow laws. In making the long car drive to Washington, DC, she couldn't find adequate rest stops and restaurants along the segregated route. She told the president about it, which Johnson said influenced his signing of the 1964 Civil Rights Act.

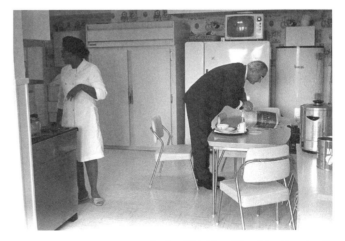

Zephyr Wright and President Lyndon B. Johnson in the LBJ Ranch kitchen, 1968

Migration and Change

Although Southern recipes have retained their character, they weren't frozen in time. Migration brought waves of immigrants through New York and the southern ports of Baltimore, Charleston, and New Orleans. They arrived to build the life they wanted—French Huguenots, English Quakers, Scots, Irish, Acadians, Italians, Swiss, Germans, and Jews from both Sephardic countries and Central and Eastern Europe. The enslaved from Africa and the Caribbean came because they were forced to.

Railroads built to shuttle cotton to market strung together towns like a mother's strand of pearls and changed what we baked forever. A small town in southern Kentucky was a hub connecting rail lines north and south, allowing imported bananas to travel from docks in New Orleans and Mobile clear up to New York and Philadelphia, which might explain why there are so many banana pudding recipes embedded in Kentucky cookbooks. Because of railroads, a bakery and a beloved hundred-year-old recipe for a spiced cookie came to remote Demopolis, Alabama. Railroads made Key lime pie famous and turned nameless places into thriving towns with tearooms and boardinghouses, employing legions of good cooks who could bake blackberry cobbler and fry chicken.

The Recipes and the People

Southern baking, just like French cooking or Italian, has foundational recipes that stand the test of time—custard, angel food cake, pound cake, lemon curd, piecrust, biscuits, even cornbread. And the years have been good to Southern baking, allowing it to grow along the way and blossom into a style unlike any other.

The recipes in this book come from fourteen states—Maryland, Virginia, West Virginia, Kentucky, North Carolina, South Carolina, Georgia, Florida, Alabama, Mississippi, Louisiana, Texas, Arkansas, and Tennessee. Like Hummingbird Cake or Black Bottom Pie, some of these recipes are famous. Others, like Cantaloupe Cream Pie or Heavenly Chocolate-Tomato Sheet Cake, you may never have heard of. You will absolutely want to bake Thomasville Cheese Biscuits or Maggie Cox's Warm Chocolate Meringue Pie during the week. Other recipes, like Elizabeth Terry's Sherry Trifle or Phila Hach's Salt-Rising Bread, are so over-the-top, you'll save them for a weekend project.

The sources for these recipes are as diverse as the recipes themselves. They come from department stores, school cafeterias, tearooms, boardinghouses, historic homes, cookbooks, churches, synagogues, restaurants, farms, mills, pastry shops, catering kitchens, home kitchens, and even the White House. I've included some of my own family's favorites, too, which were baked by my aunt and grandmother as well as my mother, a wonderful cook, and I've perfected them over the years.

Recipes are my way of introducing you to the bakers of the South, from the nationally famous chef Edna Lewis and the self-made restaurant critic and businessman Duncan Hines to lesser-known but

important cooks like Kentucky's Atholene Peyton, a Black home economist who was ahead of her time, and Malinda Russell, who wrote one of the earliest Black-authored cookbooks, to locally acclaimed bakers like Pat Lodge, who was famous for her simple spoon rolls, and Alice Jo Lane Giddens, who made the crispiest sugar cookies ever. Prior to the Nineteenth Amendment, which gave women the right to vote, many of these "ladies who baked" were referred to by their husband's initials. And many Black cooks who created these recipes were not credited at all. They are now.

From sizzling cornbread—the South's true daily bread, because corn grew everywhere—to light and flaky biscuits, to quick breads and batter cakes as well as fried breads that assuage hunger, to yeasty rolls and loaves, to puddings both baked and stirred on the stovetop, to pies large and small, to cakes that make every occasion special, to cookies, sweet and buttery—these are the recipes that tell the story of Southern baking. They open a window into the past and speak of the people who made them, where they came from, and why.

These recipes talk about the land and the harvest, when there was plenty and when there was not. They talk about the weather, adapting to it, dealing with it, and surviving it. They talk of isolation. They reveal discrimination and assimilation. They show the joy found in reunions, homecomings, and holidays. They know the unwritten code of borrowing one cup of sugar and returning two. And they are delicious.

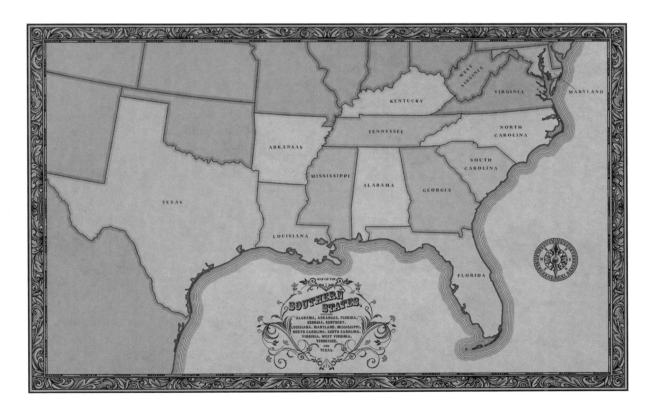

Southern Ingredients

Thirty years ago, when I was living in the Midlands of England, my new friends wanted me to bake American brownies and layer cakes, but my recipes wouldn't work to my satisfaction with the hard and gritty British flour. I wrote to White Lily, which at the time was still based in Knoxville, asking if they might ship me a sack and include a bill. I didn't expect to get a reply, much less flour. But a few weeks later, a box arrived with twenty pounds of White Lily all-purpose flour.

Today, you don't have to live in the South to access Southern ingredients. You can order Southern flour and cornmeal online. And you can absolutely make these recipes with ordinary supermarket ingredients, no matter where you live. In the best tradition of the South, use what you have.

*

This book is my attempt to address a question many people outside the South might like to ask. My answer is that when you bake a banana pudding with a tall browned meringue, a rich chocolate pound cake recreated from memory, and sweet potato biscuits filled with shaved Kentucky ham, you will understand what makes Southern baking so special.

—Anne Byrn, Nashville, Tennessee, April 2023

HOW TO BAKE THIS BOOK

*M*any a grandmother has made amazing biscuits without measuring, but most of the rest of us need precise measures. In baking, dry ingredients, especially, need to be exact. Too much flour makes bread dry. Too little flour and cakes fall.

To bake your best, nothing beats the precision of a scale. So I list the sugar and flour measures in all these recipes in both grams and cups. If you do not use a scale, you should know that I measure by spooning flour into a cup, not dipping the measure into the sack of flour, which packs in more flour than needed.

I measure white granulated sugar by filling the cup and leveling it off with a knife. For brown sugar, I lightly pack it into the cup. For vegetable shortening, I firmly pack it.

Pies, cornbread, and cookies are more forgiving than cakes and breads when it comes to measuring, so you might not see the use of a scale in some of those recipes.

And when all else fails, use your senses. That's how the good cooks in the South have baked. Look at the dough. Is it satiny? Feel it. Is it smooth? Taste the batter. Is it sweet enough? Salty? Smell the cake baking. It might be done!

How I Convert Old Recipes to Work Today

The answer in three words: "Trial and error."

I tried the recipes first as they were written, and then on retests, I made adjustments as needed. Your family's heirloom cake recipe might be so old it calls for butter but has stood the test of time with lard, shortening, and margarine. Real whipped cream tastes better on icebox pie than 1960s Cool Whip. Recipes are snapshots in time, and I don't want to erase their historical markers, but I do tell you what I think tastes and bakes best.

NUT CHARLOTTE RUSSE
SATSUMA TEA ROOM

...le 1 1/2 teas gelatine over 1/4 cup water
...et it soften 5 minutes. Scald 1 cup
...cream, remove it from the heat, and
...in 1/2 cup sugar and the gelatin until
...are dissolved. Cool the mixture and
...e it, stirring frequently, until it begins
...hicken, fold in 2 cups grated coconut,
...cups heavy cream, whipped, 2 egg white...
...ten with 1/2 cup sugar until they...

Rolls — 1 cup...
1 cake yeast 1/2...
2 eggs well beaten) 4...
14 Tablespoons crisco 4 T...
1 1/2 c milk scalded + 4 t...
Dissolve yeast in water...
milk, melt crisco over boil...
combine eggs, milk, water, sugar...
+ crisco. Stir in flour to make...
Soft dough. Let rise 2 times...
Refrigerate at this point (over)

...Spoon Breads —
4 eggs —
3/4 cup corn meal
2 " sweet milk
1 teaspoon salt
2 tab " Melted Butter
1 tab " sugar

...cornstarch and...
...ree, add cold water. Stir...
...Stir while this cooks, Mix...
...to cover and let cook 3 to 5 min...
...or until thick, stirring occasionate...
...Beat egg yolks very thick...
...with half cup sugar — add, sifted...
...hot water to mixture in...
double boiler, then spoon...
hot mixture in to eggs...
...melt them then add...
...cook vanilla...
butter

...ket boil 15 mi.
...d 1 cup dry coconut let boil 15 more
Last add 1/4 lb. butter + 7 or 8 egg
yelks and cook 10 or 15 mi. Then put
in pan lined with pastry. Bake fast
for 10 or 15 in hot oven, reduce heat and
bake until pastry is done —

Fudge

Cream

...sugars...
...almond...
...cos —
...ped nuts (alm. pecan...
...er + sugar
...2 eggs

Conversions of Common Measures from Old Recipes

Butter the size of a walnut = 2 tablespoons (about 1 ounce)

Butter the size of a hen's egg = 1/4 cup, 4 tablespoons (about 2 ounces)

Wineglass = 1/4 cup (about 2 ounces)

Teacup or gill = 1/2 cup (about 4 ounces)

Tumbler or glassful = 1 cup (about 8 ounces)

Dessert spoonful = half a tablespoon

Dash = one shake, aka "a whisper"

Pinch = as much as you can pinch between your thumb and index finger. Pinches vary as to the size of the fingertips!

Rounded teaspoon = 2 level teaspoons

Heaping teaspoon = 1 level tablespoon

Equivalencies for Modern Measures

16 tablespoons = 1 cup 5 1/3 tablespoons = 1/3 cup 3 teaspoons = 1 tablespoon

8 tablespoons = 1/2 cup 4 tablespoons = 1/4 cup

Understanding Your Oven

The oven thermostat wasn't born until 1915. Recipes predating that called for "slow" ovens or "quick" ovens, terms that might have today's cooks scratching their heads. And cookbooks, too, had to adapt to the change. By 1950, most Southern cookbooks specified temperatures in degrees. Here's a cheat sheet to oven nomenclature, thanks to *Kentucky's Cookbook Heritage* by John Van Willigen.

Very slow oven = 250ºF Moderately hot = 375ºF

Slow = 300ºF Quick or hot = 400ºF

Moderately slow = 325ºF Very hot = 450ºF

Moderate = 350ºF Extremely hot = 500ºF

You may notice that some recipes begin with a high temperature, say 450ºF for 15 minutes, then instruct you to turn the oven down to 400ºF and bake for 15 minutes, and so forth, during the cooking

process. This is called baking in a "falling" oven, and it simulates the gradually lowering temperatures of a wood-fired oven.

I love the falling-oven technique, and you will find I use this method for some of the pies in the book in order to give the crust a jump start. You can also use it with pound cakes, except in the other direction, beginning slowly, with a "slow" or "cold" oven, meaning zero degrees, and raising the temperature in stages so it bakes evenly.

Notes on Leavening—Baking Powder, Baking Soda, and Yeast

Before baking powder in a can, people made their own by combining baking soda and cream of tartar. Old recipes call for a lot more baking powder than is commonly used today because early baking powder wasn't as strong and effective. The general rule is 1 teaspoon baking powder per cup of flour.

Too much baking soda can wreck a cake or bread and give it a soapy, salty taste. If no acidic ingredient, such as buttermilk, lemon juice, or molasses, is present in the recipe, omit the baking soda and opt for baking powder instead. Remember that brown sugar is acidic because it contains molasses.

To troubleshoot old recipes, when acidic ingredients are present, use 1/4 teaspoon baking soda for every cup of flour. Another way to estimate is for every cup of molasses or buttermilk or for every tablespoon of lemon juice or vinegar, you need 1/2 teaspoon baking soda. Old recipes called for the baking soda to be stirred into something to activate it, such as a tablespoon of water, so don't be alarmed if the recipe instructs you to stir the baking soda into the buttermilk to get things going.

Many older recipes call for fresh yeast, but as those yeast cakes are hard to find, I use dry yeast instead. For every ounce of fresh yeast, I use a package of dry yeast, which is 2 1/4 teaspoons. Always store yeast in the fridge and be aware of the expiration date before baking.

BAKING AT HIGH ALTITUDE IN THE SOUTH

While we might think of the West as having the high altitudes that play havoc on baking, some of the mountainous regions of North Carolina far exceed the 3,000 feet above sea level to be deemed high altitude. I ran across a tip for baking cake successfully in the Black, Smoky, and Blue Ridge Mountains in the 1970 *High Hampton Hospitality* cookbook compiled by Lily Byrd McKee. In this spiral-bound book filled with recipes from the historic High Hampton Inn in Cashiers, McKee suggests you add 2 tablespoons more flour to a cake recipe for added structure. Cakes rise faster at higher altitude and need more structure so they don't collapse.

MY SOUTHERN
BAKING PANTRY

*B*efore you bake, here are the ingredients and equipment I use and why, plus some tips and tricks.

Ingredients

BUTTER. Use unsalted unless I call for salted butter. If the recipe calls for salted butter, you can use unsalted and add about 1/2 teaspoon salt per stick of butter. I prefer the taste of salted butter for brushing on biscuits and yeast rolls. If possible, try a salted cultured butter for serving, which has even more flavor. European butters have a higher butterfat, and while they are luscious, you don't need them in most of these recipes. If you want to splurge, use them in the frostings and glazes. I buy butter when it is on sale and freeze it for up to three months.

LARD. It is delicious in biscuits and piecrusts and helps with flavor and flakiness. The best lard is leaf lard, which has a clean and pure flavor and can be purchased from a butcher. Lard from the grocer's shelf is stronger flavored and saltier.

VEGETABLE SHORTENING. The South's substitute for lard, and it is used on occasion throughout this book. I keep a can of Crisco on hand for greasing layer cake pans and making piecrusts and rolls. A smear of Crisco, followed by a dusting of flour, has helped thousands of cake layers release from my pans and doesn't cause the unsightly buildup from vegetable oil spray and oven heat, not to mention the

tough, brown edges caused by sprays like Pam. (When shopping for vegetable oil spray, look at the label. Propellants help the oil spray from the canister but also cause the cake to bake faster around the edges.)

OIL. Unless I call for olive oil (for cakes) or peanut oil (for frying), use a canola or light vegetable oil in these recipes. Always store your oils in a cool and dark cabinet.

EGGS. They may come from the supermarket or be laid by your own hens, and if the latter is the case, as it has been throughout time in the South, those egg yolks might be the color of a deep sunset. The color of the yolk depends on the variety of the hen, and what a difference in taste and appearance fresh eggs make in pound cake, flan, and especially boiled custard and ice cream.

Eggs are larger than they used to be. I buy large eggs and open the cartons at the store and look inside, not just to check for any cracked eggs but also to make sure the eggs aren't too large for baking a cake. Overly large eggs will make a cake eggy tasting and heavy. To determine the size of the egg before embarking on a special cake (cornbread is more forgiving), crack the egg into a dish and weigh it on a kitchen scale. The egg should not weigh any more than 1.75 ounces out of the shell. Ideally in the shell it should not weigh more than 2 ounces. If it does and you don't have smaller eggs, discard a little of the white until you get to 1.75 ounces. Remove your eggs from the refrigerator an hour before making a cake, because room-temperature eggs help the cake rise.

CORNMEAL. In days past, you could find a world of cornmeal on the local grocer's shelf. But that's not the case anymore, and honestly, if you are not in an area where regional millers sell to supermarkets, the best cornmeal will be found on your own travels or purchased online. Weisenberger, made in Midway, Kentucky, is the excellent fine white cornmeal I used in many of the cornbread recipes in this book, and I can purchase it at my local grocer in Nashville. J. T. Pollard, in Hartford, Alabama, makes wonderful silky white cornmeal, and if I am in Florida, where it's available, I stock up on several bags and tuck them in the freezer when I get home. And when I travel through eastern Tennessee, I stop by The Old Mill in Pigeon Forge for the wonderfully coarse, unbolted yellow or white cornmeals and grits too. For online shopping, I look to Anson Mills in Columbia, South Carolina, for old varieties of stone-ground white corn and even the flavorful heritage grain Jimmy Red. In the recipes in this book, if I call for just "cornmeal," then any cornmeal you have on hand will do. But if I call for finely ground, then seek one out, because it will lend a softer texture. And if I call for coarse or unbolted or stone-ground, as in the hot water corn cakes, it's because I want you to taste the corn and bite into the texture of that meal. Regardless of the type of cornmeal, store it in your freezer to stay fresh longer.

FLOUR. We hear a lot about Southern wheat flour being starchy and low in protein, and that is a characteristic of winter wheat grown in the South, generally north of Interstate 20, where it's cool enough for wheat. Today you can buy White Lily off the shelf or look to smaller regional flours like those from Boonville

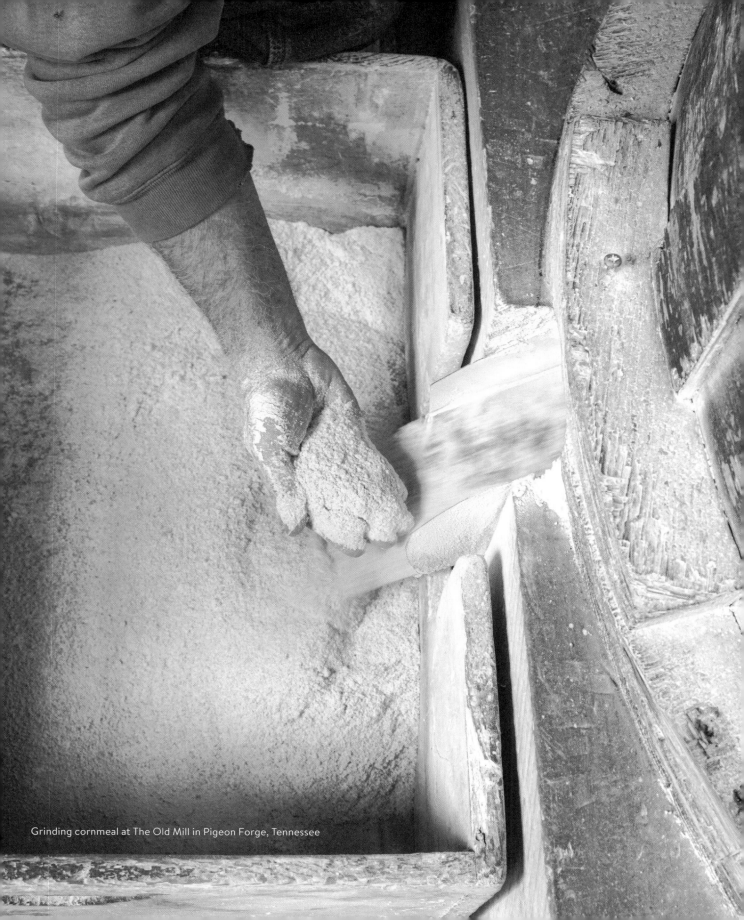

Grinding cornmeal at The Old Mill in Pigeon Forge, Tennessee

Milling in Boonville, North Carolina; Adluh Flour and Anson Mills, both in Columbia, South Carolina; or Weisenberger Mill in Midway, Kentucky. For heritage grains, try Carolina Ground in Hendersonville, North Carolina; Barton Springs Mill in Dripping Springs, Texas; or Anson Mills.

The twentieth-century roller milling and bleaching techniques changed flour's color, flavor, and texture to a white, mass-produced, standardized flour. Roller milling strips off the outer bran layer of the wheat kernel, which removes the germ, where the flavor resides. The starchy endosperm is what's left, and it is milled into flour. The old landrace wheats couldn't survive roller milling, so the industry left them behind. Their protein count isn't consistent enough to print on the side of a bag, and they are more like wine grapes in the way they change depending on the season, soil, or weather, says Glenn Roberts at Anson Mills.

Because bleaching interferes with the gluten formation in flour, bleached flour makes softer biscuits and cakes than unbleached. And yet, today many Southern cooks no longer want to bake with flour that has been chemically bleached.

Knowing the protein count of a flour is helpful in determining how a flour will work in your recipe. The higher the protein, the more structure the flour provides. The lower the protein, the more starch and softness. So your outcomes in my recipes will depend on what flour you use. I offer suggestions based on the flours I used in testing, from national and regional brands of bleached all-purpose as well as unbleached, and from higher-protein bread flours to lower-protein self-rising, all-purpose, and cake flours. And I baked with those nineteenth-century heirloom flours, too, and I'm not sure what I love more about them—their creamy color, their nutty and soft mineral flavors, or their stories.

White Lammas or White May flour from Anson Mills, for example, is milled from a soft white winter wheat originally from the British Isles. Glenn Roberts of Anson Mills says White Lammas was brought to the New World by the Jesuits. Known as "wafer wheat," it was used to bake light commun-ion wafers, and he says, during the Civil War, Indigenous People grew White Lammas. Researchers at Monticello and Colonial Williamsburg revived the nearly extinct variety for today's use. Purple Straw, with its distinctive purple or bluish stalk, is the flour that saved Southern baking, because it was resistant to the Hessian fly that decimated other wheat varieties in the South. David Shields, South Carolina food historian, says Purple Straw was a soft winter wheat "a farmer could trust year after year." Thanks to the efforts of Clemson University researchers, it is making a comeback, and you can purchase it from Barton Springs Mill in Texas.

As I write this book, there is an exciting new interest in home milling grains and reviving old wheat varieties. We can thank pastry chefs for leading this charge, as well as farmers, millers, and preservationists.

Here is a brief rundown of the protein counts in the most purchased flours on the shelf, starting with the least amount of protein (the softest) and heading upward. The more protein, the more structure, which is helpful in baking yeast loaves. Some pastry chefs like to make biscuits with a higher-protein flour to create more structured layers, but a lower-protein flour generally makes softer biscuits, and it makes cakes and piecrusts that are lighter, and muffins and cookies that are softer and spongier as well.

CAKE AND SOFT PASTRY FLOURS

Swans Down bleached cake flour: 7 to 8 percent protein

White Lily all-purpose and self-rising: 7 to 8.5 percent protein

King Arthur 00 pizza flour: 8.5 percent protein

Bob's Red Mill unbleached white fine pastry flour: 8 to 9 percent protein

ALL-PURPOSE FLOURS WITH ABOUT 10 PERCENT PROTEIN

King Arthur unbleached cake flour

Gold Medal unbleached and bleached all-purpose

Pillsbury unbleached and bleached all-purpose

Trader Joe's organic unbleached all-purpose

Carolina Ground 75 and Crema pastry flour

ALL-PURPOSE FLOUR WITH MORE THAN 10 PERCENT PROTEIN

King Arthur unbleached all-purpose: 11.7 percent protein

King Arthur bread flour: 12.7 percent protein

Caputo Dopplo Zero (00): 11.5 to 13 percent protein

OTHER FLOURS. Buckwheat, whole wheat, rye flour, and gluten-free flour blends can be used in these recipes as well. Without gluten (protein), buckwheat works when you aren't looking for structure, as in pancakes and waffles or in breads, when used along with wheat flour. It has a lovely purplish-gray color and complements blueberries and other fruit. Use whole wheat flour when you want to boost the grain flavor and give breads and cakes more heft. It's not always a one-to-one swap with white flour, so before you transform a yeast roll into a whole wheat yeast roll, ease into it, adding a quarter as much whole wheat and the next time half as much, and experiment as you go along. Whole wheat flour has a lovely nutty flavor and complements honey, pecans, and walnuts. Rye flour is fun to bake with. It doesn't have the gluten that wheat flour does, so you can't substitute it one for one with wheat. But you can sub in some rye flour to complement wheat flour in cookies, cakes, and breads. If you want to add rye to breads, substitute

rye for a quarter of the wheat. And gluten-free blends should work in any recipe calling for wheat flour, but as with any substitution, sometimes you need to try it several times to get it just right.

SUGAR AND SYRUPS. You'll need supermarket granulated white sugar, as well as light and dark brown sugar and confectioners' (powdered) sugar, if you want to bake in the Southern style. Yes, Southern desserts are sweet. With that in mind, I've offered ranges of sugar where I can, omitted sugar in crusts and whipped cream, added kosher salt to balance the sweetness, and, when possible, reduced the sugar, as in banana bread and chocolate meringue pie. Humidity in the South keeps brown sugar from getting hard and lumpy, but regardless of where you live, seal the opened bag well (I tape it shut) before storing. Sift powdered sugar before folding into icings, because a humid kitchen creates aggravating lumps. In really old recipes, you might see the words "sifted sugar," which generally means finely granulated sugar sifted over the top of the cake or pie while it is warm, so it forms a glaze. In making pecan pies and anytime a recipe calls for light or dark corn syrup, you can try a syrup with a little more flavor, such as cane syrup, sorghum, molasses, agave, or date syrup.

MILKS. I use whole cow's milk unless otherwise noted. And it's usually cold from my fridge unless I say to warm it, which I advise in making pound cakes and especially if your butter is soft and your eggs are at room temperature. The batter will beat up more smoothly, and you should get a nicer rise from the cake. If a recipe calls for scalding milk, this means heating it to 170°F, or until you see steam come off the milk and little bubbles form around the outside of the pan. Some bread recipes call for scalded milk, since people used to think the enzymes in the milk had a detrimental effect on yeast, so heating it to a "scald" took care of that, and I suggest scalding milk in some recipes. When making custards, breads, or cake, give the milk sufficient time to cool before adding it to eggs or yeast, which dies at 138°F and higher. Canned evaporated milk has a little higher fat content than whole milk, and you can substitute it for whole milk. If a recipe calls for canned milk and you don't have it, use half-and-half from the fridge instead.

DAIRY-FREE MILK. You can substitute a dairy-free milk for some recipes, depending on the recipe and why milk is in the recipe. If it's in a cake or pudding or to add richness to a recipe, as in yeast rolls, you should be able to substitute unsweetened canned coconut milk. Oat and rice milks are not as rich as coconut milk, and, in my opinion, they are less than ideal to bake with but work in glazes and anytime the fat in milk is there simply as a liquid and not to contribute texture and flavor.

SOUR MILK. When refrigeration was limited, milk soured because there was no place to keep it fresh. And so older recipes often call for "sour milk" or "clabber," milk that soured and thickened. We use buttermilk for these recipes today, or "sweet milk," which is whole milk.

BUTTERMILK. Indispensable in baking biscuits, cakes, and pies, buttermilk courses through the veins of Southern baking. We're fortunate in the South to be able to find buttermilk in just about any grocery, and it's often sold in convenience stores too. It was the beverage of old-timers, and Johnny Cash wasn't alone in his love of crumbling cornbread into a tall glass of buttermilk. I recall this was the favorite beverage of my grandfather from western Tennessee, and when he was older and came to live with us, my mother baked cornbread just for him to crumble into buttermilk. There's a difference in the buttermilk of the past and present. Buttermilk used to be the liquid left behind after churning cream into butter. But it's very hard to find that kind of buttermilk today. Most is a cultured low-fat product, thinner than yogurt. If a recipe calls for buttermilk, low-fat buttermilk is fine for everyday cornbread, but preferably buy whole, artisan buttermilk if you can find it, such as Cruze buttermilk, made in Knoxville, or Marburger, made in Evans City, Pennsylvania, and sold in many supermarkets.

If you can't find whole buttermilk, substitute crème fraiche in richer cake recipes and panna cotta. In breads like biscuits and cornbread, you might want to use unflavored, unsweetened yogurt (not Greek yogurt with gums or thickeners in it), because it has more acidity and will react with the baking soda in the recipe and create more rise and flavor. Look at the ingredient panel for the yogurt. You want milk and cultures as the sole ingredients, and not anything thickened with tapioca.

SALT. The ingredient most often left out of Southern home-baked recipes is salt, possibly because cooks don't think it's needed. But it is crucial in flavoring breads and balancing the sweetness of pie fillings and cake frostings. I realize that seasoning food with salt is a personal thing, so I like the words "to taste" because we all have our own tastes. But in baking, the salt is there to provide balance, and leaving it out unbalances the flavor and makes a baked good taste sweeter and flat. I have tested these recipes with both table salt and kosher salt, which has larger grains and is flakier, and thus its volume is different if you measure by the teaspoon. Weights are the same. So to make things simple, I say "salt" when I mean table salt. I call for "kosher salt" when it improves the recipe. I like Diamond Crystal kosher salt. If you don't have table salt and are using kosher salt, use slightly more. If you don't have kosher salt when a recipe calls for it, use slightly less table salt.

CHOCOLATE AND COCOA. The recipe tells you the type of chocolate to use—unsweetened, semisweet, bittersweet, German. You have a bit of wiggle room in the semisweet-bittersweet world, and this is a good place to experiment with some 60 percent cacao and higher, should you like things less sweet, say in a glaze or cake. When chocolate chips are called for, most people buy semisweet, but you can find 60 percent cacao chips, and they have a lot more flavor. If you don't have chips, don't stress. Just chop bar chocolate with a heavy knife until it's chip-size. One cup of chips equals 6 ounces of chocolate. As for cocoa, I'm old-school, and most of these recipes were made with Hershey's unsweetened regular cocoa, not Dutch-process. If you want a darker color and deeper flavor in a frosting, use Dutch-process.

Equipment for Baking

DRY AND LIQUID MEASURES. For measuring teaspoons and tablespoons, you need a set of little spoon measures that go in increments from 1/4 teaspoon up to 1 tablespoon. And if you prefer cup measures to a scale, use a set of dry measures from 1/4 cup up to 1 cup. For liquid measures, use a glass 1-cup measure as well as a larger 2-cup measure.

KITCHEN SCALE. Place this item on your wish list, because it will not only streamline and make baking faster, but it will make it more accurate as well. You can measure in grams or ounces, and you can zero out the mixing bowl at any time should you need to add another ingredient. In making two loaves, three cake layers, or dozens of cookies and rolls, a kitchen scale brings consistency to the process and helps you make sure each loaf, layer, dollop, or spoonful weighs the same, which means they bake in the same amount of time.

SPOONS, SPATULAS, AND WHISKS. Choose rounded or flat (for stirring custards) wooden spoons for stirring, metal spatulas for frosting cakes, and rubber spatulas for blending. Whisks in various sizes are handy for blending dry ingredients and helping yeast dissolve into a warm liquid.

ELECTRIC MIXER. You can make most all the recipes in this book with a hand mixer, but for heavier bread doughs and pound cakes, a stand mixer is crucial. A stand mixer also frees you to do other steps or wash up while you wait for it to do its job. A KitchenAid with a paddle attachment is the most powerful, and with a whisk it effortlessly whips cream and meringues.

INSTANT-READ THERMOMETER. This tool is helpful when baking bread and cake to determine when they are done, Also, you can take a quick temperature of fillings and puddings.

FOOD PROCESSOR. A food processor is useful for all sorts of tasks, from pulsing crackers into crumbs for piecrusts to blending batters.

IRON SKILLETS. Essential for cornbread and biscuits, iron skillets are handy for cakes and pies too. Most recipes call for a 10- or 12-inch skillet. I also use cast-iron wedge pans and corn stick molds.

CAKE PANS AND CAKE STANDS. Depending on the recipe, pans should be shiny and not dark 8- or 9-inch, round or square. (Dark cake pans are too absorbent and cause edges to darken.) I also bake cakes in a 10- to 12-cup Bundt pan and 10-inch tube pan. Having a 9-inch springform pan for cheesecakes is nice, as is a 9-by-13-inch pan for snack cakes. Cake stands make the simplest cakes more beautiful.

MUFFIN AND CUPCAKE PANS. The old iron muffin pans used to be called "gem irons." Use your heirloom pans for baking corn muffins, or use a standard muffin or cupcake pan. A few recipes call for mini muffin pans, which make muffins about a third of the size of a standard muffin.

SHEET PANS AND WIRE RACKS. Rimmed baking sheets from 12-by-17 to 13-by-18 inches are invaluable in cooking and baking, and I use them throughout this book for prep work, baking rolls and biscuits, and draining fried foods. A jellyroll pan is a slightly smaller 10-by-15-inch pan designed for cake rolls. Using wire racks is the best way for a cake layer to cool or fried foods to drain.

LOAF PANS. Most recipes call for 9-inch loaf pans. You can always bake loaves in smaller pans for gifts, with shorter baking times, of course.

PIE PANS. Metal, glass, and ceramic all work, and 9 inches is the most universal size.

SPECIALTY PANS. I call for a popover pan, but you can use a large muffin pan, and I suggest a 4- to 8-cup ring mold for flan. A 1- to 2-quart footed trifle dish is nice for the sherry trifle, but you can absolutely assemble it in your nicest mixing bowl. Or borrow these pans from a friend, or let someone gift them to you!

DEEP POT FOR FRYING. I use a Le Creuset Dutch oven, but any deep, heavy pot will work.

HEAVY PAN FOR CUSTARDS OR DOUBLE BOILER. A heavy copper pan or a double boiler is perfect for stirring stovetop custards involving eggs. If you don't want to invest in these, you can create your own bain-marie, or water bath, by fitting a medium stainless-steel bowl on top of a saucepan of simmering water. The bottom of the bowl needs to fit inside the top of the pan but not touch the water.

GRIDDLE. It's easier to turn corn cakes or pancakes on a griddle, but you can also use a large iron skillet.

SIZZLING —————
CORNBREAD

Perhaps no bread in the world is quite as good as Southern corn bread, and perhaps no bread in the world is quite so bad as the Northern imitation of it.

—MARK TWAIN (SAMUEL LANGHORNE CLEMENS) FROM *CHAPTERS FROM MY AUTOBIOGRAPHY, NORTH AMERICAN REVIEW*, 1906–1907

Makin' corn bread is like makin' love. No matter where you do it it's called the same thing but how you do it makes a heap o' difference.

—PRINCESS PAMELA STROBEL, *PRINCESS PAMELA'S SOUL FOOD COOKBOOK*, 1969

The best way to appreciate and understand a cracklin' is to hold a still-warm nugget between your thumb and forefinger and gently press them together. The essence that oozes out of the cracklin' is all that is good about Southern cooking, literally rendered into a speck of happiness.

—RICK BRAGG, *THE BEST COOK IN THE WORLD: TALES FROM MY MOMMA'S TABLE*, 2019

Before ovens, wheat, yeast, dough paddles, bench scrapers, and all the other accoutrements to bake bread, there was corn and fire. A little later, an iron skillet. So cornbread became the South's first daily bread.

When the European explorers ventured into the South, they found Indigenous People growing corn in fields. "Maize," as it was called, was a sacred grass farmed and stored for cooking and saved for next year's seed. While corn is native to the Americas, the Europeans introduced it to other parts of the world, including Africa. As Fred Opie wrote in his book *Hog and Hominy*, travelers in Africa in the 1600s observed women in the Congo, Angola, and São Tomé grinding corn, wrapping corn mush in banana leaves, and baking it in the cinders of the fire. That same preparation is what the Choctaw people of Mississippi, Louisiana, and Oklahoma knew as *bahana* when they were interviewed by reporters with the 1935 Works Progress Administration (WPA).

Corn was easy to grow. It could be planted in small hills on uncleared land and required no

Church in cornfield near Manning, South Carolina, 1939

plowing or animal power. Conveniently, it didn't need to be harvested at the same time as tobacco. So in early Maryland, Virginia, North Carolina, Tennessee, and Kentucky, where the economic focus of the first colonists and settlers was on tobacco, corn had advantages over more labor-intensive wheat. Even in places where tobacco wasn't the center of the economy, people grew fond of corn because they could grow a patch of it and have it milled or grind it themselves to feed their family.

Before long, in the small towns dotting the South, river currents powered mills and turned heavy millstones to grind the local corn into meal that tasted as sweet as the corn itself. It was a system of farming and food production rooted in necessity and feeding people. Cornmeal was scalded with boiling water and shaped into hoe cakes and ash cakes, and it made its way into cornbread baked in a sizzling iron skillet. Regardless of socioeconomic status or race, cornbread was accessible.

But technology and change came to corn just as it did to cotton and other products of the Southern land. At the turn of the twentieth century, steel roller mills could increase the shelf life of mass-produced cornmeal, but the flavorful germ—the heart of the corn—was removed. This new cornmeal was finer in texture than the older stone-ground, but the flavor of cornbread became less naturally sweet.

Yet in some remote places, like War Eagle Mill in northwestern Arkansas and The Old Mill in eastern Tennessee, progress didn't replace the old artisanal skill of grinding corn between stones. They've been quietly stone-milling corn and selling it to mail-order customers the way they've always done.

Today, we find cornmeal of all textures and colors—white, yellow, blue, red, and shades in between.

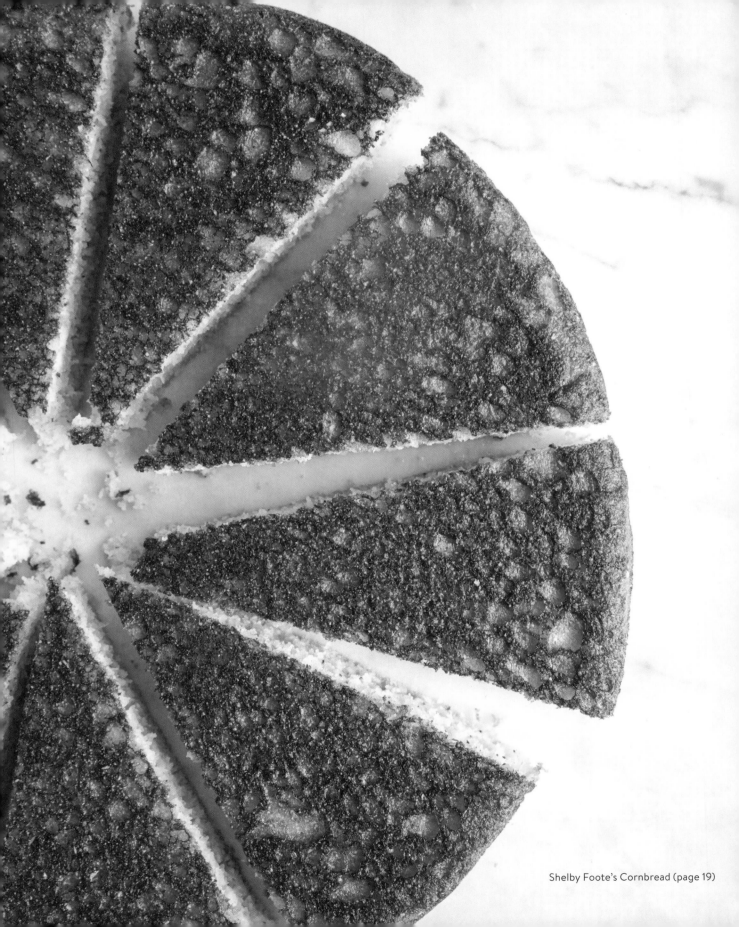

Shelby Foote's Cornbread (page 19)

We can choose cornmeal finely ground and silky to bake into creamy spoonbread, or coarse and unbolted, meaning the flavorful hull and germ haven't been removed, to make into crispy hot water corn cakes.

Many Southern cooks have as strong a preference about cornbread as they do about politics or religion. Should cornmeal be yellow or white? Should cornbread be sweet? These questions are of existential importance in the South, something that philosophers and theologians might not discuss but families do. Inevitably, cornbread is about how your mama made it.

"To me, yellow cornmeal has a more pronounced corn flavor. It's what we were raised on," says food writer Katharine Shilcutt of Houston. When she was growing up in eastern Texas, cornbread was a big deal. "It went with everything . . . beans or peas cooked with ham or with collards, kale, or mustard greens." Crescent Dragonwagon, author of *The Cornbread Gospels* (2007), who lives in Fayetteville, Arkansas, bakes with both white and yellow cornmeal and finds the white more delicate and subtle and the yellow sweeter.

Adding sugar to cornbread is even more controversial, and arguments over that have erupted everywhere. Linda Carman, who, as home economist for Nashville's Martha White Foods, taught much of the South to bake cornbread, tells the story of her predecessor, Alice Jarman, who put a teaspoon of sugar into cornbread because she thought it improved the flavor. Jarman and Tennessee Ernie Ford got into heated arguments, with the country music star saying, "I just do not want the sugar bowl anywhere close to my cornbread."

Deadrick Moon, my husband's aunt's husband, would have agreed. At his 2022 funeral in Chattanooga, his son, John, recalled that at their kitchen table his father would warn him, "Never, *never* put sugar in your cornbread." (He received further admonishments when he was discovered putting jam on his cornbread.)

Where sugar does creep into cornbread, it might be there for a reason. Because of warm climates, cornmeal could lose its freshness on the kitchen shelf, and a little sugar made it taste better.

This chapter is filled with cornbread, sweet and savory. From crispy corn cakes to corn muffins to the cornbread soufflé, better known today as spoonbread, there are so many wonderful ways to bake cornbread. There is molasses cornbread as the author Zora Neale Hurston might have baked it in Florida, and egg bread, which I grew up on in Nashville, over which my mother spooned creamed chicken. There is cracklin' cornbread with flecks of crispy pork inside, as well as cornbread baked in cake pans and sweet cornbread with coconut.

People love a good riff on cornbread, adding jalapeños and cheddar cheese or cilantro and Parmesan, what the Mississippi chef and cookbook author Vishwesh Bhatt calls "not your mama's cornbread."

You'll see there are different strategies for making cornbread, which have less to do with the cornmeal's color or how finely it's ground and more to do with the amount of buttermilk used. A few recipes, such as Rona Roberts' Brown Butter Kentucky Cornbread and the Carter White House Cornbread, call for the cornmeal to be well soaked in buttermilk or milk as a way of softening the texture. It works!

To much of the South, cornbread is simple and comforting, made from a recipe so basic you almost don't need one, or by memory the way your family made it, or from the one printed on the back of the cornmeal bag.

But in case you need recipes, I've got some you'll want to try.

CORNBREAD LINGO

Types of Cornmeal and Corn

CORNMEAL. Dried corn ground to various degrees of coarseness, from finely ground to coarsely ground to someplace in between.

 BOLTED CORNMEAL. Sifted cornmeal, often enriched with niacin.

 UNBOLTED CORNMEAL. Not sifted and contains the whole corn with no enrichments.

DENT CORN. The easy-to-grind type of corn named because of the slight dent in the center top of the kernel.

FLINT CORN. An older and harder type of corn loved for white grits and cornmeal, but it wasn't as easy to mill as dent corn.

HOMINY. Dried corn kernels soaked in an alkaline solution, so the hulls slide off. It can be cooked much like beans. This is what grits are called in the Lowcountry of South Carolina.

MASA HARINA. Cornmeal that is made from the soft center of nixtamalized corn. It has a bright corn flavor and is used to make the dough for tamales and corn tortillas. You can also use it instead of regular cornmeal to bake cornbread.

NIXTAMALIZATION. The process, originally developed by Native Americans, of simmering dried corn with an alkali such as ash or lime to remove the tough hulls, which unlocks niacin and makes the corn softer and easier to grind. Nixtamalized cornmeal has more corn flavor and a longer shelf life. It's made into masa harina.

Types of Cornbread

CHICKEN BREAD. A Mississippi term for cornbread baked in a skillet after the chicken has finished frying.

CHEROKEE BEAN BREAD. Cornmeal mush containing cooked beans that's wrapped in corn husks before cooking.

COUCHE COUCHE. An old Creole dish, loved by children, and made by cooking cornmeal like porridge until it sticks to the side of the pan. Then you scrape that off and continue stirring until all the pot is cooked in the same fashion and is full of scrapings. Celestine Eustis, author of *Cooking in Old Creole Days* (1904), shared one of the first recipes. It is believed to have been an Alsatian recipe with roots in mountainous France, where cornmeal mush was cooked like polenta.

HOE CAKE. A hand-formed cornmeal mush patty, much like a johnnycake. Edna Lewis wrote that a hoe cake should be "in a large egg shape" with the fingerprints of the maker left behind. Hoe cake can also mean a pan of cornbread, as when Vertamae Smart-Grosvenor wrote about her Grandmama Sula's Hoe Cake in her cookbook *Vibration Cooking* (1970).

JOHNNYCAKE. A small fried or griddled patty, also called "journey cake" or "corn dodger." Some historians say the term comes from the Native American "Shawnee," while the late historian Karen Hess said johnnycakes were derived from *jannocken*, the little oat cakes of Lancashire, England.

PONE. An individual corn cake. The word also has come to mean a skillet full of cornbread.

Corn Sticks (page 10)

FINDING *Family*

Family records, especially between 1750 and 1865—wills, estate inventories, letters, family Bibles, plantation books, and bills of sale—can be fonts of information for Black families searching for their stories, says Curtis Flowers of Florence, Alabama. Wills and estate inventories are usually held in the probate office of the county where the deceased person lived. "Shedding light on enslaved people as individuals honors their lives," she says. "One lady shared how she had been able to add three generations to her family history from one record. When she found that small piece, she broke down and wept at the enormity of it."

Nina Cain's Batty Cakes with Lacy Edges

Nina Cain was known for her cornmeal "batty cakes," little lacy corn cakes the size of a silver dollar and fried in hot lard. She was the cook of Curtis Flowers' grandmother in Florence, Alabama, and the family has tried for years to re-create this beloved recipe. Years ago, Flowers, at the suggestion of the late novelist Alex Haley, looked to find the names of enslaved people who worked in their cotton fields prior to Emancipation. She had once seen her great-great-great-grandfather's 1840 will and estate inventory, and she remembered it contained the names of people he'd held as slaves. Haley encouraged her to make the names available in the local history section of her public library.

When making the batter, add a little hot water, a tablespoon at a time, if it gets too thick. That keeps the edges lacy, a characteristic of the recipe.

Makes 24 (3-inch) corn cakes	Prep: 10 to 15 minutes	Cook: 2 minutes per batch

1 cup (130 grams) finely ground white
 cornmeal
1/2 teaspoon salt
1/2 teaspoon baking soda
1 1/4 cups whole buttermilk
1 large egg
1/4 cup vegetable oil or melted lard for
 frying, as needed

1. Whisk together the cornmeal, salt, and baking soda in a large bowl. Pour in the buttermilk, add the egg, and whisk until just combined. Set aside.

2. Place a heavy griddle over medium heat. When it's hot, pour on 2 teaspoons of the oil or lard and, with a metal spatula, move it around the griddle to coat.

3. Drop the batter by the tablespoon onto the griddle, 4 to 6 at a time. When bubbles begin to form around the edges, about 1 minute, flip the corn cakes with the metal spatula to cook on the other side for 1 minute. Adjust the heat as needed so the corn cakes don't get too brown too fast. Remove them to a warm platter. Repeat with the remaining batter, adding 2 teaspoons more oil for every 4 to 6 you cook. Serve.

CHANGE IT UP

Add 1/2 teaspoon cracked black pepper, 1 tablespoon minced fresh chives, or 1/2 cup fresh corn kernels to the batter.

The Colonnade's Corn Muffins

When I lived in Atlanta and was young and homesick for Southern cooking, I'd stop by The Colonnade on Cheshire Bridge Road for fried chicken, collard greens, and corn muffins. Those muffins were hot and crispy outside, but soft and creamy inside—everything a good corn muffin should be. The Colonnade is an institution in Atlanta and began in 1927 in a white columned house at the corner of Cheshire Bridge and Piedmont. It's only changed ownership hands once since 1979. I was happy to find the recipe for their muffins and be able to bake them at home.

To re-create these just like the restaurant cooks bake them, place the greased muffin pan in the preheating oven to get nice and hot and then pour in the batter, which yields those crispy edges and that creamy interior. It's all about timing to get this recipe right, but it's worth it.

Makes 12 muffins Prep: 15 to 20 minutes Bake: 15 to 20 minutes

1 tablespoon vegetable oil or melted lard for greasing the muffin cups
1 1/2 cups (195 grams) finely ground white cornmeal
1/2 cup (60 grams) all-purpose flour
4 teaspoons granulated sugar
2 1/4 teaspoons baking powder
1 teaspoon salt
3/4 cup water
1/2 cup vegetable oil
1/2 cup buttermilk
2 large eggs

1. Heat the oven to 450°F, with a rack in the middle. Grease a muffin pan with the vegetable oil or lard and place in the oven for 3 minutes as the oven gets close to 450°F.

2. Whisk together the cornmeal, flour, sugar, baking powder, and salt in a large bowl. Add the water, oil, buttermilk, and eggs and beat with a wooden spoon until just combined, less than a minute.

3. Carefully pull the hot pan from the oven, and spoon the batter into the muffin cups, filling them about two-thirds full. Bake until the muffins are golden brown, 15 to 20 minutes. Serve hot.

HOW TO MAKE PERFECT CORN STICKS

This is a wonderful recipe to pour into corn stick pans. You will need two pans of 9 sticks each. If you have just one pan, bake a batch at a time. Grease the molds generously with oil or vegetable shortening and heat in the oven at 450°F while you prepare the batter. Carefully remove the hot molds from the oven and divide the batter among them, filling right to the top of the mold. Bake until the corn sticks are golden, 12 to 15 minutes. Serve hot.

EMBRACING OUR *Roots*

Kevin Gillespie once told the Southern Foodways Alliance, "I, for one, know that when I pull that skillet from the oven, watch that hot fat dance across the shiny blackness of its surface, pour that batter in and listen to it sizzle, I am embracing the humble roots of humanity and of those people who gave me the name Gillespie."

Kevin Gillespie's Cornbread Wedges

Atlanta chef Kevin Gillespie's recipe for his crispy little cornbread wedges is in his head. He first tasted it when it was baked by his grandmother, Geneva Gillespie, in Locust Grove, Georgia, "and that recipe predates her, and her mother as well," he says.

I tried to eke the recipe out of Gillespie, asking questions like, "How much buttermilk?" His reply: "A lot." After no secrets were revealed, I ordered an eight-wedge pan from Lodge, which is what the chef uses, and bought fine white cornmeal from J.T. Pollard in southern Alabama, also what the chef uses. Then I got in the kitchen to create my version of Gillespie's cornbread. And you know what? It's pretty darned close.

While the restaurant chefs toss in sausage drippings and rendered ham fat, and Gillespie's grandmother used a bit of hog fat, bacon drippings, and lard to make her cornbread special, I keep mine simple. "My granny tells me her mother wanted the inside of cornbread to be creamy," the chef says. "My family is a cake family, not a pie family. We like our cornbread to be delicate."

Makes 12 wedges	Prep: 10 to 15 minutes	Bake: 12 to 15 minutes

2 cups (260 grams) finely ground white cornmeal

1 tablespoon baking powder

1 teaspoon kosher salt

1/2 cup vegetable oil or melted lard, divided

2 cups whole buttermilk

1. Heat the oven to 425°F, with a rack in the middle. Place an 8-wedge cast-iron skillet (see Note) over medium-high heat.

2. Whisk together the cornmeal, baking powder, and salt in a large bowl. Pour in 1/4 cup of the oil or lard and the buttermilk and stir until just combined.

3. When the skillet is hot, pour 1 teaspoon of the oil or lard into each wedge. When the oil smokes, add a heaping 1/4 cup batter to each wedge. Carefully place the pan in the oven and bake until the cornbread is lightly browned on top and each wedge feels firm when pressed lightly on top, 12 to 15 minutes. Remove the pan from the oven, run a knife around each wedge, and turn them out.

4. To use the remaining batter, place the skillet back over medium-high heat. Add 1 teaspoon oil to half of the wedge indentations and pour in the rest of the batter. Bake as directed above. Serve hot.

NOTE:

If you don't have a wedge pan, use a muffin pan that you've preheated in the oven. Bake the muffins for 15 to 20 minutes.

Hot Water Corn Cakes

My mother preferred biscuits to cornbread, but there was one cornbread she made often because my father loved it so—hot water corn cakes, which were soft and creamy inside and crispy around the edges. She whisked white cornmeal into salted boiling water, which partially cooked and hydrated the cornmeal at the same time, creating a pudding-like creamy center in the corn cakes that contrasted beautifully with the crunchy fried exterior. I knew she was trying to duplicate the corn cakes served alongside the white bean soup at a restaurant called Nero's Cactus Canyon in Nashville. I remember her hand-forming them and dropping them into a skillet and shallow-frying them, but it wasn't until years later when I got my hands on some stone-ground white cornmeal from The Old Mill that I was able to duplicate my mother's and Nero's method. And that's the beautiful thing about this recipe. It contains more memories than ingredients.

| Makes about 16 little cakes | Prep: 5 to 10 minutes | Chill: 20 minutes | Cook: 4 to 5 minutes per batch |

2 cups water

1 teaspoon salt

1 1/4 cups (170 grams) coarsely ground white cornmeal (see Note)

2 cups vegetable oil for frying

NOTE:

If you are using a finer (bolted) cornmeal, you need less water. For 1 1/4 cups fine cornmeal, use 1 1/4 to 1 1/2 cups boiling water and the same amount of salt.

1. Place the water and salt in a medium saucepan over high heat. Bring to a boil. Once the water is boiling, turn off the heat and whisk in the cornmeal until smooth and thick. Turn the cornmeal mixture into a bowl and place it in the refrigerator, uncovered, to chill, about 20 minutes.

2. When you're ready to fry, pour enough oil in a 10- to 12-inch iron skillet to measure 1 inch. Heat the oil over medium-high heat until it reaches 350°F. While the oil is heating, spoon the chilled cornmeal mixture in 2- to 3-inch rounds, about 1/2 inch thick, onto a baking sheet.

3. When the oil is hot, slide 3 or 4 cakes at a time into the oil, and let them cook until well browned on one side, then turn and let them brown on the other side, 4 to 5 minutes total. Remove to a wire rack or brown paper to drain. Repeat with the remaining cornmeal mixture. Serve hot.

Hoe Cakes and Ash Cakes

"Hoe cakes," similar to hot water corn cakes in size and texture, were supposedly named because they were cooked over fire on the blade of a hoe. But the historian Rod Codfield discovered that the word *hoe* is a Scottish term for griddle. Hoe cakes and johnnycakes were cooked on a griddle over the coals of a fire or placed on a board that leaned up next to the fire to cook by radiant heat.

Ash cakes were hoe cakes that were cooked on a hot stone or a hearth that had been swept of coals and ashes. To protect them from dirt, they might be wrapped in soaked corn husks, rather like tamales, or laid on the husks and left unwrapped.

Culinary historian Adrian Miller says the early colonists were near starvation when Native Americans showed them how to grow corn. "But the untold story is the amount of contact enslaved Blacks had with Native Americans, especially on the perimeters of plantations," Miller says. Both survived on ash cakes. They were portable too. "You could make this bread and take it with you." In a 1937 Works Progress Administration interview, Andrew Moss, a formerly enslaved man from Georgia, remembered ash cakes during the Civil War: "We was glad to eat ash-cakes and drink parched corn and rye 'stead o' coffee." In his 1855 autobiography, *My Bondage and My Freedom*, Frederick Douglass, who escaped from slavery in 1838 and changed his surname from Bailey to Douglass, noted that the enslaved took the cakes to the fields because they "do not come to the quarters for either breakfast or dinner."

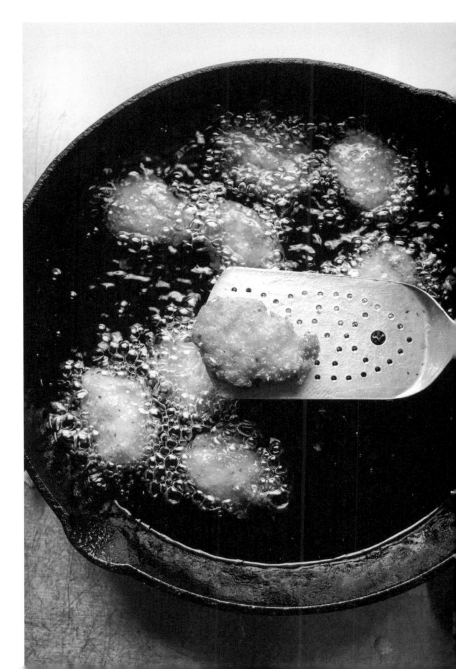

Linda Carman's Back-of-the-Bag Cornbread

The cornbread of Linda Carman's youth in Cullman, Alabama, in the 1950s was thin and crispy. Her mother baked it in a big cast-iron skillet, heating bacon grease or vegetable oil and adding that fat to the batter, which was poured back into the hot skillet and baked in a hot oven. That's the secret to great cornbread, says Carman: getting that skillet really hot. "My daddy had a couple of furniture stores in town, and he came home for dinner in the middle of the day," says Carman. "Mama would always say, 'Call Daddy and tell him dinner is about ready and he can come on home if he doesn't have a customer.' Then she'd say, 'Watch for his pickup coming down the hill,' and then she'd take the hot skillet out of the oven and pour cornbread batter in it. It was piping hot when we sat down."

Helping her mother in the kitchen gave Carman all the preparation needed for the career she would step into: home economist for Martha White, the Nashville flour and cornmeal company. She traveled into West Virginia to share the marvels of self-rising cornmeal with mountain cooks. "These women looked at me and said, 'You're gonna teach us about cooking cornbread?' I realized it was not going to work if I acted like an authority, and I'd always tell them, 'If you know how to make cornbread and your family loves it, keep making it the same way. But if you don't know how, I can show you a recipe.'"

Here is Carman's favorite cornbread recipe, just like her mother baked it, and so good she put it on the back of the Martha White cornmeal bag.

Serves 8	Prep: 10 to 15 minutes	Bake: 20 to 25 minutes

1/4 cup vegetable oil or bacon
 grease
2 cups (260 grams) finely ground
 self-rising white cornmeal mix
 (see below)
1 1/3 cups whole milk or 1 3/4 cups
 buttermilk
1 large egg

Homemade self-rising cornmeal mix: stir together 6 cups cornmeal, 1 3/4 cups all-purpose flour, 1/4 cup baking powder, and 4 teaspoons salt. Use 2 cups in this recipe.

1. Heat the oven to 450° F, with a rack in the middle. Pour the oil or bacon grease in a 10-inch cast-iron skillet and place the skillet in the oven. When the oil gets hot—keep an eye on it— pull it out of the oven.

2. Meanwhile, place the cornmeal mix, milk or buttermilk, and egg in a large bowl. Stir to combine. Pour the hot oil from the skillet into the bowl and stir to combine. When the batter is smooth, pour it into the hot skillet. (If necessary, during the time you're stirring the batter, place the skillet back in the oven to make sure it stays hot.)

3. Bake until the cornbread is golden brown, 20 to 25 minutes. Remove from the oven, run a knife around the edges, and immediately flip out onto a cutting board. Slice and serve warm.

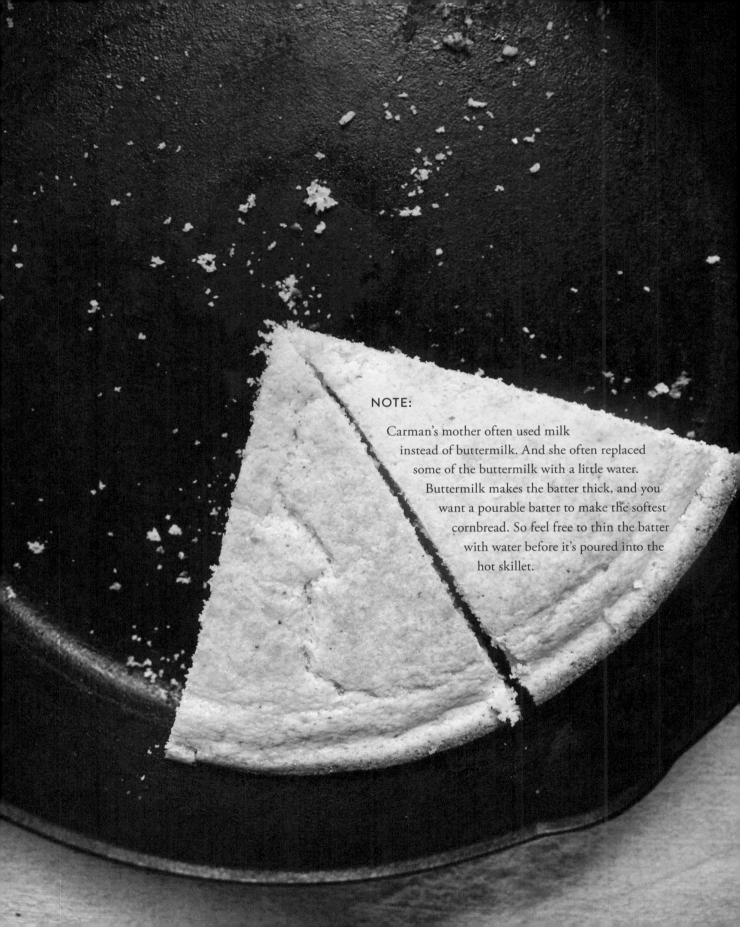

NOTE:

Carman's mother often used milk
instead of buttermilk. And she often replaced
some of the buttermilk with a little water.
Buttermilk makes the batter thick, and you
want a pourable batter to make the softest
cornbread. So feel free to thin the batter
with water before it's poured into the
hot skillet.

MARTHA WHITE AND THE GRAND OLE OPRY

The Martha White brand of flour and cornmeal began with Nashville-based Royal Flour Mills in 1899. The flour and cornmeal were named after the daughter (Martha White) of the founder, Richard Lindsey. "Self-raising" flour had been invented in England in 1845, when baker Henry Jones sought a quicker alternative to yeast. He incorporated baking soda and cream of tartar in a flour blend in the hope that the British government would adopt it and offer freshly baked bread—instead of hard-tack biscuits—to its naval forces around the world. Once self-rising flour and cornmeal came to America, the South embraced them. Martha White's self-rising products were called "Hot Rize," and they were marketed to the rural South on the radio.

Martha White became a sponsor of the Grand Ole Opry, the live weekly AM radio show featuring country and bluegrass music. Linda Carman recalls that a Martha White flour salesman in East Tennessee told his company's president, Cohen Williams, there was a band he needed to listen to. Williams did, and he hired Lester Flatt, Earl Scruggs, and the Foggy Mountain Boys and gave them a bus called the Bluegrass Express—emblazoned with the company's name, of course—to take the South by storm. But here was the catch. He told them they had to play 5:45 a.m. radio shows. "Why so early?" they asked. "Well,"

Williams replied, "people who make biscuits and cornbread and all of that are out in the field working by 8 or 9." Flatt and Scruggs would write a song about those light biscuits and cornbread and call it "The Martha White Theme."

Shelby Foote's Cornbread

Civil War historian Shelby Foote told Atlanta writer Jim Auchmutey that he spent twice as long perfecting his cornbread recipe as he did researching his massive trilogy about the Civil War. The native of Greenville, Mississippi, said, "You would think something so simple would be easy, but it isn't. . . . I've been making it all my life, but it wasn't until ten years ago that I found a recipe that pleased me. I like the top to be crunchy and as thin as newsprint. I'm very particular about it." No flour. Use bacon grease or lard and either white cornmeal or yellow. (Auchmutey said Foote preferred yellow.) And the tablespoon of sugar? Foote was lambasted by critics for adding it, but when you try this recipe, you will see how it helps balance the salt in the bacon grease and makes the cornmeal taste sweeter. From its Delta roots to Foote's Memphis kitchen, this recipe has evolved from plain old cornbread to a life's work.

Serves 8	Prep: 10 to 15 minutes	Bake: 10 to 14 minutes

1 cup (136 grams) coarsely ground white
 or yellow cornmeal
1 tablespoon granulated sugar
1 1/2 teaspoons baking powder
1/2 teaspoon baking soda
1/2 teaspoon salt
1 cup whole buttermilk
1 large egg
3 tablespoons bacon grease
1 tablespoon vegetable oil

1. Heat the oven to 450ºF, with a rack in the middle.

2. Whisk together the cornmeal, sugar, baking powder, baking soda, and salt in a large bowl. Make a well in the center.

3. In a small bowl, whisk together the buttermilk and egg and pour this mixture into the well in the cornmeal mixture. Stir with a wooden spoon or fork until just mixed.

4. Meanwhile, place a 10-inch cast-iron skillet over medium heat. Add the bacon grease and oil and heat until it begins to smoke, 2 to 3 minutes. Pour nearly all the fat into the batter and stir quickly to combine. Pour the batter into the hot greased skillet and carefully place the skillet in the oven. Bake until the cornbread is golden brown and crusty on top, 10 to 14 minutes. Remove from the oven, run a knife around the edges, and immediately flip out onto a cutting board. Slice and serve.

Rona Roberts' Brown Butter Kentucky Cornbread

Lexington, Kentucky, author and radio host Rona Roberts grew up on a farm seven miles from Monticello, in southeastern Kentucky, where her parents were teachers and farmers. The cornbread she bakes is a bit like her mother's, because she lets the cornmeal soak in the buttermilk first to soften it. But having given up gluten and bacon, Roberts uses no wheat flour in the preparation and relies on the flavor of browned butter to give the cornbread depth. "My mother believed that anything was better with browned butter," she says. It wasn't until Roberts hosted weekly community potlucks for nine years straight, baking this cornbread every week for them, that she worked out a recipe for it. "I made two 10-inch skillets of it each week. People kept asking for the recipe." What follows is her basic recipe.

Optional add-ins are coarsely ground black pepper; sliced jalapeños; some grated Parmesan or cheddar; finely chopped onions, shallots, or green onions; chopped cooked bacon; and fresh corn kernels. To make the bottom of the cornbread extra crispy, Roberts uses a trick her sister Paula taught her: scatter some cornmeal in the hot pan before adding the batter, let that heat in the residual grease in the pan, and then pour in the batter and bake.

Serves 8 Prep: 10 to 15 minutes Soak: Overnight to 24 hours Bake: 18 to 22 minutes

2 1/2 cups (340 grams) coarsely ground white cornmeal, plus 1 tablespoon for the skillet (see Note)

2 cups whole buttermilk

6 tablespoons (3/4 stick/86 grams) unsalted butter, coconut oil, or bacon fat

1 large egg

1 tablespoon baking powder

1 teaspoon salt

1/4 teaspoon baking soda

1/4 to 1/2 cup boiling water

NOTE:

Roberts uses an unbolted (unsifted) white cornmeal from Kentucky's Weisenberger Mill or hand-milled Hickory King cornmeal from Sunrise Sundries in Mount Olivet, Kentucky.

1. Place the 2 1/2 cups cornmeal in a large bowl and stir in the buttermilk. Cover the bowl and refrigerate overnight or up to 24 hours.

2. When you are ready to bake, heat the oven to 425°F, with a rack in the middle. Remove the bowl of cornmeal from the fridge.

3. Place the butter, oil, or bacon fat in a 10-inch cast-iron skillet over medium heat. (You can also place the skillet in the preheating oven, but I find the butter is easier to watch if it's on the stovetop.) Stir gently and let it melt and continue to cook until the milk solids turn to a nut-brown color, 4 to 5 minutes. Do not let it burn. (If you are using coconut oil or

bacon fat, gently heat them until hot but not smoking.) Pour all but 1 tablespoon of the fat into the bowl with the cornmeal. Add the egg, baking powder, salt, and baking soda and stir until smooth. Reheat the skillet until the fat clinging to it is hot. Pour 1/4 cup of the boiling water into the cornmeal mixture and stir until it is a pourable consistency. Add up to another 1/4 cup boiling water as needed to get to this consistency (a more pourable batter makes a creamier interior). When the skillet is hot, scatter the 1 tablespoon cornmeal over the bottom of the pan. Pour the batter into the hot skillet. It should sizzle. Turn off the heat on the stovetop and carefully place the skillet in the oven.

4. Bake until the cornbread is deeply browned around the edges and lightly browned on top, 18 to 22 minutes. Remove from the oven, run a knife around the edges, and immediately flip out onto a cutting board. Slice and serve.

SOAK IT!

There's something magical about cornmeal's powers of absorption. All it takes is 8 to 24 hours, or however much time you've got, for the cornmeal to absorb the buttermilk like a sponge in the refrigerator. When you pull it out of the fridge, it will be like thick porridge and ready for you to add the other ingredients.

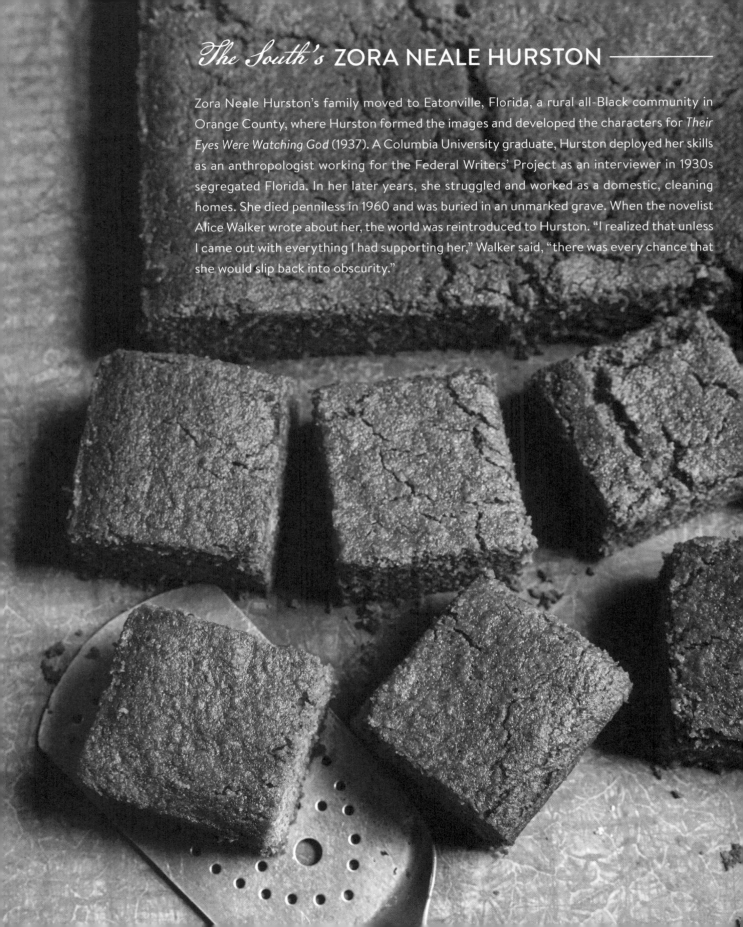

The South's ZORA NEALE HURSTON

Zora Neale Hurston's family moved to Eatonville, Florida, a rural all-Black community in Orange County, where Hurston formed the images and developed the characters for *Their Eyes Were Watching God* (1937). A Columbia University graduate, Hurston deployed her skills as an anthropologist working for the Federal Writers' Project as an interviewer in 1930s segregated Florida. In her later years, she struggled and worked as a domestic, cleaning homes. She died penniless in 1960 and was buried in an unmarked grave. When the novelist Alice Walker wrote about her, the world was reintroduced to Hurston. "I realized that unless I came out with everything I had supporting her," Walker said, "there was every chance that she would slip back into obscurity."

Molasses Cornbread for Zora Neale Hurston

The Harlem Renaissance novelist Zora Neale Hurston was born in the wintertime of 1891 in Notasulga, Alabama, back when Southerners harvested sweet potatoes and butchered hogs, using the frigid temperatures as a natural refrigerator. At the hog killings, the women made a hot lunch for the workers, wrote Fred Opie in his book *Zora Neale Hurston on Florida Food*, roasting sweet potatoes and baking hot cornbread with molasses, which makes it sweet and dense like a square of pound cake. According to the late Valerie Boyd in her biography of Hurston, *Wrapped in Rainbows*, when Hurston was nine months old, her mother gave her a piece of cornbread to placate her while she went down to the spring to wash collard greens. The door to the cabin was open, and in came a hungry sow lured by the smell of the child's cornbread. Pulling up to a chair to escape the sow, Hurston never crawled again. "I just took to walking and kept the thing a'going." Before modern ovens, molasses cornbread was steamed in an iron pot set over the hearth. This recipe, adapted from Opie's book and an 1892 *Florida Agriculturalist* bulletin, blends old and new.

Serves 8 to 12 Prep: 5 to 10 minutes Bake: 33 to 37 minutes

Vegetable oil for greasing the pan
2 cups (272 grams) coarsely ground
 yellow cornmeal
2 cups (264 grams) whole wheat flour
1 teaspoon salt
1/3 cup warm water
1 tablespoon baking soda
2 cups buttermilk
1 cup molasses

1. Heat the oven to 350°F, with a rack in the middle. Brush a 9-by-13-inch baking pan with vegetable oil.

2. Whisk together the cornmeal, flour, and salt in a large bowl. Pour the warm water into a small bowl or cup and stir in the baking soda to dissolve. Add to the cornmeal mixture, along with the buttermilk and molasses, stirring until just incorporated.

3. Pour the batter into the prepared pan and bake until the edges of the cornbread are crisp and the center is firm when gently pressed, 33 to 37 minutes. Cut into squares and serve.

Dairy Hollow House Cornbread

Cookbook author Crescent Dragonwagon has learned how people bake cornbread by paying attention. In 1969 a Brooklyn neighbor's friend named Viola, originally from Georgia, baked cornbread sweet with sugar and soft from wheat flour and shared some with her. "That cornbread blew my mind. I was sixteen," says Dragonwagon, born Ellen Zolotow in New York City. And so she wrote a book about it—*The Cornbread Gospels* (2007)—and for ten years she baked Viola's fluffy yellow cornbread for her dinner guests at the Dairy Hollow House, an inn in the Arkansas Ozark town of Eureka Springs. The trick was to bake each batch in a preheated skillet so it was crispy around the edges and soft inside. As her guests pulled back the napkin and peered into the bread basket, they would cry out, "Cornbread? I love cornbread!"

Dragonwagon, who now lives in Fayetteville, Arkansas, celebrates the diversity in cornbread. There is what she calls Yankee cornbread—sweet, made with milk, and baked in a cold pan—as well as Southern cornbread, thinner and more dense, baked in a hot skillet, and perfect for crumbling into a tall glass of buttermilk. And there is Viola's cornbread, which is how Dragonwagon likes it best, a blend of North and South, the best cornbread of all.

Serves 8	Prep: 10 to 15 minutes	Bake: 23 to 27 minutes

1 cup (136 grams) coarsely
 ground yellow cornmeal

1 cup (120 grams) unbleached
 flour

1/4 cup (50 grams) granulated
 sugar

1 tablespoon baking powder

1/2 teaspoon salt

1/4 teaspoon baking soda

1 1/4 cups buttermilk

1/3 cup vegetable oil, plus
 1 tablespoon for greasing
 the pan

1 large egg

2 tablespoons unsalted butter,
 cut into tablespoons

1. Heat the oven to 375°F, with a rack in the middle.

2. Whisk together the cornmeal, flour, sugar, baking powder, salt, and baking soda in a large bowl. In a separate smaller bowl, whisk together the buttermilk, the 1/3 cup oil, and the egg.

3. Place the 1 tablespoon oil in a 10-inch cast-iron skillet over medium heat. Add the butter and heat until the butter melts and sizzles, 2 to 3 minutes. At the same time, quickly stir the buttermilk mixture into the cornmeal mixture with a fork until just combined. Remove the skillet from the heat. Pour the batter into the hot skillet.

4. Place the skillet in the oven and bake until the cornbread is deeply golden brown around the edges and the top springs back when lightly pressed in the center, 23 to 27 minutes. Remove from the oven, run a knife around the edges, and immediately flip out onto a cutting board. Slice and serve.

HOW TO MAKE TEX-MEX CORNBREAD WITH CHEESE AND CHILIES

Reduce the sugar in the recipe to 2 tablespoons. Just before pouring the batter into the skillet, fold in 1 cup shredded sharp cheddar cheese, 1 cup fresh corn kernels, and 2 tablespoons minced jalapeño peppers.

Vishwesh Bhatt's Not Your Mama's Cornbread

Cornbread tastes like home to Mississippi chef Vishwesh Bhatt, author of the cookbook *I Am From Here*. Born and raised in the western Indian state of Gujarat, he came to the United States when his father was offered positions as a college professor in the South. Bhatt graduated from the University of Kentucky and went to the University of Mississippi for grad school. While in Oxford, he started cooking "for beer money," he says, at John Currence's restaurant City Grocery. He also collaborated with Currence on his own restaurant, Snackbar, where he fuses the foods of his Indian homeland with those of his adopted South. Bhatt's cornbread recipe, which I have adapted from one published in *The Local Palate*, incorporates yogurt alongside the buttermilk, because straight buttermilk doesn't have enough flavor to him. "These are the flavors of my childhood," says Bhatt. "My cooking comes from the places I remember."

Serves 8	Prep: 20 to 25 minutes	Bake: 22 to 27 minutes

2 teaspoons cumin seeds

1 1/4 cups (170 grams) coarsely ground white or yellow cornmeal

3/4 cup (90 grams) all-purpose flour

1 tablespoon baking powder

1 1/2 teaspoons granulated sugar

1 teaspoon baking soda

1/4 teaspoon salt

1/4 teaspoon black pepper

1/2 cup fresh corn kernels

1/4 to 1/2 cup grated Parmesan cheese

1/4 cup chopped fresh cilantro

1 tablespoon minced fresh jalapeño pepper

2 large eggs

1 cup plain full-fat yogurt

1 cup whole buttermilk

7 tablespoons unsalted butter, divided

1. Place the cumin seeds in a small heavy skillet over medium-low and heat, stir, and cook until they toast, 4 to 5 minutes. Turn off the heat.

2. Heat the oven to 400°F, with a rack in the middle.

3. Whisk together the cornmeal, flour, baking powder, sugar, baking soda, salt, and pepper in a large bowl. Fold in the cumin seeds, corn, Parmesan, cilantro, and jalapeño. Make a well in the center and add the eggs, yogurt, and buttermilk. Melt 5 tablespoons of the butter and pour it into the center of the bowl. Mix with a wooden spoon until just combined.

4. Place the remaining 2 tablespoons butter in a 10-inch cast-iron skillet over medium heat to melt. When the butter has melted and the skillet is hot, pour in the batter. Carefully place the skillet in the oven and bake until the cornbread is deeply brown around the edges and the top springs back when lightly pressed in the center, 22 to 27 minutes. Remove from the oven, run a knife around the edges, and immediately flip out onto a cutting board. Slice and serve.

MOTEL ROOM CORNBREAD

Robbie Montgomery was one of Tina Turner's backup singers in the 1960s, when Black performers like herself couldn't go out to eat after a show in the South because of Jim Crow laws. That didn't stop this Columbus, Mississippi, native from enjoying cornbread at the end of the day. She cooked her mother's buttermilk cornbread in a skillet on a hot plate in the motel room and wrote about it years later in her *Sweetie Pie's Cookbook* (2015). "On the road we rented motels with kitchenettes. . . . We made it work. I was the designated cook. Everybody seemed to like it."

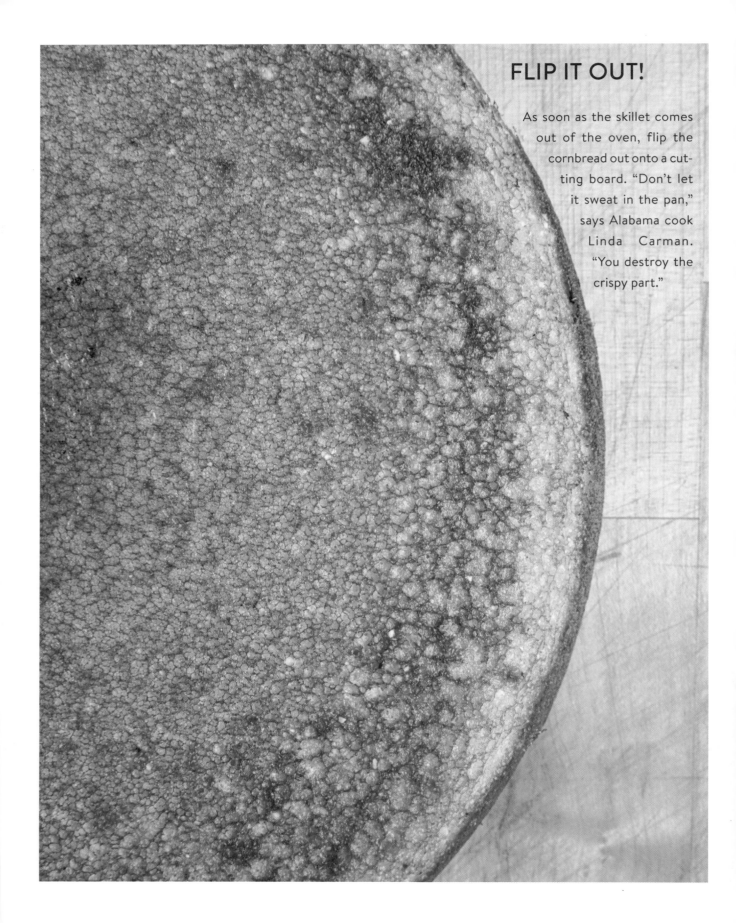

FLIP IT OUT!

As soon as the skillet comes out of the oven, flip the cornbread out onto a cutting board. "Don't let it sweat in the pan," says Alabama cook Linda Carman. "You destroy the crispy part."

Cracklin' Cornbread

Before refrigeration, back when you butchered hogs in the wintertime so the chilly temperatures prevented the meat from spoiling, there was cracklin' cornbread, called simply "cracklin' bread." The choice cuts like shoulder, butt, loin, and bacon were removed, and then the fat-streaked meat was cooked down to render or melt the lard. And once that melted lard was poured off to use in cooking, what was left in the pot were the crispy defatted pieces called "cracklings," or, affectionately, "cracklins." Today you can make your own cracklins from fresh pork belly, sometimes called pork side meat. Edna Lewis suggested you cook them in a heavy saucepan or iron skillet with a little water to prevent them from sticking to the pan at the beginning of the process. Once the cooking continues, the water evaporates and enough fat has rendered so sticking is no longer an issue. You will get about 1 cup cracklins for every pound of meat.

Serves 6 to 8	Prep: 15 to 20 minutes	Cook the cracklins: 40 to 45 minutes	Bake the cornbread: 15 to 20 minutes

CRACKLINS

4 to 6 ounces (120 to 170 grams) pork side meat or pork belly

1/2 cup cold water

CORNBREAD

2 cups (272 grams) coarsely ground white or yellow cornmeal

2 teaspoons baking powder

1/2 teaspoon salt

1/4 teaspoon baking soda

2 cups buttermilk

1 large egg

1. **Make the cracklins:** Remove the rind from the pork and discard. Dice the fat into small pieces and place in a 10-inch cast-iron skillet with the water. Bring to a simmer over medium heat. Cook slowly until the fat melts and the cracklin' pieces turn a light golden color, 40 to 45 minutes. When they are done, they float to the top. With a slotted spoon, remove the cracklins to a brown paper bag to drain. Reserve 2 tablespoons of the fat to use in the cornbread. You'll need 2/3 cup cracklins for the cornbread.

2. Heat the oven to 450°F, with a rack in the middle. Drain the skillet and wipe it dry.

3. **Make the cornbread:** Whisk together the cornmeal, baking powder, salt, and baking soda in a large bowl. Fold in the drained cracklins. Pour 2 tablespoons of the reserved fat into the skillet and place it over medium heat. Whisk together the buttermilk and egg in a small bowl and pour into the cornmeal mixture. Stir to combine. When the fat in the skillet is hot, pour it into the batter and stir. Pour the batter back into the hot skillet and place in the oven.

4. Bake until the top of the cornbread is golden brown and springs back when lightly pressed in the center, 15 to 20 minutes. Remove from the oven, run a knife around the edges, and immediately flip out onto a cutting board. Slice and serve.

"HIGH ON THE HOG"

Owning a hog meant that you also had the land to raise one. Sharecropping farmers in the South, who worked the land but did not own it, were continuously at the mercy of their white landlords. But if they helped in hog killings, they might receive the head, feet, and ears in lieu of payment. The owner, however, was able to eat high on the hog—prime spareribs, ham, and pork loin—the more desirable cuts from higher on the torso.

WHEN LARD WAS KING

Allan Benton, the purveyor of Tennessee's famous slow-cured hams, describes the self-sufficient way of life of rural farmers in the South. "When I was a kid growing up," he says, "we lived in a remote, isolated area just over the Tennessee line in Virginia. We raised everything we ate. Everything we grew was heirloom because we had to save the seeds because we couldn't afford to buy them. The manure went from the barn stalls to the fields. When we killed hogs, both sides of the families helped, and it was on Thanksgiving weekend and it would take all day that Thursday, Friday, and Saturday to work that meat up. We canned it in jars or preserved it, and the most important commodity from the hogs was the lard. Lard was used for everything, for seasoning, to cook and fry, and in breads and pastries. Leaf lard, the fat that wrapped around the kidneys, was especially prized. We didn't go to the stores and buy Crisco or olive oil. My mother's dad wouldn't allow anybody else to tend to that lard and the fire. It was in an old pot, and it rendered slowly. If he scorched the fat, he had to live with that lard for a year."

HOW CORN WAS NAMED

Like Jimmy Red, which grows deeper red closer to harvest, corn was often named by its appearance. Or it might be named by the person who grew it. John Haulk, yellow corn with a red hull, was named for the South Carolina man who faithfully farmed it on Wadmalaw Island for fifty years, preserving an heirloom variety for future generations, with the help of researchers at Clemson University. There's also Appalachian Blue, Cherokee White, Hickory King, Pencil Cob, Sea Island Guinea Flint (an old nutrient-dense corn), and many others.

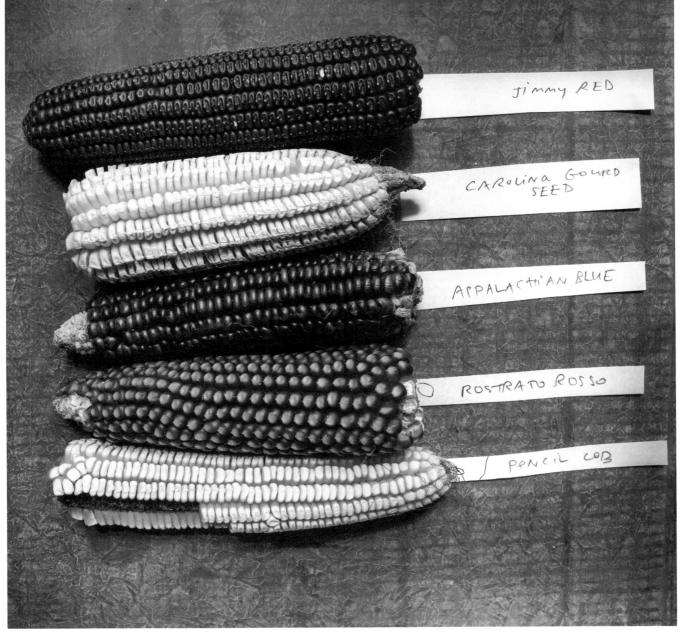

Cleora Butler's Jalapeño Cornbread

This cornbread is in the last chapter of a cookbook by Tulsa's premier caterer in the 1960s, and it stands the test of time. Cleora Butler was born in Texas in 1901, the daughter of former slaves. In 1889 Congress had opened land seized from Indian Territory in Oklahoma for homestead settlements, and Butler's family moved there by covered wagon. Butler and her parents cooked professionally for Tulsa's wealthy citizens from the 1920s through the 1940s. She opened a bakery and catering company with her husband in the 1960s. And in her own home kitchen, she baked cornbread and cooked chicken and dumplings for Black entertainers like Cab Calloway and Duke Ellington, who stayed and dined in Black homes and kitchens when they toured the segregated South and Southwest. Calloway said the highlight of playing in Tulsa was Butler's cooking: "It was the best food in America." Butler died in 1985, the very day her cookbook, *Cleora's Kitchens*, was released. I've adapted the recipe to sauté the onions and jalapeños first in the fat, and then fold everything into the batter.

| Serves 8 | Prep: 20 to 25 minutes | Bake: 18 to 21 minutes |

1/4 cup bacon fat or vegetable oil

1/2 cup chopped onion

1 tablespoon minced jalapeño pepper

1 1/2 cups (204 grams) coarsely
 ground yellow cornmeal

3/4 teaspoon baking soda

1/2 teaspoon salt

1 cup buttermilk

2 large eggs

1/2 cup pureed or creamed corn

1/2 cup shredded sharp cheddar
 cheese

NOTE:

If you don't have canned or frozen creamed corn, you can pulse fresh corn kernels in a food processor to yield 1/2 cup.

1. Heat the oven to 400°F, with a rack in the middle.

2. Place the bacon fat or oil in a 10-inch cast-iron skillet over medium heat. Add the onion and jalapeño and cook, stirring, until softened, 4 to 5 minutes. Meanwhile, whisk together the cornmeal, baking soda, and salt in a large bowl. Add the buttermilk and eggs and stir until smooth. Fold in the corn and cheese, then the sautéed onion and pepper.

3. Reheat the skillet over medium heat for a few minutes or until hot. Turn off the heat and pour the batter into the hot skillet. Place the skillet in the oven and bake until the cornbread is lightly golden brown and the top springs back when lightly pressed in the center, 18 to 21 minutes. Remove from the oven, run a knife around the edges, and immediately flip out onto a cutting board. Slice and serve.

Jimmy Red Cornbread Bites

The Jimmy Red corn of James Island, South Carolina, is the holy grail of corn flavor in the South. Old-timers say it used to grow everywhere—along the roads, in cracks of sidewalks, in backyards, and farms where tax revenuers wouldn't notice. On James Island, a bootlegger making hooch from Jimmy Red corn almost took the legacy of this corn with him when he died. Yet two ears were rescued from his garden and given to a farmer and seed saver who grew the corn and saved Jimmy Red from extinction. A cousin of the dark red Bloody Butcher variety and native to Appalachia, this heirloom corn went under the radar until chef Sean Brock fancied it. Today Anson Mills grows Jimmy Red in different regions of the South, so it never gets close to extinction again. Its pinkish-purple meal bakes into these spicy cornbread bites that are the perfect accompaniment to what else? A bowl of red chili.

Makes 2 dozen	Prep: 15 to 20 minutes	Bake: 10 to 15 minutes

Vegetable oil spray for misting the pan

2 cups (260 grams) Jimmy Red cornmeal or finely ground yellow or white cornmeal

1 tablespoon baking powder

1 teaspoon kosher salt

1/2 teaspoon chili powder

1/4 teaspoon baking soda

1/4 teaspoon ground cayenne pepper

2 cups buttermilk

2 large eggs

1/3 cup vegetable oil

1 cup (4 ounces) packed shredded sharp cheddar cheese

1. Heat the oven to 425ºF, with a rack in the middle. Mist miniature muffin pans with the vegetable oil spray.

2. Whisk together the cornmeal, baking powder, salt, chili powder, baking soda, and cayenne pepper in a large bowl. In a separate small bowl, whisk the buttermilk, eggs, and oil until combined and pour into the cornmeal mixture. Add the cheese and stir with a wooden spoon until just combined.

3. Scoop the batter into the muffin pans using a 1-inch scoop or tablespoon to nearly fill. Place in the oven and bake until the bites are beginning to brown and the tops spring back when lightly pressed in the center, 10 to 15 minutes. Run a small metal spatula around the edges, flip out onto a wire rack, and serve.

ENRICHMENT PROGRAM

In the early 1900s, pellagra, a disease caused by niacin deficiency, ravaged the working poor. Orphanages, prisons, hospitals, tenant farms—wherever the diet was based solely on corn—were the hardest hit. (Native American people were spared, since they nixtamalized their corn, which unlocked niacin.) The enrichment of cornmeal and flour with three B vitamins (niacin, riboflavin, and thiamine) began during World War II. Today, heirloom stone-ground or home-milled cornmeal isn't enriched, but our diets are more varied than they used to be.

Jimmy Red Cornbread Bites (page 34), left, and Holly's Broccoli Cornbread, right (page 51)

Carter White House Cornbread

Jimmy Carter, thirty-ninth president of the United States, was raised on a Plains, Georgia, farm where his family grew cotton, peanuts, and a little sugarcane. "We had it ingrained in us that hard work was an important part of life," Carter wrote in *The Best of Georgia Farms*, published by the Georgia Department of Agriculture. "Our bell rang every morning at four o'clock—before daybreak. We would get up, dress, go to the barn, catch the mules, put our plowstocks on the back of the wagon, and drive the mules and wagons to the fields. . . . All of the cultivation, all of the breaking of the land, all of the harvesting was done with hand labor and mules. We didn't get our first truck until the year I went off to college, which was in the winter of 1941." Even when Carter was in the White House, Plains farm life never left him.

The White House chef Henry Haller became well-versed in baking cornbread, and this was the recipe he made for President Carter. The secret, according to Haller, was letting the batter rest before baking, so the cornmeal soaked in the warm milk and butter to make a smoother, softer cornbread.

| Serves 8 | Prep: 10 to 15 minutes | Rest: 15 minutes | Bake: 15 to 20 minutes |

8 tablespoons (1 stick/114 grams) unsalted butter, cut into tablespoons, plus 1 teaspoon, at room temperature, for greasing the pan

1 cup (120 grams) unbleached all-purpose flour

1/2 cup (65 grams) finely ground white cornmeal

1/2 cup (65 grams) finely ground yellow cornmeal

1 tablespoon granulated sugar

4 teaspoons baking powder

1/2 teaspoon salt

1 cup whole milk

1 large egg

1. Heat the oven to 425°F, with a rack in the lower middle.

2. Grease an 8-inch square cake pan with the 1 teaspoon butter and set aside.

3. Whisk together the flour, both cornmeals, sugar, baking powder, and salt in a large bowl.

4. Melt the 8 tablespoons butter in a small saucepan over medium heat, 2 minutes. Pour in the milk and heat until the milk is warm and the butter has completely melted, about 2 minutes more. Turn off the heat.

5. Pour the butter and milk mixture into the bowl with the cornmeal mixture and stir gently. Crack the egg into the bowl and stir until smooth. Let the batter rest for 15 minutes.

6. Turn the batter into the prepared pan and place in the oven. Bake the cornbread until it is deeply golden brown and feels firm when lightly pressed in the center, 15 to 20 minutes. Let the cornbread cool for 10 minutes, cut into squares, and serve.

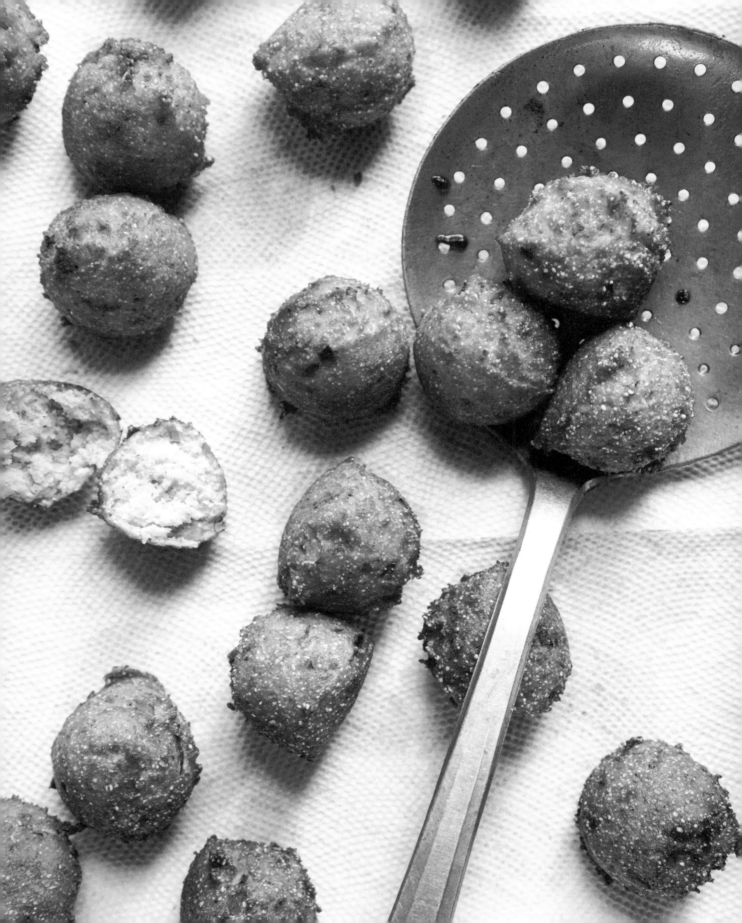

Craig Claiborne's Hush Puppies

It might seem odd to feature a hush puppy recipe from a former *New York Times* food editor in a Southern cookbook. But Craig Claiborne never let go of Mississippi, where he was born and raised on chicken spaghetti and coconut cake. Even when he was cooking for East Hampton parties, he had Southern flair. Hush puppies were those crunchy, sweet, deep-fried bites of cornbread and onion served at fish fries and political rallies in the Deep South. You can tell a good recipe when it calls for boiling water to scald the cornmeal first. Claiborne's recipe, from *Craig Claiborne's Southern Cooking* (1992), calls for white cornmeal and baking powder, but I've substituted self-rising cornmeal. In the Mississippi Delta and Indianola, where Claiborne's mother, Kathleen, moved the family to open a boardinghouse once the Depression impoverished them, hush puppies are always served with fried catfish.

Makes 12 to 15 hush puppies Prep: 15 to 20 minutes Cook: 4 to 6 minutes per batch

1 1/2 cups (204 grams) coarsely
 ground self-rising white cornmeal
 (see Note)
3 tablespoons all-purpose flour
1 tablespoon granulated sugar
1/2 teaspoon salt
1 cup boiling water
1 large egg
1/3 cup minced onion
3 to 4 cups vegetable or peanut oil for
 frying

NOTE:

To make self-rising cornmeal, use
1 1/2 cups (195 grams) white cornmeal,
2 1/4 teaspoons baking powder, and
3/4 teaspoon salt (in addition to the
1/2 teaspoon salt called for in the recipe).

1. Whisk together the cornmeal, flour, sugar, and salt in a large bowl. Pour the boiling water into the bowl and stir until the cornmeal absorbs all the water and is thick like mush, 2 to 3 minutes. Stir in the egg and onion. Place the bowl in the refrigerator while the oil heats.

2. Pour enough oil into a 10- to 12-inch cast-iron skillet or Dutch oven to measure 2 to 3 inches. Place it over medium-high heat until the oil reaches 365°F to 375°F. Scoop or spoon about 1 1/2 tablespoons of the hush puppy batter into the hot oil, frying 6 or 7 at a time. Cook for 1 to 2 minutes on one side, then turn with a slotted spoon to cook on the other side. When the hush puppies are browned all over, continue to cook until they reach 195°F in the center using an instant-read thermometer, 3 to 4 minutes, and are deeply browned. Remove to paper towels to drain, and repeat with the remaining batter.

Ruth Jackson's Cornbread Gingerbread

When *Ruth Jackson's Soulfood Cookbook* was published in 1978, Plains, Georgia, was the subject of worldwide attention, being the home of then president Jimmy Carter. Jackson was a Black resident of the town and a faithful member of Lebanon Baptist Church. Throughout this heartfelt book full of family photos and recipes, you get glimpses of her life growing up as one of fourteen children on the family farm and how cooking for church meals and other people sustained her. "My mother and grandmother picked all kinds of fruit. They grew apples, peaches . . . All the women would gather the fruit and press it out flat—like figs, for example—and then we'd lay it out in the sun to dry. It didn't take long in the Georgia sun. Then we'd pack away the dried fruit for winter desserts. It was good, I tell you."

I had marked this recipe to bake for many years because it seemed like such an unusual cross between gingerbread and cornbread. It's proof of how a creative cook can transform cornmeal into something soft and ethereal with just ginger and molasses. And a good bit of know-how too.

Serve with butter or Warm Lemon Sauce (page 446).

Serves 9 to 12 Prep: 15 to 20 minutes Bake: 25 to 30 minutes

2 tablespoons vegetable oil for greasing the pan

1 cup (136 grams) coarsely ground white or yellow cornmeal

1 cup (120 grams) all-purpose flour

2 teaspoons ground ginger

1 teaspoon baking soda

1/2 teaspoon salt

6 tablespoons (3/4 stick/86 grams) unsalted butter, at room temperature

1/2 cup (96 grams) lightly packed light brown sugar

1/2 cup molasses

1 large egg

2/3 to 3/4 cup hot water, divided

1. Heat the oven to 400°F, with a rack in the middle. Pour the oil in a 10-inch cast-iron skillet and place in the oven while it heats.

2. Whisk together the cornmeal, flour, ginger, baking soda, and salt in a medium bowl.

3. Place the butter and brown sugar in a large mixing bowl, and with a wooden spoon or a hand mixer, beat until creamy, 2 to 3 minutes by hand or 1 minute with the mixer. Add the molasses and egg and beat until just combined. Alternately add the cornmeal mixture and 2/3 cup of the hot water to the

butter mixture, beginning and ending with the cornmeal mixture. The batter should be runny. If it's not, add a little of the remaining water. Carefully pull the hot skillet from the oven and pour in the batter.

4. Bake until the top of the cornbread springs back when lightly pressed in the center, 25 to 30 minutes. Let it cool in the pan for 30 minutes before serving. (This helps the cornbread hold its shape.)

Key West Coconut Cornbread

The Ladies' Annex of the Civic Improvement Society wrote and illustrated the *Key West Cook Book* (1949) during World War II, capturing the bucolic, tropical scene of Key West in that moment. You will be swept up in conch salads, fried plantains, and coconut-guava desserts as you flip the pages, but my eyes settled on Mabel B. Whitley's cornbread recipe that had this explanation: "The world is divided into two schools of thought on cornbread: the sweet'ners and the non-sweet'ners; only the Capulets' and the Montagues' feud was sharper. With this recipe I take my stand with the sweet'ners!" Key West might have been detached from the mainland until railroads were connected and drinking water was piped in, but it was like the rest of the South when it came to disagreeing about cornbread! I decided to lean into the sweetness of this cornbread and add coconut to make it even more tropical.

Serves 8 Prep: 10 to 15 minutes Bake: 22 to 27 minutes

1 cup (130 grams) finely ground yellow cornmeal

3/4 cup (90 grams) all-purpose flour

1/4 cup (50 grams) granulated sugar

1 tablespoon baking powder

1/2 teaspoon salt

1/4 teaspoon baking soda

2 large eggs

1 1/4 cups coconut milk

5 tablespoons (71 grams) unsalted butter

1/2 cup (23 grams) sweetened shredded coconut

1. Heat the oven to 400°F, with a rack in the middle.

2. Whisk together the cornmeal, flour, sugar, baking powder, salt, and baking soda in a large bowl. Add the eggs and coconut milk, stirring with a fork just to break up the eggs.

3. Place the butter in a 10-inch cast-iron skillet and melt over medium-low heat, 1 to 2 minutes. Pour the butter into the batter and stir with the fork until just combined. Scatter the coconut over the bottom of the skillet. Pour the batter over the coconut and place the skillet in the oven.

4. Bake until the cornbread is golden brown and the top springs back when lightly pressed in the center, 22 to 27 minutes.

5. Remove the skillet from the oven, let the cornbread cool in the skillet for 5 minutes, then run a knife around the edges, flip out onto a cutting board, and serve.

THE WOMAN'S EXCHANGE MOVEMENT

In the nineteenth century, "genteel" white women who had fallen on hard times found few opportunities to bring in money. They often didn't have the skills or education to be employed, and anyway, many jobs wouldn't be available to them until World War I. But if they could cook, bake, make pickles and preserves, or sew, they could sell their wares through Woman's Exchange consignment shops, the brick-and-mortar version of today's Etsy. This charitable association was begun by women who wanted to help other women help themselves. The first exchange was the Philadelphia Ladies' Depository in 1832. After the Civil War, the Woman's Exchange of Memphis, one of the oldest nonprofits in the city, opened its doors in 1885, followed by Houston in 1887, St. Augustine in 1893, and others. Often the shops became so successful that they morphed into tearooms or restaurants, with the women running them and cooking, and volunteers writing down the recipes as fast as they could and publishing cookbooks to keep the efforts going.

Minnie Pearl's Corn Light Bread

Most of the world knew country music's Minnie Pearl as the cheerful comic from the make-believe town of Grinder's Switch. A price tag dangled from her straw hat as she hollered a big "How-dee!" to the live studio audience at the Grand Ole Opry each week. But when she was out of costume, Sarah Cannon, the Middle Tennessee actor and philanthropist, led a more private life, enjoying friends and a regular game of bridge. She baked corn light bread, a sweet, cake-like cornbread, in a pound cake pan. It's good with barbecue and a side of slaw.

With no eggs and a lot of sugar, this bread has a compact texture made for sopping up sauces and gravies. And when you taste it, you'll see why everyone thinks corn light bread is as special as Minnie Pearl. Cannon died in 1996 and left her name to the Sarah Cannon Cancer Center.

Serves 12 to 16 Prep: 10 to 15 minutes Bake: 48 to 52 minutes

Vegetable oil spray for misting the pan

3 cups (390 grams) finely ground white cornmeal

1 cup (200 grams) granulated sugar

1/4 cup (30 grams) all-purpose flour

1 teaspoon baking powder

1 teaspoon salt

1/2 teaspoon baking soda

3 cups buttermilk

1/2 cup vegetable oil

1. Heat the oven to 400°F, with a rack in the middle. Mist a 10-inch tube pan with vegetable oil spray.

2. Whisk together the cornmeal, sugar, flour, baking powder, salt, and baking soda in a large bowl. Add the buttermilk and oil and stir with a wooden spoon until smooth. Pour into the pan, smoothing the top, and place in the oven.

3. Bake until the bread is deeply golden brown and the top springs back when lightly pressed in the center, 48 to 52 minutes. Place the pan on a wire rack and let the bread cool for 15 minutes. Run a knife around the edges and invert it once, and then again so it is right side up. Let cool completely, 45 minutes, before slicing and serving.

My Grandmother's Virginia Spoonbread

I tend to associate spoonbread, the soufflé of the South, with Virginia—not just with the state, but also with my grandmother Virginia, who was raised in middle Tennessee but taught school briefly in Abingdon, Virginia. Her recipe is similar to the famous Boone Tavern recipe from Berea, Kentucky, where spoonbread is brought to the table and, true to its name, spooned onto your plate. In my grandmother's spoonbread, white cornmeal is cooked in milk until thick. Egg yolks are added for richness, and then egg whites are beaten until nearly stiff peaks and folded in carefully. No other leavening is needed. And while baking powder might have been added to some spoonbread recipes around the turn of the twentieth century, purists didn't add it.

You need to have the meal ready once spoonbread is in the oven, because once it's out of the oven, it starts sinking like a popped balloon. But that is the drama of spoonbread! One bite, and you will see why cooks have revered it and why historians have waxed poetic about it. The late food historian John Egerton once wrote, "A properly prepared dish of spoonbread can be taken as testimony to the perfectability of humankind."

Serves 6 to 8 Prep: 15 to 20 minutes Bake: 40 to 45 minutes

6 tablespoons (3/4 stick/86 grams) unsalted butter, plus 2 teaspoons for greasing the pan

3 cups whole milk

2 teaspoons salt, plus a pinch

1 cup (130 grams) finely ground white cornmeal

1 tablespoon granulated sugar

1/4 teaspoon ground nutmeg

1/4 teaspoon ground cayenne pepper

3 large eggs

1. Heat the oven to 350°F, with a rack in the middle. Grease a 2-quart casserole dish or 6-cup soufflé dish with the 2 teaspoons butter (see Note).

2. Place the milk and the 2 teaspoons salt in a large heavy saucepan. Bring to a boil over medium-high heat, and while it is boiling, slowly whisk in the cornmeal, stirring to keep the mixture smooth. Reduce the heat to low so it simmers and switch to a wooden spoon. Cook, stirring, until very thick, about 5 minutes.

3. Remove the pan from the heat. Add the 6 tablespoons butter, sugar, nutmeg, and cayenne and stir until the butter melts.

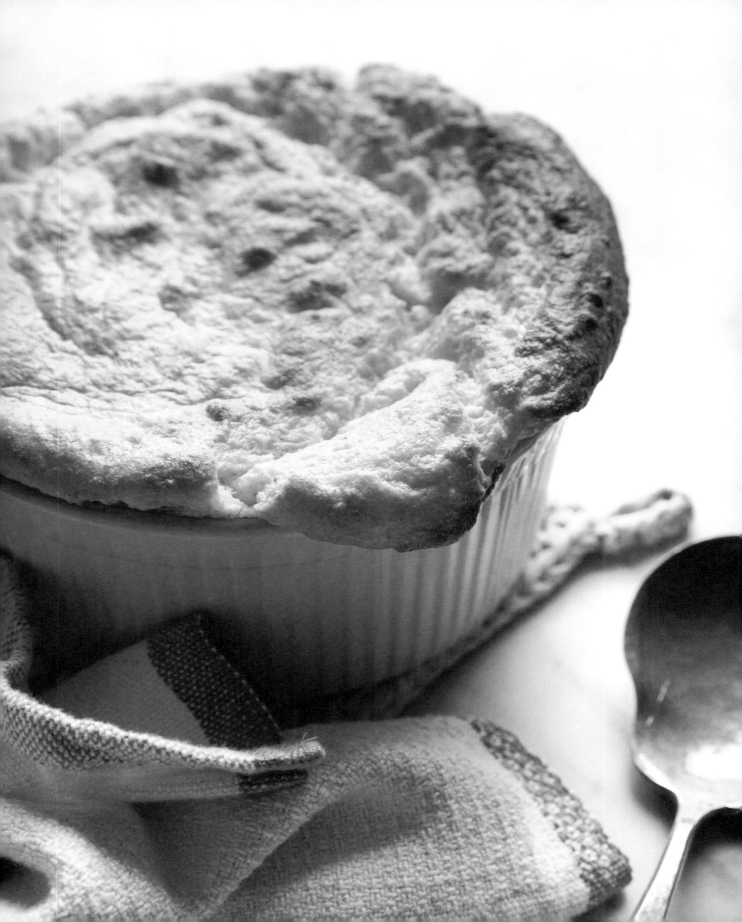

4. Separate the eggs, placing the yolks in a small dish and the whites in a large stainless-steel bowl. Add the pinch of salt to the whites and set aside. Blend a spoonful of the cornmeal mixture into the egg yolks and stir to temper them (gradually bringing up their temperature). Add the egg yolks back to the pan of cornmeal and stir until smooth. Set aside.

5. Beat the egg whites on high speed with an electric mixer until stiff but not dry, 2 to 3 minutes. Fold the beaten whites into the cornmeal mixture until nearly smooth. Turn the batter into the prepared dish and smooth the top. Place the pan in the oven.

6. Bake until the spoonbread has puffed up and is golden brown, 40 to 45 minutes. Serve at once.

NOTE:

You can pile the spoonbread into any 2-quart casserole dish, but a more elegant presentation is in a straight-sided ceramic soufflé dish. Once the spoonbread is in the oven, it begins to rise, and by 40 to 45 minutes, it hits its peak and has a glorious golden crown on top. That's when it's time to carefully pull it from the oven, take it straight to the table, and serve with butter.

HISTORY AT THE OLD MILL

The Little Pigeon River in Pigeon Forge, Tennessee, is fed by streams that flow down steep Mount Le Conte in North Carolina. For nearly two hundred years, that river has provided power to turn the wheel and two-ton French buhrstones that grind corn into cornmeal at The Old Mill. This circa 1830 gristmill was where its owner, John Trotter, a Unionist, set up secret knitting looms on the second floor to make clothing for Union soldiers. A makeshift hospital was on the third floor. The Civil War is found deep in the floor joists of mills such as these. They were at the very center of town life in the rural South.

Glenn Roberts' Awendaw

In *The Carolina Housewife* (1847), Sarah Rutledge said "Owendaw" had the "delicacy of a baked custard." If you look in the culinary bible of the Lowcountry, *Charleston Receipts* (1950), you'll see it was a recipe born out of leftovers. Grits (hominy, as they are called in South Carolina) were served at breakfast with butter, and what was left in the pot began Awendaw for supper.

The Awendaw of memory for Glenn Roberts, founder of Anson Mills, an heirloom grain producer, is his mother's recipe made with his own Carolina Gourdseed grits and cornmeal, the same variety of grain the Native American Awendaw people grew. Roberts created Anson Mills to restore the vanished grains of the antebellum South.

Serves 8	Prep: 20 to 25 minutes	Bake: 25 to 30 minutes

2 tablespoons (29 grams) unsalted butter, plus 2 teaspoons, at room temperature, for greasing the pan

3 large eggs

1/2 cup (85 grams) yellow or white grits (not too coarse)

2 cups water (preferably spring or filtered)

1 1/4 teaspoons fine sea salt

1/2 teaspoon freshly ground black pepper

2 cups whole milk

1 cup (130 grams) finely ground yellow or white cornmeal

1 1/2 teaspoons baking powder

1/4 cup heavy cream

NOTE:

In the summer, you can use some fresh corn scraped from the cob when you add the cornmeal.

1. Heat the oven to 450°F, with a rack in the middle. Rub a 9-inch cast-iron skillet or 1 ½–inch quart casserole dish with the 2 teaspoons butter and set aside.

2. Crack the eggs into a large mixing bowl, whisk lightly, and set aside.

3. Place the grits in a medium heavy saucepan and add the water. Stir once and let the grits settle a minute. Tilt the pan and skim off and discard any chaff and hulls with a strainer. Set the pan over medium-high heat and bring to a simmer, stirring with a wooden spoon until the grits cook and thicken, about 5 minutes. Reduce the heat to low and continue cooking and stirring until they hold their shape on the spoon, 20 to 25 minutes.

4. Stir in the 2 tablespoons butter, salt, and pepper and then gradually whisk in the milk. Cover the pan and bring to a simmer over medium-high heat. Whisk in the cornmeal. Remove the pan from the heat.

5. Ladle about 1 cup of the hot grits mixture into the bowl with the beaten eggs, and whisk to warm them. Pour the egg mixture back into the pan with the grits mixture. Stir in the baking powder. Turn the mixture into the prepared pan and spoon the cream over the top. Place in the oven and bake for 10 minutes. Lower the heat to 375°F and bake until risen and golden brown, 15 to 20 minutes more. Remove and serve at once.

Holly's Broccoli Cornbread

Sometimes cornbread moves into the realm of casserole. Take broccoli cornbread, a recipe shared with me nearly twenty years ago by the late Holly Westcott, who first tasted it at a covered-dish supper in Florence, South Carolina. The key ingredient—besides broccoli—is a box of Jiffy corn muffin mix. Jiffy mix speaks to a lot of people in the South. As with cake mixes, Southerners find ingenious ways to turn it into something more interesting. This recipe had to be adapted because package sizes have changed since it was created. I could not find the box of frozen chopped broccoli that was in Westcott's original recipe, so I used a bag of frozen florets. Because our contemporary eggs are larger, I reduced the number in her recipe by one. Jiffy has salt, so I don't add any. But it is still baked in a 9-by-13-inch glass casserole and is still a crowd-pleaser at covered-dish suppers.

Serves 8 to 12 | Prep: 12 to 15 minutes | Bake: 23 to 28 minutes

Vegetable oil spray for misting the pan

8 tablespoons (1 stick/114 grams) unsalted butter, cut into pieces

1 package (10.8 ounces) frozen broccoli florets, thawed and chopped

1/2 cup finely chopped onion

3 large eggs

3/4 cup (6 ounces) small curd cottage cheese

1 package (8.5 ounces) Jiffy corn muffin mix

1. Heat the oven to 400°F, with a rack in the middle. Lightly mist a 9-by-13-inch glass or ceramic baking dish with vegetable oil spray and set aside.

2. Place the butter in a large microwave-safe glass bowl and microwave on high power until melted, 50 to 60 seconds. Stir in the broccoli, onion, eggs, cottage cheese, and muffin mix until well combined. Pour the batter into the prepared pan.

3. Bake until the cornbread is lightly browned and the top springs back when lightly pressed in the center, 23 to 28 minutes. Let the cornbread cool for 10 minutes before cutting it into squares and serving.

Nashville Chicken on Egg Bread

When you had eggs in the rural South—like in the summertime, when the hens are laying prolifically— you said so through your cornbread. This recipe is a cross between cornbread and spoonbread and is often called "batter bread." And when you had a chicken to cook, you could make Chicken on Egg Bread, popularized in the 1940s and '50s at a downtown Nashville restaurant called Kleeman's. The recipe was one of my mother's favorites. I serve it to friends, and we all love the comfort of it. This is that rare main dish in a baking book, adapted slightly from Jeanne Webb's recipe in *The Nashville Cookbook* (1976). Cut the warm egg bread into squares, place in bowls, and spoon the warm chicken and creamy sauce over the top.

| Serves 6 to 8 | Prep: 30 to 35 minutes | Cook the chicken and sauce: 2 to 2 1/2 hours | Bake the egg bread: 22 to 27 minutes |

CHICKEN

1 (3- to 4-pound) chicken, rinsed and backbone cut out of the chicken

1 small onion, rinsed and halved

3 bay leaves

2 teaspoons kosher salt

Coarsely ground black pepper

EGG BREAD

1 cup whole milk

1 cup water

2 1/4 cups (293 grams) finely ground white cornmeal, divided

2 cups whole buttermilk

1 teaspoon baking soda

3 large eggs

1 teaspoon salt

2 tablespoons vegetable oil

CREAM SAUCE

5 tablespoons (71 grams) unsalted butter

1/2 cup finely chopped celery

1/2 cup finely chopped onion

5 tablespoons (45 grams) all-purpose flour or gluten-free flour blend

4 cups chicken broth

3/4 cup heavy cream

Seasonings to taste: onion salt, paprika, chicken base, salt, pepper, and nutmeg

Finely chopped fresh parsley for garnish

NOTE:

Control the texture of this egg bread with the cornmeal you use. Coarse meal will make a firmer egg bread, while a more finely milled cornmeal will be softer. Measure the cornmeal before whisking it into the hot liquid, because it will get lumpy if you don't add it all at once.

1. **Cook the chicken:** Place the chicken in a large heavy pot with water to nearly cover over medium-high heat. Add the onion, bay leaves, salt, and pepper. When the mixture comes to a boil, reduce the heat to low, cover the pot, and let the chicken simmer until quite tender and done, 1 3/4 to 2 hours. Turn off the heat and let the chicken rest in the broth for 1 hour.

2. Pull the chicken out of the broth and remove the skin. Pull the chicken from the bones and set aside. Discard the bones and skin.

3. **Make the egg bread:** Heat the oven to 400°F, with a rack in the middle.

4. Place the milk and water in a saucepan and bring to a boil over medium-high heat. Quickly whisk in 2 cups of the cornmeal all at once to make a mush. It will be stiff. Turn off the heat.

5. Whisk together the buttermilk and baking soda in a large bowl. Add the eggs and salt and beat with an electric mixer on low speed until just combined. Drop the mush, bit by bit, into the egg mixture and beat until just smooth.

6. Place a 12-inch cast-iron skillet or a 9-by-13-inch cast-iron baking dish over medium-high heat and pour in the oil. When it is smoking hot, turn off the heat. Pour the oil into the bowl with the cornmeal mixture, stirring constantly, and fold in the remaining 1/4 cup cornmeal. Carefully pour the batter back into the hot skillet or pan, and place in the oven. Bake until lightly browned and the top springs back when lightly pressed in the center, 22 to 27 minutes. Set aside. It will be soft and jiggly, not as firm as cornbread.

7. **Make the cream sauce:** Place the butter in a large skillet over medium-low heat. Add the celery and onion and sauté until soft, 4 to 5 minutes. Stir in the flour until blended. Add the broth and cream and whisk to combine. Cook over medium-low to low heat, at a simmer, until the sauce reduces by half, 25 to 30 minutes. Season with onion salt, paprika, a dab of chicken base, or salt and pepper. You can also add a pinch of nutmeg.

8. To serve, cut the egg bread into squares. Cut each square in half horizontally and place the bottom half in a shallow bowl. Pile chicken on top, top with the other half of the egg bread, and spoon over a generous amount of warm sauce. Garnish with the parsley and serve at once.

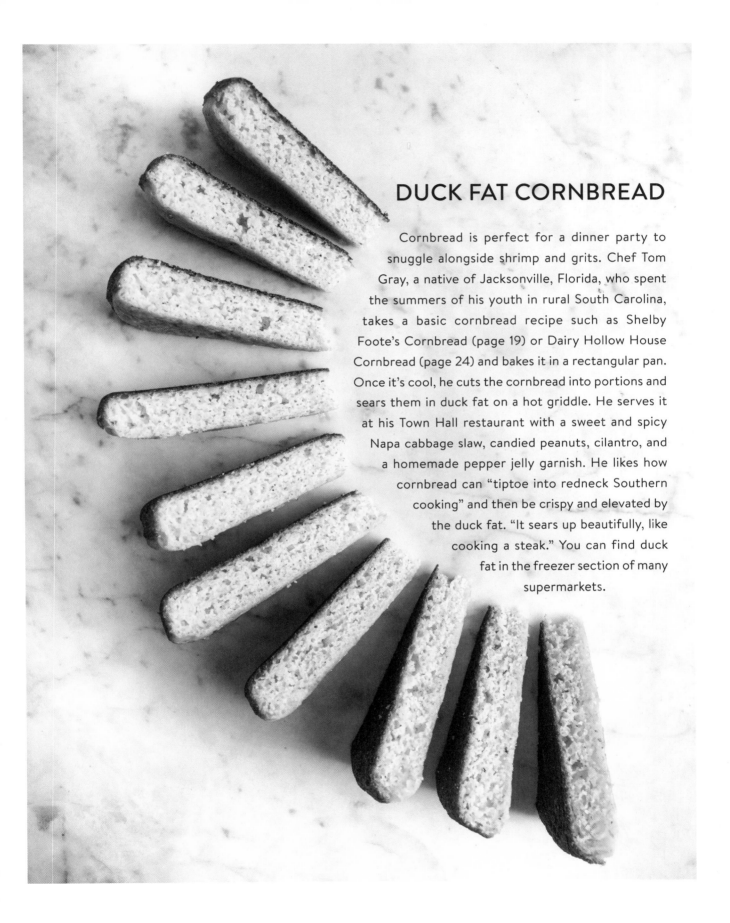

DUCK FAT CORNBREAD

Cornbread is perfect for a dinner party to snuggle alongside shrimp and grits. Chef Tom Gray, a native of Jacksonville, Florida, who spent the summers of his youth in rural South Carolina, takes a basic cornbread recipe such as Shelby Foote's Cornbread (page 19) or Dairy Hollow House Cornbread (page 24) and bakes it in a rectangular pan. Once it's cool, he cuts the cornbread into portions and sears them in duck fat on a hot griddle. He serves it at his Town Hall restaurant with a sweet and spicy Napa cabbage slaw, candied peanuts, cilantro, and a homemade pepper jelly garnish. He likes how cornbread can "tiptoe into redneck Southern cooking" and then be crispy and elevated by the duck fat. "It sears up beautifully, like cooking a steak." You can find duck fat in the freezer section of many supermarkets.

HOT
BISCUITS

It's an old tale that the South is known as the land of the hot biscuit. . . . We serve cold baker's bread only to our enemies, trusting that they will never impose on our hospitality again.

—MARJORIE KINNAN RAWLINGS, *CROSS CREEK COOKERY*, 1942

I opened the safe, took a biscuit off a plate, and punched a hole in it with my finger. Then, with a jar of cane syrup, I poured the hole full, waited for it to soak in good, and then poured again.

—HARRY CREWS, *A CHILDHOOD: THE BIOGRAPHY OF A PLACE*, 1978

There are still a lot of people in this world who are convinced that a snow pea piped with an indiscernible pink paste is chicer than, say, a humble ham biscuit. . . . They are wrong of course.

—JULIA REED, *HAM BISCUITS, HOSTESS GOWNS, AND OTHER SOUTHERN SPECIALTIES*, 2008

*I*t was soft flour, ground from red winter wheat low in protein, that placed Southern biscuits on a pedestal. And it was the South's devotion to hot biscuits, deemed more precious than cornbread, that made them distinctive. Every Southern kitchen had a shallow pan for making biscuits, and every good cook had a dedicated place to land their biscuits right out of the oven.

No wonder biscuits are central to so many people's recollections of childhood. Cookbook author Shirley Corriher recalls her grandmother baking biscuits three times a day on her farm in Covington, Georgia. And I remember reaching into the covered wooden biscuit barrel where my mother placed her hot biscuits and pulling out one still warm enough to melt the butter. She baked her biscuits small for our little hands so we could have another and maybe just one more.

Biscuits were based on more expensive white wheat flour, not your everyday cornmeal. They hinted of Sunday dinner and starched shirts and were speedier than yeast breads. Yeast tied you down, and even our grandmothers were trying to untie the confining apron strings of the kitchen.

While cornbread couldn't be simpler, biscuits get deliciously complicated. They can be made with lard, Crisco, butter, or cream. They can be simply dropped onto the baking pan or rolled out and cut or folded to create architectural layers. They can be flavored with cheese, lemon, sweet potatoes, or nothing at all, just slathered with butter and doused with sorghum or molasses. And now that this chapter of recipes is all in one place, I am amazed at the ways something as simple as flour, fat, and buttermilk is turned into a best-loved breakfast bread.

From Scott Peacock's shaggy, wet biscuit dough to the old French Huguenot way of adding eggs to

rich tea biscuits, to the light-as-air Angel Biscuits you let rise a bit at the back of the stove before baking, there are many ways to make biscuits. And there are always biscuits you haven't yet baked.

History tells us biscuits were baked in the South even before cooks had access to ovens. Scottish and English settlers cooked hardtack-like biscuit bread and oat scones on the griddle, providing sustenance for people on the move. In 1824 *The Virginia Housewife*, by Mary Randolph, included a version of what we know as a beaten biscuit cooked on a griddle. (In the days before chemical leavening, beating the biscuit whipped air into the dough, creating a lighter biscuit.) Fifteen years later, *The Kentucky Housewife*, by Lettice Bryan, included seven biscuit recipes—lard biscuit, light biscuit, milk biscuit, short biscuit, soda biscuit, tea biscuit, and a biscuit made with saleratus, an early leavening agent and the precursor to baking soda—clearly a sign that biscuits had grabbed hold.

Two things needed to take place for biscuits to flourish—an oven to bake them in and leavening to help them rise. Conveniently, baking soda was available before the Civil War, as were wood-fired ovens. Baking powder came a little later, and it wasn't until the early twentieth century that it took off, thanks to the recipes and cookbooks created by baking powder companies.

Some biscuit makers will tell you technique is more important than the particular flour you use. Others proclaim the flour is everything. The Lexington, Kentucky, pastry chef and author Stella Parks is in the latter camp. She uses Gold Medal bleached flour because it's nationally available and consistent. And when I made biscuits with Anson Mills' White Lammas flour, an old wheat brought by Jesuit priests to the New World, I was transported to another place and time.

One thing is certain: the best way to learn to bake biscuits is just to bake them. And once you bake them, you want to bake more of them to make them even better, and the more you bake, the more comfortable you are with biscuit making.

Whatever flour, method, or recipe you choose to bake in this chapter, make sure to butter your biscuits while they're hot. And never, ever serve a cold biscuit to company!

Biscuit Rules: Ingredients and Technique

I asked pastry chef Stella Parks of Lexington, Kentucky, the author of *BraveTart*, to help me better understand biscuits.

FLOUR DETERMINES TEXTURE. If you want soft and fluffy biscuits, use a bleached flour such as White Lily or Gold Medal. If you want biscuits with more structure, use an unbleached pastry flour such as White Lammas from Anson Mills, or a higher-protein unbleached flour such as King Arthur.

FAT ADDS FLAVOR AND RICHNESS. Lard, Crisco, butter, cream—there are lots of choices. But before adding the fat, ask yourself, *What's the purpose of the biscuit?* Butter and lard bring flavor, so if you're aiming for a biscuit sandwich with country ham, which also packs flavor, you might want to use a more neutral vegetable shortening. Butter is Parks' favorite fat for basic biscuits.

COLD DOUGH CREATES STEAM, WHICH HELPS BISCUITS RISE. The fat should be cold when it goes into the dough. Many recipes in this chapter call for chilling or freezing the fat. Or, for the best rise, freeze the cut biscuits before baking.

LIQUIDS AFFECT TEXTURE. Recipes in this chapter may call for buttermilk (low-fat,) whole buttermilk (higher in butterfat), whole milk (called "sweet milk" in old recipes), full-fat yogurt, or even cream. The higher the butterfat, the richer and more delicious the biscuit. If you can't find whole buttermilk, use yogurt.

A HOT OVEN BRINGS FLAVOR, COLOR, AND HEIGHT. Not an ingredient, but it's essential! To get the lift that biscuits need, crank up the oven. Anywhere from 400°F to 450°F is best for biscuits, creating a crunchy exterior, creamy interior, more flavor from the browning, and taller biscuits.

And Three More Little Things That Matter

A WET "SHAGGY" DOUGH MAKES BETTER BISCUITS. This kind of sticky dough, bordering on cottage cheese in appearance, might have you worried you need more flour. But it bakes into soft, moist biscuits.

REROLL THE SCRAPS OR NOT? Biscuit scrap pieces always look different than the first cuts. That's because they are—they've got more flour and they've been worked more, so they have a tougher texture. Carrie Morey, author of *Callie's Biscuits & Southern Traditions* and creator of Callie's Hot Little Biscuits, rolls the scraps into snakes and curls them around the biscuits in the pan to keep them tall and upright. And

author Dori Sanders avoids rerolls by plopping the entire piece of dough onto the pan and baking it, and then slicing it into pieces as you would pizza.

SPACING. Close together or far apart? That's personal preference, depending on whether you want biscuits with crispy edges, because they were baked apart from each other, or taller, soft-sided biscuits that baked snuggled up together. When biscuits can't move left or right, they have nowhere to go but up.

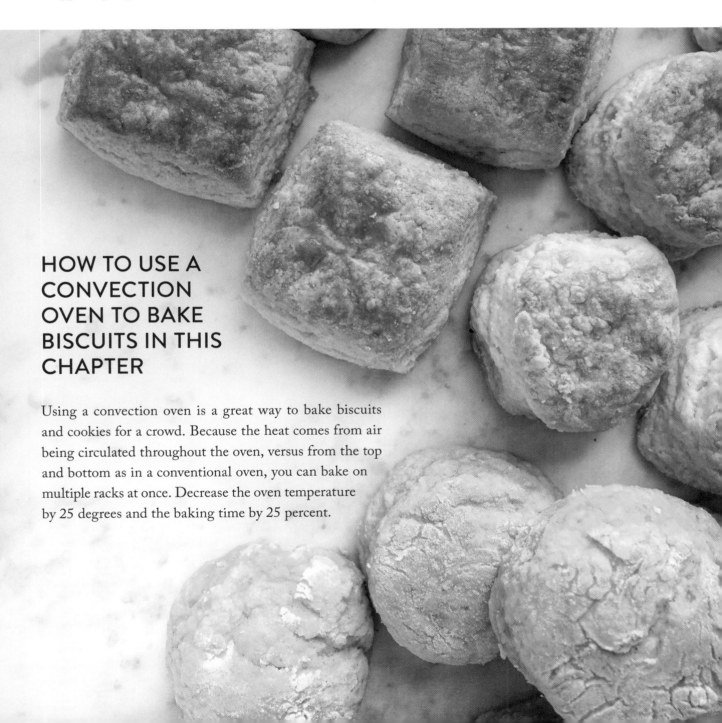

HOW TO USE A CONVECTION OVEN TO BAKE BISCUITS IN THIS CHAPTER

Using a convection oven is a great way to bake biscuits and cookies for a crowd. Because the heat comes from air being circulated throughout the oven, versus from the top and bottom as in a conventional oven, you can bake on multiple racks at once. Decrease the oven temperature by 25 degrees and the baking time by 25 percent.

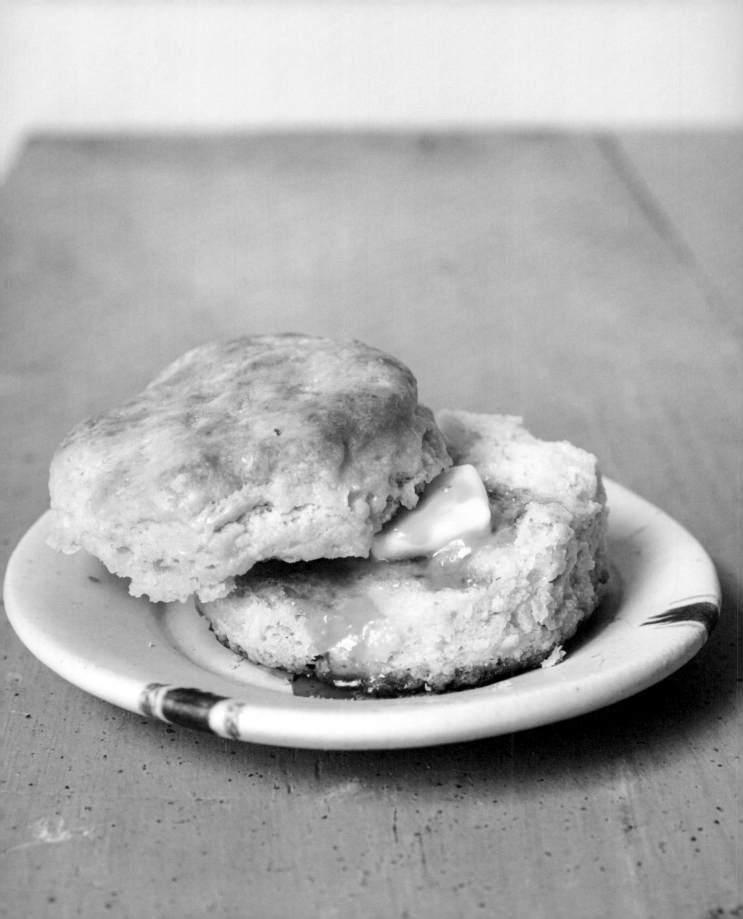

Stella Parks' Light and Fluffy Biscuits

Lexington, Kentucky, pastry chef Stella Parks has written extensively about the science of cooking and baking. According to her parents, she made biscuits by herself at age three, under the tutelage of her eastern Kentucky maternal grandmother. This recipe from her column in *Serious Eats* calls for yogurt. It has a higher acidity that translates into more rise once it's combined with baking soda and baking powder. Parks advises cooks to use yogurt rather than buttermilk because it's easier to find, and supermarket buttermilk isn't always great. Her yogurt biscuits are lovely, fluffy, and buttery. She suggests waiting five minutes to sample one of them. "When biscuits first come out of the oven, they might not be fully done. They might be still building steam and be wet and gummy," she says. "Don't worry. They'll still be hot when you eat them."

Makes 16 to 18 (2-inch) biscuits Prep: 20 to 25 minutes Bake: 18 to 22 minutes

2 1/4 cups (270 grams) all-purpose
 flour, plus more for handling
 the dough (see Notes)
1 tablespoon granulated sugar
1 tablespoon baking powder
1 1/2 teaspoons kosher salt or
 3/4 teaspoon table salt
1/2 teaspoon baking soda
8 tablespoons (1 stick/114 grams)
 unsalted butter, cold, cut into
 1/2-inch cubes
1 cup plus 2 tablespoons plain,
 unsweetened, unstrained
 yogurt (see Notes)

NOTES:

Parks uses Gold Medal flour.

Inspect the ingredient list of your yogurt: it should just contain cultured milk. Avoid yogurt with thickeners, gums, and stabilizers, which make biscuits gummy.

1. Heat the oven to 400°F, with a rack in the middle.

2. Sift the flour into a medium bowl and whisk in the sugar, baking powder, salt, and baking soda. Scatter the cubes of butter on top of the flour mixture. With your fingers, toss the butter with the flour and smash each cube flat. Smash and rub the butter into the flour until most of it has disappeared into the mix; a few larger pieces may remain. Add the yogurt and stir with a rubber spatula until combined. Once it forms a rough ball, turn it out onto a lightly floured surface.

3. With your hands, pat the dough into a square about 1/2 inch thick. Fold in half, picking up the side farthest from you and bringing it toward you. Pat it back out to 1/2 inch thick and fold in half again, using a little more flour to keep the dough from sticking to your hands or the work surface. Repeat one more time. Finish by patting the dough to 3/4-inch thickness. Cut into 2-inch rounds and place them in a 12-inch cast-iron skillet. Gather any scraps into a ball and pat and fold once again, then cut as many biscuits as you can. The last scraps can be gathered and formed into a single biscuit by hand.

4. Place the skillet in the oven and bake the biscuits until golden brown, 18 to 22 minutes. Remove and let cool for 5 minutes, then serve.

Mrs. Wilkes' Boarding House Biscuits

Judging from the line that still forms down the block before lunchtime, Mrs. Wilkes Dining Room in Savannah is one of the South's best-loved restaurants. More than six hundred of these biscuits are baked and served there each day, using this recipe, the same one the cooks have relied on for seventy-five years. When Wilkes House founder Sema Wilkes was seven, her mother died, and she started cooking for her family and their Toombs County, Georgia, field hands. After marrying at sixteen, she arrived in Savannah, moved into Mrs. Dixon's boardinghouse with her new husband, and helped out in the kitchen. The couple bought the boarding house in 1943 and would eventually make it their own.

What makes these biscuits different is that they are hand-formed. There's no rolling or cutting; instead, you pinch off pieces of dough, place them side by side in a cake pan, press them lightly to flatten, and then bake. The biscuits bake up touching, and you pull them apart. This recipe is adapted from Wilkes' 1976 cookbook, *Famous Recipes from Mrs. Wilkes' Boarding House in Historic Savannah*.

Makes 14 (2 1/2- to 3-inch) biscuits | Prep: 20 to 25 minutes | Bake: 12 to 15 minutes

1 tablespoon unsalted butter,
 melted, for greasing the pan
2 cups (240 grams) self-rising flour
1 teaspoon granulated sugar
1/2 teaspoon baking powder
2 tablespoons salted butter, cold,
 each cut into 4 pieces
2 tablespoons vegetable
 shortening
1/3 cup buttermilk
1/3 cup whole milk
1 to 2 tablespoons all-purpose flour
 for handling the dough

NOTE:

You can also bake these spaced
1/2 inch apart if you like a crispier
biscuit.

1. Heat the oven to 450°F, with a rack in the middle. Brush an 8- or 9-inch square cake pan with the melted unsalted butter.

2. Whisk together the self-rising flour, sugar, and baking powder in a large bowl. Cut in the salted butter and shortening, using two dinner knives, until the mixture resembles coarse cornmeal. Make a well in the center and add the buttermilk and milk. Mix with a fork to form a dough that leaves the sides of the bowl.

3. Sprinkle the all-purpose flour onto a work surface. Turn the dough onto the flour. With floured hands, knead the dough by picking up the far side of the dough and then pressing down with your palms to push the dough away. Do this 6 or 7 times. Work the dough into a ball. Pinch off 1-inch (1-ounce) pieces of dough and place them side by side in the pan, pressing down on each to flatten them. Place the pan in the oven.

4. Bake until the biscuits are golden brown, 12 to 15 minutes. Serve hot.

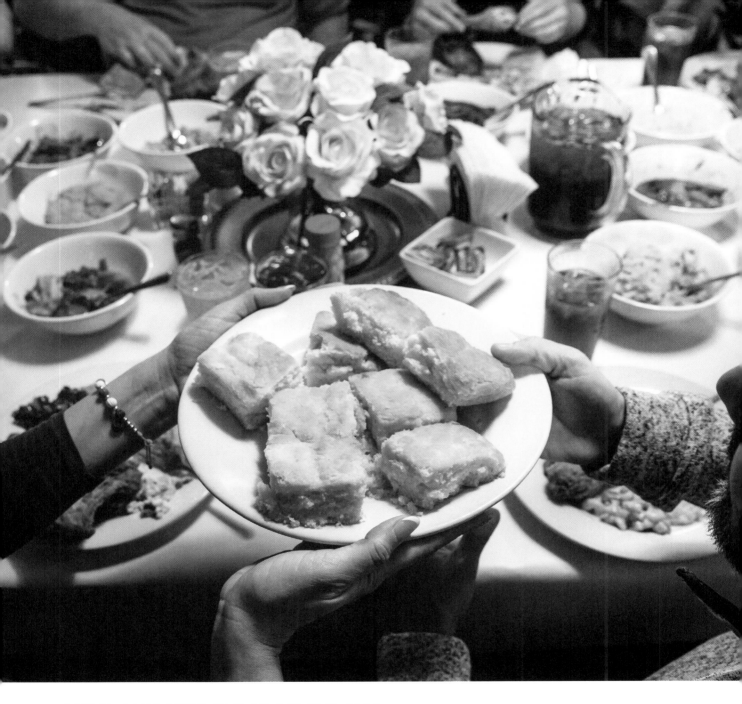

MRS. WILKES DINING ROOM

Marcia Thompson, Sema Wilkes' granddaughter, says Mrs. Wilkes Dining Room has been a family affair as long as she can remember. "In the late 1950s, we would take these long vacations and drive to Seattle or Canada." Her grandmother "would tell us the recipes. My mother, Margie, who worked at Savannah Electric, would write them all down while we were riding. It was for the cookbook." Wilkes thought she'd sell just a few copies of that book, but before she died in 2002 at ninety-five, she had sold more than 350,000.

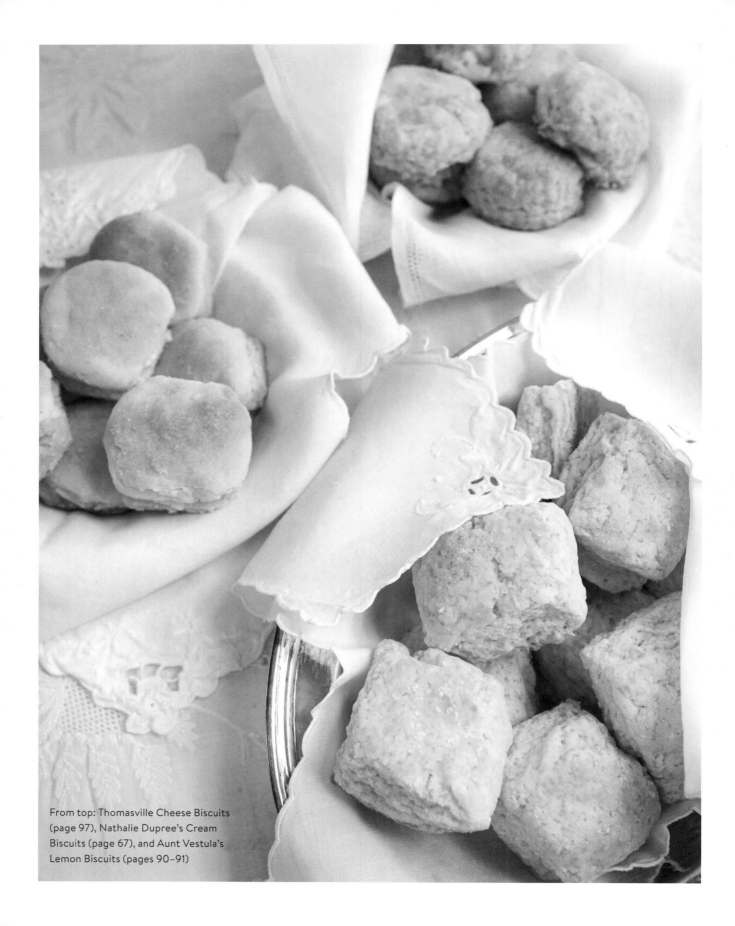

From top: Thomasville Cheese Biscuits
(page 97), Nathalie Dupree's Cream
Biscuits (page 67), and Aunt Vestula's
Lemon Biscuits (pages 90–91)

Nathalie Dupree's Cream Biscuits

Nathalie Dupree says every biscuit has a purpose. If you ask her, "What is the best biscuit?" she will answer, "Best biscuit for what? Butter and jam? Sausage patties? Pork tenderloin? Breakfast? Dinner?" And when you've written thirteen Southern cookbooks, run a restaurant in Newton County, Georgia, and taught cooking in nine television series as well as in person at Rich's Cooking School in Atlanta for a decade, you have a pretty good idea about biscuits. This secretly simple recipe is her favorite because it just has two ingredients in addition to melted butter for brushing. "It's the easiest to do and doesn't make a mess." Biscuits should be quick to fix, says Dupree. These are ethereal. Dupree serves them filled with slices of grilled pork tenderloin.

Makes 14 (2-inch) biscuits Prep: 15 to 20 minutes Bake: 14 to 18 minutes

2 tablespoons butter, melted, for brushing the pan and finishing the biscuits, divided

2 1/4 cups (270 grams) self-rising flour, plus a little more for handling the dough (see Note)

1 1/4 cups heavy cream

1. Heat the oven to 450°F, with a rack in the middle. Brush a 9-inch round cake pan with about 1 tablespoon of the melted butter and set aside.

2. Place the flour in a large bowl and pour in 1 cup of the cream. Stir with a fork until the ingredients come together, and add the remaining 1/4 cup cream as needed so the dough comes together into a ball.

3. Turn the dough out onto a lightly floured surface. With floured hands, pat the dough into a rough rectangle and fold in half. Pat it out again into a rectangle and fold in half again. Pat it to 3/4-inch thickness and cut out 14 (2-inch) rounds. If necessary, patch together the scraps, roll again, and cut out the last biscuits. Place them side by side in the prepared pan.

4. Bake until golden brown, 14 to 18 minutes. Brush with the remaining 1 tablespoon melted butter while hot. Serve hot.

NOTE:

Dupree suggests a soft flour such as White Lily for this recipe.

BEATEN BISCUITS HISTORY

The late Charles Patteson, a caterer, cookbook author, and native of Campbellsville, Kentucky, said beaten biscuits are a part of Southern foodways that wasn't fussy or pretentious. "When you say 'beaten,' it doesn't mean whipped together for lightness with an egg beater or whisk," he said. "It means placed on a flat surface and pounded with a blunt instrument . . . a tire iron will do. . . . Granny used to beat 'em with a musket." Seriously, beating the dough aerated it and made it lighter before there was leavening.

Trying to trace the history of the beaten biscuit is a little like searching for a needle in that haystack. In Harriott Pinckney Horry's 1770 recipe for Baps, you "beat it till 'tis quite light." ("Bap" can be also spelled "bop," which in the *Cambridge English Dictionary* means "to hit something lightly.") By 1885 a Maryland biscuit was properly made if beaten with a rolling pin.

Evelyn L. Edwards of Vineland, New Jersey, received patent No. 186,7117 on January 30, 1877, for a dough-kneading machine with a hand crank to turn two rollers, and between these the dough was passed until it reached the texture desired.

John Egerton's Beaten Biscuits

When John Egerton, sage of Southern cooking and biscuit baking and a crusader for civil rights, was growing up in Cadiz, Kentucky, he and his brother would turn the crank of his grandmother's beaten biscuit kneading machine, called a "brake," to aerate the dough. Egerton continued to crank and bake beaten biscuits until he died in 2013.

But he also knew the genius of using a food processor to beat the dough. Once they're baked, beaten biscuits are cracker-like and smooth and destined for a sliver of salty country ham. Egerton's biscuits use lard, the solid white fat obtained from slowly cooking down (rendering) fatty cuts of pork. The purest lard and best for frying and cooking is called "leaf lard" and comes from the fatty tissues surrounding the pig's kidneys.

Makes 46 (1 ½–inch) biscuits	Prep: 40 to 45 minutes	Bake: 25 to 30 minutes

2 cups (240 grams) all-purpose flour, plus more for rolling

1 tablespoon granulated sugar

1/4 teaspoon baking powder

1/4 teaspoon salt

1/4 cup (2 ounces) lard

1/3 cup cold milk or half-and-half

1. Heat the oven to 325ºF, with a rack in the middle.

2. Whisk together the flour, sugar, baking powder, and salt in a large bowl. Sift the mixture 3 times. Cut in the lard with a pastry cutter, with two knives, or by using your fingertips to rub the lard into the flour mixture until coarse crumbs form. Add the milk or half-and-half and knead into a firm ball. If more milk is needed, add it a teaspoon or two at a time. Do not get the dough too moist.

3. Break the ball into 4 pieces and place them all in a food processor fitted with a steel blade. Process the dough for 2 minutes, which may be hard on some processors; hold the machine down if it starts jumping around on the counter. Remove the dough. It will be satiny and smooth. Roll it out on a lightly floured (if needed) surface and fold it in half. Repeat the rolling and folding several times.

4. For the final roll-out, roll out until 1/4 inch thick and cut into 1 1/2–inch rounds. Prick each round with a fork and place on a 12-by-17-inch rimmed baking sheet 1/2 inch apart. Bake until lightly browned on the bottom and still pale on top, 25 to 30 minutes. The biscuits should be dry inside. Taste one and see. If it isn't dry inside, turn off the oven and leave them in the oven with the door open for 15 to 20 minutes. Let the biscuits cool on wire racks and store in a tin with a tight-fitting lid for up to 2 weeks. To serve, split the biscuits with a fork or a small paring knife.

Scott Peacock's Crusty Buttermilk Biscuits

Scott Peacock teaches biscuit baking classes from the kitchen of an 1858 Greek Revival mansion named Reverie in south Alabama's peanut country, near where he was born. He met his mentor, the Black chef and author Edna Lewis, in Atlanta while he was the chef at the Georgia Governor's Mansion. He was her assistant at a charity dinner, and he remembers the biscuits they baked that night, crunchy and light. His own biscuits are works of art, and he presses fork holes into them—called "docking"—before baking, which is a touch he learned from Lewis. The holes allow the steam to escape from the moist dough, making more tender biscuits.

This is Peacock's recipe that I halved for my kitchen. Those biscuit scraps are delicious, either dunked into butter and honey or turned into a quick biscuit pudding.

Makes 12 biscuits Prep: 15 to 20 minutes Bake: 10 to 13 minutes

Parchment paper for
 lining the pan
2 3/4 cups (330 grams)
 unbleached flour,
 plus more as
 needed
2 teaspoons baking
 powder (see Edna
 Lewis' Homemade
 Baking Powder;
 recipe follows)
1 1/2 teaspoons kosher
 salt
5 tablespoons (71 grams)
 unsalted butter,
 cold, cut into 1/2-
 inch pieces
1 cup whole buttermilk,
 cold

1. Heat the oven to 500°F, with a rack in the middle. Line a 12-by-17-inch rimmed baking sheet with parchment paper.

2. Whisk together the flour, baking powder, and salt in a large bowl.

3. Toss the cold butter into the flour. Get your hands in there and use your fingers to press the butter into the flour. Work quickly; the goal is to have pieces of butter of varying sizes throughout the flour.

4. Make a well in the center and pour in the buttermilk. With a wooden spoon, quickly stir the ingredients together. It's okay to stop before you incorporate all the stray floury bits; the dough should be very sticky.

5. Lightly flour a surface and immediately turn out the sticky dough. With a quick and gentle touch, gather the dough and shape it into a ball. Try not to add more flour. The dough will be sticky. Flatten with your fingers to about 1-inch thickness.

6. Lightly flour a rolling pin, but not the dough. Roll once from the center to the top and lift the rolling pin. Starting from the center again, roll to the bottom and lift the rolling pin. Repeat one or two more times, just to even out the tops of the biscuits.

7. Dip a dinner fork in flour and pierce the dough every inch or so. With a 2-inch biscuit cutter dipped in flour, stamp out biscuits and arrange them on the pan. Do not twist when you cut. A little flip is all you need to lift the biscuits from the dough.

8. When you've stamped out all the biscuits that you can, place the extra dough wherever it will fit on the pan. Bake the biscuits until crusty and deeply golden brown, 10 to 13 minutes.

9. Remove the pan from the oven and let the biscuits cool for a few minutes on the pan. Serve hot.

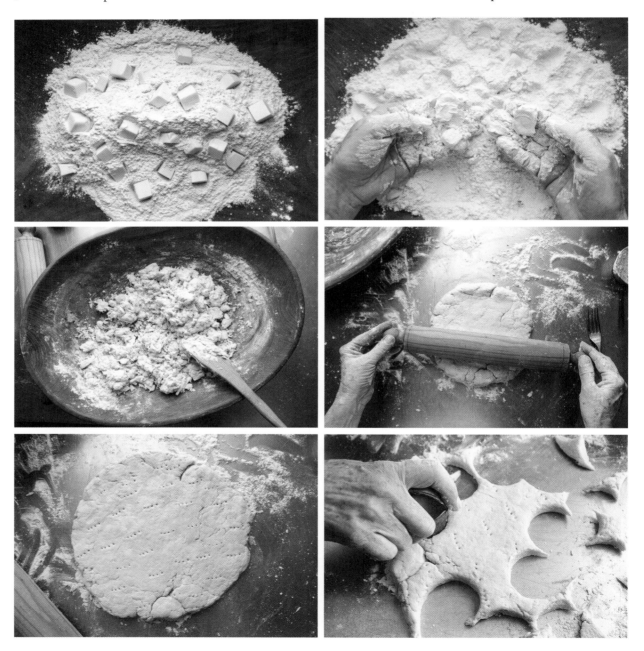

SCOTT PEACOCK'S BISCUIT-MAKING TIPS:

What's the most important ingredient for great biscuits? Fearlessness, says Peacock. "Biscuits can smell fear."

FLOUR. You can make good biscuits from grocery store flour, but to make great biscuits, find regional unbleached flours.

BAKING POWDER. Peacock prefers to make homemade baking powder, using cream of tartar and baking soda (recipe follows), because it's fresher than store-bought.

BUTTER. Use good butter, either unsalted or European Kerrygold or Plugra.

BUTTERMILK. You need full-fat whole buttermilk. He uses Marburger Farm Dairy Gourmet Buttermilk.

MIXING FAT INTO FLOUR. Use your fingers.

POKING HOLES. He "docks" (pricks) the dough with a fork, then cuts it into rounds without twisting. Docking allows the steam to escape from the wet dough and enhances the rise.

NO REROLLING. He cuts the biscuits out with a biscuit cutter, then tucks the "leavings" into the edges and corners of the baking sheet, to give the biscuits something to lean against so they rise better.

EDNA LEWIS' HOMEMADE BAKING POWDER

1/4 cup cream of tartar
 (organic preferred)
2 tablespoons baking soda

Sift together the cream of tartar and baking soda and store in a glass jar. Sift again before using, because the ingredients tend to clump when stored. Store in a cool, dry place like a spice cabinet for up to 6 weeks.

Bellegarde Heirloom Biscuits

Take a trip back in time and taste biscuits as they used to be, before flour was bleached, and when wheat was grown regionally and you used what you had. This recipe contains a mix of unbleached cake and all-purpose flours, as well as white cornmeal. It's sweetened with maple or cane syrup and enriched with lard, whole buttermilk, and an egg. The recipe comes from New Orleans' Bellegarde Bakery, named after the first bakery built in the Crescent City in 1722. Founded by Graison Gill in 2008, Bellegarde is now owned and operated by its employees. The bakery calls this recipe a "baker's biscuit," because it's a favorite of bakers and because it's designed to be flexible, so that they can add their own flourishes to it. I baked these biscuits with an heirloom White Lammas cake flour from Anson Mills, some King Arthur unbleached all-purpose flour, and Weisenberger's finely ground white cornmeal. And I sliced them neatly into squares so there were no scraps.

| Makes about 16 (2-inch) biscuits | Prep: 20 to 25 minutes | Bake: 15 to 20 minutes |

Parchment paper for lining the pan

2 1/2 cups (280 grams) heirloom white flour, such as White Lammas, or unbleached cake flour

3/4 cup plus 1 tablespoon (105 grams) unbleached all-purpose flour, plus more for handling the dough

2 tablespoons stone-ground white cornmeal

1 tablespoon baking powder

1 1/2 teaspoons baking soda

4 teaspoons sea salt

10 tablespoons (1 1/4 sticks/143 grams) unsalted butter, cold

5 ounces (10 tablespoons/143 grams) lard

1 cup whole buttermilk, or as needed

2 tablespoons cane or maple syrup

1 large egg

1. Heat the oven to 425°F, with a rack in the middle. Line a 12-by-17-inch rimmed baking sheet with parchment paper.

2. Whisk together both flours and the cornmeal, baking powder, baking soda, and salt in a large bowl. Cut the butter and lard into 1-inch pieces and scatter them on top of the flour mixture. Using your fingertips, work the fat into the flour until it feels like coarse meal. It's fine if the pieces are slightly different sizes.

3. Place the buttermilk in a separate small bowl and whisk in the cane or maple syrup and egg. Pour into the flour mixture and stir together using a fork. Add more buttermilk to moisten if needed. The dough should hold together but still be a little shaggy.

4. Turn the dough out onto a lightly floured surface. With floured hands and a bench scraper or floured tea towel, press the dough out with your fingers to 1-inch thickness and fold the dough into thirds. Turn the dough a quarter turn to the right. Do this 3 more times to create layers, then press into an 8-inch square about 1 inch thick. With

a large floured knife, cut the square into quarters and then cut each square into four smaller squares to yield the 16 biscuits.

5. Place the biscuits 1/2 inch apart on the baking sheet and bake until golden brown, 15 to 20 minutes. Serve hot.

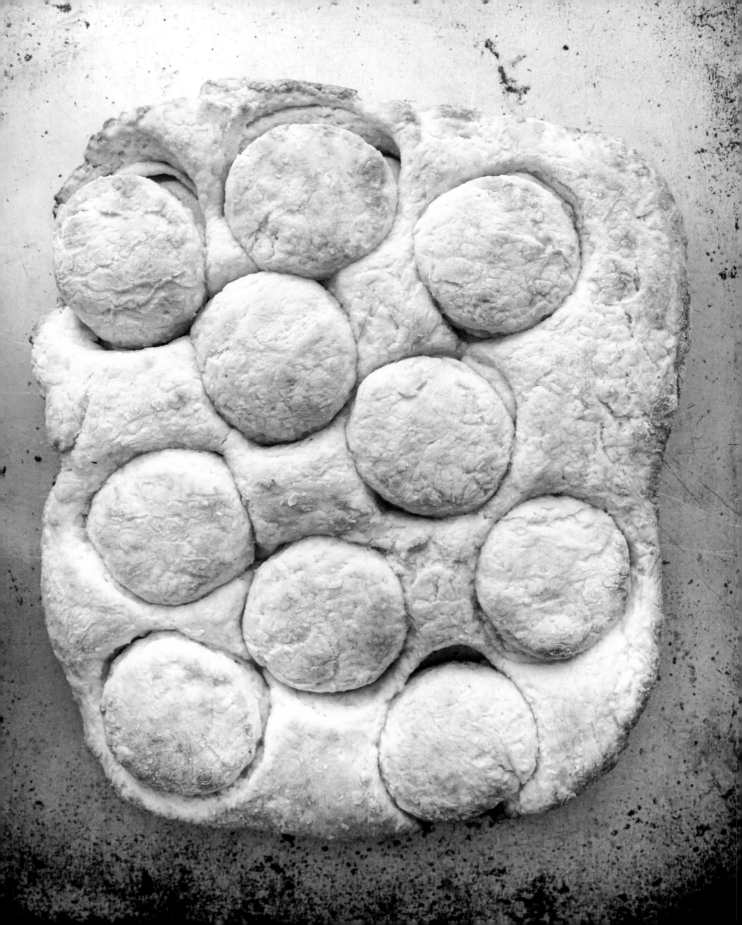

Dori Sanders' Biscuit Bread

When novelist and cookbook author Dori Sanders' family had a lot of people to feed on their South Carolina peach farm, they'd make what she called "biscuit bread," biscuit dough pressed onto a baking sheet in one slab. Although it contains a little yeast, it can go straight to the oven without being left to rise. But if you have time to leave it at room temperature for 20 minutes, it will rise a bit more.

I've baked this with and without sugar and prefer it without. If you want to upgrade the recipe, use an heirloom pastry flour like Crema from Carolina Ground or White Lammas cake flour from Anson Mills, and you will notice a big flavor difference. If you prefer to make individual biscuits, lay the dough on the pan, then cut out rounds, but don't separate them from the rest of the dough. Then you have something for everyone—rounds, scraps, and crispy end pieces just right for dunking into sorghum or honey.

Serves 8 to 12 Prep: 10 to 15 minutes Bake: 20 to 25 minutes

1 1/2 teaspoons dry yeast (see Note)

1 tablespoon warm water

2 1/2 cups (300 grams) all-purpose flour, plus more for handling the dough

2 tablespoons granulated sugar (optional)

1 teaspoon baking powder

1/2 teaspoon salt

4 ounces (8 tablespoons/about 114 grams) fat, unsalted butter, shortening, lard, or a combination of them, cold and cut into pieces

3/4 cup whole buttermilk

NOTE:

No yeast? No worries. Increase the baking powder to 2 teaspoons.

1. Heat the oven to 450°F, with a rack in the middle.

2. Stir the yeast into the warm water in a small bowl and set aside.

3. Whisk together the flour, sugar (if using), baking powder, and salt in a large bowl. Distribute the cold pieces of fat over the top of the flour and, with your fingers, toss them with the flour. Work the fat into the flour by pressing with your fingertips. It should start to look like coarse meal, and it is fine to have some larger pieces of butter. Stir in the buttermilk until you have a sticky dough.

4. Turn the dough out onto a lightly floured surface. With your fingers, press it out into a rectangle about 1 inch thick; then, using a metal spatula or bench scraper, fold it over in half. Turn the dough 45 degrees. Repeat the process 2 more times. With floured hands, transfer the dough to a 12-to-17-inch rimmed baking sheet and press it into a 1-inch rectangle. Place in the oven, or cut rounds into the rectangle, if desired. Bake until deeply golden brown, 20 to 25 minutes. Serve hot.

Southern Railway's Buttermilk Biscuits

Southern Railway was the South's largest railway system, serving states below the Mason-Dixon Line and east of the Mississippi River. By the early 1900s, Chattanooga was a railroad center for passenger trains and freight. These biscuits would have been baked in the train cars that traveled the Southern Railway line pulling into Terminal and Union Stations in Chattanooga. This recipe is adapted from James Porterfield's 1993 book, *Dining by Rail*. Kitchens in those early trains were intensely hot before air-conditioning came in the 1930s and not well sealed, letting in outside dust and dirt. In a typical Louisville & Nashville dining car, the kitchen would have been eight by five feet and had a staff of four cooks to prepare six hundred meals a day.

Makes about 16 (2 1/2–inch) biscuits	Prep: 20 to 25 minutes	Rise: 30 minutes	Bake: 12 to 15 minutes

1/2 cup buttermilk

1 heaping teaspoon dry yeast

1/4 cup warm water (110°F)

1 tablespoon granulated sugar

2 cups (240 grams) self-rising flour, plus about 2 tablespoons for handling the dough (see Note)

3 tablespoons vegetable shortening

2 to 3 tablespoons salted butter, melted, divided

NOTE:

If using all-purpose flour, add 1 teaspoon baking powder and 1/2 teaspoon salt. You can cut 2-inch biscuits or go slightly smaller, as these biscuits rise and get a bit larger than usual biscuits do when baking. If the biscuits are smaller than 2 inches, they will need slightly less time to bake.

1. Pour the buttermilk into a small saucepan and place over low heat until bubbles form around the edges of the pan, about 2 minutes. Remove from the heat.

2. Stir the yeast into the warm water and stir in the sugar.

3. Place the 2 cups flour in a large bowl and add the shortening. With your hands or two knives, work the shortening into the flour until well distributed. Pour the buttermilk into the bowl, followed by the yeast mixture. Stir with a fork to mix, and it will come together in a sticky ball. Brush a 12-by-17-inch rimmed baking sheet with some of the melted butter.

4. Sprinkle about 2 tablespoons flour onto a work surface and turn the dough onto the flour. With floured hands, knead the dough gently by picking up half of the dough and folding it toward you, followed by pushing it away with the heel of your hands. Turn the dough 90 degrees and repeat. Do that several more times. Pat the dough out to a thickness of about 1/2 inch or slightly more. With a floured cutter, cut the dough into rounds and place them on the baking sheet, either close together or about 1 inch apart,

whichever you choose. The closer together you put them, the softer and taller they'll be. Farther apart and they will get crispy around the edges. Prick the top of the biscuits with a fork. Place in a warm spot to rise, covered with a light kitchen towel, about 30 minutes.

5. Heat the oven to 450ºF, with a rack in the middle.

6. When the biscuits have plumped up, but not doubled, remove the towel and brush them with the remaining melted butter. Bake the biscuits until they are golden brown, 12 to 15 minutes. Remove and serve hot.

WHITE LILY FLOUR

In the early 1880s, an ambitious Georgia-born wholesale grain merchant named J. Allen Smith arrived in Knoxville and erected a flour mill on the Tennessee River. Knoxville was a good spot for a mill because it was on a railroad line, making it easy to get wheat from the South and the Midwest and transport the resulting flour all across the region.

Though Allen produced cornmeal and other kinds of flour, White Lily, the whitest and lightest of the flours, was everyone's favorite and became the company's name. To make it white, White Lily was bleached with chlorine, a process that extends a flour's shelf life and changes its protein structure to weaken the gluten and make it silkier in texture.

The son of a Methodist minister, Allen not only milled the flour but manufactured the wooden bins in which it was shipped. A white flour with a white flower emblazoned on the bag became all the assurance Southern women needed. In the wake of the Civil War, they were exhausted from the uncertainties of the food supply and were tired of baking with coarse, dirty, unsifted flour.

In the 1930s, *Atlanta Journal* food editor Henrietta Dull gave the flour her stamp of approval, and Pearl Maples Davis, a former Kentucky home demonstration agent, was hired to show Southern housewives how to bake biscuits with it. Today White Lily is the most recognizable ingredient in Southern biscuits.

Bryson City Cathead Biscuits

The term *cathead* is used across the South for an oversized drop biscuit about the size of a cat's head. But the biscuit size can vary, of course, as can cats' heads. Catheads appear frequently in the recipes of southern Appalachia and, in particular, North Carolina and Georgia in the Great Smoky Mountains and Nantahala National Forest in the 1910s and '20s. This recipe from the late Joe Dabney's book *Smokehouse Ham, Spoon Bread, & Scuppernong Wine* (1998) comes from the late Beuna Winchester of Bryson City, North Carolina, who lived on the eastern edge of the Great Smoky Mountains. The recipe was originally baked in a woodstove, and to mimic the flavor and color you would get from baking in it, you've got to crank up the oven temperature pretty high.

Dabney wrote in his book that when he was a new student at Berry College in North Georgia, he eyed the largest Sunday morning cafeteria biscuits he had ever seen. One of his classmates pulled him aside and whispered, "What you see there, Joe, is what we call the Cathead Biscuit, the gift of an all-knowing and benevolent God."

Makes 5 or 6 (4 1/2–inch) biscuits	Prep: 10 to 15 minutes	Bake: 13 to 17 minutes

2 1/4 cups (270 grams) all-purpose
 flour
2 teaspoons baking powder
1 teaspoon salt
1/4 teaspoon baking soda
5 tablespoons (2.5 ounces) lard or
 vegetable shortening
1 cup plus 1 tablespoon buttermilk

1. Heat the oven to 450°F, with a rack in the middle.

2. Whisk together the flour, baking powder, salt, and baking soda in a large bowl. Pinch off small pieces of the lard or shortening and drop them into the bowl. Massage with your fingers into the flour until you have coarse crumbs. Pour in the buttermilk and stir until just combined.

3. Drop five or six 1/3-cup spoonfuls of the dough onto an ungreased 12-by-17-inch rimmed baking sheet. (They should be about 2.75 to 3 ounces each.) Bake until deeply golden brown on top and bottom, 13 to 17 minutes. Serve hot, with gravy (page 82), if you like.

NOTE:

To save time, you can use self-rising flour in this recipe instead of the all-purpose flour, baking powder, salt, and baking soda.

BISCUITS AND *Gravy*

In a 1988 *Atlanta Journal-Constitution* story, Betty McMillan of Monroe, Louisiana, was interviewed about the cathead biscuits she baked for hungry loggers in North Georgia. The loggers kept coming back for seconds and were eating so fast that she didn't have time to roll the dough. To keep up with them, she just dropped it in big portions on the baking sheets. Her sawmill gravy, also known as logging gravy, was made from the drippings of cooked sausage or bacon and thickened with cornmeal, thus resembling sawdust.

What's better with cathead biscuits than gravy? Take your pick:

TOMATO GRAVY: Heat 2 tablespoons bacon drippings or unsalted butter in a heavy skillet and stir in 2 tablespoons flour. Cook until the flour begins to brown. Add a can (14.5 ounces) of stewed tomatoes or 1 1/2 cups chopped fresh tomatoes, plus 1/2 cup tomato juice. Simmer for 5 minutes and let it thicken. Adjust the seasoning, and add a pinch of sugar if the tomatoes need sweetening.

SAWMILL GRAVY: Heat 1 tablespoon bacon or sausage drippings in a heavy skillet and stir in 3 tablespoons white cornmeal and 1/2 teaspoon salt. Stir until it lightly browns. Pour in 2 to 2 1/4 cups milk and a dash of pepper and stir until thickened.

RED-EYE GRAVY: Place a dab of butter in a heavy skillet and add some country ham slices. Cook for 2 minutes a side, until browned and crispy. Set the ham aside and keep warm. Increase the heat under the skillet and pour in 1 cup black coffee and 1/2 teaspoon sugar. Scrape up the browned bits and reduce the heat to let it simmer until slightly reduced, 2 to 3 minutes.

ARKANSAS CHOCOLATE GRAVY: Bring 2 cups whole milk or water to a boil in a medium saucepan. Stir together 1/2 cup sugar, 3 tablespoons unsweetened cocoa powder, 2 tablespoons flour, and a dash of salt. Pour into the boiling liquid and whisk until thickened and smooth, 3 to 4 minutes.

Granny's Sourdough Biscuits

Alabama cook Jamie Dietrich's grandmother Kate Martin was known for her sourdough biscuits. Each night, she left a scrap of dough in her biscuit bowl of flour. The next morning, she'd grab some lard, add some fresh buttermilk, and roll out more biscuits. Dietrich recalls those next-day biscuits fondly because they baked up flatter and had a tangy flavor. I was intrigued and made her grandmother's recipe, covered the bowl with a sheet of waxed paper, and let it rest on the kitchen counter overnight. The biscuits baked up just as Dietrich said. They were almost creamy in texture as well. I pushed my thumb into the center of one and filled it with fresh sorghum molasses. It was a rare treat from a different time, back when things were simpler.

You have two options with this recipe: bake them fresh—but they won't taste like sourdough—or let any leftover dough rest overnight until the next morning to help you bake more biscuits. If you do that, add a little buttermilk to soften the dough.

Makes 16 to 18 (2-inch) biscuits Prep: 10 to 15 minutes Bake: 12 to 15 minutes

2 cups (240 grams) all-purpose flour, plus a little more for handling the dough
1 tablespoon baking powder
1 tablespoon granulated sugar
1 teaspoon salt
6 tablespoons (3/4 stick/86 grams) unsalted butter, cold, cut into tiny cubes
1 cup buttermilk

1. Heat the oven to 425ºF, with a rack in the middle.

2. Whisk together the flour, baking powder, sugar, and salt in a large bowl. Using your fingers, work the butter into the flour until the flour resembles coarse meal, but don't overwork it. Add the buttermilk and stir with a fork until the dough forms a ball and pulls away from the sides of the bowl.

3. Turn the dough onto a floured surface and knead lightly 15 to 20 times. Using your hands, pat the dough into a disk about 3/4 inch thick. Use either a glass or an open-top cutter dipped in flour. (A cutter that is not deep enough or is closed on the top can press the dough back down.) Brush off the excess flour and place the biscuits in a 12-inch cast-iron skillet or on a baking sheet. Bake until lightly golden, 12 to 15 minutes. If you want the biscuits darker on top, switch the oven to broil and cook for an additional minute to brown the tops, but take care not to burn them. Serve hot.

Angel Biscuits

When a biscuit meets a yeast roll, you have an Angel Biscuit—or what's sometimes called "bride's biscuits" and "riz biscuits." Part roll, part biscuit, they rise tall and light in the oven and are the best biscuit to bake ahead of time for events and parties. I received this favorite recipe from Holly Wulfing Chute of Atlanta, when she was the chef at the Georgia Governor's Mansion in the 1980s. And I came across this clever trick for Angel Biscuits from the Jackson, Mississippi, Junior League cookbook called *Southern Sideboards*: "Cut and freeze these biscuits in foil pans. Place them in a cold oven at night. Next morning, turn oven to 450°F when the bacon starts frying. Presto! Hot biscuits for breakfast!"

Makes 44 (2-inch) biscuits Prep: 20 to 25 minutes Rise: 15 to 20 minutes Bake: 12 to 15 minutes

2 tablespoons warm water (115°F)

2 1/4 teaspoons (1 package) dry yeast

5 cups (600 grams) all-purpose flour, plus more for dusting

3 tablespoons granulated sugar

1 tablespoon baking powder

1 teaspoon baking soda

1 teaspoon salt

1 cup (6.75 ounces/191 grams) vegetable shortening

1 1/2 to 2 cups buttermilk

4 to 6 tablespoons (1/2 to 3/4 stick/57 to 86 grams) salted butter, melted, for brushing the pan and biscuits

1. Spoon the warm water into a small bowl and stir in the yeast to dissolve.

2. Whisk together the flour, sugar, baking powder, baking soda, and salt in a large bowl. Drop the vegetable shortening by spoonfuls into the bowl and, with your fingertips, lightly work the shortening into the flour mixture until it looks like large peas.

3. Pour the yeast and water into the bowl and add 1 1/2 cups of the buttermilk. Stir with a wooden spoon until just combined, adding the remaining 1/2 cup buttermilk as needed to create a dough that pulls together but is not sticky.

4. Turn the dough out onto a lightly floured surface. Press or roll to 1/2-inch thickness. Brush a 12-by-17-inch rimmed baking sheet with some of the melted butter. Cut the dough into 2-inch rounds, dipping the cutter into flour each time you cut. Place the biscuits nearly touching on the pan. Brush the tops with the remaining melted butter. Reroll any scraps and cut out more biscuits. Cover with a light kitchen towel and place the pan in a warm place until the biscuits begin to plump up, 15 to 20 minutes. The dough keeps for 2 days in the fridge.

5. Heat the oven to 400°F, with a rack in the middle. Bake the biscuits until golden brown, 12 to 15 minutes. Serve hot.

Mama Dip's Sweet Potato Biscuits

In 1976 Mildred Cotton Council, affectionately known as "Mama Dip," opened Mama Dip's Kitchen, a beloved restaurant featuring her family's Southern cooking in Chapel Hill. These sweet potato biscuits, with their soft orange hue and near-caramel flavor, are what her granddaughter, Atlanta biscuit baker Erika Council, says most remind her of her grandmother. This recipe is adapted from Mildred Council's cookbook *Mama Dip's Kitchen* (1999).

Council was born the youngest of seven children in Baldwin Township, North Carolina. Her mother died before she was two. In this cookbook, she wrote that she got her nickname from the way she gathered water for cooking and cleaning: "When the water was low in the barrels, I learned how to take a gourd dipper, jump up, hang over with my belly button on the rim of the barrel, and dip out the water. I was called 'Dip' by my brothers and sisters from an early age because I was so tall"—she was 6 feet, 1 inch— "and I had such long arms that I could reach way down in the rain barrel to scoop up a big dipperful of water when the level was low." All that work had its benefits. On her trips in and out of the kitchen with water, she watched how others in her family cooked and absorbed those lessons. An entrepreneurial Black woman, Mama Dip died in 2018 at eighty-nine, leaving her legacy to her children and grandchildren.

Makes 12 (2-inch) biscuits Prep: 45 to 50 minutes Bake: 15 to 20 minutes

1 large (8 to 10 ounces) unpeeled sweet potato

4 tablespoons (1/2 stick/57 grams) unsalted butter, at room temperature

1 1/2 tablespoons light brown sugar

2 cups (240 grams) all-purpose flour, plus 1/2 cup (60 grams) for handling the dough

1 tablespoon baking powder

1/2 teaspoon salt

Pinch of baking soda

1/2 cup whole milk

1. Rinse the sweet potato. Place it in a medium saucepan and cover with water. Bring to a boil over medium heat, reduce the heat to low, cover, and simmer until tender, 25 to 30 minutes. Drain, and when cool enough to handle, peel and mash in a large bowl. You'll need 1 cup of mashed sweet potato for the recipe. Add the butter and brown sugar and stir until the butter melts. Set aside.

2. Heat the oven to 400°F, with a rack in the middle.

3. Whisk together the 2 cups flour and the baking powder, salt, and baking soda in a small bowl. Turn the flour mixture into the bowl with the sweet potatoes. Add the milk and stir with a fork until combined. The dough will be sticky.

4. Dust a surface with the 1/2 cup flour. Turn the dough out onto the flour, and with floured hands, fold and knead the dough, using a bench scraper or metal spatula to help if the dough is too sticky to handle. Work with the dough until you can touch it without your fingers sticking. With floured hands, pat the dough out to 1-inch

thickness and cut into 2-inch rounds. To keep the cutter from sticking to the dough, dip it in flour each time before cutting. Reroll the scraps and cut the rest of the biscuits. Place on a 12-by-17-inch rimmed baking sheet and bake until they begin to lightly brown, 15 to 20 minutes. Serve hot.

NOTE:

To cook sweet potatoes for this recipe and all the recipes in this book that call for mashed sweets, roast them at 400°F for 30 minutes, then reduce the heat to 375°F and roast for 45 minutes more. Or you can boil them "in their jackets" (not peeling them) in a saucepan. They'll be soft enough to mash in about 25 minutes, depending on the size of the sweet potatoes.

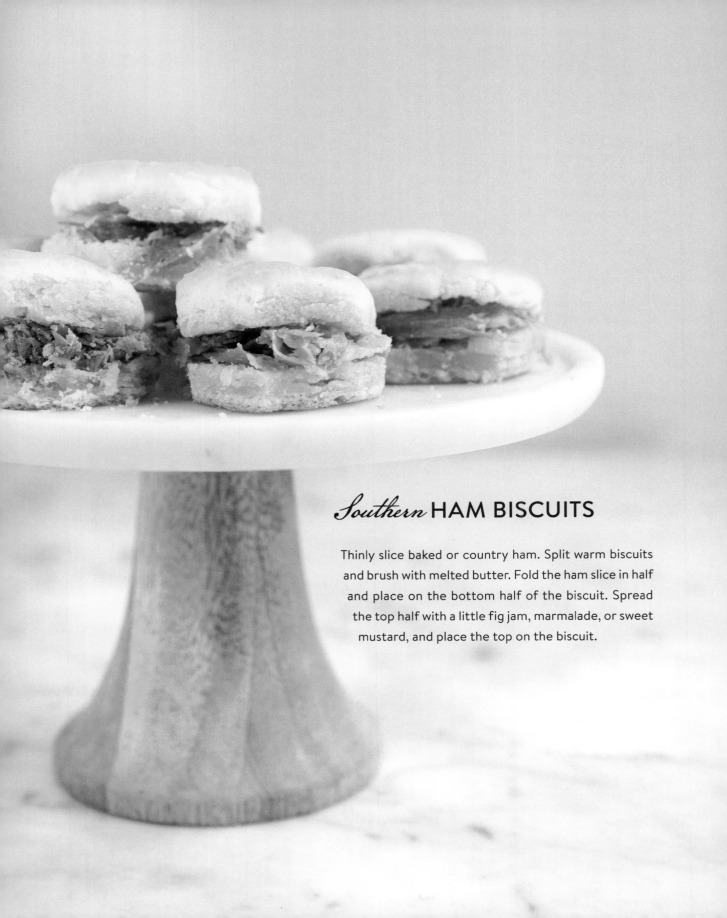

Southern HAM BISCUITS

Thinly slice baked or country ham. Split warm biscuits and brush with melted butter. Fold the ham slice in half and place on the bottom half of the biscuit. Spread the top half with a little fig jam, marmalade, or sweet mustard, and place the top on the biscuit.

Grandma's French Biscuits

I was intrigued by a recipe on page 159 of *Charleston Receipts* (1950). Called Grandma's French Biscuits, it was submitted by Mrs. Thomas R. Waring (Laura Witte Waring). Recipes in older cookbooks with names attached allow us to dive deeper and learn who once baked the recipe. Laura Waring's family was German and French Huguenot. To share her childhood memories with her children, she wrote a memoir called *The Way It Was in Charleston*, which was edited by her husband, Thomas R. Waring, after her death in 1975. Her French grandmother, Ellen Jackson Bounetheau Reeves, "had a genius for cooking," Waring noted, and her biscuits were unparalleled. They are rich, contain an egg, and are creamy golden. This recipe is lovely and makes dozens of smaller biscuits, or you can cut larger biscuits and let them bake a little longer.

Makes 35 (1 1/2–inch) biscuits Prep: 20 to 25 minutes Bake: 12 to 16 minutes

3 cups (360 grams) all-purpose flour, plus
 more for handling the dough
1 1/2 teaspoons baking powder
1 1/2 teaspoons granulated sugar
1/2 teaspoon salt
12 tablespoons (1 1/2 sticks/170
 grams) unsalted butter, cold, or
 8 tablespoons butter and 1/4 cup
 (2 ounces) lard
2 large eggs
1/2 cup whole milk

HOW TO MAKE GLUTEN-FREE FRENCH BISCUITS

Substitute a gluten-free flour blend and keep the rest of the ingredients the same. They need a little longer to bake, 18 to 20 minutes at 450ºF.

1. Heat the oven to 450ºF, with a rack in the middle.

2. Sift the flour, baking powder, sugar, and salt into a large bowl. Cut the butter into 1/2-inch pieces and distribute on top of the flour mixture. Add the lard in tablespoons, if using. With your fingers, mash the fat into the flour until well distributed and just a few larger pieces remain. Place the eggs and milk in a small bowl and beat lightly. Pour this mixture into the flour, a bit at a time, holding back a tablespoon or two. Stir with a fork or use your hands to mix the dough until it comes together into a sticky ball. Add the last of the milk and egg mixture if you need it.

3. Dust a surface with a couple tablespoons of flour. Turn the dough out onto the surface and pat it with flour on the top and underside so it doesn't stick. Handle the dough as little as possible. Pat to 1-inch thickness. Cut into 1 1/2–inch rounds and place 1/2 inch apart on a 12-by-17-inch rimmed baking sheet. Bake until golden brown, 12 to 16 minutes. Serve hot.

Aunt Vestula's Lemon Biscuits

Dori Sanders, a Black novelist, peach farmer, and author of *Dori Sanders' Country Cooking*, says these lemon biscuits were the specialty of her Aunt Vestula. They are light as air and scone-like because they contain eggs. Sanders recalls that in the 1940s and early 1950s, when her aunt got time off from her cooking job at a plantation near Charleston, she would arrive in the little town of Filbert in York County, South Carolina, with a trunk full of seasonings like sherry, herbs, and capers, expanding the minds and palates of her country relatives. On Sunday afternoon, the whole town was invited to their family home for a "silver tea," so called because the women brought a quarter to help pay for the food, dropping it into a small pressed glass bowl by the front door. "Some arrived early and brought their aprons and helped in the kitchen." The women who contributed money sat on the front porch, while the others spread out on the yard in the shade of the oak tree and ate homemade peach ice cream. "Aunt Vestula changed the way we thought about cooking," Sanders says. Later, Vestula came to live with Sanders' family and sat in the corner of the kitchen on a cane-bottomed chair near the woodstove, instructing Sanders' mother on how to cook, or she'd sit on the porch and eat cake and sip tea. "My mama said Aunt Vestula sometimes truly believed that she was the mistress of a large plantation and that my mama was the cook, as Aunt Vestula herself had once been."

Makes 16 (1 1/2–inch square) biscuits Prep: 25 to 30 minutes Bake: 12 to 15 minutes

2 cups (240 grams) all-purpose flour, plus 2 tablespoons for handling the dough

2 tablespoons granulated sugar, plus 2 tablespoons for sprinkling

4 teaspoons baking powder

1/2 teaspoon salt

4 tablespoons (1/2 stick/57 grams) unsalted butter, cold, cut into 1/2-inch pieces

4 tablespoons heavy cream, plus 2 tablespoons for brushing

1/2 teaspoon grated lemon zest

2 tablespoons fresh lemon juice (from 1 large lemon)

2 large eggs

1. Heat the oven to 400°F, with a rack in the middle.

2. Place the 2 cups flour, 2 tablespoons sugar, baking powder, and salt in a large bowl and whisk to combine. Scatter the pieces of butter on top of the flour and, with your fingers, toss the butter with the flour to coat. Mash the butter with your fingertips or, using a pastry blender, cut in the

butter until it resembles coarse meal. Make a well in the center of the flour mixture with the back of your hand.

3. In a small bowl, stir the 4 tablespoons cream, lemon zest and juice, and eggs until combined. Pour about half into the flour mixture and stir with a fork. Pour in the rest of the cream mixture as needed to pull together the dough. If needed, add a drop or two more cream. Handle the dough as little as possible.

4. Dust a surface with the 2 tablespoons flour. Turn the dough out onto the flour and pat the dough into a 6-inch square that is about 3/4 inch thick. Flour a knife and cut the square into quarters, and then each quarter into quarters, making 16 square biscuits. Carefully transfer them to a 12-by-17-inch rimmed baking sheet, using a small metal spatula or your hands. Brush with the 2 tablespoons cream and sprinkle generously with the 2 tablespoons sugar.

5. Bake until the biscuits are lightly golden brown, 12 to 15 minutes. Serve hot.

WHAT YOU NEED TO BAKE THE BEST BISCUITS

A COLD COUNTERTOP, MARBLE SLAB, OR FLOURED TEA TOWEL. A towel will prevent you from using too much flour, which dries out biscuits, and it helps you move a sticky dough, much like a bench scraper does. When you're finished making the biscuits, you can just gather up the towel and throw away the scraps.

GOOD SHARP CUTTERS. When cutting out your biscuits, press straight down into the dough and then release—don't twist—to create tall, straight-sided biscuits. Or cut with a chef's knife in straight lines.

A LIGHT TOUCH. Quick movements, not working the dough a lot, are best for light biscuits.

Callie's Cream Cheese Biscuits

Cookbook author Carrie Morey learned biscuit making from her mother, Callie White, a South Carolina caterer known for her cream cheese biscuits filled with country ham. The cream cheese keeps the biscuits soft and moist so they can be baked ahead of time and reheated, a caterer's dream. The mother-daughter team went on to create Callie's Charleston Biscuits in six flavors sold nationwide.

The biscuits are dense and cake-like, but you won't catch Morey or her bakers folding or kneading the dough. "The less you mess with it, the better. Our biscuits disintegrate in your mouth." I baked these biscuits in a 10-inch cake pan with the dozen biscuits placed right up next to each other, and they were exactly as Morey said—soft and spectacular. She uses White Lily self-rising flour, but any self-rising flour will do.

Makes 12 biscuits	Prep: 20 to 25 minutes	Bake: 15 to 20 minutes

2 cups (240 grams) self-rising
　　flour, plus 1/2 cup (60 grams)
　　for dusting and cutting
4 tablespoons (1/2 stick/57
　　grams) salted butter, at
　　room temperature, plus
　　2 tablespoons, melted, for
　　brushing the pan and biscuits
1/4 cup (56 grams) cream cheese,
　　at room temperature
3/4 to 1 cup whole buttermilk

1. Heat the oven to 450°F, with a rack in the middle.

2. Place the 2 cups flour in a large bowl and scatter the 4 tablespoons butter on top. Using your fingers, work the butter into the flour until the mixture looks like coarse meal. Drop the cream cheese on top of the mixture in small pieces and work it in with your fingers as well. Stir in 3/4 cup of the buttermilk until just combined. You want a damp dough but not sloppy wet. Add more buttermilk to make it slightly sticky.

3. Lightly flour a surface with the 1/2 cup flour and turn the dough out on it. Dust the top of the dough with some of the flour and, with floured hands, pat the dough to 3/4-inch thickness. Dip a 2-inch round biscuit cutter into the flour and cut out 12 rounds, dusting the cutter between cuts.

4. Brush a 10-inch round cake pan with some of the melted butter. Arrange the biscuits in the pan, placing 9 around the outside edges and 3 in the center. Brush the biscuit tops with the remaining melted butter and place the pan in the oven.

5. Bake until the biscuits are golden brown, 15 to 20 minutes. Serve hot.

FLORIDA ARROWROOT BISCUITS

ARROW-ROOT.

Most of Florida was unpopulated when it became a US state in 1845, and it had no paved roads or railroads. Wheat wouldn't grow in its sandy soil and intense heat, but something called "koonti" could. The Muskogee (Creek) and Seminole people introduced European settlers and free and enslaved Africans to the starch of the Florida arrowroot plant, which they called "koonti" or "coontie." It became a food of survival and later, before citrus and pineapple, a cash crop. Tampa chef and food writer Greg Bailey, who has studied the foodways of Florida, says early settlers just used what they had. "If you're hungry and you want to make a biscuit, you learn to adapt." The coontie plant's tuberous stems (roots) below ground were dug up and softened in water. They were pounded or milled to a pulp. And then the pulp was washed in a cloth or sieve to leach out the plant's toxins, because, being a member of the cycad family, coontie is high in cyanide. This separated the starch grains that sank into the water from the rest of the pulp. The pulp was discarded or used as fertilizer. But the starch in the water was left to dry in the sun, leaving a white powder that replaced wheat flour and had an infinite shelf life in Florida's moist climate. To make biscuits, coontie flour was mixed with animal fat, salt, water, milk, or buttermilk and beaten to incorporate air.

Shirley Corriher's Touch of Grace Biscuits

Shirley Corriher's career has evolved around the science of cooking and baking, so it was providential that she spent childhood summers at her grandmother's farm sampling buttermilk biscuits and making pretend mud pies. "Nanny [Orrie Piper Ogletree] spoiled me rotten," says Corriher, remembering the hot biscuits her grandmother baked thrice daily in her Conyers, Georgia, kitchen. To make them, she'd pull out an oblong bread bowl holding self-rising flour and add a good bit of Crisco and buttermilk, then mix it with her hands until it was a "wet gooey mess," like cottage cheese. "She'd pinch off a biscuit-size piece of wet dough and roll it in flour, shake off the excess flour, and place them in a cake pan, squished against each other," Corriher recalls.

Corriher graduated with a chemistry degree from Vanderbilt University, consulted with Pillsbury on their line of frozen biscuits, and wrote two cookbooks where she dived into cooking science, *CookWise* in 1997 and *BakeWise* in 2008.

A wet dough makes these biscuits light as a feather.

Makes 16 to 18 biscuits Prep: 15 to 20 minutes Bake: 10 to 15 minutes

Vegetable oil spray for misting the
 pan
2 cups (240 grams) self-rising
 flour
2 tablespoons granulated sugar
1/2 teaspoon salt
1/4 cup (2 ounces) vegetable
 shortening
3/4 cup buttermilk
2/3 cup heavy cream
1 cup (120 grams) all-purpose
 flour, for shaping the biscuits
Melted butter for brushing

1. Heat the oven to 450°F, with a rack in the middle. Mist the bottom of a 9- to 10-inch round cake pan with vegetable oil spray and set aside.

2. Whisk together the self-rising flour, sugar, and salt in a large bowl. Add the shortening and work it into the flour with your fingertips to create coarse crumbs. Pour in the buttermilk and cream and stir with a fork until just mixed. It will be wet and gooey and have the consistency of cottage cheese.

3. Spoon the all-purpose flour onto a pie plate. Scoop up generous tablespoons of the dough and place on the pie plate. Sprinkle the flour all over the dough and, with your hands, roll the dough through the flour. Shaking off the excess flour, shape each piece of dough into a round, about 1 inch thick. Place the biscuit round in the cake pan and continue making biscuits in this fashion, pressing them next to each other in the pan. Bake until deeply browned, 10 to 15 minutes. Brush with melted butter while hot. Turn out the panful of biscuits onto a serving platter and separate them with a paring knife.

SHARON BENTON'S TWO-INGREDIENT BISCUITS

When Sharon Benton bakes biscuits to hold the ham made by her husband, country ham king Allan Benton, she uses just two ingredients: Our Best, a self-rising flour from Boonville Mill in the Piedmont of North Carolina, and Cruze buttermilk from Knoxville, made from the milk of Jersey cows, high in butterfat and not homogenized. "When you get a half gallon of Cruze buttermilk, you can see the three inches of butterfat sitting at the top. That's the reason I don't have to put fat in my biscuits," Benton says. There's a third ingredient to her biscuits. It's called know-how. "I don't even measure," she says. "I've been making biscuits so long I can just tell by the feel of the dough."

In her Madisonville, Tennessee, kitchen, about thirty-five miles south of Knoxville, Benton fills a pottery biscuit bowl with about 2 cups self-rising flour. She pours in about 1 cup buttermilk—sometimes more and sometimes less—stirring with a metal spoon until the dough follows the spoon around the bowl. The dough is wet and a little sticky to work with, and she pats it out on a flour-dusted pastry cloth and folds it 2 or 3 times, bringing some of the flour into the dough as needed so it's not sticky anymore. Then she dusts her hands with flour and pats out the dough to 1/2 inch thick and cuts out the biscuits. "I use a 2-inch floured biscuit cutter and cut straight down. My pan is so old I don't grease it. It's dark. If you want crispy sides, then I wouldn't let them touch. If you want softer biscuits, put them closer together. And I put a small pat of butter on top. You don't have to do that, but I just do."

My turn. I patted the dough out to nearly 3/4 inch thick, a little thicker than hers. I cut out about 12 biscuits and placed them in a 12-inch cast-iron skillet, which I lightly buttered. I baked them at 450°F for 13 to 14 minutes. Then I split them and filled them with Benton's country ham. Perfection!

SORGHUM: SWEET IN HARD TIMES

A lack of white sugar during the War of 1812 got people thinking of other sources for sweetening. Corn sugar (syrup) was introduced in 1836, and then sorghum, a dark-amber syrup pressed from grasslike sorghum canes in 1854. The sugar industry came to a halt during the Civil War, and the refineries moved north to New York City and Brooklyn. With the fall of Vicksburg toward the end of the Civil War and control of the Mississippi River shifting to the Union, trade was cut off with much of the South, and so was sugar and molasses. Sorghum, often called "sorghum molasses," took its place on dinner tables.

Even today, sorghum has its devotees who appreciate how each year's vintage varies from the next, just like wine. For Scott Elder, who makes sorghum in Sevierville, Tennessee, within sight of the Great Smoky Mountains, it is a fascination but also a responsibility to carry on a craft that's been handed down in his family for generations. "To me, 2015 was the best year for taste. You remember the years it was so good," Elder says. And if the rain, sunshine, soil, and type of sorghum he plants don't have enough to do with the final caramel-like flavor, how long he boils down the amber syrup from thin to thick and jammy certainly does.

Thomasville Cheese Biscuits

From deep in the southwestern corner of Georgia comes this irresistible cheese biscuit that's a cross between a biscuit and a cheese straw. It belongs to Mary Jo Beverly, who shared it when the Vashti Auxiliary published Thomasville's *Pines and Plantations* cookbook in 1976. Add a thin slice of ham and a spoonful of homemade pear preserves, and I am not sure how anything gets better, unless, I suppose, you put a toasted pecan on top. You can use either sharp cheddar or blue cheese in these biscuits. But if you bake with the blue, serve with fig preserves.

Makes 20 to 24 (2-inch) biscuits	Prep: 15 to 20 minutes	Bake: 15 to 18 minutes

1 3/4 cups (210 grams) all-purpose flour, plus more for handling the dough

1 1/2 teaspoons baking powder

1 teaspoon kosher salt

1/4 teaspoon ground cayenne pepper

3/4 cup (3 ounces/86 grams) shredded sharp cheddar cheese or crumbled blue cheese

4 tablespoons (1/2 stick/57 grams) salted butter, cold, cut into 1/2-inch pieces

3/4 cup whole milk

1. Heat the oven to 425°F, with a rack in the middle.

2. Whisk together the flour, baking powder, salt, and cayenne in a large bowl. Stir in the cheese. Drop the pieces of butter on top and, with your fingertips, work the butter into the flour mixture until it resembles coarse crumbs. With a fork, stir in the milk until a ball forms and leaves the sides of the bowl.

3. Turn the dough out onto a lightly floured surface and pat to about 1/3-inch thickness. Cut with a 2-inch cutter dipped in flour.

4. Place the biscuits about 1 inch apart on a 12-by-17-inch rimmed baking sheet (so they crisp on all sides) and bake until golden brown, 15 to 18 minutes. Serve hot.

LAMINATING BISCUITS TO CREATE LAYERS

In pastry parlance, folding biscuit dough to create layers is called lamination. And although you might think it sounds like a trick savvy pastry chefs came up with, it's been around awhile. In 1839, Lettice Bryan wrote in her *The Kentucky Housewife* cookbook about layering crumbled butter onto biscuit dough and folding it into layers.

Cheese Straws

Southerners have embraced cheese straws—the long, willowy, crispy cheese biscuits that shatter when you bite into them—for as long as we can remember. North Carolina food writer Kathleen Purvis once wrote that they are as much a part of weddings as "cheap champagne and dyed satin shoes." When I think of cheese straws, I think of bridal showers, holidays, silver trays, punch glasses, and the green velvet dresses my mother insisted I wear at Christmas. I think of the funerals of favorite aunts and grandmothers too. The late great Southern food writer Julia Reed said that if you want to entertain Southern style, you need only two things: libations and a good recipe for cheese straws.

Here is my favorite recipe.

Makes about 5 dozen Prep: 15 to 20 minutes Chill: 30 minutes Bake: 15 to 20 minutes

1 pound extra-sharp cheddar cheese, shredded (about 4 packed cups)

12 tablespoons (1 1/2 sticks/171 grams) unsalted butter, at room temperature

2 cups (240 grams) unbleached all-purpose flour, plus more for rolling

1 heaping teaspoon ground cayenne pepper

Kosher salt for sprinkling

1. Place the cheese in the bowl of a large stand mixer or food processor. Add the butter, flour, and cayenne pepper. Mix or process until the mixture comes together in a ball, 1 to 2 minutes. Wrap in waxed paper and place in the refrigerator to chill for 30 minutes.

2. When you're ready to bake, preheat the oven to 350ºF and set aside two ungreased 12-by-17-inch baking sheets. Remove the dough from the fridge and cut the ball in half. Return one wrapped half to the fridge. Place the other half on a lightly floured surface. Roll out the dough to 1/4-inch thickness. With a pastry cutter or pizza wheel, cut the dough into 1/2-inch strips and gently transfer them to a baking sheet. Place one pan at a time in the oven and bake until the straws are puffed up and golden brown, 15 to 20 minutes.

3. Sprinkle with salt while still hot and on the pan. With a metal spatula, transfer the salted cheese straws to a wire rack to cool completely. Repeat with the remaining dough. (Or, you can freeze the unbaked dough for up to 1 month.) Serve with cocktails. Store in airtight tins for up to 1 week at room temperature or up to 3 months in the freezer.

Old-Fashioned Strawberry Shortcake

In the short window of deliciousness that is strawberry season, strawberry shortcake is our reward. The recipe was first created to use up the wild "Virginia" variety of strawberries that grew generations ago across much of the eastern United States. When I was young, the Tennessee berry season ran from April through May, and my older sister's birthday fell during this window, so her birthday cake was always strawberry shortcake.

The word *shortcake* implies that fat has been incorporated to make the sweet biscuit "short," or flaky. And when baked using the soft wheat flour of the South, the shortcake is even more tender. The less you work the dough, the more delicate and fragile your shortcakes will be. Split the hot biscuits with a fork, if you like, and tuck a little butter inside to melt. Spoon sweetened, fragile local berries onto the shortcakes, and on top, dab real cream—lightly whipped and barely seasoned with sugar.

Serves 8 to 12	Prep: 25 to 30 minutes	Bake: 15 to 20 minutes

6 cups (about 2 1/4 pounds/1 kilogram) ripe fresh local strawberries

2/3 cup (135 grams) granulated sugar, or more to taste, divided

3 cups (360 grams) all-purpose flour, plus more for dusting

2 teaspoons baking powder

1 teaspoon salt

12 tablespoons (1 1/2 sticks/170 grams) unsalted butter, soft but cool to the touch, plus 2 tablespoons for serving (optional)

1 cup heavy cream

1 large egg

3 cups Whipped Cream (page 458)

1. An hour before serving, hull the berries and halve all but 8, saving those for garnish. Toss the berry halves with 1/3 cup of the sugar and set aside at room temperature.

2. Heat the oven to 425ºF, with a rack in the middle.

3. Whisk together the flour, remaining 1/3 cup sugar, baking powder, and salt in a large bowl. Cut the 12 tablespoons butter into tablespoons and distribute over the top of the flour mixture. With two sharp paring knives or a pastry blender, cut the butter into the flour mixture until it looks like peas and is uniform in size. Put the cream into a small bowl and crack the egg into it. Stir with a fork to break up the yolk. Pour into the dough mixture and stir together with a wooden spoon or spatula until the liquid is just combined.

4. Scatter flour on a surface and turn the dough out onto the flour. With floured hands, pat to a generous 1-inch-thick round. Flour a 2- to 3-inch cutter and cut the dough into 8 to 12 rounds. (Or, if you're in a hurry and don't want to cut out circles, slice the round of dough into wedges and bake.)

5. Place the shortcakes 1/2 inch apart on a 12-by-17-inch rimmed baking sheet and place the pan in the oven.

6. Bake the shortcakes until they are golden brown around the edges, 15 to 20 minutes. Remove the pan from the oven and let the shortcakes cool a few minutes, then split them open with a fork and spread with the 2 tablespoons butter, if desired.

7. To serve, place the bottom half of the shortcake into a serving bowl. Spoon some of the sweetened berries and juice on top, place the top half of the biscuit over the berries, and spoon more berries and juice on top. Spoon the whipped cream over the berries. Repeat with the remaining shortcakes. Drizzle any remaining juice in the bowl over the shortcakes before serving. Garnish with remaining strawberries.

TIPS FOR AN EVEN MORE DELICIOUS STRAWBERRY SHORTCAKE

- Add grated orange zest to the dough.
- Add vanilla to the whipped cream.
- Mash a quarter of the berries and slice the rest.

BUTTER ROLLS

Large families in the Deep South, especially Mississippi, used to make Butter Rolls, or "Butterroll," from biscuit dough. You roll out your favorite dough, slather it with soft butter, brown sugar, and spices, then roll it up and, just before baking, pour a sweet custard sauce over the top.

Make the biscuit dough: Mrs. Wilkes' Boarding House Biscuits (page 64) or Bryson City Cathead Biscuits (page 81). Roll it out to a rectangle that is 12 inches long on one side and 8 to 16 inches on the other.

Spread on a filling of 4 tablespoons (1/2 stick) soft butter, 1/4 cup brown sugar, 1/2 teaspoon cinnamon, and a dash of nutmeg. Add chopped pecans or raisins, if you like.

Roll it up from the 12-inch side and slice it into 12 (1-inch) rounds. Place the rounds in a rectangular baking pan.

Make the cream sauce: Place 1 (14-ounce) can sweetened condensed milk, 2 cups half-and-half or evaporated milk, 1/2 cup sugar, and a pinch of salt in a medium pot. Whisk well, bring to a boil just to dissolve the sugar, and then pour it over the butter rolls in the pan. Bake for about 40 minutes at 350°F, or until the rolls are golden brown and the sauce is thick and bubbly. Serve warm.

Fresh Berry Dumplings

Not all biscuit dough is baked. Sometimes it's spooned into a saucepan with simmering berries and sugar, covered, and steamed, and then it's called a "dumpling." The best sauce for these dumplings is made with a medley of berries, so you can see how this recipe was a seasonal one for when berries start to ripen. My dad made extra spending money by picking raspberries, blackberries, and black raspberries to sell at the Nashville farmers market when he was young. Picking berries, whether on a farm or the roadside, is full of memories . . . and chiggers! And you may eat more than you put in the bucket, but do save some for dumplings.

Dewberries, or small wild blackberries, finish up their fruit in early May. Black raspberries and blackberries cultivated on farms or in your garden will continue to ripen a little later into the summer and in some places even into fall. How to tell the difference? A blackberry has a soft white or green center, whereas black raspberries are hollow on the inside. Both are delicious.

Serves 4	Prep: 30 to 35 minutes	Cook: 17 to 21 minutes

FRUIT

3 cups (about 1 pound/454 grams)
 fresh berries (blueberries,
 blackberries, dewberries,
 or raspberries), rinsed and
 drained

1/4 cup (50 grams) granulated
 sugar, plus more as needed

1/2 teaspoon grated lemon zest

DUMPLINGS

1/2 cup (56 grams) cake flour

1 1/2 teaspoons baking powder

1/4 teaspoon salt

1 tablespoon unsalted butter, cold,
 cut into small cubes

1/4 cup whole milk or half-and-half

1 tablespoon granulated sugar

Vanilla ice cream for serving

1. **Prepare the fruit:** Place the berries, sugar, and lemon zest in a medium skillet with a lid over medium heat. Bring to a simmer, then mash the berries with a potato masher and add a couple tablespoons of water. Bring back to a simmer, reduce the heat to low, cover, and cook until the berries form a sauce, 5 to 6 minutes. If you need to add another tablespoon or two of water, do so. Turn off the heat.

2. **Make the dumplings:** Whisk together the flour, baking powder, and salt in a large bowl. Scatter the butter on top of the flour mixture and, with your fingertips, rub it in until it forms coarse crumbs. Pour in the milk or half-and-half and mix with a fork until it pulls together into a sticky mass.

3. To cook the dumplings, bring the berry syrup back up to a simmer and drop the dough by tablespoonfuls into the syrup, leaving space between them. Sprinkle the tops with the sugar. Place the lid on the skillet and simmer until the dumplings are cooked through, 12 to 15 minutes.

4. Turn off the heat and spoon the dumplings with berry sauce into serving bowls with vanilla ice cream.

QUICK LOAVES, GRIDDLE CAKES, WAFFLES, AND FRITTERS

The South has long been famous for its great hot breads and pancakes. I think the rich buttermilk or naturally soured milk, home rendered lard, and single-acting baking powder Southern cooks have always baked with have given our breads this deserved reputation.

—EDNA LEWIS, *IN PURSUIT OF FLAVOR*, 1988

Southern cooks avoid baking in the hot months whenever possible; they may offer stove-top dumplings instead or the more elegant fritter—a deep fried, batter-coated fruit that New Orleans, Charleston, and Mobile (cities with large French and Spanish populations) particularly fancied.

—BILL NEAL, *BISCUITS, SPOONBREAD & SWEET POTATO PIE*, 1990

henever I need a quick, special breakfast, an impromptu baked good to give to a friend, a no-fuss treat to stash in the freezer for an unexpected guest, or an afternoon pick-me-up, I turn to the recipes in this chapter.

It takes just moments to throw together my mother's banana bread or stir up a batter to make blueberry-buckwheat pancakes for breakfast. You won't be in the kitchen long making a vibrant lemon teacake I've re-created from a nineteenth-century recipe of Malinda Russell, the first Black woman to write a cookbook. And my zucchini muffins, the well-kept secret of a Dallas cafeteria I've managed to replicate, taste far more complicated than they are. None of these requires much in the way of advance planning. All are risen by baking powder or baking soda. (Just a couple of them get a little boost from yeast and so take a bit more time. They're worth it, trust me.)

To the rural, isolated cooks of the South, commercial baking soda and baking powder, which predated the invention of dried yeast, must have seemed almost miraculous when they first appeared on the market. Early baking soda, called "potash," was a primitive product made from the ash of hardwood trees after they were burned to clear land. In some parts of the South, the ash came from burnt corncobs. Women ran water through the ash and used the resulting lye water for cleaning. The residue was dried to make the potash. When this alkaline substance was combined with something acidic, like buttermilk or molasses, the chemical reaction between the two created tiny, explosive bubbles of carbon dioxide, which powered the rise of breads and cakes.

The problem with potash, and pearlash, a purified version of potash, though, was that they tasted bitter. That's why early cakes and breads were highly spiced: to cover up the harsh flavor of potash. Saleratus, or potassium bicarbonate, and baking soda, or sodium bicarbonate, came later. With an acidic ingredient like sour milk, lemon juice, or vinegar, they produced carbon dioxide more quickly and had less aftertaste.

First created in England in the 1840s, baking powder was developed in America a decade later. It was a combination of alkaline baking soda and cream of tartar, the acidic salt found on the inside of wine barrels after fermentation, which was imported from France and Italy. In 1859 the Rumford Company introduced the first calcium phosphate baking powder, which had cornstarch added to make it moisture resistant and help keep the alkaline and acidic ingredients from reacting with one another in the container.

The recipes in this chapter rely on the speed of those handy leavening agents. I begin with quick loaves of cake and bread, move into griddled goodies for breakfast and brunch, and then turn to the skillet or fryer from which delicacies like beignets and banana fritters have emerged golden and glorious for generations.

When my children come home to visit, we place the waffle iron on the counter and turn breakfast into an event. (We don't go quite as far as the Scottish families in the Lowcountry of South Carolina, who had their family crests emblazoned onto their waffle irons.) Even without a crest, Marion Flexner's Perfection Waffles can be counted on to amp up your waffle game.

The last recipes in this chapter, for the fried treats, speak of heritage and celebration. They are the food of festivals and street fairs, of Mardi Gras and holidays. They are served to commemorate Hanukkah or the final night of Kwanzaa. They include the soft, crackling beignets of New Orleans' French Market, smothered under a blanket of powdered sugar; sweet rice fritters called calas, a taste of an older New Orleans; and apple cider fritters, which are synonymous with fall in the little mountain towns in Virginia, Tennessee, and Arkansas.

"People tell me they don't like fried food, and I think they are either lying or they haven't had it done properly," says John Martin Taylor, author of the *Fearless Frying Cookbook* (1997). I agree. In one way, this chapter feels a bit like the beloved kitchen "junk" drawer, the one you rummage through to find tape, matches, string, or a birthday candle—different things that may have little in common, except they are all essential and I can't stop making them.

Martha Nesbit's Blueberry Muffins

If you love blueberry muffins, why not make the best ones? My friend Martha Giddens Nesbit, the food editor of the *Savannah Morning News* for many years, took it upon herself to perfect them. These muffins are gigantic, and the batter is rich and thick enough to suspend the blueberries so they don't sink to the bottom. Nesbit likes to serve them with her pan-fried flounder, cheese grits, and salad. You can add a pinch of cinnamon or lemon zest, but she prefers them plain and simple, so the blueberry flavor comes through. Stash these in the freezer for weekend houseguests, holiday breakfasts, and bake sales.

Makes 12 muffins	Prep: 15 to 20 minutes	Bake: 25 to 30 minutes

Vegetable oil spray for misting the pans or paper liners

8 tablespoons (1 stick/114 grams) unsalted butter, at room temperature

1 cup (200 grams) granulated sugar, plus 2 tablespoons for topping (or substitute demerara sugar for the topping)

2 large eggs

1/2 cup whole milk

1 teaspoon vanilla extract

2 cups (240 grams) all-purpose flour

2 teaspoons baking powder

1/2 teaspoon salt

2 cups (12 ounces/340 grams) fresh blueberries

1. Heat the oven to 375ºF, with a rack in the middle. Mist a 12-cup muffin pan with vegetable oil spray or line with paper liners.

2. Place the butter and the 1 cup sugar in a large bowl and beat with an electric mixer on medium-low speed until creamy, 2 minutes. Add the eggs, milk, and vanilla and beat on low just to combine. Turn off the machine.

3. Whisk together the flour, baking powder, and salt in a small bowl and stir into the batter. Gently fold in the blueberries.

4. Using a 1/3-cup dry measuring cup or an ice cream scoop, divide the batter among the muffin cups, filling them nearly to the top. Sprinkle the tops with the 2 tablespoons granulated or demerara sugar. Place the pan in the oven and bake until the muffins are lightly golden brown and the tops spring back when lightly pressed, 25 to 30 minutes. Lift the muffins out of the pan carefully, and transfer them to a wire rack to cool completely, about 30 minutes.

5. Serve at once or let cool, then place in zipper-top bags to freeze for up to 4 months.

Highland Park Cafeteria's Zucchini Muffins

Anyone who grows a backyard garden knows the beauty of a zucchini muffin recipe. This one is a goodie, full of finely chopped walnuts and flavored with nutmeg. It was the signature bread at the Highland Park Cafeteria, which opened on Dallas' Knox Street in 1925. It grew to eight locations in good times and, in more challenging times, contracted just to one in East Dallas, until it finally closed in 2020 during the COVID pandemic. Cafeterias like this were places of comfort and reminiscence, where people went to order the foods of their childhoods for lunch after church and where they went on a first date or to get a first job. While the recipe for the cafeteria's zucchini muffins is a well-guarded family secret, Lisa Fain of the *Homesick Texan* blog and the food sections of the *Fort Worth Star-Telegram* and the *Dallas Morning News* have attempted to reconstruct it. Here is my attempt. The actress Shirley MacLaine was mad about them, and I understand why!

Makes 12 muffins	Prep: 15 to 20 minutes	Bake: 25 to 30 minutes

Vegetable oil spray for misting the pan or paper liners

2 cups (240 grams) all-purpose flour

2 teaspoons baking powder

2 teaspoons ground cinnamon

1/2 teaspoon ground nutmeg

1/2 teaspoon salt

1 cup (200 grams) granulated sugar

3/4 cup vegetable oil

2 large eggs

2 teaspoons vanilla extract

2 cups (8 ounces/242 grams) lightly packed shredded fresh zucchini (from 1 large or 2 small zucchini)

1/2 cup (2 ounces/57 grams) finely chopped walnuts or pecans

1. Heat the oven to 350°F, with a rack in the middle. Lightly mist a 12-cup muffin pan with vegetable oil spray or line with paper liners.

2. Whisk together the flour, baking powder, cinnamon, nutmeg, and salt in a large bowl. Set aside.

3. Place the sugar, oil, eggs, and vanilla in a large bowl and stir with a wooden spoon to combine well. Fold the zucchini and walnuts or pecans into the flour mixture and then fold this into the egg mixture. The batter will be thick.

4. Scoop or spoon the batter into the muffin cups, filling them three-quarters full. Bake until the muffins are browned and spring back when lightly pressed in the center, 25 to 30 minutes.

5. Remove the pan from the oven and let the muffins rest in the pan for 1 minute. Run a small knife around the edges of the muffins to loosen them, then lift the muffins out of the pan carefully with the knife and transfer them to a wire rack to cool completely, about 30 minutes.

6. Serve at once or let cool, then place in zipper-top bags to freeze for up to 4 months.

Ouita Michel's Sweet Potato Streusel Muffins

What's nice about sweet potato muffins like these is you get all the flavors of a Thanksgiving casserole in just a few bites. They are a fixture at the Midway Bakery of Ouita Michel, Kentucky's "most prominent and successful chef/restaurateur," according to *Kentucky Monthly* magazine. They were created by manager Carrie Warmbier and are in Michel's cookbook, *Just a Few Miles South* (2021). The recipe calls for roasting the sweet potatoes first, which gives the muffins a deep near-caramel flavor and makes them fluffier than if you had just boiled the sweet potatoes. Warmbier does this the night before, then lets the potatoes cool overnight, which makes them easier to peel and puree.

Makes 12 to 16 muffins Prep: 1 hour, 20 minutes (includes the time to roast the sweet potatoes) Bake: 30 to 35 minutes

2 large (1 1/2 pounds) unpeeled sweet potatoes

Vegetable oil spray for misting the pan

1 1/2 cups (180 grams) all-purpose flour

1 teaspoon ground cinnamon

3/4 teaspoon baking powder

3/4 teaspoon baking soda

1/2 teaspoon salt

1 cup (200 grams) granulated sugar

1/2 cup plus 2 tablespoons vegetable oil

2 teaspoons vanilla extract

2 large eggs

STREUSEL

1/4 cup (30 grams) all-purpose flour

1/4 cup (48 grams) lightly packed light brown sugar

1/2 teaspoon ground ginger

2 tablespoons unsalted butter, cold, cut into small pieces

1. Heat the oven to 400°F, with a rack in the middle.

2. Wash and dry the sweet potatoes, prick them with a knife several times, and place on a foil-lined baking pan. Place the pan in the oven and bake until the potatoes are tender, 1 hour. A knife should insert into the center of the potatoes with ease. Let cool, then peel and puree the pulp in a food processor until smooth. You'll need 2 cups puree.

3. Decrease the oven temperature to 375°F. Mist a muffin pan with vegetable oil spray and set aside.

4. Whisk together the flour, cinnamon, baking powder, baking soda, and salt in a large bowl. Place the sugar, oil, vanilla, and eggs and 2 cups of the sweet potato puree in a medium bowl and stir to combine well. Turn the sweet potato mixture into the flour mixture and stir until just smooth. Scoop or spoon the batter into the muffin pan, filling them either three-quarters full to make 12 muffins or two-thirds full to make 16 muffins.

5. **Make the streusel:** Place the flour, brown sugar, and ginger in a small bowl and whisk to combine. Scatter the butter pieces on top and cut them into the flour mixture, using two knives or a pastry blender, until the mixture resembles large

peas. Sprinkle a heaping teaspoon of the streusel over the top of each muffin and place the pan in the oven. Bake until a toothpick inserted in the center comes out clean, 25 to 28 minutes for the 16 small muffins or 30 to 35 minutes for the 12 large muffins.

6. Remove the pan to a wire rack to let the muffins cool for 5 minutes, then run a metal spatula around the edges of the muffins and underneath them and transfer to the rack to cool completely, 30 minutes, before serving.

OUITA MICHEL

From the small town of Thermopolis, Wyoming, where she was born, to the Kentucky Bluegrass where she was raised, to the Culinary Institute of America in Hyde Park, New York, where she learned classic cooking and baking, then back to Midway, Kentucky, where she makes her home and bases her restaurant and catering business, Ouita Michel has done a bit of traveling. She's embraced old Kentucky recipes like jam cake, beaten biscuits, and lace cookies, many of which come from the family files of friends and employees. She bakes with locally grown wheat milled at Weisenberger Mill, located on the banks of the South Elkhorn Creek, near Midway, and founded in 1865. She's proud to cook with local hickory nuts, blackberries, apples, wild pecans, pears, dandelion greens, sweet potatoes, and bourbon, and she embraces all the regional nuances Kentucky offers. "On the east side of the state you find apple stack cake and dark gingerbread," she says. "But western Kentucky cooking is more like Missouri—a lot of pies."

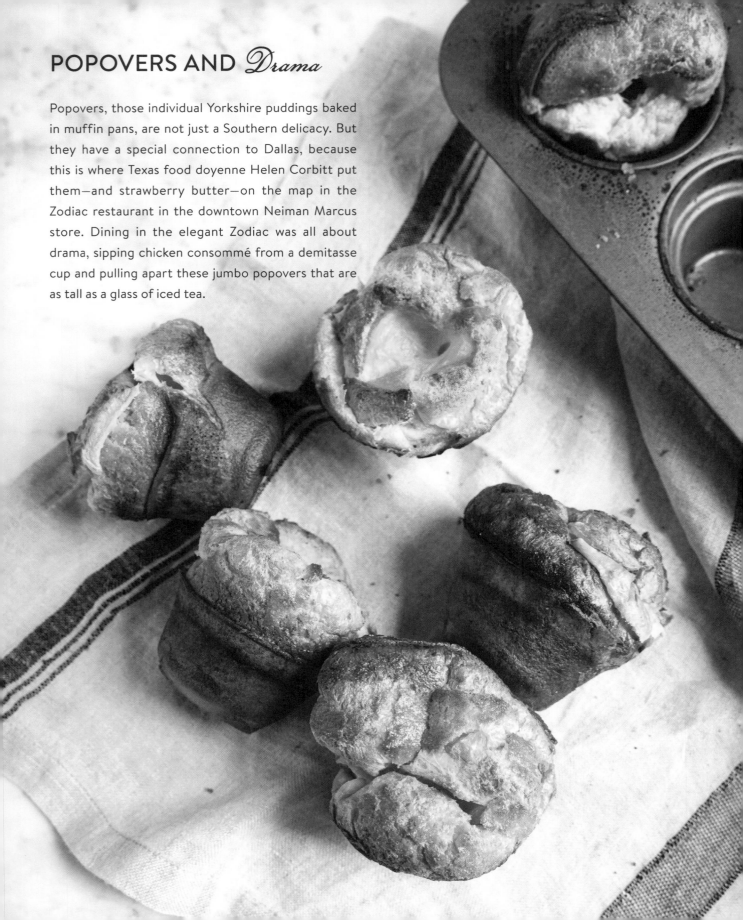

POPOVERS AND *Drama*

Popovers, those individual Yorkshire puddings baked in muffin pans, are not just a Southern delicacy. But they have a special connection to Dallas, because this is where Texas food doyenne Helen Corbitt put them—and strawberry butter—on the map in the Zodiac restaurant in the downtown Neiman Marcus store. Dining in the elegant Zodiac was all about drama, sipping chicken consommé from a demitasse cup and pulling apart these jumbo popovers that are as tall as a glass of iced tea.

Helen Corbitt's Neiman Marcus Popovers

A newspaper columnist, cookbook author, hospital dietitian, and professor of catering and restaurant management, Helen Corbitt had hoped to go to medical school when the Depression dashed her plans. But in the end, she became a doctor of cuisine, a creator of poppy seed dressing, Texas caviar, and flowerpot cakes. A bold and brave woman, she challenged Texans to take a bite of chicken salad with white grapes. "In a career that spanned nearly forty years in Texas, she delivered us from canned fruit cocktail, plates of fried brown food, and too much bourbon and branch into a world of airy soufflés, poached fish, chanterelle mushrooms, fresh salsify, Major Grey's Chutney, crisp steamed vegetables, and fine wine. She was a creative pioneer who came here reluctantly and learned to love us," wrote Prudence Mackintosh in *Texas Monthly* in December 1999.

Makes 6 large popovers Prep: 10 to 15 minutes Bake: 32 to 37 minutes

4 large eggs

1 cup minus 1 tablespoon whole milk

1 tablespoon butter, melted, plus 1 teaspoon, melted, for greasing the pan (or substitute vegetable oil)

1 cup (120 grams) all-purpose flour

1/2 teaspoon salt

1 tablespoon grated Parmesan cheese (optional)

NOTE:

While Corbitt's recipe called for just 2 eggs, I have increased the eggs to 4 to get more rise in the pan.

1. Heat the oven to 425°F, with a rack in the middle.

2. Place the eggs and milk in a large bowl of an electric mixer or in a blender. Beat or blend until light, 2 to 3 minutes on medium speed. Add the 1 tablespoon butter or oil and combine well. Place the flour in a small bowl and stir in the salt. Gradually add the flour mixture to the egg mixture, beating or blending until smooth and well incorporated, 1 minute.

3. Brush a popover pan with 6 cups or a large cupcake tin with the 1 teaspoon melted butter or oil. Place the pan in the oven to get hot, 1 to 2 minutes.

4. Remove the pan from the oven and pour in the batter, dividing it among the cups, filling them one-third to one-half full. Sprinkle with a little Parmesan cheese, if desired. Place the pan in the oven.

5. Bake for 20 minutes, then reduce the oven temperature to 350°F and bake for 15 minutes more, or until the popovers are well browned and crispy and not wet inside. Serve hot.

Malinda Russell's Lemon Drizzle Loaves

One of the earliest mentions of lemon cake in a Southern cookbook is in *A Domestic Cook Book* (1866), thirty-nine pages of recipes by Malinda Russell. It was the first US cookbook authored by a Black woman, according to the late Jan Longone, a University of Michigan historian and an antique cookbook collector. Russell, born and raised in East Tennessee, had been trained in the kitchen by a formerly enslaved cook in Virginia and ran both a boardinghouse and a pastry shop prior to the Civil War. She baked professionally in a distinctive English style, flavoring cakes and pastries with lemon, brandy, rose water, and almonds. In this recipe based on one of hers, I have made only slight adjustments for the modern kitchen, adding a little cream and using fewer eggs because eggs are larger now than they used to be. The result is a rich and lemony quick bread or cake with a tight crumb that slices well and keeps for several days.

Makes 2 to 3 loaves	Prep: 20 to 25 minutes	Bake: 55 to 62 minutes

1 pound (4 sticks/454 grams) unsalted butter,
 soft but cool to the touch, plus 2 teaspoons
 for greasing the pans

3 1/2 cups (420 grams) unbleached all-purpose
 flour, plus 1 teaspoon for sprinkling the pans

2 cups (400 grams) granulated sugar

6 large eggs, at room temperature

2 teaspoons baking powder

1 teaspoon salt

1/4 cup heavy cream

2 teaspoons grated lemon zest

1/4 cup fresh lemon juice

GLAZE

2 cups (216 grams) sifted confectioners' sugar
 (sift before measuring)

4 teaspoons grated lemon zest

1/4 cup fresh lemon juice or half lemon juice and
 half milk

Lemon zest, kumquat slices, and edible flower
 blossoms for garnishes

1. Heat the oven to 350°F, with a rack in the middle. Using the 2 teaspoons butter and the 1 teaspoon flour, grease and flour three 7 1/4-by-3 1/2-inch loaf pans or two 9-by-5-inch pans and set aside.

2. Place the 1 pound butter and sugar in a large bowl and beat with an electric mixer on medium speed until the mixture lightens in color and texture, 3 to 4 minutes. Scrape down the sides of the bowl. Continue beating, adding the eggs one at a time until combined. Stop the machine.

3. Stir together the 3 1/2 cups flour, baking powder, and salt in a bowl. Add half to the butter mixture and beat on low until just combined. Add the cream, along with the lemon zest and juice, and beat until combined. Add the remaining flour mixture and beat until incorporated.

4. Turn the batter into the prepared pans and bake until the cakes are golden brown and the tops spring back when lightly pressed in the center, 55

to 60 minutes for the smaller loaves or 58 to 62 minutes for the larger. Remove to a wire rack to cool in the pans for 15 minutes.

5. **Meanwhile, make the glaze:** Place the sugar in a small bowl and whisk in the zest and juice until smooth.

6. Run a knife around the sides of the pans, invert the loaves into your hand, and place them on the rack right side up. Spoon the glaze over the warm loaves, allowing it to run down the sides. Top with the garnishes, if desired. Let cool completely before slicing, about 1 hour.

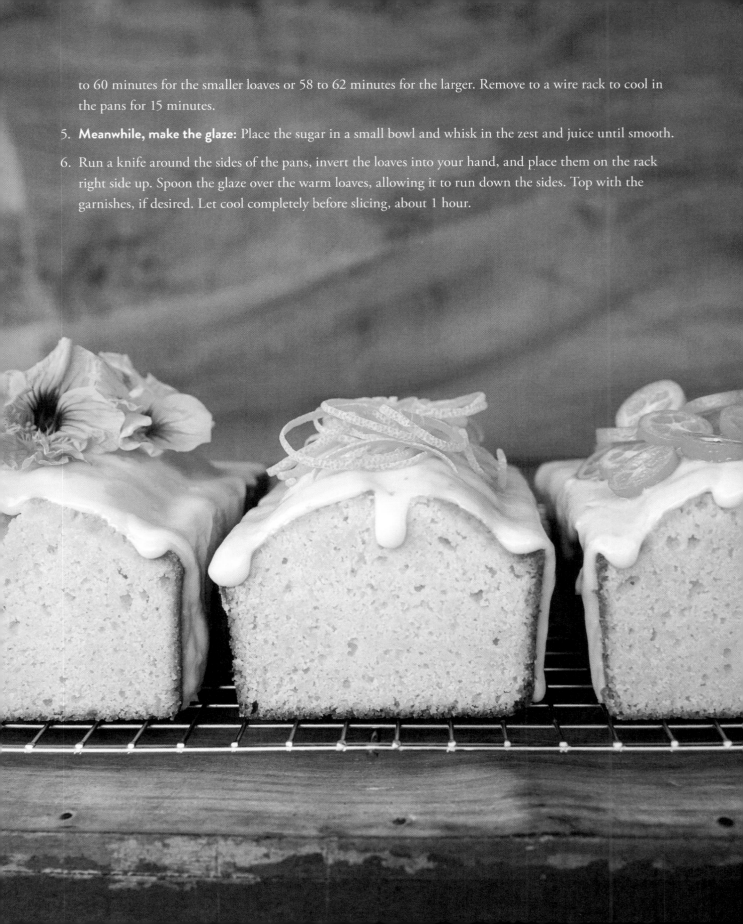

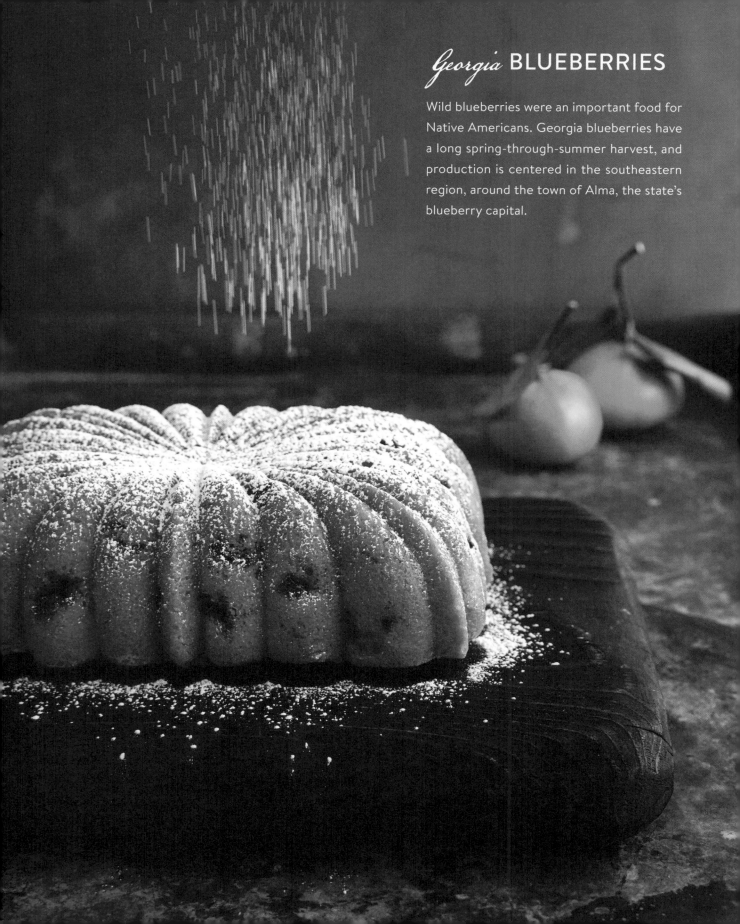

Georgia BLUEBERRIES

Wild blueberries were an important food for Native Americans. Georgia blueberries have a long spring-through-summer harvest, and production is centered in the southeastern region, around the town of Alma, the state's blueberry capital.

Alma Blueberry Bread

When I was the food editor of the *Atlanta Journal-Constitution* in the late 1970s, blueberries were new to the scene, and everyone was crazy about them. This tea loaf recipe won a blueberry baking contest. I included it in my first cookbook, *Cooking in the New South*, and I've since heard from so many people who have grown up with this recipe that I decided to share it again, this time in a fluted loaf pan. When shopping for fresh blueberries for baking, look for a powdery blue-gray color. If the berries are dull, they are overripe.

Makes 1 loaf Prep: 20 to 25 minutes Bake: 60 to 65 minutes

Vegetable oil or soft butter and flour for prepping the pan

2 large or 3 medium oranges

2 tablespoons unsalted butter

1/4 cup water

2 cups (240 grams) all-purpose flour

1 teaspoon baking powder

1/2 teaspoon salt

1/4 teaspoon baking soda

1 large egg

1 cup (200 grams) granulated sugar

1 rounded cup (7 ounces/90 grams) fresh blueberries

2 teaspoons confectioners' sugar for dusting the top (optional)

1. Heat the oven to 325°F, with a rack in the middle. Grease and flour a 9-by-5-inch loaf pan and set aside.

2. Wash the oranges and pat dry. Zest the oranges, cut them in half, and juice them. You'll need 1 tablespoon zest and 1/2 cup juice.

3. Place the butter and water in a small saucepan over medium-high heat. Bring to a boil to melt the butter, 1 to 2 minutes. Turn off the heat. Stir in the orange zest and juice. Set aside. Whisk together the flour, baking powder, salt, and baking soda in a medium bowl. Set aside.

4. Place the egg and sugar in a large bowl and beat with an electric mixer on medium speed until lightened, 30 seconds. Add the flour mixture and orange juice mixture alternately, beginning and ending with the flour mixture and beating on low until just combined. Fold in the blueberries and pour the batter into the prepared pan.

5. Place the pan in the oven and bake until the loaf is lightly browned and a toothpick inserted in the center comes out clean, 60 to 65 minutes. Remove to a wire rack and let the loaf cool for 10 minutes. Run a dinner knife around the edges of the pan and turn the loaf out onto the rack right side up. If desired, spoon the confectioners' sugar into a sifter or sieve and dust over the top. Slice and serve.

Margaret Milam's Date Nut Bread

My father was recovering from a stroke in Nashville in 1994 when Margaret Milam came to the door with a loaf of date nut bread and a jar of homemade pimento cheese (her recipe for the spread is on the next page). It is the most delicious combination of flavors, with the salt of the cheese playing nicely with the sweetness of the dates. People across the South used to spread date nut bread with cream cheese and cut it into little finger-size sandwiches.

Makes 1 loaf Prep: 35 to 40 minutes, includes the Bake: 54 to 58 minutes
soaking time for the dates

1 cup water

1 teaspoon baking soda

1 heaping cup (8 ounces) packed
 pitted dates, halved

4 tablespoons (1/2 stick/57 grams)
 unsalted butter

Vegetable shortening or butter
 for prepping the pan

1 1/2 cups (180 grams) all-purpose
 flour, plus more for prepping
 the pan

1 cup (200 grams) granulated
 sugar

Pinch of salt

1 large egg, beaten

2 teaspoons vanilla extract

1 cup (4 ounces/114 grams) finely
 chopped pecans

1. Heat the water in a 2-quart saucepan over medium heat and stir in the baking soda until it dissolves. Stir in the dates and butter. Bring the mixture to a boil, then remove the pan from the heat and stir until the butter has melted. Let cool in the pan for 20 minutes.

2. Meanwhile, heat the oven to 325°F, with a rack in the middle. Grease and flour a 9-by-5-inch loaf pan and set aside.

3. Mash the date mixture with a potato masher until the dates are soft. Whisk together the flour, sugar, and salt in a large bowl. Make a well in the center and pour in the date mixture. Add the beaten egg and vanilla. Stir to combine and fold in the pecans.

4. Pour the batter into the prepared pan and bake until the loaf springs back when lightly pressed in the center, 54 to 58 minutes. Remove to a wire rack and let the bread cool in the pan for 15 minutes. Turn out to cool completely, about 1 hour, before slicing. You can freeze the loaf, wrapped in foil and placed in a zipper-top bag, for up to 6 months.

MARGARET'S PIMENTO CHEESE

Combine 2 1/2 cups shredded sharp cheddar cheese, 2 cups shredded Monterey Jack, and 8 ounces cream cheese, cut into cubes, in a large bowl. With an electric mixer, blend on low until it comes together. Fold in a 4-ounce jar of diced pimentos that's been drained. Add 1 to 2 tablespoons grated onion, 1 teaspoon Worcestershire sauce, 1 teaspoon prepared horseradish, and a few drops of hot sauce. Fold in 1/2 cup mayonnaise. Cover and chill.

HOW TO BAKE PAWPAW BREAD

America's indigenous pawpaw, the vitamin-packed fruit known to Native Americans, foraging early settlers, and wild animals, was often the only fresh fruit found in the rural Southeast. It is the largest edible fruit native to America, and its trees with large drooping leaves grow in forests and backyards from northern Florida up to Canada. The harvest occurs in August and September, when clusters of the thin-skinned ripened pawpaws turn mottled yellow-green, are soft to the touch, and become incredibly fragrant. I was introduced to pawpaws by Columbia, Tennessee, grower Anthony Petrochko, a college biology major turned pawpaw superfan. He picked a dozen ripe pawpaws for me to bake with, and I found their vivid orange flesh much like a mango but the flavor and aroma more banana-mango-pineapple. After removing the large brown seeds, I substituted 1 cup of the pawpaw pulp in my mother's banana bread recipe (Bebe's Banana Bread, page 122). It was fitting that this "poor man's banana" or "Kentucky banana," as pawpaws have been called, substituted so well.

Bebe's Banana Bread

Every waste-not woman in my family has spent a lifetime baking banana bread and talking about it at the bridge table. What I didn't know until I dug into its origin is that this is a Depression bread, which makes sense. Can you bear to throw away black ripening bananas? I can't! Guilt sweeps over me, so I pull out the bread pan and my mother's recipe, which I have adapted through the years to be less sweet and rich, using oil instead of butter.

Makes 1 loaf · Prep: 25 to 30 minutes · Bake: 1 hour, 15 to 20 minutes

Vegetable oil spray for misting the pan

1 1/2 cups (180 grams) all-purpose flour, plus more for dusting the pan

1 scant cup (190 grams) granulated sugar

3/4 teaspoon baking soda

1/2 teaspoon salt

3/4 cup vegetable oil

3 tablespoons buttermilk (see Note)

2 large eggs, lightly beaten

1 cup (250 grams) mashed bananas, from 3 very ripe bananas

1. Heat the oven to 325°F, with a rack in the middle. Lightly mist a 9-by-5-inch loaf pan with vegetable oil spray and dust with flour. Shake out the excess flour. Set the pan aside.

2. Whisk together the flour, sugar, baking soda, and salt in a large bowl. Make a well in the center of the dry ingredients and add the oil, buttermilk, lightly beaten eggs, and mashed bananas. Stir with a wooden spoon until the ingredients are well combined, 1 to 2 minutes. Turn the batter into the prepared pan and place the pan in the oven.

3. Bake until the loaf is golden brown and the top springs back when lightly pressed in the center, 1 hour and 15 to 20 minutes. Remove the pan from the oven and place it on a wire rack to cool for 15 minutes. Run a knife around the edges and turn the loaf out right side up to cool completely, about 1 hour. Slice and serve. If you want to freeze it, let it cool completely, wrap in foil, and then place in a zipper-top bag and freeze for up to 6 months.

NOTE:

If you don't have the buttermilk called for here, you can make your own by whisking 1/2 teaspoon lemon juice into 3 tablespoons whole milk. Or you can use 1 tablespoon buttermilk powder and 3 tablespoons water.

BANANA MUFFINS AND LITTLE LOAVES

Divide the batter among 12 muffin cups that have been lined with paper liners or greased and floured. Bake at 350°F until lightly browned, 20 to 25 minutes. Or bake in three 5 1/2-by-3-inch loaf pans at 325°F for 45 to 50 minutes.

Charleston Rice Waffles

These light, flavorful waffles are unlike any I have had. They are based on a rice flour called Thirteen Colony Rice Waffle Flour, a blend of Carolina Gold rice flour and Red May soft wheat flour, from Anson Mills. They taste like you are forking into history. But you can also substitute your own blend of cake flour and rice flour.

 The batter needs to sit overnight.

Serves 6 to 8; makes about 8 waffles	Prep: 12 to 15 minutes	Rise: Overnight rise in fridge	Cook: 4 to 5 minutes per waffle, depending on your waffle iron

1 3/4 cups (225 grams) Thirteen Colony Rice Waffle Flour from Anson Mills (see Note)

1 tablespoon granulated sugar

1/2 teaspoon fine sea salt

4 tablespoons (1/2 stick/57 grams) unsalted butter

1 cup plus 1 tablespoon cold whole milk, plus more to thin the batter before cooking

1 large egg

1/2 teaspoon dry yeast

Vegetable oil spray for cooking the waffles

Butter and honey for serving

NOTE:

This batter keeps covered in the fridge for 2 days.

 If you are making your own rice flour blend, use half rice flour and half unbleached cake flour, such as King Arthur.

1. Whisk together the flour, sugar, and salt in a large bowl. Melt the butter in a small saucepan over medium-low heat, letting it brown slightly, 6 to 7 minutes. Remove the pan from the heat and stir in the milk. Crack the egg into a small bowl and beat with a fork. Ladle 1/2 cup of the warm milk mixture into the egg to bring up its temperature, then turn the egg into the saucepan. Whisk in the yeast and let stand for 5 minutes.

2. Pour the milk mixture into the flour mixture and stir until smooth. Cover the bowl and refrigerate overnight.

3. When you are ready to cook, stir the batter and add 1 or 2 tablespoons, or more, milk to thin it slightly if it is too thick to spoon onto the waffle iron. Heat a waffle iron to medium-hot and spray with vegetable oil. When it's hot, ladle on the batter (the amount you add will depend on your waffle iron), close the iron, and cook until done, 4 to 5 minutes. Repeat with the remaining batter. Serve with butter and honey.

HOW CAROLINA RICE BUILT AN ECONOMY

In the 1700s, enslaved workers were forcibly brought to South Carolina from Africa's rice-growing region, the Windward Coast, also known as the "Rice Coast." According to Michael W. Twitty, author of *The Cooking Gene* (2017), slave owners preferred Rice Coast workers and paid more for them because of their rice expertise. To feed the enslaved passengers, slave owners purchased native African rice, which was winnowed and processed by enslaved women on the ships, then boiled in iron cauldrons. The enslaved "brought with them their knowledge of rice cultivation and their memories of a rice-based cuisine," noted Jessica B. Harris in *High on the Hog* (2011). They cleared more than 40,000 acres of land in the state, extracting vast trees from the swamps and digging 780 miles of irrigation canals.

By 1840 the Georgetown District, just north of Charleston, produced nearly half of the total rice crop of the United States. But untold numbers of the enslaved died from malaria and the brute labor; the average slave lived only a few years after beginning this work.

Most of the crop was a variety transported from Madagascar. Called Carolina Gold, it was named for its golden hulls and prized for its long grains, subtle fragrance, and nutty flavor. After the Civil War and Emancipation, rice production declined in the South. A 1911 hurricane breached the dikes and salted the soil, sealing the coffin on production until the 1980s, when Savannah eye surgeon Dick Schulze, an avid duck hunter, went looking for the famed Carolina Gold. He owned property along the Wright River in Jasper County, South Carolina, where rice had once been farmed. And he knew that rice in the fields would attract more ducks.

In 1985, Schulze received two bags of Carolina Gold rice seed from a Texas research scientist, and the next spring he planted it. By September it was ripe and golden, and he harvested sixty-four pounds and continued each year in the same fashion, until he amassed 470 pounds of rice. A December 1988 celebratory dinner was planned with rice in every course, and Lowcountry author John Martin Taylor wrote an article for the *New York Times* on Carolina Gold's repatriation. A Carolina Gold Rice Foundation was formed as a cooperative of rice farmers and university researchers, and in addition to Schulze and his son, Richard Schulze, it included Glenn Roberts of Anson Mills and University of South Carolina professor and author David Shields. Carolina Gold rice now grows from Maryland south to Georgia, and in Texas, Arkansas, and Missouri.

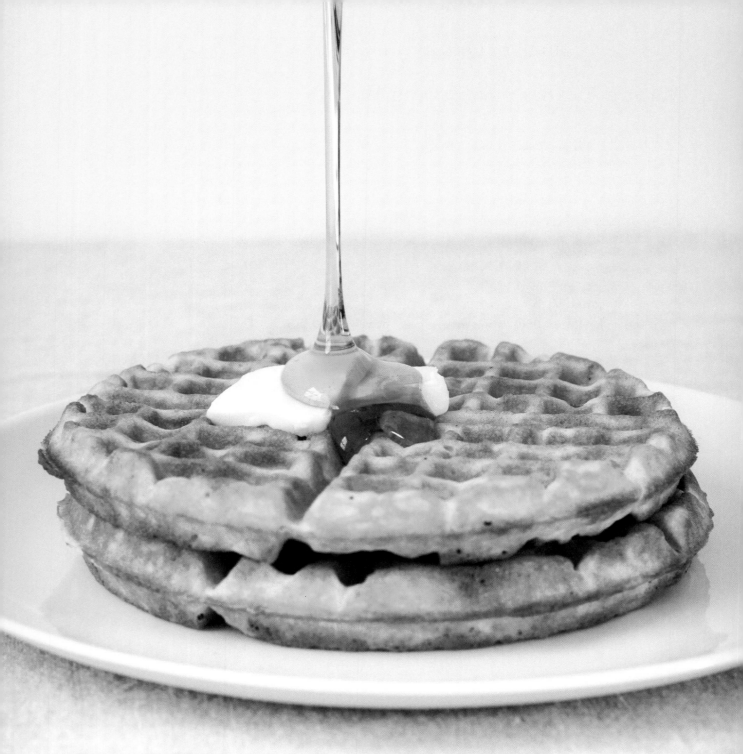

WAFFLE IRONS

Waffles date back to twelfth-century England and were originally wafers baked in round or square long-handled irons held over a fire. But we would not know them as "waffles" until Dutch immigrants introduced their *wafelijzer* to Scotland. Thomas Jefferson wrote about tasting waffles in Holland in 1789, and he bought a pair of waffle irons to bring home to Monticello.

Marion Flexner's Perfection Waffles

Marion Weil Flexner, the dame of Kentucky cooking, thought these were the best waffles she had ever eaten—"Crisp on the outside, yet they have body." She was right about that. These waffles are the epitome of a waffle—well shaped, crispy on the edges, but moist in the center. Flexner was the author of *Out of Kentucky Kitchens* and five other cookbooks, and she also wrote about food and culture for Louisville's *Courier-Journal*. She made her waffles with the help of Louis Smith, her Black cook, topping them with creamed oysters or chicken à la king and substituting them for biscuits in strawberry shortcake. After she died in 1992, her son, John M. Flexner, MD, professor of medicine emeritus at Vanderbilt University, donated her recipe notes, revisions, cookbooks, and photographs to the university, where I spent hours in the archives learning about Marion Flexner.

If you add a little milk to the batter, you've got pancakes.

Serves 6; makes 8 to 10 (4-inch) waffles or about 6 (6-inch) waffles | Prep: 20 to 25 minutes | Cook: 2 to 4 minutes per waffle, depending on your waffle iron

2 cups (240 grams) all-purpose flour

2 tablespoons granulated sugar

1 tablespoon baking powder

1/2 teaspoon salt

1 1/2 cups whole milk

2 large eggs, separated

1/2 cup vegetable oil, plus more for brushing the waffle iron

4 tablespoons (1/2 stick/57 grams) unsalted butter, melted

Maple syrup for serving

1. Sift the flour with the sugar, baking powder, and salt into a large bowl. Place the milk in a small bowl and whisk in the egg yolks. Whisk in the oil and melted butter. Beat the egg whites in a bowl with an electric mixer on high speed until stiff peaks form, about 3 minutes.

2. Pour the milk mixture into the flour mixture and stir to combine. Thoroughly fold in the whites until only a few bits of white remain.

3. To cook the waffles, lightly brush a waffle iron with a little oil and heat until smoking hot. Pour 1/4 cup (for the smaller waffles) to 1/2 cup onto the hot iron and close. (The amount you add will depend on your waffle iron.) Cook until browned or the waffle iron indicates it is done, 2 to 4 minutes. Repeat with the remaining batter. Serve hot with maple syrup.

NOTE:

Flexner stored any leftover waffle batter in the refrigerator and used it the following day. She notes that the leftover batter needs 1/2 to 1 teaspoon baking powder dissolved in 1 to 2 tablespoons water for every cup of batter, so the waffles cook up light once again.

127

Blueberry Buckwheat Pancakes

Buckwheat was brought to America by Dutch settlers in the early 1600s, and it adapted well to the high altitudes and short growing seasons of places like the Shenandoah Valley of Virginia. Buckwheat has long been used in sustainable farming as a ground cover and to break up the heavy clay soil of the South. Despite its name, it isn't a grain and has no gluten. Partly for this reason, it is enjoying a culinary resurgence among gluten-free bakers. The pale violet, high-fiber flour has hints of nuttiness and earthiness that marry well with blueberries in this recipe. Baking powder, baking soda, and egg all help these pancakes rise and contribute to their light texture.

Makes about 16 (3- to 4-inch) pancakes

Prep: 10 to 15 minutes

Cook: 4 minutes per batch

1 cup (130 grams) buckwheat flour

1 teaspoon granulated sugar

1 teaspoon baking powder

1/4 teaspoon baking soda

1/4 teaspoon salt

1 1/4 cups buttermilk

1 large egg

1 tablespoon butter, melted

1/4 teaspoon vanilla extract

1 cup (6 ounces/170 grams) fresh blueberries

Oil for greasing the griddle or frying pan

Maple syrup or sorghum for serving

1. Place the buckwheat flour, sugar, baking powder, baking soda, and salt in a large bowl and whisk to combine. Pour the buttermilk into a 2-cup measuring cup or a small bowl and stir in the egg, melted butter, and vanilla. Pour the buttermilk mixture into the flour mixture and stir until smooth. Fold in the blueberries.

2. Oil a griddle or frying pan and place it over medium-high heat. When a drop of water dances on the griddle, spoon 2 tablespoons of batter onto the griddle for each pancake. Cook until bubbles appear, about 2 minutes, then flip the pancake and cook on the other side for 2 minutes, or until lightly browned on both sides. Serve hot. Repeat with the remaining batter and serve with maple syrup or sorghum.

BLUEGRASS BUCKWHEAT GRIDDLE CAKES

In *The Blue Grass Cook Book* (1904), written by Minnie C. Fox, buckwheat cakes are made with yeast. It's possible to re-create this recipe today. Begin with 2 cups buckwheat flour, mixed with 2 tablespoons dry yeast and 1/2 teaspoon salt. Pour in 2 cups warm water and 1 tablespoon molasses. Stir until smooth and place in the refrigerator overnight. The next morning, ladle the batter onto a hot, greased griddle and cook for 2 minutes per side.

Edna Lewis' Sourdough Pancakes

According to the late Edna Lewis, an early proponent of regional baking, there is nothing like the flavor of sourdough when it comes to pancakes. I so agree. Making them is as simple as letting flour, yeast, and water ferment for 8 to 10 hours at room temperature to develop that flavor. A purist, Lewis believed in using bottled water that has no chemicals in it.

When she was growing up in Freetown, Virginia, a farming community settled by people freed from slavery, Lewis' family threshed its own wheat and took it to the mill, where it was ground into flour. "It came back full of seeds and stones that had to be sifted out before we could bake with it, but that flour really tasted of the wheat berries," she wrote in her book *In Pursuit of Flavor* (1988). She couldn't fathom why people would buy chemically bleached white flour.

What's nice about this batter is that the starter is prepped a day before and the rest put together right before you cook. Lewis, whom many have called "the grande dame of Southern cooking," served these pancakes with butter, guava jelly, and stewed blueberries.

Serves 6; makes about 24 (4-inch) pancakes	Prep: 10 to 15 minutes	Starter time: 8 to 10 hours, or overnight	Cook: 4 to 5 minutes per batch

STARTER

1 1/2 cups (180 grams) unbleached all-purpose flour

1 1/2 teaspoons dry yeast

1 cup bottled water, heated to lukewarm

BATTER

1 cup whole milk

1 tablespoon unsalted butter

1 teaspoon granulated sugar

1/2 teaspoon salt

1 large egg

1 teaspoon baking soda

1/2 cup (60 grams) unbleached all-purpose flour

Vegetable oil for greasing the griddle or cast-iron skillet

1. **Make the starter:** Whisk together the flour and yeast in a medium bowl. Slowly whisk in the water until well mixed. Cover and leave on the counter overnight or for at least 8 to 10 hours.

2. **When you are ready to cook, make the batter:** Place the milk, butter, sugar, and salt in a small saucepan and stir. Heat until lukewarm to the touch, 100°F to 110°F. Add to the starter, along with the egg and baking soda. Whisk to combine. Whisk in the flour until smooth.

3. Heat a griddle or large cast-iron skillet over medium heat and brush liberally with oil. When the griddle is hot, spoon 1/4 cup of the batter onto the hot griddle and cook until the pancake is dotted with small bubbles, 2 minutes, then turn over and cook for 2 to 3 minutes on the other side. Repeat with the remaining batter and serve hot.

ROSA PARKS' FEATHERLITE PEANUT BUTTER PANCAKES

In 2015, the Library of Congress released Rosa Parks' personal documents, including postcards from the Reverend Doctor Martin Luther King Jr., lists of volunteers for the Montgomery Bus Boycott, and a simple but delicious pancake recipe handwritten on the back of a bank envelope. It is a sweet and simple pancake, and as an option, I fold in sliced bananas as well as chocolate chips because they go so well with the peanut butter. The Featherlite in the title refers to a brand of self-rising flour once sold in the Deep South.

Born in Tuskegee, Alabama, Parks rose to prominence on December 1, 1955, when she refused to give up her seat to a white man on a segregated Montgomery, Alabama, bus. That bold move was the spark that ignited a yearlong Montgomery bus boycott and nonviolent civil rights protests led by King and others in the years to come.

TO MAKE ABOUT 14 (4-INCH) PANCAKES, whisk together 1 cup all-purpose flour, 2 tablespoons baking powder, 2 tablespoons sugar (optional), and 1/2 teaspoon salt in a large bowl. In a medium bowl, stir together 1/3 cup peanut butter, 1 large egg, and 1 tablespoon oil. Stir in 1 1/4 cups milk until smooth. Turn the milk mixture into the flour mixture, stirring until just combined. It's okay if a few lumps remain. Heat a griddle or large cast-iron skillet over medium-low heat. Brush the surface with a few teaspoons of vegetable oil. Spoon 1/4 cup of batter onto the griddle and, if desired, press a few banana slices or chocolate chips into the batter. Cook until tiny bubbles appear on the surface, about 2 minutes, then flip and cook on the other side until browned. Repeat with the remaining batter. Serve hot with butter and syrup.

Corn Griddle Cakes

In the Beaumont, Texas, Junior League cookbook *Lagniappe* (1982), these corn cakes contributed by the late D'Anne DeMoss McGown are called Jimbo's Pancakes. Light and delicate, they are made with white or yellow sifted cornmeal, plus a little flour, a good bit of buttermilk, and just one separated egg. You've got to beat the white with a mixer, a bit of a fuss, but it makes the pancakes pillowy and delicious. The griddle needs to be hot, and once you pour on the batter, wait until you see bubbles around the outside edge of the pancake before flipping it. If you only have unbolted (unsifted) cornmeal, pull out a sieve or a sifter and sift away the coarse bits, leaving only fine cornmeal, which is one of the things that make these corn cakes so special.

Makes 18 (4-inch) corn cakes Prep: 20 to 25 minutes, includes resting time Cook: 3 to 4 minutes per batch

1 1/2 cups (195 grams) finely ground white or yellow cornmeal

1/4 cup (30 grams) all-purpose flour or gluten-free flour blend

1 teaspoon baking soda

1 teaspoon granulated sugar

1 teaspoon salt

2 cups buttermilk

2 tablespoons vegetable oil

1 large egg

Vegetable oil or spray for cooking

1. Whisk together the cornmeal, flour, baking soda, sugar, and salt in a large bowl. Add the buttermilk and oil. Separate the egg, adding the yolk to the bowl with the buttermilk, and stir to combine. Place the egg white in a separate medium bowl, beat with an electric mixer on high speed to stiff peaks, 2 minutes, and fold into the batter. Let the batter rest for 10 minutes.

2. Grease a griddle with vegetable oil or spray and place it over medium-high heat. Once a drop of water dances on it, you are ready to cook. Spoon a generous 2 tablespoons batter onto the griddle, leaving several inches between each corn cake. Cook until bubbles form around the outside of the cake, slide a metal spatula underneath, glance to see if it's browned sufficiently, then flip the cake over to cook on the other side. It takes about 2 minutes to cook per side, and you may need to increase or decrease the heat to get the cakes to cook more or less quickly. Slide the pancakes onto warm plates and repeat with the rest of the batter. Serve hot.

French Market Beignets

To cover oneself in a blizzard of powdered sugar while scarfing down beignets is a rite of passage for every New Orleans tourist. How the beignet wound up being the iconic doughnut of the French Quarter is most likely due to seventeenth-century French immigrants in Acadia, in the eastern coastal part of Canada. The Cajuns brought beignets and chicory coffee with them during the Great Upheaval in 1755 when they moved away from Canada after refusing to pledge allegiance to Britain.

The word *beignet* (pronounced BEN-yay) comes from the French *baigner*, meaning "to bathe," since the square pillows of dough are bathed in hot fat. In 1957 Mary Alice Fontenot, a Louisiana food writer, wrote in *The Eunice News* of her Cajun grandfather who single-handedly downed trees for firewood and hauled them through the bayous so he could create a fire to heat hog fat and fry *les beignets*.

Making beignets at home is much more delicious than savoring them in New Orleans. When you shake them in a brown paper bag with sugar until they are well coated and then take a bite, you will experience the best beignet of your life. Yes, even better than in NOLA.

Makes about 3 dozen beignets	Prep: 40 to 45 minutes	Rise: 1 hour, 20 minutes for 2 rises	Cook: 3 minutes per batch

2 1/4 teaspoons (1 package) dry yeast

1/4 cup warm water

1/4 cup granulated sugar

1/2 teaspoon salt

1 large egg, beaten

3/4 cup evaporated milk

2 tablespoons melted and cooled butter or vegetable oil

3 to 3 1/2 cups (360 to 420 grams) all-purpose flour, plus more for dusting

4 cups vegetable or peanut oil for frying

1/2 cup (54 grams) confectioners' sugar for dusting

1. Place the yeast and warm water in a large bowl and stir with a fork to dissolve. Add the sugar and salt and stir to combine. Add the beaten egg, evaporated milk, and butter or oil. Beat with a wooden spoon until smooth. Add 3 cups of the flour and beat until well incorporated. Add another 1/2 cup of the flour as needed to pull the dough together. It should no longer be sticky. Cover the bowl with plastic wrap and place it in a warm place to rise until doubled, about 1 hour.

2. Punch down the dough and turn it out onto a lightly floured surface. Knead it with your hands a few times and roll it into an 18-by-12-inch rectangle, about 1/8 inch thick. Cut into 2-by-3-inch rectangles. Cover them with waxed paper or plastic wrap and let rise again for about 20 minutes.

3. Pour the oil into a deep heavy 12-inch skillet. Heat over medium-high heat until the oil reaches 365°F. Drop 2 or 3 rectangles into the oil and fry until they are golden brown on one side (about 1 1/2 minutes), then turn them over to cook on the other side, about 1 1/2 minutes more, spooning oil from the skillet over the top to bathe them. Remove the

beignets with a slotted spoon to a wire rack set over brown paper or paper towels to drain. Repeat with the remaining batter.

4. Place the confectioners' sugar in a paper bag and add the warm, drained beignets, a few at a time. Toss until well coated. Serve warm.

CAFÉ DU MONDE

In the mid-1800s, the port of New Orleans was a coffee hub, and the French Market was where residents came to shop for meat, produce, and flowers. In 1862, in the middle of the Civil War, a German named Fred Koeniger opened a coffee stand in the French Market, serving fried doughnuts. When the Union Army blockaded the port of New Orleans and imported coffee couldn't get through, the French tradition of using chicory root as a substitute for coffee was popularized. In 1942 Hubert Fernandez bought Koeniger's coffee stand and named it Café du Monde. And in the 1970s, Café du Monde was discovered by Vietnamese refugees in New Orleans because the half-coffee, half-chicory brew it served was similar to their French-inspired coffee back home, and the beverage has become a vital part of the Vietnamese diaspora.

DEEP-FRYING WITH *Ease*

Here are some tips to make frying manageable and less messy.

- Fry in a deep Dutch oven or heavy and wide cast-iron skillet.
- Use fresh oil, preferably peanut oil, which doesn't smoke at high temperatures (at which point oil breaks down, releases free radicals, and can make the food taste bitter).
- Insert an instant-read thermometer into the oil to make sure it's hot enough before frying, at least 350°F.
- To avoid splatters and keep grease off your stove, place a screen top over the pan.
- Place a cooling rack on a sheet pan lined with paper towels and drain the hot fritters and beignets on the rack so they stay crispy.
- To dispose of the used oil, let it cool, then funnel it into a jar and dispose with your household waste. Or add it to your compost for gardening.

Poppy Tooker's Sweet Calas

Poppy Tooker's great-grandmother impressed on her that the foods she was raised on wouldn't be around forever unless she continued to make them. Tooker, who hosts a New Orleans weekly radio show and writes local cookbooks, has become outspoken about calas (pronounced ka-LAS), the yummy African fried rice breakfast croquettes. She enlisted the Louisiana chapter of the Slow Food Movement to help her, and the organization added calas to its list of endangered foods in 1999. Many recipes call for yeast, but Tooker's recipe uses baking powder instead. With two antique sterling silver soup spoons, she cradles the calas batter until it's oval-shaped like a French quenelle and slides it into the hot oil. "Once you put it in the oil, you don't have to mind it. It flips itself over as it cooks," she says. In one bite, you taste the crossroads of cultures—African, Caribbean, French, Native American, Spanish—and you get the feeling you're not just frying, you're preserving history.

This recipe is a delicious way to use up leftover cooked rice; you'll need about 2 cups and omit the water in the recipe.

Makes 12 to 16 croquettes	Prep: 15 to 20 minutes to cook the rice, plus 15 minutes to assemble	Cool: 30 minutes in fridge or 2 hours at room temperature	Cook: 2 to 3 minutes per batch

3/4 cup (139 grams) medium- or
 long-grain rice

1 1/2 cups water

1/2 cup (60 grams) all-purpose flour

3 heaping tablespoons granulated
 sugar

2 teaspoons baking powder

1/4 teaspoon salt

2 large eggs, lightly beaten

1/2 teaspoon vanilla extract

3 cups vegetable oil

Confectioners' sugar for sprinkling

1. Place the rice and water in a medium saucepan and bring to a boil over medium heat. Reduce the heat to low, cover, and let simmer until the rice is cooked, 15 to 20 minutes. Remove the lid to the pan, fluff the rice with a fork, and turn it into a bowl to cool to room temperature, at least 2 hours. Or place in the refrigerator, uncovered, to chill, 30 minutes.

2. In a separate small bowl, stir together the flour, sugar, baking powder, and salt. Pour into the bowl with the rice and, with your hands, mix until every grain of rice is well coated with the flour mixture. Add the lightly beaten eggs and vanilla and mix well.

3. Heat the vegetable oil in a deep skillet or pot over medium-high heat to 360°F. To form the calas, scoop up a mound of batter with a large soup spoon and place another large soup spoon over the top to press it down. Turn the top spoon

and slide it under the bottom spoon and the batter to form an oval mound, or what the French call a quenelle. Carefully drop 3 to 4 calas into the hot oil and fry until deeply golden brown, 2 to 3 minutes.

4. With a slotted spoon, remove the calas from the oil and drain on paper towels. Sprinkle with confectioners' sugar and serve hot. Repeat with the remaining batter.

Poppy Tooker at home in New Orleans

BUYING FREEDOM

Rice has been grown in the Niger delta floodplain for more than 1,500 years, and the word "calas" traces to the Nigerian Nupe people, as well as the Vai people of Sierra Leone. Jessica B. Harris, an authority on the African cooking diaspora, says calas are still found in the open-air markets of Liberia and sold by the Bong women. When enslaved Africans were shipped to Louisiana to work in the sugar plantations, they brought the tradition of calas with them.

Calas got their start in New Orleans when it was under French rule as the indirect result of Code Noir, which regulated the interaction between the enslaved, free people of color, and whites. (It was abolished in 1848.) One part of the code required the enslaved to rest on Sundays and holidays, and on their "days off," they often sold calas in the street. Most often slave owners kept the proceeds, but in some cases the enslaved and their families were able to keep the money to purchase their freedom. Calas were always sold by female vendors, who balanced the baskets of the warm fritters on their heads, calling out, *"Calas, calas! Belle calas tout chaud, madame!"* (Beautiful calas, very hot.) So entwined were the calas and their vendors that a recipe for them in the Christian Woman's Exchange's *Creole Cookery Book* (1885) appeared under the name "callers."

Apple Cider Fritters

One of the joys of driving through western North Carolina, East Tennessee, and Virginia, as well as Arkansas, is stopping for apple cider and apple cider fritters, which may be one of my favorite fall flavors. The fritters are crispy, moist, and full of spice. For this recipe, choose an unfiltered fresh, nonalcoholic apple cider. The only trick is to make sure the fritters are small, because the batter is dense and needs to cook through. Toss these with confectioners' sugar while they're hot and serve with—what else?—a mug of cider.

Makes about 20 fritters　　　　Prep: 35 to 40 minutes　　　　Cook: 3 to 4 minutes per batch

2 large eggs

1/2 cup apple cider

1/2 cup whole milk

2 tablespoons unsalted butter, melted

1 teaspoon vanilla extract

1/2 cup (100 grams) granulated sugar

2 cups (240 grams) self-rising flour, divided

1 teaspoon ground cinnamon

1/2 teaspoon ground nutmeg

2 1/2 cups finely chopped apples (about 4 medium apples, peeled and cored)

Peanut oil for frying

1/2 cup confectioners' sugar for dusting

1. Place the eggs, apple cider, milk, melted butter, and vanilla in a large bowl and whisk to combine. Whisk in the granulated sugar and set aside.

2. Measure 1 1/2 cups of the flour into a small bowl. Stir in the cinnamon and nutmeg. In a small bowl, toss the apples with the remaining 1/2 cup flour. Turn the flour mixture into the egg mixture and whisk until it is smooth, about 1 minute. Fold in the floured apples until combined.

3. Place enough peanut oil in a large deep cast-iron skillet or Dutch oven to measure 2 inches. Place the pan over medium-high heat and bring the oil to 350ºF to 365ºF. When the oil is hot, drop generous tablespoons of the batter into the pan, frying about 4 fritters at a time. Let the fritters fry for 1 1/2 to 2 minutes per side, turn, and continue cooking 1 1/2 to 2 minutes on the other side. Remove to a wire rack set on top of brown paper or paper towels to drain. Repeat with the remaining batter, giving the oil time to reheat to 350ºF to 365ºF before frying. With a slotted spoon or sieve, clean up the oil between frying, removing any burnt bits from the oil. Dust the warm, drained fritters with sifted confectioners' sugar and serve.

CIDER: A DRINK OF THE PEOPLE

By 1855 the foothill country of Virginia and North Carolina had become known for its superior apples, especially the Albemarle Pippin, a favorite of Thomas Jefferson, which, along with the Taliaferro variety, had the high acidity needed for cider making. Wealthy people imported wine to accompany their meals, but regular folks drank beverages fermented and distilled from fruit, so most of the apple crop was grown for cider. The names of apples our ancestors knew— Golden Russet, Pearmains, Winter Queening—aren't as common today, but you will still find the old varieties Rome Beauty, Pink Lady, Winesap, Mutzu, Stayman, and Jonathan, as well as Arkansas Black, a dark-red apple thought to be a seedling of the Winesap, born in Arkansas in 1870.

Mobile Banana Fritters

The earlier fritters were crisp, fried puffs encasing something wonderful—in this recipe, banana. For these fritters, I adapted an old recipe belonging to the late Mobile writer and bon vivant Eugene Walter. I love how he brings orange into the batter. (Walter probably would have also added a splash of rum!)

The word *fritter* comes from the French word *friture*, a generic term used for foods fried in deep fat. In the South, you'll find fritter recipes on menus and in cookbooks of cities with French ancestry, like Mobile. Until World War II, when it became a wartime port, Mobile was a nexus between imported Central American bananas and kitchens across the country.

| Serves 12 | Prep: 30 to 35 minutes | Cook: 2 to 3 minutes per batch |

3/4 cup plus 2 tablespoons
 whole milk

1 large egg

1 1/3 cups (160 grams) all-
 purpose flour

2 tablespoons granulated sugar

1 teaspoon grated orange zest

1/2 teaspoon baking soda

1/2 teaspoon baking powder

1/4 teaspoon salt

4 medium-ripe bananas

Peanut or vegetable oil for
 frying

1/4 teaspoon ground cinnamon
 for dusting

1/4 cup confectioners' sugar
 for dusting

1. Place the milk and egg in a large bowl and whisk to combine. Set aside. Whisk together the flour, sugar, orange zest, baking soda, baking powder, and salt in a medium bowl. Turn the flour mixture into the milk mixture and whisk until smooth, about 1 minute. Set aside while you prepare the fruit.

2. Peel the bananas and cut each one crosswise into 3 equal sections. Cut each section lengthwise into 4 strips. You should have about 48 pieces of banana. Set the fruit aside.

3. Place enough oil in a large heavy pot or Dutch oven to measure 1 1/2 inches. Heat the oil over medium-high heat until it is 365°F. Line a baking sheet with brown paper or paper towels and place a wire rack on top. Combine the cinnamon and confectioners' sugar in a small bowl and set aside.

4. Piece by piece, dunk the fruit into the batter, using your fingers, a fork, or small tongs. Once the fruit is coated, drop about 6 pieces at a time into the hot oil. Fry until well browned on one side, 1 to 1 1/2 minutes, then turn with a slotted spoon or spatula to brown on the other side, 1 to 1 1/2 minutes. With a slotted spoon, transfer the fritters from the oil to the rack to drain. Repeat with the remaining pieces of banana. Dust with the cinnamon-sugar while the fritters are warm. Serve at once.

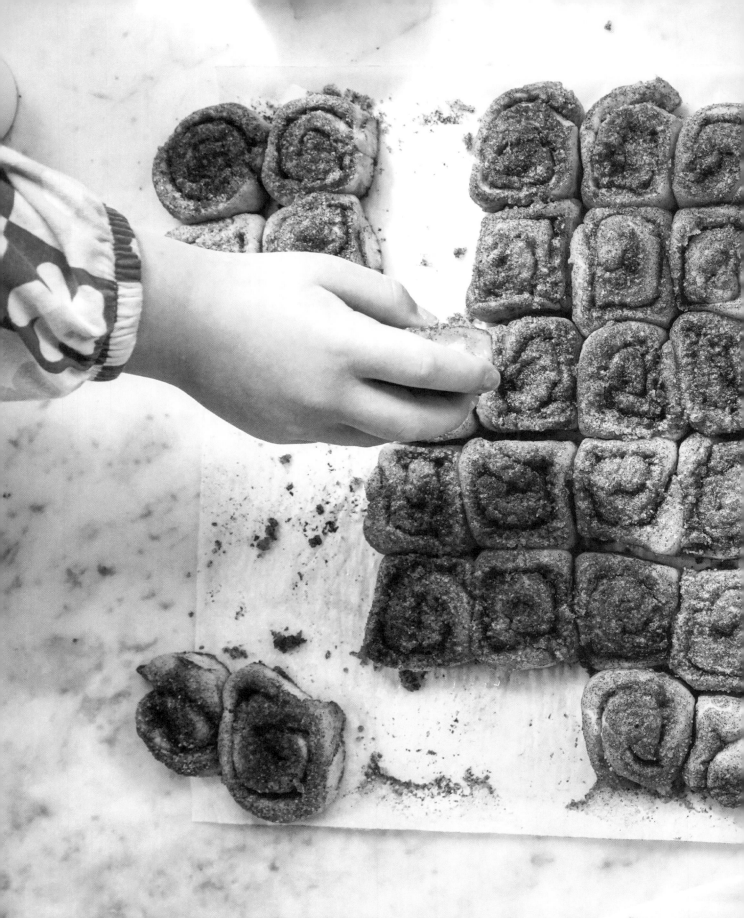

ROLLS,
BREADS,
AND
YEAST-
RAISED
CAKES

Southern bread has been a front-line weapon against poverty, hunger, and malnutrition; a litmus test for accomplished practitioners of the culinary arts; and a repeated gastronomic delight for people of every race, sex, age, and income level.

—JOHN EGERTON, *SOUTHERN FOOD*, 1987

Southerners have always had a fondness for hot, soft yeast rolls.

—SUSAN PUCKETT, *EAT DRINK DELTA*, 2013

In the North man may not be able to live by bread alone. But in the South, and particularly in Charleston, he comes mighty near to it, provided the bread is hot.

—BLANCHE S. RHETT, *TWO HUNDRED YEARS OF CHARLESTON COOKING*, 1934

It wasn't until I was about twelve years old that I realized all bread wasn't like the kind my mother made at home. We'd gone to Miami, where we were wowed by the signature half-sour pickles and cheesecake from the famous Wolfie's delicatessen. But when the server brought the bread, I was stunned to discover that it was hard, crunchy, and cold, so different from the soft, warm rolls on my mother's table.

Later, in Paris, I learned to make shatteringly crisp baguettes, but I seldom baked that sort of bread after I returned home to the South. For holidays and special meals, what everyone wanted was the bread of tradition: soft, cake-like, and slicing well. And what we loved most were yeast rolls, crammed tightly into a pan and brushed generously with butter.

Exactly when did the South fall in love with yeast rolls? The moment they were pulled from the oven. They've fed us at Thanksgiving, birthdays, and black-tie balls. You might even say they are a religious experience, because so many are baked for church suppers and synagogue meals. In this chapter, I share stories of people who have baked soft rolls for children in a school cafeteria or who sold them out of the back door of their home kitchens.

Before yeast came in a packet, Moravian brides in the 1700s leavened their cinnamon-swirled, buttery, yeasty coffee cakes with a bit of starter dough given to them by their mothers or neighbors, and they reserved a bit of that for the next round of baking. In New Orleans, natural yeasts found in the air or in the flour itself leavened rum-drenched baba au rhum and king cake for Epiphany.

In other places, yeast often came from a local brewer. In *A Domestic Cook Book* (1866), Tennessee's Malinda Russell wrote of adding "three tablespoons of hop yeast" to her Hop Rolls. In remote areas

without breweries and during Temperance, yeast was not easy to find, so some cooks turned back to an old-timey method: making a starter, then placing it over a warmed container of salt, which both absorbed and retained heat, hastening the fermentation and propelling the rise. I share the recipe for that pioneer bread, known as salt-rising bread. The potato-cornmeal starter smells like stinky cheese, but what a miraculous and beautifully fragrant bread emerges from the oven once you are done!

Granular dry yeast that was stable until mixed with water was created by Fleischmann's for the battlefield in 1943, to give soldiers a taste of home. American cooks were introduced to it after the war. But in the agricultural South, many cooks didn't have a lot of time to spend in the kitchen, so they combined yeast with self-rising flour, which contains baking powder, giving them the best of both worlds—flavor and speed.

The key to soft and light breads and rolls, even more than Southern low-protein and high-starch flour, is a wet, sticky dough. Look at recipes and you'll see they contain a lot of liquid—milk or water, as well as fat (butter or vegetable shortening) and often eggs. That's why they melt in the mouth.

The high moisture content makes the dough impossible to knead because it sticks to your hands and the counter. Many cooks automatically reach for more flour to fix this "problem." But then the rolls turn out dry, tough, and nothing like the ones your grandmother made.

The secret is not your bag of flour, but time. Place the bowl of dough in the refrigerator—or icebox, as your grandmother called it—and let it rest for most of the day or, even better, overnight. That's why she called them icebox rolls or refrigerator rolls. The cool refrigerator slows down the process of the yeast feasting on the sugar and starch and creates flavor and a more workable dough for you. Throughout this chapter, cold refrigerated dough—what pastry chefs call a "cold proof"—is the secret to many of the recipes. Make time for them. Let these recipes become two-day projects.

This chapter is filled with buttery rolls as well as sweet rolls. Whether infused with cinnamon or orange, sweet rolls are welcome any time of the day. After rolls, I move to loaves. Two of my favorites are a Louisiana recipe calling for mashed sweet potatoes and one for a cult-favorite sourdough that begins with potato flakes.

Southern yeast breads may take a little longer than your average bread or cake to assemble, but what you get in return is unparalleled flavor and a bite of history.

Pat Lodge's Spoon Rolls

Sarah ("Pat") Kirkwood Lodge married into the Lodge Cast Iron family, and yet it wasn't cornbread in an iron skillet that she became known for, but her quick version of yeast rolls, called "spoon rolls," so named because you drop them from a spoon into a muffin pan. Her daughter, Sarah Augusta Lodge, says her mother would make curried chicken and a rhubarb pie, and bake these rolls. Raised in her grandmother's home near Auburn, Alabama, Sarah was called "Pat" because her older brother said she "pitty-patted" across the floor when she walked. Her husband, John Richard Lodge, one of Lodge founder Joseph Lodge's grandsons, was an Episcopal priest serving congregations in Tennessee, Alabama, Georgia, and Alaska, and Pat Lodge, mother of four, fed anyone who gathered around the table, collecting recipes along the way.

Spoon rolls, which are soft, yeasty, and almost cake-like, don't need to rise. They begin with self-rising flour and yeast, and the batter keeps in the fridge for a week. Spoon into greased muffin pans as Pat Lodge did, but make sure to not fill the cups more than halfway, so they're more the size of a roll than a muffin.

Makes 2 dozen rolls	Prep: 15 to 20 minutes	Rise: At least 3 hours in fridge	Bake: 15 to 20 minutes

12 tablespoons (1 1/2 sticks/170 grams) salted butter or margarine (see Notes), plus 3 tablespoons, melted, for brushing and prepping the pans

2 cups warm water

1/4 cup (50 grams) granulated sugar

2 1/4 teaspoons (1 package) dry yeast

1 large egg

4 cups (480 grams) self-rising flour, whisked or sifted to remove any lumps (see Notes)

1. Place the 12 tablespoons (1 1/2 sticks) butter or margarine in a medium saucepan and melt over low heat. Add the water and stir to combine. With an instant-read thermometer, check the temperature to make sure it's no higher than 125°F.

2. Place the sugar and yeast in a large bowl. Pour the butter mixture over and stir, then stir in the egg and whisk in the flour until smooth. The mixture will have the consistency of thick pancake batter. You can use it right away, but the texture of the roll is best if you can place it in the fridge for at least 3 hours.

3. Heat the oven to 400°F, with a rack in the middle.

4. Brush two muffin pans generously with the 3 tablespoons melted butter.

5. Using a large soup spoon, spoon the batter into the muffin pans, filling one-third full. Bake until lightly browned around the edges and on top and the rolls spring back when lightly pressed in the center, 15 to 20 minutes. Serve hot.

NOTES:

If using unsalted butter or margarine, add 1/2 teaspoon salt.

When self-rising flour sits in the pantry for a while, it can collect moisture, which results in lumps. Just sift the flour or whisk it well before measuring and baking.

Ella Beesley's Refrigerator Rolls

For many years, I didn't bake yeast rolls, nor did my mother. We didn't need to, because Ella Beesley, my mother's dear friend in Nashville, baked better "pocket-book rolls" than anyone. The Southern version of Parker House rolls, they were folded in the middle and light as a feather and yet wickedly rich, "flip-flopped" through melted butter, as Beesley used to say, before being placed side by side in the pan. Every holiday, in the last-minute countdown to dinner, my mother or I would point out to each other that if the rest of the menu failed, it would be okay, because Beesley's rolls would be a hit.

Beesley had quite a brisk roll business going. She baked and wrapped them in foil, first placing a sheet of waxed paper on top of them because she didn't like them to touch the foil, then sealed and stashed them in her basement freezer. The recipe had been handed down from her mother, Mary Priestly Cox of Huntington, in West Tennessee, and she guesses it was her mother's recipe before that. "There's nothing better than a hot roll," she says. For my family, there's nothing better than Beesley's rolls.

Plan ahead: the soft dough must be refrigerated overnight so it is easier to work with.

| Makes 6 to 7 dozen rolls | Prep: 25 to 30 minutes | Rise: 2 to 2 1/2 hours for 2 rises, plus overnight in fridge | Bake: 18 to 22 minutes |

4 cups whole milk

1 cup (200 grams) granulated sugar

1 cup (6.75 ounces) vegetable shortening

3 3/8 teaspoons (1 1/2 packages or 10 grams) dry yeast

7 1/4 cups (870 grams) all-purpose flour, divided, plus 1/2 cup (60 grams) for pressing

1 tablespoon kosher salt

1 heaping teaspoon baking powder

1 teaspoon baking soda

8 tablespoons (1 stick/114 grams) salted butter, for brushing (or add 1/4 teaspoon salt if using unsalted butter)

Parchment paper for lining the pan

1. Pour the milk into a medium saucepan over medium heat. Heat it just until tiny bubbles form around the edges of the pan, 4 to 5 minutes. Remove from the heat.

2. Place the sugar in a large bowl and cut the shortening into it with two knives, so the pieces of shortening are smaller and it's easier for the milk to melt them. Pour the hot milk over the sugar and shortening and stir to melt. Check the temperature of the mixture with an instant-read thermometer and let it cool to 125°F or lower. Stir in the yeast to dissolve.

3. Place 6 1/2 cups (780 grams) of the flour and the salt in another large bowl and whisk until combined. With a wooden spoon or whisk, fold the flour into the milk and yeast mixture until smooth and free of lumps and the dough is a thick batter.

4. Cover the bowl with a light kitchen towel and let rise in a warm place until doubled, about 1 hour.

5. Stir the baking powder and baking soda into the remaining

153

3/4 cup (90 grams) flour in a small bowl. Turn the dough and this flour mixture into the large bowl of a stand mixer and beat with a paddle or dough hook on medium speed until the dough is webby and begins to pull away from the sides of the bowl, 4 to 5 minutes. You want it to be thick but sticky. Return the dough to a large clean bowl. Cover with plastic wrap and refrigerate overnight.

6. The next day, remove the dough from the fridge and uncover. The dough will still be sticky. Push it down in the bowl with a rubber spatula. Scatter half of the 1/2 cup flour on a surface, turning the dough out and sprinkling with a little more flour as needed. Cut the dough in half with a bench scraper or knife. Working with half the dough at a time, press out to a 16-inch round, about 1/3 inch thick.

7. Melt the butter in a small saucepan over low heat. Line a 12-by-17-inch rimmed baking sheet with parchment paper or brush four 9-inch round cake pans with butter. With a 1 1/2– to 2-inch floured biscuit cutter, cut into rounds and flip-flop them in the melted butter and fold in half like a pocketbook.

8. Place them tightly side by side on the prepared pan in rows, placing them 8 across and 10 down if using the baking sheet or about 18 to a pan if using the cake pans. If you can't fit them all on the baking sheet, put any leftovers in a cake pan. You will get 6 to 7 dozen, depending on the size of the cutter. After cutting the rounds, pick up the scraps and shape them into rounds, dip in butter, and continue (there is no need to reroll). Or turn them into cinnamon rolls (recipe is on the opposite page).

9. Drape the pan or pans with a kitchen towel and let the rolls rise again in a warm spot until nearly doubled, 1 to 1 1/2 hours.

10. Heat the oven to 350ºF, with a rack in the middle.

11. Bake the rolls until lightly golden brown, 18 to 22 minutes. (They brown more in a more shallow pan.) Serve warm or let cool, then wrap in foil and freeze for up 3 months. To reheat, open the foil slightly to vent the package and place in a 325ºF oven for 20 minutes, or until warmed through. Serve.

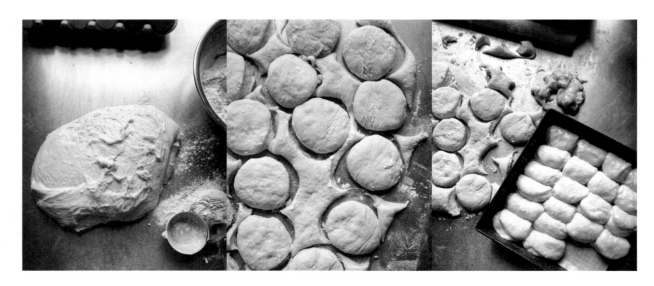

CINNAMON ROLLS FROM *Scraps*

Pull the scraps of this recipe or any of the yeast roll recipes in this chapter into one ball and with floured hands, press out to 1/3-inch thickness. Brush generously with melted butter. Generously scatter brown sugar on top and sprinkle with ground cinnamon and, if you like, a pinch of cardamom and a handful of chopped raisins. Roll up into a tight jellyroll and, with a floured serrated knife, slice 1/2 inch thick. Place cut side down, close together, on a greased baking pan and let rise until doubled, which will take about 1 hour. Bake at 350°F until golden brown, 18 to 22 minutes. Serve hot.

PROOF POSITIVE: A GOOD SPOT TO RISE DOUGH

If you enjoy making yeast bread, chances are you have a warm and sunny spot in the kitchen where the dough can rest and rise (called "proofing"). My proofing spot is at the back of my stove, because the heat of the stove keeps that area warm. If it's not warm enough, I turn on the overhead vent light to warm things up or stash the bowl in the microwave oven and shut the door. I've had to be more creative in my previous homes. In a cold and drafty house in England, the top of the washing machine in the warm cellar was the best place. I've also proofed bread in a turned-off shower!

MIX BY HAND

Enjoy the feel of the doughs in this chapter as you shape the rolls and loaves. Use a bench scraper to help you move the dough on a floured kitchen counter. In fact, most all these recipes can be made with a large mixing bowl and a long-handled wooden spoon. It takes some strength, but that's how they were made before mixers. If mixing with the spoon becomes too difficult, turn the dough out onto the counter and work the rest of the flour into the dough with the help of the bench scraper or a pastry cloth, since these doughs are soft and may stick to your hands. In the recipes that are expedited with a mixer, I call for a "stand mixer" because of its strength, whether it be a Sunbeam with beaters or a KitchenAid with a paddle, which has even more power. In those recipes where I suggest you beat the dough several minutes until it's elastic, almost webby, use the mixer's dough hook.

Mr. Charlie's Yeast Rolls

For thirty-three years, Charlie Moore was a cook at Martin Elementary School, as well as the high school, in the rural farmland of West Tennessee. He was known for his kind disposition and his soft homemade rolls. To hear former students talk, his big, square yeast rolls not only tasted like home but helped you eat a good lunch. To get a second roll, you had to bring Mr. Charlie your plate to prove you had eaten everything, even if it was cabbage or salmon croquettes or other things you didn't like.

Moore was born in Guthrie, Kentucky, in 1910. In addition to cooking at the school, he was a scoutmaster and deacon at Oak Grove Baptist Church. His roll recipe made use of dry milk powder, which was cheaper than fresh milk and a staple in cafeteria kitchens. Although his original recipe made 140 rolls, I've reduced it to three dozen. Moore died in 2005 at ninety-four, but he continues to be eulogized on social media. His obituary in the *Weakley County Press* noted, "He became famous for his yeast rolls and traveled throughout the state demonstrating them."

Plan ahead: The dough should be refrigerated overnight.

Makes 3 dozen rolls	Prep: 20 to 25 minutes	Rise: 2 hours for 1 rise, plus overnight in the fridge	Bake: 22 to 27 minutes

2 cups water

3/4 cup (5 ounces) vegetable shortening

1/3 cup (68 grams) granulated sugar

1/4 cup (28 grams) dry milk powder

4 1/2 teaspoons (2 packages) dry yeast

4 1/2 cups (540 grams) all-purpose flour, plus
 1/4 cup (30 grams) for handling the dough

2 teaspoons salt

Parchment paper for lining the pan

2 tablespoons salted butter, melted, for
 brushing the rolls after baking

1. Bring the water to a boil in a small saucepan. Place the shortening, sugar, and milk powder in the large bowl of a stand mixer and pour the boiling water over. Whisk to melt the shortening and dissolve the sugar. Check the temperature with an instant-read thermometer and let the mixture cool to 125°F.

2. Sprinkle the yeast over the top and whisk to dissolve. Place the 4 1/2 cups flour in a medium bowl and stir in the salt. Turn the flour mixture into the yeast mixture. Beat on medium speed until the ingredients are incorporated and the dough begins to leave the sides of the bowl, 4 to 5 minutes. Cover the bowl with plastic wrap and place it in the refrigerator overnight.

3. The next day, punch down the dough to deflate it. Sprinkle the 1/4 cup flour on a surface, and turn the dough on top of the flour. With floured hands, knead the dough several times, pushing back and forth, over and under, and if it gets too sticky, use a bench scraper or plastic spatula to help you.

4. Line a 12-by-17-inch rimmed baking sheet with parchment paper. Pinch off ping-pong-ball-size pieces of dough (1 1/4 ounces each) and place them side by side on the pan, pressing them lightly to flatten. Drape the pan with a light kitchen towel and place in a warm spot for the rolls to rise until doubled, about 2 hours.

5. Heat the oven to 350ºF, with a rack in the middle. Bake the rolls until golden brown, 22 to 27 minutes. Brush the tops with the melted butter and serve.

HOMEMADE HAMBURGER BUNS

If you make these rolls twice as large, you will have 18 homemade hamburger buns. Bake them a few extra minutes, or until done.

BREAD BAKING CAME LATE TO THE SOUTH

Baking bread in an oven came late to the South, compared to New England and Europe, both because of home construction and the absence of wheat flour. In seventeenth-century Virginia and Maryland, the homes were made of wattle and daub, where wooden stakes—wattles—were woven with horizontal twigs and branches and then "daubed" with mud or clay. The chimneys were also made of wattle and daub and not suitable for withstanding the heat of bake ovens, says Maryland historian Joyce White.

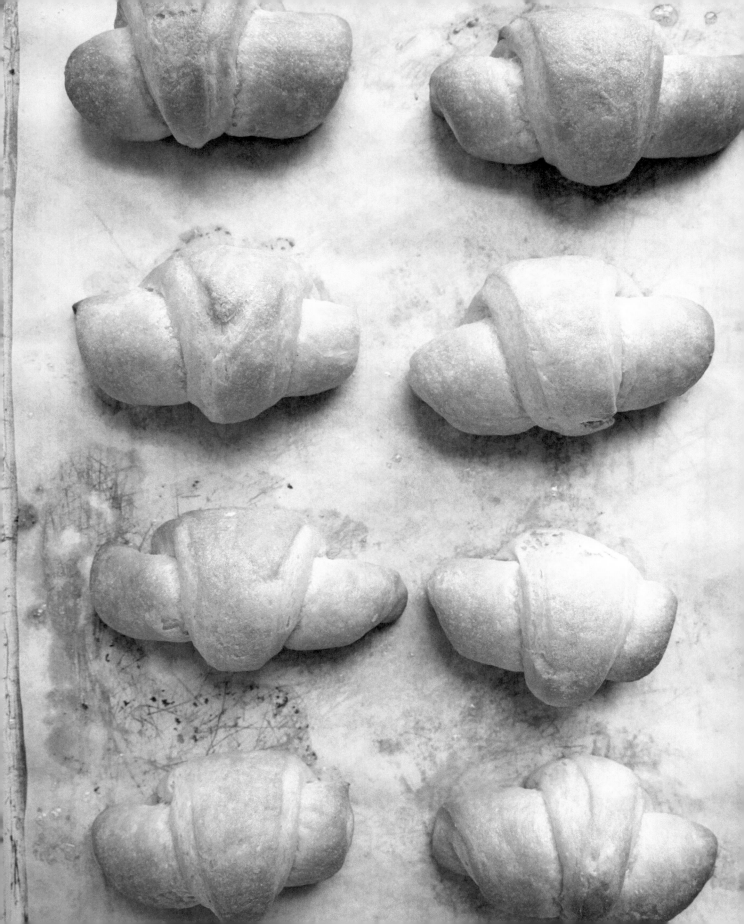

Duncan Hines' Butterhorns

Unlike Betty Crocker, Duncan Hines was a real person and an early food influencer as well. Born in Bowling Green, Kentucky, in 1880, Duncan and his brother, Porter, spent their summers with their maternal grandparents on a farm, where his love of good food began. His mother had died of pneumonia when he was four, and he relied on his connections to family all his life, sending a Christmas card to them with the names of great restaurants he found while he was a traveling salesman. That card evolved into collecting recipes from these restaurants, and then became cookbooks and travel books. His nephew, Hugh Hines Jr. of Danville, Kentucky, recalls those recipes because his mother, Geraldine Hines, was the one who tested Uncle Duncan's recipes. "My mother would cook them and the family would gather around and say 'yes' or 'no.' He had a briefcase of recipes he'd acquired by the time he got back home. His favorites were country ham and yeast rolls."

Duncan Hines died in 1959. He had come from a family of good farm cooks where people raised their own chickens, put up hams, grew their vegetables, and made everything from scratch. In addition to his cookbooks, he created his own cake mix, which he sold, along with his name, to Procter & Gamble.

This beautiful and buttery roll recipe, which has Mennonite origins, was one of the family's favorites for special occasions. The dough is easy to work with and keeps for 3 to 5 days in the fridge, so you can take out one ball of dough at a time during the holidays and have fresh hot rolls each day.

Plan ahead: start the day before.

Makes 3 dozen rolls	Prep: 20 minutes	Rise: 1 1/2 hours for 2 rises, plus overnight in the fridge	Bake: 12 to 15 minutes

1 cup whole milk

12 tablespoons (1 1/2 sticks/170 grams) unsalted butter, cut into tablespoons, plus more for greasing the bowl

1/2 cup (100 grams) granulated sugar

2 1/4 teaspoons (1 package) dry yeast

4 cups (480 grams) all-purpose flour, plus about 3 tablespoons for handling the dough

1 1/2 teaspoons salt

3 large eggs, lightly beaten

Parchment paper for lining the pan

4 tablespoons (1/2 stick/57 grams) salted butter, melted, for brushing, divided

1. Place the milk and unsalted butter in a medium saucepan over medium-low heat and stir until the butter nearly melts, 3 to 4 minutes. Remove from the heat and stir in the sugar. Let the mixture cool to room temperature or to no more than 125°F on an instant-read thermometer. Whisk in the yeast.

2. Turn the mixture into the large bowl of a stand mixer. Add 2 cups of the flour and beat on low speed to combine. In a separate bowl, stir the salt into the remaining 2 cups flour. Add this flour mixture, alternating with the lightly beaten eggs, to the bowl of the stand mixer, beating on low until smooth. The dough will be sticky. Lightly grease a large clean bowl with a little unsalted butter. With a rubber spatula, turn the dough into the bowl. Cover with a light kitchen towel and place it in a warm spot to rise until double, about 1 hour.

3. Dust a work surface with 1 tablespoon of the flour. Punch down the risen dough with the rubber spatula and turn it onto the flour. With floured hands and using a bench scraper or metal spatula, knead the dough for several minutes by folding it over again and again, until you can work with it and it springs back. It may still be a little sticky. Try not to use a lot of flour during this step, which will result in dry rolls—just enough to stop it from sticking. Clean out the bowl in which it rose and turn the dough back into the bowl. Cover with plastic wrap and place in the fridge overnight. (Or you can skip this step and let it rise until doubled again, 1 hour.)

4. The next day, remove the dough from the fridge and divide it into 3 pieces, about 14 ounces each. Working with one at a time on a lightly floured surface, roll out a 10- to 11-inch round, about 1/4 inch thick.

5. Line a 12-by-17-inch rimmed baking sheet with parchment paper. Cut the dough round into 12 wedges, using a pizza cutter or sharp knife. Starting at the wide end, roll up and tuck the pointed end underneath the roll. Place several inches apart on the pan. Brush with about half of the melted salted butter. Let rise again, uncovered, until the rolls rise slightly but are not doubled, 30 minutes.

6. Heat the oven to 375°F, with a rack in the middle.

7. Bake until the rolls are golden brown on top and bottom, 12 to 15 minutes. Brush with the remaining melted salted butter and serve.

NOTE:

You can make all the rolls at one time, or, after dividing the dough into thirds, you can store 2 pieces of the dough in the fridge, covered, for up to 2 days. I have also frozen the dough for up to a month, let it defrost, and then baked fresh rolls.

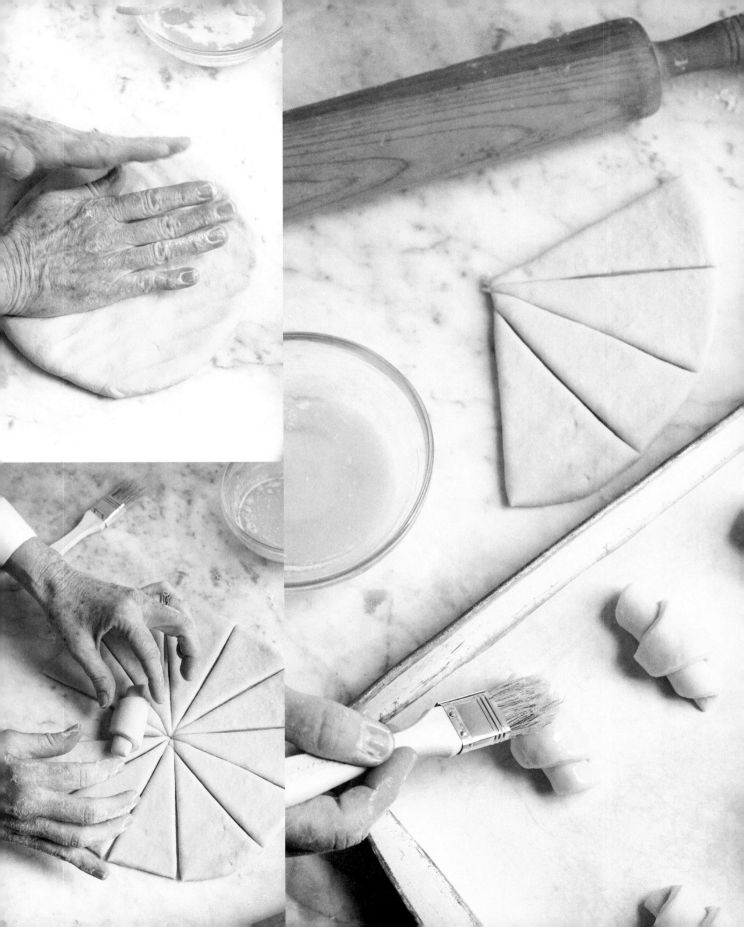

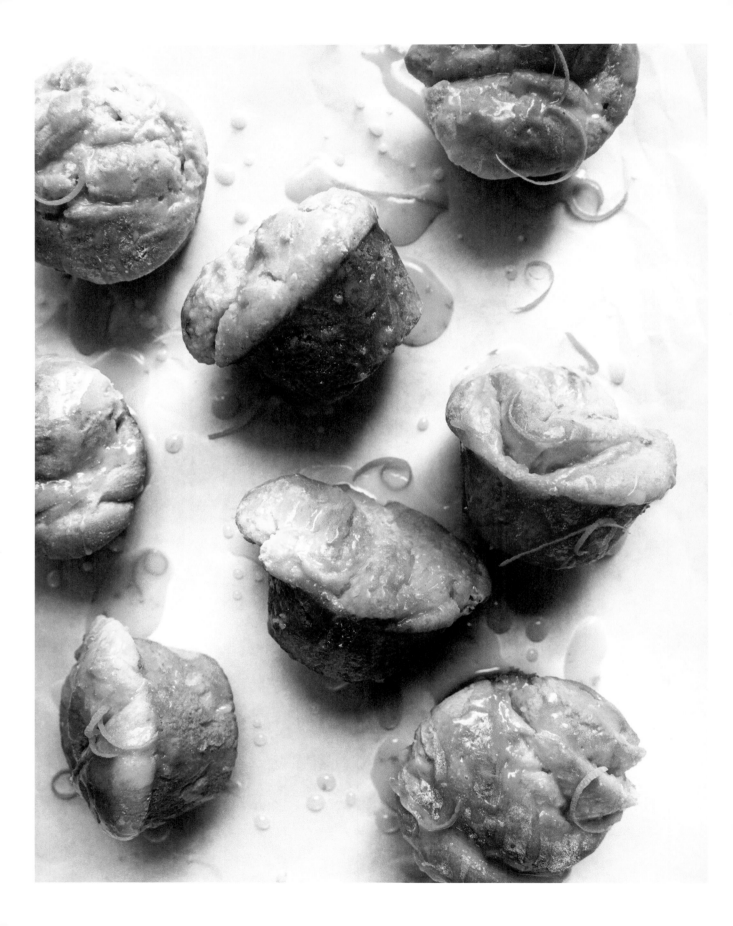

Ewing Steele's Alabama Orange Rolls

One of the South's most delicious sweet roll recipes hails from Alabama, but where in the state is debated. The buttery coiled rolls with intense orange flavor may have been first created by Ewing Steele, the chef of Vestavia Gardens in Birmingham, who sprinkled her orange roll fairy dust throughout the private clubs and restaurants where she worked all over the Magic City.

The restaurant itself had a colorful history. It was once the home of former Birmingham mayor and Renaissance man George Ward, who built it at the top of Shades Mountain to resemble a Roman temple in the 1920s and named it after Vesta, the Roman goddess of the hearth. It became the social gathering spot of the rich and famous. Following Ward's death, his family sold it to developer Charles Byrd, who created the first Birmingham subdivision in the hills surrounding it. Byrd refurbished the "temple" as a tourist attraction in 1949, with a fancy restaurant called Vestavia Gardens.

But many credit All Steak restaurant in Cullman, about 45 minutes north of the city, with the roll's origin. All Steak opened in the late 1930s, but the orange roll didn't appear on the menu until the 1960s. Regardless of debates about origin, if you want the best orange rolls to serve at breakfast or brunch or anytime, you need to make them from Steele's recipe.

Makes 2 dozen rolls

Prep: 35 to 40 minutes

Rise: 1 1/2 hours for the first rise or overnight in the fridge; 45 minutes for the second rise

Bake: 15 to 20 minutes

DOUGH

2 cups whole milk

1/2 cup (3.5 ounces) vegetable shortening

1/2 cup (100 grams) granulated sugar

1 3/4 teaspoons dry yeast

4 cups (480 grams) all-purpose flour, plus 4 to 5 tablespoons to pull the dough together and shape the dough

1 teaspoon baking soda

1 teaspoon baking powder

1 teaspoon salt

1 large egg

8 tablespoons (1 stick/114 grams) unsalted butter, melted, for brushing the pan and dough

FILLING

1/3 cup (68 grams) granulated sugar

1 tablespoon grated orange zest (from 2 small oranges or tangerines)

ICING

1 cup (108 grams) confectioners' sugar

Pinch of salt

3 tablespoons fresh orange juice

1. **Make the dough:** Pour the milk into a saucepan and heat over medium, until bubbles form around the edges of the pan and the milk scalds, 3 to 4 minutes.

2. Place the shortening and sugar in the large bowl of a stand mixer and cut into coarse pieces with two dinner knives. Pour the hot milk over and stir until the shortening melts. When the mixture has cooled to lukewarm (115°F to 120°F on an instant-read thermometer), whisk in the yeast.

3. Whisk together the 4 cups flour, baking soda, baking powder, and salt in a medium bowl. Add the egg to the yeast mixture and beat until smooth. Fold in the flour mixture and beat on low speed until incorporated. Scrape down the sides of the bowl with a rubber spatula. Increase the mixer to medium and beat until the dough begins to pull away from the sides of the bowl but is still sticky, 4 to 5 minutes. Add 2 or 3 tablespoons more flour if necessary to pull the dough together. Cover the bowl with plastic wrap and place in the refrigerator overnight. Or cover with a kitchen towel and place in a warm spot to double, about 1 1/2 hours.

4. When you're ready to bake, punch down the dough. Scatter the remaining 2 tablespoons flour on a surface and turn the dough out onto the flour. With floured hands, press it out into a long rectangle. Flip the dough so it doesn't stick to the counter. With a floured rolling pin, roll it into a rectangle that is about 24 inches long and 10 to 12 inches wide.

5. Brush two 12-cup muffin pans with a little of the melted butter. Brush the dough with the remaining melted butter.

6. **Make the filling:** Toss the sugar and orange zest together in a small bowl and sprinkle evenly over the top. Beginning with the long side, roll the dough into a jellyroll and, with a floured serrated knife, cut into 1-inch slices. Carefully place each slice cut side up into a muffin cup. Drape the pans with a kitchen towel and let the rolls rise until doubled, 40 to 45 minutes. (If the dough is cold, it might take 1 hour.)

7. Heat the oven to 350°F, with a rack in the middle.

8. Bake the rolls until they are lightly golden brown, 15 to 20 minutes. Place the pan on a wire rack to cool slightly while you make the icing.

9. **Make the icing:** Place the confectioners' sugar and salt in a small bowl. Whisk in the orange juice until smooth. Drizzle the icing over the top of the warm rolls still in the pans. Let cool for 20 minutes, then serve. Or let cool completely, wrap in foil, and freeze.

NOTE:

To simplify this recipe, stagger the preparation by placing the dough in the refrigerator overnight for the first rise, then the next morning, remove, punch down and prep the rolls, let them rise a second time, then bake.

Birmingham's ROLL MAKER

Ewing Steele was "the final word in food and hospitality for over twenty-five years in Birmingham," according to the 2013 book *Lenten Lunches, recipes from the Cathedral Church of the Advent*. Ewing Frances Hulsey was born in Birmingham in 1895. When she was twenty, she married Sears Childers Steele. After her son was born and her husband was diagnosed with tuberculosis, the young family moved to the drier climate of the West. Ewing and her fourteen-year-old son came back home after her husband died.

Following in the footsteps of her mother, a well-respected caterer and cook in the city, Steele became the catering manager at Birmingham Country Club and then at Fort McClellan Army base in Anniston during World War II, where she worked with German POWs in the kitchen. After the war, she made three trips to Germany to reconnect with them. She opened Vestavia Gardens restaurant and later worked at the Mountain Brook Club, the Noel Hotel in Nashville, and The Club, a Birmingham restaurant that still bakes her roll recipe to this day. In 1973 she published a cookbook, *Secrets of Cooking*, as a fundraiser for the Cathedral Church of the Advent, where she was a longtime parishioner, trimming down her much-loved "serves 100" recipes for home use. That book lives on in a 2013 edition.

The Optimist Buttermilk and Honey Rolls

Chrysta Poulos, who is in charge of the pastry program at Ford Fry's restaurants, located throughout the Southeast, started baking biscuits with her grandmother Sara Sprayberry when she was just four. Her favorite biscuit was always the one in the center of the pan, soft sided and warm. Poulos says her approach to baking is like her grandmother's, filled with love and guided by instinct. For his seafood restaurant, The Optimist, in Atlanta, Fry wanted a soft, slightly sweet yeasty roll. The one Poulos came up with is all that, and incredibly addicting. I've taken the restaurant's recipe down to something manageable for a home kitchen. You still may have more rolls than you need, but what I love about this recipe is the dough can spend another night in the fridge, or you can bake all the rolls off at one time and freeze the leftovers for later.

Plan ahead: Letting the dough rise in the fridge overnight makes the rolls easier to shape and adds to their flavor.

Makes 2 dozen rolls	Prep: 20 to 25 minutes	Rise: 1 1/2 to 3 hours for 1 rise, plus overnight in the fridge	Bake: 15 to 20 minutes

1 1/4 cups whole buttermilk, at room temperature

6 tablespoons warm water

1/4 cup honey

2 tablespoons dry yeast

2 large eggs

4 3/4 cups (590 grams) unbleached all-purpose flour, plus more for handling the dough

1/2 cup (100 grams) granulated sugar

4 teaspoons kosher salt

3 tablespoons vegetable shortening

2 tablespoons plus 2 teaspoons unsalted butter, soft but cool

Parchment paper for lining the pan

EGG WASH

1 large egg

1 teaspoon water

Honey for drizzling (optional)

Coarse salt for sprinkling (optional)

1. Place the buttermilk, water, and honey in a small bowl and whisk to combine. If the buttermilk is cold and straight from the fridge, place it in the microwave briefly to warm. Do not let it reach more than 125°F on an instant-read thermometer. Whisk in the yeast and set aside to soften.

2. Place the eggs in the large bowl of a stand mixer and beat on low speed until just combined. Add the yeast mixture and beat until combined. Add the flour, sugar, and salt and beat on low speed until well combined. Scrape down the sides of the bowl with a rubber spatula. Add the shortening and butter. Beat on low until combined, then increase the mixer speed to medium and beat until the dough gets elastic and sticky, 5 to 7 minutes. Cover the bowl with plastic wrap and place it in the refrigerator overnight.

3. The next day, line a 12-by-17-inch rimmed baking sheet with parchment paper. Uncover the bowl and punch down the dough with a wooden spoon. Turn the dough out onto a lightly floured surface. Divide the dough into 24 pieces (each about 1 3/4 ounces). With floured hands, roll the dough into balls. Place them nearly touching on the baking sheet, arranging them 4 across and 6 down. Drape a light kitchen towel over the top and let the rolls rise until almost doubled. This will take anywhere from 1 1/2 to 3 hours, depending on the warmth of your kitchen.

4. Heat the oven to 375ºF, with a rack in the middle.

5. **Make the egg wash:** Beat the egg with the water in a small bowl. Brush the risen rolls with the egg wash.

6. Place the pan in the oven and bake until the rolls are deeply golden brown and glossy, 15 to 20 minutes. Drizzle with honey and sprinkle with salt, if desired, then serve.

Herren's Sweet Rolls

What do you serve a dozen preschoolers who visit the photo shoot for your cookbook? Bite-size, irresistible Herren's cinnamon sweet rolls and glassfuls of cold milk. In 1934 a former prizefighter named Charlie Herren opened a small restaurant in Five Points, the heart of Atlanta. Herren's eventually moved to 84 Luckie Street. Later, it became the place where Atlanta's movers and shakers dined on steaks and lobster and these coin-size cinnamon rolls. Herren's was not only the first fine dining establishment in downtown Atlanta but also the first white-owned restaurant to open its doors voluntarily to Black customers, in 1963. Before Herren's closed in 1987, I met some friends there for lunch. For the last time, we inhaled the entire basket of these little warm rolls, and I asked for the recipe. You don't have to be a child to love them!

The key is to work with a third of the dough at a time, and roll it into a long, thin jellyroll so you can slice small rolls that fit tightly together in the pan.

Makes 5 to 6 dozen rolls Prep: 40 to 45 minutes Rise: 1 3/4 hours for 2 rises Bake: 15 to 20 minutes

1 cup whole milk

4 tablespoons (1/2 stick/57 grams) unsalted butter, cut into tablespoons, plus 8 tablespoons (1 stick/114 grams) unsalted butter, melted, divided, and more for greasing the bowl

1 1/4 cups (250 grams) granulated sugar, divided

1 1/4 teaspoons salt

1/4 cup warm (115°F to 120°F) water

4 1/2 teaspoons (2 packages) dry yeast

4 cups (480 grams) all-purpose flour, plus more for kneading

2 tablespoons ground cinnamon

Parchment paper for lining the pan

1. Place the milk in a heavy saucepan over medium-low heat and bring to a boil. Remove from the heat and stir in the 4 tablespoons butter and 1/4 cup of the sugar and the salt. Stir until the butter melts and the sugar dissolves. Let cool to lukewarm or 115°F to 120°F on an instant-read thermometer.

2. Meanwhile, pour the warm water into the large bowl of a stand mixer. Stir in the yeast to dissolve. When the milk mixture has cooled, stir it into the yeast mixture. Add the flour, 1/4 cup at a time, blending on low speed until the flour is incorporated and the mixture is smooth.

3. Lightly dust a surface with flour and turn out the dough. With floured hands, knead the dough gently, folding it over and under until it is smooth and satiny, 5 to 6 minutes. Place the dough in a clean large bowl, lightly greased with butter, turn the dough over, and drape with a light kitchen towel. Place the dough in a warm spot to rise until doubled, about 45 minutes.

4. When the dough has doubled, punch it down and turn out onto a lightly floured surface. Roll the dough into a rectangle about 24 inches by 8 inches and about 1/4 inch thick. Cut into three 8-inch squares. Working with one square at a time, spread the

square generously with about a third of the remaining 8 tablespoons melted butter. Place the remaining 1 cup sugar and the cinnamon in a small bowl and stir to combine. Reserve half of the mixture for sprinkling on top of the rolls before baking. Sprinkle about a third of the remaining cinnamon-sugar over the butter. Repeat with the remaining 2 squares of dough.

5. Line a 12-by-17-inch rimmed baking sheet with parchment paper. Starting with one side, roll each square of dough into a jellyroll and continue to roll back and forth on the counter until it is 16 inches long. With a sharp knife, slice crosswise into about 1/2-inch-thick slices. Place the rolls, cut side up, close together on the pan. Brush the top of the rolls with any remaining melted butter. Sprinkle with the remaining cinnamon-sugar. Drape lightly with the kitchen towel and place in a warm spot to rise until doubled, about 1 hour.

6. When you're ready to bake, heat the oven to 350ºF, with a rack in the middle.

7. Bake until the rolls are golden brown, 15 to 20 minutes. Serve.

NOTE:

These rolls freeze well. To reheat, cover with aluminum foil and place in a 300ºF oven until warmed through.

Texas Kolaches

A Czech community flourished around Texas' state capital, Austin, in the mid-1800s, continuing until World War I. According to the Texas State Historical Association, the first Czech immigrants were poor laborers, most from the eastern Czech region of Moravia, drawn by the abundant relatively inexpensive farmland, as well as by the prospect of religious freedom. They lived close to the land, had tightly knit families, and held onto vibrant folkways that included baking these pillowy yeast rolls—kolaches. Filled with apricot or prune preserves (or any of your favorites) or cream cheese, they are much like a Danish but less sweet. No wonder Texans have adopted this delicious recipe as their own. I looked to two cookbooks, *The Texas Cookbook*, by Mary Faulk Koock, and *Sweet on Texas*, by Denise Gee, for inspiration. The cream cheese filling is a must. The streusel isn't really necessary, but it adds crunch and makes these authentic.

Plan ahead: Allow 2 days—one to make the dough, and the next to finish and bake them.

Makes 2 to 2 1/2 dozen kolaches	Prep: 35 to 40 minutes	Rise: 30 minutes for 1 rise, plus overnight in the fridge	Bake: 18 to 22 minutes per batch

DOUGH

2 cups whole milk

4 tablespoons (1/2 stick/57 grams) unsalted butter

1/2 cup (3.5 ounces/95 grams) vegetable shortening

1/2 cup (100 grams) granulated sugar

2 large eggs

4 1/2 teaspoons (2 packages) dry yeast

5 cups (600 grams) bread flour, plus 1/2 cup (60 grams) for rolling

1 tablespoon kosher salt

Parchment paper for lining the pans

1 egg yolk, lightly beaten

STREUSEL (OPTIONAL)

2 tablespoons unsalted butter, cold

1/3 cup (68 grams) granulated sugar

1/4 cup (30 grams) all-purpose flour

QUICK FILLINGS

Cream cheese (recipe follows)

1 cup (8 ounces) apricot or prune (recipe follows), warmed

1 cup (8 ounces) guava jam, warmed

1 cup (8 ounces) fig jam or preserves, warmed

MAKE YOUR OWN FILLINGS

Apricot or prune: Cover 12 ounces dried apricots or pitted prunes with boiling water and let sit at least 3 hours or overnight. Drain off the liquid. Simmer the fruit with 1/2 cup sugar and 2 tablespoons butter and cook over low heat until soft enough to mash. Add a little almond extract to the apricot filling and a little cinnamon, lemon zest, or vanilla to the prune.

Cream cheese: Beat 6 ounces soft cream cheese (or half ricotta and half cream cheese) with 1/4 cup sugar, 1/2 tablespoon all-purpose flour, and a dash of vanilla extract or lemon juice until creamy.

1. **Make the dough:** Place the milk and butter in a medium saucepan over low heat and stir until the butter melts, 3 to 4 minutes.

2. Place the shortening and sugar in the large bowl of a stand mixer fitted with the paddle attachment, and beat on low speed until creamy, 1 minute. Pour the hot milk mixture into the bowl and beat until it is combined. Add the eggs and beat until smooth. Add the yeast and beat until it is dissolved.

3. Add the 5 cups flour gradually to the mixture, beating on low, and adding as much flour as needed to bring the dough together. Add the salt and beat briefly. The dough will still be sticky. Place plastic wrap over the top of the bowl and place in the refrigerator overnight.

4. **Make the streusel (if using):** Pulse the butter, sugar, and flour in a food processor or place in a bowl and use two knives to cut into the mixture until crumbly.

5. When you're ready to bake, remove the dough from the fridge. Scatter the 1/2 cup flour on a surface. Line two 12-by-17-inch rimmed baking sheets with parchment paper. Drop the dough by large egg-size pieces, 1 1/2 to 2 ounces each, onto the floured surface and, using only as much flour as you need to prevent sticking, roll into a ball. Place the dough balls 1 inch apart on the baking pan. You will get 12 to 15 to a pan. Repeat with the remaining dough. Cover the pans with light kitchen towels and let the dough rise in a warm place until nearly doubled, 30 minutes.

6. Heat the oven to 375°F, with a rack in the middle.

7. When the dough has risen, flour the bottom of a 1/4-cup dry measuring cup and press down firmly on each ball to make an indention. Fill with about a tablespoon of your choice of filling—preserves or cream cheese—alternating the fillings for an attractive presentation.

8. Brush the edges of the dough with the lightly beaten egg yolk and sprinkle the streusel (if using) over the dough, but not the filling. Bake, one pan at a time, until golden brown and the streusel has lightly browned, 18 to 22 minutes.

HOW TO MAKE MONKEY BREAD

There are countless variations on this pull-apart yeast bread. For any of the roll recipes in this chapter, let them have the first rise, then:

- Roll out the dough and cut into 2-inch pieces, either rounds or squares. Dip each roll into melted butter (and, if you like, a mixture of cinnamon and sugar, or Parmesan cheese and garlic) and pile them into a lightly greased Bundt pan until it is half full. Cover the top lightly with a kitchen towel and place in a warm spot to double.
- Heat the oven to 400°F. Place the pan in the oven and bake until golden brown, about 30 minutes.
- Turn out onto a serving plate and pull off the pieces.

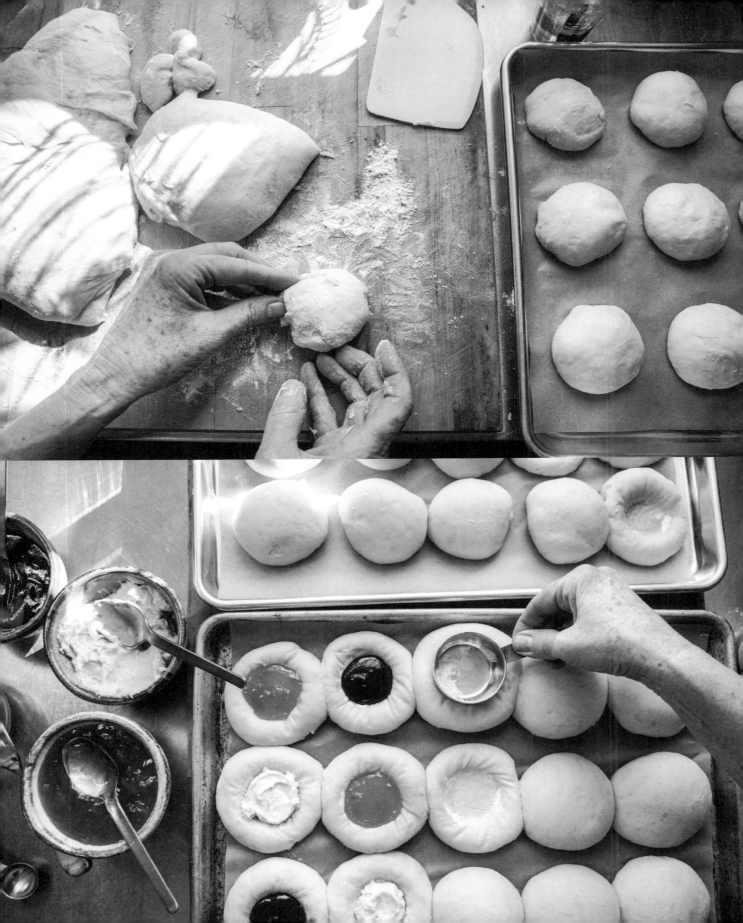

Phila Hach's Salt-Rising Bread

Known as salt-rising bread because the early settlers let it rise above a container of salt that was warmed by the sun, taking advantage of the mineral's ability to hold heat, this delicious bread tells the Appalachian baking story. It was born out of necessity in the late 1700s, before commercial yeast, and crafted from a homemade starter of sliced potatoes and a little cornmeal and flour, which gives off a pungent cheese odor. Like yeast, the starter creates carbon dioxide gas that pushes the dough upward. The bread itself has a nice cheese flavor, especially once it's toasted and buttered. Embraced by the rural South, for many, it was the only "yeast" bread they knew.

I am grateful to the late Phila Hach, who included this recipe in one of her many cookbooks. Hach, the daughter of Swiss immigrants, was one of Tennessee's most loved culinary stars, appearing on local television in the 1950s. My parents were fond of this bread, which they bought from the Dutch Maid bakery near Tracy City, Tennessee, on the Cumberland Plateau.

Plan ahead: This is a project bread, needing 2 days from start to finish.

Makes 1 (9-inch) loaf and 2 (7 1/4-inch) loaves	Prep: 30 minutes	Rise: 24 hours fermentation, plus 3 3/4 hours rising	Bake: 40 to 45 minutes

DAY 1

1 large potato (8 ounces), thinly sliced

1/4 cup (34 grams) coarsely ground cornmeal, white or yellow

1/4 cup (30 grams) all-purpose flour

1 tablespoon granulated sugar

1/2 teaspoon baking soda

1/2 teaspoon baking powder

1/2 teaspoon salt

2 cups boiling water

DAY 2 (24 HOURS LATER)

Step 1

3 cups (360 grams) all-purpose flour, divided

1 teaspoon granulated sugar

1/2 teaspoon salt

1/2 teaspoon baking powder

1/2 teaspoon baking soda

Step 2

6 1/2 cups (780 grams) all-purpose flour, divided, plus more for handling

1/2 cup (100 grams) granulated sugar

1 tablespoon salt

3/4 cup (5 ounces) vegetable shortening

2 cups whole milk, warmed

Vegetable oil spray or soft butter for prepping the pans

1. **Day 1:** Place the potato slices in a large (2 quart-size, 64 ounces) heat-resistant canning jar. Add the cornmeal, flour, sugar, baking soda, baking powder, and salt. Pour in the boiling water and stir with the handle of a wooden spoon to dissolve the baking soda and baking powder. Cover the jar with a kitchen towel and place a rubber band around the neck of the jar to hold the towel in place. Place the jar in a small heavy pan filled with 1 inch of hot water. From time to time, check the temperature of the water

and, if necessary, heat the pan on low with the jar still in the water so the water reaches 115ºF on an instant-read thermometer, then turn off the heat. Leave the jar in the water overnight.

2. **Day 2:** Continue heating underneath the pan to keep the water around the jar at 100ºF to 115ºF. You will see the contents appear to foam, and if you remove the kitchen towel and smell the contents, it should smell stinky. Stinky is good when you are making this bread! You can't go on to the next step until the contents begin to bubble up and foam. Be patient and keep the jar warm. It will take at least 24 hours.

3. *Step 1:* Once the jar contents are foaming, remove the kitchen towel and strain the liquid from the jar into a 2-quart bowl. Discard the potato slices. Whisk in the flour, sugar, salt, baking powder, and baking soda. Drape the top of the bowl with the kitchen towel and place the bowl in a warm spot until the dough rises to the top of the bowl, about 2 hours.

4. *Step 2:* Once the dough has risen, punch it down with a rubber spatula. Place 3 cups of the flour in a 4-quart bowl. Stir in the sugar and salt. Add the shortening and cut it into the flour mixture with two knives or a pastry blender, as if you are making biscuits. Pour the risen dough into the bowl and add the warm milk. Stir until smooth. The dough will be liquidy. Stir in 3 to 3 1/2 cups more flour until the dough comes together into a soft dough that you can handle. Turn it out onto a floured surface, and with a bench or dough scraper, divide it into 3 or 4 sections, depending on how many loaf pans you have. Grease the loaf pans with vegetable oil spray or soft butter. Working with one piece of dough at a time, with floured hands, shape it into a loaf and carefully transfer it to a pan. Repeat with the remaining dough. Drape kitchen towels over the loaves and let the dough rise until doubled, 1 hour and 45 minutes.

5. Heat the oven to 400ºF, with a rack in the middle. Bake the loaves for 10 minutes, then reduce the temperature to 350ºF and bake until they are lightly browned, they are hard if you tap them on top, and the internal temperature registers 190ºF in the center using an instant-read thermometer, 30 to 35 minutes. Slice and serve warm. Or let cool and slice for toasting. These loaves freeze well.

IRISH SODA BREAD IN MISSISSIPPI

Salt might have kept the salt-rising bread dough at the right temperature to speed fermentation, but it was the natural yeast found in the potatoes and cornmeal that first caused breads to rise in the South. You didn't have to live in the mountains to be so resourceful as to bake bread without yeast. When the Irish settlers came into the South in the 1840s and '50s, fleeing the potato famine known as the Great Hunger, they built railroad lines and brought their way of making a quick bread using fresh milk from local cows. It was baked in a Dutch oven over coals overnight, something we now know as soda bread.

John Taylor's Carolina Rice Bread

My friend John Martin Taylor, who opened the landmark culinary bookstore called Hoppin' John's in Charleston in 1986, enticed me to bake this bread from his book *Hoppin' John's Lowcountry Cooking* (1992). He told me it makes the best toast he's ever eaten—densely textured and fragrant. The recipe has just a few ingredients—cooked rice, salt, water, yeast, and flour. It's amended somewhat from Taylor's recipe: I use long-grain basmati if I can't find Carolina Gold rice, Nashville tap water instead of spring water, and King Arthur all-purpose flour. You cook the rice and let it cool to around 120°F so as not to kill the yeast, then stir in the yeast and the flour and work the dough with your hands.

This recipe uses what Taylor calls the falling-oven technique, starting at 450°F, then reducing to 400°F, and finally to 375°F. This simulates the heat of a wood-fired oven, which is how this loaf was originally baked. When nearly done, the loaves are tipped out of their pans to bake on their sides, so all the edges become nice and crisp. What you get are two loaves of bread, an incredibly fragrant kitchen, the feeling you are baking something as it was done 200 years ago, and, yes, wonderful toast!

Makes 2 (8- to 9-inch) loaves Prep: 30 minutes Rise: 2 1/2 hours for 2 rises Bake: 45 to 50 minutes

1 1/4 cups (228 grams) long-grain rice

4 cups water

1 1/2 tablespoons kosher salt

1 1/2 tablespoons (1/2 ounce) active dry yeast

About 8 cups (960 grams) unbleached all-purpose or bread flour (not pastry flour)

Vegetable oil or melted butter for brushing the dough (optional)

NOTE:

Don't be discouraged if, after you've incorporated all the flour, the dough doesn't look right. It appeared dry to me, so I put a kitchen towel over it and let it rest. An hour later, it had pulled itself together.

1. Rinse the rice and place in a large pot with the water and salt. Stir to combine. Bring to a boil over medium-high heat. Reduce the heat to low, cover, and simmer until all the liquid is absorbed and the rice is quite soft, 15 to 20 minutes. Place the rice in a very large bowl. Set aside to cool to 120°F on an instant-read thermometer.

2. Stir in the yeast. With a wooden spoon, and then with your hands, work in the flour, cup by cup. Be patient. It takes time, and you need to get your hands in it.

3. Turn the dough into a large clean bowl, even if it is not completely smooth and you don't feel everything is incorporated. Cover with plastic wrap. If your bowl is not large enough to allow the bread to double in size, you may want to lightly brush the top of the dough with oil or melted butter to keep it from sticking to the plastic. Cover the entire bowl with a towel and set in a warm place to rise until doubled, 2 hours.

4. Lightly grease two 8- or 9-inch loaf pans with the vegetable oil or butter and set aside. When the dough has doubled, punch it down and knead it lightly so that it is evenly textured again. Divide it into two parts and roll each part into a log that tucks nicely in each pan, with all edges on the bottom, and only the smooth top of the dough showing. Cover with a towel and place in a warm spot to rise, about 30 minutes. (Or, if you want to bake the loaves the next day, cover the loaves with plastic wrap and place in the fridge overnight.)

5. After the loaves have risen nearly to the top of the pans, heat the oven to 450ºF, with a rack in the middle.

6. Bake for 15 minutes at 450ºF, reduce the oven temperature to 400ºF, and bake for 15 minutes, then reduce the temperature to 375ºF. Reach into the oven and carefully shake the loaves out of the pans and lay them on their sides on the oven rack. Remove the pans and shut the oven door. Bake for 15 to 20 minutes, or until the loaves are firm and the internal temperature registers 190ºF in the center. Remove to a wire rack to cool completely, 1 hour, before slicing and serving.

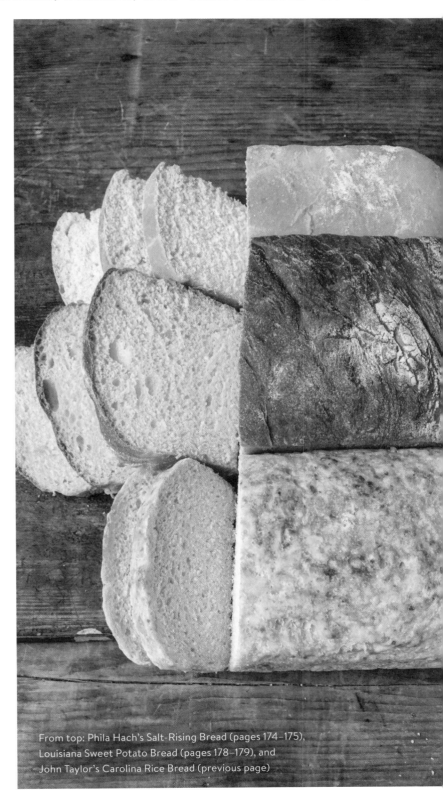

From top: Phila Hach's Salt-Rising Bread (pages 174–175), Louisiana Sweet Potato Bread (pages 178–179), and John Taylor's Carolina Rice Bread (previous page)

Louisiana Sweet Potato Bread

You are going to love this gorgeous bread, with its golden-coral hue, moist texture, and distinct sweet potato flavor. Sweet potatoes have been a cheap, dense, and versatile ingredient in Southern baking from the Depression forward to today. Though they're often called yams, sweet potatoes are different from the yams of Africa, and it is the orange sweet potato that lends this bread its characteristic color. This recipe is adapted from one in *Louisiana Real & Rustic*, by Emeril Lagasse and Marcelle Bienvenu. While it needs no adornment, it is spectacular sliced and piled with turkey and a dab of cranberry sauce.

Makes 1 (9-inch) loaf Prep: 20 to 25 minutes Rise: 2 hours, 15 to 20 minutes for 2 rises Bake: 42 to 46 minutes

1 medium (6 to 7 ounces) unpeeled sweet potato (see Note)

1/2 cup water

3 tablespoons unsalted butter, plus more for the bowl and the pan

2 1/4 teaspoons (1 package) dry yeast

1/4 cup (50 grams) granulated sugar

2 large eggs

3 1/4 cups (390 grams) unbleached all-purpose flour, divided

2 teaspoons kosher salt

NOTE:

You can either boil the sweet potato in its jacket (unpeeled), then peel and mash it when it's cool enough to handle, or you can roast it unpeeled until soft for an even sweeter flavor, then scoop out the flesh.

1. Rinse the sweet potato and pat dry. Place in a small saucepan and cover with water. Bring to a boil over medium heat, then cover and reduce the heat to low to simmer until tender, about 20 minutes. Remove from the water and let cool, then peel and mash. You'll need 1/2 cup mashed sweet potato.

2. Place the water and butter in a medium saucepan and heat until the butter melts. Remove from the heat and let cool. Check the temperature on an instant-read thermometer and make sure it is under 125ºF. Whisk in the yeast to dissolve. Whisk in the sugar. Whisk in one egg at a time until combined. Fold in the sweet potato.

3. Measure 2 3/4 cups (330 grams) of the flour into a large bowl. Whisk in the salt. Pour in the sweet potato mixture and stir with a wooden spoon until combined. Stir more vigorously until the dough leaves the sides of the bowl. Dust the counter with 2 tablespoons of the remaining flour and turn the dough onto the flour. Knead until smooth, incorporating the remaining 6 tablespoons flour if needed. If you do not need the flour, don't add it. It is fine if the dough is still a little sticky. Lightly

grease a bowl with butter, place the dough in the bowl, and turn the dough to grease the top. Cover with a light kitchen towel and place in a warm spot to rise until doubled, 1 1/2 hours.

4. When the dough has doubled, punch it down with your fist and turn it out onto a floured surface. Lightly grease a 9-inch loaf pan with butter. Press the dough into a rectangle about 9 inches long and about 6 inches wide. With floured hands and with the help of a metal spatula or dough scraper, roll the dough up into a log and carefully place it, seam side down, in the loaf pan. Cover with the kitchen towel and let rise in a warm spot until doubled, 45 to 50 minutes.

5. When you are ready to bake, heat the oven to 350°F, with a rack in the middle.

6. Bake until well browned and the loaf begins to pull back from the sides of the pan, 42 to 46 minutes, or until an instant-read thermometer inserted into the loaf registers 190°F. Remove to a wire rack to cool for a few minutes, then run a knife around the edges of the pan and turn the loaf out onto its side to cool completely, 1 hour. Slice and serve.

Beatrice Mize's Raisin Bread

Thornton Kennedy was just a baby in 1974 when Beatrice Mize, or "Bea Bea," as he called her, was hired to be his nurse and cook for him and his two older siblings at their Atlanta home. Kennedy has fond memories of her baking this rich and moist raisin bread and toasting it for breakfast.

Mize was born in 1893 in North Georgia and was raised by her grandparents, who worked as domestics for an executive of Georgia Power. When she was fourteen, she was offered cooking lessons by the wife of her grandparents' employer. She married and moved to Cornelia, Georgia, before being lured back to the North Georgia mountains to cook for workers who were coming in to build the big Tugalo Dam along the Tallulah River. She cooked in the home of the chief engineer of that Georgia Power project and moved to Atlanta, where she lived out the years of her life as a domestic, cooking and cleaning. Her story was one captured by Fred DuBose in his 1986 book, *Four Great Southern Cooks*. I can't decide what I love more about this recipe—toasting thick slices or dredging them in beaten egg for French toast and frying in butter until golden.

Plan ahead: the first rise is in the refrigerator overnight.

Makes 2 (9-inch) loaves	Prep: 30 to 35 minutes	Rise: 1 1/2 hours for 1 rise, plus overnight in the fridge	Bake: 32 to 36 minutes

1 cup whole milk

1 cup water

1 tablespoon dry yeast

1/4 cup (2 ounces) vegetable shortening or 4 tablespoons (1/2 stick) unsalted butter, at room temperature

3/4 cup (150 grams) granulated sugar

5 cups (600 grams) all-purpose flour, plus 2 tablespoons for shaping

1 1/4 teaspoons kosher salt

1 cup (5 ounces/150 grams) raisins

Vegetable oil or soft butter for greasing the bowl

Vegetable oil spray for misting the pans

GLAZE

1 large egg

1 teaspoon water

1. Pour the milk in a small saucepan and warm over medium heat. When bubbles form around the edges of the pan, 3 to 4 minutes, and the milk has scalded, turn off the heat. Stir in the water. Check the temperature of the liquid—it should be under 125ºF. When it is, whisk in the yeast.

2. Meanwhile, place the shortening or butter and the sugar in the large bowl of a stand mixer and beat on low speed until just combined. Place the 5 cups flour in a large bowl and stir in the salt. Add half of the flour mixture to the butter mixture, along with the yeast mixture. Beat until combined. Toss the raisins into the bowl with the remaining flour mixture and add that to the batter. Mix until the dough comes together in a sticky ball. Grease a large clean bowl with a little oil or soft butter and turn the dough into this bowl. Cover with plastic wrap and place in the refrigerator overnight.

3. The next day, scatter the 2 tablespoons flour onto a work

surface. Punch down the dough with a rubber spatula and turn the dough out onto the flour. Knead it gently so it is not sticky anymore. Divide the dough in half. Press each half into a rectangle that is about 8 inches long and about 6 inches wide. With the longest side near you, roll into a jellyroll. Mist two 9-inch loaf pans with vegetable oil spray. Fit each roll into a loaf pan. Place the pans in a warm spot in the kitchen and cover the tops with a light towel. Let the dough rise until doubled, about 1 1/2 hours.

4. Heat the oven to 400°F, with a rack in the middle.

5. **Make the glaze:** Beat the egg with the water. Brush the egg glaze generously over the loaves and place the pans in the oven.

6. Bake until the tops are deeply browned and the bread is done, with an internal temperature of 190°F in the center on an instant-read thermometer, 32 to 36 minutes. Place on a wire rack to cool for 10 minutes, then run a dinner knife around the edges of each loaf and turn out to cool completely, 1 hour. Slice and serve.

ATLANTA: THE ELECTRIC CITY

When Bea Mize was born, Atlanta was the fastest-growing city in the South. In 1883, Atlantans organized the formation of an electric company. They didn't want to lag behind other towns in acquiring this great new invention and formed the precursor to today's Georgia Power. As a result, stores, homes, streets, and streetcars all got electric lights in 1889. Electric ovens for baking followed later. It was electricity, among other things, that put Atlanta on the map.

Dollywood Cinnamon Bread

Within view of the Great Smoky Mountains, a Tennessee theme park pays homage to the queen of country music, Dolly Parton. And while a lot of people come here because they love Dolly, and others because of the big-time roller coaster, the cinnamon bread, drenched in butter and cinnamon-sugar, draws crowds as well. You can re-create it at home even if you never set foot in Dollywood, where they add a cinnamon icing and apple butter. I think the bread's plenty good on its own.

If possible, make the dough the day ahead and chill overnight so it will be easier to slice into, which allows the topping to penetrate deeply and create pockets, so when you pull the bread apart—just as they do at Dollywood—you get cinnamon-sugar in every bite.

Makes 1 (9-inch) loaf	Prep: 25 to 30 minutes	Rise: 2 1/4 to 2 3/4 hours for 2 rises	Bake: 28 to 32 minutes

DOUGH

1 cup whole milk, plus
 1 tablespoon
4 tablespoons (1/2 stick/57
 grams) unsalted butter, at
 room temperature
1 1/2 teaspoons dry yeast
3 cups (360 grams) bread flour,
 plus more for handling
2 tablespoons granulated sugar
1 teaspoon salt
Parchment paper for lining the
 pan

TOPPING

4 tablespoons (1/2 stick/57
 grams) unsalted butter
1/4 cup (50 grams) granulated
 sugar
1/4 cup (48 grams) lightly
 packed light brown sugar
1 tablespoon ground cinnamon

1. **Make the dough:** Pour the 1 cup milk in a small saucepan and warm over medium heat until bubbles form around the edges of the pan and it scalds, 3 to 4 minutes. Turn off the heat. Add the butter and stir to melt. When the milk mixture cools to the touch, 125°F or lower on an instant-read thermometer, whisk in the yeast.

2. Place the flour, sugar, and salt in the large bowl of a stand mixer. (Or you can combine without a mixer and knead by hand.) Beat on low speed until just combined. Pour in the yeast mixture and beat on low until incorporated. If the dough is dry, add the extra 1 tablespoon milk. Increase the mixer speed to medium and beat until the dough pulls away from the sides of the bowl and is smooth and elastic, 4 to 5 minutes. Scrape down the sides of the bowl and clean up the edges. Cover with plastic wrap and place in the refrigerator overnight, or cover with a kitchen towel and let rise until doubled, 1 1/2 to 2 hours.

3. Line a 9-inch loaf pan with parchment paper that extends over the short ends of the pan. Remove the parchment and set aside on a baking sheet. Punch down the dough and turn out onto a lightly floured surface. Press the dough into an 8- by 7-inch rectangle. Starting with the 8-inch side, roll up into a loaf and place seam side down on the piece of parchment.

4. **Make the topping:** Melt the butter in a small saucepan. Place both sugars and the cinnamon in a small bowl and stir to combine.

5. Slit the loaf 6 to 8 times with a sharp serrated knife or razor blade, slicing halfway down through the loaf to create deep slits. Pour the melted butter over the top of the loaf, letting it seep into the slits. Spoon the sugar topping into the slits and onto the top of the loaf. With the ends of the parchment paper, pick up the loaf and place it in the pan. Cover with a kitchen towel and place in a warm spot to rise until doubled, about 45 minutes.

6. Heat the oven to 350ºF, with a rack in the middle. Place the pan in the oven and bake until lightly browned and the internal temperature in the center registers 190ºF, 28 to 32 minutes. Remove from the oven. Lift the bread out of the pan, using the parchment paper. Place on a wire rack and let cool in the paper for 15 minutes, then serve warm.

Dina's Sourdough Friendship Bread

Dina Jennings of Burlington, North Carolina, has been making sourdough bread since the COVID pandemic of 2020. A modern adaptation of an old-fashioned potato bread that originated in Europe, it's based on a starter of instant potato flakes, sugar, and yeast. It is often called "friendship" bread because you get the starter from a friend. The tricky part is you have to bake bread regularly to keep the starter alive. And to some, babying a bread starter is a lot like raising a puppy—it takes your full attention!

Jennings stirs the yeast into the warm water in a large Mason jar with a lid. She stirs in the sugar and potato flakes and places it in a warm place in her kitchen, uncovered, overnight. She then places the lid on and refrigerates it to ferment for three days. See below how she continues to feed the starter. But if you are impatient like me, you can skip that step and use 1 cup of the starter as early as day two, discard the rest, not feel guilty in the least, and still bake delicious bread for friends!

Makes 3 (8- to 9-inch) loaves Prep: 25 to 30 minutes Rise: 4 to 5 hours for 2 rises, plus an overnight rise for starter Bake: 40 to 45 minutes

STARTER

2 1/4 teaspoons (1 package) dry yeast

1 1/2 cups warm water

1/4 cup (50 grams) granulated sugar

3 tablespoons instant potato flakes

BREAD

6 to 6 1/4 cups (720 to 750 grams) bread flour, divided, plus 1/4 cup (30 grams) for handling the dough

1/4 cup (50 grams) sugar

1 teaspoon salt

1/2 cup vegetable oil

1 1/2 cups warm water

3 tablespoons butter, melted, for greasing the pans and brushing the loaves

1. **Make the starter:** Stir the yeast into the warm water in a Mason jar or bowl, then stir in the sugar and potato flakes. Place it in a warm place, uncovered, overnight. (Or use a longer 3-day refrigerated ferment as Dina Jennings does and bake on day 4.) You will use 1 cup for the bread. (See Note for how to maintain your starter, if you like.)

2. **Make the bread:** Whisk together 6 cups of the flour and the sugar and salt in a large bowl. Pour in the oil and water and 1 cup of the starter. Mix with a wooden spoon until the dough comes together and begins to leave the sides of the bowl. It should pull together, but it will be sticky; if it doesn't come together, add the remaining 1/4 cup flour. Stir vigorously. Scrape the sides of the bowl clean. Cover with a light kitchen towel and place in a warm spot in the kitchen until doubled, 3 to 4 hours. (Jennings places her dough in the microwave oven overnight.)

3. When the dough has risen, generously flour a surface with the 1/4 cup flour and turn the dough out onto the flour. Divide into 3 portions and, with floured hands, knead the

dough until smooth. Brush three loaf pans (from 8 to 9 inches long) with butter. (You can make these loaves any size you like.) Shape the dough into a loaf by pressing it out into an 8- to 9-inch rectangle and then rolling it up into a log shape and placing it into the pan. Cover with the light towel again and let rise until doubled, at least 1 hour.

4. Heat the oven to 325ºF, with a rack in the middle. When the loaves have risen, brush them with melted butter and bake until lightly golden and the internal temperature registers 190ºF in the center on an instant-read thermometer, 40 to 45 minutes. Place the pans on wire racks to cool for a few minutes, run a knife around the edges, turn the bread out of the pans, and let the loaves cool on their sides for 1 hour before slicing.

NOTE:

To keep the starter alive after the first bake, return it to the refrigerator. In 3 to 5 days, remove it and stir in 1 cup warm water, 1/2 cup sugar, and 3 tablespoons potato flakes. Leave at room temperature for 8 to 12 hours, then use 1 cup to make bread by this recipe. Return the remainder to the fridge, and 3 to 5 days later, repeat. If you are not able to make bread, still feed the starter, but discard the 1 cup on those days you do not bake. Or share the 1 cup with a friend!

GROWING GRAINS ON OLD TOBACCO LAND

North Carolina is a diverse agricultural state, from the mountains to the Piedmont to the sandy Tidewater and coastlines. Through history it was where tobacco and corn grew because the two crops had complimentary harvesting schedules. Wheat, on the other hand, didn't always work in concert with tobacco. But when the tobacco industry was faced with lawsuits and the Fair and Equitable Tobacco Reform Act of 2004 ended Depression-era subsidy payments to tobacco farmers, many switched to organic vegetable and grain farming. Today in North Carolina there has been a grain resurgence on old tobacco land. Abruzzi rye is grown around Pinehurst, and bread and pastry wheat is grown east of Raleigh. They are milled west of Asheville at Carolina Ground, founded by Jennifer Lapidus in 2012. She grew up in Miami with a mother who baked challah and was a consummate entertainer, feeding 200 people for Labor Day and hosting all the holiday meals for extended family. But Jennifer would form her own relationship with baking, milling whole grains into flour and working with bakers to create flour that is "an experience of mouthfeel and flavor."

Sally Lunn:
BELLE OF THE
PARTY

In early nineteenth-century Maryland, Sally Lunn bread
was assembled in the morning and served at six o'clock tea.
Down in the Lowcountry of South Carolina, it was baked for company. A letter,
sent with a recipe to Philadelphian Emily Wharton Sinkler, who wrote about life on a plantation in the
antebellum South and during the Civil War, said the bread "will cause your friends to rejoice," and once
you place the dough in the pan, "Sally should again rise up before being shoved into the oven, to be
brought out and presented to your friends as the beauty and belle of the evening."

Sally Lunn

The buttery bread called Sally Lunn, a bit like brioche and a bit like cake, is beloved in Virginia, Maryland, and other parts of the South. The name is believed to come from the French *soleil et lune*, meaning "sun and moon," because the top of the bread was golden like the sun and the bottom white like the moon. Another story says the bread originated in the town of Bath, England, with a Huguenot refugee named Sally Lunn who sold the buns from her basket as she walked the cobbled streets. I've adapted a wonderful 1845 recipe from Elizabeth Ellicott Lea, a Quaker from Baltimore, whose family grew wheat in former tobacco fields and became a large flour exporter. A widow, Lea wrote a cookbook for her daughter called *Domestic Cookery*.

Two hundred years later, the recipe is still relevant, and the tone of Lea's words rings true. The only ingredient that has changed is the eggs, which are larger today. You stir together the ingredients, let the dough rise for about an hour and a half, punch it down, place it in a tube or Bundt pan, and let it rise another 45 minutes; then it's into the oven to bake. The bread should bake in the lower third of the oven, so the bottom of the pan receives more direct heat and gets crispier. I can't decide when I like this bread better, buttered for breakfast or alongside a bowl of soup at lunch.

Serves 12	Prep: 20 to 25 minutes	Rise: 2 1/4 hours for 2 rises	Bake: 28 to 32 minutes

3 1/3 cups (458 grams) unbleached bread flour or
 all-purpose flour

1 teaspoon salt

1 cup whole milk

6 tablespoons (3/4 stick/86 grams) salted butter,
 plus more melted butter for greasing the pan
 and brushing the top of the baked loaf

1/4 cup honey or granulated sugar

2 1/4 teaspoons (1 package) dry yeast

3 large eggs

NOTE:

You can also shape the dough into 12 to 16 buns, rounding them with your palms, setting them 2 to 3 inches apart on a baking sheet, and baking at 350°F until golden, about 25 minutes.

1. Whisk together the flour and salt in a medium bowl and set aside.

2. Heat the milk in a medium saucepan over low heat until steamy, several minutes. Remove from the heat. Add the butter and stir to melt. Stir in the honey or sugar, and then check the temperature of the mixture with an instant-read thermometer. It should not exceed 125°F. Whisk in the yeast to dissolve.

3. Place the eggs in the large bowl of a stand mixer and beat on medium speed for 1 minute. Add the yeast mixture and beat on low just to combine. Add half of the flour mixture, beating on low to incorporate. Add the rest of the flour mixture, as needed, to create a dough that is sticky but begins to leave the sides of the bowl as you beat on medium-low, 3 to 4 minutes.

4. Turn the dough into a large clean bowl and cover the top with a light kitchen towel. Place in a warm spot to rise until doubled, about 1 1/2 hours.

5. Press down on the dough with a rubber spatula. Grease a 10-inch tube pan or 12-cup Bundt pan with melted butter. Pick up the dough, shape it into a rough log, and turn it into the pan, pressing the dough ends together to seal. If the top of the dough looks too rough, turn it upside down. Place the kitchen towel over the pan and let rise again until doubled, 45 minutes.

6. Heat the oven to 350°F, with a rack in the lower middle.

7. When the bread has risen, place the pan in the oven and bake until the loaf is golden, 28 to 32 minutes. Place on a wire rack to cool in the pan 20 minutes, run a dinner knife around the edges, give the pan a gentle shake, and, for a tube pan, turn it out once and then invert onto a rack to cool right side up. For a Bundt, turn it out onto the rack to cool bottom side up, about 30 minutes, before brushing with a little melted butter, slicing, and serving.

Challah at Collis Bakery, 165 King Street in Charleston, 1918

Gloria Smiley's Honey and Olive Oil Challah

Gloria Smiley has been teaching people how to bake all her life. She was raised in Savannah in a family of Jewish bakers. Her paternal grandfather delivered bread via horse and buggy. And after her father died, her mother married Leon Gottlieb of Gottlieb's Bakery, a Russian Jewish family of five sons, who baked and shipped rye bread and challah to all parts of the South via Greyhound bus. Today Smiley braids challah in her Atlanta kitchen, using a recipe adapted from one given to her by her late friend, the baker Doris Koplin. Smiley substitutes honey and olive oil for the sugar and canola oil in Kaplan's recipe. She uses a bread machine to mix the ingredients, then kneads and shapes the dough by hand. The bread is delicious, and the dough is easy to work with.

While Jewish immigrants assimilated into Southern life, cooking fried chicken and field peas like their Gentile neighbors, challah was their own and distinguished their holy days and religious heritage. While Kaplan's original recipe called for two risings, Smiley's uses a third rise to improve texture. You can shape the bread as you like—as a braid or a round—or just divide the dough in half, shape into loaves, and tuck into lightly greased loaf pans.

| Makes 1 large loaf | Prep: 40 to 45 minutes | Rise: 2 to 2 1/2 hours for 2 rises | Bake: 30 to 35 minutes |

3/4 cup warm water (125°F or less)

2 1/4 teaspoons (1 package) dry yeast

2 large eggs

1/4 cup extra-virgin olive oil, plus more for greasing the bowl

1/4 cup honey

3 1/2 cups (420 grams) bread flour, divided

1 1/2 teaspoons kosher salt

1 large egg, beaten with 1 teaspoon water, for the egg wash

Parchment paper for lining the pan

NOTE:

You can use 1/4 cup vegetable oil instead of the olive oil and 1/4 cup sugar instead of the honey.

1. Place the warm water in a measuring cup and stir in the yeast to dissolve.

2. Place the eggs in a small bowl. Pour in the olive oil and honey and whisk to combine.

3. Place 3 cups (360 grams) of the flour and the salt in the large bowl of a stand mixer and beat on low speed to combine. Pour the yeast mixture and the egg mixture into the bowl and beat on low until just incorporated. Stop the machine and scrape down the sides of the bowl with a rubber spatula. Beat on low to incorporate the remaining 1/2 cup flour, so the dough is moist but not sticky. Increase the speed to medium and beat until the dough begins to leave the sides of the bowl and is elastic and smooth, 4 to 5 minutes. Turn the dough into a large clean bowl greased with a little olive oil. Cover with a kitchen towel and place in a warm spot to rise until doubled, about 1 hour. (If you are not ready to make your loaf, cover the bowl with plastic wrap and chill until you are.)

4. Punch down the dough with your fist or a wooden spoon. (Here Smiley sneaks in a second rise, repeating the first.)

5. Line a 12-by-17-inch rimmed baking sheet with parchment paper. **For a braided loaf,** divide the dough in thirds. Roll each piece to about 18 inches long and line the long pieces up side by side. Pinch the ends of the strands to connect them at the top. Take the strand on the far right and begin braiding, with the right strand over the left and the left over the right, braiding around the center strand, tugging gently at the strands as you work. Pinch the ends of the braid and tuck them underneath the loaf, then transfer to the parchment-lined pan. **For a round loaf,** divide the dough in half and roll into 2 strands about 28 inches long. Twist the strands together, then roll up into a coil, tucking the end underneath. Transfer to the parchment-lined pan.

6. Brush the top of the dough with the egg wash. Place in a warm spot to rise uncovered until doubled, 1 to 1 1/2 hours.

7. Heat the oven to 350°F, with a rack in the middle.

8. Brush the dough again with the egg wash and place in the oven. Bake until the loaf is deeply golden brown and registers 190°F in the center on an instant-read thermometer, 30 to 35 minutes. Let cool on the baking sheet, then slice and serve.

GEORGIA OLIVE OIL

Olive oil has a long history in South Georgia and its barrier islands. Spanish missionaries brought olive trees in the mid-sixteenth century, and olive trees were planted in Savannah's first public experimental garden, the Trustees Garden, by Sephardic Jews in the eighteenth century. What olive trees were left were destroyed when the fierce 1898 hurricane slammed into Georgia's coast. Since the 1980s, olive oil production has been resurrected in the state's southeast sandy soil. Woodpecker Trail Olive Farm in Glennville, fifty miles west of Savannah, produces an award-winning first cold pressed oil, a fruity and herbaceous extra virgin oil made from the first pressing of the olives.

HOW TO MAKE CHALLAH WITH A BREAD MACHINE

Mix the water, yeast, eggs, olive oil, and honey in a large glass measure or a small bowl. Pour into the bread machine pan. Add the flour. On one side of the flour, place the salt, and on the other side, place the yeast. Set the bread machine to Dough Only, which is about 1 hour and 50 minutes. Turn the machine on. Check to make sure all the flour is mixed in.

When the bread machine says the dough has mixed, lightly oil a large bowl and place the dough in the bowl, turning it to coat with a little oil. Cover with a kitchen towel and place in a warm spot to rise until doubled. Once the dough as risen, punch it down, and braid as directed.

Baba au Rhum

A festive, boozy bread-meets-cake studded with yellow raisins, flecked with orange zest, and drenched in rum, baba tastes like New Orleans. It is a classic brioche, originating in the early 1700s in the Austro-Hungarian Empire. The turban-shaped cake, raised with yeast, can be found from Germany to Italy and from Eastern Europe to the Alsace-Lorraine region of France. It's likely that the French brought it to New Orleans, and by 1901, it was unlike anything else baked in the city. It is still baked on Christmas Eve as the fitting conclusion to the special meal called Réveillon, a late-night dinner to end a day of fasting. Only in the most international city of the South, where free Blacks and Creoles, the African enslaved, French Haitians, Spanish, Germans, and Sicilians have all influenced the food, could a cake like baba exist. This recipe is adapted from the one in the *Picayune's Creole Cook Book* and one shared in *New Orleans Magazine*.

Serves 8 to 12 Prep: 30 to 35 minutes Rise: 1 3/4 hours for 2 rises Bake: 20 to 25 minutes

3/4 cup (4 ounces/113 grams) golden raisins

2 tablespoons dark rum

6 tablespoons (3/4 stick/86 grams) unsalted
 butter, at room temperature, plus
 2 teaspoons, at room temperature, to prep
 the pan

1 tablespoon dry yeast

1/3 cup whole milk

2 tablespoons granulated sugar

3 large eggs

1 3/4 cups (210 grams) unbleached all-purpose
 flour

1/2 teaspoon salt

2 teaspoons grated fresh orange zest

SYRUP

1 cup water

1 cup (200 grams) granulated sugar

1/2 cup dark rum

Slivered orange zest, tossed with sugar, if desired
Whipped Cream for serving, if desired (page 458)

1. Place the raisins in a small bowl and pour in the rum. Toss to coat and place in the microwave oven to warm for 20 seconds. Rub a 12-cup Bundt pan with the 2 teaspoons soft butter. Set the raisins and the Bundt pan aside.

2. Place the yeast in a large bowl. Heat the milk in a small saucepan over medium heat to 120°F on an instant-read thermometer (very warm to the touch) and pour over the yeast. Add the sugar and whisk until the sugar and yeast dissolve. Place in a warm spot until it puffs up, about 5 minutes.

3. Crack the eggs into the bowl with the yeast mixture and stir with a wooden spoon to combine. Add the flour, salt, and orange zest and stir until smooth. Add the 6 tablespoons soft butter and continue to stir until the dough is smooth. It will be soft but elastic. Cover with a kitchen towel and place in a warm spot to rise until double in size, about 1 hour.

4. Push down the dough with a rubber spatula and fold in the raisins and rum until well mixed. Turn the dough into the prepared pan, cover with the kitchen towel, and let the dough rise until nearly to the top of the pan, 45 minutes.

5. Heat the oven to 375ºF, with a rack in the middle.

6. When the dough has risen, remove the towel, place the pan in the oven, and bake until the cake is golden brown and begins to pull away from the sides of the pan, 20 to 25 minutes. Remove the pan to a wire rack to cool for 15 minutes, then run a dinner knife around the edges, give the pan a gentle shake, and turn the cake onto the rack and let cool completely, 30 minutes.

7. **Make the syrup:** Heat the water and sugar in a small saucepan until the sugar dissolves and the syrup cooks down just a bit, 5 minutes. Turn off the heat and pour in the rum.

8. When the cake has cooled, place it on a serving plate and spoon the syrup over the top, doing so slowly to allow the syrup to soak into the cake. Let the cake rest for 30 minutes. If desired, serve with whipped cream and garnish with orange zest slivers.

Winkler's Moravian Sugar Cake

Known for their devotion to church, community, schools, and handiwork, the Moravians were also famous for their baking and staged "love feasts" in church, passing warm yeast buns and sweetened coffee around to the congregation. Their signature bread, baked on Easter morning, is called "sugar cake." It's a rich yeast dough topped with puddles of brown sugar and butter. In 1800 a bakery was built to serve the Moravian town of Salem, North Carolina, and a baker named Christian Winkler arrived seven years later to operate it. You can still buy sugar cake at Winkler's Bakery today in Old Salem, or you can bake it at home.

This irresistible recipe originally belonged to Beth Tartan, who was the food editor of the *Winston-Salem Journal* for many years, and it was given to me by food writer Sheri Castle. The mashed potatoes in the dough make it moist. The early Moravians would have used lard instead of vegetable shortening.

Serves 12 to 16	Prep: 40 to 45 minutes	Rise: 4 1/4 to 4 1/2 hours for 3 rises	Bake: 25 to 30 minutes

1 medium baking potato, peeled and cut into 1-inch pieces

2 1/4 teaspoons (1 package) dry yeast

1 cup granulated sugar, plus 1/2 teaspoon for the yeast mixture

1/2 cup (3.5 ounces) vegetable shortening

20 tablespoons (2 1/2 sticks/286 grams) unsalted butter, at room temperature, divided, plus more for the bowl and pan

1 teaspoon salt

2 large eggs, beaten, at room temperature

3 cups (360 grams) all-purpose flour, plus up to 1/2 cup for kneading

1 cup (192 grams) lightly packed light brown sugar

2 teaspoons ground cinnamon

1. Place the potato in a small saucepan, cover with water to a depth of 1 inch, and simmer, covered, until tender, 10 to 15 minutes. Drain well, reserving the cooking water. Force the potato through a ricer into a small bowl or mash as smooth as possible with a fork. Measure 1 cup gently packed potatoes, place in a small bowl, and stir in 2 tablespoons of the cooking water, reserving the rest. Cover and keep warm.

2. Place the yeast, the 1/2 teaspoon sugar, and 1/4 cup of the reserved warm cooking water in a glass measuring cup and let stand until the mixture bubbles, 5 minutes.

3. Combine the potatoes, the 1 cup sugar, the shortening, 4 tablespoons of the butter, and the salt in a large bowl and beat with an electric mixer on medium speed for 2 minutes, or until the shortening melts. Stir in the yeast mixture and beat on low for 30 seconds. Cover the bowl with a kitchen towel and place it in a warm place to rise until spongy and light, 1 hour and 30 minutes.

4. Stir in the eggs and the 3 cups flour to make a soft dough. Shape the dough into a ball. Grease a large bowl with butter. Place the dough in the bowl, turning it to grease the

top. Cover the bowl with plastic wrap and place it in a warm place, free from drafts, for the dough to rise for 2 hours. The dough will increase in size by half.

5. Turn the dough out onto a lightly floured surface, using only as much of the 1/2 cup remaining flour as needed, and knead until it is smooth and elastic, 5 minutes. Grease a 9-by-13-inch baking pan with butter. Pat the dough evenly into the greased pan. Cover the pan with plastic wrap and place it in a warm place, free from drafts, for the dough to rise for 45 minutes to 1 hour.

6. Heat the oven to 375°F, with a rack in the middle.

7. Slice the remaining 16 tablespoons butter into 1/8-inch slices. With your thumb or the end of a wooden spoon, deeply dimple the dough. Tuck the slices of butter into the dimples and over the top of the dough. Place the brown sugar and cinnamon in a small bowl and stir to combine; sprinkle this evenly over the dough and down into the dimples.

8. Place the pan in the oven and bake until the cake is well browned and cooked through, 25 to 30 minutes. Let cool for 30 minutes in the pan before serving.

THE MORAVIANS

One of the oldest Protestant groups, the Moravians have roots in what is now the Czech Republic. Religious persecution drove them to Germany, across Europe, and then to England before they arrived in Bethlehem, Pennsylvania, and then in Salem, North Carolina, in 1753. Those missionary travels have influenced their culture and baking, says Daniel Ackermann, historian with Old Salem Museum and Gardens. They built missions for the Cherokee People in Georgia and Oklahoma, and, before that, for the enslaved Africans, who became part of their church. The Saint Philips Moravian Church, organized in 1822, is the oldest standing Black church in North Carolina and is part of today's historic Old Salem.

New Orleans King Cake

Each year in January, I think I'm done with holiday baking. But then comes January 6, Epiphany, and so I go to the fridge, grab the butter and yeast, and begin making king cake. This yeasted ring-shaped cake, with its green, gold, and purple glaze, called *gâteau de rois* in France, is traditionally baked on the twelfth day of Christmas to commemorate the twelve-day journey of the three wise men to see the newborn Jesus. Traditionally, the baker hides a bean or a plastic baby inside the cake, and whoever finds it is declared king for a day. King cake is especially popular in Mobile and New Orleans, where it was brought by Basque settlers in 1718. This is my favorite king cake, based on a recipe from *Cooking Up a Storm* by Judy Walker and the *Times-Picayune* food department. The colorful glazes are as much a part of the cake as its rich history. Here I've made those optional.

| Serves 12 to 18 | Prep: 30 to 45 minutes | Rise: 1 3/4 to 2 hours for 2 rises | Bake: 25 to 30 minutes |

DOUGH

1/4 cup warm water (105°F to 115°F)

2 1/4 teaspoons (1 package) dry yeast

1/4 cup warm whole milk (105°F to 115°F)

8 tablespoons (1 stick/114 grams) unsalted butter, melted and cooled to room temperature, plus soft butter for greasing the bowl

2 tablespoons granulated sugar

1/2 teaspoon ground nutmeg

1/2 teaspoon salt

2 1/2 to 3 cups (300 to 360 grams) bread or all-purpose flour, divided, plus more for kneading the dough

2 large eggs, lightly beaten

FILLING

6 tablespoons (3/4 stick/86 grams) unsalted butter, melted

1 cup (192 grams) lightly packed light brown sugar

2 teaspoons ground cinnamon

1/4 teaspoon ground cardamom

Parchment paper to line the pan

1. **Make the dough:** Pour the warm water into a large warmed bowl. Sprinkle in the yeast and stir until it dissolves. Stir in the warm milk, butter, sugar, nutmeg, and salt. Add 1 cup of the flour and blend well. Stir in the lightly beaten eggs and the remaining flour to make a soft dough. At the end of the blending, you may need to use your hands to work in all of the flour.

2. Lightly flour a surface and turn out the dough. Knead until it is smooth and elastic, about 5 minutes. Add a little more flour if needed, if the dough sticks. Place the dough in a large bowl lightly rubbed with soft butter. Turn the dough to grease the top of the dough. Cover the bowl with a kitchen towel or plastic wrap and place in a warm place until the dough doubles in size, 1 to 1 1/4 hours.

3. Punch down the dough with your hands. Transfer it to a lightly floured surface and, with your hands or a floured rolling pin, roll the dough to a 24-by-9-inch rectangle.

4. **Make the filling:** Brush the dough with the melted butter. Combine the brown sugar and cinnamon in a small bowl and sprinkle this mixture evenly over the butter to within 1/2 inch of the edges. Sprinkle with the cardamom.

5. Line a baking sheet with parchment paper. Beginning at the long end, roll the dough up tightly, as for a jellyroll. Along the seam, blot some water lightly so the dough edges stick together and pinch them together well. Carefully pick up the rolled dough and place it, seam side down, on the lined baking sheet. Bring together the two ends to make a circle, seal the ends with a little water, and pinch the ends together. Using a sharp knife or razor blade, slice open the middle of the circle all the way around, slicing through layers and almost to the bottom of the dough. Cover the dough with a kitchen towel and place in a warm place to rise and double in size, about 45 minutes.

6. Heat the oven to 325°F, with a rack in the middle.

7. Uncover the dough and place the pan in the oven. Bake until it is lightly browned all over, 25 to 30 minutes. Remove the cake from the baking sheet with a spatula and place on a wire rack to cool for 15 minutes. (If you want to insert a plastic baby figurine or bean, push it into the underside of the cake or one of the grooves in the top.)

8. If you like, drizzle the cake with the Mardi Gras Glaze (below), either white or tinted with the traditional food coloring, glazing one third of the cake purple, one third green, and one third yellow. Slice and serve. Store at room temperature for up to a week, but it is best served the day it is baked.

Mardi Gras Glaze

1 1/2 cups (162 grams) confectioners'
 sugar, sifted
2 to 3 tablespoons whole milk
1/4 teaspoon almond extract (optional)
Purple, green, and yellow food coloring
 to tint the glaze (optional)
Purple, green, and yellow sugar sprinkles
 for garnish (optional)

Place the sugar in a medium bowl and whisk in enough milk to make a smooth glaze. Add the almond extract, if desired. If you want to tint the glaze, divide it into thirds in small bowls and tint each third either purple, green, or yellow. Spoon or drizzle each color over a third of the cooled cake. Or, just drizzle the cake with the glaze, and garnish with the sprinkles in alternating bands, if desired. Allow 20 minutes for the glaze to set before serving.

COMFORTING
PUDDINGS

Promptitude is necessary in all our actions, but never more so
than when engaged in making cakes and puddings.

—MARY RANDOLPH, *THE VIRGINIA HOUSEWIFE*, 1824

The fall day when frost nips the persimmon tree is the day a lot of puddings go into the oven.

—BETH TARTAN, *NORTH CAROLINA & OLD SALEM COOKERY*, 1955

It is impossible to make too much banana pudding.

—BILL SMITH, *SEASONED IN THE SOUTH*, 2006

*T*he puddings in this chapter are both humble and haughty. They're put together with what you have on hand or made of extravagant ingredients and planned well in advance. They're so cozy you'll eat them right from the pan or so fancy you'll want to save them for company and serve them in your grandmother's pressed glass bowl.

The English adored savory and sweet puddings and based their menus around them, and so did early American and Southern cooks. While Southerners had their own cookbook authors with fresh ideas, they also couldn't get enough of British food writers like Eliza Smith, Hannah Glasse, Susannah Carter, Elizabeth Raffald, and Maria Rundell for all manner of puddings—stirred on the stovetop, baked, and made of fruit, bread, or rice.

In fact, we can credit those old English recipes for our love of bread pudding, so much so that more of it may be baked in New Orleans today than in England. In her 1845 book, *Domestic Cookery*, Maryland cookbook author Elizabeth Ellicott Lea offered two bread pudding recipes, the first of stale bread, milk, eggs, and raisins, stirred on the stovetop, and the second a more embellished recipe with apples and cinnamon.

Puddings made excellent vehicles to show off the plenitude of Southern fruits. The local wild berries—blackberries and dewberries—were folded into puddings, as were apples. Marion Cabell Tyree's *Housekeeping in Old Virginia* (1877) shared seven apple pudding recipes and no fewer than six plum puddings, the most British pudding of all, made with raisins but no plums. In addition, she gave ten sauces for puddings, from brandy to lemon to a rich custard.

Persimmons, gathered from the ground after the first frost, also made their way into the recipes and proved to be an early example of a new style of baking taking place in the American South. You see persimmon puddings in cookbooks from Florida's First Coast (the Jacksonville area) up through

the Carolinas, into Tennessee, and down to Mississippi and Louisiana. Persimmon trees have been a friend to foragers, Native Americans, and early settlers, as well as deer, who all knew not to eat them when they were unripe and full of tannins but to wait until they were sweet and a deep coral color.

Wherever rice was on the dinner table, rice pudding was sure to come out of the oven the next day. Where bananas could be had for a song, banana pudding was served to company. The same was true of lemons, coconuts, and chocolate.

Of all the Southern puddings, without a doubt the most famous is banana pudding, with meringue or whipped cream slathered over. The earliest recipe was just custard and meringue piled on top of sliced bananas. Pound cake and then vanilla wafers as a base came later. I share my aunt Elizabeth's banana pudding, a required dessert at family reunions.

A boozy trifle with Savannah roots and plenty of pomp and circumstance is in this chapter. I've also welcomed desserts like flan, clafoutis, and buttermilk panna cotta garnished with slices of bright-orange satsumas that speak to how puddings have taken different turns and been influenced by the Spanish, French, and Italian cultures in the South.

For purists, children, and old folks, I've got two stirred puddings, one a decadent chocolate and the other natilla, aka Crying-Stopper Pudding, a Mexican-inspired milk custard flavored with vanilla and drizzled with chocolate, which chef Eddie Hernandez of Atlanta swears stops any child from crying in a restaurant.

As Hernandez knows so well, puddings make us feel better. Prepare to be cozied.

Grown-Up Chocolate Pudding

When I was young and our mother wasn't inviting friends over for a dinner party, just cooking for our family, she'd make us chocolate pudding for dessert. She'd pull out a heavy saucepan, add sugar, flour, cocoa powder, and salt, pour in scalded milk, and cook the mixture until thickened. If she felt decadent, she'd enrich the pudding with egg yolks, butter, and more chocolate. It was simple yet divine, and if I was in the kitchen keeping her company, she'd hand me the wooden spoon to lick. Today as I riff on her pudding, adding dark rum instead of vanilla, I realize chocolate pudding may satisfy children, and it just might remind us of childhood, but it can also be the most luscious and comforting grown-up dessert I know. Serve with hot coffee or cordials.

| Serves 4 | Prep: 15 to 20 minutes | Cook: 7 to 8 minutes |

1 3/4 cups whole milk

1 cup (200 grams) granulated sugar

1/4 cup (48 grams) lightly packed light brown sugar

1/3 cup (40 grams) all-purpose flour

1/4 cup (25 grams) unsweetened Dutch-process cocoa powder

1/2 teaspoon kosher salt

2 large egg yolks

2 tablespoons unsalted butter

1/3 cup (2 ounces/57 grams) chopped bittersweet chocolate or bittersweet chocolate chips

1 tablespoon dark rum or vanilla extract

Unsweetened Whipped Cream for serving (page 458)

1. Pour the milk in a small saucepan over medium heat and simmer until small bubbles form around the edges of the pan, about 4 minutes. Remove from the heat.

2. Meanwhile, whisk together both sugars and the flour, cocoa, and salt in a medium saucepan. Gradually pour in the hot milk, whisking constantly until smooth.

3. Place the egg yolks in a medium bowl and whisk well. Pour in 1/4 cup of the chocolate mixture, whisking well, to temper the eggs (raise their temperature gradually). Pour the egg mixture into the saucepan, and, over low heat, stir with a wooden spoon and cook until the mixture is thickened, 3 to 4 minutes. Remove from the heat. Stir in the butter, chopped chocolate or chips, and rum or vanilla. When the butter and chocolate have melted, taste for seasoning, adding more salt if needed. Serve warm with softly whipped cream.

Eddie's Crying-Stopper Pudding, aka Natilla

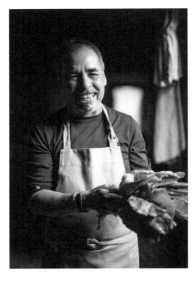

Eddie Hernandez, chef and co-owner of Taqueria del Sol restaurants in Georgia and Tennessee, was born in Monterrey, Mexico, in the foothills of the Sierra Madre Oriental, 115 miles from Texas. He was raised on his mother's and grandmother's *natilla* (*natilla* means "custard" in Spanish), and he carried the love of pudding with him to Atlanta, where he cooked his way up in restaurant kitchens. The memory of that pudding came in handy. "Every now and then, some customers would show up with their kids, and the kids didn't behave. They were crying, and I would go take them a little natilla to the table, and they calmed down and wouldn't cry when they ate it. I call it a child crying stopper," he says. To be prepared for fussy children, Hernandez keeps about sixteen servings of natilla ready in the fridge just in case. Then, if no crying children show up, the staff enjoys them.

The natilla is cold, smooth, and creamy. It is garnished with a squiggle of chocolate syrup and a generous dusting of cinnamon—a pudding version of a pacifier if there ever was one. This recipe comes from the 2018 book *Turnip Greens & Tortillas*, which Hernandez wrote with Susan Puckett.

Serves 6 to 8	Prep: 10 to 15 minutes	Cook: 5 to 10 minutes	Chill: At least 2 hours or preferably overnight

1/2 cup whole milk, cold

1/2 cup (80 grams) cornstarch

4 cups half-and-half

1 cup (200 grams) granulated sugar

1 1/2 teaspoons vanilla extract

1 cinnamon stick

Chocolate syrup for drizzling

Ground cinnamon for sprinkling

1. Whisk together the milk and cornstarch in a small bowl until smooth. Set aside.

2. Pour the half-and-half in a medium saucepan over medium heat and stir in the sugar, vanilla, and cinnamon stick. Continue stirring as the sugar dissolves, and when the mixture begins to bubble, about 5 minutes, pour in the cornstarch mixture in a steady stream, stirring constantly with a wooden spoon as the pudding thickens.

3. Remove the pan from the heat and remove the cinnamon stick. Pour into a serving dish or in 6 to 8 bowls. Cover with plastic wrap and chill until cold, at least 2 hours or preferably overnight.

4. To serve, drizzle with chocolate syrup and sprinkle with cinnamon.

Aunt Elizabeth's Banana Pudding

My aunt Elizabeth would walk into the family gathering, holding a Pyrex casserole dish swaddled in towels like she was cradling a baby about to be baptized. Banana pudding is sacred in the South, and she made a seriously good one, but only if there were to be at least a dozen people on hand to eat it—preferably people who wouldn't argue about whether it was covered with whipped cream or meringue. Banana pudding, or as it is affectionately called, "nana puddin," is good any whichaway. People have cut all kinds of corners making it, and they've added all kinds of embellishments—Nutter Butter cookies instead of vanilla wafers, banana cake on the bottom, melted white chocolate in the pudding—but I love my aunt's classic version and see no need to mess with a good thing.

For this pudding, you want bananas that hold their shape but are ripe enough to have flavor—medium-ripe.

Serves 12	Prep: 45 to 50 minutes	Bake: 12 to 15 minutes

PUDDING

1 1/3 cups (267 grams) granulated sugar

2/3 cup (80 grams) all-purpose flour

3/4 teaspoon salt

4 cups whole milk

6 large egg yolks

4 tablespoons (1/2 stick/57 grams) unsalted butter

2 teaspoons vanilla extract

54 to 58 vanilla wafers

4 to 5 medium-ripe bananas, sliced 1/4 inch thick (about 3 full cups)

MERINGUE

6 large egg whites

3/4 cup (150 grams) granulated sugar

1. **Make the pudding:** Place the sugar, flour, and salt in a heavy, large saucepan and stir to combine. Set aside.

2. Place the milk in a medium saucepan over low heat and stir until bubbles form around the edges of the pan and the milk is scalded, 3 to 4 minutes. Gradually stir the hot milk into the sugar mixture until combined, then place the large pan over medium-low heat and cook, stirring with a wooden spoon, until it thickens, 7 to 8 minutes. Remove the pan from the heat.

3. Place the egg yolks in a small bowl and beat with a fork until lightly combined. Spoon a tablespoon or two of the hot milk mixture into the egg yolks and stir with a fork to warm the eggs. Gradually spoon the egg mixture into the milk mixture in the saucepan, stirring constantly with a wooden spoon. Place the pan over medium-low heat and cook, stirring, until the mixture is smooth and thick, about 2 minutes. Stir in the butter and vanilla and let the pudding cool.

4. Line the bottom and sides of a 9-by-13-inch glass or ceramic baking dish with the vanilla wafers, flat side down. Arrange the sliced bananas on top of the cookies. Spoon the pudding over the bananas and spread to cover them.

5. Heat the oven to 350° F, with a rack in the middle.

6. **Make the meringue:** Place the egg whites in a large clean bowl and beat on high speed with an electric mixer until soft peaks form, 2 minutes. Gradually add the sugar and continue beating until stiff peaks form, 3 to 4 minutes.

7. Using a rubber spatula, spread the meringue on top of the pudding so it covers the surface and nearly touches the edges of the dish. Bake until lightly browned, 12 to 15 minutes. Serve at once!

1903 BANANA *Pudding*

Kentucky cookbook author Mary Harris Frazer was raised in Louisiana, where bananas were a part of the local cuisine. She wrote *The Kentucky Receipt Book*, published in 1903, and, according to Kentucky historian John Van Willigen in *Kentucky's Cookbook Heritage*, her recipe is considered to be the first mention of banana pudding in a cookbook.

Because of railroads, banana pudding became a recipe for all the South to enjoy. Bananas had first shown up in recipes in New Orleans and Mobile. In 1880 the Illinois Central Railroad introduced a refrigerated car to ship bananas north, and in Fulton, Kentucky, there was a railroad switch point and a distribution center built for fruit. Fulton became known as the "banana crossroads of America."

To create this 1903 banana pudding, make half a recipe of my aunt's banana pudding. Slice 2 to 3 bananas into a 1 1/2-quart oven-safe dish or bowl. Spoon the pudding over. Spread the meringue on top, using a soup spoon to create dips and swirls. Place the dish in a 350°F oven and bake until the meringue browns, 12 to 15 minutes.

MERINGUE SECRETS

A meringue is nothing more than beaten egg whites that you gradually add sugar to, beating until the whites form stiff peaks and hold their shape. Use 2 to 3 tablespoons of sugar for each egg white in the meringue. Heat the oven to 350°F and spread the meringue over the custard. Aunt Elizabeth spread it to the edges, because, as all good cooks know, a meringue shrinks back less when it can cling to the crust. But I also love a banana pudding where the meringue does not quite extend to the side so I can see the pudding and bananas underneath, visible teasers of tastes to come.

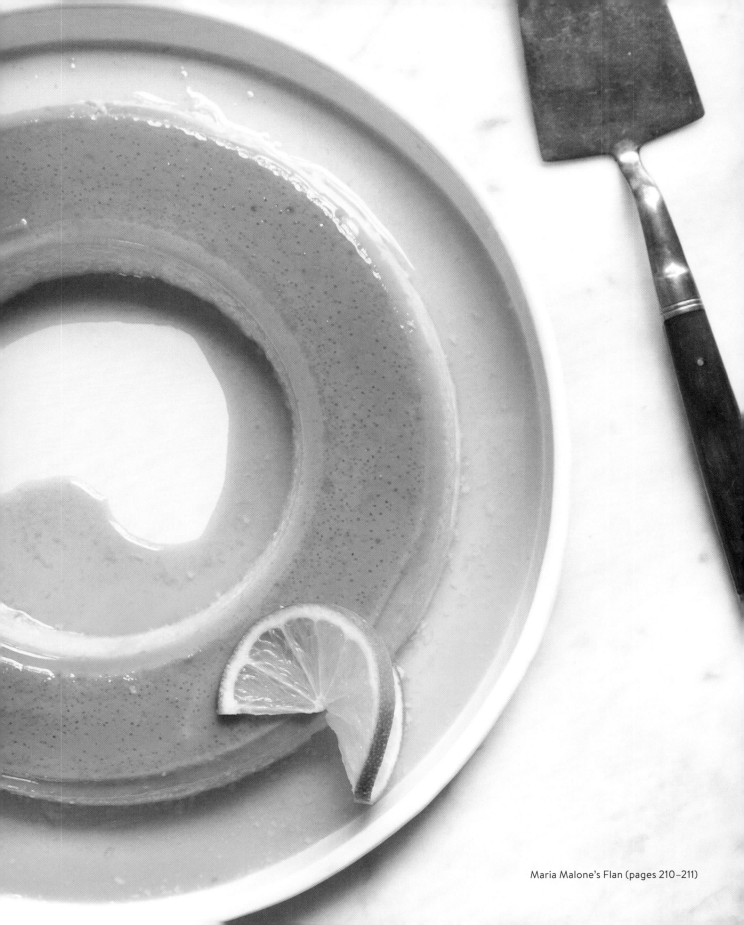

Maria Malone's Flan (pages 210–211)

Maria Malone's Flan

Flan, a traditional Brazilian dessert, is a great do-ahead for dinner parties, and it's splashy. This recipe comes from Maria Izabel de Schüller Barbosa Malone, a Brazilian who adopted the South and spent her life teaching music. She was an accomplished pianist and organist when she came to Fort Worth in 1957 to study sacred music at Texas Theological Seminary. She taught French, Spanish, Portuguese, Italian, and Latin in universities in Texas, South Carolina, Mississippi, and Tennessee. Each step along the way, she brought this Brazilian flan recipe with her. Every time she had company, no matter where she lived, she made flan, says her daughter, Lisa Malone Dunn of Nashville. College towns in the South were home to some of the more interesting cooking in the 1960s and '70s, and after getting to know a Cuban professor at the University of Tennessee at Martin, Malone began adding some grated lime zest to the flan at her suggestion.

For parties, double the custard recipe and use an 8-cup ring mold to serve 8 to 12. Bake about 1 hour. And if you don't have a ring mold, get creative and portion the caramel and custard into little cups and bake them individually. The baking time will be 30 to 35 minutes or less, and the flans should look golden brown and feel firm when done. But don't overcook, as they continue to cook while they rest outside the oven.

Serves 4 to 6	Prep: 10 to 15 minutes	Bake: 40 to 45 minutes	Chill: At least 6 hours or preferably overnight

CARAMEL
1 cup (200 grams) granulated sugar
1/3 cup water

CUSTARD
1 can (14-ounces) sweetened condensed milk
1 cup whole milk
2 large eggs
1/4 teaspoon grated lime zest (optional)

1. Heat the oven to 350° F, with a rack in the middle.

2. **Make the caramel:** Place the sugar and water in a medium heavy saucepan and bring to a simmer over medium heat. Do not stir. It will need to cook 10 to 12 minutes.

3. **Meanwhile, make the custard:** Place both milks and the eggs, and lime zest, if desired, in a blender or food processor and pulse to combine well. Set aside.

4. Have ready a 4-cup ring mold. Place a kettle or large saucepan with water on to boil.

5. Check on the caramel. When it gets a deep amber color, after 10 to 12 minutes, remove it from the heat and swirl it around. Pour it into the mold. Carefully tilt the pan to coat the sides; the caramel is very hot. Place the mold in a baking or roasting pan with deep sides. Pour the custard mixture over the caramel. Place the roasting pan in the oven and, with the oven door open, carefully pour boiling water into

the outer pan to reach halfway up the sides of the mold. (If you need more water, shut the oven door and refill the kettle.) Bake in the water bath until the top of the flan is deeply golden brown and it is just firm to the touch, 40 to 45 minutes. Remove the roasting pan and flan from the oven and let the flan rest in the water bath outside the oven for 1 hour.

6. Run a paring knife around the outside and inside edges of the flan to loosen it. Cover the pan with plastic wrap and place in the fridge to chill for at least 6 hours or overnight.

7. When time to serve, shake the flan gently. Warm the bottom of the pan in a sink filled with an inch of hot water and invert the pan onto a serving platter. Slice and serve with the caramel sauce spooned over the top.

Buttermilk Panna Cotta with Caramel Satsumas

Good local buttermilk is a beautiful thing, and this bright and cheery dessert celebrates it, letting the acidity and rich texture shine in a classic cold Italian pudding known as panna cotta. Those two words mean "cooked cream," and that's how you begin this smashing do-ahead dessert, adding gelatin, a bit of lemon, sugar, and good whole-fat buttermilk. Small, sweet satsuma mandarin oranges are related to the tangerine and grow along the Gulf coast. They don't tolerate cold, and they don't ship well. Their bright-orange flesh is sweet, and their rind thin and leathery. When they come into season in late fall and winter, they are something to celebrate, so I slice them and bathe them in caramel to surround this panna cotta. I mold individual servings of the panna cotta in paper cups. This ingenious technique was suggested by Lucy Allen, the mother of this book's photographer, Rinne Allen. It was a North Carolina pastry chef, the late Karen Barker, who first molded panna cotta in paper cups, Lucy Allen says. You can also serve the panna cotta from a glass bowl, spooning the caramel and satsumas onto each serving.

Serves 8	Prep: 20 to 25 minutes	Chill: At least 8 hours or preferably overnight

PANNA COTTA

2 tablespoons room-temperature water

1 1/2 teaspoons unflavored gelatin

1 cup heavy cream

1/2 cup (100 grams) granulated sugar

1 teaspoon grated lemon zest

Pinch of kosher salt

2 cups whole buttermilk

1 teaspoon vanilla extract

CARAMEL SATSUMAS

4 to 6 satsuma oranges, tangerines, or small Cara Cara oranges

1 cup (200 grams) granulated sugar

1/2 cup warm water

1. **Make the panna cotta:** Pour the water into a small bowl, sprinkle the gelatin over the top, stir, and then let the gelatin soften for 10 minutes.

2. Meanwhile, place the cream, sugar, lemon zest, and salt in a large saucepan over medium heat and bring just to a simmer, stirring constantly to dissolve the sugar, 3 to 4 minutes. Remove from the heat. Whisk in the gelatin mixture until the gelatin is dissolved. Whisk in the buttermilk and vanilla.

3. Pour into eight custard cups or 5-ounce paper cups, filling them about two-thirds full. Or pour into a 1-quart glass bowl. Place the cups on a tray. Chill, uncovered, for at least 8 hours or until firm.

4. **Make the caramel satsumas:** Trim the top and bottom off each orange. Cut down the sides to remove the peels and pith and discard. Slice each orange crosswise into 4 to 5 slices and remove any seeds. Place them in a medium bowl.

5. Fill a large bowl about halfway with ice and cold water and set aside. You will use this to cool down the pan of caramel.

6. Place the sugar in a large heavy saucepan or stainless-steel skillet, and place over medium heat to let the sugar melt and caramelize. This takes 4 to 6 minutes, and you will need to stir around the edges and swirl the pan to mix the liquid sugar with the granules that have not liquified yet. Once all the sugar is liquid and it is a dark caramel color but not smoking, remove the pan from the heat and place it in the bowl with ice water for 3 to 4 minutes to stop cooking.

7. Place the pan of caramel back on the stove. Over low heat, carefully pour the warm water into the pan with the caramel, being careful not to let it burn you. Stir, slowly and patiently, as the caramel dissolves into the water and it creates a sauce, 8 to 10 minutes. You will have about 1/2 cup caramel sauce. Let it cool slightly.

8. Pour the sauce over the orange slices and let cool at room temperature at least 30 minutes, or until time to serve.

9. To unmold the panna cotta, run a thin metal icing spatula around the edges of each custard cup and dip the bottom of the cups into warm water to loosen. For paper cups, poke a hole in the bottom of each cup with a metal skewer or sharp knife. To serve, turn the cups upside down on the serving plate or platter, and give them a good shake to release. Spoon the caramel oranges and caramel sauce around the panna cotta.

THE FOUR SEASONS OF PANNA COTTA

Citrus and caramel are my wintertime go-to for serving with panna cotta. In spring, I serve it with local strawberries tossed with a little sugar. When peaches ripen in summer, I spoon those on. In the fall, I slice plums and pears into a saucepan with some sugar and spices and let them stew until syrupy and serve the panna cotta with them. The soft texture of this pudding tastes like comfort no matter where you live or what season you celebrate.

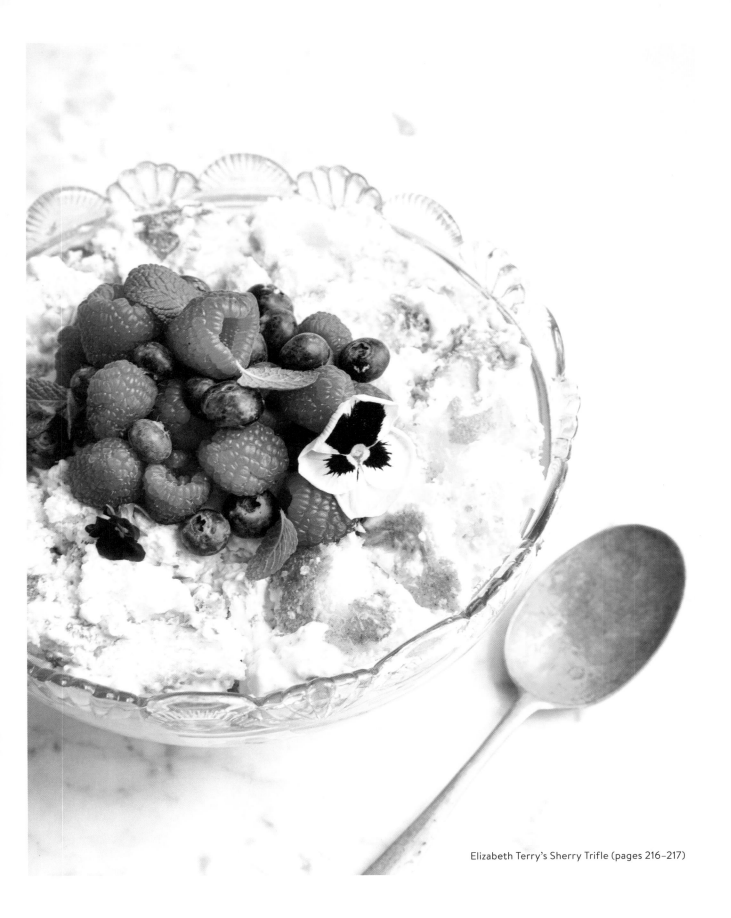

Elizabeth Terry's Sherry Trifle (pages 216–217)

Elizabeth Terry's Sherry Trifle

For her legendary restaurant, Elizabeth's on 37th in Savannah, former chef Elizabeth Terry spent a great deal of time researching generations-old Georgia recipes to place on the menu, like this fabulous layered dessert she called Savannah Cream Cake. But once I spooned it into my favorite footed glass bowl, I called it what it is—a trifle. What's brilliant about this recipe is that it combines a sherry-infused custard with torn bits of angel food cake, store-bought or homemade, to create a light, rich, and boozy but somehow acceptable dessert in the Bible Belt.

In 1981 Terry and her husband, Michael, restored a rambling Victorian home at the corner of Drayton and 37th Street, making the second floor their family home and the first floor the restaurant. It became one of the South's first true regional fine dining restaurants. The late author Pat Conroy, a frequent patron, said Elizabeth's "stimulated the kitchens of rival chefs and the palates of diners throughout the region." I dined at Elizabeth's on more than one occasion, writing about how a talented transplant from Ohio embraced the story of Savannah and lifted up its food.

This recipe is adapted from *Savannah Seasons* (1996), by Terry and her daughter Alexis.

| Serves 10 to 12 | Prep: 1 hour | Chill: At least 4 hours or overnight |

SHERRY CUSTARD

2 1/2 teaspoons (1 packet) unflavored gelatin

3/4 cup warm water, divided

4 large egg yolks

1/2 cup medium-dry (amontillado) sherry

3/4 cup (150 grams) granulated sugar

2 cups heavy cream

1 tablespoon vanilla extract

6 to 8 packed cups torn (1-inch pieces) angel food cake, store-bought (8 ounces) or homemade (recipe follows)

TOPPING

1 cup heavy cream

1 tablespoon granulated sugar (optional)

2 cups (12 ounces/340 grams) fresh berries (optional), for garnish

1 teaspoon freshly grated nutmeg

Edible flowers, if desired

1. **Make the sherry custard:** Sprinkle the gelatin over 1/2 cup of the warm water in a small bowl and stir. Let the mixture sit for the gelatin to soften.

2. Place the eggs yolks in a large mixing bowl and beat with a whisk until they lighten in color. Whisk in the sherry, sugar, and remaining 1/4 cup warm water and beat until well combined, 1 to 2 minutes by hand. Pour into a small heavy saucepan and place over low heat. Stir with a flat wooden spoon or spatula and cook until the mixture is steamy and thickens, 8 to 10 minutes, adjusting the heat up or down to make sure it doesn't boil but comes together. Remove from the heat and stir in the gelatin mixture. Pour into a large stainless-steel bowl and place in the refrigerator to cool, uncovered, for 30 minutes.

3. Meanwhile, pour the cream and vanilla into a large bowl and beat with an electric mixer on high speed until stiff peaks form, 3 to 4 minutes. Place in the fridge to chill.

4. When the sherry custard has chilled, fold in the whipped cream, and then fold in the cake pieces (if you use 6 cups, the mixture will be more mousse-like, and if you add more cake, it will be stiffer).

5. Spoon the custard into a large footed trifle dish or a 9-by-13-inch glass pan. Cover with plastic wrap and chill for 4 hours or up to a day before serving.

6. **Make the topping:** Whip the cream with the sugar, if desired, in a medium bowl with an electric mixer on high speed until stiff peaks form, about 3 minutes.

7. Spoon the cream onto the top of the sherry custard and garnish with the berries, if desired, nutmeg, or edible flowers, and serve.

SARAH HYDE MORGAN'S ANGEL FOOD CAKE

Cakes with just egg whites and no yolks used to be called "silver cakes," "lady cakes," or "angel food cakes" and were prized for their white color, volume, and delicate texture. The following 1895 recipe has only been slightly adapted for the modern kitchen from *The Atlanta Exposition Cookbook* (1984). I find unbleached flour gives angel food cake more body.

Heat the oven to 350°F, with a rack in the middle. Set aside an ungreased 10-inch tube or angel food pan. Sift 1 cup (120 grams) unbleached all-purpose flour 4 times in a large bowl. The last time, sift in 1 teaspoon cream of tartar. Set this mixture aside.

Place 11 large room-temperature egg whites in the large bowl of a stand mixer, and beat on medium-high speed until they are a stiff froth, 4 to 5 minutes. Add 1 1/2 cups (300 grams) granulated sugar, 2 tablespoons at a time, while beating for 4 to 5 minutes more, until stiff and glossy. Beat in 2 teaspoons vanilla extract and 1/8 teaspoon salt. Gently fold the flour mixture into the egg white mixture with a rubber spatula, until just combined. Turn the batter into the pan, smooth the top with the spatula, and bake until it is lightly browned and springs back when lightly pressed in the center, 30 to 35 minutes. Remove the cake from the oven and immediately turn it upside down on a wire rack and cool for 1 hour.

Turn the pan right side up and run a long, sharp knife around the edges. Give the cake a gentle shake to loosen it from the pan. Invert it onto a plate or rack, then invert again so the cake is right side up. Slice and serve.

Fig and Lemon Clafoutis

One of the most delicious puddings is the French clafoutis, a cross between a Dutch baby and a custard, something a French grandmother might make using the first fresh fruit of the season. And if that French grandmother was at my house in the summertime, she might notice the massive fig tree outside my kitchen window and get to work prepping clafoutis.

Figs, whether Brown Turkey or the thinner-skinned Celeste, love well-drained soil and sunshine. The season comes at once, and you have to work quickly to put them up into preserves or just immerse yourself in figs—on green salads with blue cheese, on pizza instead of fresh tomatoes, and tucked into the cozy comfort of this clafoutis.

Notice the special step of pouring a little custard into the dish and letting it bake. This sticky base keeps the figs in place once the rest of the lemon-scented custard is poured around them. I adapted this recipe from one from Atlanta chef Anne Quatrano, who is as crazy about figs as I am, and I'm not sure what is more enjoyable, spooning into the soft and squiggly figgy custard or just saying the word as it is pronounced in France—"Cla-fou-TEE!"

| Serves 6 to 8 | Prep: 15 to 20 minutes | Bake: 29 to 35 minutes |

1 teaspoon soft butter for greasing
 the pan
4 large eggs
3/4 cup whole milk
3/4 cup heavy cream
2/3 cup (135 grams) granulated
 sugar
1 teaspoon grated lemon zest
1/4 teaspoon salt
1/4 cup (30 grams) all-purpose
 flour
8 to 9 figs (about 8 ounces),
 halved and stems removed

1. Heat the oven to 425°F, with a rack in the middle. Brush a 9- to 10-inch pie pan or gratin dish with the butter and set aside.

2. Place the eggs, milk, cream, sugar, lemon zest, and salt in a large bowl. Beat with an electric mixer on low speed until well combined, 1 minute. Increase the mixer speed to medium and beat until lightened, 1 minute longer. While the mixer is running, add the flour and beat until just combined.

3. Pour about 1/2 cup of the batter into the prepared pan and place in the oven until set, 4 to 5 minutes. Remove the pan from the oven and place the figs, cut side up, in the custard so they stick in place. Carefully pour the remaining batter around them. Return the pan to the oven and bake for 15 minutes. Reduce the temperature to 375°F and bake until the clafoutis is well browned and just firm to the touch in the center, 10 to 15 minutes more. Remove and serve warm or cool to room temperature, 1 hour, then serve.

Persimmon Pudding

Persimmons, also known as sugarplums, are a sweet and indigenous fruit growing wild across the South. They are full of tannin and inedible when unripe, but once they turn bright coral-orange in late fall, the pulp softens to the consistency of sweet jam. If no wild persimmons grow near you and you want to re-create old recipes calling for them, use the Asian persimmons that come into market in the fall, either the Fuyu, which looks like a small tomato, or the Hachiya, which is shaped like a large acorn. This is a lovely warm pudding, rich but light, and the spices play up the natural honeyed flavor of the persimmons. I adapted two recipes to create this pudding, one a 1980s recipe of the late Bill Neal, chef of the restaurant Crook's Corner in Chapel Hill and author of *Southern Cooking*, and the other a 1970s-era recipe from a Mississippi church cookbook, *Bayou Cuisine*.

Serves 6 to 8	Prep: 20 to 25 minutes	Bake: 1 hour, 5 to 10 minutes

1 pound (5 to 6) ripe Asian
 persimmons or 2 pounds ripe
 wild persimmons
1 cup whole buttermilk
4 tablespoons (1/2 stick/57 grams)
 unsalted butter, melted
 and cooled, plus more for
 greasing the pan
1/2 cup (100 grams) granulated
 sugar
1 large egg
3/4 cup (90 grams) all-purpose
 flour
1/2 teaspoon ground cinnamon
1/2 teaspoon baking soda
1/2 teaspoon baking powder
1/4 teaspoon salt
1/4 teaspoon ground nutmeg
1/4 teaspoon ground ginger
Vanilla ice cream or Whipped
 Cream (page 458) for serving

1. Heat the oven to 325ºF, with a rack in the middle. Fill a 9-by-13-inch pan with 1 inch of water.

2. If using Asian persimmons, core and peel them. Cut into quarters as you would an apple. Cut the quarters into pieces and place in a food processor. Puree until smooth, 1 to 2 minutes. If using wild persimmons, press them through a sieve to extract the pulp and discard the core and skins. You'll need 1 cup of persimmon puree.

3. Leave the puree in the food processor or turn it out into a large bowl. Add the buttermilk, melted butter, sugar, and egg and pulse or whisk to combine well. In a separate bowl, whisk together the flour, cinnamon, baking soda, baking powder, salt, nutmeg, and ginger. Fold into the persimmon mixture by hand or pulse gently in the processor.

4. Grease a 2-quart baking dish with a little butter. Pour the persimmon mixture into the dish and place it in the pan with the water. Carefully place the pan in the oven. Bake until the pudding is just set, 1 hour and 5 to 10 minutes.

5. Remove from the oven and serve warm with vanilla ice cream or whipped cream.

PERSIMMON *Prophecy*

The home I was raised in was surrounded by persimmon trees, which my father marveled at because the woods surrounding his boyhood home had also been filled with them. Old-timers said you could predict winter weather by looking at the shape of the persimmon seed inside. If it was spoon-shaped, expect to shovel snow. If it was fork-shaped, you would know it would be a milder winter, with light snow. And if it was knife-shaped, cold winds will cut you like a knife. Persimmons were once an abundant source of food for early peoples and one of the great Southern foraged foods that included hickory nuts, muscadine grapes, and oysters.

BILL NEAL

When Bill Neal's cookbook *Bill Neal's Southern Cooking* was published in 1985, he became the South's most articulate culinary ambassador. His eldest child, Matt Neal, who was a teenager when his father was leading the kitchen at Crook's Corner restaurant in Chapel Hill and had been a young child when Neal opened La Residence in 1976 with former wife and Matt's mother, Moreton, says his dad would tell the other cooks that the food they were crafting didn't have to look perfect. "We don't want it to be too fancy or too frilly," his father would say. "We want it to look homemade." Neal had studied French at Duke University and developed a love of French cooking that would grow into an appreciation of Southern regional cooking, with its Native American, African, and European elements. The father of shrimp and grits, he was a preservationist as well as a trendsetter who cooked with locally harvested persimmons, knew an unstrained lemon pie filling has more flavor, and saw a grandmother's biscuit recipe as a way of preserving the identity of the region he so loved. Neal died in 1991 at forty-one.

Lena Richard's Apple Bread Pudding

Born in New Roads, Louisiana, in 1892, Lena Richard was a trailblazer. She cooked for Alice Baldwin Vairin in New Orleans and was so accomplished that Vairin sent her to Fannie Farmer's Boston cooking school. Vairin's friends always asked Richard for her recipes, so she started writing them down, and with the blessing of Vairin, she opened a cooking school and compiled her recipes into a book. In 1939 she self-published *Lena Richard's Cook Book*, which she dedicated to Vairin. A year later, Houghton Mifflin republished it as *New Orleans Cook Book*. It was the first Creole cookbook written by a Black author. Richard was also a caterer and a television personality on the NBC affiliate in New Orleans, WDSU-TV, from 1947 to 1949. In addition, she created her own line of frozen foods, including shrimp Creole, chicken fricassée, and gumbo. The fact that she was a woman of color at this time in history makes her contributions all the more remarkable.

Before Richard's book, Creole recipes like this elegant apple bread pudding—creamy custard, apples, raisins, and nutmeg, with a proud meringue on top—were enjoyed only by the wealthy.

While some bread puddings can be heavy, this one is as well constructed as a French souffle. Richard said of her pudding, "There is no need to experiment, for I have done the experimenting in my own laboratory-kitchen as well as in my cooking school."

Serves 8 to 12 Prep: 35 to 40 minutes Bake: 50 to 57 minutes

2 cups sliced apples (from 2 large or 3 small apples)

1 cup (200 grams) granulated sugar, divided

8 slices (8 ounces) stale sandwich bread or brioche

3/4 cup (7.5 ounces/113 grams) raisins

4 large eggs

8 tablespoons (1 stick/114 grams) salted butter, melted

4 cups whole milk

1/4 teaspoon ground nutmeg, or to taste

1 teaspoon vanilla extract

1 tablespoon confectioners' sugar

1/4 teaspoon cream of tartar

1. Heat the oven to 350ºF, with a rack in the middle.

2. Place the apples in a medium saucepan and toss with 1/4 cup of the granulated sugar. Cover the pan and place over medium heat, letting the apples cook gently in their own juices, simmering for 8 to 10 minutes. Check to make sure they don't stick and that the heat isn't too high. Remove the pan from the heat and uncover the pan.

3. Arrange 4 of the bread slices in the bottom of a glass 9-by-13-inch baking dish. Distribute half

of the apples on top of the bread slices. Sprinkle with half of the raisins. Place the remaining 4 slices of bread on top of the raisins and top with the rest of the apples and the rest of the raisins.

4. Separate 3 of the eggs, placing the whites in a large bowl for the meringue. Crack the last egg and add it to the yolks, whisking to combine. Whisk in the remaining 3/4 cup granulated sugar and the melted butter, milk, nutmeg, and vanilla. Pour this mixture over the bread, pushing down on the bread with a large spoon as you add the milk mixture so the bread can absorb it all. Place the pan in the oven.

5. Bake until the edges of the pudding are golden brown, it has risen high in the pan, and the center is nearly set but still jiggles a little, 42 to 47 minutes. Remove the pan from the oven. Leave the oven on.

6. For the meringue, beat the egg whites with the confectioners' sugar and cream of tartar with an electric mixer on high speed until stiff peaks form, 2 to 3 minutes. Spoon the meringue on top of the pudding, using a small metal spatula or soup spoon to create dips and swirls. Return the pan to the oven and let the meringue brown, 8 to 10 minutes, then remove and serve warm.

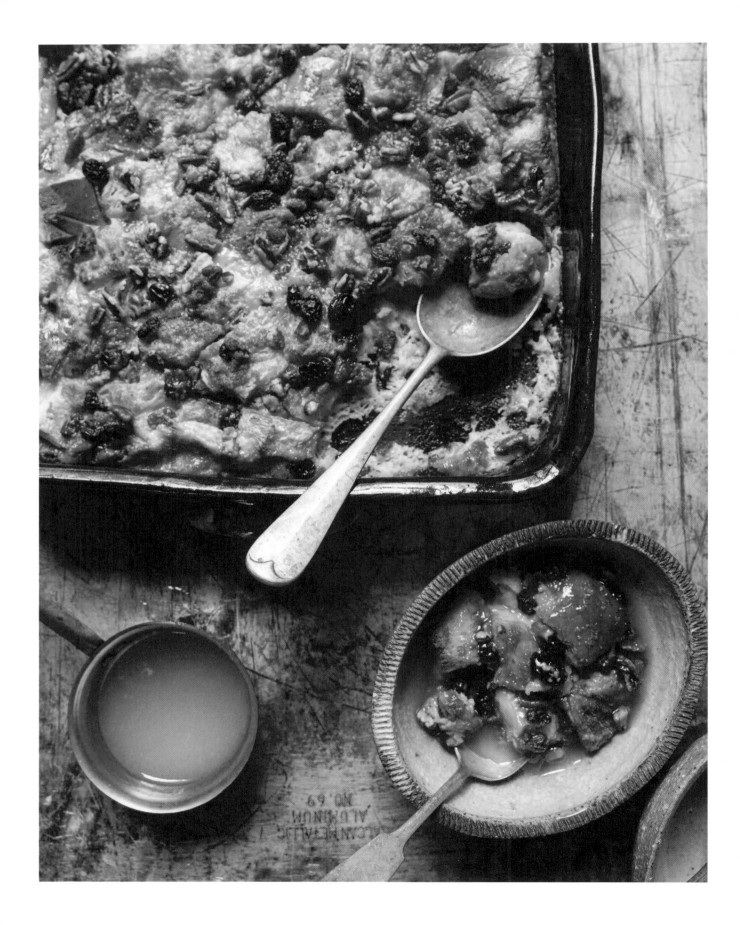

Sarah's Kentucky Bread Pudding with Bourbon Sauce

Sarah Halcomb of Walnut Grove Farms, a large family farm in southern Kentucky, has tweaked and perfected her bread pudding recipe, always using the state's famed bourbon in the sauce. The corn that goes into the bourbon is grown on the land that her husband, John's, family has farmed since the late 1800s.

It's the unctuous sauce that sets Halcomb's bread pudding apart from others. Thickened with egg and no cream, it screams Kentucky once you add that bourbon. Halcomb says she likes a pudding that is cake-like. I tote this to friends' houses for dinner, and it is a winner not only in flavor but also because I can bake it ahead and cut it into portions once I get there.

You can omit the apples, or you can substitute pears or peaches. Just don't use anything other than Kentucky bourbon in the sauce!

Serves 8 to 12	Prep: 40 to 45 minutes	Bake: 35 to 40 minutes

PUDDING

8 ounces store-bought or homemade challah (pages 189–190) or Sally Lunn bread (pages 187–188), cut into 1-inch cubes (4 heaping cups)

1 teaspoon butter for greasing the pan

5 large eggs

2 cups whole milk

1 cup (200 grams) granulated sugar

2 teaspoons vanilla extract

CRUMBLE

1/2 cup (96 grams) lightly packed light brown sugar

4 tablespoons (1/2 stick/57 grams) unsalted butter, at room temperature

3/4 cup (3 ounces/86 grams) chopped pecans

1/2 cup (2.5 ounces/75 grams) raisins

1/2 to 1 cup chopped apples, from 1 medium apple (optional)

BOURBON SAUCE

8 tablespoons (1 stick/114 grams) unsalted butter

1/2 teaspoon salt

1 cup (200 grams) granulated sugar

1 large egg

2 tablespoons water

2 to 3 tablespoons bourbon

1. **Make the pudding:** Place the bread cubes on a baking sheet on the kitchen counter to dry out for several hours.

2. When you're ready to cook, heat the oven to 350°F, with a rack in the middle. Butter a 9-by-13-inch pan. Place the dried bread cubes in the pan, arranging them in an even layer.

3. Place the eggs and milk in a large bowl and whisk to combine. Whisk in the sugar and vanilla. Pour over the bread cubes and let sit for 10 minutes.

4. **Meanwhile, make the crumble:** Combine the brown sugar, butter, pecans, raisins, and apples, if desired, in a medium bowl.

5. With your hands, crumble the mixture on top of the bread cubes and, with a fork, push the crumble down into the milk mixture. Place the pan in the oven and bake until the pudding bubbles, is lightly browned around the edges, and is firm to the touch when pressed in the center, 35 to 40 minutes. Remove from the oven.

6. **Make the bourbon sauce:** Place the butter, salt, and sugar in a medium saucepan over medium heat and cook, stirring until the butter melts and the sugar dissolves, 4 to 5 minutes. Remove the pan from the heat. Whisk together the egg and water in a small bowl and whisk in a couple tablespoons of the hot butter mixture to bring up the temperature of the egg. Pour the egg mixture into the butter sauce and, with a wooden spoon, stir constantly over low heat until it thickens, 1 to 2 minutes. Remove from the heat and stir in the bourbon.

7. Serve the bread pudding with the warm sauce.

NOTE:

If need be, you can reheat the sauce gently, in a glass jar, resting in an inch or two of simmering water on low heat in a saucepan.

EGGS: BE GENTLE

Because many of these pudding recipes contain eggs for their richness, it's a different way of cooking, requiring, as Mary Randolph said in *The Virginia Housewife*, "promptitude." So read the recipes carefully. I will ask you to prepare a water bath—known as a bain-marie in classical French cooking—when needed to protect the eggs from the direct heat. That's because eggs don't like to be surprised by heat. They will seize up and curdle. I show you how to coax them into the pudding mixture, adding just enough warm milk to bring up their temperature—a process called "tempering"—so they gradually blend with the rest of the mixture and create a smooth and creamy bliss.

James Hemings' Snow Eggs

"Snow eggs," "floating islands," "soft meringues with crème Anglaise," whatever you wish to call it, this is a dessert of contrasting colors and textures, and bliss for those of us who love custard and soft meringues. It is the recipe of James Hemings, the enslaved cook of Thomas Jefferson. Gently cooking an egg custard, whipping egg whites (long before stand mixers), poaching tender meringues in a simmering custard: everything about this recipe shows the skill of a chef de cuisine who prepared the famous dinners at Monticello. The recipe is pre-vanilla, from a time when desserts were flavored with citrus or rose water.

Hemings has been credited with creating macaroni and cheese, a chocolate cream, Jefferson's ice cream (which might have used this custard as its starting point), and snow eggs. Jefferson's granddaughter Virginia Jefferson Randolph Trist saved this recipe, which is a part of the papers of the Trist and Burke Family Members in Monticello's collections.

Serves 4 to 6	Prep: 45 to 50 minutes	Cook: 10 to 15 minutes for the custard and 4 minutes per batch for the meringues

5 large eggs

2 cups whole milk

3/4 cup (150 grams) granulated sugar

1/2 teaspoon rose water or orange blossom water or 1/4 teaspoon grated orange zest

1 tablespoon confectioners' sugar

Small pinch of salt

Honey for serving (optional)

1. For the sauce, separate the eggs, placing the yolks in a medium bowl and the whites in a large one for the meringue. Place a large stainless-steel bowl full of ice in the sink and a smaller stainless-steel bowl inside it to chill.

2. Heat the milk, granulated sugar, and flavoring of choice in a medium heavy saucepan over low heat, stirring occasionally. When the milk is simmering but not boiling, temper the egg yolks by spooning 1/2 cup of the hot milk into them, whisking vigorously to raise their temperature, and then add another 1/2 cup and whisk again. Pour the yolk mixture back into the saucepan. Stir with a flat wooden spoon over low heat until the mixture steams and thickens enough to coat the back of the spoon, 8 to 10 minutes.

3. Pour the hot custard through a fine mesh sieve into the smaller bowl in the sink and leave to chill, stirring occasionally. Place in the fridge to chill further until it's time to serve.

4. For the meringue, beat the egg whites, confectioners' sugar, and salt in a large bowl with an electric mixer until the whites are stiff, 3 to 4 minutes, or "until you can turn the vessel bottom upward without their leaving it," in Hemings' words, meaning you turn the bowl upside down and the whites stay in it.

5. To poach the meringues, place a wide, shallow pan of water over medium-high heat. As it comes to a simmer, line a large plate or baking sheet with paper towels. Using a large tablespoon, scoop a generous dollop of the egg white mixture into the simmering pan of water, where it will float. You should be able to fit 2 or 3 meringues. After cooking 2 minutes, carefully flip them over and poach for another 2 minutes, then lift out and drain on the paper towels.

6. To serve, spoon the custard into serving dishes and top with the meringues. Drizzle with honey, if desired.

JAMES HEMINGS

Two hundred years later, James Hemings is remembered for his role in bringing French cuisine not just to the South but to America. He was the son of Thomas Jefferson's father-in-law and the brother of Sally Hemings, who gave birth to several of Jefferson's children. He became Jefferson's property at nine, and by nineteen, he was being trained in French cooking and language. Michael W. Twitty, food historian and author of *The Cooking Gene: A Journey Through African American Culinary History in the Old South*, noted that "Hemings' literacy made him an anomaly." Hemings traveled with Jefferson to Paris, and, according to Jessica B. Harris in *High on the Hog* (2011), he was there when crowds stormed the Bastille on July 14, 1789. In exchange for his freedom in 1796, he trained the cooks who would replace him, including his brother, Peter, as his agreement with Jefferson required. Hemings took his own life in 1801 when he was thirty-six.

Belvidere Rice Pudding

You don't have to be recovering from illness or surgery to enjoy the comfort and vibrancy of rice pudding. This recipe appeared in Jane Grant Gilmor Howard's cookbook, *Fifty Years in a Maryland Kitchen* (1873). Howard was a Baltimore socialite, the wife of a prominent lawyer, a mother of twelve, and the president of the Ladies' Southern Relief Association of Maryland, which disbursed funds to families in need. Howard wrote her book when she was seventy-two, a year after her husband died. She cooked this lovely pudding, named after her home, in a low oven until it was thick and looked "like rich yellow cream." The combination of orange and cinnamon is irresistible. If you want to bake this in the oven, do so at 275°F and stir often.

But I chose the stovetop. Stir the pudding a good bit in the beginning so the rice doesn't stick, and also toward the end, when the mixture is thickening. And at the very end, you fold in grated orange zest, but not too much. If you want to gild the lily, serve cream on the side to pour over the top of the pudding, which has changed in color from white to a creamy yellow.

Serves 6 Prep: 15 to 20 minutes Cook: 50 to 55 minutes

4 cups whole milk

3/4 cup (144 grams) lightly packed light brown sugar or organic cane sugar

Rounded 1/3 cup (2 ounces) long-grain white rice such as jasmine or basmati, rinsed in a colander and drained

1 cinnamon stick

Pinch of ground nutmeg or a grating of whole nutmeg

Pinch of salt

Grated orange zest (optional)

1. Pour the milk into a large heavy pot and stir in the brown sugar or cane sugar and rice. Add the cinnamon stick, nutmeg, and salt. Place over low heat and simmer, stirring constantly. Regulate the heat under the pot as needed to keep it at a very gentle simmer. You do not want the rice to stick or cook too quickly, so keep it low and slow.

2. Cook for 50 to 55 minutes, stirring every 10 minutes. At the end of the cooking, the mixture will pull together quickly, so keep an eye on it. Taste a spoonful, and if the rice has cooked through and you are happy with the seasonings and texture, turn off the heat. Stir around the sides and edges of the pot. Let sit for a few minutes, then remove the cinnamon stick and spoon the pudding into bowls. Garnish with orange zest, and serve warm.

SUFFRAGE: NOT A TRIFLING CAUSE

A tearoom called Satsuma in downtown Nashville was known for its Charlotte russe, a trifle similar to Elizabeth Terry's recipe on pages 216–217. Opened by two home economists, Mabel Ward and Arlene Ziegler, in 1918, Satsuma couldn't have arrived at a more interesting time. In December 1917, the 18th Amendment, also known as the Prohibition Amendment, was passed by Congress and sent to the states for ratification, which would happen in January 1919. Thus, no sherry in the trifle. Within a year and a half, Satsuma became ground zero for those who supported ratification of the next amendment, the 19th Amendment, granting women the right to vote. Tennessee became the crucial thirty-sixth state to ratify in the hot summer of 1920. The liquor lobby opposed the vote, as did the church ladies, who felt voting would take women out of the home. In the end, the deciding vote was cast by the statehouse's youngest member, Harry Burn, of rural eastern Tennessee. He had received a letter from his mother, Febb Burn, in which she asked him to "be a good boy" and vote for the amendment.

HIS DAUGHTER
And he thought she was "just a little girl"

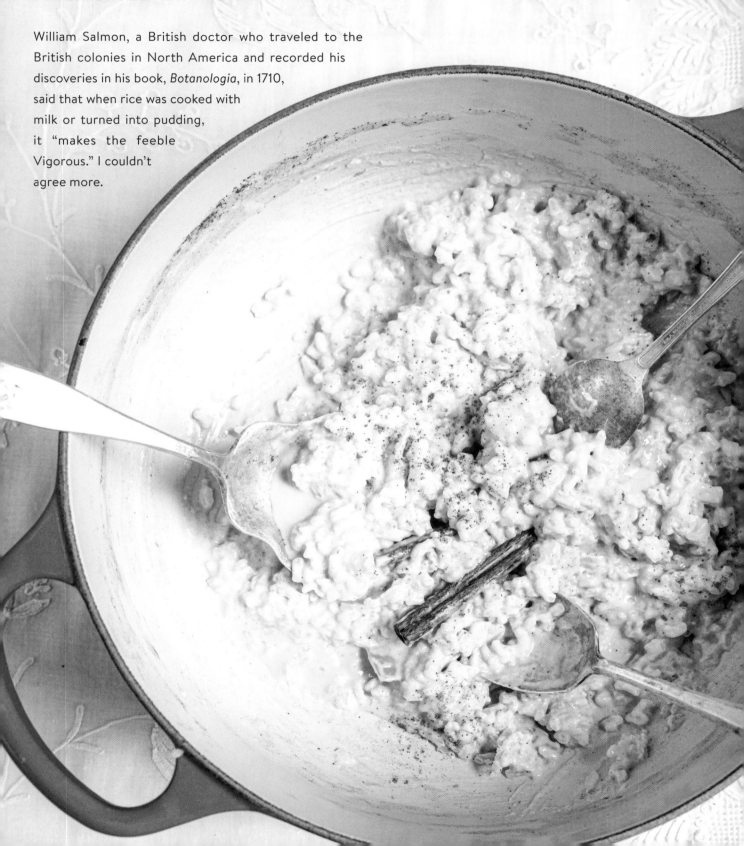

Belvidere Rice Pudding (page 229)

RESTORED BY *Rice*

William Salmon, a British doctor who traveled to the British colonies in North America and recorded his discoveries in his book, *Botanologia*, in 1710, said that when rice was cooked with milk or turned into pudding, it "makes the feeble Vigorous." I couldn't agree more.

Chocolate pie

Mix by hand:

3 egg yolks-beat with fork

1 cup of sugar

3 Tablespoons of flour

3 even Tablespoons of cocoa

2 Tablespoons butter

1 cup of milk

1 Tablespoon of vanilla

Pour on crust and cook at 350.for 45 minutes on bottom rack

Whip 3 egg whites in mixer for about 4 minutes.

Add 6 Tablespoons of sugar for meringue and whip for about

2 more minutes. Add meringue to pie and brown.

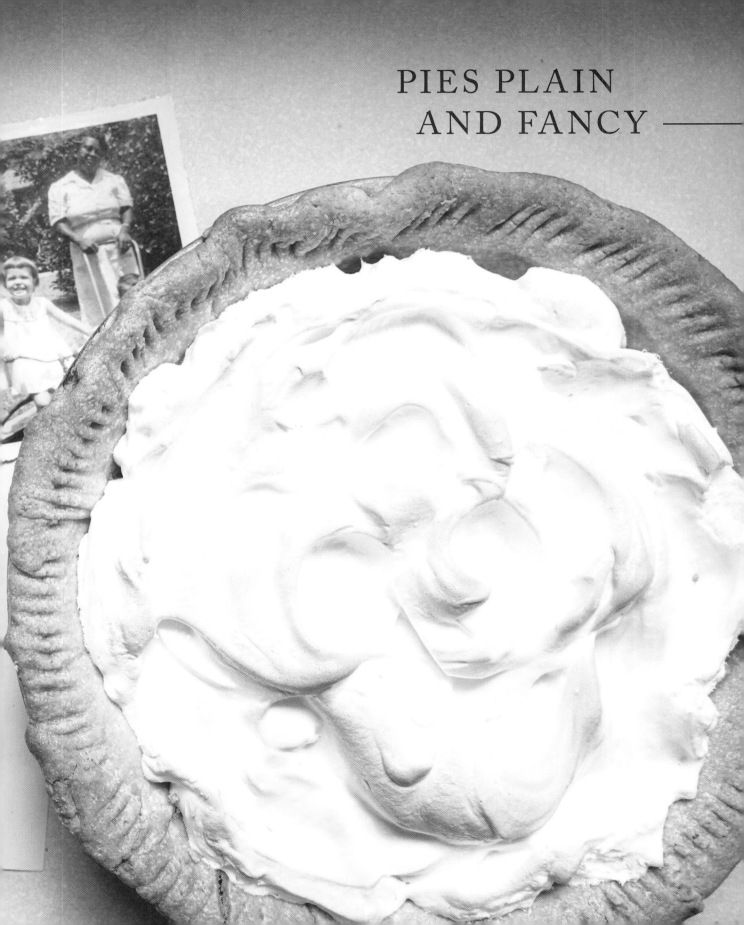

Pie was glorious. Pie was, well, pie.

—RICK BRAGG, *THE BEST COOK IN THE WORLD: TALES FROM MY MOMMA'S TABLE*, 2019

There was always a cool evening brought on by a heavy thunderstorm and this would be a night for a boiled ham. The meat with the skin on was often served warm and invariably thought to taste more delicious with new boiled vegetables and the first peach cobbler of the summer.

—EDNA LEWIS, *THE TASTE OF COUNTRY COOKING*, 1976

Ask the average man what he prefers for dessert, and almost invariably he will answer "pie."

—MRS. S. R. (HENRIETTA) DULL, *SOUTHERN COOKING*, 1941

The Pennsylvania Dutch used to think there were two kinds of people—cake people and pie people. The former ate slices with silver forks to celebrate and impress. And the latter baked pies with what they had, even when times weren't so happy.

In the South, the same is true. Pies are made for people who have work to do. In a kitchen in Kentucky tobacco country, it might be fat slices of brown sugar meringue pie to feed the farm hands. At a gas station in the middle of Virginia farmland, it might be fried apple pies at the checkout. Pies are woven into the routines of life, and recipes are memorized but seldom eulogized.

They don't require fancy utensils to make, and, in fact, you can roll out pie dough with a jelly glass. They don't need fancy ingredients either, just staple stuff found in most every kitchen. They've been baked in foil, glass, ceramic, and iron pans and been toted to meetings, churches, picnics, homecomings, bake sales, and, of course, Thanksgiving.

"Pies were something people just had around," says North Carolina cookbook author and pie baker Nancie McDermott. "People knew how to make piecrust through repetition. Just like you learn to make biscuits by making biscuits, they made beautiful pies by making pie."

And that ease begged for improvisation. Foraged black walnuts and pecans, local molasses, freshly churned butter and buttermilk, homegrown sweet potatoes—they could all transform a simple pantry pie into a venerable pecan pie, a Christmas molasses pie, a beloved buttermilk pie, or a sweet-potato custard pie.

Freshly laid eggs meant egg custard pie or coconut cream pie. And when you didn't have fruit, you baked a chess or transparent pie, and when the summer was so hot and you couldn't bear to turn on the oven, you made lemon icebox pie.

June's blackberries and blueberries, July's freestone peaches, August's early apples, and those sweet potatoes just in time for Thanksgiving—they were reasons to bake pie in the South. The seasons and the soil have provided the inspiration, and this chapter reflects that. I begin with the kitchen cupboard pies—chess, transparent, molasses, egg custard—and move into fruit pies and cobblers, then chocolate and other flavors, and end with an irresistible outlier—tomato pie.

As sugar became more affordable and available, people baked with more of it. In the 1960s, our tastes got sweeter as we added sugar-filled convenience products— Cool Whip and Jell-O pudding mix—to family pie recipes.

I've approached these recipes of the past with reverence but also using today's palate and looking to cut back on sugar where I can. I have preserved nods to the past, like the teaspoon white vinegar that grandma added, because she said it made the crust more tender. Honestly, a teaspoon isn't going to reduce the gluten formation, but that crust will have a nice twang to it.

It's fine to use a frozen piecrust or a refrigerated sheet of pie pastry when you're busy. Crusts made with chocolate cookies, saltines, or Ritz cracker are fast and cheap when you don't have time or flour, and they

offer a textural and salty contrast to sweet fillings. But when it's a special occasion, make the crust yourself. When you care about ingredients, make the crust. When you want to get better at pie baking, make the crust.

Pies are for sharing, toting, and celebrating, or for no reason at all. And they taste of love, something pie people have known for a long time.

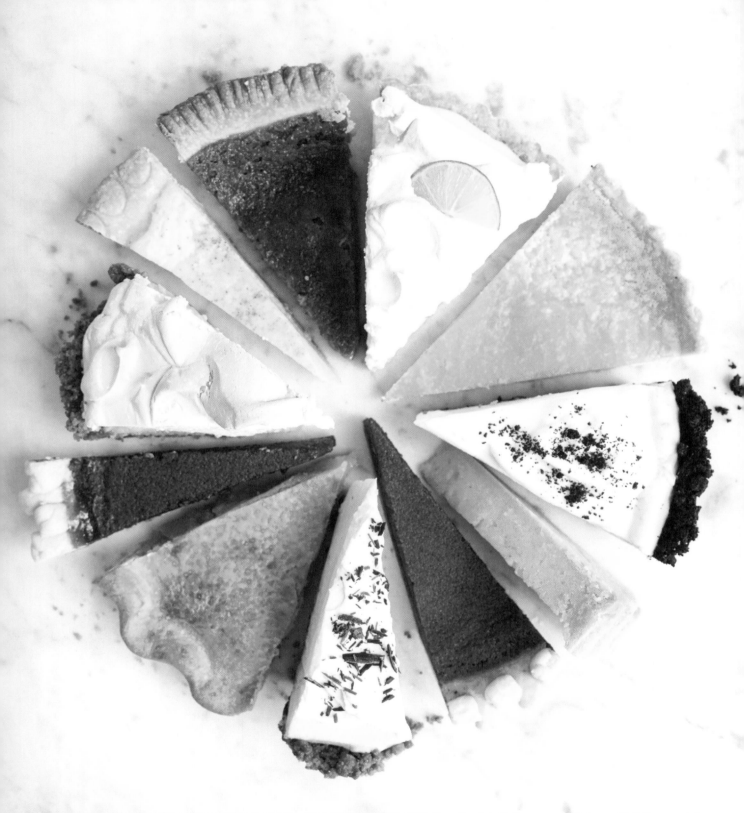

Starting at the Key Lime Pie and moving clockwise: Key Lime Pie (pages 254–255), Mary Randolph's Transparent Pie (page 237), Peppermint Chiffon Pie (pages 297–298), 1748 Bakehouse Lemon Chess Tart (page 245), Chocolate Chess Pie (page 247), Betty Kennedy's Black Bottom Pie (pages 294–295), Shaker Lemon Pie (page 260), Chocolate Chess Pie (page 247), Johnetta Miller's Lemon Icebox Pie (pages 257–258), Panky Brown's Egg Custard Pie (page 240), and Fisk Club Cookbook's Molasses Pie (page 238)

Mary Randolph's Transparent Pie

Aptly named, the rich and velvety filling of this pristine pie is nearly transparent. It's what used to be called a "desperation" pie—one you would bake when fruit wasn't in season or when you wanted sweet and creamy pie without fanfare. The recipe is an homage to both Mary Randolph of Virginia and Annabella Hill of Georgia, who published books in the nineteenth century. Randolph's 1824 recipe is actually for "Transparent Pudding," stirred like a custard and poured into a pastry-lined dish before baking. Her book, *The Virginia Housewife: or, Methodical Cook*, was the South's first cookbook and a sophisticated and successful one, with nineteen reprints before the Civil War. (Eliza Smith's book, *The Compleat Housewife*, had been published in Williamsburg eight decades earlier in 1742, but it was a reprint of her earlier English cookbook with a few adaptations for the new American housewife.) Hill's 1872 recipe in her *Mrs. Hill's Southern Practical Cookery and Receipt Book* introduces cream to the transparent recipe, a prelude to our buttermilk pie.

What's important in this old recipe and in all the stirred pies, such as buttermilk, is to not overbeat them, which causes cracking when the pie bakes. Just use a fork or a whisk and have all your ingredients at room temperature for easy blending.

Serves 8	Prep: 15 to 20 minutes	Bake: 58 to 62 minutes

1 (9-inch) piecrust (pages 306 to 313)

3 large eggs

1 1/2 cups (300 grams) granulated
 sugar

1 cup heavy cream

2 tablespoons all-purpose flour

1/4 teaspoon salt

4 tablespoons (1/2 stick/57 grams)
 unsalted butter, melted

1 teaspoon vanilla extract

1. Heat the oven to 350ºF, with a rack in the lower middle. Crimp the edges of the piecrust, prick the bottom lightly with a fork, and set aside.

2. Crack the eggs into a large mixing bowl and whisk to combine. Gradually whisk in the sugar, cream, flour, salt, melted butter, and vanilla. Pour the mixture into the crust and bake until deeply golden brown, 58 to 62 minutes. It will still be a little soft in the center if you shake it but will set up as it cools.

3. Place on a wire rack to cool for 1 hour, then slice and serve.

Fisk Club Cookbook's Molasses Pie

This molasses pie with a deeply caramel flavor was shared by Mrs. Richard Harris in the *Fisk Club Cookbook* (1912). Molasses boiled from pressed homegrown sugarcane became the accessible sweetener of a struggling South. "In slavery days, molasses pie, a cinnamon-spiced syrup-based pie without the nuts, was a Christmas treat," wrote author Toni Tipton-Martin in her book *Jubilee*. And Christmas was the most celebrated holiday for the enslaved, wrote Fred Opie in *Hog and Hominy*, a time when they were allowed the freedom to go to church, visit nearby plantations where friends and relatives lived, and prepare their most festive foods. Fisk University in Nashville was the first Black institution to receive accreditation from the Southern Association of Colleges and Schools. It is home to the world-famous Fisk Jubilee Singers, who first went on tour in October 1871 to earn money for the school and, more than 150 years later, they are still performing.

Serves 8	Prep: 15 to 20 minutes	Bake: 45 to 50 minutes

1 (9-inch) piecrust (pages 306 to 313)

2 large eggs

1/2 cup buttermilk

1/2 cup molasses or sorghum

1/2 cup (100 grams) granulated sugar

1 heaping tablespoon all-purpose flour

1/2 teaspoon baking soda

1/4 teaspoon ground nutmeg or
cinnamon

2 tablespoons unsalted butter, melted

Whipped Cream (page 458) for serving

1. Heat the oven to 350°F, with a rack in the lower middle. Crimp the edges of the piecrust, prick the bottom lightly with a fork, and set aside.

2. Crack the eggs into a large bowl and whisk in the buttermilk, molasses or sorghum, sugar, flour, baking soda, and nutmeg or cinnamon until smooth. Whisk in the melted butter. Pour into the piecrust and place in the oven.

3. Bake until the crust is golden brown and the filling puffs (it will fall as it cools) and is still a little jiggly when you shake the pan gently, 45 to 50 minutes. Remove to a wire rack to cool for 30 minutes.

4. Slice and serve with whipped cream.

SUGAR AND MOLASSES

Until sugarcane from Jamaica was planted in coastal Georgia and Louisiana in the early 1800s, the islands of Madeira and then Barbados and Jamaica dominated the white sugar industry. According to Katharine E. Harbury in her book, *Colonial Virginia's Cooking Dynasty*, imported sugar was shaped into cones and was a costly status symbol. Sarah Russell, the wife of the wealthy Charleston importer-exporter Nathaniel Russell, wore the key to her sugar chest like a locket around her neck. Most white sugar went to England, and the molasses drained out during the refining process was sent to American colonists, who used it to make gingerbread and rum. Even when sugarcane came to the South and sugar prices fell, making white sugar more accessible to the middle class, many Southerners still could not afford it and continued to sweeten their pies and cakes with molasses.

Panky Brown's Egg Custard Pie

Loved by young and old, comfy egg custard pie is rich like homemade custard, with a hint of vanilla and a dusting of nutmeg on top. But as with other simple pies, there's an art to making a really good one. This recipe is based on two recipes for egg custard pie I found in a slender spiral-bound book called *Panky's Pantry Secrets* (1976). The book was in my late mother-in-law's cookbook collection in Chattanooga and stars Katherine ("Panky") Brown, born in Pikeville, Tennessee, who learned to cook and bake alongside her mother. She catered dinner parties across Chattanooga and cooked for the Hedges family, who turned her recipes into this small cookbook and gave her the proceeds. Since sweetness is personal, I'm giving you a range for the sugar to suit your tastes.

Serves 8 Prep: 15 to 20 minutes Bake: 42 to 47 minutes

1 (9-inch) piecrust (pages 306 to 313), edges crimped and partially prebaked (see page 308)

3 large eggs

1/3 to 1/2 cup (67 to 100 grams) granulated sugar

Pinch of salt

1 tablespoon all-purpose flour

1/2 teaspoon vanilla extract

2 cups whole milk

1 tablespoon unsalted butter

Ground nutmeg for dusting (optional)

1. Set aside the crust to cool. Leave the oven on, increasing the temperature to 400ºF, with a rack in the lower middle.

2. Place the eggs, sugar, and salt in a large bowl and whisk to combine well. Whisk in the flour and vanilla. Meanwhile, place the milk and butter in a small saucepan and heat just until the butter melts. Remove from the heat. Gradually whisk the hot milk into the egg mixture until thickened. Pour into the piecrust and sprinkle nutmeg over the top, if desired.

3. Place the pie in the oven. Bake for 10 minutes, then reduce the heat to 350ºF. Bake until the pie has set and a knife inserted in the center comes out clean, 32 to 37 minutes more. Let cool on a wire rack for 20 minutes before slicing and serving.

Margaret Bragg's Buttermilk Pie

In *The Best Cook in the World*, Alabama's storyteller and author Rick Bragg wrote about his mother, Margaret Bragg, watching her mother bake a buttermilk pie to mend fences with a neighbor in their Appalachian foothills. "My mother stood in a chair, well back from the stove and its bubbling, molten, sugary delightful mess, and watched her momma cook not just for the usual reasons but for detente." This cousin of chess pie and transparent pie is simple to pull together and bake, and as Bragg's mother and grandmother knew, it is peacemaking too. Who can resist it? What makes Bragg's recipe special is the blend of buttermilk and whole milk and the smidgen of flour to keep the filling creamy and smooth.

Serves 8	Prep: 15 to 20 minutes	Bake: 1 hour, 5 to 10 minutes

1 (9-inch) piecrust (pages 306 to 313)

8 tablespoons (1 stick/114 grams) salted butter, very soft (see Note)

1 1/2 cups (300 grams) granulated sugar

3 large eggs

3 tablespoons all-purpose flour

3/4 cup whole buttermilk

1/4 cup whole milk

1 teaspoon vanilla extract

Dusting of ground cinnamon or nutmeg (optional)

1. Heat the oven to 350°F, with a rack in the lower middle. Crimp the edges of the piecrust, prick the bottom lightly with a fork, and set aside.

2. Place the butter and sugar in a large mixing bowl and beat with an electric mixer on medium speed until light and creamy, 2 to 3 minutes, or mix really well with a wooden spoon. Add the eggs, one at a time, beating between each addition. Scrape down the sides of the bowl with a rubber spatula. Add the flour, buttermilk, milk, and vanilla and beat until just combined.

3. Pour the filling into the piecrust and, if desired, sprinkle a little cinnamon or nutmeg on top. Bake until the filling and crust are deeply golden brown and the center is set when you shake the pan gently, 1 hour and 5 to 10 minutes. By 45 to 50 minutes, the pie will be brown. Lay a sheet of foil on top if the crust seems to be overbrowning before the pie is done.

4. Let the pie rest on a wire rack for at least 1 hour before slicing.

NOTE:

If you have only unsalted butter, you can use it; just add 1/2 teaspoon salt.

Nashville Chess Tartlets

Found in farm journals and church cookbooks, chess pie recipes were the easy, everyday pies baked by people who did their own baking. They needed no fresh fruit or refrigeration, and that was fortuitous, because before the 1930s, home refrigerators as we know them didn't exist. Having spent a lifetime baking chess pie and eating other people's variations on chess pie, I can confidently say this recipe is the best. What makes middle Tennessee chess pie different from that in other parts of the South is the cornmeal and vinegar. I grew up with little chess tarts at summer barbecues, packed in box lunches, and on the table at holiday parties. Because those premade tartlet shells aren't so easy to find anymore, I make my own by cutting a piecrust into rounds, pressing them into muffin pans, and then filling and baking. So good!

Makes 18 tartlets or one pie, see below　　Prep: 40 to 45 minutes　　Bake: 12 to 15 minutes

1 (9-inch) piecrust (pages 306 to 313),
　　rolled to a 12-inch diameter
4 tablespoons (1/2 stick/57 grams)
　　unsalted butter
1 cup (200 grams) granulated sugar
1/4 cup (48 grams) lightly packed light
　　brown sugar
3 large eggs, lightly beaten
1 tablespoon white cornmeal
1 tablespoon all-purpose flour
1 tablespoon apple cider or white
　　vinegar
1/2 teaspoon salt
2 tablespoons whole milk or buttermilk

TO BAKE A WHOLE PIE

Pour the filling in a 9-inch pie crust and bake at 425°F for 10 minutes. Reduce heat to 350°F and bake until golden and set, 25 to 30 minutes more.

1. Heat the oven to 425°F, with a rack in the lower middle.

2. Cut the piecrust into 12 (2 3/4– to 3-inch) rounds and reroll the dough to cut 6 more rounds. Press each round into the bottom of a shallow muffin pan, prick with a fork a few times in the bottom, and place in the fridge while you make the filling.

3. Place the butter in a small saucepan over low heat until it has melted, 2 to 3 minutes. Turn off the heat.

4. Place both sugars in a large mixing bowl and pour in the melted butter. Stir with a wooden spoon until creamy and combined, about 1 minute. Add the beaten eggs, cornmeal, flour, vinegar, salt, and milk or buttermilk. Mix until well combined, 1 minute more.

5. Remove the muffin pans from the refrigerator. Spoon about 1 1/2 tablespoons filling into each tartlet crust and bake until golden, 12 to 15 minutes. Leave in the pan for 10 minutes, then run a small, thin metal spatula around the edges and carefully lift the tartlets out onto a wire rack to cool completely.

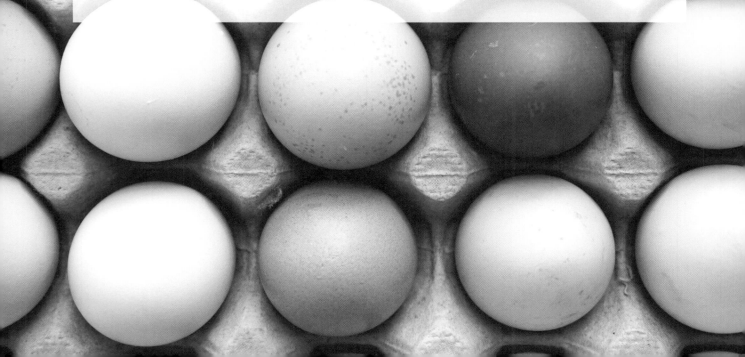

HOW CHESS PIE GOT ITS NAME

The words *chess pie* have prompted much head-scratching among food historians. Katharine Shilcutt of East Texas was told her ancestors baked chess pie and stored it in a chest of drawers, which calls to mind a variation on the name "chest" pie. Most experts, though, think "chess" is a corruption of the word "cheese," because the baked filling has a creamy consistency like cheese curds. The late Bill Neal, chef of Crook's Corner, pointed us to the last part of the *Oxford English Dictionary*'s second definition of a cheesecake: "A cake or tort of light pastry, originally containing cheese; now filled with a yellow buttermilk compound of milk-curds, sugar and butter, or a preparation of whipped egg and sugar."

Virginia historian Katharine E. Harbury wrote in *Colonial Virginia's Cooking Dynasty* (2004) that the Virginia chess pie, cheesecake, and lemon cheese didn't contain cheese at all, and the name simply describes their texture. In 1891 in *The People's Press* newspaper of Winston-Salem, North Carolina, "cheese pie" is the name given to a pie in which eggs are beaten with butter and sugar, poured into pans of pastry, and baked with a meringue in a hot oven, while a similar recipe in nearby Greensboro was called "chess pie." The Piedmont of North Carolina had been settled by English Quakers, Scottish Highlanders, Moravians, and Germans who came down the Great Wagon Road from Pennsylvania.

1748 Bakehouse Lemon Chess Tart

When Allison Vaughan bakes chess pie at 1748 Bakehouse, her bakery in historic Springfield, just north of downtown Jacksonville, Florida, she squeezes in local orange and lemon juice. She might get playful and, just before baking, throw fresh cranberries on top in the wintertime or blueberries in the spring and summer. This Virginia native learned to bake through intuition, mostly from her late paternal grandmother, Elizabeth Segar Hinkle Vaughan of Lynchburg, who was the wife of a War College general at Fort McNair and accustomed to fine food and recipes of English origin like lemon chess pie. Allison Vaughan's recipe uses a little white cornmeal. "I love the tooth the cornmeal gives," she says.

Serves 8 to 10 Prep: 30 to 35 minutes Bake: 58 to 62 minutes

1 (9-inch) piecrust (pages 306 to 313)

1 cup plus 3 tablespoons (240 grams) granulated sugar

1 tablespoon coarsely ground white cornmeal

2 teaspoons all-purpose flour

1/2 teaspoon kosher salt

4 tablespoons (1/2 stick/57 grams) unsalted butter, melted and cooled

4 large eggs

1/2 cup heavy cream

1 teaspoon grated lemon zest

6 tablespoons fresh lemon juice (2 large lemons or 3 medium)

2 tablespoons fresh orange or blood orange juice (1 medium orange)

1 teaspoon vanilla extract

1. Heat the oven to 350°F, with a rack in the lower middle. Crimp the edges of the piecrust, prick the bottom with a fork, and place in the fridge while you make the filling.

2. Place the sugar, cornmeal, flour, and salt in a large bowl and stir to combine. Add the melted butter and the eggs, one at a time, stirring well until combined. Add the cream, lemon zest and juice, orange juice, and vanilla. Pour the filling into the crust. Carefully slide the pan into the oven.

3. Bake until the filling is golden brown and the center has a slight wiggle to it, 58 to 62 minutes. The filling will set as it cools. Let the pie cool on a wire rack for 1 hour. Slice and serve.

Chocolate Chess Pie

While you see chocolate chess pie in every state in the region, it is especially revered in Mississippi, where you'll find it at funeral wakes, fancy dinner parties, and filling (gas) stations. It's just made of pantry ingredients, but when served warm with buttermilk ice cream, it's suitable for royalty! Best of all, it is a good starter pie for beginning bakers to make on their own. Keep it uncomplicated like it was intended to be. Pass on the fancy chocolate and stick with basic cocoa powder. Opt for canned milk, not heavy cream. Save some time and buy a frozen piecrust. This recipe is adapted from the fan-favorite Junior League of Jackson, Mississippi, cookbook, *Southern Sideboards* (1978).

| Serves 8 | Prep: 10 to 15 minutes | Bake: 40 to 45 minutes |

1 (9-inch) piecrust (pages 306 to 313)

1/4 cup (25 grams) unsweetened cocoa powder

3/4 cup plus 2 tablespoons (175 grams) granulated sugar

1/2 cup (96 grams) lightly packed light brown sugar

1/4 teaspoon salt

2 large eggs, lightly beaten

4 tablespoons (1/2 stick/57 grams) unsalted butter, melted

1 can (5 ounces) evaporated milk

1 teaspoon vanilla extract

Whipped Cream (page 458) or The Lee Brothers' Buttermilk Ice Cream (page 459) for serving

1. Crimp the edges of the piecrust and set aside in the fridge.

2. Heat the oven to 350°F, with a rack in the lower middle.

3. Whisk to combine the cocoa, both sugars, and the salt in a large bowl. Add the eggs, melted butter, evaporated milk, and vanilla. Stir to combine. Pour into the unbaked crust and place in the oven.

4. Bake until the crust has lightly browned and the filling has just set, 40 to 45 minutes. Remove and let cool for 1 hour, then slice and serve with whipped cream or buttermilk ice cream.

Tarte à la Bouille

Burnt milk tart, or *tarte à la bouille*, is a big, celebratory custard pie rarely baked outside of Louisiana. With a thick sugar cookie–like crust and a creamy custard filling, it tastes like heaven. First, you make the crust, lay it in the pan, and let it chill. In the Ursuline Academy fundraising cookbook, *Recipes and Reminiscences of New Orleans* (1971), Clara McCann added a bit of nutmeg to her crust. The velvety custard is stirred on top of the stove and cools down in the fridge before it's poured into the crust that's been pressed into a 10-inch pan. And then the pie is frozen briefly before baking, to keep its shape. If you can check off these boxes, you will assemble a spectacular heirloom pie just like a Cajun grandmother. Custard plus sugar cookie: How can you go wrong?

Serves 8	Prep: 1 hour, 15 minutes	Chilling and freezing: 2 hours, 5 minutes	Bake: 58 to 62 minutes

CRUST

2 1/2 cups (300 grams) unbleached flour, plus
 more for rolling

1 cup (200 grams) granulated sugar

2 teaspoons baking powder

8 tablespoons (1 stick/114 grams) unsalted
 butter, cut into 1-inch cubes

2 large eggs

2 tablespoons whole milk

Pinch of salt

1 teaspoon vanilla extract

1/2 teaspoon almond extract

FILLING

2 cups whole milk

1 cup heavy cream

1 cup (200 grams) granulated sugar

1/4 cup (40 grams) cornstarch

1/4 teaspoon kosher salt

3 large eggs

4 tablespoons (1/2 stick/57 grams) salted butter

1 tablespoon vanilla extract

Granulated sugar or cinnamon-sugar for sprinkling
 (optional)

1. **Make the crust:** Place the flour, sugar, and baking powder in a food processor or large bowl and pulse or whisk to combine. Scatter the butter cubes on top and toss with the flour. If using a processor, pulse 7 or 8 times to create big crumbs. If making by hand, press the butter flat into the flour, using your fingertips. Crack one of the eggs into a small bowl. Separate the second egg and add the yolk to the egg in the bowl. Set aside the egg white for glazing the top of the pie. Add the milk, salt, and both extracts to the eggs, mix lightly with a fork, then turn into the flour mixture and pulse or stir until the mixture comes together in a mass. Turn the dough onto a lightly floured surface and roll to a 13- to 14-inch circle (1/3-inch thickness).

2. Carefully place the crust in a 10-inch metal or heat-resistant pie pan that is 1 1/2 to 2 inches deep. Let the crust overlap the edges. Place in the refrigerator to chill for 30 minutes.

3. **Meanwhile, make the filling:** Pour the milk and cream in a medium heavy saucepan. Place the sugar, cornstarch, and salt in a small bowl and whisk to combine. Whisk the sugar mixture into the cold milk and cream until well combined. Cook over medium-low heat, stirring, until the mixture comes to a boil, 4 to 5 minutes. Meanwhile, whisk the eggs in a small bowl. Spoon 1/4 cup of the hot milk mixture into the eggs to raise their temperature, or temper them. Continue adding the hot milk in increments. After adding about 1 cup, turn the egg yolk mixture into the saucepan with the milk mixture, whisking well to combine. Continue to cook and stir over low heat with a flat wooden spoon or spatula until thickened and smooth, 8 to 10 minutes. Turn off the heat and stir in the butter and vanilla. Turn the custard into a large stainless-steel bowl and place in the refrigerator for 20 minutes.

4. When the crust is cool, remove it and the custard from the refrigerator. Pour the custard into the crust and fold the overlapping crust back over the custard. Place in the freezer for 15 minutes until very firm.

5. Heat the oven to 350°F, with a rack in the middle. Remove the pan from the freezer and brush the top of the crust with the egg white. Sprinkle the top of the pie with the sugar or cinnamon-sugar, if desired. Bake until well browned and the custard is nearly set, 58 to 62 minutes. Remove and let cool for 1 hour, then slice and serve.

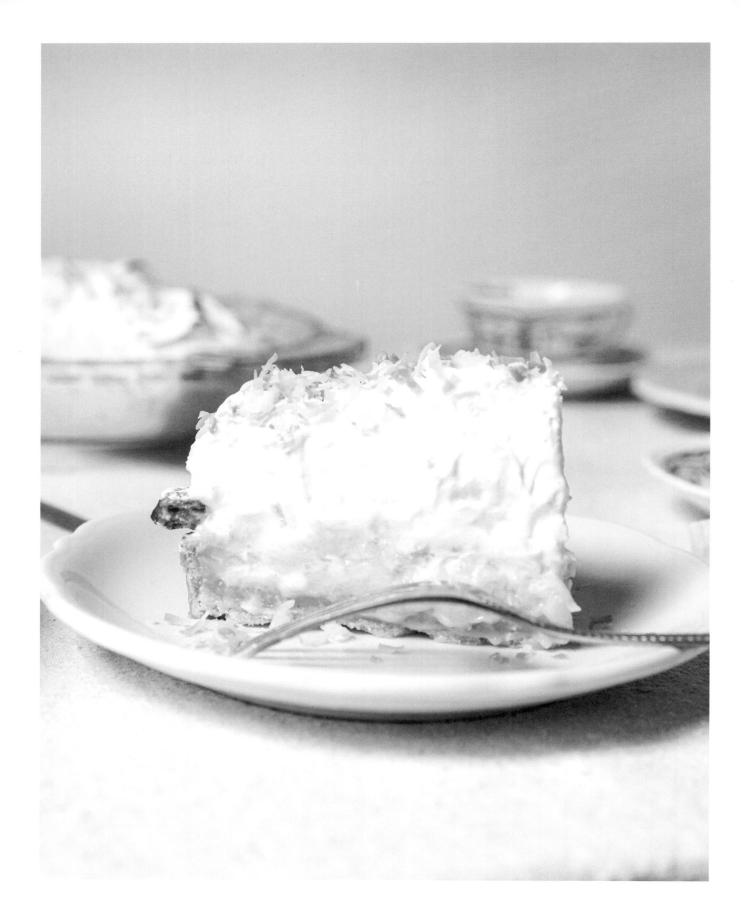

Coconut Cream Pie

Chalkboard signs outside pharmacies—what we once knew as "drugstores"—used to announce the pie of the day—chocolate, caramel, lemon, banana, or coconut. While your prescription was being filled, you could fork into a tall slice of meringue pie. Cool and cozy, this coconut meringue pie is the pie of memory, with creamy custard underneath a soft meringue piled with coconut. The recipe, called Bob's Coconut Cream Pie, was shared in a publication from the Alabama Farmer's Federation. I've added a few embellishments in the form of coconut extract and butter to amp up the flavor for those of us who are forever crazy about coconut cream pie.

Serves 8 to 10 Prep: 40 to 45 minutes Bake: 14 to 16 minutes

1 (9-inch) piecrust (pages 306 to 313), edges crimped and completely prebaked (see page 308)

CUSTARD
2 cups whole milk
2/3 cup (133 grams) granulated sugar
1/3 cup (40 grams) all-purpose flour
3/4 teaspoon salt
3 large eggs
2 teaspoons vanilla extract
1/4 teaspoon coconut extract
3/4 cup (48 grams) sweetened shredded coconut

MERINGUE
3 egg whites (from above)
6 tablespoons granulated sugar
Pinch of salt
1/4 cup (16 grams) sweetened shredded coconut for topping

1. Set aside the piecrust to cool. Leave the oven on, decreasing the temperature to 350ºF, with a rack in the middle.

2. **Make the custard:** Pour the milk into a small saucepan and bring to nearly a simmer, just until it steams. Place the sugar, flour, and salt in a large saucepan and whisk to combine. Whisk in the hot milk, turn the heat under the pan to low, and cook while continuing to whisk until the mixture thickens, 3 to 4 minutes. Meanwhile, separate the eggs and place the whites in a large bowl and set aside. Place the yolks in a small bowl and whisk until blended. Spoon a cup of the hot milk mixture into the egg yolks and, when it's blended, turn the mixture back into the saucepan with the hot milk mixture. Whisk over low heat until it thickens, 3 minutes more. Stir in the vanilla, coconut extract, and coconut. Spoon the filling into the baked piecrust and set aside.

3. **Make the meringue:** Beat the reserved egg whites with an electric mixer until frothy, 1 minute. While beating, slowly add the sugar and salt. Beat until stiff peaks form, about 3 minutes more. Dollop the meringue on top of the warm filling, spreading it to the edges of the crust. Sprinkle with the coconut. Place the pie in the oven and bake until lightly browned, 14 to 16 minutes. Remove to a wire rack to cool for 1 hour before slicing.

Bill Smith's Atlantic Beach Pie

Bill Smith was born into a large family in New Bern, a town along coastal North Carolina. You might know Smith's name if you dined at Crook's Corner restaurant in Chapel Hill, where he built on the legacy of the restaurant founder, the late Bill Neal, and focused on regional foods and recipes, elevating Southern cooking in an honest yet elegant way. The Catholic side of Smith's family ate fish every Friday, followed by lemon pie. Light and lemony, it was thick with sweetened condensed milk, rested on a salty bed of crushed crackers, and was piled high with meringue or whipped cream. When he created a menu to serve to the Southern Foodways Alliance, he chose his family's lemon pie, naming it after his favorite beach town in North Carolina.

Serves 10 Prep: 30 to 35 minutes Bake: 37 to 46 minutes total time
(crust, filling, meringue)

CRUST

60 Ritz or saltine crackers (about 6 ounces or 1 1/2 sleeves)

8 tablespoons (1 stick/114 grams) unsalted butter, at room temperature

3 tablespoons granulated sugar

FILLING AND MERINGUE

4 large eggs

1 can (14 ounces) sweetened condensed milk

1/2 cup fresh lemon juice, from 4 to 5 lemons

1/4 cup (50 grams) granulated sugar

NOTE:

To serve the pie with whipped cream instead of a meringue, omit the last step, prepare Whipped Cream (page 458), and spread over the top.

1. Heat the oven to 350ºF, with a rack in the middle.

2. **Make the crust:** Crumble the crackers into a food processor. Add the butter and sugar and pulse until nearly combined, 20 seconds. The mixture should still be a little coarse. Pat into the bottom and up the sides of a 9-inch pie pan. Place in the fridge for 15 minutes, then place in the oven and bake until the crust is golden brown, 15 to 18 minutes. Remove from the oven but leave the oven on.

3. **Make the filling:** Separate the eggs and reserve the whites for the meringue. Whisk together the egg yolks, condensed milk, and lemon juice in a large bowl. Pour into the crust and place in the oven to bake until it sets, 15 to 20 minutes. Remove from the oven but leave the oven on.

4. **Make the meringue:** In a large bowl, beat the egg whites with an electric mixer at high speed until soft peaks form, 2 to 3 minutes. Gradually add the sugar and continue beating until stiff peaks form, 1 to 2 minutes. Spread the meringue over the top of the filling, nearly to the crust. Return to the oven and bake until golden, 7 to 8 minutes. Remove from the oven, let cool for 30 minutes, then slice and serve.

HOW A BAD MEMORY CREATED A USEFUL MILK

Gail Borden, a newspaperman and surveyor, was returning from a trip to England in 1851 when he saw children die on the ship after they were fed milk from diseased cows on board. Born in New York and raised in Kentucky and Indiana, he had moved south to Liberty, Mississippi, and later Texas for health reasons and a warmer climate, but his wife and children died of yellow fever in 1844 and 1845. After that, Borden focused on making food safer to eat for all. He created an early form of beef jerky. Then, spurred by the memory of the children on the ship, he invented condensed milk, in which sugar helped soak up the water in the milk and inhibited the growth of bacteria. The concoction was yellowish, sweet, and thick, and at first it didn't sell. But the US government purchased it as rations for the Union Army during the Civil War, and after the war, production really took off.

Unsweetened evaporated milk came later. In 1884 the Helvetia Company received a patent for evaporating milk without sugar. The company became Pet Milk, a staple in kitchens nationwide. Even as the quality of fresh American milk improved in the 1900s and the refrigerator came into homes, family recipes continued to call for "Pet Milk" or "Eagle Brand."

Key Lime Pie

When our family started vacationing in the Keys, my Key lime pie journey began. It didn't matter what island we were on; there was always Key lime pie in the cooler of the fish shop and the boat rental and always a fat slice piled with whipped topping at the seafood restaurants we visited.

This recipe is adapted slightly from one baked by Key West resident Anne Parker Otto, who lived for years on the island with her husband, Gene Otto, in a Victorian home called The Artist House. A consummate entertainer, Otto used six eggs in her pie for company and four for everyday baking. Eggs weren't always available on the island, so many recipes just say to use what you've got, or you can even make the pie without eggs (however, the pie will be less rich).

Some cooks bake this pie with a traditional piecrust, and I think you can taste the bright punch of lime much better that way. Pile a meringue on top or just smother it with whipped cream, but to make this pie authentic, you must use canned milk and Key lime juice, which is more bracingly tart and also more floral than the larger, sweeter Persian limes. (I buy bottled Key lime juice, because it takes a dozen or more of those tiny limes to produce enough juice for one pie!) And if you want to make an even more authentic Florida citrus pie, substitute the juice of sour orange, the puckery and intensely perfumed citrus that grows throughout the state. Sour oranges are also known as *naranjas agrias* in Latin markets.

Serves 8 Prep: 10 to 15 minutes Bake: 45 to 50 minutes total

1 (9-inch) piecrust (pages 306 to 313), edges crimped, or Graham Cracker Crust (page 312), partially prebaked (see page 308)

1 can (14 ounces) sweetened condensed milk

6 large eggs

1/2 cup Key lime juice

3/4 cup (150 grams) granulated sugar

1. Set aside the piecrust to cool. Leave the oven on, decreasing the temperature to 350°F, with a rack in the middle.

2. Pour the condensed milk into a large bowl. Separate the eggs, placing the whites in a second large bowl and the yolks in the bowl with the canned milk. Whisk the lime juice into the bowl with the egg yolks and mix until smooth. Pour this mixture into the piecrust and place in the oven to bake until firm, 15 to 20 minutes. Remove to a wire rack.

3. Meanwhile, make the meringue. Beat the egg whites with an electric mixer on high speed until foamy, 1 to 2 minutes. With the mixer running, add the sugar, a tablespoon at a time, beating until stiff peaks form, another 3 minutes.

4. Dollop the meringue by large spoonfuls onto the baked filling, spreading it to the crust edges and using the spoon to create dips and swirls. Place the pie in the oven and bake until the meringue has browned, about 15 minutes. Let cool for 1 hour, then slice and serve.

THE STORY BEHIND KEY LIME PIE

Key Lime Pie

An authentic Key Lime Pie with native key limes. Note the creamy yellow inside. Key Lime Pie is world famous for a just right tart taste.

RECIPE

4 eggs
1 can Condensed Milk
½ cup Key Lime Juice

Beat the yolk of 4 eggs and the white of one until thick. Add the condensed milk and beat again. Add the lime juice and beat until thick. Beat the 3 remaining egg whites until dry and fold in the mixture. Pour into a baked pie shell. Separate two eggs, beat the whites with two tablespoons of sugar until stiff and forms peaks, spread on top of pie and bake in oven until meringue is brown.

Florida's Key Lime Pie

Only in Key West would a prized lime pie recipe involve mansions, canned milk, and hurricanes. The original makers of Key lime pie were likely the wives of Bahamian sponge divers. But when David Sloan, the island's longtime resident and tour guide, was interviewed by the late *New York Times* reporter Molly O'Neill, he told the story of William "Bill Money" Curry, who made a fortune in hardware by provisioning ships and brought the first sweetened condensed milk to the Keys. His mansion cook is believed to have baked some of the first lime pies with that milk. Tampa chef and longtime Florida resident Greg Baker says the Curry family dominated the import-export business out of Key West, once the largest city in Florida. A 1926 hurricane wiped out bridges and native lime trees, but it couldn't destroy Key lime pie. And even after refrigeration came to island kitchens and the road was built connecting the islands to the rest of Florida, canned milk remained in recipes. So vital to the state's tourism, Key lime was named the state pie in 2006.

KEY LIMES

The real Key lime (*Citrus aurantiifolia*) is also called a West Indian lime and is smaller than the limes (Persian) in our markets today. It looks like a yellowish-green ping-pong ball and packs a puckery punch of floral lime flavor, much tarter than the Persian limes Florida growers planted when the real Key limes were wiped out in the 1926 hurricane. Today only 10 percent of Key limes sold in the United States come from southern Florida. Most are grown in Mexico and Guatemala.

Johnetta Miller's Lemon Icebox Pie

In warm Southern climates, there is nothing more refreshing than cool lemon pie. It is the classic pie you make ahead of time and place in the fridge to chill, then take to church or a party. Originally a 1930s French Creole recipe that came out of New Orleans, lemon icebox pie is based on sweetened condensed milk. The pie made its way into the Delta of Mississippi and through Alabama and into Tennessee and other parts of the South, and even traveled to Denver, which is where *Soul Food* author Adrian Miller's mother, Johnetta Solomon Miller, baked it for her church gatherings. After she moved west from Chattanooga and joined Denver's Campbell Chapel African Methodist Episcopal Church, this sweet confection of tangy lemon filling on top of crushed vanilla wafers was what she made whenever people came together to share food. I love Miller's simple recipe, to which I have made a couple of adaptations, adding another egg and placing the pie in the oven to bake for a bit.

Serves 8	Prep and cook: 30 to 35 minutes	Bake: 30 to 35 minutes

VANILLA WAFER CRUST

6 tablespoons (3/4 stick/86 grams) unsalted butter
58 vanilla wafer or thin ginger cookies or 12 whole graham crackers

FILLING AND MERINGUE

4 large eggs
1 can (14 ounces) sweetened condensed milk
4 to 5 medium lemons
1/2 cup granulated sugar

1. Heat the oven to 350ºF, with a rack in the middle.

2. **Make the crust:** Place the butter in a small saucepan over low heat to melt. Break the cookies or crackers into a food processor and pulse into crumbs, 10 to 15 seconds. (You can also smash the crumbs using a large zipper-top bag and rolling pin and mix the crust in a large bowl. You'll need 1 1/2 cups crumbs.) Pour the melted butter into the processor and pulse 6 to 8 times so the ingredients pull together. (Or stir the butter into the crumbs.) Press the crust mixture into the bottom and up the sides of a 9-inch pie pan or a 1 1/2-quart casserole.

3. **Make the filling:** Separate the eggs, placing the whites in a large bowl for the meringue and the yolks in a large bowl for the filling. Pour the condensed milk into the yolks and whisk to combine well or beat with an electric mixer on low speed until well combined, 1 to 2 minutes.

4. Grate the zest of 1 of the lemons into the bowl with the yolk mixture. Cut all the lemons in half and juice them to yield 1/2 cup lemon juice. Pour the juice into the yolk mixture and whisk well to combine or mix

on low speed for 1 minute until well incorporated. Pour into the crust and place in the oven to bake until set, about 15 minutes. Leave the oven on.

5. **Make the meringue:** Beat the egg whites with an electric mixer on high speed until foamy, 1 to 2 minutes. Continue beating, while gradually adding the sugar, until stiff and glossy peaks form, about 2 minutes more.

6. Spoon the meringue over the top of the filling and create swirls with a spoon or spatula. Place in the oven to brown, 15 to 20 minutes. Remove from the oven and let cool to room temperature, 1 to 2 hours, before slicing and serving. Chill leftover pie, uncovered, for up to 3 days.

FROZEN LEMON ICEBOX PIE

In places without air-conditioning, you didn't turn on the oven to bake in the peak of summer. Aluminum ice cube trays that came with refrigerators did double duty and were filled with icebox pies. You'd remove the inserts that made the cubes, press the graham cracker crust mixture into the bottom and up the sides, fill them, and freeze them for at least 3 hours. The filling is similar to Miller's pie. Fold about 2 cups whipped cream (from 1 cup heavy cream) and the beaten egg whites into her lemon filling mixture (page 257). For parties, slice and top each serving with whipped cream and maybe a sprinkle of the crust mixture.

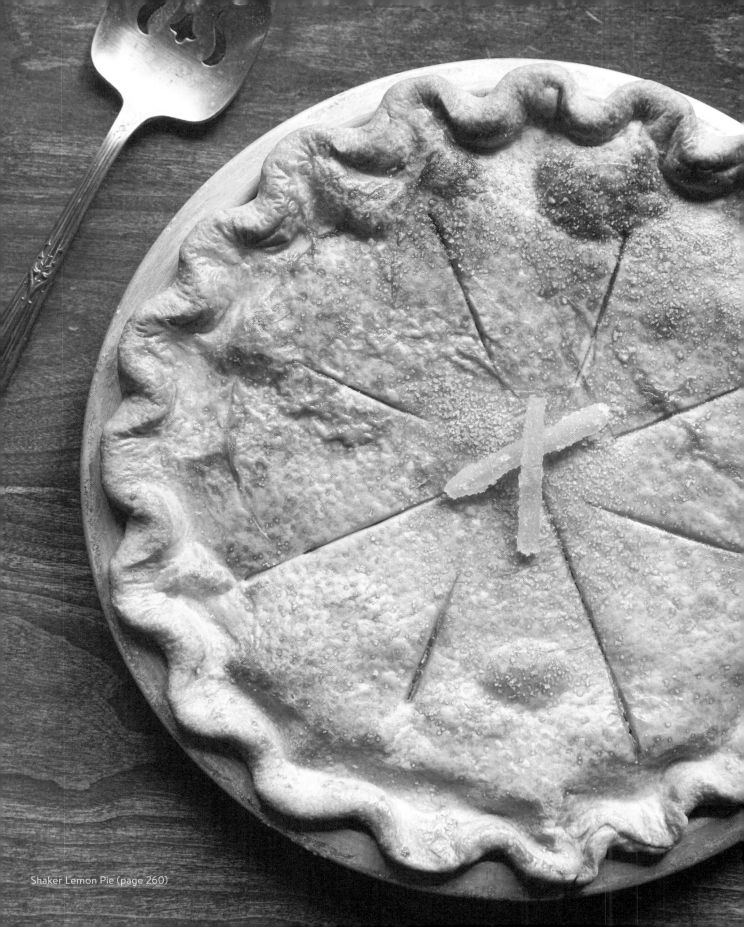

Shaker Lemon Pie (page 260)

Shaker Lemon Pie

I grew up with this intensely flavored lemon pie, the recipe for which my mother brought home from Shaker Village in central Kentucky. It's a unique pie with sliced whole lemons—the rind, pith, flesh, and all, minus the seeds—very "waste-not," just like the Shakers. Back before there were seedless lemons, the Shakers and my mother searched for the thinnest-skinned lemons they could find. The lemons macerate overnight in sugar, which makes the filling custardy and rich once baked. I've added a little butter and flour, so it's easier to slice. It's the original sweet tart.

This is a plan-ahead pie: you soak the sliced lemons and sugar on the kitchen counter overnight before baking the pie the next day.

Serves 8 Prep: 25 to 30 minutes Soaking: Overnight on the counter Bake: 35 to 40 minutes

2 (9-inch) piecrusts (pages 306 to 313), 1 in a pan with edges crimped and 1 ready to roll for the top crust

2 to 3 thin-skinned organic lemons, such as Meyer

2 cups (400 grams) granulated sugar, plus 1 tablespoon for sprinkling

4 large eggs, beaten

1/4 teaspoon salt

2 tablespoons unsalted butter, melted

2 tablespoons all-purpose flour

1 large egg white for topping

1. Set the piecrusts aside in the refrigerator.

2. Wash the lemons and pat dry. Slice them as paper-thin as possible, using a sharp paring knife or serrated knife. (You can use a mandoline if you have one, but this often is more trouble.) Discard the seeds. Place in a large bowl and add the 2 cups sugar. Mix with a spoon and let sit, lightly covered, at room temperature overnight until the sugar dissolves.

3. Heat the oven to 450°F, with a rack in the lower middle.

4. Add the lightly beaten eggs, salt, melted butter, and flour to the lemon mixture and stir well.

5. Pull the piecrusts from the fridge and pour the lemon mixture into the piecrust-lined pan. Use the other piecrust for the top, rolling it out, placing it over the filling, and crimping the edges. Slice a few vent holes in the top crust for steam to escape. Place the egg white in a small bowl and beat it with a small whisk until frothy. Brush the top of the pie with the beaten egg white. Sprinkle with the 1 tablespoon sugar.

6. Bake for 15 minutes, then reduce the oven to 375°F and bake for 20 to 25 minutes more, until the crust is deeply golden brown and a knife inserted in the center comes out clean. Let cool to room temperature before slicing, 1 to 2 hours.

THE *Shakers*

The Shaker Village of Pleasant Hill in central Kentucky, which locals call Shakertown, is one of the most beautifully rustic places in the South. Between 1805 and 1910, this was home to America's third-largest Shaker community. Today it's the largest restored Shaker village in the country. The Shakers were hardworking and religious people, originally British Quakers, and so named because they shook and danced ecstatically during religious services to rid themselves of sin. Celibate, their numbers dwindled, and only a small community in Maine remains. In the 1800s, the Shakers were self-sustaining, faithful, excellent carpenters and craftsmen, and skilled in the kitchen. The original recipe for Shaker lemon pie came from the Shakers of Cleveland, Ohio, according to Becky Soules, curator of collections at Kentucky's Shaker Village. Caroline Piercy included it in her 1953 cookbook, *The Shaker Cook Book: Not By Bread Alone*. And the first restaurant manager of Pleasant Hill, Elizabeth Kremer, placed it on the menu. Soules doubts the Kentucky Shakers ever made the pie, because they would have had to buy the lemons, something that would have gone against their tenet of self-sufficiency. Whether or not authentic, it is still delicious.

The Best Lemon Meringue Pie

It would be hard to imagine Southern baking without lemon meringue pie. Lemons have grown in sunny backyards along the coasts, and lemon meringue pie was always a big deal and something baked for holidays and birthdays. It launched the business of famed New Orleans baker Beulah Ledner, who started catering out of her home kitchen during the Depression and became known for this pie. One of my favorite recipes was shared by the late Bill Neal in his *Southern Cooking* cookbook (1985). You juice the lemons but save one to peel and slice into tiny lemon sections without membranes (called suprêmes) and fold those into the filling for even more flavor. It may sound a bit fussy, but making the suprêmes is easy, and it's fine if they fall apart as you get them into the saucepan. They make the pie profoundly lemony, a celebration ready to be sliced. Neal said this recipe was based on an 1871 recipe from *The Rural Carolinian* cookbook.

This pie is even more delectable when made with the faintly orange-flavored Meyer lemons.

Serves 8	Prep and cook: 30 to 35 minutes	Bake: 15 to 20 minutes for the meringue

1 (9-inch) piecrust (pages 306 to 313), edges crimped and partially prebaked (see page 308)

4 medium (13 ounces/370 grams) regular or Meyer lemons

3 large eggs

1 1/3 cups (267 grams) granulated sugar, plus 6 tablespoons for the meringue

1/4 cup (40 grams) cornstarch

1/4 teaspoon salt

1/2 cup cold water

1 1/4 cups boiling water

4 tablespoons (1/2 stick/57 grams) unsalted butter, cut into pieces

1. Set aside the piecrust to cool. Leave the oven on, decreasing the temperature to 350°F, with a rack in the middle.

2. Wash and pat dry the lemons. Zest 1 lemon finely to yield about 1 teaspoon and place the zest in a medium bowl. Using a serrated knife, remove the skin and pith from the same lemon. Switch to a small, sharp paring knife to section the lemon. Working over the bowl to collect the juices, cut between the membranes to release the sections (suprêmes), letting them fall into the bowl. Keep an eye out for the seeds and fish them out with a spoon. Juice the remaining 3 lemons to yield a scant 1/2 cup lemon juice and add to the bowl with the sections and zest.

3. Separate the eggs, placing the whites in a large bowl and setting it aside for the meringue. Place the yolks in the bowl with the lemon juice and pulp and whisk well. Set aside.

4. Place the 1 1/3 cups sugar, cornstarch, and salt in a medium heavy saucepan and whisk to combine. Whisk in the cold water to combine well, about 30 seconds. Add the egg yolk and lemon mixture and whisk to combine well. Whisk the boiling water gradually into the saucepan, 1 to 2 tablespoons every 10 seconds,

until all the water is added. Place the pan over medium heat and, with a flat wooden spoon or spatula, stir until the mixture has thickened and comes to a low boil for 1 minute, which takes about 10 minutes.

5. Remove the pan from the heat and continue to stir, adding pieces of the butter, until it's incorporated. Pour the hot filling into the cooled crust. Set aside.

6. Make the meringue by beating the egg whites on high speed until foamy, about 1 minute. While the machine is running, add the 6 tablespoons sugar gradually and beat until stiff peaks form, 2 to 3 minutes. Dollop the meringue on top of the filling and, with a small metal spatula or soup spoon, swirl the meringue and spread it to the crust. Place the pan in the oven.

7. Bake until the meringue is browned, 15 to 20 minutes. Let cool on a wire rack for 3 hours before slicing.

Pontchatoula Strawberry Icebox Pie

To celebrate our sweet local strawberries, festivals are held throughout the South. Louisiana hosts the oldest in April in Ponchatoula, just north of New Orleans across Lake Ponchartrain. Maryland has twenty strawberry festivals in May and June, and Florida has a dozen. Even if you can't attend, you can still honor local berries when they come into season with this ruby-red refrigerator pie. It couldn't be simpler—fresh berries, a buttery graham cracker crust, and whipped cream! The recipe is adapted from one in *Louisiana Real & Rustic* (1996) by chef Emeril Lagasse with Marcelle Bienvenu, a food writer and chef who worked at Commander's Palace and in her own restaurant.

Serves 8	Prep: 40 to 45 minutes	Chill: At least 6 hours

4 tablespoons (1/2 stick/57 grams) salted butter

1 cup (118 grams) graham cracker crumbs (from 7 or 8 crackers)

2 pounds (907 grams) fresh strawberries

1 cup (200 grams) granulated sugar, plus 3 tablespoons for the topping

1/2 teaspoon vanilla extract

3 tablespoons cornstarch

3 tablespoons brandy (see Note)

1 cup heavy cream

NOTE:

If you don't want to use the brandy in this recipe, just omit it and whisk the cornstarch into 3 tablespoons water.

1. Heat the oven to 375°F, with a rack in the middle.

2. Place the butter in a medium saucepan over low heat to melt, 2 to 3 minutes. Turn off the heat and stir in the graham cracker crumbs. Press into the bottom and sides of a 12-by-7 1/2-inch glass pan or a 2-inch deep 9-inch pie pan. Bake until lightly golden, 7 to 9 minutes. Remove from the oven and let cool. Turn off the oven.

3. Meanwhile, prepare the strawberries. Rinse and drain very well on paper towels. Remove the caps and slice lengthwise into thirds. Turn into a large saucepan over medium heat and add the 1 cup sugar and vanilla. Stir until the sugar dissolves, 3 to 4 minutes. While the strawberries are heating, whisk the cornstarch into the brandy in a small bowl and add to the berries. Continue to cook and stir until the mixture thickens, 4 to 5 minutes. Remove from the heat and let cool, 20 minutes.

4. Pour the strawberry mixture into the piecrust. Lightly cover with plastic wrap and chill until it sets, at least 6 hours.

5. When you are ready to serve, whip the cream in a large bowl with an electric mixer on high speed, gradually adding the 3 tablespoons sugar, until soft peaks form, 2 minutes. Slice and serve the pie with dollops of whipped cream.

Cantaloupe Cream Pie

A ripe cantaloupe smells like summer. You can tell a good one just by its aroma—you don't even have to cut into it to smell the honey sweetness. But alas, the problem with ripe cantaloupe is that it spoils quickly, and so this pie is a way to use it before it's too late. I'll admit that I had never heard of making a pie using cantaloupe until I picked up Mary Land's *Louisiana Cookery* and found Percy's Cantaloupe Cream Pie. In addition, a 1992 article in the *Fort Worth Star-Telegram* says Edward Pierce, who was a chef on the Texas & Pacific Railway in the 1950s and '60s, made such a pie after he saw a coworker try to throw away a case of the ripe fruit that had been ordered for breakfast. Back then Arkansas was the leading producer of cantaloupe, and railroad chefs were reprimanded for throwing away food they had ordered. This pie is about extending sweet summer cantaloupe just a bit longer, before it's gone, and it's also about how railroads influenced Southern baking. And if you take a bite and close your eyes, you'd swear you were eating a ripe slice of Athena or Pecos melon.

Serves 8	Prep: 35 to 40 minutes	Bake: 15 to 20 minutes

1 (9-inch) piecrust (pages 306 to 313), edges crimped and completely prebaked (see page 308)

1 medium cantaloupe, very ripe (2 to 3 pounds)

3 large eggs

1/3 cup (40 grams) all-purpose flour

1/3 cup granulated sugar (67 grams), plus 6 tablespoons for the meringue

1/8 teaspoon ground nutmeg

2 tablespoons unsalted butter

1/2 teaspoon vanilla extract, divided

1/4 teaspoon salt, divided

1. Set aside the piecrust to cool. Leave the oven on, decreasing the temperature to 350°F, with a rack in the middle.

2. For the filling, rinse and drain the cantaloupe. Cut off the rind and discard. Cut the flesh into 1-inch chunks and place in a microwave-safe bowl. Microwave for 1 minute on high power to warm the fruit. Transfer the chunks to a food processor in several batches and pulse until it resembles crushed pineapple, 30 to 40 seconds. Pour the contents of the processor bowl through a strainer into a clean bowl, pressing to extract as much juice as possible. Discard the drained fruit (or save for smoothies) and repeat with the rest of the cantaloupe chunks until you have 2 cups of juice. Rinse the bowl and blade of the processor of all fruit.

3. Separate the eggs, placing the whites in a large bowl and placing the yolks in the food processor. Add the flour, the 1/3 cup sugar, and the nutmeg to the yolks. Pulse until smooth, about 15 seconds. While the processor is running, slowly pour in the cantaloupe juice. Pour this mixture into a medium heavy saucepan.

4. Cook over medium heat, stirring with a flat wooden spoon or rubber spatula, until the mixture thickens. Reduce the heat to low. Once it has thickened and has the appearance of loose pudding, about 15 minutes, remove from the heat and add the butter, 1/4 teaspoon of the vanilla, and 1/8 teaspoon of the salt, stirring until the butter melts. Pour into the cooled, baked piecrust and smooth the top with the rubber spatula. Set aside.

5. For the meringue, beat the egg whites until frothy, 1 minute. While beating, slowly add the 6 tablespoons sugar, the remaining 1/4 teaspoon vanilla, and the remaining 1/8 teaspoon salt. Beat until stiff peaks form, 2 to 3 minutes more. Dollop the meringue on top of the warm filling, spreading it to the edges of the crust. Place the pie in the oven and bake until lightly browned, 15 to 20 minutes. Remove to a wire rack to cool for 2 hours before slicing.

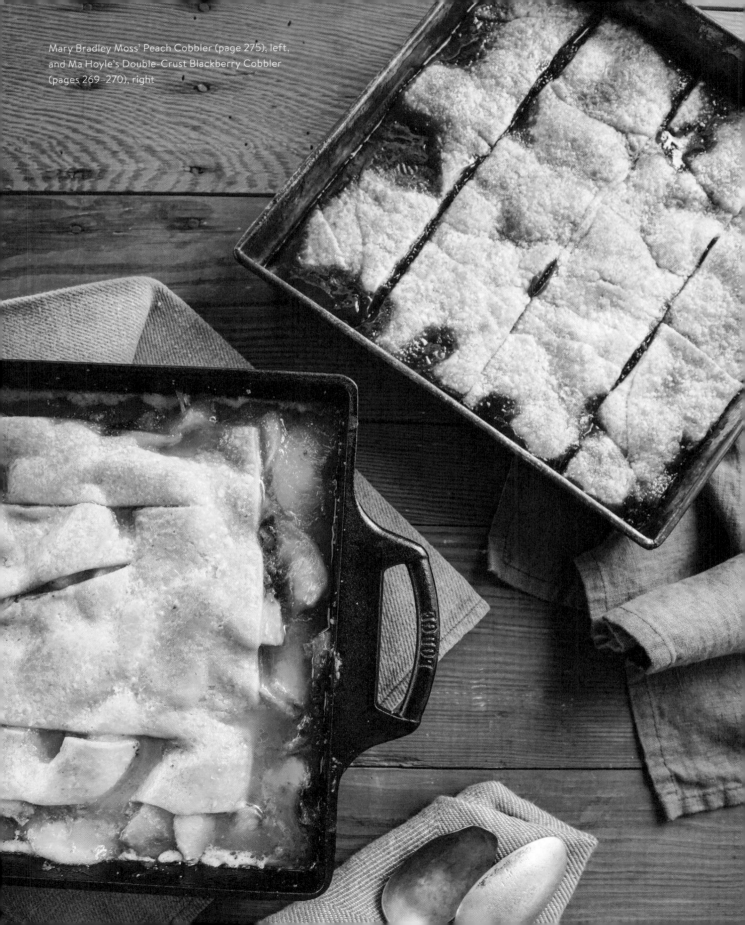

Mary Bradley Moss' Peach Cobbler (page 275), left,
and Ma Hoyle's Double-Crust Blackberry Cobbler
(pages 269–270), right

Ma Hoyle's Double-Crust Blackberry Cobbler

Beulah Hinton Hoyle, known as Ma Hoyle, ran a boardinghouse in Gastonia, North Carolina, just west of Charlotte, in the 1930s. She was Beth Carpenter's great-grandmother, and Carpenter says the midday meal at Ma Hoyle's for boarders and locals was called dinner, and the nightly meal supper. There was a meat, five or six vegetables, biscuits and cornbread, plus dessert, and as it was during the Depression, people took home any leftovers. Hoyle was especially known for this blackberry cobbler, and she had a unique way of layering fruit and pastry two times in the pan. What emerged from the oven was a triumph, worth traveling many miles for, no doubt!

After the Civil War, boardinghouses were often the only places for travelers to spend the night in the rural South. Operating one was a way for widowed women to survive financially while rearing their children. (Ma Hoyle's husband died in 1931). The mothers of two illustrious food writers both ran boardinghouses: Elizabeth Brennan Beard, the mother of food legend James Beard, and Kathleen Claiborne, the mother of *New York Times* food editor Craig Claiborne.

Serves 12	Prep: 30 minutes	Bake: 58 to 67 minutes

DOUBLE CRUSTS

2 1/4 cups all-purpose flour, plus more
 for rolling

1 1/2 teaspoons baking powder

3/4 teaspoon salt

12 tablespoons (1 1/2 sticks/170
 grams) butter or cold vegetable
 shortening, cut into tablespoon-
 size pieces

3/4 cup cold whole milk

FILLING

9 cups blackberries (about 48 ounces or four 12-ounce
 packages/1361 grams) or a mix of berries

2 1/4 cups granulated sugar

2 1/2 tablespoons all-purpose flour

8 tablespoons (1 stick/114 grams) unsalted butter, cut into pieces

1 to 2 tablespoons milk for brushing

2 tablespoons granulated sugar or cinnamon-sugar for sprinkling

1. Heat the oven to 375°F, with a rack in the middle.

2. **Make the double crusts:** Place the flour, baking powder, and salt in a food processor and pulse to combine. Scatter the butter or shortening on top of the flour and toss to coat with your fingers. Pulse 8 to 9 times to blend the butter into the flour. Add the milk and pulse until a soft dough forms. Set aside.

3. **Make the filling:** Place the blackberries in a large bowl. Stir the sugar and flour in a small bowl and fold into the berries, tossing to combine.

4. Turn the dough out onto a lightly floured counter and divide in half. Roll each half into roughly a 10- to 12-by-8-inch rectangle. Cut each rectangle into four 2-inch strips. Spoon half of the sweetened blackberries in a 10-inch square or 9-by-13-inch baking dish. Dot with half of the butter. Arrange 4 strips of pastry over the berries, leaving space between each. Place in the oven and bake until the pastry just begins to brown, 28 to 32 minutes.

5. Meanwhile, place the remaining sweetened blackberries in a medium saucepan over medium heat. Stir until the sugar on the berries begins to dissolve into a syrup, then turn the heat down to low and bring to a simmer, stirring constantly, until slightly thickened, 25 minutes. Keep the fruit at a low simmer while the first half of the cobbler bakes. If it thickens too quickly, turn off the heat.

6. Remove the pan from the oven and spoon the cooked fruit and juices from the saucepan on top of the pastry. Dot with the remaining butter. Lay the remaining 4 pastry strips on top, brush them with the milk, and sprinkle with the sugar or cinnamon-sugar. Place in the oven to bake until golden brown and bubbly, 30 to 35 minutes.

7. Remove from the oven and let cool for 15 minutes. Serve warm in bowls.

BLACKBERRIES FOR VICTORY

The Surry-Wilkes Counties region of North Carolina "had an incredible abundance of blackberries in colonial days that persisted into living memory," according to Kate Rauhauser-Smith of the Mount Airy Museum of Regional History in Surry County. "Many families have stories of extending family food stores by sending children and women into the mountain brambles with buckets in the summer to gather blackberries. Canning factories were established in the early twentieth century, and government contracts were awarded to local businesses for canned or barreled blackberries during both World Wars to feed both military personnel and the starving war populations."

Blueberry Peach Sonker

If you bake a vast deep-dish fruit pie, in most places in the South, you've made a cobbler. But in Surry and Wilkes Counties in North Carolina, the same dish is called a "sonker," and it bakes up with plenty of pan juices for spooning onto vanilla ice cream. As if that isn't enough, it's served with a custardy sauce on the side called "dip." Cratis Williams of Appalachian State University in Boone says sonker was the invention of Scottish and Scots-Irish immigrants, who began settling in the Yadkin Valley of North Carolina in the early 1700s. The word traces to the Gaelic *songle* or *sonkle*, meaning "little mess." This recipe is adapted from ones shared by food writers Nancie McDermott and Kate McDermott, both pie people but no relation.

You can absolutely substitute blackberries for the blueberries.

Serves 12	Prep: 40 to 45 minutes	Bake: 55 to 60 minutes

CRUST

2 1/2 cups (300 grams) unbleached flour, plus more for rolling
the dough

1 tablespoon baking powder

1/2 teaspoon salt

14 tablespoons (1 3/4 sticks/200 grams) cold unsalted butter,
cut into pieces

2/3 cup whole milk

FILLING

1 1/4 cups (250 grams) granulated sugar, plus 2 tablespoons for
dusting the top

2 1/2 tablespoons all-purpose flour

4 1/2 cups (30 ounces/907 grams) fresh blueberries or blackberries

3 cups sliced ripe peaches, peeled (about 6 peaches)

2 tablespoons unsalted butter, cut into small pieces

1 large egg

2 teaspoons water

MILK DIP

2 1/2 teaspoons cornstarch

6 tablespoons (75 grams) granulated sugar

Pinch of salt

1 1/2 cups whole milk

1 teaspoon vanilla extract

1. **Make the crust:** Place the flour, baking powder, and salt in a food processor (or a mixing bowl) and pulse or whisk to combine. Scatter the butter on top of the flour mixture and toss into the flour. Pulse 8 to 9 times until crumbly or rub the butter in with your fingertips. Add the milk and pulse or mix with

a fork until the dough comes together into a mass. Turn the dough out onto a floured surface and cut in half. Set one half aside for the top.

2. Working with half of the pastry dough on a lightly floured surface, roll it into a long rectangle about 18 inches long and about 4 inches wide. With a paring knife, cut the rectangle in half lengthwise. There is no crust on the bottom of the pan. Pat one of the rectangles into the sides and corners of a 9-by-13-inch pan. It will go about halfway. Repeat with the remaining strip and set the pan aside.

3. Heat the oven to 375ºF, with a rack in the middle.

4. **Make the filling:** Place the 1 1/4 cups sugar and flour in a large bowl and stir to combine. Add the berries and peaches and toss to mix. Turn the fruit into the pan. Dot with the butter.

5. Roll out the remaining dough on a floured surface into a rectangle large enough to nearly cover the berries, about 12 by 8 inches. With a 1- to 1 1/2–inch round cutter, cut random holes in the pastry for the steam and juices to escape. Fold the sheet of dough in half and then in half again, pick up the dough, and transfer it to the pan, unfolding the quarters of it. Mix the egg and water in a small bowl until combined and brush the top of the pastry. Sprinkle the 2 tablespoons sugar over the top.

6. Place the pan in the oven and bake until bubbly and golden, 55 to 60 minutes.

7. **Meanwhile, make the milk dip:** Whisk together the cornstarch, sugar, and salt in a small saucepan and whisk in the milk. Bring to a boil over medium heat, whisking. Cook until thickened, about 2 minutes, whisking constantly. Remove from the heat and stir in the vanilla.

8. Serve the milk dip on the side or, when the sonker is half-baked, pour 1/2 cup of the dip over the top and return it to the oven to finish baking, and serve the rest of the dip on the side.

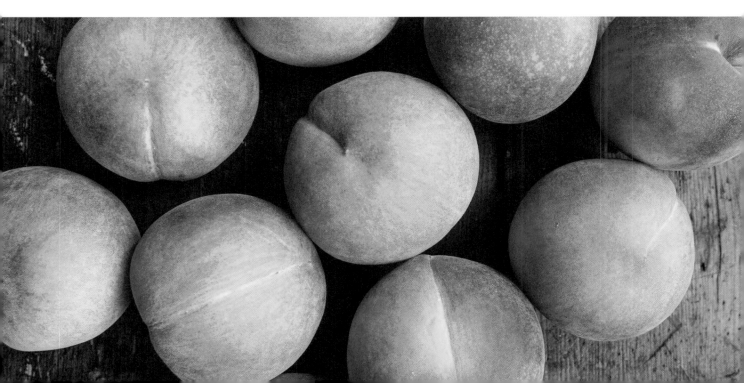

PEACH COBBLER AND *Hair Salons*

Food historian Adrian Miller says peach cobbler is one of soul food's most heralded desserts, right up there with pound cake and sweet potato pie. Dutch ovens full of this cobbler, or, as they were called in Virginia, "bucklers," were placed on a bed of coals, with more coals on top, so the cobbler baked from all sides. The first cobblers literally were made by cobbling together dough and fruit from the big-house kitchen, says author Fred Opie.

There have always been people willing to pay for home-baked peach cobbler. In the Southern Foodways Alliance's publication, *Gravy*, writer Rosalind Bentley wrote about how a cottage food industry of selling the dessert sprung up in the Black hair salons in Atlanta. Tiffany M. Gill, author of *Beauty Shop Politics: African American Women's Activism in the Beauty Industry*, says salons have nurtured business endeavors and embraced informal economies like these because "it's not a place where people are going to ask, 'Where's your food license?'"

Mary Bradley Moss' Peach Cobbler

The British brought pie to America, but the South transformed it into peach cobbler, which was baked in a Dutch oven, often called a "bake oven," or in a woodstove. To make the best cobbler, you need ripe summertime peaches with plenty of juice and high heat to brown the crust and condense the juices for even more flavor. Choose a darker roasting pan, too, such as cast iron, and place it in the lower third of the oven so the heat browns the bottom crust.

This recipe comes from Mary Bradley Moss, a Scott County, Kentucky, schoolteacher and administrator in the 1920s, and it was shared in the African American Heritage Center, Inc., of Simpson County's *Heritage Cookbook*. How she laid on the top crust, allowing space around the edges, and slit the crust so juices could bubble up, is not just functional but a work of art. It is the most delicious and memorable peach cobbler I have baked.

Serves 8 to 12	Prep: 35 to 40 minutes	Bake: 42 to 47 minutes

Crostata Dough (page 310)

8 cups sliced, peeled peaches (12 to 16 medium peaches or 3 to 4 pounds)

1 cup (200 grams) granulated sugar, divided

2 tablespoons all-purpose flour, plus more for rolling the dough

3 tablespoons unsalted butter, cut into small pieces

2 tablespoons whole milk for brushing

1. Place the dough for the crust in the fridge to chill.

2. Heat the oven to 450°F, with a rack in the middle.

3. Slice the peaches into a 9-by-13-inch cast-iron or dark metal baking dish. Measure 2 tablespoons of the sugar and set aside for the topping. Stir together the remaining sugar and the flour and scatter the mixture over the top of the peaches. Scatter the butter on top.

4. Pull the dough from the fridge and, on a lightly floured surface, roll it into a rectangle that is about 1 inch shorter than both the length and width of the pan. Carefully place the dough on top of the butter. Cut 3 vertical slits in the center. Brush the top with the milk and sprinkle with the reserved 2 tablespoons sugar.

5. Place in the oven and bake until bubbly and the pastry is golden brown, 42 to 47 minutes. Serve warm.

Frank Stitt's Peach Crostata

Birmingham chef Frank Stitt comes from Cullman in northern Alabama, where self-reliant small farmers once raised nearly everything they ate. "These Appalachian communities where people could have a couple hogs and chickens and a cow they milked and used that to make butter, dried their own apples, grew their own peaches, that is the story I wanted." He trained in French cooking at Chez Panisse with Alice Waters in Berkeley, California, and in the South of France with Richard Olney before coming home to his native state. Stitt says it took "some evolution" to unite the Southern and French traditions when he opened Highlands Bar & Grill in the mid-1980s, but what he was really starting was a Southern food *revolution*. This rustic and glorious peach crostata embodies the amalgamation of European and Southern flavors. Follow Stitt's example and choose big, meaty peaches that can stand up to a sturdy crust and high oven heat. He uses Chilton County Red Havens and is also a fan of fragrant Georgia Belle white peaches. I've adapted his recipe slightly to use a cast-iron skillet, which creates a crisp bottom crust that contrasts nicely with the soft and sweet summer peaches.

| Serves 8 | Prep: 45 to 50 minutes | Bake: 25 to 30 minutes |

Crostata Dough (page 310)

FILLING

4 to 5 cups sliced ripe peaches (from
 6 to 8 medium peaches or 1 1/2
 to 2 pounds; see Note)
1/4 cup (30 grams) all-purpose flour,
 plus more for rolling
1/3 cup (67 grams) granulated sugar
4 tablespoons (1/2 stick/57 grams)
 unsalted butter, cut into 1/2-inch
 pieces

EGG WASH AND TOPPING

1 egg yolk
1 tablespoon heavy cream
1 tablespoon coarse sugar

1. Place the dough in the refrigerator to chill while you slice the peaches.

2. Heat the oven to 425°F, with a rack in the middle.

3. Scatter some flour on a work surface and remove the dough from the refrigerator. Roll the dough into a 12-inch circle and drape in a 12-inch cast-iron skillet.

4. **Make the filling:** Place the peaches in the center of the dough, leaving a 1 1/2– to 2-inch border around them. Mix the flour and sugar together in a small bowl and sprinkle on top. Dot with the butter. Pull the dough up and over the peaches, forming pleats. Press down slightly on the pleats.

5. **Make the egg wash and topping:** Whisk together the egg yolk and cream in a small bowl. Brush the pastry with the egg wash and sprinkle with the sugar. Place the skillet in the oven.

6. Bake until the peaches give off juice and are bubbly in the center of the crostata and the dough has lightly browned, 25 to 30 minutes. Remove the skillet from the oven and let the crostata rest in the skillet for 15 minutes. With a metal spatula, transfer to a platter to slice and serve warm.

NOTE:

Whether to peel the peaches is your call. If your peaches are not ripe, you can use nectarines or punch up the flavor with fresh berries. But when your fruit is at its peak and it's never touched refrigeration, no embellishments are needed. Even if you are too modest on the amount of sugar, that can always be corrected with a scoop of vanilla ice cream!

Fried Apple Hand Pies

They've been called "hand pies," "half-moon pies," and "mule's ears," but unlike the fried pies you see at state fairs, home-fried pies use just a glimmer of oil in the skillet. The trick is to cook the crust until crispy without burning it and give the pie time to cook through. Some people use pie pastry, and others biscuit dough, as I do in this recipe. The fruit in the pie should begin as dried, not fresh, for two reasons. You want the concentration of flavor that dried apples, peaches, or apricots offer, without the liquid fresh fruit releases, which would cause the oil to spatter. Fresh fruit also turns the pastry soggy. Author John Martin Taylor remembers drying apples on concrete blocks at his grandmother's West Tennessee house.

Makes 18 fried pies Prep: 1 hour, 20 minutes Cook: 6 to 8 minutes per batch

FILLING

4 ounces (113 grams) dried apples, peaches, pears, or apricots

3 cups water or apple cider

1/4 cup (50 grams) granulated sugar

1 tablespoon butter

1/2 teaspoon ground cinnamon

1/2 teaspoon one other spice (ground allspice, ginger, nutmeg) or grated lemon zest

BISCUIT DOUGH

3 cups (360 grams) unbleached flour, plus more for rolling

1 teaspoon baking soda

1 teaspoon cream of tartar

1 teaspoon salt

1/2 cup (3.5 ounces) cold vegetable shortening or lard, or a mixture of the two

3/4 cup buttermilk, plus 1 tablespoon, if needed

1 cup peanut oil for frying

Confectioners' sugar for dusting

1. **Make the filling:** Place the fruit in a medium saucepan over medium heat with the water or apple cider. Bring to a boil, reduce the heat to low, and simmer, covered, until very tender, 45 to 50 minutes, checking the pan from time to time to make sure the liquid doesn't evaporate. If it does, add more water in 1/4-cup increments as needed while cooking until the apples are soft. Mash with a potato masher and stir in the sugar, butter, cinnamon, and spice of your choice or lemon zest. Let cool. (This makes about 2 cups.)

2. **Make the dough:** Place the flour, baking soda, cream of tartar, and salt in a large bowl or in a food processor and whisk or pulse to combine. Scatter teaspoons of the cold shortening or lard around the bowl and pour in the 3/4 cup buttermilk. Working with two knives or pulsing with the processor, mix until the dough pulls together. Add the 1 tablespoon buttermilk if the dough seems dry. Turn the dough out onto a lightly floured surface and press with your fingertips to 1/2-inch thickness. Cut out 18 (2-inch) biscuit rounds.

3. With a small rolling pin, roll each round into a 4- to 5-inch circle. Place a scant tablespoon of the filling in the center. Pick up the round and fold it in half to create a half-moon shape. Pinch the edges together with your fingertips. Press the edges together with a fork to create lines and a good seal. Flip the pie over and repeat the sealing with the fork on the other side. Set the pie aside and repeat with the rest of the biscuit rounds.

4. To fry, pour the oil into a 10- to 12-inch cast-iron skillet to measure 1/4 inch. Heat over medium heat until the oil reaches 365ºF. Slide 3 pies at a time into the skillet and cook as slowly as possible until deeply browned on one side, 3 or 4 minutes. Then, with the help of a fork, flip them over to cook for another 3 to 4 minutes; if the pies are browning quickly, just keep turning them one side to the other so they continue to cook for a total of 6 to 8 minutes. Remove to brown paper or a wire rack to drain and cool. Repeat with the remaining pies. When the pies are cool, dust with confectioners' sugar.

NOTE:

Keep the heat under the skillet at a constant 365ºF, if possible. If it runs hotter, the oil will burn the pies before they cook through. If this happens, don't despair; pull them out of the skillet, transfer them to a baking sheet, and finish cooking them in a 350ºF oven, about 10 minutes.

FRIED PEACH AND BASIL PIES

Use dried peaches and place a handful of fresh basil leaves in the pot as they simmer. You can remove the basil leaves before mashing or leave them in.

DRIED APPLES AND STACK CAKES

In the mountainous apple-growing regions of the South, what fresh apples you didn't eat or cook with were sliced and dried on a tin roof covered with a window screen to keep out the bugs or placed on a bed sheet on the hood of a car in the blazing sun. Or they were strung up with string in a sunny window or near a woodstove to dry. These dried apples could be tucked in a pillowcase or canning jars until you wanted to cook them down as a filling for fried apple pies or apple stack cake, also known as Washday Cake, Poor Man's Fruit Cake, or Appalachian Wedding Cake. In a region where poverty has played such a key role in what people ate, mountain apples offered simple indulgences.

Cherry Nut Pie

Tasting a bit like lemon icebox pie, with cherries and pecans inside, this pie was born at Roy Fisher's Steak House in Little Rock in the 1940s and was served until 2005, when the restaurant closed. Ever since, Arkansas newspaper food writer Kelly Brant has been deluged with requests for this particular recipe from her family's cookbook, *Recipes From Our Family Tree: A Book of Favorite Recipes*, by the descendants of Steven Ellis and Ora Agnes Lasley, her maternal great-grandparents who lived just north of Little Rock in Faulkner County. Either canned or frozen cherries, sweetened or unsweetened, can go into this pie, which is fit for a king, or The King, because Elvis Presley often visited Roy Fisher's restaurant.

Serves 8 Prep: 20 to 25 minutes Bake: 10 to 14 minutes for the crust Chill: 2 to 3 hours

Vanilla Wafer Crust (page 313)

1 package (8 ounces) cream cheese, at room temperature

1 can (14 ounces) sweetened condensed milk

1/2 cup fresh lemon juice (from 2 large lemons)

1 teaspoon vanilla extract

1 can (14 to 15 ounces) unsweetened pitted cherries, drained

1 cup finely chopped pecans

1. Heat the oven to 350ºF, with a rack in the middle.

2. Press the crust into the bottom and about 1 inch up the sides of a 9-inch pie pan. Place the pan in the oven and bake until the crust takes on some color and is lightly golden brown, 10 to 14 minutes. Remove from the oven to cool.

3. Place the cream cheese in a large mixing bowl and whip with an electric mixer on medium speed until fluffy, 1 minute. Gradually add the condensed milk, beating until well blended, and add the lemon juice and vanilla. Fold in the drained cherries and pecans.

4. Pour the mixture into the cooled piecrust. Chill for 2 to 3 hours, then slice and serve.

Marion Flexner's Green Tomato Pie

Louisville's Marion Flexner was an accomplished cook, first trained by Black help in the kitchen when she was a girl growing up in Montgomery, Alabama. And her mother, Adele Kahn Weil, was a nationally known Jewish cook and author of *The Twentieth Century Cook Book* (1898) with Lena Moritz. Flexner wrote about all facets of cooking and baking in the *Louisville Courier-Journal*, as well as *Vogue* and *Gourmet* magazines. This pie recipe was published in the most famous of her six books, *Out of Kentucky Kitchens* (1949). It calls for firm green tomatoes, spices, raisins, and a "spilling glass" of brandy or bourbon. It's a fragrant, resourceful, and elegant way to use end-of-the-season tomatoes.

Serves 8 Prep: 20 to 25 minutes Bake: 43 to 45 minutes

2 (9-inch) piecrusts (pages 306 to 313), 1 in
 a pan with edges crimped and 1 ready
 to roll for the top crust
3 large green tomatoes (1 1/2 pounds)
2/3 cup water
1/2 cup (2.5 ounces/75 grams) raisins
1 cup (200 grams) granulated sugar
2 tablespoons all-purpose flour
3/4 teaspoon ground cinnamon
1/2 teaspoon ground ginger
1/4 teaspoon ground nutmeg
2 tablespoons unsalted butter
1 medium lemon
1/4 cup brandy or bourbon
Vanilla ice cream for serving

1. Prick the bottom of the crust in the pan and place the other, to be used for the top, in the fridge. Heat the oven to 450°F, with a rack in the middle.

2. Slice the tomatoes 1/4 inch thick. You'll need 4 cups sliced tomatoes. Cut the slices in half, place them in a 10-inch skillet, and pour over the water. Cook over medium heat until the tomatoes are translucent and have softened, 8 to 10 minutes. Add the raisins, toss, and cook for 1 minute more. Remove from the heat.

3. Ladle the tomatoes and raisins (and any cooking juices) onto the bottom crust. Place the sugar, flour, cinnamon, ginger, and nutmeg in a small bowl and toss to combine. Set aside 1 tablespoon and scatter the rest on top of the tomatoes. Cut the butter into small pieces and scatter over the top. Zest the lemon and scatter the lemon zest over the butter. Cut the lemon in half and juice it to extract 1 1/2 tablespoons and pour over. Then pour the brandy or bourbon across the top.

4. Remove the crust from the fridge, roll it out, and then cut it into 1/2-inch strips. Lattice these on top of the pie, pinching on the sides to secure them to the bottom crust. Scatter the reserved 1 tablespoon spice mixture over the top. Place the pie on a rimmed baking sheet to catch any juices and place the pan in the oven.

5. Bake for 15 minutes, then reduce the oven temperature to 375ºF and cook until the pie is bubbly and the crust is deeply browned, 28 to 30 minutes more. About 10 minutes before the pie has finished baking, or when the pie is getting deeply browned, lightly cover the top with foil to prevent overbrowning.

6. Remove from the oven, let the pie cool for 30 minutes, then slice and serve with vanilla ice cream.

GREEN TOMATOES

September's cooler weather, fewer sunny days, and the garden's lack of interest to ripen tomatoes bring us the annual bittersweet bounty of green tomatoes. I just place them in a sunny kitchen window and don't give them a lot of thought until those tomatoes ripen in a week and are incredibly delicious on a bacon sandwich, or I slice the green tomatoes and make Marion Flexner's wonderful pie.

Jean Young's Sweet Potato Custard Pie

Pie made from sweet potatoes took hold in church basements and grandmothers' kitchens and became the dessert embraced by Black cooks—the pie of the diaspora as they traveled out of the South during the Great Migration. This recipe for a big, rich sweet potato custard pie comes from the late Jean Childs Young, the wife of Andrew Young, Atlanta's mayor from 1982 to 1990. I was fortunate to interview Jean Young when I was the food editor of the Atlanta newspapers, and this recipe is adapted from her recipe found in Margaret Wayt DeBolt's *Georgia Sampler Cookbook* (1983).

Serves 8	Prep: 30 to 35 minutes	Bake: 53 to 58 minutes

1 (9- or 10-inch) piecrust (pages 306 to 313)

3 medium (1 1/4 pounds) unpeeled sweet potatoes

4 tablespoons (1/2 stick/57 grams) unsalted butter, at room temperature

1 teaspoon vanilla extract

1 1/2 cups heavy cream or evaporated milk

3 large eggs

1/2 cup (96 grams) lightly packed dark brown sugar

1/2 cup dark corn syrup or sorghum

1 teaspoon ground cinnamon

1/2 teaspoon ground nutmeg

1/2 teaspoon ground ginger

1/2 teaspoon salt

Whipped Cream (page 458) for serving (optional)

1. Place the piecrust in a 9- to 10-inch deep-dish pie pan, crimp the edges, and set aside in the fridge.

2. Rinse and pat dry the sweet potatoes. Place them in a large saucepan, cover with water, and boil in their "jackets" (unpeeled) until very tender when pierced with a fork, 25 to 30 minutes, depending on the size of the potato. You should be able to stick a fork nearly through with ease. Drain, and when cool enough to handle, peel and mash. You'll need 1 3/4 cups mashed sweet potatoes.

3. Heat the oven to 375°F, with a rack in the lower middle.

4. Place the warm sweet potatoes, butter, and vanilla in a large bowl and stir until the butter melts. Stir in the cream or evaporated milk.

5. Separate the eggs, placing the whites in a large clean bowl and the yolks in the bowl with the sweet potatoes. Stir vigorously to incorporate the yolks. Stir the brown sugar, corn syrup or sorghum, cinnamon, nutmeg, ginger, and salt into the sweet potato mixture until smooth.

6. Beat the egg whites with an electric mixer on high speed until nearly stiff peaks form, about 3 minutes. Fold the beaten whites into the sweet potato mixture until smooth. Pour into the piecrust and place the pan in the oven.

7. Bake until a knife inserted in the center comes out clean and the pie is browned around the edges, 53 to 58 minutes. Let cool in the pan for 1 hour before slicing and serving with whipped cream, if desired.

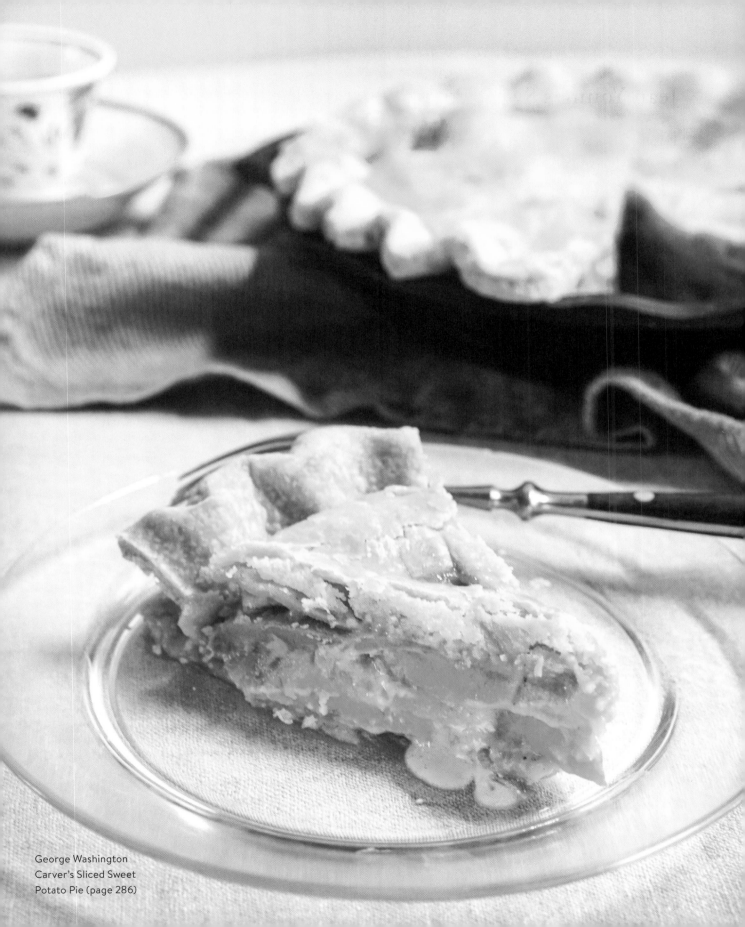

George Washington
Carver's Sliced Sweet
Potato Pie (page 286)

George Washington Carver's Sliced Sweet Potato Pie

Scientist and inventor Dr. George Washington Carver, the child of a Mississippi slave, believed peanuts, sweet potatoes, and science could free Southern farmers from poverty. Cotton had exhausted the soil of the Deep South, and at Tuskegee Normal and Industrial Institute (now Tuskegee University) in southeastern Alabama in the early twentieth century, he showed farmers the benefits of planting sweet potatoes. They were well suited to Alabama, and he worked to grow demand by developing 118 products made from them, including flour, vinegar, molasses, ink, rubber, and even postage stamp glue.

And, of course, he cooked with them, slicing them into this tantalizing pie where, with spices, molasses, and cream, they cook down inside the flaky pastry. When you fork into a bite, it's a bit like pie and a bit like your favorite sweet potato casserole. This recipe is adapted from *The Historical Cookbook of the American Negro* (1958).

Serves 6 to 8	Prep: 30 to 35 minutes	Bake: 62 to 67 minutes

2 (9-inch) piecrusts
(pages 306 to 313)

2 medium (1 pound)
unpeeled sweet
potatoes

1/2 teaspoon ground
allspice

Dashes of ground ginger,
cloves, and nutmeg

4 tablespoons (1/2 stick/57
grams) salted butter,
cut into tablespoons

1/2 cup (100 grams)
granulated sugar

1/4 cup molasses

1 cup heavy cream

1 tablespoon all-purpose
flour

1/3 cup hot water

1. Line a 9-inch deep-dish pie pan or 1 1/2–quart casserole with one piecrust and set aside. Keep the other piecrust refrigerated.

2. Rinse and pat dry the sweet potatoes. Place them in a large saucepan, cover with water, and boil in their "jackets" (unpeeled) until nearly tender, 15 to 20 minutes. They should be soft but still firm. Drain and set aside to cool.

3. Heat the oven to 350°F, with a rack in the middle.

4. When the potatoes are cool enough to handle, peel them and slice lengthwise 1/3 inch thick. Lay the sweet potatoes on top of the crust. Sprinkle with the allspice, ginger, cloves, and nutmeg. Scatter the butter over the top, sprinkle on the sugar, and pour over the molasses and cream. Sprinkle the flour over the top and pour over the hot water.

5. Lay the second piecrust on top and trim the edges. With a fork, press the edges of the crust together to seal. Cut 6 (2-inch) slits in the top of the crust. Place in the oven and bake until golden brown and bubbly, 62 to 67 minutes. Remove from the oven and let cool for 30 minutes, then slice and serve.

Tidewater Peanut Pie

The Tidewater is a sandy coastal region covering eastern Maryland, Virginia, and North Carolina, named because the rivers that flow through it rise and fall with the tide from the ocean. Peanuts are so ingrained in the Virginia Tidewater that, by law, the prestigious Smithfield ham must come from hogs that graze on these colossal nuts. I found this recipe in the *Nashville Seasons* cookbook, published in 1964. The late Keith Cutchins DeMoss, who grew up in Franklin, Virginia, in the Tidewater, said it's "much like pecan pie, but to those who love peanuts, it is better." So true.

Serves 8 Prep: 25 to 30 minutes Bake: 45 to 50 minutes Cool: 3 hours

1 (9-inch) piecrust (pages 306 to 313)

1/2 cup (96 grams) lightly packed light brown sugar

1 1/4 cups light corn syrup

4 tablespoons (1/2 stick/57 grams) unsalted butter

3 large eggs

1/2 teaspoon vanilla extract

1 1/4 cups (6 ounces) roasted, salted peanuts

1. Crimp the edges of the piecrust and set aside in the fridge.

2. Place the brown sugar, corn syrup, and butter in a medium saucepan over medium heat and bring to a boil, stirring constantly, until the brown sugar has dissolved, the butter has melted, and the mixture is syrupy, 7 to 8 minutes.

3. Crack the eggs into a large bowl and whisk until combined. Pour the hot syrup into the eggs, whisking constantly. Whisk in the vanilla. Fold in the peanuts. Let the mixture cool in the bowl for 15 minutes.

4. Meanwhile, heat the oven to 400°F, with a rack in the middle.

5. Once the filling has cooled, pour the mixture into the piecrust and place in the oven. Bake for 10 minutes, then reduce the temperature to 375°F and bake until the pie is golden brown and nearly set in the middle, 35 to 40 minutes more. Let cool to room temperature, 3 hours, then slice and serve.

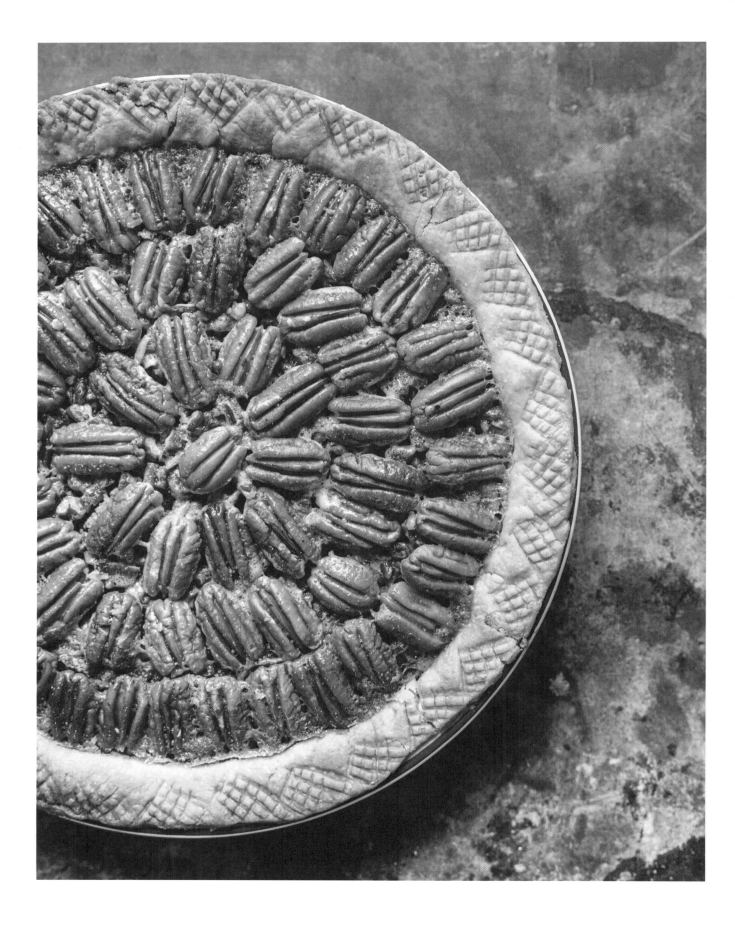

Zephyr Wright's Pecan Pie

Zephyr Wright was majoring in home economics at Wiley College in Marshall, Texas, in 1942 when she was hired by Lady Bird Johnson to cook for the family. Eventually she became the First Family's personal chef, traveling to the White House. She knew the foods President Lyndon Johnson loved, like this rich and gooey pecan pie, made with dark corn syrup and plenty of pecans. At the Texas ranch and the White House, Wright was referred to as "the queen of the kitchen," and she influenced President Johnson's passing the Civil Rights Act of 1964 by relating her personal stories of discrimination and Jim Crow segregation to him.

Karo corn syrup, an essential ingredient in this pie, became a Depression substitute for white sugar. Before its invention, Southerners had been baking pecan pie with sugarcane syrup. Karo would hold a recipe contest in the 1930s and thereafter, a Karo Prize Pie was printed on the back of both the blue-label (dark corn syrup) and red-label (white corn syrup) bottles, whichever one you bought. Today, for even more flavor, you can substitute cane, agave, or date syrup for the Karo.

Serves 8 Prep: 15 to 20 minutes Bake: 40 to 45 minutes

1 (9-inch) piecrust (pages 306 to 313)
1 cup (200 grams) granulated sugar
1/2 cup dark corn syrup
4 tablespoons (1/2 stick/57 grams) unsalted butter, melted and cooled
1 1/2 teaspoons vanilla extract
1/2 teaspoon salt
3 large eggs
1 1/2 to 2 cups (171 to 228 grams) pecan halves

1. Crimp the edges of the piecrust and set aside in the fridge. Heat the oven to 375°F, with a rack in the lower middle.

2. Place the sugar, corn syrup, melted butter, vanilla, and salt in a large mixing bowl and stir to combine well. Lightly beat the eggs in a small bowl and stir into the mixture. Fold in the pecans.

3. Pour the filling into the piecrust and, using a fork, arrange the pecan halves on top so the rounded sides are up. Place the pan in the oven and bake until the pie is deeply golden brown and no longer jiggles when you shake the pan, 40 to 45 minutes. (If necessary, shield the crust with a piece of aluminum foil to prevent overbrowning.)

4. Remove the pan from the oven and let the pie cool for at least 1 hour before slicing. If possible, bake a day in advance and keep lightly covered at room temperature.

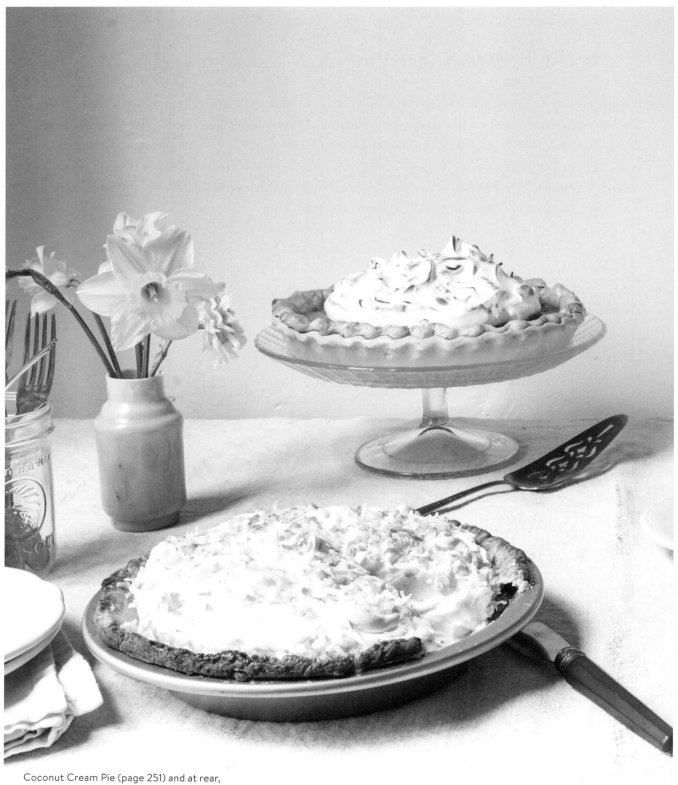

Coconut Cream Pie (page 251) and at rear,
Kentucky Brown Sugar Pie (recipe on next page)

Kentucky Brown Sugar Pie

Jackie Drake's grandmother, Timie Jane Richardson Martin, spent her life in central Kentucky, and in 1932 she and her husband bought a 168-acre farm in Bloomfield, where they raised tobacco and hogs. When it was tobacco season, she fed up to a dozen farm hands lunch, often ending with this easy-to-assemble brown sugar meringue pie. "I couldn't count how many tobacco hands they fed each year," says Drake, a home cook in Bardstown. Brown sugar was easier to get than white sugar in the World War II rationing years, so it became a part of this family recipe, adding both color and flavor.

Serves 8 Prep: 25 to 30 minutes Bake: 10 to 15 minutes

1 (9-inch) piecrust (pages 306 to 313), edges crimped and partially prebaked (see page 308)

1 cup (192 grams) lightly packed dark brown sugar

1/3 cup (40 grams) all-purpose flour

1/4 teaspoon salt

2 cups whole milk

3 large eggs, at room temperature

1 tablespoon unsalted butter

1 1/2 teaspoons vanilla extract, divided

1/4 teaspoon cream of tartar

6 tablespoons granulated sugar

1. Set aside the piecrust to cool. Leave the oven on, decreasing the temperature to 350°F, with a rack in the middle.

2. Place the brown sugar, flour, and salt in a medium saucepan and stir to combine. Slowly whisk in the milk. Place the pan over medium heat and cook, stirring constantly, until the filling begins to thicken and is bubbly, 4 to 5 minutes. Reduce the heat to low and continue to cook the filling until it has completely thickened, 2 minutes longer. Remove the pan from the heat.

3. Separate the eggs, placing the yolks in a small bowl and the whites in a medium stainless-steel or glass bowl. Reserve the egg whites for the meringue. Beat the yolks with a fork to combine. Add 3 tablespoons of the hot filling to the yolks and stir well. Then whisk the yolk mixture back into the filling. Place the pan over low heat and cook, whisking, until the yolks are well combined and the filling is thick, creamy, and smooth, about 2 minutes. Remove the pan from the heat and stir in the butter and 1 teaspoon of the vanilla. Pour the filling into the prebaked crust.

4. To make the meringue, beat the egg whites with an electric mixer on high until frothy, 1 to 2 minutes. Add the cream of tartar and the remaining 1/2 teaspoon vanilla and continue beating on high, gradually adding the granulated sugar. Beat until stiff peaks form, 2 to 3 minutes more.

5. Pile spoonfuls of meringue on top of the filling. Using a spatula, push the meringue to the edge of the crust to seal in the filling. Place in the oven and bake until the meringue deeply browns, 10 to 15 minutes. Let cool for 3 hours at room temperature before slicing.

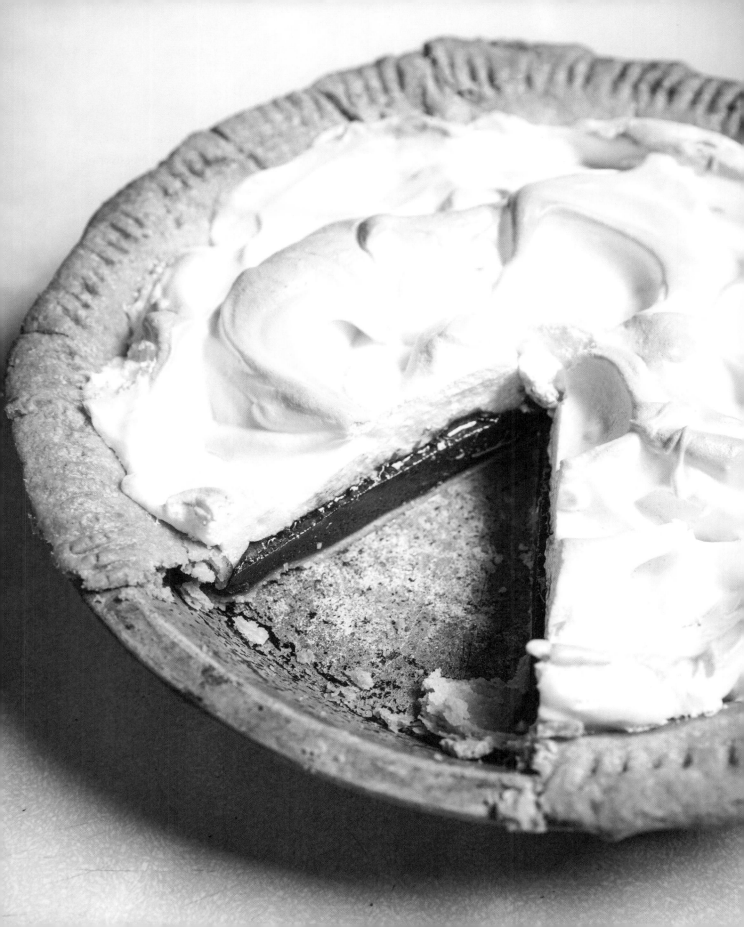

Maggie Cox's Warm Chocolate Meringue Pie

Sometimes chocolate meringue pie is a stroke of genius. Maggie Lean Cox was born in southern Louisiana and well trained in Creole cooking when she came to work for the Buford family in Glendora, Mississippi, in 1958. Lee Buford Threadgill of Jackson remembers her well-seasoned and fine food. Her specialty was a meringue pie with a rich chocolate filling that doesn't need to be stirred over a hot stove. Once the pie is baked, the meringue is spread onto its warm surface, and it goes back in the oven to brown. But unlike most meringue pies, this pie can be sliced warm and doesn't run all over the pan, should you try to grab a slice before it's cooled! Cox died in 1989 at seventy-nine. I traveled to Glendora to bake this pie with Threadgill and learn more about the culinary legacy of Cox.

Serves 8	Prep: 30 to 35 minutes	Bake: 54 to 60 minutes

1 (9-inch) piecrust (pages 306
 to 313)

3 large eggs

1 cup granulated sugar (200
 grams), divided

3 tablespoons all-purpose flour

3 tablespoons unsweetened
 cocoa powder

1 tablespoon vanilla extract

1 cup whole milk

2 tablespoons salted butter

1. Heat the oven to 350°F, with a rack in the lower middle. Crimp the edges of the piecrust and prick holes in the bottom. Set aside in the fridge until ready to fill.

2. Separate the eggs, placing the whites in a large bowl and the yolks in another large bowl. Measure 6 tablespoons of the sugar and set aside for the meringue. Place the remaining sugar in the bowl with the egg yolks and whisk to combine well. Whisk in the flour, cocoa, and vanilla until smooth. Place the milk and butter in a small saucepan over medium heat until the butter melts, then whisk the hot milk mixture gradually into the egg yolk mixture until well incorporated. Remove the crust from the fridge and pour the filling into the crust. Place in the oven and bake until the pie is firm to the touch, 44 to 48 minutes. Remove from the oven to a wire rack.

3. Beat the egg whites with an electric mixer on high speed until foamy, 1 minute. With the mixer running, gradually add the reserved 6 tablespoons sugar, beating on high until stiff peaks form, 2 minutes more. Spoon the meringue on top of the filling and, with a soup spoon, spread it to the edges and create waves and dips. Place the pan in the oven. Bake until the meringue is golden brown, 10 to 12 minutes. Remove to the rack, then slice.

Betty Kennedy's Black Bottom Pie

Marjorie Kinnan Rawlings once said black bottom pie was "the most delicious pie I have ever eaten . . . I hope to be propped up on my dying bed and fed a generous portion." The pie began as a 1920s plain Jane chocolate custard pie, piled high with whipped cream, and was popular on the West Coast. But when it gained a gingersnap crust and a little rum extract in the South, it got some attention. It got even more attention when Prohibition ended. By 1947 the *Louisville Courier-Journal*'s food editor Cissy Gregg was pouring Kentucky bourbon into the filling. In Memphis, it was flavored with rum. Some people thought the pie was named for the rich bottom land of the Mississippi Delta. I believe it's intended to describe the chocolate custard sandwiched between vanilla custard on top and gingersnap crust below.

Betty Kennedy, who made black bottom pie famous in Alabama, served this version of the signature pie at the Gaines River Dinner Club, which was housed in her circa-1827 antebellum home. It was selected as one of the 100 Dishes to Eat in Alabama by the state's tourism board. Use rum or bourbon—it's your choice. But I recommend making the pie the night before serving, so it has more time to chill and will be easier to slice.

Serves 8	Prep: 45 to 50 minutes	Bake: 10 to 12 minutes for the crust	Chill: At least 4 hours, or overnight

GINGERSNAP CRUST

33 gingersnap cookies (7 to 8 ounces; see Notes)

2 tablespoons granulated sugar (optional)

4 tablespoons (1/2 stick/57 grams) unsalted
 butter, melted

FILLING

1 1/2 ounces unsweetened chocolate, chopped

2 teaspoons vanilla extract, divided

1 package (0.25 ounce) unflavored gelatin

1/4 cup cold water

2 cups whole milk

2/3 cup (133 grams) granulated sugar, plus 1/4 cup
 (50 grams)

2 1/2 teaspoons cornstarch

4 large eggs (see Notes)

1/4 to 1/3 cup bourbon or dark rum

TOPPING

1 cup heavy cream

1 tablespoon (12 grams) granulated sugar

Semisweet chocolate shavings for garnish

1. Heat the oven to 350ºF, with a rack in the middle.

2. **Make the crust:** Place the cookies on a large cutting board and, with a heavy knife, chop them into halves. Transfer the broken cookies to a food processor and pulse, in batches if necessary, until they are in small crumbs. You should get about 1 3/4 cups. Spoon the crumbs into a medium mixing bowl and stir in the sugar, if desired, and the melted butter. Turn the crust mixture into a 9-inch glass pie pan and

press the mixture across the bottom and up the sides. Place the pan in the oven and bake until it is firm and takes on a little color, 10 to 12 minutes. Remove and let cool while you assemble the rest of the pie.

3. **Make the filling:** Place the chocolate and 1 teaspoon of the vanilla in a small bowl and set aside. Place the gelatin in a small bowl and add the water. Stir until it is dissolved.

4. Pour the milk into a medium saucepan over medium-high heat and bring it nearly to a boil, until it steams. Remove the pan from the heat. Meanwhile, stir together the 2/3 cup sugar and cornstarch in a bowl. Separate the eggs, stirring the yolks into the cornstarch mixture. Set aside the whites in a large bowl.

5. Carefully and briskly whisk 1/2 cup of the hot milk into the egg yolk mixture. Add the rest of the hot milk, whisking constantly. Turn the milk–egg yolk mixture into the top of a double boiler (or see Note, page 375) set over a pan of simmering water. Cook over medium heat, stirring constantly with a wooden spoon until it thickens, about 10 minutes. Remove the custard from the heat. Pour 1 cup of the custard into the chopped chocolate (reserve the rest for the vanilla custard) and stir to melt the chocolate. Let the chocolate custard cool.

6. Fold the gelatin mixture into the remaining hot plain custard until incorporated. Pour that mixture into a clean bowl and let it cool to room temperature, about 20 minutes. (You can speed things up by placing the bowl in a large bowl filled with ice water.) When the plain custard is cool, add the bourbon or rum and the remaining 1 teaspoon vanilla. Set the vanilla custard aside.

7. To assemble the pie, spread the cooled chocolate custard in the bottom of the piecrust. Place in the refrigerator.

8. Beat the reserved egg whites with an electric mixer on high speed until soft peaks begin to form, about 2 minutes. Gradually add the 1/4 cup sugar, continuing to beat until stiff peaks form. Fold the beaten egg whites into the vanilla custard until well incorporated. Remove the pie from the fridge and ladle the vanilla custard over the chocolate layer. Return the pie to the fridge and chill for at least 4 hours or preferably overnight.

9. **Make the topping:** When you're ready to serve, pour the cream and sugar into a large chilled bowl and beat with an electric mixer on high speed until it is of a spreading consistency (not stiff peaks), about 2 minutes. Remove the pie from the fridge, spread the topping over the pie, garnish with chocolate shavings, and serve.

NOTES:

I used Keebler cookies, about 33 of them, pulsed in a food processor.

While the egg yolks are cooked in the custard filling, the egg whites are not cooked. If you prefer, use pasteurized eggs, such as Eggland's Best.

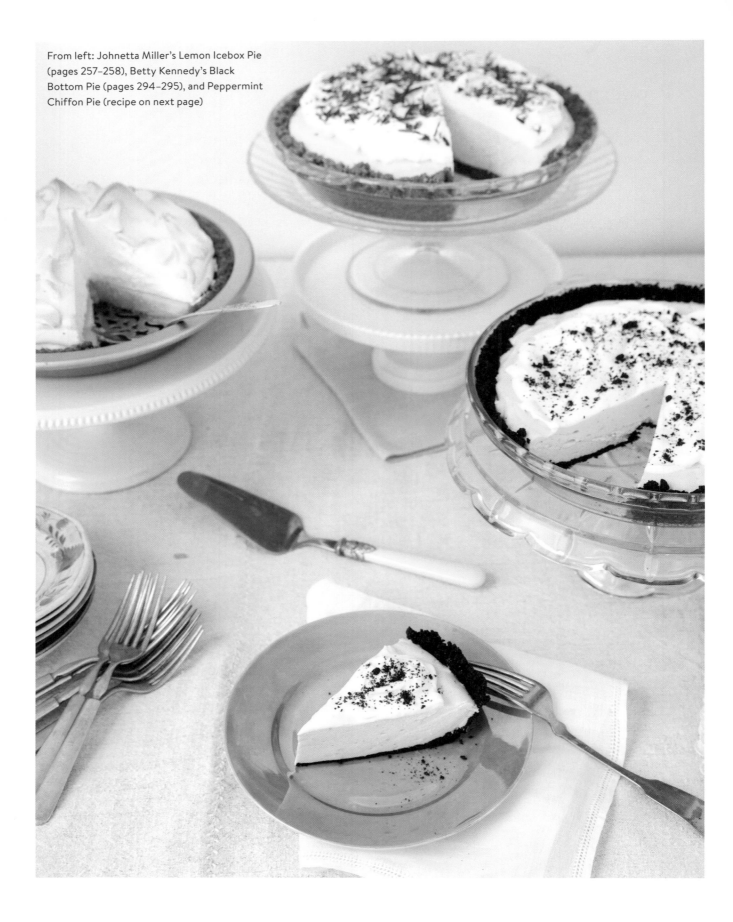

From left: Johnetta Miller's Lemon Icebox Pie (pages 257–258), Betty Kennedy's Black Bottom Pie (pages 294–295), and Peppermint Chiffon Pie (recipe on next page)

Peppermint Chiffon Pie

A peppermint icebox pie with chocolate cookie crust was Southern novelist Flannery O'Connor's favorite dessert to order at the Sanford House restaurant in Milledgeville, Georgia. Its pastel filling, the color of heirloom pink peonies, is made from melted soft peppermint candies and cream. Thanks to a little gelatin, it slices beautifully and keeps its cool composure even in warm weather, a hallmark of a good refrigerator pie and probably a good lesson for all of us. While O'Connor's literary subjects were known for their imperfections, this pie was just about perfect. Still is.

| Serves 8 | Prep: 50 to 55 minutes | Bake: 10 to 12 minutes for the crust | Chill: 45 minutes at room temperature, 4 hours in the refrigerator |

CRUST

28 (5.5 ounces) chocolate wafer cookies (see Note)

1 tablespoon granulated sugar

4 tablespoons (1/2 stick/57 grams) unsalted butter, melted

FILLING

1 tablespoon (about 1 1/2 envelopes) unflavored gelatin

1/4 cup cold water

3 large eggs

3/4 cup (150 grams) granulated sugar, divided

1/8 teaspoon salt

1 can (5 ounces) evaporated milk or half-and-half

3/4 cup water

8 (1 ounce) soft, round peppermint candies

TOPPING

Whipped Cream (page 458)

1. Heat the oven to 350°F, with a rack in the middle.

2. **Make the crust:** Break the wafers into a food processor and pulse until they are crushed into crumbs, 7 to 8 pulses. Add the sugar and pulse to combine. Add the melted butter and pulse until well distributed, 8 to 10 times. Press all but 2 tablespoons of the mixture into the bottom and sides of a 9-inch pie pan. (Reserve the rest for garnish.) Place the pan in the oven and bake until it is firm to the touch, 10 to 12 minutes. Set aside on a wire rack to cool completely. Turn off the oven.

3. **Make the filling:** Whisk the gelatin into the cold water in a small bowl. Set aside. Separate the eggs, placing the whites in a large mixing bowl and the yolks in a medium bowl. Set aside the whites. Whisk 1/4 cup of the sugar and the salt into the yolks.

4. Place the evaporated milk or half-and-half and water in a large heavy saucepan over medium heat and stir until steaming but not boiling, 5 to 6 minutes. Remove from the heat and stir in the peppermint candies. Whisk constantly until nearly melted. Whisk about 1/2 cup of this hot peppermint-milk into the egg yolk mixture,

then pour back into the saucepan. Cook gently, reducing the heat under the pan as needed, to keep the mixture cooking slowly. Stir with a flat wooden spoon constantly until it thickens, 10 to 12 minutes. Remove from the heat and pour the custard into a large clean bowl to cool more rapidly. Add the gelatin mixture, whisking to combine. Set aside to cool at room temperature, 45 minutes.

5. When the custard has cooled to room temperature, beat the egg whites with an electric mixer on high speed until frothy, 1 minute. Continue beating, adding the remaining 1/2 cup sugar gradually by tablespoons, until soft peaks form, 3 minutes. Spoon about a quarter of the beaten egg whites onto the cooled custard mixture, and fold into the custard to lighten it. Continue folding in the rest of the whites until well combined. Pour this mixture into the cooled crust. It will be quite full. Carefully place in the fridge to chill for at least 4 hours.

6. Spread the whipped cream evenly over the top of the chilled and firm pie, garnish with the reserved crushed crumbs, slice, and serve.

NOTE:

I use Nabisco Famous Chocolate Wafers, which at this writing are hard to find. You can substitute chocolate sandwich cookies without the crème filling.

FLANNERY O'CONNOR

Born in Savannah in 1925, Flannery O'Connor suffered from lupus. This autoimmune illness drove her back to her mother, Regina, and their peacocks on the family's Georgia farm, after her literary pursuits in Iowa and New York. The cortisone medicine she took to keep the lupus at bay weakened her bones and put her on crutches. Scholars say her Catholic faith allowed her to endure her debilitating illness, and her illness gave her the ability to see humanity for what it was: imperfect, striving, humorous, isolated. O'Connor died in Milledgeville in 1964 at thirty-nine. Two years later, the 1825 home that housed the restaurant where O'Connor and her mother lunched was moved and saved from demolition, preserving a page in the history book of Milledgeville.

Arkansas Possum Pie

Don't worry: there are no marsupials in this pie! Kat Robinson, an Arkansas food writer who is the author of *Another Slice of Arkansas Pie* and a fifth-generation Arkansan, says the pie, which is especially popular in western and northern parts of the state, features a pecan cookie bottom topped with cream cheese, then chocolate, hidden under the cover of whipped cream. So how did the pie get its name? It's pretending, she says, pretending to look white. When you fork into the yummy chocolate pudding filling, you may find that this is one of the most decadent chocolate pies you will ever taste. Set aside a pie pan or a glass casserole dish for Robinson's recipe and enjoy. I have added a little extra chocolate to the filling.

Serves 8	Prep: 45 to 50 minutes	Bake: 20 to 25 minutes for the crust	Chill: 30 to 35 minutes for the second layer; 4 hours for the pie

PECAN SHORTBREAD CRUST

1 1/4 cups (142 grams) pecan halves

1 cup (120 grams) all-purpose flour

Pinch of salt

6 tablespoons (3/4 stick/86 grams) unsalted butter, cold

2 tablespoons ice water

Parchment paper and dried beans

FIRST LAYER

6 ounces cream cheese, at room temperature

3/4 cup (78 grams) confectioners' sugar

SECOND LAYER

1 cup (200 grams) granulated sugar

1/3 cup (30 grams) unsweetened cocoa powder

3 tablespoons all-purpose flour

2 tablespoons cornstarch

Pinch of salt

3 large egg yolks

2 cups whole milk

2 tablespoons unsalted butter

1/3 cup (2 ounces/57 grams) chopped bittersweet or semisweet chocolate

2 teaspoons vanilla extract

THIRD LAYER

1 cup heavy cream

Grated chocolate for garnish

1. Heat the oven to 350°F, with a rack in the middle.

2. **Make the crust:** Place the pecan halves on a baking sheet and toast while the oven heats. Keep an eye on them, as they will burn easily, and stir if necessary so they toast evenly. When they are glossy and browned, 5 to 6 minutes, remove from the oven to cool. With your hands, break up the pecans

into a food processor. Process in pulses until fine but not a powder, about 30 seconds. Measure out 2 tablespoons and reserve for the garnish. Add the flour and salt to the processor and pulse to combine. Grate the cold butter into the processor and process until crumbly. Add the ice water and process until the dough pulls together, 15 to 20 seconds. Press the dough into the bottom and up the sides of a 10-inch metal pie pan and trim the edges. Place in the refrigerator for 15 minutes to chill. Cut a square of parchment paper to fit into the pie pan and fill with dried beans. Place the crust in the oven to prebake (page 308) until lightly golden, 20 to 25 minutes. Remove and let cool.

3. **Make the first layer:** Beat the cream cheese and confectioners' sugar in a medium bowl by hand with a wooden spoon until creamy and smooth. Spread over the bottom of the cooled crust. Set aside.

4. **Make the second layer:** Whisk together the sugar, cocoa, flour, cornstarch, and salt in a medium heavy saucepan. In a medium bowl, whisk together the egg yolks and milk, pour into the saucepan, and whisk until smooth. Place over medium heat and cook, stirring constantly with a wooden spoon or flat wooden spatula, until the mixture has thickened and comes to a boil, 6 to 8 minutes. Remove from the heat and stir in the butter, chocolate, and vanilla and stir until the chocolate melts. Spoon into a shallow bowl, cover with plastic wrap or waxed paper right on the surface, and chill for 30 to 35 minutes.

5. **Make the third layer:** Pour the cream into a large bowl and whip with an electric mixer on high speed until nearly stiff peaks form, 2 to 3 minutes.

6. To assemble, spread the chilled chocolate mixture over the cream cheese layer. Spread the whipped cream on top of the chocolate layer. Sprinkle with the reserved chopped pecans and chocolate shavings. Chill for at least 4 hours, until it's time to slice and serve.

Martha Pearl Villas' Frozen Mud Pie

Endure one summer without air-conditioning anywhere in the South, and you will see the appeal of a no-bake ice cream pie. A 1980s rendition called "mud pie" was popular in Mississippi and Memphis and involves a dark cookie crust, followed by chocolate and coffee ice cream, which supposedly resembles the mud of the Delta. This recipe comes from the late Southern mother-son writing duo Martha Pearl Villas and James Villas. She lived in North Carolina and he on Long Island. This pie was served "to our Yankee friends" each Labor Day, Villas wrote in his book, *My Mother's Southern Desserts*. Double the recipe for a 9-by-13-inch pan.

Serves 8 (see Notes) Prep: 35 to 40 minutes Freeze: 2 hours

CRUST

16 Oreos (6 ounces/170 grams)

4 tablespoons (1/2 stick/57 grams) unsalted butter, melted

FILLING

1 pint chocolate ice cream, slightly softened

1 pint coffee ice cream, slightly softened

CHOCOLATE SAUCE

3/8 cup (75 grams) granulated sugar

5 tablespoons half-and-half, evaporated milk, or whole milk

1/3 cup (2 ounces/58 grams) semisweet chocolate chips

3 tablespoons unsalted butter

1/4 teaspoon salt

TOPPING

1 cup heavy cream

1 teaspoon vanilla extract

1/4 cup (1 ounce/28 grams) chopped toasted peanuts or slivered almonds

1. **Make the crust:** Break the Oreos into a food processor. Pulse for 20 seconds. Turn off the machine and run a fork through the crumbs to make sure they are broken up. If not, pulse for another 10 to 20 seconds. Pour in the melted butter and pulse several times to combine. Turn the mixture into a 9-inch pie pan and press it across the bottom and up the sides.

2. **Make the filling:** Spread the chocolate ice cream on top of the crust and place in the freezer until firm, at least 1 hour. Spread the coffee ice cream on top of the chocolate and return to the freezer, at least 1 hour.

3. **Make the sauce:** Place the sugar, half-and-half or milk, chocolate chips, butter, and salt in a medium saucepan over medium heat and stir until melted. Let the mixture come to a simmer, stirring, until thickened, 4 to 5 minutes. Remove from heat and cool to room temperature, 30 minutes. Remove the pie from the freezer and spread sauce over top. Return to the freezer.

4. **Make the topping:** Place cream and vanilla in a large bowl and beat with an electric mixer on high until stiff peaks form, 3 to 4 minutes. Remove the pie from the freezer and spread the topping over it. Garnish with the nuts. Dip a slicing knife in hot water, slice, and serve.

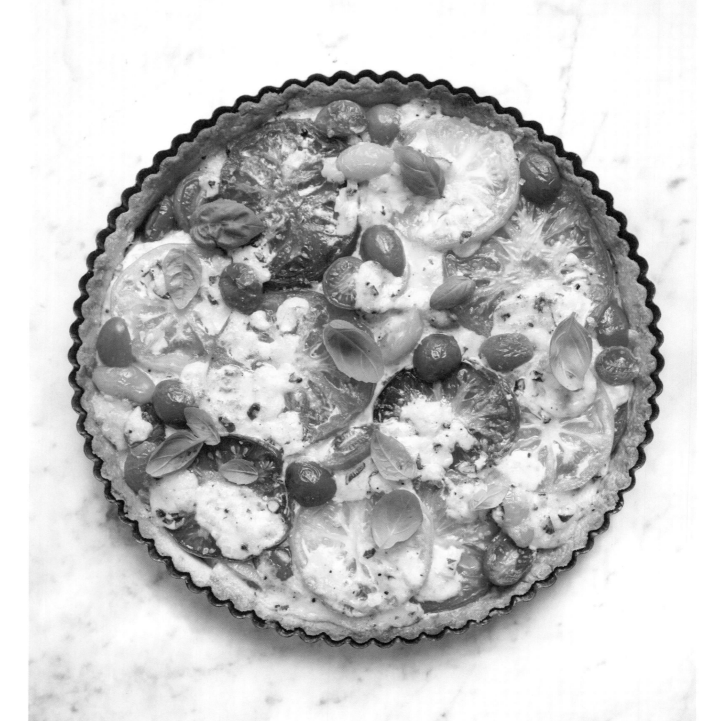

Red Ripe Tomato Pie

Tomato pie is very much a part of a Southern summer and one of those urgent recipes you pull out to savor ripe garden tomatoes while you have them. They might be the pink Bradleys or deep-red Cherokee purples, maybe fat slices of Mortgage Lifters, or tiny yellow Sungolds. In fact, that is the beauty of this pie. It's your pie using your tomatoes, and a variety of slices makes the most beautiful presentation.

If you have a French tart pan with a removable bottom, use it. I crank up the oven to 400°F, which allows the tomatoes to release their juices and the filling to bubble up and take on vibrant color.

Serves 6 to 8	Prep: 20 to 25 minutes	Bake: 15 minutes to prebake the crust; 25 to 30 minutes to bake the pie

1 (9-inch) piecrust (pages 306 to 313)

1 1/4 to 1 1/2 pounds ripe summer tomatoes, sliced 1/4 to 1/2 inch thick

Kosher or sea salt for sprinkling the tomatoes

1/2 cup mayonnaise

1 cup (4 ounces) shredded Monterey Jack, sharp cheddar, or a blend of cheeses

1/4 cup (15 grams) minced or thinly sliced sweet onion, like Vidalia

2 tablespoons or more chopped fresh basil

Coarsely ground black pepper

Sprinkling of dried oregano (optional)

1. Heat the oven to 400°F, with a rack in the middle.

2. Crimp the edges of the piecrust. Follow the directions for partially prebaking the crust on page 308, but bake at 400°F.

3. Meanwhile, place the sliced tomatoes on a wire rack set over a sheet pan or waxed paper. Lightly salt them and let sit while the crust bakes. After you remove the crust from the oven, blot the tomatoes dry with paper towels.

4. Place the mayonnaise, cheese, onion, basil, pepper, and oregano, if desired, in a small bowl and stir to combine.

5. Spread a tablespoon of the cheese mixture thinly over the bottom of the crust. Place half of the tomato slices on top. Spoon about half of the remaining cheese mixture around the tomatoes and sparsely over their tops. Place the remaining tomatoes in a second layer, placing them on top of the gaps where you've spread the cheese mixture. Dollop the remaining cheese mixture around the tomatoes and spread it barely over their tops. Place the pan in the oven and bake until bubbly and browned, 25 to 30 minutes.

6. Remove the pan from the oven and let the pie cool to room temperature before slicing.

7 TIPS FOR BEAUTIFUL PIECRUST

1. If possible, make the pie dough ahead of time and chill it. Chilling allows the flour to hydrate and relax, so it's easier to roll and bakes up lighter.

2. If the dough isn't supple and easy to roll, let it rest on the counter until it is.

3. Work light and fast. Begin rolling in the center and roll to the outside edge in brief one-way strokes. For a 9-inch pie, roll a circle of dough between 12 and 14 inches in diameter.

4. To transfer the dough to the pie pan, wrap the dough around the rolling pin to help you lift it into the plate. Or fold in half once and then fold in half again to make a quarter circle. Place the point into the center of the plate and unfold, being careful to tuck the pastry into the sides of the pan without stretching it. If the dough tears, just patch it.

5. Crimping the piecrust keeps the pastry in place so it doesn't shrink down the sides of the pan. The easiest way is just to press the outside edges to the plate with the tines of a fork. For a more intriguing pattern, press for an inch, then leave blank for an inch, press again for an inch, and so on. For an easy V pattern, use your thumb and first finger on the left, and with your forefinger on the right, push the dough into it to form a V.

6. Freeze a butter crust that's been crimped for 10 minutes or chill it for 20 minutes before baking, or however much time you have. That helps preserve the crimping pattern and reduce shrinkage.

7. If the filling isn't set but the piecrust has browned, lay a sheet of foil gently on top to shield it from overbrowning and continue to cook until the pie is done.

All-Butter Flaky Piecrust

A buttery, flaky crust for fruit pies and cobblers. For flaky layers, fold the dough into thirds like a business letter.

Makes 2 (9-inch) crusts

2 1/2 cups (300 grams) unbleached flour, plus more for rolling

1/2 teaspoon kosher salt

14 tablespoons (1 3/4 sticks/200 grams) cold unsalted butter, cut into 1-inch pieces

7 to 8 tablespoons ice water

1. Place the flour and salt in a large bowl and whisk to combine. Scatter the pieces of cold butter on top and smash each one flat with your fingers. Add 6 tablespoons of the ice water. Stir with a fork. Add another tablespoon ice water and stir. You want a shaggy dough. Add the last tablespoon water, if needed.

2. Turn the dough out onto a lightly floured surface and gather into a ball, then press lightly with your hand into a flat disk. If you want layers, roll to a 10-by-15-inch rectangle, then fold into thirds, pulling one third toward the middle then the other third on top, like you are folding a business letter. Turn the dough 90 degrees and repeat one or two times, placing the dough in the fridge between turns if the kitchen is warm. Cut the dough in half. Wrap each half in plastic or waxed paper and chill for at least 1 hour before rolling.

3. When ready to roll out the crust, work with one half at a time. Place the dough on a lightly floured surface. Beat the dough with the rolling pin until it is 1 inch thick. Roll out the dough from the middle to the edges, flipping the round over every few rolls and adding a dusting more flour to the surface as needed, until the round is 12 to 14 inches. Transfer to the pie pan. Repeat with the remaining half of the dough. If making ahead, you can slip the crust into a zipper-top bag and refrigerate for up to 5 days or freeze for up to 3 months.

Food Processor Piecrust

This is a versatile recipe that's easy to work with, and you can use any kind or combination of fat—butter, shortening, or lard—and flour—wheat flour or gluten-free baking blend. No food processor? Make this by hand, placing the dry ingredients in a large bowl and pressing the fat into the flour, using your fingertips. Then add the vinegar, which will give your crust a little tangy old-school flavor, and ice water and stir together with a fork. With your hands, knead gently, then roll.

Makes 1 (9-inch) crust

1 1/2 cups (180 grams) all-purpose
 flour, plus more for rolling
1/2 teaspoon granulated sugar
1/4 teaspoon salt
8 tablespoons (1 stick/114 grams)
 cold unsalted butter, or
 1/2 cup cold vegetable
 shortening, or 1/2 cup lard,
 cut into pieces
1 teaspoon white vinegar
 (optional)
2 to 3 tablespoons ice water

1. Place the flour, sugar, and salt in a food processor. Pulse a few times to combine. Scatter the butter, shortening, or lard pieces on top and pulse until the mixture looks like coarse crumbs, 7 to 8 times.

2. Add the vinegar, if desired, and 2 tablespoons of the ice water. Pulse again 7 to 8 times. The dough should be crumbly, not wet, and hold together. If it is too dry, add a little more ice water.

3. Turn the dough onto a lightly floured surface and work gently into a disk shape. Press it lightly with the palm of your hand to flatten slightly. Wrap in plastic or waxed paper and chill for 1 hour.

4. When ready to roll out the crust, place the dough on a lightly floured surface. Beat the dough with the rolling pin until it is 1 inch thick. Roll out the dough from the middle to the edges, turning the round over every few rolls, and dusting the surface with more flour as needed until the round is about 12 inches in diameter. Transfer to the pie pan. Or, if making ahead, you can slip the crust into a zipper-top bag and refrigerate for up to 5 days or freeze for up to 3 months.

HOW TO PREBAKE (BLIND-BAKE) PIECRUST

Baking the crust before you fill it is called blind-baking. It helps the piecrust stay crisp.

First, chill or freeze the dough in the pie plate until it's firm.

TO PARTIALLY PREBAKE CRUSTS: Place a rack in the lower middle of the oven and heat the oven to 375°F. Line the frozen or chilled piecrust with a crumpled 12-inch square of parchment paper or foil. Pour in 1 cup dried beans or rice nearly to the top to weigh down the dough while it bakes. (I keep a bag of beans with my pastry supplies just for blind-baking, and I pour the cooled, used beans back into the bag.) Shake the pan gently to distribute the beans or rice around the pan. Place in the oven and bake until the edges start to brown, 15 minutes. Remove the pie from the oven and carefully lift out the parchment paper (with the beans or rice) or foil. Prick holes over the bottom crust with a fork. Let cool, then proceed with the recipe.

TO COMPLETELY PREBAKE CRUSTS: Follow the directions for partially prebaking the crust. After you remove the parchment or foil and prick the bottom of the crust, return it to the oven and bake until the bottom just begins to brown, 10 minutes more. Remove to a wire rack to cool completely.

MATCHING THE PAN TO THE CRUST

- Metal pans work well for pies you want to freeze. If you bake your pie in a metal pan, opt for a darker pan to facilitate browning of the crust, because dark metal absorbs heat. Baking on the lower middle rack of the oven also helps brown the crust.

- Cast iron absorbs and retains heat, so use it when making a sweet potato pie or fruit pie, where you want the juices of the fruit and sugar to caramelize and develop flavor. Watch for signs of doneness, because cast iron bakes hotter, and pies baked in it are done sooner.

- Berry pies that sit leftover in the pan are more suitable for glass, because their acidity can eat away at an aluminum pan.

- Ceramic pans are often deeper than metal or glass, which means the top of the pie may not brown as quickly, but they're nice for fruit or other pies when leftovers will be reheated in the oven.

- Most of the recipes in this chapter were created for pans that are 9 inches in diameter and 1 1/2 to 2 inches deep. If you switch to a different pan, baking times will change.

- If you want to bake smaller tarts of any of the pies, just cut out circles of pie dough and place them in tart pans or shallow muffin pans. If you want to bake "tassies," smaller than a tart, stamp a smaller circle and fit the dough into a mini muffin pan. If you need to feed a crowd, make a cobbler or slab pie by doubling the recipe and baking it in a rimmed 12-by-17-inch sheet pan.

- When you buy frozen crusts, choose deep dish, so the filling won't boil over. The only reason to buy the "regular"—more shallow—size frozen crust is if you are making a batch of pies for a fundraiser or bake sale and want to stretch the filling into more pies.

- Refrigerated pie sheets are handy around the holidays and have more of a homemade look than frozen. They work well with larger 10-inch pans, because you've got a little more crust to work with. Brands differ in size and taste, so read the ingredient panels; some contain lard and others palm oil. Before you begin, let the crust warm on the counter for 30 minutes until you can unroll it without breaking.

Crostata Dough

Use this substantial dough for free-form pies as well as cobblers, like Mary Bradley Moss' Peach Cobbler (page 275) and Frank Stitt's Peach Crostata (pages 276–277).

Makes 1 (10-inch) crostata or enough dough for a 10-inch pie pan

1 2/3 cups (205 grams) all-purpose flour
1 tablespoon granulated sugar
1/2 teaspoon salt
8 tablespoons (1 stick/114 grams) unsalted butter
1 large egg
3 to 3 1/2 tablespoons ice water

1. Place the flour, sugar, and salt in a food processor or large mixing bowl. Process for 5 to 10 seconds (or whisk) until the ingredients are blended.

2. Cut the butter into 1/2-inch cubes, scatter around the bowl, and toss with the flour. Pulse for 15 seconds, or until the mixture is the size of big peas. (By hand, press the butter into the flour with your fingertips.) Separate the egg and add the yolk to the flour mixture. Reserve the white for brushing the crostata. Pour in 3 tablespoons of the ice water and process (or stir) until the dough pulls together, 10 to 15 seconds. Add a little more ice water, about 1/2 tablespoon, if needed. Remove the dough, flatten with the palm of your hand, wrap in plastic or waxed paper, and refrigerate until you're ready to bake, at least 30 minutes. (Depending on the recipe, brush the egg white on the edges of a crostata, pie, or cobbler just before baking.) The dough keeps in the fridge for up to 3 days and may be frozen for a month.

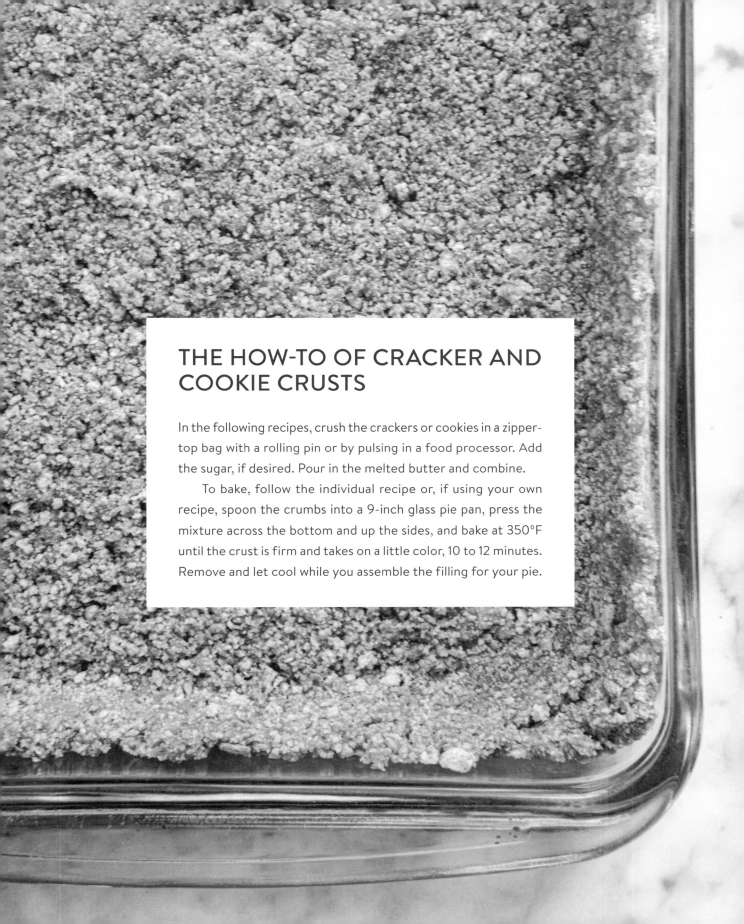

THE HOW-TO OF CRACKER AND COOKIE CRUSTS

In the following recipes, crush the crackers or cookies in a zipper-top bag with a rolling pin or by pulsing in a food processor. Add the sugar, if desired. Pour in the melted butter and combine.

To bake, follow the individual recipe or, if using your own recipe, spoon the crumbs into a 9-inch glass pie pan, press the mixture across the bottom and up the sides, and bake at 350°F until the crust is firm and takes on a little color, 10 to 12 minutes. Remove and let cool while you assemble the filling for your pie.

Cracker and Cookie Crusts

Use these crusts for icebox and meringue pies that are refrigerated. You can add a pinch of cinnamon or lime zest or a tablespoon of shredded coconut or chopped pecans or cashews to personalize them.

Cracker Crust

Use this crust for lemon and lime icebox pies.

Makes 1 (9-inch) crust

54 Ritz, saltine, or Club crackers (about 200 grams)

1 to 2 tablespoons granulated sugar (optional)

4 tablespoons (1/2 stick/57 grams) unsalted butter, melted

Gingersnap Crust

Use this crust for Betty Kennedy's Black Bottom Pie (pages 294–295). Ginger cookies vary from the milder-flavored and thicker supermarket cookies to the spicier and thinner wafers at IKEA and Trader Joe's.

Makes 1 (9-inch) crust

33 thick gingersnap cookies or 54 thin ones (200 grams)

2 tablespoons granulated sugar (optional)

4 tablespoons (1/2 stick/57 grams) unsalted butter, melted

Graham Cracker Crust

This crust is delicious with chocolate, lemon, or Key lime pie (pages 254–255), or just about any refrigerated or frozen pie.

Makes 1 (9-inch) crust

9 whole (18 halves) graham crackers (200 to 225 grams)

1 tablespoon granulated sugar (optional)

6 tablespoons (3/4 stick/86 grams) unsalted butter, melted

Chocolate Cookie Crust

Use this crust for any ice cream pie that's made in a 1 1/2– to 2-quart glass casserole. For a less sweet crust, use thin chocolate wafers without the filling, but use just 6 ounces and just 4 tablespoons butter. If desired, add 1 tablespoon sugar to the crust if using the wafers.

Makes 1 deep-dish 9-inch crust

32 Oreo cookies (12 ounces/340 grams)

8 tablespoons (1 stick/114 grams) unsalted butter, melted

Vanilla Wafer Crust

This crust is a change of pace from graham cracker crust. It's softer in texture.

Makes 1 (9-inch) crust

48 vanilla wafers (5 ounces/144 grams)

1 tablespoon granulated sugar (optional)

5 tablespoons (71 grams) unsalted butter, melted

BAKE ME
A CAKE ─────────

"Oh my," she exclaims, her breath smoking the windowpane, "it's fruitcake weather!"

—TRUMAN CAPOTE, *A CHRISTMAS MEMORY*, 1956

Mother made a big dark fruitcake. She would store her cakes in a lard
can, and I always liked to take the top off to smell them.

—HUGH EMMA EIRD IN *SPECIAL RECIPES OF HUGH EMMA EIRD: A LIFETIME OF COOKING*, 1998

Cakes were the pride and joy of many a cook, and at times almost an insignia of status. . . .
Everyone in the neighborhood knew who made the best caramel or coconut or chocolate
cake, and at community dinners those prized creations were the first to disappear.

—JOHN EGERTON, *SOUTHERN FOOD*, 1987

*I*f the kitchen is the heart of a Southern home, then surely cakes are its long-term memory, for they reach way back into the past and connect you to people you might have never met. Southern women have traditionally lavished hours of attention on a cake to take to a church supper, bake sale, or funeral visitation. And even when some of these cakes—caramel, coconut, lemon— require an entire afternoon in the kitchen, we'll gladly do it all over again.

Cakes bring bragging rights, are a calling card, and turn the ordinary into an occasion. They've long been a side hustle, too, for cooks who've sold them out of their kitchens. They have been written about in glowing detail in the pages of Southern literature, from Mashula's coconut cake in Eudora Welty's *Delta Wedding* to Minny's caramel cake in Kathryn Stockett's *The Help* to cousin Sook's fruitcake delivered in a baby carriage in Truman Capote's *A Christmas Memory* to the pound cake and a marriage proposal in Vertamae Smart-Grosvenor's *Vibration Cooking*.

Because I am a cake person, winnowing down to just these cakes was an excruciating process! This chapter is loosely organized by the type of cake, from coffee cakes and simple gingerbread spice cakes to pound cakes and cakes made with fruit to chocolate cakes and layer cakes to cupcakes. Some of these cakes are works of art, baked to captivate, like the tall coconut and pecan layer cake pastry chef Dolester Miles put on display for the entire restaurant to see at Chez Fonfon in Birmingham a couple years back. Others, like sour cream coffee cake or buttermilk cupcakes, are baked in the old familiar pans and made simply to please a family.

One of our earliest cakes, pound cake, or "poundcake," with its tight, dense crumb and crunchy top, is well designed for the South's heat and humidity, needing no frosting, no refrigeration, and no fuss.

Because of that, pound cakes are the best travelers of all. Even when it's hot and humid and there's no air-conditioning, they look calm and collected.

Pound cakes also had the advantage of being simple. In fact, all you really needed to know was the weight of your eggs, and then you added the same weight of everything else.

The deeper meaning of this dessert has not been lost on Blacks. In racially tense Alabama, it became a social justice cake to raise monies for fighting segregation.

The first cakes in the South were baked over a wood fire, either at the hearth in cast-iron covered "baking" ovens (Dutch ovens) or later in wood-fired ovens. Not only did the hearth and oven need to be stoked with wood, but you had to know what kind of wood burned the best for baking.

Baking was time-consuming and dangerous. Not until homes had chimneys made of stone, rather than the fragile and flammable wood and clay popular with early settlers, could baking even take place. After the Civil War, freestanding wood-fired and coal-fired cookstoves changed what was baked and who could bake it.

Parting with wood and coal stoves was hard when a new and better oven model came along. The South came late to gas. Cooks were fearful of blowing up their kitchens by igniting the stove with a lit roll of newspaper. Then, too, other forms of fuel were cheaper. Gas had to be purchased, while wood could be cut from trees on your own land and, in West Virginia, coal came straight from the earth.

Cooking teachers such as Henrietta Dull and Kate Brew Vaughn traveled the South and appeared on behalf of gas utility and baking powder companies to explain the craft of cake to Southerners. In the 1930s, cakes placed in a turned-off oven were called "cold oven" cakes. Initially dreamed up to save fuel, the cakes developed a distinctive crackly top and smooth texture throughout because they had gradually baked as the oven temperature climbed.

Henrietta (Mrs. S. R.) Dull

After gas ovens came electric. Baking a cake without odors, smoke, and flames was safer and more reliable. But old habits died hard. My grandmother was raised cooking on a woodstove at the turn of the twentieth century in Tennessee's Sequatchie Valley. She was so used to the woodstove's heavy door that she still took great care to close the door of her electric oven very gently when she baked a cake. And as with the woodstove, she never opened the door while the cake was baking, fearing the cold air rushing inside would make it fall.

Since much of the South was rural, many homes in the remote mountains or along the coasts didn't have electric ovens until the early 1950s. Progress came slowly to an isolated and rural South, so whole generations of Southern cooks just learned to bake cakes by practice.

Thankfully, the South was blessed with soft wheat flour, and while that flour didn't have enough structure to produce crusty bread loaves, it made for light cakes. And so cake became a part of our culture.

10 TIPS FOR BAKING A BETTER CAKE

1. Read the recipe before you begin.
2. Pull the butter and eggs out of the fridge to come to room temperature.
3. Use a scale for measuring the flour and sugar.
4. Beat with an electric mixer, unless the recipe says stir by hand.
5. Choose the right type of flour, usually cake or pastry flour, unless another flour is specified.
6. Use the right size pan, or if you need to substitute the pan, change the baking time to reflect that. A 9-inch layer pan bakes in less time than an 8-inch one, for example.
7. Prep the pan as directed by my recipe. When in doubt, brush with vegetable shortening and dust with flour for easy release.
8. Turn the light on in the oven so you can watch for visual signs of doneness, such as the top browning, the cake rising, and, with layers, the cake pulling back from the sides of the pan. Open the oven door and carefully touch the center of the cake. It should spring back when done. With a heavy cake that is difficult to gauge, prick it with an instant-read thermometer, and if it registers 200°F, it is done.
9. Follow the recipe for how long to let the cake cool in the pan and on the rack.
10. Let the cake cool before stacking, frosting, and slicing.

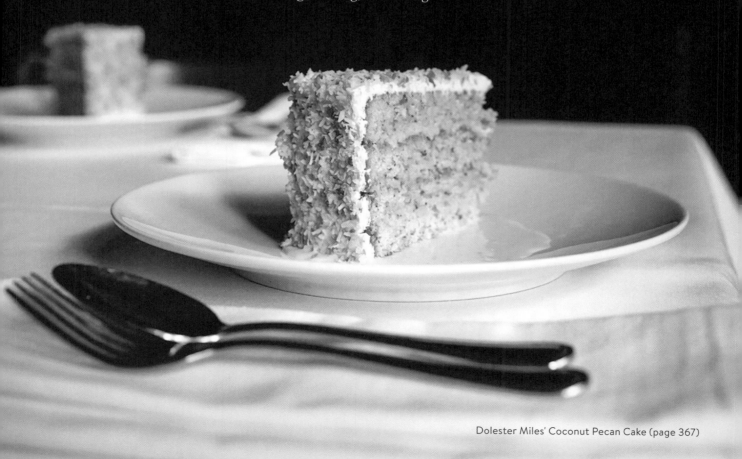

Dolester Miles' Coconut Pecan Cake (page 367)

Grandmother Bailey's Soft Gingerbread with Warm Lemon Sauce

I was driving through West Virginia, listening to the *Inside Appalachia* program on West Virginia Public Radio, when I heard reporter Connie Bailey-Kitts talking about her grandmother Alice Bailey's gingerbread served warm with lemon sauce. Gingerbread has a deep connection to America, and especially in regions like West Virginia, Virginia, and Kentucky, where everyone had a little patch of sorghum to make into syrup to sweeten their gingerbread.

Alice Imogene Melissa Shutt Bailey was born in Princeton, West Virginia, in 1877 and raised in Rock, West Virginia. She was known for her quilting and crocheting, learning the Latin names for the flowers she grew, and baking this soft and fragrant gingerbread in her coal stove. Bailey and other subsistence farmers in the Depression years grew and raised what they needed to eat and sold milk and eggs to get by. "It wasn't like parts of the South with those big plantations," Bailey-Kitts says. "The farm sustained them, and it gave them a little income too."

Serves 8 to 12	Prep: 25 to 30 minutes	Bake: 40 to 45 minutes

Vegetable oil spray for prepping the pan

1 cup (200 grams) granulated sugar

1 cup vegetable oil, or 1/2 cup oil and 1/2 cup unsweetened applesauce

2 large eggs

1/2 cup sorghum or molasses

2 cups (240 grams) all-purpose flour

2 teaspoons ground ginger

1 teaspoon ground cinnamon

1/2 teaspoon ground cloves or nutmeg, or both

1/2 teaspoon salt

1 1/2 teaspoons baking soda

1/2 cup hot water

Warm Lemon Sauce (pages 319–320)

1. Heat the oven to 350°F, with a rack in the middle. Mist a 7-by-11-inch glass dish (or a 9-inch square or 9-inch springform) with vegetable oil spray and set aside.

2. Place the sugar and oil (or combination of oil and applesauce) in a large bowl and beat with an electric mixer on low speed (or by hand) until combined, 30 seconds. Add the eggs and sorghum or molasses and beat until the eggs are well combined, 1 minute more.

3. Whisk together the flour, ginger, cinnamon, cloves (and/or nutmeg, if you like), and salt in a medium bowl. Dissolve the baking soda in

the hot water. Stir the flour mixture into the batter alternately with the hot water, blending until just combined. Pour into the prepared pan.

4. Bake until the cake springs back when lightly pressed in the center, 40 to 45 minutes. Serve warm with Warm Lemon Sauce.

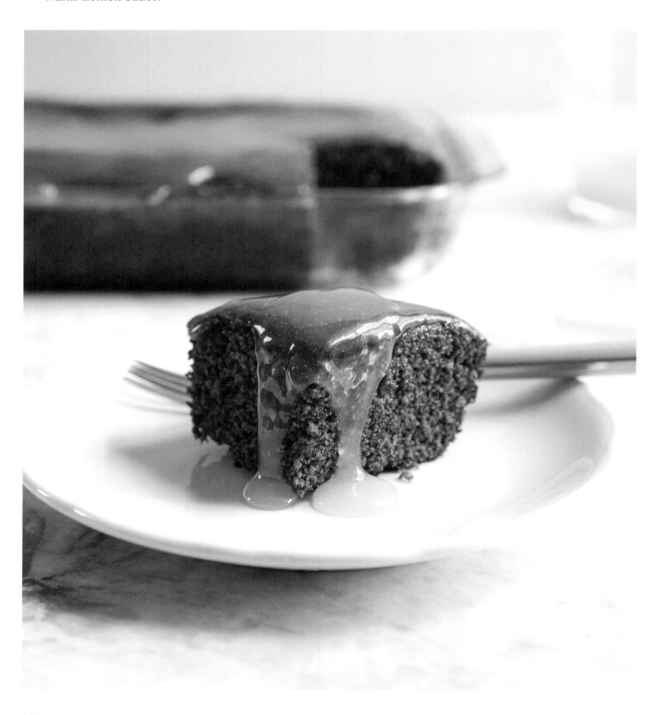

Cold-Oven Brown Sugar Pound Cake

One of the first mentions of pound cake in America is a recipe dated 1754 from Wicomico Church, Virginia. Ever since, pound cakes have adapted to new ingredients at hand. Bakers in sugarcane-growing regions of Louisiana, Texas, and Florida have long used brown sugar. It has more acidity and moisture than white sugar, so it reacts with baking soda to produce a light cake that stores well for days on the kitchen counter. This recipe starts the cake in a cold oven, which creates an irresistibly moist and even crumb. Serve it with peach ice cream and, to gild the lily, a spoonful of Caramel Glaze (page 449).

Serves 12 Prep: 30 to 35 minutes Bake: 1 hour, 15 to 20 minutes

Butter or vegetable shortening and flour for prepping the pan

16 tablespoons (2 sticks/227 grams) unsalted butter, at room temperature

1 1/2 cups (288 grams) lightly packed light brown sugar

1 cup (200 grams) granulated sugar

6 large eggs, at room temperature

1 teaspoon vanilla extract

3 cups (360 grams) all-purpose flour

3/4 teaspoon salt

1/4 teaspoon baking soda

1 cup sour cream

Caramel Glaze (page 449) or 1 teaspoon confectioners' sugar for dusting

1. Grease and flour a 10-inch tube pan and set aside.

2. Place the butter in a large bowl and beat with an electric mixer on medium speed until creamy, 1 minute. Add both sugars and continue beating until the mixture is well blended and lightens, 2 to 3 minutes. Scrape down the sides of the bowl with a rubber spatula. Add the eggs, one at a time, beating until each is blended. Scrape down the sides of the bowl again and add the vanilla.

3. Stir the flour, salt, and baking soda together in a small bowl. Add the flour mixture alternately with the sour cream to the batter, beginning and ending with the flour mixture. Pour the batter into the prepared pan.

4. Place the pan in a cold oven, with a rack in the middle, then set the temperature for 300°F. Bake for 45 minutes. Increase the temperature to 325°F and bake for 30 to 35 minutes more, or until the top of the cake springs back when lightly pressed in the center. Remove to a rack to rest in the pan for 20 minutes. Run a knife around the edges of pan, give it a shake to loosen the cake, then invert the cake once and then again so it cools right side up on the rack for 1 hour before glazing with Caramel Glaze (page 449) or dusting with the confectioners' sugar. Slice and serve.

Church Ladies' Sour Cream Coffee Cake

Sour cream and cinnamon coffee cakes are as much a part of morning gatherings in the South as hot coffee and conversation. They straddle the line between bread and cake, which means they're appropriate all day long, due to the fact they're not overly sweet or covered in icing. This simple recipe is from the *Favorite Recipes Collected by United Methodist Women of Pleasant View, Tennessee* cookbook and shared by church member Carolyn Lockert. Pleasant View is a small town in central Tennessee where church has been central to life, and you could say that about much of the South. We serve this rich and tender cake in fat squares right from the pan.

Serves 12 to 16	Prep: 20 to 25 minutes	Bake: 28 to 32 minutes

Vegetable oil spray and
 parchment paper for
 prepping the pan
16 tablespoons (2 sticks/227
 grams) unsalted butter,
 at room temperature
1 cup (200 grams)
 granulated sugar
3 large eggs
1 teaspoon vanilla extract
1 teaspoon fresh lemon juice
1 cup sour cream
2 1/2 cups (300 grams) all-
 purpose flour
2 teaspoons baking powder
1 teaspoon baking soda

FILLING

1/2 cup (100 grams)
 granulated sugar
1/2 cup (2 ounces/57 grams)
 finely minced pecans
1 teaspoon ground cinnamon
1/4 teaspoon ground nutmeg

1. Heat the oven to 350°F, with a rack in the middle. Lightly mist the bottom of a 9-by-13-inch pan with vegetable oil spray. Line the bottom with parchment paper for easy cleanup.

2. Place the butter and sugar in a large bowl and beat with an electric mixer on low speed until just combined, 1 minute. Increase the speed to medium and beat until creamy and light, 2 minutes more. Add the eggs, one at a time, beating after each addition until just incorporated, and add the vanilla. Stop the machine and scrape down the sides of the bowl.

3. Stir the lemon juice into the sour cream in a small bowl and set aside. Whisk together the flour, baking powder, and baking soda in a medium bowl. With the mixer on low speed, alternately add the flour mixture and the sour cream mixture to the batter, beginning and ending with the flour.

4. **Make the filling**: Stir the sugar, pecans, cinnamon, and nutmeg in a small bowl to combine.

5. Dollop half of the batter into the prepared pan and smooth the top with a metal spatula to reach the edges. Spoon half of the filling over the top. Dollop the remaining batter on top, carefully spreading to the edges, taking care not to disturb the filling underneath. Spoon the remaining filling on top and place the pan in the oven.

6. Bake until the cake is deeply golden brown and the top springs back when lightly pressed in the center, 28 to 32 minutes. Remove to a wire rack to cool for at least 30 minutes, then slice and serve.

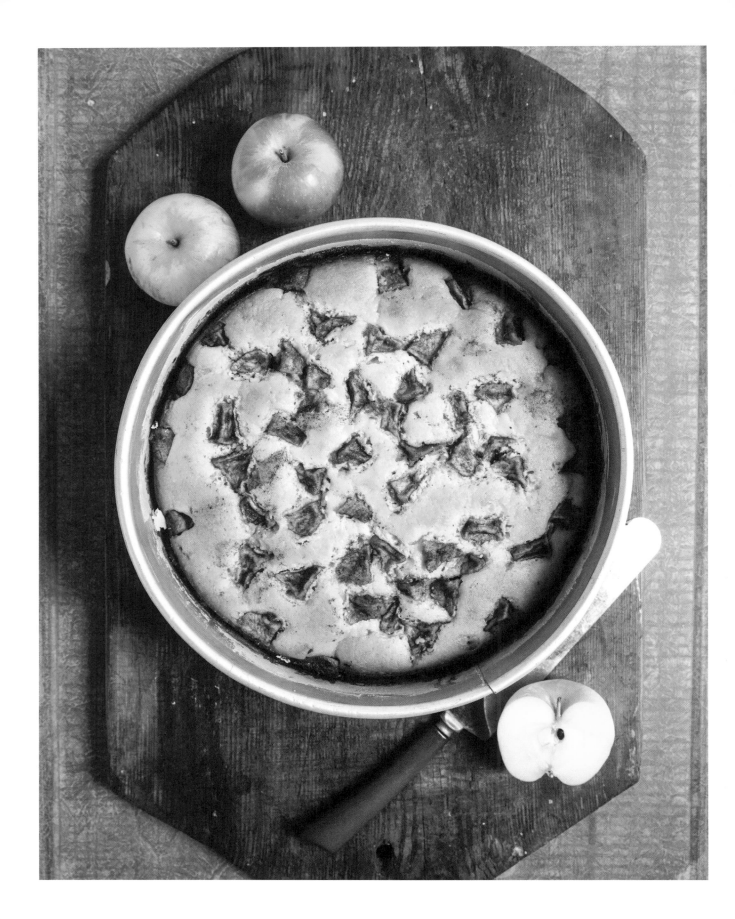

Maryland Jewish Apple Cake

Apples have flourished in the cooler climates of the South, and while most of them made their way into pies, many were saved for cake. This rich and dense coffee cake with a layer of apple and cinnamon inside and on top has been linked to Baltimore, and the recipe comes from the Jewish Museum of Maryland and historian Joyce White. From the 1830s to the 1870s, more than 10,000 Jewish people arrived in Baltimore from Germany and Central and Eastern Europe, bringing their baking traditions with them.

I bake this cake in a springform pan, and it needs no embellishment. It is the taste of fall!

Serves 12 to 16 Prep: 30 to 35 minutes Bake: 1 hour, 5 to 10 minutes

APPLES

5 to 6 medium-size tart apples (1 1/2 pounds)

1/3 cup (67 grams) granulated sugar

2 teaspoons ground cinnamon

1/2 teaspoon ground nutmeg

1/4 teaspoon ground cardamom

CAKE

Butter and flour for prepping the pan

2 cups (240 grams) unbleached all-purpose flour

2 teaspoons baking powder

1 teaspoon salt

12 tablespoons (1 1/2 sticks/170 grams) unsalted butter, at room temperature

1 cup (200 grams) granulated sugar

3 large eggs

2 teaspoons vanilla extract

2/3 cup sour cream

1. **Prepare the apples:** Peel, quarter, and chop the apples into 1/4- to 1/3-inch dice (you'll have about 3 cups). Turn into a medium bowl and toss with the sugar, cinnamon, nutmeg, and cardamom. Set aside.

2. Heat the oven to 350°F, with a rack in the middle. Grease and flour a 9-inch springform pan.

3. **Make the cake:** Place the flour, baking powder, and salt in a medium bowl and whisk to combine. In a large bowl, beat the butter and sugar with an electric mixer on medium speed until creamy and light, 2 to 3 minutes. Add the eggs and beat to incorporate, 1 minute. Add the vanilla. On low speed, add the flour mixture and sour cream alternately until smooth and combined.

4. Pour half of the batter into the prepared pan. Drain the apples of any juice and spoon half of them on top, spreading them to the edges. Carefully spread on the rest of the batter and top with the remaining apples.

5. Bake until the cake is golden brown and springs back when lightly pressed in the center, 1 hour and 5 to 10 minutes. Place on a wire rack to cool in the pan for 20 minutes. Unhinge the sides of the pan and let the cake cool completely, 40 minutes, before slicing.

Nellie McGowan's Cream Cheese Pound Cake

I'll wager that nearly every community cookbook in the South has a recipe for cream cheese pound cake. And for good reason, as this cake is rich and beautifully textured, slices well, and smells so good while it's baking that you'll be drawn to the kitchen. The late Nellie McGowan of Guyton, Georgia, was known for her cream cheese pound cake, and she said the secret is in the mixing. Or should I say, not overmixing. McGowan beat the sugar, butter, and cream cheese for a total of seven minutes and then alternately added eggs and flour. Beating the batter for too long causes streaks or wet spots running through the cake. I am so grateful to my friend Martha Nesbit of Savannah for sharing this recipe. It has become a family favorite, and I have mixed it up with both my hand mixer and my KitchenAid stand mixer and baked it countless times. It will never disappoint, as long as you set the timer.

Serves 12 Prep: 20 to 25 minutes Bake: 1 hour, 20 to 25 minutes

Soft butter or vegetable shortening and flour for
 prepping the pan

24 tablespoons (3 sticks/340 grams) unsalted butter, at
 room temperature

8 ounces cream cheese, at room temperature

3 cups (600 grams) granulated sugar

1 teaspoon vanilla extract

6 large eggs, at room temperature

3 cups (336 grams) cake flour, measured then sifted,
 divided

ORANGE DRIZZLE:

If desired, drizzle the top of the cooled cake with a glaze made by whisking 1 to 2 tablespoons fresh orange juice into 1/2 cup sifted confectioners' sugar.

1. Heat the oven to 325°F, with a rack in the middle. Grease and flour a 10-inch tube pan and set aside.

2. Place the butter and cream cheese in a large bowl and beat with an electric mixer on medium speed until lightened in color and texture, about 2 minutes. With the mixer running, gradually add the sugar, beating for 5 minutes total, until the mixture is fluffy and has increased by half in volume. Add the vanilla and beat briefly to combine. Stop the machine and scrape down the sides of the bowl with a rubber spatula.

3. With the mixer on medium-low speed, add one egg and 1/2 cup of the cake flour until the flour is just blended. Continue adding one egg and 1/2 cup flour until all the flour is added. Do not overbeat.

4. Pour the batter into the prepared pan and smooth the top with the rubber spatula. Bake until the cake is golden brown and the top is firm when pressed lightly, 1 hour and 20 to 25 minutes, or until it reaches an internal temperature of 200°F on an instant-read thermometer. Remove the cake to a rack to cool in the pan for 15 to 20 minutes. Run a knife around the edges of the pan, give the pan a good shake to loosen the cake, then invert it once and then again so it is right side up on the rack. Let cool completely before slicing, about 1 hour.

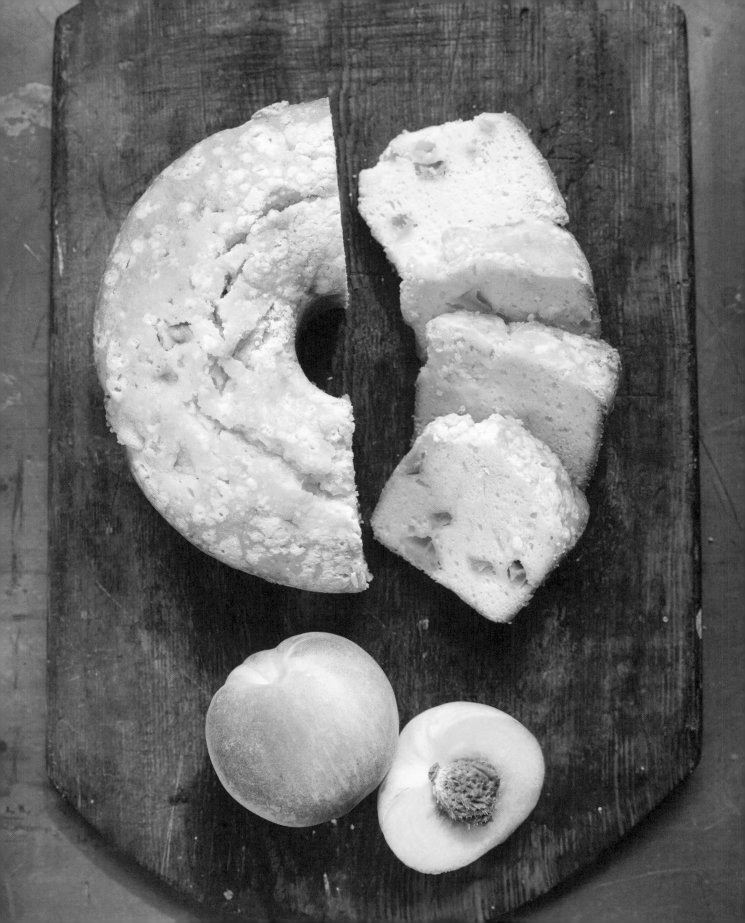

Peach Pound Cake

When you're the food editor of the largest newspaper in the Peach State, at some point you're going to make a peach pound cake. I first created one in the summer of 1985 using early clingstone peaches, and it baked into the most beautiful peach-flecked cake that everyone wanted to talk about. Thereafter I baked one each summer. After I shared this recipe with my newsletter readers, to bake with their local peaches, they agreed the recipe needed to be in this book. My mother spooned sliced sweetened summer peaches over the top of her pound cake, but in this recipe, they come together as one.

Serves 12 to 16	Prep: 20 minutes	Bake: 1 hour, 15 to 20 minutes

Butter or vegetable shortening and
 flour for prepping the pan

16 tablespoons (2 sticks/227 grams)
 unsalted butter, at room
 temperature

2 1/2 cups (500 grams) granulated
 sugar

6 large eggs, at room temperature

2 teaspoons vanilla extract

1/2 teaspoon almond extract
 (optional)

3 cups (360 grams) all-purpose flour

1/4 teaspoon baking powder

3/4 teaspoon salt

1/2 cup sour cream

1 1/4 cups finely chopped ripe,
 well-drained peaches (from 4
 medium peaches)

1. Heat the oven to 325°F, with a rack in the middle. Grease and flour a 10-inch tube pan and set aside.

2. Place the butter and sugar in a large bowl and beat with an electric mixer on medium speed until light in color and fluffy, 4 to 5 minutes, stopping the machine once or twice to scrape down the sides with a rubber spatula. Add the eggs, one at a time, beating until each egg is incorporated. Add the vanilla and almond extract, if desired.

3. Scrape down the sides of the bowl again. In a small bowl, whisk together the flour, baking powder, and salt. Turn a third of the flour mixture into the butter mixture and mix on low speed until just incorporated. Add half of the sour cream, mixing until just incorporated. Continue adding the flour mixture and the sour cream alternately, beginning and ending with the flour mixture. Turn off the mixer, remove the beaters, and fold in the well-drained peaches.

4. Pour the batter into the prepared pan and bake the cake until the top is golden brown and springs back when lightly pressed in the center, 1 hour and 15 to 20 minutes. Let the cake cool in the pan for 15 to 20 minutes, then run a knife around the edges and invert it once and then again so it cools right side up on the rack. Let the cake cool for 1 hour before slicing.

Georgia Gilmore's Pound Cake

In the fall of 1955, two months before Rosa Parks was arrested in Montgomery, Alabama, for refusing to give up her bus seat to a white man, Georgia Gilmore was leaving her job as a cook at the National Lunch Company when she entered a crowded city bus and dropped her fare in the cash box. The driver told her to get off the bus and enter through the back door. When she stepped off, the bus sped off, and Gilmore turned civil rights activist the best way she knew how—by baking pound cake. This was her recipe, an evenly textured, rich loaf, which I have lightened slightly with a little baking powder.

Gilmore organized Black women to bake and sell pound cakes, as well as sweet potato pies and fried fish meals at churches and beauty salons, efforts that went largely unnoticed, since home-cooked food has always been sold this way in the South. And if anyone asked, the money came from "nowhere," so the ladies became the Club from Nowhere, Gilmore's sister Betty Gilmore told John T. Edge, author of *The Potlikker Papers* (2017). The monies they raised helped pay for alternative transportation to and from work for people who took part in a 381-day boycott of Montgomery's segregated bus system. A little over a year later, in November 1956, the US Supreme Court struck down laws requiring segregated seating on public buses.

Makes 1 (10-inch) loaf or 2 (8- to 9-inch) loaves	Prep: 20 to 25 minutes	Bake: 60 to 65 minutes for the smaller loaves; or 1 hour, 30 to 35 minutes for the large loaf

Butter or vegetable shortening and flour for prepping the pan
16 tablespoons (2 sticks/227 grams) unsalted butter, at room temperature
3 cups (600 grams) granulated sugar
6 large eggs, at room temperature
1 teaspoon vanilla extract or 1/2 teaspoon lemon extract
3 cups (360 grams) all-purpose flour
2 teaspoons baking powder
1/2 teaspoon salt
1 cup whole milk, warmed

1. Heat the oven to 350°F, with a rack in the middle. Grease and flour a 10-inch loaf pan or two 8- to 9-inch loaf pans.

2. Place the butter and sugar in a large bowl and beat with an electric mixer on medium speed until it lightens in texture and color and increases its volume by half, 4 to 5 minutes. With the mixer running on medium, add the eggs, one at a time, beating until just incorporated. Add the vanilla or lemon extract and blend until smooth. Scrape down the sides of the bowl with a rubber spatula.

3. In a separate bowl, whisk together the flour, baking powder, and salt. Add a third of the flour mixture to the batter, beating on low speed, and then half of the milk, followed by another third of the flour, the remaining milk, and the remaining flour. Scrape down the sides of the bowl and turn the batter into the prepared pan or pans.

4. Bake until the cake is golden brown and firm when pressed, 1 hour, 30 to 35 minutes for a 10-inch pan. Tent with foil after 1 hour to prevent the loaf from getting too brown. For 8- to 9-inch pans, bake for 60 to 65 minutes. Let the pans cool on a wire rack for 20 minutes, then run a knife around the edges and invert the cakes once and then again so they cool right side up on the rack. Let cool completely before slicing, about 1 hour.

HOW TO STORE POUND CAKE

You can keep pound cakes at room temperature, covered, for up to 5 to 6 days. Or freeze, wrapped in heavy-duty foil, for up to 6 months.

Eliza Ashley's Buttermilk Pound Cake

Ever gracious, the late Eliza Jane Ashley, the Black executive chef of the Arkansas Governor's Mansion, fed seven governors and their families for thirty-six years, ending with the second term of Bill Clinton. While the governors had different tastes and ways of governing, they all loved Ashley's rich buttermilk pound cake. She would bake one routinely and leave it out for slicing. It was particularly loved by Governor Orval Faubus.

In her cookbook, *Thirty Years at the Mansion* (1985), Ashley wrote about the historic events in Little Rock during the Faubus administration after the Supreme Court's 1954 *Brown v. Board of Education* decision calling for school desegregation. A plan of gradual integration was to be phased in, and in 1957, nine Black students were selected for their high grades and attendance and enrolled in the previously all-white Little Rock Central High. But when the school year began, Governor Faubus called out the Arkansas National Guard to prevent the students from entering. Then in another turn of events, President Dwight Eisenhower issued an executive order to support integration and sent in federal troops to protect the Black students.

Ashley died in 2020 at 103 years of age.

Serves 12 to 16 Prep: 25 to 30 minutes Bake: 1 hour, 27 to 32 minutes

Butter or vegetable shortening and flour for prepping the pan

16 tablespoons (2 sticks/227 grams) unsalted butter, at room temperature, cut into tablespoons

3 cups (600 grams) granulated sugar

5 large eggs, at room temperature

1 teaspoon vanilla extract

3 1/2 cups (392 grams) cake flour

1 cup whole buttermilk, at room temperature (see Note)

NOTE:

If you don't have buttermilk, stir 1 tablespoon white vinegar into 1 cup whole milk.

1. Heat the oven to 325°F, with a rack in the middle. Grease and flour a 10-inch tube pan and set aside.

2. Place the butter and sugar in a large bowl, and with an electric mixer, beat on medium speed until light and fluffy and increased in volume by half, 3 to 4 minutes. Stop the machine and scrape down the sides of the bowl with a rubber spatula.

3. Add the eggs, one at a time, beating each until just combined. Add the vanilla and beat on low to combine.

4. Add a third of the flour, beating on low, then half of the buttermilk, then another third of the flour, then the rest of the buttermilk, then the last of the flour, stopping to scrape down the sides of the bowl. Pour the batter into the prepared pan and place in the oven.

5. Bake until the cake is golden brown and firm to the touch when pressed in the center, 1 hour, 27 to 32 minutes. Cool on a wire rack for 20 minutes, then run a knife around the edges of the pan and invert the cake once and then again so it cools right side up on the rack. Let cool completely before slicing, about 1 hour.

Cakes clockwise from top left: Eliza Ashley's Buttermilk Pound Cake (previous page), Memphis Chocolate Pound Cake (page 334), Cold-Oven Brown Sugar Pound Cake (page 321), and Mrs. Collins' Sweet Potato Cake (pages 346–347)

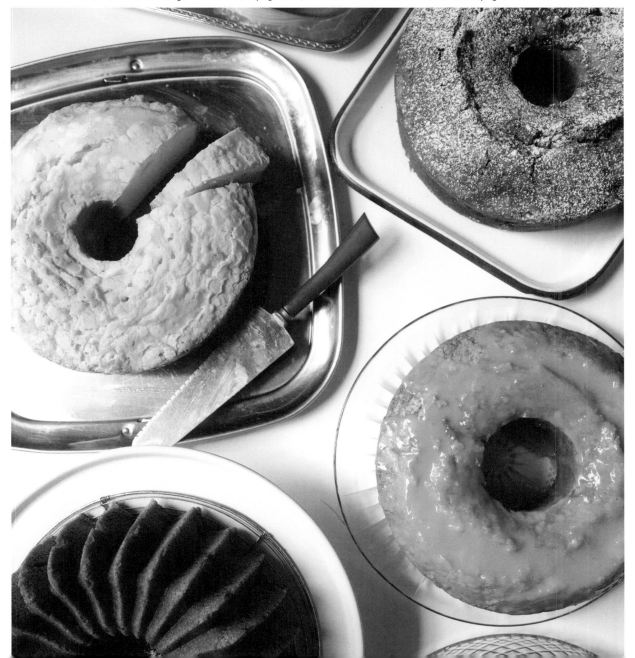

Memphis Chocolate Pound Cake

My mother used to bake a chocolate pound cake, and even as the years have flown by, I still remember the smell of the butter, eggs, and chocolate and how that intoxicating aroma wafted throughout the house. I've wanted to re-create that cake many times, but I had no recipe. My mother died in 2001. While writing this book a few summers ago, I shared this story with a room full of people at Monteagle Assembly on Tennessee's Cumberland Plateau. Helen Bird from Memphis came up afterward and told me how her mother also used to bake chocolate pound cake, and she, too, had no recipe. So we went on a hunt. I found a recipe in the 1964 *Woman's Exchange Cook Book* of Memphis, contributed by Jane Maury. As I pulled the fragrant cake from the oven, those sweet memories came rushing back. I sent the recipe to Bird; she baked it and gave it her blessing. While you may absolutely add a little espresso powder or whatever embellishments seem fitting, we think it's perfect as is. Dense and rich, it's a pound cake that never needs frosting and never leaves your mind.

Serves 12 to 16　　　　Prep: 20 to 25 minutes　　　　Bake: 1 hour, 23 to 28 minutes

Vegetable shortening and flour
　　for prepping the pan
3 cups (336 grams) cake flour
1/2 cup (50 grams) unsweetened
　　cocoa powder
1/2 teaspoon baking powder
1/2 teaspoon salt
24 tablespoons (3 sticks/340
　　grams) unsalted butter, at
　　room temperature
3 cups (600 grams) granulated
　　sugar
5 large eggs, at room
　　temperature
1 tablespoon vanilla extract
1 cup half-and-half, evaporated
　　milk, or whole milk
Whipped Cream for serving
　　(page 458)

1. Heat the oven to 325°F, with a rack in the middle. Grease and flour a 10-inch tube pan and set aside.

2. Sift together the flour, cocoa powder, baking powder, and salt in a medium bowl. Place the butter and sugar in a large bowl and beat with an electric mixer on medium speed until lightened in texture and color, 2 to 3 minutes. Scrape down the sides of the bowl with a rubber spatula. Add the eggs, one at a time, beating on medium-low until just combined. Add the vanilla and blend. Spoon a third of the flour mixture into the bowl, beating on low, and then add half of the half-and-half or milk, then another third of the flour, the rest of the half-and-half, and then the remaining flour until just combined. Turn the batter into the prepared pan and place in the oven.

3. Bake until the cake is firm to the touch, 1 hour and 23 to 28 minutes. Cool on a wire rack for 20 minutes, then run a knife around the edges of the pan and invert the cake once and then again so it cools right side up on the rack. Let cool completely, about 1 hour. Slice and serve with big dollops of whipped cream.

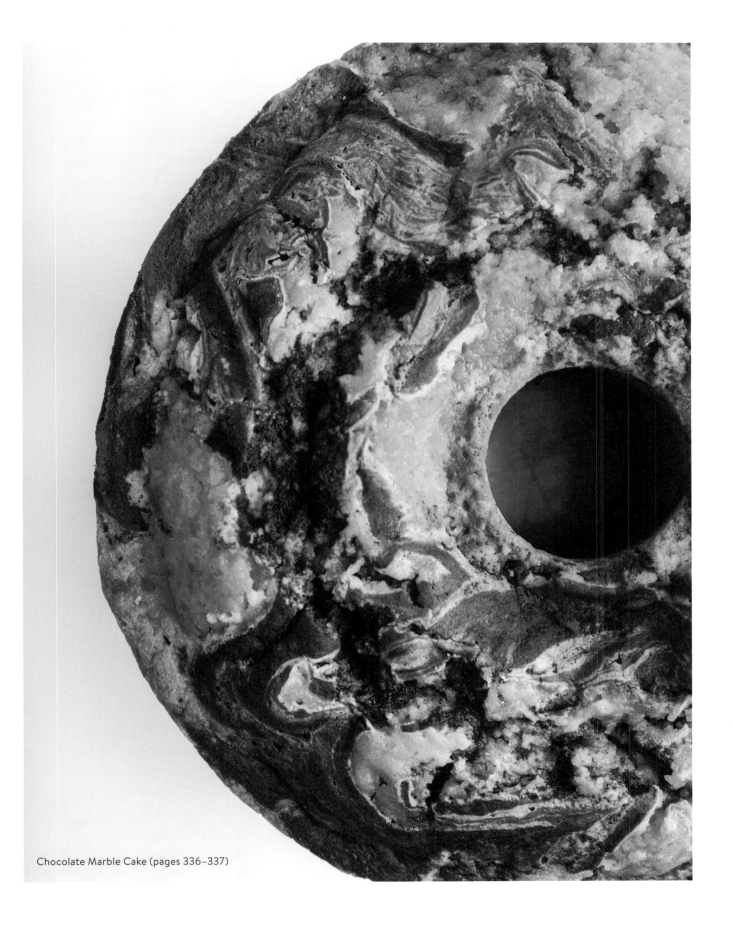

Chocolate Marble Cake (pages 336–337)

Chocolate Marble Cake

Marbling cake with some dark chocolate or spice batter is an old Eastern European and German technique to add visual interest, appearing in Jewish recipe boxes across the South. To create the swirls, you fold chocolate into part of the batter, dollop this alternately with the plain batter in the pan, and then run a knife through it. I baked this buttermilk cake, which has all the comfort of pound cake with the unexpected ribbons of chocolate, and sent it with my husband to an office staff meeting. I felt it needed a glaze, so at the last minute I stirred together confectioners' sugar, Kahlúa, and half-and-half, which was just perfect. But honestly, this cake is fabulous on its own and needs no adornment. Southern cooks have known this for generations.

Serves 12	Prep: 35 to 40 minutes	Bake: 1 hour, 5 to 10 minutes

Butter or vegetable shortening and
 flour for prepping the pan
1/2 cup (50 grams) unsweetened
 cocoa powder
2 1/2 cups (500 grams) granulated
 sugar, divided
1/2 cup water
4 ounces semisweet chocolate,
 chopped
16 tablespoons (2 sticks/227 grams)
 unsalted butter, at room
 temperature
4 large eggs, at room temperature
2 teaspoons vanilla extract
3 cups (360 grams) all-purpose flour
1 teaspoon baking powder
3/4 teaspoon salt
1/2 teaspoon baking soda
1 cup whole buttermilk

Kahlúa Glaze (recipe follows,
 optional), or Chocolate Glaze
 (page 447, optional)

1. Heat the oven to 325°F, with a rack in the middle. Grease and flour a 10-inch tube pan and set aside.

2. Whisk together the cocoa, 1/2 cup of the sugar, and the water in a medium saucepan until smooth. Place over medium-low heat and bring to a simmer, stirring, 2 to 3 minutes. Remove from the heat and stir in the chocolate until melted. Set aside to cool.

3. Place the butter and the remaining 2 cups sugar in a large bowl and beat with an electric mixer on medium speed until creamy and light, 3 to 4 minutes. Stop the machine and scrape down the sides of the bowl. Add the eggs, one at a time, and the vanilla, beating until smooth.

4. Whisk together the flour, baking powder, salt, and baking soda in a medium bowl. With the mixer on low, alternately add the flour mixture and the buttermilk to the batter, beginning and ending with the flour mixture.

5. Spoon about 2 1/2 cups of the batter into the saucepan with the cooled chocolate and stir to combine. Alternately dollop spoonfuls of the plain and chocolate batters into the prepared pan, overlapping the dollops. Smooth the top. Zigzag a dinner knife once through the batter to swirl it.

6. Bake until the cake is firm to the touch, 1 hour and 5 to 10 minutes. Cool on a wire rack for 20 minutes, then run a knife around the edges of the pan and invert the cake once and then again so it cools right side up on the rack. Let cool 1 hour. Glaze, if desired, and let the glaze set for 30 minutes, then slice and serve.

Kahlúa Glaze

Whisk together 1 cup confectioners' sugar with 2 tablespoons Kahlúa and 1 tablespoon half-and-half or whole milk, plus a pinch of salt.

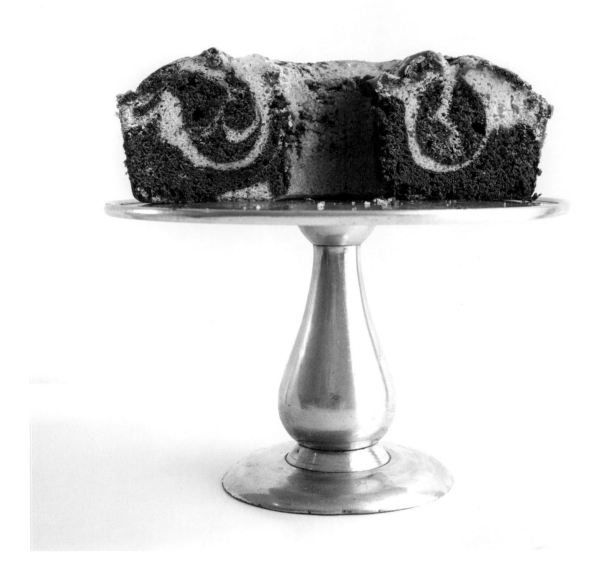

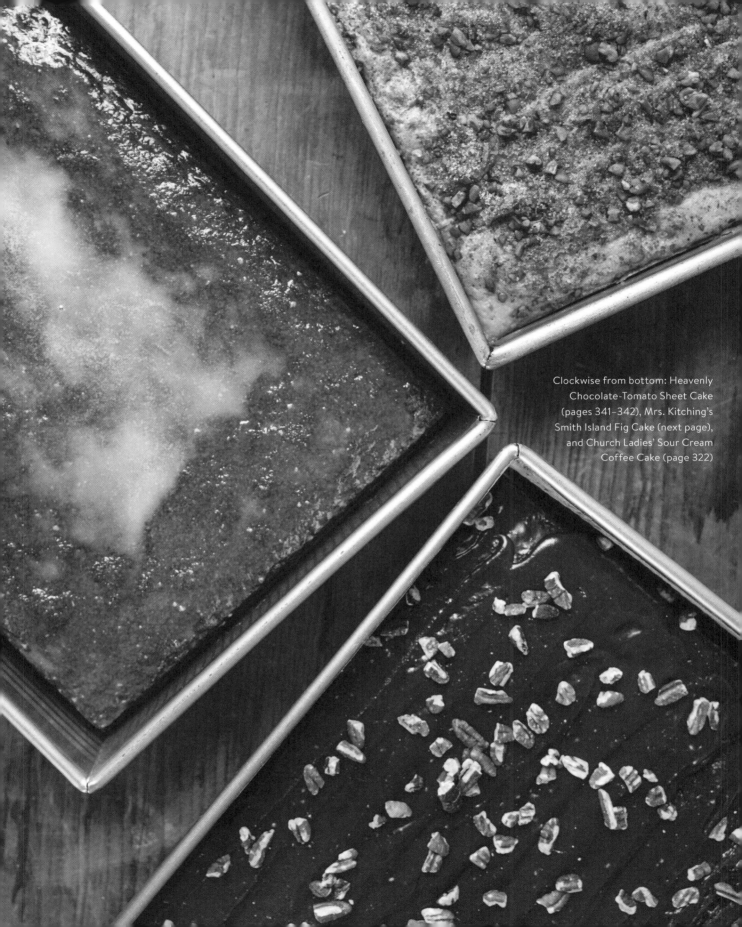

Clockwise from bottom: Heavenly Chocolate-Tomato Sheet Cake (pages 341–342), Mrs. Kitching's Smith Island Fig Cake (next page), and Church Ladies' Sour Cream Coffee Cake (page 322)

Mrs. Kitching's Smith Island Fig Cake

As I poured warm buttermilk glaze over the top of this freshly baked fig and spice cake and watched it seep into the cake's pores, I was reminded of the late Frances Kitching, the famous boardinghouse cook on Maryland's Smith Island. This was her cake—sticky and wet like an island summer just after a rainstorm. The nutmeg, allspice, and cinnamon bring flavor to the buttermilk batter, and the figs come from preserves, either homemade or off-the-shelf. Tiny Smith Island, a remote fishing community settled in the 1600s by the English, was the only home Kitching knew. The island was located twelve miles off the coast of Maryland in the Chesapeake Bay, and electricity only came there in the early 1950s. Kitching cooked crab cakes and corn pudding for the linemen who brought it in. She also created Maryland's state cake, the ten-layer chocolate fudge Smith Island Cake. Kitching died in 2003 at eighty-four.

Figs have grown in the South for centuries. The trees came with Spanish and Italian explorers and thrived where there was sufficient sunlight, salt, and wind. A perishable fruit, figs don't ship well. To savor their unique sweet flavor, you eat them while they last or make preserves from them for this cake.

| Serves 10 to 12 | Prep: 25 to 30 minutes | Bake: 45 to 50 minutes |

Vegetable shortening and flour for
 prepping the pan
1/2 cup (2 ounces/57 grams) finely
 chopped walnuts or pecans
2 cups (240 grams) all-purpose flour
1 1/2 teaspoons baking powder
1 teaspoon ground nutmeg
1 teaspoon ground allspice
1 teaspoon ground cinnamon
1 teaspoon salt
1/4 teaspoon baking soda
3 large eggs
1 1/4 cups (250 grams) granulated sugar
1 cup vegetable oil
1/2 cup buttermilk
1 teaspoon vanilla extract
1 cup (11.5-ounce jar) fig preserves
Buttermilk Glaze (page 447; optional)

1. Heat the oven to 350°F, with a rack in the middle. Grease and flour a 9-by-13-inch pan and set aside.

2. While the oven heats, place the nuts in a small baking pan in the oven to toast until they are golden brown, 4 to 5 minutes. Remove from the oven and let them cool. Finely chop and set aside.

3. Sift together the flour, baking powder, nutmeg, allspice, cinnamon, salt, and baking soda in a large bowl and set aside.

4. Place the eggs in a large bowl and beat with an electric mixer on medium-low speed, gradually adding the sugar, until lemon colored and slightly thickened, about 2 minutes. Add the oil, buttermilk, vanilla, and fig preserves and blend on low until smooth, 1 minute. Fold in the flour mixture and the nuts and stir until smooth.

5. Turn the batter into the prepared pan and bake the cake until the top springs back when lightly pressed in the center, 45 to 50 minutes. Remove from the oven and let cool in the pan for 20 minutes.

6. Pour the Buttermilk Glaze over the cake, if desired, and spread to the edges. Slice and serve.

CIVIL WAR BOILED RAISIN CAKE

Civil War Boiled Raisin Cake, War Cake, Depression Cake, Victory Cake—they're different names for an eggless, dairy-free cake that has made life a little sweeter during times of hardship. Women in the blockaded South during the Civil War often had no sugar, salt, butter, leavening, meat, or soap, according to the 1863 *Confederate Receipt Book*. Unable to purchase salt, they boiled the dirt of their smokehouses, let it evaporate in the sun, then scraped the salt off the bottom of the pan. They boiled watermelon down to make a sweet syrup for baking. Or they boiled raisins, to which they added flour, baking soda, spices, and a tablespoon of lard, along with a little of the cooking water, to make an eggless and butterless cake.

Heavenly Chocolate-Tomato Sheet Cake

When *Arkansas Democrat-Gazette* newspaper food writer Kelly Brant told me her state was known for a chocolate-tomato sheet cake, I thought she was joking. Her recipe for this rich, moist cake is similar to a Texas sheet cake but calls for tomato juice. Like its cousin, it's spread with the chocolate fudge icing while still warm in the pan and is so good. If I didn't tell you, you'd never know about those tomatoes. But if you're a tomato farmer, then you've heard of Bradley County, Arkansas, famous for its sweet soft-pink tomatoes. In fact, this recipe is based on one first shared by Sharon Rice and Mary Ann Clinton in the *50th Anniversary Bradley County Pink Tomato Festival Cookbook 1956–2006*.

 While the oven is still hot from baking the cake, place the pecans inside and let them toast until fragrant. You'll sprinkle them on top of the iced cake.

Serves 16	Prep: 30 to 35 minutes	Bake: 28 to 32 minutes

CAKE

Vegetable oil spray and flour for prepping the pan

8 tablespoons (1 stick/114 grams) unsalted butter, at room temperature

1/2 cup vegetable oil

2 cups (400 grams) granulated sugar

2 large eggs

2 cups (240 grams) all-purpose flour

1/4 cup (25 grams) unsweetened cocoa powder

1 teaspoon baking soda

1 cup hot water

1 1/2 cups (70 grams) miniature marshmallows

1/2 cup tomato juice

1 teaspoon vanilla extract

ICING

2 cups (216 grams) sifted confectioners' sugar

4 tablespoons (1/2 stick/57 grams) unsalted butter

3 tablespoons tomato juice

1 tablespoon water

2 1/2 tablespoons unsweetened cocoa powder

1/8 teaspoon salt

1/2 cup (2 ounces/57 grams) chopped pecans for topping

1. Heat the oven to 350°F, with a rack in the middle. Grease and flour a 9-by-13-inch baking pan and set aside.

2. **Make the cake:** In a large bowl with an electric mixer, beat the butter, oil, and sugar on low speed until creamy, about 3 minutes. Add the eggs, one at a time, and beat until just combined, then scrape down the sides of the bowl.

3. In a separate bowl, whisk together the flour, cocoa, and baking soda. Add it to the creamed mixture, a little at a time, mixing on low, until just combined.

4. In a third bowl, combine the hot water, marshmallows, tomato juice, and vanilla. Pour the mixture into the batter, a little at a time, beating on low, until just combined. The batter will be thin. Pour into the prepared pan and move the marshmallows that rise to the top as needed to distribute them.

5. Bake until the cake springs back when lightly pressed in the center, 28 to 32 minutes. (Leave the oven on, as this is a good time to place the pecans in the oven if you want to toast them for 3 to 4 minutes.) Let the cake rest in the pan while you make the icing.

6. **Make the icing:** Place the confectioners' sugar in a medium bowl and set aside. Place the butter, tomato juice, water, cocoa, and salt in a medium saucepan over medium heat and bring to a boil, stirring to melt the butter, 6 to 7 minutes. Pour over the confectioners' sugar and beat with a wooden spoon until smooth and no lumps remain. Spread warm over the cake, top with the toasted pecans, and serve.

MAKING A TEXAS SHEET CAKE AND COCA-COLA CAKE

Texans might differ about some things, but they will agree cinnamon-scented Texas Sheet Cake is their state cake. You can make one with the Heavenly Chocolate-Tomato Sheet Cake recipe, substituting buttermilk for the tomato juice and adding 1 teaspoon ground cinnamon to the cake, and for the icing, use milk or buttermilk instead of tomato juice. The Texas version is defined by the chopped and toasted pecans folded into the icing before it's spread over the cake. Coca-Cola Cake is similar to the Heavenly Cake but uses Coca-Cola as the liquid in the cake and icing.

Soft drinks have a special place in twentieth-century Southern cake baking. As a Temperance movement swept the South, Atlanta pharmacist John Pemberton created a pharmaceutical tonic and a way of sipping a nonalcoholic beverage that would be deemed kosher by rabbis. He would die before his "soft" drink made the fortune it did for Asa Candler, who bought Pemberton's formula and marketed Coca-Cola as the "Champagne of the South."

Chocolate Moonshine Cake

In the Appalachian South a farmer could make more money distilling corn than grinding it into grits or meal. Corn liquor, white lightning, hooch—whatever you want to call it—made its way into cakes, as long as it was kept out of sight of tax revenuers and Temperance ladies. Cookbook author and pastry chef Brian Noyes, founder of the Red Truck Bakery in Virginia's rolling Piedmont region, knows how a little booze transforms a cake into something more moist and flavorful, and he shared this recipe.

The cake is deeply chocolate and seriously boozy. As I was testing this recipe, I used some moonshine my son had brought back from a college friend whose father still makes it in East Tennessee. If you don't have a local source and you can't find it at the package store, substitute vodka for the moonshine.

Adding 2 tablespoons instant pudding mix is a pastry chef trick to keep this cake fresh for a week.

Serves 12 Prep: 40 to 45 minutes Bake: 46 to 50 minutes

Butter or vegetable shortening and flour for
 prepping the pan

2 1/2 cups (300 grams) unbleached all-purpose flour

2 tablespoons (13 grams) unsweetened cocoa
 powder

2 tablespoons vanilla instant pudding mix

1/2 teaspoon baking soda

1/2 teaspoon ground nutmeg

1/4 teaspoon kosher salt

12 tablespoons (1 1/2 sticks/170 grams) unsalted
 butter, at room temperature

2 cups (384 grams) lightly packed dark brown sugar

1/4 cup vegetable oil

3 large eggs

1 cup (6 ounces) semisweet chocolate chips

1/2 cup moonshine or vodka

1/3 cup buttermilk

2 tablespoons dark rum

1/2 teaspoon grated orange zest

3/4 cup warm water

Chocolate Glaze (page 447; optional) or vanilla ice
 cream

1. Heat the oven to 350°F, with a rack in the middle. Grease and flour a 12-cup Bundt pan and set aside.

2. Whisk together the flour, cocoa, pudding mix, baking soda, nutmeg, and salt in a medium bowl.

3. Place the butter, brown sugar, and oil in a large bowl and beat with an electric mixer on medium-low speed until creamy and fluffy, 2 to 3 minutes. Scrape down the sides of the bowl with a rubber spatula. Add the eggs, one at a time, beating until just combined.

4. Melt the chocolate in a small glass bowl in the microwave on high power for 45 seconds. Stir the chocolate and, if needed, return it to the microwave to heat another 5 seconds, then stir again until the chocolate has melted. Fold it into the butter mixture. Add the moonshine or vodka, buttermilk, rum, and orange zest, and beat on low speed until just blended. Add a third of the flour mixture

and blend on low until just combined. Add half of the water and blend until just combined, continuing to alternate the flour mixture and the remaining water and beating until combined and smooth.

5. Pour the batter into the prepared pan and smooth the top with the rubber spatula. Bake until the cake springs back when lightly pressed and it just begins to pull away from the sides of the pan, 46 to 50 minutes. Remove the pan from the oven and place on a wire rack to cool for 15 minutes. Run a knife around the edges of the pan, give it a shake to loosen the cake, then invert it on the rack to cool to room temperature, 45 minutes.

6. If desired, make the Chocolate Glaze and pour over the top of the cake. Or leave it plain, slice, and serve with vanilla ice cream.

MONETIZING MOONSHINE

Mother grieved that Father made whiskey, drank it, and sold it to other people who got drunk. She felt he was breaking the laws of the land and the laws of God. But Father could make more money selling moonshine whiskey than any other way, and he needed cash.
—Sidney Saylor Farr, *More Than Moonshine* (1983)

Appalachian author Sidney Saylor Farr's father would sell a bushel of his corn for $2 or $3, but if he turned just a fourth of that into corn whiskey, or moonshine, he'd make $100. During Prohibition and after, her father and all the men in his family were known for making the best and purest moonshine in Bell County, Kentucky, Farr said. They used clean, cold, running water, which is why moonshiners set up their stills near flowing streams. It took some skill to arrive at smooth, charcoal-filtered moonshine with 100 proof.

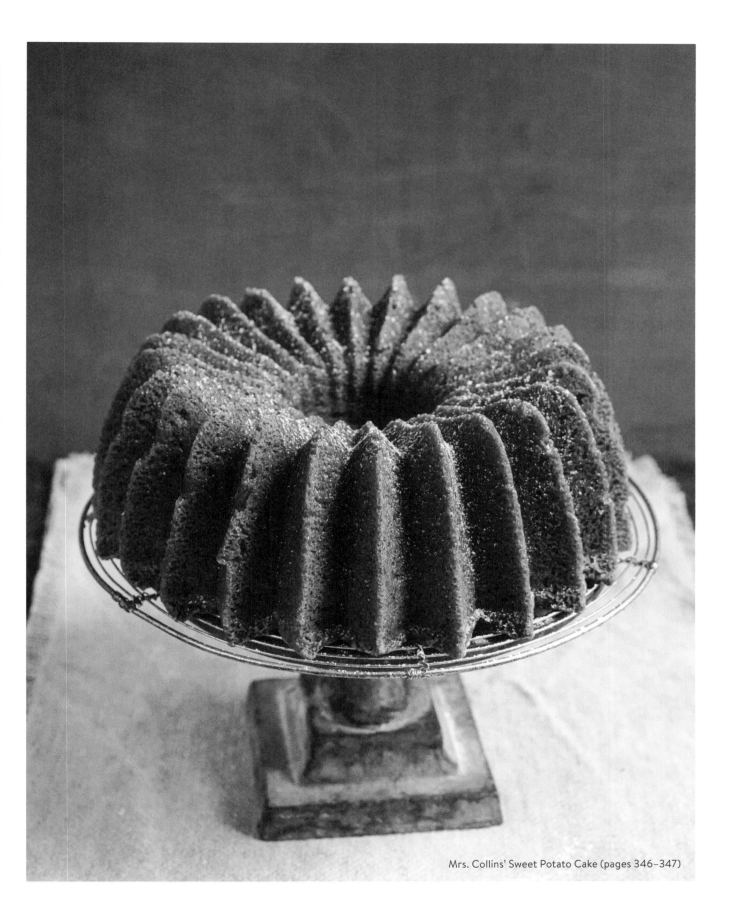

Mrs. Collins' Sweet Potato Cake (pages 346–347)

Mrs. Collins' Sweet Potato Cake

Sweet potatoes make some of the most glorious cakes because they have it all—color, flavor, and moisture to keep a cake fresh days after it's baked. This gorgeous cake comes from the late Elizabeth Cate Collins—whom I only knew as Mrs. Collins—who raised her family in the Nashville house before us and grew sweet potatoes in the back garden. Each year after the harvest, she would bake a sweet potato cake to send to a son in Berkeley, California, for his birthday. A taste of home, the cake was shipped frozen and arrived redolent of spice and seemingly fresh from her oven. In fact, she was so adept at baking and shipping cake that in her 2023 obituary it read, "She was one of the best local customers for FedEx and UPS, whose agents viewed her as a friend."

Serves 10 to 12 Prep: 35 to 40 minutes Bake: 50 to 55 minutes

3 medium (1 to 1 1/4 pounds) unpeeled
 sweet potatoes
Vegetable shortening and flour for
 prepping the pan
1/2 cup (2 ounces/57 grams) roughly
 chopped pecans
2 cups (240 grams) all-purpose flour
1 1/2 teaspoons baking soda
1 1/2 teaspoons ground cinnamon
1 teaspoon ground nutmeg
1 teaspoon baking powder
1 teaspoon salt
1/2 teaspoon ground cloves
1/4 teaspoon ground ginger
1 1/2 cups vegetable oil
1 3/4 cups (350 grams) granulated sugar
2 teaspoons vanilla extract
4 large eggs
1 teaspoon confectioners' sugar for dusting
 (optional)

1. Wash the sweet potatoes and pat dry. Place them in a large saucepan and nearly cover with water. Place the pan over medium-high heat and bring to a boil. Reduce the heat to low, cover, and let simmer until tender, about 25 minutes. Test for doneness by piercing them with a fork, which should easily slide through. Drain and, when cool enough to handle, peel the potatoes and mash. You'll need about 2 cups mashed sweet potatoes. Set aside.

2. Heat the oven to 325°F, with a rack in the middle. Grease and flour a 10- to 12-cup Bundt pan.

3. Place the pecans in a small pan in the oven to toast while the oven heats, 4 to 5 minutes. When the pecans are cool enough to handle, finely chop and set aside.

4. Place the flour, baking soda, cinnamon, nutmeg, baking powder, salt, cloves, and ginger in a large bowl and whisk to combine well.

5. Place the oil and sugar in a large bowl and beat with an electric mixer on medium-low speed until they are well combined, about 1 minute. Add the vanilla and eggs, one at a time, beating well after each addition, a total of 2 minutes. The mixture should be thick and smooth. Stop the mixer, add the sweet potatoes, and blend to combine. Add the flour mixture and beat on low until just combined and smooth, about 1 minute. Fold in the toasted pecans.

6. Pour the batter into the prepared pan and bake until the cake springs back when lightly pressed in the center, 50 to 55 minutes. Remove to a wire rack to cool in the pan for 20 minutes. Run a knife around the edges of the pan, give it a few good shakes to loosen the cake, then invert the cake onto a serving plate. If desired, spoon the confectioners' sugar into a sieve and dust it generously over the top of the cake. Let the cake cool for 45 minutes, then slice and serve.

BAKING A *Beauty*

I once asked Mrs. Collins how she presented this cake fresh from the oven, and she told me her simple trick of dusting powdered sugar over it while it is still warm, so it makes its own glaze. Now I bake her cake in the Nordic Ware Brilliance pan, simply because this sturdy cake releases well from fancy pans and looks absolutely stunning, with or without a dusting of sugar.

TO FREEZE CAKES

- Unfrosted, cakes freeze well, up to 6 months if well wrapped and stored in a deep chest freezer.
- First, let the cake cool completely.
- Wrap it first in plastic or parchment, and then in foil.
- If possible, place in a zipper-top bag and seal.
- Write the name of the cake and the date on the bag before freezing.
- To thaw, remove the cake from the bag and open the packaging to let the cake breathe and the moisture escape.
- If you are frosting the layers, don't let them thaw all the way. They will be easier to stack and frost if still a little frozen.

Mrs. Mosal's White Fruitcake

In the foreword to *The Jackson Cookbook* (1971), Eudora Welty wrote that each Christmas she baked a white fruitcake from a recipe her mother had gotten from a friend. *What took me so long to bake Mrs. Mosal's fruitcake?* I wondered, as I chopped the candied cherries and pecans and reached to the back of the cabinet for the bottle of whiskey. I have adapted the recipe only slightly, keeping the red and green cherries, but using fewer of them. What you get is a lovely and festive fruitcake drenched in bourbon, and after one bite, it will change your mind about fruitcake. Slice and serve with Boiled Custard (page 443).

Fruitcake has many faces. In *Mrs. Porter's New Southern Cookery-Book* (1871), Mary Elizabeth Porter mentions several kinds of fruitcakes: light (white), like this one, or dark (black; see pages 353–354), as well as Yankee (with butter and white sugar) or Confederate (with lard and molasses). Sally White Fruitcake has coconut and almonds, and Japanese Fruit Cake isn't really a fruitcake at all but more of a unique layer cake with a citrus and coconut filling popular in the Deep South. Fruitcake making was once an annual affair, just like winterizing your house or putting chains on the tires of the car to prepare for snow days ahead. If baked and soaked in bourbon at Thanksgiving, the fruitcake would be ready for slicing by Christmas.

Plan ahead: Bake this cake several days to weeks before serving, so it can soak in the liquor.

Serves 8 to 10	Prep: 40 to 45 minutes	Bake: About 2 hours

Soft butter and flour for prepping the pan (see Note)

1 pound mixed dried fruit of your choice (currants, raisins, dried apricots, dried cherries, or red and green candied cherries)

2 cups (228 grams) pecan halves or chopped pecans

2 cups (240 grams) all-purpose flour, divided

12 tablespoons (1 1/2 sticks/170 grams) unsalted butter, at room temperature

1 cup (200 grams) granulated sugar

3 large eggs, at room temperature

1 teaspoon vanilla extract

1 teaspoon baking powder

1/2 teaspoon ground nutmeg

1/2 cup bourbon or brandy, plus more for soaking the cake

1. Heat the oven to 250°F, with a rack in the middle. Grease and flour a 9-by-5-inch loaf pan.

2. Chop the fruit into small uniform pieces, 1/4 to 1/2 inch in size. Place in a small bowl. Chop the pecans into the same size pieces and place in a separate bowl. Toss the fruit with 1/2 cup of the flour. Set aside.

3. Place the butter and sugar in a large bowl and beat with an electric mixer on medium speed until light and fluffy, about 3 minutes. Scrape down the sides of the bowl. With the machine running, add the eggs, one at a time, and beat on low until incorporated. Add the vanilla and beat until blended.

4. Whisk the baking powder and nutmeg into the remaining 1 1/2 cups flour. Add the flour mixture alternately with the bourbon or brandy to the butter mixture, mixing on low until just blended. Fold in the fruit and pecans. Turn into the prepared pan.

5. Bake until the cake is firm and very lightly brown, about 2 hours. The internal temperature should be 200ºF on an instant-read thermometer. Remove from the oven and, while hot, drizzle over additional bourbon or brandy. Let the cake cool in the pan for 30 minutes. Run a knife around the edges of the pan, then invert the cake once and then again so it cools right side up the rack. Let cool completely before serving, about 1 hour. To store, wrap in clean cheesecloth. Place in a metal tin and store covered in a cool place for up to a month. Each week, pour another 1/4 cup bourbon or brandy over the cake, if desired.

NOTE:

Back when my mother and grandmother baked fruitcakes, they would grease the loaf or tube pans with butter and then line them with brown paper. I remember seeing the paper peeled off the sides of the baked fruitcake and my mother telling me it was to protect the cake from overbaking and keep the edges soft.

THE FALL OF FRUITCAKE

The humorist Calvin Trillin swore there was only one fruitcake ever made, and it was handed back and forth but never actually eaten! In former times, though, fruitcakes were baked to show off your baking prowess and your ability to afford the best ingredients. So what happened to make the poor fruitcake the butt of jokes?

Two things, actually. First, the Depression made the ingredients of the cake unaffordable, and old, reliable recipes were changed to include cheaper ingredients like grape juice, rum extract, margarine, and fruit saturated with corn syrup. Then came Prohibition, and suddenly there was no bourbon or rum to invigorate the cake, leaving it bland and saccharine.

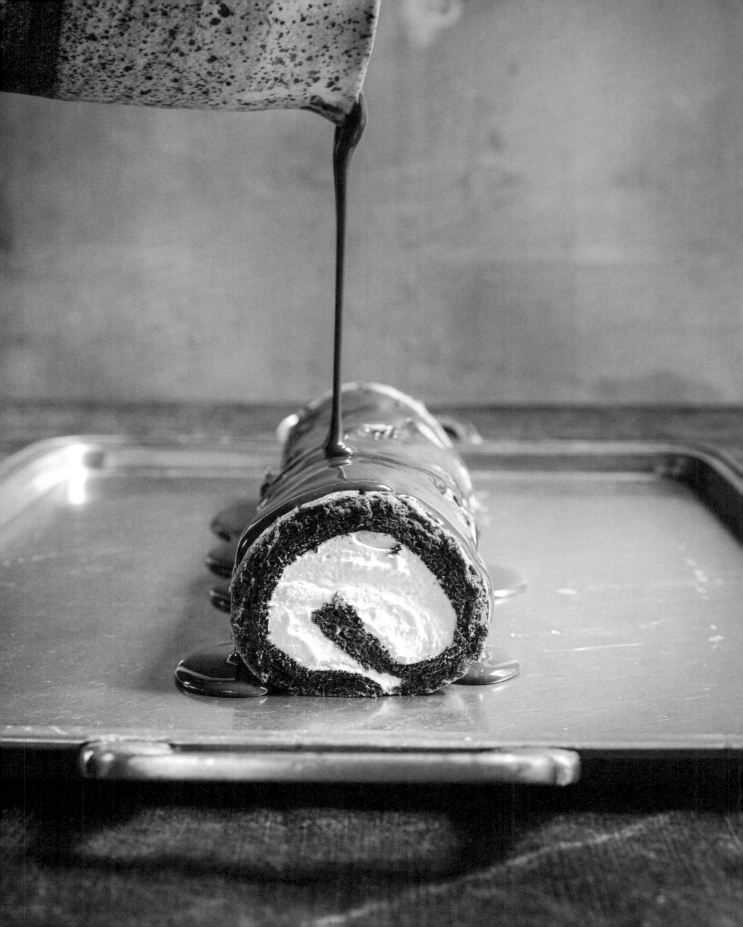

Mrs. Pritchard's Chocolate Roll

In the family cookbook of Sophie Meldrim Shonnard of Savannah is a chocolate roll recipe from a "Mrs. Pritchard." I dug through old recipes and archives to find out who Mrs. Pritchard was, to no avail. But I do know a bit about Shonnard, who was born in Savannah in 1888 and died and was buried in Savannah's Bonaventure Cemetery in 1980. She became a famous fashion designer in New York City, and Jackie Kennedy wore her hand-sewn pink bouclé suit and pillbox hat on November 22, 1963, in Dallas when her husband, President John F. Kennedy, was assassinated.

It seems appropriate that a woman with an eye for Chanel couture fashion would include a chocolate roll recipe resembling a French genoise in her family cookbook. Chocolate rolls are beloved across the South. They were often Passover desserts, as there is no flour in the recipe, just cocoa. Pritchard's delicate roll is filled with sweetened whipped cream with no glaze or adornment, but I have added a simple mocha glaze if you wish to pour it over the top.

Serves 8 to 10	Prep: 45 to 50 minutes	Bake: 20 to 25 minutes

Waxed paper or parchment paper for lining the pan

5 large eggs, at room temperature

1 cup (108 grams) sifted confectioners' sugar, plus more for dusting the kitchen towel

1/4 cup (25 grams) unsweetened cocoa powder

1 teaspoon vanilla extract

Pinch of salt

Whipped Cream (page 458)

MOCHA GLAZE (OPTIONAL)

2 cups (216 grams) sifted confectioners' sugar, plus more for dusting (optional)

3 tablespoons unsweetened cocoa powder, plus more for dusting (optional)

1 teaspoon vanilla extract

3 to 4 tablespoons strong coffee

1. Heat the oven to 350°F, with a rack in the middle. Line a 10-by-15-inch jellyroll pan with waxed or parchment paper and set aside.

2. Separate the eggs, placing the whites in one large bowl and the yolks in another large bowl. Add the sugar to the yolks and beat with an electric mixer on medium speed until lightened in color, the shade of butter, and nearly doubled in volume, 3 to 4 minutes. Add the cocoa and vanilla and beat on low until just combined.

3. Add the salt to the egg whites and, with clean beaters, whip them on high speed until stiff peaks form, 3 minutes. Fold the egg whites into the egg yolk and chocolate mixture with a rubber spatula until just combined. It's fine if a few flecks of egg white remain. Turn into the prepared pan and smooth the top. Bake until the cake springs back when lightly pressed in the center, 20 to 25 minutes.

4. Meanwhile, dust a light kitchen towel with a little confectioners' sugar. The cake will land on this sugar. When the cake is done, run a paring knife around the edges and turn it out onto the sugar. Carefully, because the cake is hot, peel off the waxed or parchment paper. Place a damp kitchen towel or damp paper towels on top of the cake. Let the cake cool, about 20 minutes.

5. **Make the glaze, if desired:** Place the sugar and cocoa in a medium bowl and whisk to combine. Pour in the vanilla and 3 tablespoons of the coffee, adding more coffee as needed for a smooth, spreadable glaze.

6. Remove the damp towels and spread the Whipped Cream smoothly over the top of the cake. Starting with the long side nearest you, roll up the cake, working carefully so it does not crack. (But even if it does, you can spread glaze over the top, and there is always a dusting of confectioners' sugar to cover cracks!) Carefully transfer the cake to a serving platter, seam side down. Spread the glaze over the top or dust with cocoa or confectioners' sugar, if desired. Slice and serve or chill in the refrigerator for up to 4 hours before it's time to serve.

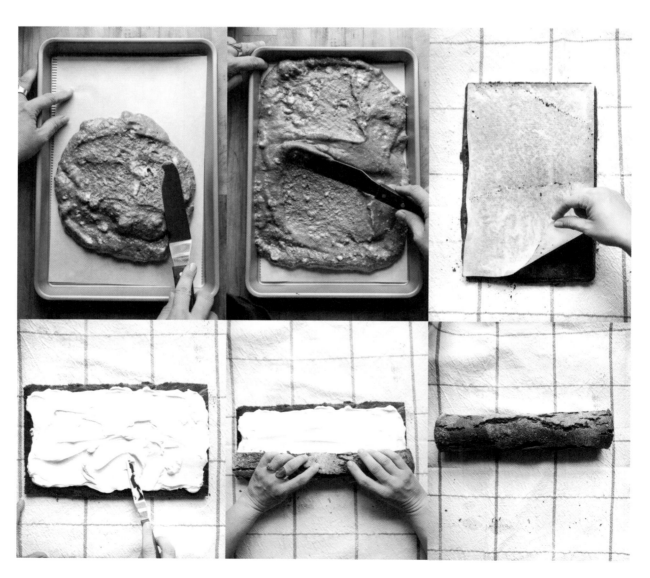

Christmas Black Cake

In *Spoonbread and Strawberry Wine* (1978), authors Carole and Norma Jean Darden write about their cousin Glen's black cake that he once kept for eight years. That's fun to read about, but obviously, I don't advise! With this type of fruitcake, so named because the spices and dark molasses tint it a nearly black hue, you start soaking the dried fruit in the rum at least a day ahead.

Rum-soaked black cake is a Christmas tradition in the Caribbean and parts of the coastal South. This recipe, inspired by New Orleans chef Nina Compton, who was born in Saint Lucia, is made from a mixture of dried fruits of your choosing, which is something I love about black cake. Instead of searching all over town for candied cherries and citron, which are not only seasonal but expensive, you use the dried fruit you might already have on your pantry shelf—prunes, raisins, peaches, apricots, cherries, and figs. You soak the fruit, and as they grow drunk and plump, you're getting closer to baking the cake. You puree half the fruit and chop the rest, creating a texture soft and boozy like plum pudding.

Serves 12	Prep: 25 to 30 minutes	Soaking the fruit: Overnight or up to a week	Bake: 1 hour, 5 to 15 minutes

1 pound (454 grams) dried fruit (prunes, apricots, peaches, cherries, raisins, or figs)

1 cup dark rum, divided

Soft butter and flour for prepping the pan

16 tablespoons (2 sticks/227 grams) unsalted butter, at room temperature

1 cup (200 grams) granulated sugar

1 1/2 cups (12 ounces) molasses or sorghum

5 large eggs, at room temperature

1 large lime

1 teaspoon vanilla extract

1 1/2 cups (180 grams) all-purpose flour

2 teaspoons baking powder

1 teaspoon ground cinnamon

1/2 teaspoon salt

1/2 teaspoon ground nutmeg

1/2 teaspoon ground allspice

1/4 teaspoon ground ginger

Boiled Custard (page 443; optional) for serving

1. Cut the large pieces of fruit, like the peaches, apricots, or figs, into smaller pieces. Place the fruit in a medium bowl and pour over 1/2 cup of the rum. Toss to coat. Cover with plastic wrap and let soak at room temperature overnight or for several days, stirring the fruit once a day, until all the rum is absorbed.

2. When you're ready to bake, heat the oven to 350°F, with a rack in the middle. Grease and flour a 10-inch tube pan. Set aside.

3. Remove half of the fruit, place it in a food processor or blender, and puree with 5 tablespoons of the remaining rum. It should be nearly smooth and in one mass, about 1 minute of pulsing. Set aside, along with the remaining fruit.

4. Place the butter and sugar in a large bowl and beat with an electric mixer on medium

353

speed until creamy and light, 2 to 3 minutes. Stop the machine and scrape down the sides of the bowl. Add the molasses or sorghum and beat until well combined, 1 minute. Add the eggs, one at a time, beating after each addition.

5. Rinse and pat dry the lime. Grate the zest into a small dish and measure 1 teaspoon. Add to the batter. Cut the lime in half, squeeze the juice through a strainer into a small dish, and measure 1 tablespoon. Add to the batter, along with the vanilla. Beat until combined, 30 seconds.

6. Place the flour, baking powder, cinnamon, salt, nutmeg, allspice, and ginger in a small bowl and whisk to combine. Turn the reserved fruit into the flour mixture and toss to coat. Add it to the batter, along with the remaining 3 tablespoons rum, beating on low until smooth. Stop the machine and scrape down the sides of the bowl. Turn the batter into the prepared pan and place in the oven.

7. Bake until the top of the cake is firm to the touch and an instant-read thermometer inserted in the center of the cake registers 200°F, 1 hour and 5 to 15 minutes. The cake will begin to pull away from the sides. Place on a wire rack to cool for 45 minutes.

8. Run a knife around the edges of the pan, then invert the cake once and then again so it cools right side up on the rack. Let cool completely before slicing, at least 2 hours. Preferably, wrap the cake in plastic wrap and store overnight before slicing. Serve with Boiled Custard, if desired.

LITERARY *Cakes*

From Mashula's coconut cake in *Delta Wedding* by Eudora Welty to Esther Bolick's orange marmalade cake in the 1990s Mitford series by Jan Karon to the loaded Lane cake in Harper Lee's *To Kill a Mockingbird*, cakes are baked for fundraisers, weddings, and church suppers in Southern novels. In the case of Lady Baltimore cake, a dazzling white cake filled with sherry-soaked figs, raisins, and walnuts and crowned with fluffy boiled sugar icing, it provides the name for Owen Wister's 1906 romantic novel. In *Lady Baltimore*, a groom enters a fictional Kings Port (Charleston) bakery to purchase a wedding cake and, having second thoughts about his upcoming nuptials, falls in love with the young woman taking his order. In real life, Nina Ottolengui, who owned the Woman's Exchange tearoom with her older sister, Florrie, developed the recipe for the first Lady Baltimore. It's quite possible Wister tasted her cake before he wrote his novel.

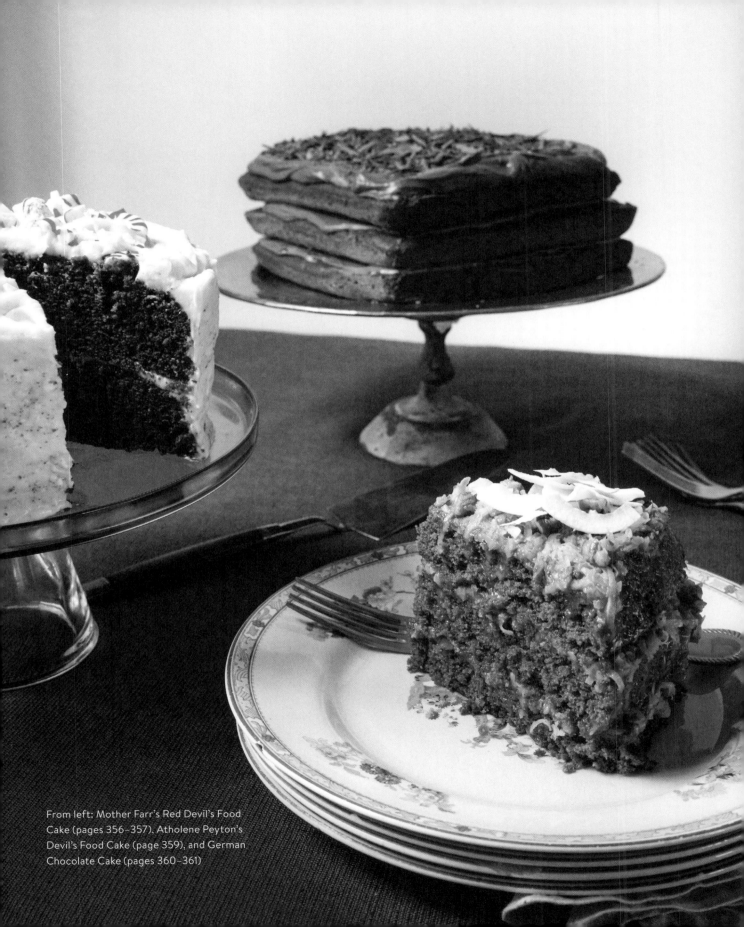

From left: Mother Farr's Red Devil's Food
Cake (pages 356–357), Atholene Peyton's
Devil's Food Cake (page 359), and German
Chocolate Cake (pages 360–361)

Mother Farr's Red Devil's Food Cake

The first red velvet cake was the result of a natural reaction between buttermilk, cocoa powder, and baking soda, before artificial red food coloring appeared in the 1920s. This recipe is a blend of both methods—natural reaction plus a teaspoon of food coloring. The late Appalachian writer and poet Sidney Saylor Farr called it Red Devil's Food Cake, and it was a recipe her mother-in-law baked for the holidays. What I love about this cake is that it is more chocolaty than red velvet. Since Farr doesn't mention a frosting, I took the liberty of going peppermint.

Farr was raised in coal camps and on subsistence farms in Bell County, Kentucky, in the mid-twentieth century. In spite of the poverty, she said, there was the warmth of a woodstove and the chatter at the kitchen table, and once you put your roots down, they can't be pulled up and moved elsewhere. "Mountain people have a strong sense of place; they know where they belong," she wrote in her book *More Than Moonshine* (1983). Baking cakes for church was a big part of southeastern Kentucky social life. "Poor people scrimp and save so they can take desserts and other fine dishes to these affairs." For fourteen years, Farr was the editor of *Appalachian Heritage* magazine, where she encouraged others to write their own mountain stories. She died in Berea, Kentucky, at ninety in 2011.

Serves 10 to 12	Prep: 40 to 45 minutes	Bake: 35 to 40 minutes

Vegetable shortening and flour for prepping the pans

8 tablespoons (1 stick/114 grams) unsalted butter or 1/2 cup (3.5 ounces) vegetable shortening, at room temperature (see Note)

1 1/2 cups (300 grams) granulated sugar

2 large eggs

1/4 cup hot coffee

1/4 cup (25 grams) unsweetened cocoa powder

1 teaspoon red food coloring

1 teaspoon vanilla extract

2 cups (240 grams) all-purpose flour

1 teaspoon baking soda

1/2 teaspoon salt

1 cup buttermilk

Crushed Peppermint Buttercream Frosting (page 456), Ermine Frosting (page 457), or Cream Cheese Frosting (page 454)

1. Heat the oven to 350°F, with a rack in the middle. Grease and flour two 8-inch round cake pans.

2. Place the butter or shortening and sugar in a large bowl and beat with an electric mixer on medium speed until light and creamy, 3 minutes. Add the eggs, one at a time, beating well after each addition. Scrape down the sides of the bowl.

3. Pour the coffee into a small bowl and stir in the cocoa, food coloring, and vanilla until smooth. Pour into the bowl with the butter mixture and beat on low speed until just blended, 30 seconds.

4. Whisk together the flour, baking soda, and salt and add to the butter mixture

alternately with the buttermilk, beating on low until just combined. Scrape down the sides of the bowl and stir to blend the batter one last time. Divide the batter between the prepared pans and place in the oven.

5. Bake until the cakes spring back when lightly touched and begin to pull back from the sides of the pan, 35 to 40 minutes. Remove to a wire rack to cool for 10 minutes. Run a knife around the edges of the pans, give them a shake to loosen the cakes, then invert the layers once and then again so they cool right side up on the rack.

6. To assemble the cake, place one layer on a cake plate. Spread about 3/4 cup of the frosting evenly to the edges. Place the second layer on top. Spread a thin layer of frosting on the sides and on top, creating what is called a "skim coat." Place the cake in the refrigerator to chill 15 minutes. (This seals the crumbs and prevents them from being dragged into the frosting and turning the frosting pink.)

7. Remove the cake from the refrigerator and, with the remaining frosting, generously frost the top and sides of the cake. Slice and serve.

NOTE:

Sidney Saylor Farr and other mountain cooks of the mid-twentieth century would have used vegetable shortening, but I prefer the flavor of butter.

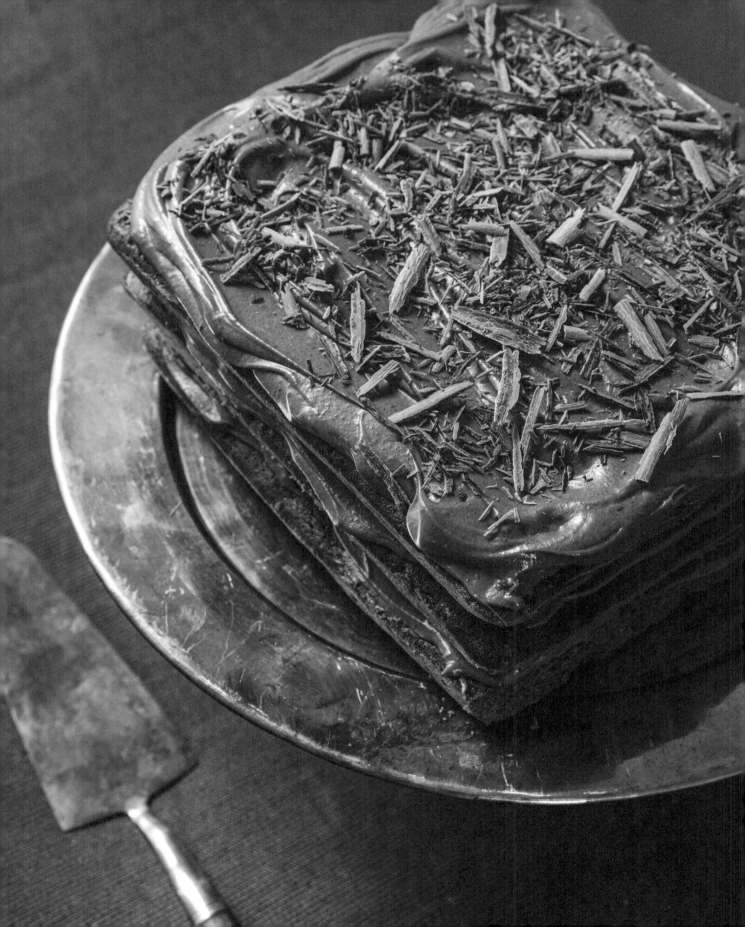

Atholene Peyton's Devil's Food Cake

In 1906, Atholene Peyton, a Louisville home economist and high school teacher, wrote the earliest Black-authored Kentucky cookbook. Called the *Peytonia Cook Book*, it was groundbreaking, offering recipes for housewives as well as for domestic and restaurant workers. It included this decadent layer cake of brown sugar, unsweetened chocolate, and cream. Peyton unabashedly loaded this cake with chocolate at a time when home economists elsewhere were just tiptoeing around it. The crumb seems light, but don't be fooled: this cake is wickedly rich. Spread with your choice of icing or whipped cream.

Serves 12 to 16 Prep: 40 to 45 minutes Bake: 19 to 22 minutes

Vegetable shortening or butter and parchment paper for prepping the pans

18 tablespoons (2 1/4 sticks/256 grams) unsalted butter, at room temperature

3/4 cup heavy cream

1/2 cup water or brewed coffee

4 ounces unsweetened or 72 percent cacao chocolate, chopped

1 cup (200 grams) granulated sugar

1/2 cup (96 grams) lightly packed light brown sugar

4 large eggs, at room temperature

1 1/2 teaspoons vanilla extract

1 3/4 cups (191 grams) cake flour

2 tablespoons unsweetened cocoa powder

1 1/2 teaspoons baking powder

3/4 teaspoon salt

Whipped Cream (page 458), Chocolate Fudge Icing (page 452), or Boiled White Icing (page 444)

Chocolate shavings for garnish

1. Heat the oven to 350°F, with a rack in the middle. Grease the bottom of three 8-inch square cake pans and line with parchment paper.

2. Place the butter, cream, and water or coffee in a large saucepan over low heat until the butter melts, 2 minutes, stirring occasionally. Remove from the heat. Add the chopped chocolate and stir until the chocolate melts. Stir in both sugars until combined. Whisk in one egg at a time and the vanilla until the mixture is smooth.

3. In a large bowl, whisk together the flour, cocoa, baking powder, and salt. Pour the chocolate mixture into the bowl and whisk until smooth. Divide the batter among the three prepared pans and place in the oven. If your oven is not large enough to place three layers on one rack, place two on the center rack and one layer on the rack above, watching to make sure the top cake does not overbake.

4. Bake until the cakes spring back in the center, 19 to 22 minutes. Remove to a wire rack to cool for 10 minutes. Run a knife around the edges of the pans and invert the cakes onto the rack to completely cool. Peel off the parchment paper.

5. To assemble, place one layer on a serving plate. Spread with about 3/4 cup icing. Place the second layer on top and repeat. Place the third layer on top and spread with frosting. Garnish the top with chocolate shavings.

German Chocolate Cake

The first German Chocolate Cake recipe with coconut and pecans was printed in an Irving, Texas, newspaper, and then in the *Dallas Morning News* in 1957. The recipe became a favorite of home cooks and county extension agents, and I know why. It's rich and moist, filled with that sweet, mild German chocolate that was invented by Englishman Sam German in 1852 and sold in the green boxes by the Walter Baker company, and later General Foods. I've baked this same recipe for decades.

While I carefully stir the filling on top of the stove, waiting until the filling sets like custard before folding in toasted pecans and coconut, that's not the way home cooks do it in Texas. There, they toss all the coconut-pecan filling ingredients in the pan from the onset, because they say the coconut and pecans prevent the eggs from curdling. There's no convincing Texans otherwise, so I'm not going to try.

Serves 12 to 16 Prep: 1 hour, 30 minutes Bake: 28 to 32 minutes

CAKE

Butter and flour for prepping the pans

2 cups (240 grams) all-purpose flour

1 teaspoon baking soda

1/2 teaspoon salt

1 package (4 ounces) German's Sweet Chocolate

1/2 cup boiling water

16 tablespoons (2 sticks/227 grams) unsalted butter, at room temperature (see Notes)

2 cups (400 grams) granulated sugar

4 large eggs, at room temperature, separated

1 teaspoon vanilla extract

1 cup buttermilk

COCONUT-PECAN FILLING

1 1/2 cups (12-ounce can) evaporated milk

1 1/2 cups (300 grams) granulated sugar

4 egg yolks, slightly beaten

12 tablespoons (1 1/2 sticks/170 grams) unsalted butter, cut into tablespoons

1 1/2 teaspoons vanilla extract

1/4 teaspoon salt

2 1/3 cups (about 7 ounces) unsweetened flaked coconut (see Notes)

1 1/2 cups (6 ounces/171 grams) chopped toasted pecans (see Notes)

1. Heat the oven to 350°F, with a rack in the middle. Lightly grease and flour three 9-inch round cake pans. Set the pans aside.

2. **Make the cake:** Place the flour, baking soda, and salt in a large bowl and whisk to combine. Set aside.

3. Chop the chocolate into 1/2-inch pieces and place in a medium bowl. Pour the boiling water over it and stir to melt the chocolate. Set aside.

4. Place the butter and sugar in a large bowl and beat with an electric mixer on medium speed until light and fluffy, 2 to 3 minutes. Add the egg yolks, one at a time, beating after each addition. Add the vanilla. Blending on low speed, alternately add the flour mixture and the buttermilk to the batter, beginning and ending with the flour mixture. Fold in the melted chocolate. Set aside.

5. Place the egg whites in a large mixing bowl and, with clean beaters, beat on high speed until almost-stiff peaks form, 3 to 4 minutes. Fold the egg whites into the batter. Divide the batter among the prepared pans and place in the oven. If your oven is not large enough to place three layers on one rack, place two on the center rack and one layer on the rack above, watching to make sure the top cake does not overbake.

6. Bake the cakes until they spring back when lightly pressed in the center, 28 to 32 minutes. Remove the pans from the oven and place on a wire rack to cool for 15 minutes. Run a knife around the edges of the pans, give them a shake to loosen the cakes, then invert the layers once and then again so they cool right side up on the rack. Let cool completely, about 45 minutes.

7. **Make the filling:** Place the milk, sugar, egg yolks, butter, vanilla, and salt in a large saucepan over medium heat and cook, stirring constantly, until the mixture thickens and is caramel in color, about 15 minutes. Remove the pan from the heat, fold in the coconut and pecans, and let cool until it is thick enough to spread. You can refrigerate the filling while the cake layers cool. (Or to speed the process along, you can make the filling before you bake the cake.)

8. To assemble, place one cake layer on a serving plate and cover with 1 cup of filling, spreading it to the edges. Top with the second layer and repeat. Top with the third layer and pile the remaining filling on top, leaving the sides bare. Chill for 1 hour for easier slicing. Serve.

NOTES:

If you use salted butter, reduce the salt in the cake to 1/4 teaspoon and omit salt from the filling.

Use unsweetened coconut, but if you can't find it, sweetened will do.

Pecans are much more delicious if toasted first. Place them on a baking pan in the turned-off oven while you are preparing the filling. When they are medium brown and fragrant, after 3 to 5 minutes, remove from the oven.

Sonya Jones' Sweet Potato Cheesecake

Atlanta pastry chef and cookbook author Sonya Jones vividly remembers her mother, Catherine Thomas Johnson, baking sweet potato pie and red velvet cake. She opened a bakery called Sweet Auburn Bread Company in 1997 to recreate her mother's cherished recipes. She says there weren't Black-owned bakeries when she was growing up in Atlanta. People in her neighborhood baked their own cakes and pies, sold them at church, and grew much of what they ate. Once, in a vast garden behind their southwest Atlanta home, within view of Westview Cemetery, her family grew peaches, blackberries, and sweet potatoes. That garden was lost when Interstate 20, the main east-west route through Atlanta, was constructed, leaving Jones with bittersweet nostalgia.

Jones would graduate from the Culinary Institute of America, and when President Bill Clinton walked into her bakery in 1999 and tasted her sweet potato cheesecake, her life changed. That cheesecake with a pound cake crust and a filling with a hint of nutmeg made national news and her bakery became a destination for cake lovers in and out of the South. This is a wonderful do-ahead dessert for fall holidays and gatherings from her cookbook, *Sweet Auburn Desserts* (2012).

Serves 12	Prep: 50 to 55 minutes	Bake: 1 hour, 30 to 35 minutes

CRUST

Vegetable oil spray for misting the pan

Parchment paper for lining the pan (optional)

5 slices (1/4 inch) pound cake, store-bought or make Eliza Ashley's Buttermilk Pound Cake (pages 332–333)

FILLING

4 medium (1 3/4 pounds) unpeeled sweet potatoes

24 ounces (three 8-ounce packages) cream cheese, at room temperature

1 1/2 cups (300 grams) granulated sugar

3 large eggs, at room temperature

1 teaspoon vanilla extract

1 teaspoon ground nutmeg

1 cup half-and-half

Whipped Cream (page 458) for serving

1. **Make the crust:** Mist the bottom and sides of a 9-inch springform pan with the vegetable oil spray. For extra insurance, if desired, line the bottom of the pan with a circle of parchment paper. Place the pound cake slices in the bottom of the pan, cutting them as needed to press together into a bottom crust. Make sure no spaces remain between the slices. Set aside.

2. **Make the filling:** Rinse and pat dry the sweet potatoes. Cover them in a large saucepan with water and boil in their "jackets"—unpeeled—until very tender when pierced with a fork, 25 to 30 minutes, depending on the size of the potatoes. You should be able to stick a fork nearly through the potatoes with ease. Drain and, when cool enough to handle, peel and mash. You'll need 2 cups mashed potatoes. Let cool.

3. Heat the oven to 350°F, with a rack in the middle.

4. Place the cream cheese in a large bowl and beat with an electric mixer on medium speed, gradually adding the sugar, until fluffy, 2 to 3 minutes. Scrape down the sides of the bowl. Add the eggs, one at a time, beating on low, until blended. Scrape down the sides of the bowl again. Add the reserved sweet potatoes, vanilla, nutmeg, and the half-and-half and beat on low until just blended. Pour into the prepared pan and place in the oven.

5. Bake until the center is almost set and the top has lightly browned, 1 hour and 30 to 35 minutes. Remove to a warm spot near the oven to cool to room temperature, 3 to 4 hours. Chill for 2 hours before slicing. To serve, unlock the sides of the pan, transfer to a serving plate, slice, and serve with whipped cream.

Sonya Jones, Atlanta chef

The Hummingbird Cake

One of the South's favorite cakes, the lovely triple-layer banana and pineapple Hummingbird, shot into stardom in February 1978 after being printed in "The Magazine of the Modern South"—*Southern Living*. Submitted by the late Eva Wiggins of Greensboro, North Carolina, the cake was spread generously with cream cheese frosting and became the most popular recipe in the publication's nearly sixty-year history. For years no one knew much about Wiggins, until *Southern Living*'s business manager, Nellah Bailey McGough, was able to locate her family and learn that Wiggins was an accomplished pianist who loved to bake and travel. She died in 1995 at eighty-one. Truth be told, a Hummingbird Cake had been printed in the *Charlotte Observer* in 1969, but it was a Bundt cake from a recipe that former food editor Helen Moore had received in a press packet from Jamaica Airlines. The cake is so named because the symbol for the airline was a type of hummingbird.

While Wiggins' original recipe called for 1 1/2 cups oil, I bake this cake with less, just 1 cup, but suit yourself. Also, she was more generous with the pecans (or walnuts, she said), using 1 cup in the cake and another cup on top, but that is up to you. This cake is a better keeper (and slicer) if you omit the nuts, as nuts draw moisture out of the cake.

Serves 12 to 16	Prep: 50 to 55 minutes	Bake: 20 to 25 minutes

CAKE

Vegetable shortening or butter and parchment
 paper for prepping the pans

3 cups (360 grams) all-purpose flour

2 cups (400 grams) granulated sugar

1 teaspoon ground cinnamon

1 teaspoon baking soda

1 teaspoon salt

3 large eggs, lightly beaten

1 to 1 1/2 cups vegetable oil

1 1/2 teaspoons vanilla extract

1 can (8 ounces) crushed pineapple packed in juice,
 undrained

1 cup (4 ounces/114 grams) finely chopped pecans
 (optional)

2 cups mashed ripe bananas (from 5 to 6 medium bananas)

GARNISH AND FROSTING

1/2 to 1 cup (57 to 114 grams) chopped toasted pecans
 (optional)

Cream Cheese Frosting (page 454)

Pineapple Flowers (recipe follows; optional)

1. **Make the cake:** Heat the oven to 350ºF, with a rack in the middle. Grease three 9-inch round cake pans and line the bottoms with parchment paper. Set aside.

2. Whisk together the flour, sugar, cinnamon, baking soda, and salt in a large bowl. Add the eggs, from 1 to 1 1/2 cups oil, and vanilla and beat with an electric mixer on low speed until combined, 1 to 2

minutes. Fold in the pineapple, pecans (if desired), and bananas. Divide the batter among the prepared pans and place the pans in the oven. If your oven is not large enough to place three layers on one rack, place two on the center rack and one layer on the rack above, watching to make sure the top cake does not overbake.

3. Bake until the cakes just pull away from the edges of the pans, 20 to 25 minutes. Remove the pans from the oven and place them on a wire rack to cool for 10 minutes. Run a knife around the edges of the pans and give them a gentle shake to loosen. Invert the cakes once and then again onto the racks. Let the layers cool to room temperature, at least 30 minutes.

4. **If using the pecans as garnish,** toast them in a 350°F oven for 4 to 5 minutes.

5. To assemble the cake, place one layer on a serving plate. Spread with about 2/3 cup frosting. Top with a second layer and repeat with frosting. Top with the third layer and frost the top and sides of the cake with smooth strokes. Garnish the top of the cake with the pecans, if desired, or Pineapple Flowers. Slice and serve. Or, chill for 1 hour uncovered for easier slicing.

HOW TO MAKE PINEAPPLE FLOWERS

Heat the oven to 200°F, with a rack in the middle. Cut the top and bottom off a large pineapple and trim off the rind, leaving the core intact. Cut the pineapple into very thin slices, 1/6 to 1/8 inch thick. (A mandoline helps tremendously.) Lay the slices out on a single layer of paper towel to absorb as much moisture as possible. Line a baking sheet with a silicone mat or parchment paper and place the pineapple slices in a single layer on the mat. Bake until dried and the edges start to look frilly, 1 1/2 to 2 hours. The baking time varies depending on the width of your slices. Once dried, carefully peel the slices off the mat and place each one in the cup of the cupcake pan, pressing against the sides to help form their shape. Let cool completely before using.

Dolester Miles' Coconut Pecan Cake

The James Beard Award–winning pastry chef Dolester Miles just might have created the most famous coconut cake in the South. It's the oft-photographed signature dessert at Frank Stitt's Chez Fonfon and Highland Bar & Grill in Birmingham. Layers of butter cake filled with coconut and pecans are swabbed with sugar syrup and filled with an eggy custard of more coconut, and then enrobed with whipped cream and even more coconut. The cake is over-the-top and time-consuming, but worth it. Miles was a teenager in Bessemer, Alabama, cooking with her mother, Cora Mae Miles, and aunt, Queen Ester Harris, when she first preheated an oven and sifted flour. When she got to Stitt's restaurants in the 1980s, that experience paid off, and she was able to create something that faintly reminds you of Italian cream cake and German chocolate cake but is its own cake. An original.

To toast the coconut for the garnish, place the 2 cups coconut on a baking sheet while the oven preheats. Turn the oven light on so you can watch it brown. It takes 5 to 7 minutes.

Serves 12 to 16 Prep: 60 to 65 minutes Bake: 30 to 35 minutes

CAKE

Butter or vegetable shortening and parchment
 paper for prepping the pans
1 cup (45 grams) lightly packed sweetened
 shredded coconut
3/4 cup (3 ounces/74 grams) pecan halves, toasted
2 cups (400 grams) granulated sugar, divided
2 1/4 cups (270 grams) all-purpose flour
1 tablespoon baking powder
3/4 teaspoon salt
12 tablespoons (1 1/2 sticks/170 grams) unsalted
 butter, at room temperature
1/4 cup cream of coconut (Coco Lopez)
4 large eggs, at room temperature
1/4 teaspoon coconut extract
1 cup plus 2 tablespoons unsweetened coconut milk

FILLING

2 large egg yolks
3/4 cup sweetened condensed milk
4 tablespoons (1/2 stick/57 grams) unsalted butter
1 tablespoon cream of coconut
1 cup (45 grams) shredded sweetened coconut,
 chopped

SIMPLE SYRUP

1/2 cup (100 grams) granulated sugar
1/2 cup water

ICING AND GARNISH

1 1/2 cups heavy cream
1/4 cup (27 grams) confectioners' sugar
1/2 teaspoon coconut extract
2 cups (90 grams) shredded sweetened coconut,
 toasted

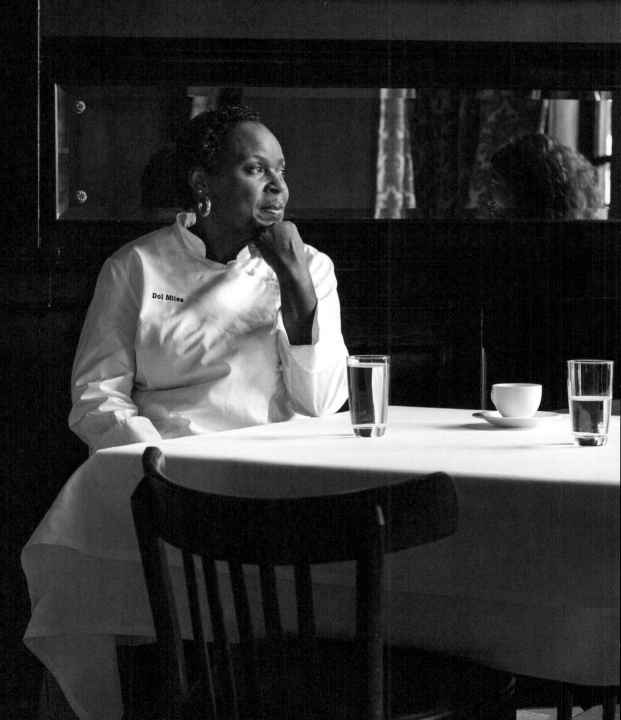

Dolester Miles,
Birmingham chef

1. **Make the cake:** Heat the oven to 350ºF, with a rack in the middle. Grease two 9-inch round cake pans with butter or vegetable shortening and line them with parchment paper. Finely grind the coconut, using a food processor. Finely grind the pecans with 2 tablespoons of the sugar.

2. Place the flour, baking powder, and salt in a large bowl and stir to combine. Stir in the coconut and pecans. Set aside.

3. Place the butter, cream of coconut, and remaining sugar in a large bowl and beat with an electric mixer on medium speed until light and fluffy, 4 minutes. Scrape down the sides of the bowl. Continue beating, adding the eggs, one at a time, until combined. Add the coconut extract. By hand or with the mixer on low speed, alternate adding the flour mixture and the coconut milk until just combined. Divide the batter between the prepared pans and smooth the tops with a rubber spatula. Place in the oven.

4. Bake until the cakes are lightly browned and spring back when lightly pressed in the center, 30 to 35 minutes. Remove the pans from the oven and place on a wire rack to let the cakes cool for 10 minutes. Run a knife around the edges of the pans, give them a gentle shake to loosen the cakes, then invert and then invert once again onto racks so they can cool right side up.

5. **Meanwhile, make the filling:** Beat the egg yolks lightly with a fork in a heatproof bowl. Set aside. Place the condensed milk, butter, and cream of coconut in a medium saucepan over medium heat and stir until the butter melts. Whisk a third of this mixture into the yolks to temper them and bring up their temperature, and, whisking constantly, turn the yolks into the mixture in the saucepan. Reduce the heat to medium-low and cook, whisking, until the filling is pudding-like and begins to thicken, 3 to 4 minutes. Remove the pan from the heat, fold in the coconut, and let the filling cool at room temperature while you prepare the rest of the cake. If you make this earlier in the day, cover the top with plastic wrap and place in the fridge.

6. **Make the simple syrup:** Place the sugar and water in a small saucepan over medium heat and whisk until the sugar dissolves and the mixture reduces slightly, 4 to 5 minutes.

7. To assemble the cake, using a serrated knife, split the layers horizontally into 4 layers. Brush the top of each with the simple syrup. Stack, spreading the filling between the layers, and place in the fridge to chill.

8. **Make the icing and garnish the cake:** Pour the cream into a large bowl. Add the sugar and coconut extract and beat with an electric mixer on medium-high speed until stiff peaks form, 2 to 3 minutes. Spread onto the sides and top of the cake. Pack the top and sides with the shredded toasted coconut. Slice and serve.

Janie Cheney's Sticky Lemon Cake

Janie Cheney was born in Columbus, Georgia, in 1918 and grew up in that southwestern corner of the state that's part of the Lane cake belt, where baking caramel, Japanese fruit cake, and a lemon "cheese" cake with White Lily flour was what you did for holidays and birthdays. She would transport that tradition north to Dalton, where she lived out her life. "My grandmother never showed up without a cake," says Kyle Tibbs Jones of Athens. "My mother says that she preferred cake over pie because they served more people."

Lemon cheese cake is not the cheesecake made of cream cheese most people think of, but a much older hot milk sponge cake sandwiched with a sticky lemon curd and frosted with a bright-white icing that seeps deliciously into the cake. Cheney was eighty-seven when she died in 2005. She didn't leave the family directions for making her cake, but I helped them transform memories into this recipe.

| Serves 12 to 16 | Prep: 60 to 65 minutes | Bake: 20 to 25 minutes |

STICKY LEMON FILLING

4 tablespoons (1/2 stick/57 grams)
 unsalted butter

3/4 cup (150 grams) granulated sugar

2 large lemons

3 large eggs

1/4 teaspoon salt

CAKE

Butter and flour for prepping the pans

4 large eggs, at room temperature

2 cups (400 grams) granulated sugar

2 cups (240 grams) all-purpose flour,
 plus 1 tablespoon

1 cup whole milk

8 tablespoons (1 stick/114 grams)
 unsalted butter

1 tablespoon baking powder

1/2 teaspoon salt

1 teaspoon vanilla extract

Boiled White Icing (page 444) or
 Whipped Cream (page 458)

1. **Make the filling:** Place the butter and sugar in the top of a double boiler set over a pan filled with 2 inches of cold water (see Note, page 375, for improvising one). Wash and dry the lemons. Grate the zest onto a plate to yield 1 rounded teaspoon. Add the zest to the butter and sugar. Cut the lemons in half and juice them to yield 1/4 cup plus 1 tablespoon. Add the juice to the pan. Turn the heat under the saucepan to medium and stir until the butter melts and the mixture is warm. Meanwhile, beat the eggs with the salt in a small bowl. Whisk 2 tablespoons of the hot lemon mixture into the eggs to raise their temperature. Turn the eggs into the double boiler and whisk until thickened, 2 to 3 minutes. Remove the top insert from the pan and place it in the sink filled with an inch of ice water to stop the cooking. Stir until smooth and place in the fridge while you bake the cake. (You can do this step the day before and let chill overnight.)

2. **Make the cake:** Heat the oven to 350°F, with a rack in the middle. Grease and flour three 9-inch round cake pans and set aside.

3. Crack the eggs into a large bowl and beat with an electric mixer on medium speed for 30 seconds, just to blend. Gradually add the sugar, beating, until the mixture is lemon colored and doubled in volume, 2 to 3 minutes. Set aside.

4. Sift the 2 cups flour twice and add to the egg mixture a little at a time, beating on low speed until just combined and stopping several times to scrape the bowl, 30 to 45 seconds.

5. Place the milk and butter in a medium saucepan over medium-high heat. Stir until the butter melts and the mixture comes just to a boil, about 4 minutes. Slowly pour the butter and milk into the batter, while beating on medium speed, about 1 minute, until smooth. The batter will be thin. Stir the 1 tablespoon of flour into the baking powder and salt in a small bowl and add to the batter, along with the vanilla, beating until just combined, 1 minute. Divide the batter among the prepared pans and place the pans in the oven. If your oven is not large enough to place three layers on one rack, place two on the center rack and one layer on the rack above, watching to make sure the top cake does not overbake.

6. Bake the cakes until lightly golden brown, 20 to 25 minutes. Remove the pans from the oven and place them on wire racks to let the cakes cool for 10 minutes. Run a knife around the edges of the pans, give the pans a gentle shake, then invert the cakes once and then again so they rest right side up on the racks to completely cool, 30 minutes.

7. To assemble the cake, place one layer on a cake plate or platter and spread half of the filling to within 1/2 inch of the edges. Top with a second layer and spread with the other half of the filling. Place the third layer on top. Place the cake in the fridge to chill for 30 minutes.

8. To finish assembling, remove the cake from the refrigerator and frost the top and sides with Boiled White Icing or Whipped Cream. Slice and serve.

TO USE FRESH COCONUT IN CAKES AND CUPCAKES

Preheat the oven to 375°F. Hammer a nail into the three "eyes" of the coconut. Remove the nail to create three holes. Pour the coconut milk into a small bowl, straining it to remove any bits of husk.

Place the coconut on a baking pan in the oven and bake until it cracks, 15 to 20 minutes. It may not split all the way open. Remove the pan and coconut from the oven, and with potholders or oven mitts take the coconut to a hard surface, and hit with a hammer to crack the coconut open completely. Let cool.

Using a sharp knife, pry the meat away from the hard shell, and with a smaller paring knife peel away the thin, dark skin. Rinse the coconut of husk and dry.

Drop similar- size pieces into the food processor and pulse until finely grated, 1 1/2 to 2 minutes. Repeat until all the coconut has been grated.

From left: Blackberry Jam Cake (pages 377–378),
The Hummingbird Cake (pages 365–366), and
Emma Rylander Lane's Prize Cake (pages 374–375)

Emma Rylander Lane's Prize Cake

More than a century ago, Emma Rylander Lane won first prize for baking this cake at a fair in Columbus, Georgia, and she shared the recipe in her cookbook, *Some Good Things to Eat* (1898). When she moved to Alabama with her husband's railroad job, she took the cake across state lines and thus began a two-state love affair with the cake that oozes bourbon the longer it's stored. Lane Cake, named after its creator, or sometimes called "prize cake," gets your attention with bright-red maraschino cherries, plump raisins, and pecans. It's Alabama's state cake, popularized in Harper Lee's *To Kill a Mockingbird*; Jimmy Carter's favorite cake; and Georgia's Christmas cake, loved by all, even the Baptists who send someone else to pick up the bourbon at the liquor store. (Or, they could bake something called an "Amalgamation Cake," which is a Lane without the booze.) This recipe is from the late Mary Jim Pianowski of Andalusia, Alabama, and unlike other versions, is not spread with Boiled White Icing around the sides. But suit yourself. You need to plan enough time to make the filling/frosting the day before baking the cake.

Alabama author Emily Blejwas sees Lane Cake aligning with the changing roles of women in the Progressive Era of the early twentieth century. This bright and boozy feminist cake was baked by the same outspoken women who pushed for the right to vote, equality in marriage, and better educational and workplace opportunities. Lane died in Cananea, Mexico, in 1904 at forty-seven.

| Serves 8 to 12 | Prep: 1 hour, 30 minutes to 1 hour, 45 minutes | Bake: 25 to 30 minutes |

FILLING AND FROSTING

2 cups (400 grams) granulated sugar

16 tablespoons (2 sticks/227 grams) salted butter, at room temperature

10 large egg yolks

2 cups (10 ounces/300 grams) raisins, chopped

1 cup (5 ounces/150 grams) maraschino cherries (save a few for garnish, chopped in half; optional)

1 cup (4 ounces/114 grams) chopped pecans (save a few whole nuts for garnish; optional)

1 teaspoon vanilla extract

1/2 cup bourbon

CAKE

Vegetable shortening and waxed paper for prepping the pans

16 tablespoons (2 sticks/227 grams) salted butter, at room temperature

8 tablespoons (1 stick/114 grams) margarine, at room temperature

3 cups (600 grams) granulated sugar

5 large eggs, at room temperature

3 cups (360 grams) all-purpose flour

1/2 teaspoon baking powder

1/4 teaspoon salt

1 cup whole milk

1 teaspoon vanilla extract

1. **Make the filling:** Place the sugar and butter in a large bowl and beat with an electric mixer on medium speed until the mixture comes together and lightens, about 2 minutes. In a separate, smaller bowl, beat the egg yolks with a whisk until they turn light yellow in color. Beat the egg yolks into the butter mixture on low until just combined.

2. Fill the saucepan of a double boiler with 2 inches of water (see Note). Place the pan over medium-high heat and bring to a boil, then reduce the heat so the water simmers. Turn the sugar and egg mixture into the pan on top. Cook, stirring constantly, over simmering water until the custard thickens and is smooth, 30 to 40 minutes. Remove the pan from the heat and stir in the raisins, cherries, pecans, and vanilla. Stir to combine the ingredients well and then stir in the bourbon. Transfer the mixture to a bowl, cover with plastic wrap, and chill until ready to assemble. It can be made a day in advance.

3. **Make the cake:** Heat the oven to 350ºF, with a rack in the middle. Lightly grease the bottom of three 9-inch round cake pans with vegetable shortening. Cut waxed paper rounds to fit the bottom of the pans. Set the pans aside.

4. Place the butter and margarine in a large mixing bowl and add the sugar. Cream the mixture by beating with an electric mixer on medium-low speed until the mixture comes together and lightens, 2 to 3 minutes. Add the eggs, one at a time, beating well after each addition.

5. In a separate, smaller bowl, sift together the flour, baking powder, and salt. Add the flour mixture and milk alternately to the butter mixture, beginning and ending with the flour mixture. Blend in the vanilla. Divide the batter among the prepared pans and place the pans in the oven. If your oven is not large enough to place three layers on one rack, place two on the center rack and one layer on the rack above, watching to make sure the top cake does not overbake.

6. Bake the cakes until they are lightly browned and spring back when lightly pressed in the center, 25 to 30 minutes. Remove the pans from the oven to a wire rack to cool for 10 minutes. Run a knife around the edges of the cakes, give the layers a gentle shake, and invert the layers once and then again onto the rack to cool completely, right side up, about 30 minutes.

7. To assemble the cake, you have some choices. The first is to place the filling between the layers and on top of the cake, the second is to place the filling between the layers and all over top and sides of the cake, and the third is like the second, except using Boiled White Icing (page 444) on the sides. Decorate the top of the cake with the reserved cherries and pecans, if desired. Chill until it's time to slice and serve.

NOTE:

To improvise a double boiler, fill a saucepan with an inch of water and place a stainless-steel bowl on top of the pan, so it doesn't touch the water.

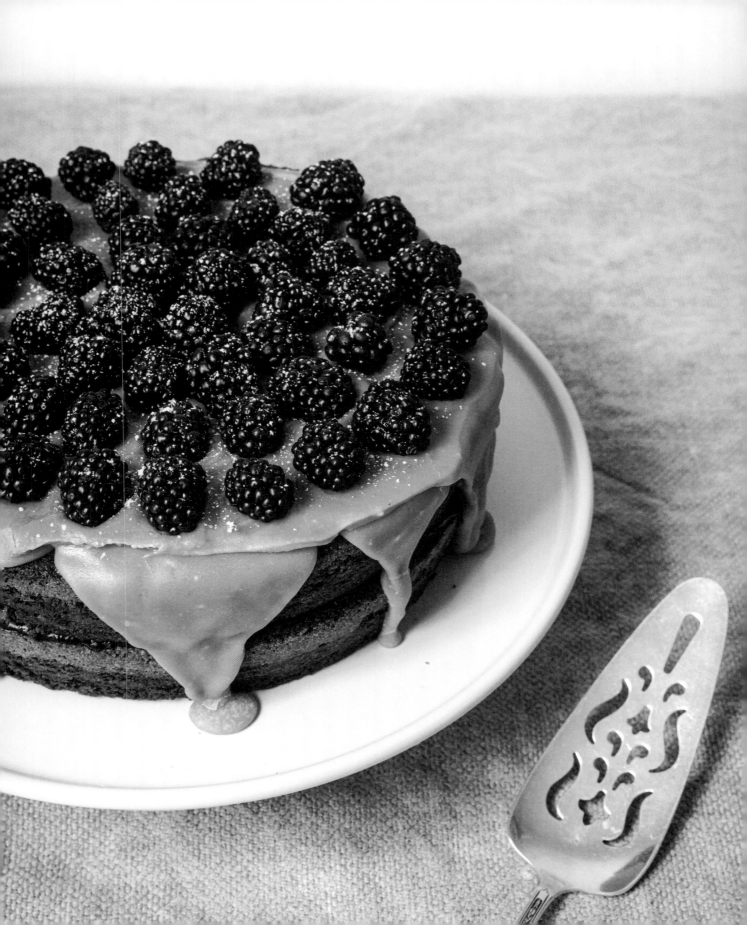

Blackberry Jam Cake

Hulda (Huddy) Horowitz Cohen learned about Southern cake baking from her neighbor Julia Haralson in Blytheville, Arkansas, in the 1950s. Haralson baked a blackberry jam Bundt cake each year for Christmas, and Cohen would bake the cake for Rosh Hashanah to toast in the Jewish New Year. Jam cake, fragrant with spice, has shown up across the South, most often in Kentucky and Tennessee, with blackberry or strawberry jam-filled layers draped with a caramel icing.

A decade ago, when my own family was hosting a German exchange student, Philip walked into the kitchen where I was baking and knew the aroma as jam "kuchen," just as his grandmother made for holidays back in Germany. The story goes that German immigrants, arriving via steamboats into Louisville in the early 1800s, traveled south searching for land on which to settle. When they found black walnut trees, it predicted rich limestone soil for farming. And they brought a spice cake recipe to bake with the berries that grew lush in their new home.

Instead of layers, if you wish to bake this recipe as a Bundt like Cohen, it will need about 1 hour of baking time at 350°F. Dust with confectioners' sugar after it has cooled.

Serves 12	Prep: 35 to 40 minutes	Bake: 30 to 35 minutes

Vegetable shortening or butter, flour, and parchment paper for prepping the pans

2 1/4 cups (270 grams) unbleached all-purpose flour

1 1/2 teaspoons ground cinnamon

1 teaspoon ground allspice

1/2 teaspoon ground cloves or ginger

1/2 teaspoon ground nutmeg

1/2 teaspoon salt

1 cup whole buttermilk

3/4 teaspoon baking soda

16 tablespoons (2 sticks/227 grams) unsalted butter, at room temperature

2 cups (400 grams) granulated sugar

4 large eggs, at room temperature

1 teaspoon vanilla extract

1 cup (10.5 ounces) blackberry jam, preferably seedless, divided

1 cup (4 ounces/114 grams) finely chopped pecans (optional)

Quick Caramel Icing (page 448)

1 quart (32 ounces/907 grams) fresh blackberries

1 teaspoon confectioners' sugar for dusting (optional)

1. Heat the oven to 350°F, with a rack in the middle. Generously grease and flour two 9-inch round pans. Cut parchment paper to fit in the bottom of the pans. Set aside.

2. In a large bowl, whisk together the flour, cinnamon, allspice, cloves or ginger, nutmeg, and salt. Pour the buttermilk into a 2-cup glass measure or small bowl and stir in the baking soda. It will foam up slightly.

3. Place the butter in a large bowl and beat with an electric mixer on medium speed until creamy, 1 minute. Gradually beat in the sugar until light and fluffy, 2 minutes more. Add the eggs, one at a time, beating well after each addition. Stop the machine and scrape down the sides of the bowl with a rubber spatula. Add the vanilla. With the mixer at low speed, gradually add the flour mixture, alternately with the buttermilk, until just blended. Turn off the mixer. Stir in 1/2 cup of the jam and the pecans, if desired.

4. Pour the batter into the prepared pans and smooth the tops with the spatula. Bake until the cakes are springy to the touch, 30 to 35 minutes. Remove the pans from the oven and place on a wire rack to let the cakes cool for 15 minutes. Then run a knife around the edges of the pans, give the pans a gentle shake, and invert the cakes once and then again so they rest right side up on the racks to completely cool, 30 minutes.

5. To assemble, carefully remove the parchment from the bottom of the layers. Place one layer on a serving plate and spread with the remaining 1/2 cup jam. Place the second layer on top. Set aside. Make the Quick Caramel Icing and, while it is warm, pour it over the top of the cake, letting it drip down the sides. Immediately place the blackberries on top and dust with the confectioners' sugar, if desired. Let set for 15 minutes, then slice and serve.

JAM CAKE MEMORIES FOR JEWS

Jewish peddlers and merchants began arriving in small Southern towns to sell clothing and household goods in the late nineteenth century, long before Walmart, says Marcie Cohen Ferris, Southern Jewish foodways scholar, author of *Matzoh Ball Gumbo*, and daughter of Huddy Cohen. For Jews living in towns without synagogues and rabbis, one way of feeding their soul was at the dinner table, she says. And while fried chicken, beaten biscuits, and sliced tomatoes could be found on Jewish and Gentile menus alike, jam cake reminded Jews of cakes baked by their ancestors. Ferris's paternal grandparents, immigrants from Russia, had arrived in the Arkansas Delta from New York City in 1920. They assimilated into a world of church socials, football, and layer cake.

Crushed Banana Cake with Brown Sugar Icing

The best-known Czech recipe in Texas may be the yeasty fruit-filled kolache, but I would be remiss to not share another—Lillian's Crushed Banana Cake from Mary Faulk Koock's *The Texas Cookbook* (1965). The layers of this unexpectedly delicious cake taste like your mother's banana bread, but lighter. And the frosting is a vintage boiled icing, but using brown sugar instead of white brings real flavor. Lillian was born Lillian Parma in New York City but lived her life in Texas. She raised a large family and was active in her local Catholic church. She died at ninety-nine in 2004. Koock, who traveled to kitchens across Texas to capture what was cooking and baking, credited Czech cooks for bringing new flavors to the state. I couldn't agree more.

| Serves 12 | Prep: 50 to 55 minutes | Bake: 35 to 40 minutes |

CAKE

Butter or vegetable shortening and flour
 for prepping the pans
16 tablespoons (2 sticks/227 grams)
 unsalted butter, at room temperature
2 cups (400 grams) granulated sugar
4 large eggs, at room temperature
2 cups mashed ripe bananas (from 5 to 6
 medium bananas)
1 cup (4 ounces/114 grams) finely chopped
 toasted pecans, divided
1/4 teaspoon salt
1/2 cup whole buttermilk
1 1/2 teaspoons baking soda
3 cups (360 grams) all-purpose flour

BROWN SUGAR ICING

3 large egg whites, at room temperature
3/4 cup (144 grams) lightly packed dark
 brown sugar
3/4 cup light corn syrup
1 tablespoon water
1 teaspoon vanilla extract

1. **Make the cake:** Heat the oven to 350°F, with a rack in the middle. Grease and flour two 9-inch round cake pans.

2. Place the butter and sugar in a large bowl and beat with an electric mixer on medium speed until creamy and light, about 3 minutes. Separate the eggs, placing the egg whites in a large bowl and the egg yolks in a smaller one. Add the yolks to the batter and beat until just combined. Scrape down the sides of the bowl with a rubber spatula. Add the bananas and blend on low speed. Measure out 1 tablespoon of the pecans and reserve for the garnish. Add the remaining pecans and salt to the batter and blend. Place the buttermilk in a 1-cup glass measure and stir in the baking soda. Add a third of the flour to the batter, beating on low, add half of the buttermilk, then another third of the flour, the rest of the buttermilk, then the rest of the flour, beating just to combine after each addition. Scrape down the sides of the bowl.

3. Beat the reserved 4 egg whites with clean beaters on high speed until soft peaks form, about 3 minutes.

379

Fold a quarter of the whites into the batter until just combined. Fold in the remaining whites. Divide the batter between the prepared pans and place in the oven.

4. Bake the cakes until they are deeply browned and spring back when pressed in the center, 35 to 40 minutes. Remove the pans from the oven and place on a wire rack to let the cakes cool for 10 minutes. Run a knife around the edges of the pans, give them a gentle shake, and invert the cakes once and then again to cool right side up on the rack until they are room temperature, about 30 minutes.

5. **Make the icing:** Place the egg whites, brown sugar, corn syrup, water, and vanilla in the top pan of a double boiler set over cold water (or see Note, page 375, to improvise one). Turn the heat under the pan to medium. Once the mixture warms, adjust the heat to keep it at a gentle heat. Beat the mixture, still over the water, with an electric mixer on medium speed until it comes together in peaks, and as the whites warm and thicken, increase the mixer speed to medium-high. This will take 8 to 12 minutes.

6. To assemble, place one layer on a cake plate and spread with 1 cup of the frosting. Top with the second layer and spread the top and sides of the cake with the rest of the frosting. Garnish with the reserved toasted pecans, then slice and serve.

VEGETABLE SHORTENING AND THE SOUTH

The South had been reared on lard, but for dietary or religious reasons, not everyone in the region could eat it. Jews keeping kosher avoided lard, as did vegetarian Seventh Day Adventists. And in the 1960s, there was a rising vegetarian movement among Blacks.

When cotton boomed in the early 1800s, scientists searched for ways to make oil from its seeds, but it was brown and bitter and was mainly used for fuel in oil lamps. After David Wesson, a Chicago chemist, figured out how to deodorize and bleach the cottonseed oil, which he named Wesson Oil, it became widely used in cooking. Four years later, his company's chemists hydrogenated the oil to make it solid, selling it as Snowdrift vegetable shortening. Procter & Gamble created Crisco (an acronym for "crystalized cotton-seed oil") in 1911.

Vegetable shortening would change how the South cooked and baked. In replacing butter in cakes, shortening was less expensive, yet devoid of flavor.

Southern cooks would spend the next century either loving shortening or hating it. In 2015 the Food and Drug Administration ruled that artificial trans fats in shortening and other products were unsafe to eat and gave manufacturers three years to eliminate them. Today, shortening is nearly trans fat–free and, love it or hate it, a boon to vegan baking for a whole new generation.

Mississippi Caramel Cake

You can bet this grand cake sprang out of New Orleans with its knowledge of caramelizing local sugar and spread north into the Delta, where cooks have opined for years about the labor and love of baking caramel cake, and childhood memories of it have surfaced in novels such as *The Help* by Kathryn Stockett. It's dense and moist and was meant to travel, since the caramel icing clings to the buttery cake like a protective hairnet. The cake recipe is a classic 1–2–3–4 (1 cup butter, 2 cups sugar, 3 cups flour, and 4 eggs), and the flour is most certainly Swans Down, the South's favorite cake flour in the red box. But some cooks employ the ease of cake mix to focus on the finicky icing, which needs two pans—one cast iron in which you caramelize white sugar and a second to simmer the icing until smooth and spreadable.

Mississippi author John T. Edge says baking caramel cake has provided a second income to cooks in poor Mississippi. Here, a caramel wedding cake is bragged about on the society pages, but at its heart, it's entrepreneurial. Only in Mississippi do gas stations sell caramel cake and people drive for miles in search of the elusive golden beauty of this cake. I did that once en route from Jackson to Memphis. I headed off the highway toward Calhoun City and Buck's One Stop convenience store and gas station, where I joined the line of folks coming in for a slice of cake, a cold beer, and a lottery ticket. It was just before Thanksgiving, and caramel cakes in white boxes were stacked tall in one corner of the store. The recipe that follows is my way of re-creating that cake.

Serves 12 to 16　　　　Prep: 45 to 50 minutes　　　　Bake: 25 to 30 minutes

Butter and flour for prepping the pans

16 tablespoons (2 sticks/227 grams) unsalted butter, at room temperature

2 cups (400 grams) granulated sugar

4 large eggs, at room temperature

3 cups (336 grams) cake flour

1 tablespoon baking powder

1/2 teaspoon salt

1 cup whole milk, at room temperature or warmed

1 teaspoon vanilla extract

Old-Fashioned Caramel Icing (page 451) or Quick Caramel Icing (page 448)

1. Heat the oven to 350°F, with a rack in the middle. Grease and flour two 8-inch square or 9-inch round cake pans and set aside.

2. Place the butter in a large bowl and beat with an electric mixer on medium speed until creamy, 1 minute. Gradually add the sugar and beat on medium until light and fluffy, 3 minutes. Add the eggs, one at a time, beating after each addition. Turn off the mixer and scrape down the sides of the bowl with a rubber spatula.

3. Sift the cake flour, baking powder, and salt into another bowl. Add this to the butter and sugar mixture, alternately with the milk, beginning and ending with the flour mixture, and beating on

low. Do not overmix the batter. Blend in the vanilla. Divide the batter between the two prepared pans, smoothing the tops with the spatula, and place in the oven.

4. Bake until the cakes are lightly golden brown and the tops spring back when pressed lightly in the center, 25 to 30 minutes. Remove the pans from the oven and place on a wire rack to cool for 10 minutes. Run a dinner knife around the edges of the pans, give them a shake to loosen, then invert the cakes once and then again so they cool right side up. When cool, slice them in half horizontally.

5. Prepare the icing. To assemble the cake while the icing is still warm, place a bottom half of one cake layer on a serving plate. Spoon over a generous ladle of the warm icing and spread it to the edges of the cake with a metal spatula. Place the top of that layer on top, and spoon a ladle of icing over the top, smoothing it out with the spatula. Repeat with the third and fourth layers. Spoon a generous couple of ladles of icing over the top of the cake and let the icing run down the sides. When the top of the cake is frosted and pretty, use the remainder of the icing to frost the sides. If the icing has gotten hard and is not spreadable, place the pan over very low heat for just a minute, stirring, to warm it, adding a splash of milk or cream to thin it if needed. Or, place the saucepan in a large bowl filled with 2 inches of hot water. Dip the spatula into the saucepan and run this icing around the cake in clean strokes, being careful not to tear the cake. Let the cake cool for 30 minutes so the icing hardens, then slice and serve.

Frosting caramel cake at Buck's
One Stop in Calhoun City,
Mississippi

Chocolate Mayo Cupcakes with Peanut Butter or Chocolate Frosting

Mayonnaise wasn't on the World War II ration list, so wartime cooks got inventive with it and found that by using it in a cake recipe, they might not need eggs, butter, or oil. And people naturally shared those budget-friendly recipes, which is how mayo wound up in these deep, dark, and chocolaty cupcakes that I spread with peanut butter frosting. In the South, we reach for Duke's mayonnaise of Greenville, South Carolina, which also has a wartime connection. It was created in 1917 when Eugenia Duke spread sandwiches with a special sauce and sold them to World War I soldiers stationed at Camp Sevier, six miles outside Greenville.

You can also frost these with Cream Cheese Frosting (page 454).

| Makes 12 large cupcakes | Prep: 25 to 30 minutes | Bake: 20 to 25 minutes |

12 paper cupcake liners
2 cups (240 grams) unbleached flour
1 cup (200 grams) granulated sugar
1/4 cup (25 grams) unsweetened cocoa
 powder
2 teaspoons baking powder
1/2 teaspoon salt
1/4 teaspoon baking soda
1 cup water
1 cup mayonnaise
2 teaspoons vanilla extract
Peanut Butter Frosting (page 457) or
 Three-Minute Chocolate Icing
 (page 453)

1. Heat the oven to 350°F, with a rack in the middle. Line 12 muffin cups with paper liners and set aside.

2. Place the flour, sugar, cocoa, baking powder, salt, and baking soda in a large bowl and whisk to combine well. Stir together the water, mayonnaise, and vanilla in another bowl. Pour into the flour mixture and stir until smooth.

3. Scoop or spoon the batter into the paper liners, filling them three-quarters full. Bake until the cupcakes spring back to the touch, 20 to 25 minutes. When they're cool enough to handle, remove the cupcakes to a wire rack to cool completely, 30 minutes.

4. When the cupcakes are cool, spread the frosting over the tops and serve.

Buttermilk Cupcakes with Fudge Icing

The first cupcakes I baked were yellow with chocolate icing. And I don't care how many cupcakes I have baked since then, this combination is always the most popular. You stir them by hand, bake them with little helpers, and invite the neighborhood over for a party. We did just that at the photo shoot for this book. I had barely pulled the fudge icing from the stove when I heard the young voices in the hallway. Our preschool visitors had arrived a bit early. I hurriedly frosted the yellow cupcakes with a simple metal spatula and searched for my sprinkles. The kids loved them. Who doesn't?

To give homemade cupcakes a bit more structure, I add a little instant pudding mix. It's my twist on a recipe originally from *The Picayune's Creole Cook Book* (1900).

Makes 16 cupcakes	Prep: 20 to 25 minutes	Bake: 25 to 30 minutes

16 paper cupcake liners

1 cup buttermilk or whole milk

4 tablespoons (1/2 stick/57 grams) unsalted butter

2 teaspoons vanilla extract

2 cups (400 grams) granulated sugar

4 large eggs

1/3 cup vegetable oil

2 cups (240 grams) all-purpose flour

2 tablespoons vanilla instant pudding mix (optional)

2 teaspoons baking powder

1 1/4 teaspoons salt

Chocolate Fudge Icing (page 452) or Chocolate Buttercream Frosting (page 456)

1. Heat the oven to 350ºF, with a rack in the middle. Line 16 muffin cups with paper liners and set aside.

2. Pour the buttermilk or milk into a small saucepan and add the butter. Heat over low heat until the butter melts, about 2 minutes. The buttermilk will curdle, but this is fine. Pour in the vanilla and set aside.

3. Place the sugar and eggs in a large bowl and whisk until light and lemon colored, 3 to 4 minutes. Add the oil and whisk to combine, 30 seconds more. Whisk together the flour, vanilla instant pudding mix (if desired), baking powder, and salt in a small bowl. Add to the egg and sugar mixture, alternately with the buttermilk mixture, beginning and ending with the flour mixture and stirring with a wooden spoon just until smooth.

4. Scoop the batter into the paper liners, filling them three-quarters of the way full. Bake until golden brown and springy to the touch, 25 to 30 minutes. When they're cool enough to handle, remove the cupcakes to a wire rack to cool.

5. Spoon the warm fudge icing over the top and allow it to set before serving. Or, frost generously with the chocolate buttercream.

Pineapple Upside-Down Cupcakes

I found this recipe in one of my favorite cookbooks, *Spoonbread and Strawberry Wine*, written by sisters Norma Jean and Carole Darden in 1978. By then these young, successful sisters—Norma, a fashion model and now Harlem restaurateur, and Carole, a social worker—had set out to unearth old family recipes and the people who came with the recipes, traveling back to Alabama and North Carolina to find relatives of their parents who didn't leave the South as part of the Great Migration. These rich and moist pineapple cupcakes were baked by their great-aunt, Norma. While the authors note that this recipe can be poured into a 9-inch skillet using 5 pineapple rings instead of the crushed pineapple, I prefer the fanciful little cupcakes. They can be reheated right in the pan to serve warm.

Makes 12 cupcakes Prep: 25 to 30 minutes Bake: 16 to 20 minutes

Vegetable shortening or vegetable oil
 spray for prepping the pan

TOPPING

4 tablespoons (1/2 stick/57 grams) unsalted
 butter, at room temperature

7 tablespoons (85 grams) dark brown sugar

1 can (8 ounces) crushed pineapple

6 maraschino cherries, cut in half (optional)

CUPCAKES

1 large egg, at room temperature

4 tablespoons (1/2 stick/57 grams) unsalted
 butter, at room temperature

1/4 cup (50 grams) granulated sugar

1 cup (112 grams) cake flour

1 1/2 teaspoons baking powder

1/4 teaspoon salt

1/2 teaspoon vanilla extract

Whipped Cream (page 458) or Lee
 Brothers' Buttermilk Ice Cream
 (page 459)

1. Heat the oven to 350°F, with a rack in the middle. Generously grease or mist 12 muffin cups and set aside.

2. **Make the topping:** Melt the butter in a small saucepan over medium heat, stir in the brown sugar, and bring to a simmer. Remove from the heat. Drain the pineapple, reserving the juice in a glass measure for the cake. Stir the pineapple into the butter and brown sugar. Place a level tablespoon of pineapple into each muffin cup. If desired, press a cherry half in the center. Set aside.

3. **Make the cupcakes:** Separate the egg and place the white in a small bowl and the yolk in another small bowl. Beat the white with an electric mixer on high speed until stiff, about 3 minutes. Set aside.

4. Place the butter and sugar in a medium bowl and beat with the mixer (no need to wash the beaters) until creamy and light, about 3 minutes. Add the egg yolk and beat to combine, 30 seconds. Scrape down the sides of the bowl with a rubber spatula. Add enough water to the reserved pineapple juice to measure

1/2 cup. Sift together the cake flour, baking powder, and salt in another bowl. Add this to the batter, alternately with the pineapple juice, beginning and ending with the flour mixture. Beat in the vanilla and fold in the beaten egg white. Dollop about 3 tablespoons of batter into each muffin cup, on top of the pineapple and cherry (if using). Smooth the tops and place in the oven.

5. Bake until the edges just begin to turn light brown and the tops spring back when lightly pressed, 16 to 20 minutes. Run a knife around the edges and immediately serve warm with whipped cream or ice cream.

Coconut Snowballs

Eudora Welty's *Delta Wedding*, set in 1923 Mississippi, has the most irresistible description of coconut cake woven throughout the novel. Mashula's Coconut Cake is an almond- and lemon-flavored cake spread with a buttercream frosting, then piled with coconut. "Cakes have been traditional proof of a cook's skill, particularly in the South," according to Ann Romines, who was a Welty scholar at George Washington University when she transformed the cake description in *Delta Wedding* into a real recipe. Here I nod to Welty, Aunt Mashula, and Romines by turning that great cake into some serious coconut cupcakes for bridal showers and holiday parties. And I share how to turn it back into a cake as well (page 391)!

Makes 20 to 24 cupcakes Prep: 50 to 55 minutes Bake: 23 to 27 minutes

20 to 24 paper cupcake liners

12 tablespoons (1 1/2 sticks/170 grams) unsalted butter, at room temperature

2 cups minus 2 tablespoons (370 grams) granulated sugar

3 large eggs, at room temperature

1/2 teaspoon coconut extract

2 1/4 cups (270 grams) all-purpose flour

2 1/2 teaspoons baking powder

3/4 teaspoon salt

1 cup whole milk, warmed

Cream Cheese Frosting (page 454) that has been flavored with 1/2 teaspoon coconut extract, or Whipped Cream (page 458) to which you fold in 1/2 cup sour cream

2 cups (90 grams) sweetened flaked coconut

1. Heat the oven to 350°F, with a rack in the middle. Line 20 to 24 muffin cups with paper liners and set aside.

2. Place the butter in a large bowl and beat with an electric mixer on medium speed until creamy, 2 minutes. Gradually add the sugar, beating until it lightens in color, 2 minutes. Add the eggs, one at a time, beating until combined. Add the coconut extract and beat until combined.

3. Place the flour, baking powder, and salt in a small bowl and sift to combine well. Spoon a third of the flour mixture into the butter mixture and blend on low, then add half of the warm milk and blend. Add another third flour mixture, then the rest of the milk and the rest of the flour mixture, blending until smooth. Set aside.

4. Using a scoop, fill the liners three-quarters full. Place the pans in the oven.

5. Bake until the cupcakes are lightly browned and spring back to the touch, 23 to 27 minutes. When they're cool enough to handle, remove the cupcakes to a wire rack to cool completely, 30 minutes.

6. Fold the coconut extract into your choice of frosting.

7. Frost the cooled cupcakes generously, pat the coconut on top of each, and serve.

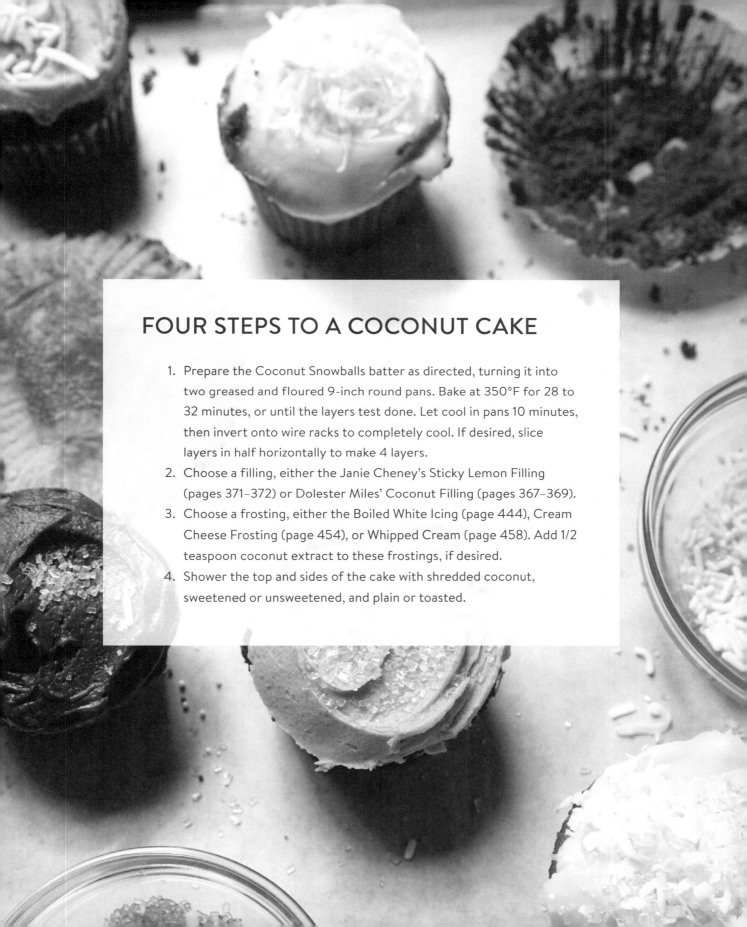

FOUR STEPS TO A COCONUT CAKE

1. Prepare the Coconut Snowballs batter as directed, turning it into two greased and floured 9-inch round pans. Bake at 350°F for 28 to 32 minutes, or until the layers test done. Let cool in pans 10 minutes, then invert onto wire racks to completely cool. If desired, slice layers in half horizontally to make 4 layers.

2. Choose a filling, either the Janie Cheney's Sticky Lemon Filling (pages 371–372) or Dolester Miles' Coconut Filling (pages 367–369).

3. Choose a frosting, either the Boiled White Icing (page 444), Cream Cheese Frosting (page 454), or Whipped Cream (page 458). Add 1/2 teaspoon coconut extract to these frostings, if desired.

4. Shower the top and sides of the cake with shredded coconut, sweetened or unsweetened, and plain or toasted.

COOKIES AND BARS
BY THE DOZEN

Grandma's tea cakes were legend. There was always a cookie jar full of them next to the kitchen sink. . . . The tea cakes inside were lightly perfumed with either mace or nutmeg—to this day when I smell either of those spices, Grandma's kitchen all but materializes before me.

—JOHN MARTIN TAYLOR, *CHARLESTON TO PHNOM PENH: A COOK'S JOURNAL*, 2022

Before bedtime, by the fireplace, we played a game called "heavy, heavy, hang over your head," where you had to quack like a duck, or cluck, or meow, or do something like that to get your treat of warm molasses cookies and milk.

—MILDRED ("MAMA DIP") COUNCIL, *MAMA DIP'S KITCHEN*, 1999

After Hurricane Katrina devastated the Gulf Coast in 2005 and people lost their keepsake family recipes, they turned to the *Times-Picayune* newspaper in New Orleans and its vast readership for help. They knew how to make gumbo and jambalaya from memory, but they lost cherished Christmas cookies and crispy sugar cookies right out of their grandmother's recipe box, the cookies they didn't have memorized.

Cookies may be small, fitting into the tiny hands of children, but they preserve the past for us. It might be a grandmother's recipe or one always baked for Juneteenth or Christmas Eve, cookies stashed in a tin and toted to every family vacation.

In my family, that would be crescent tea cookies, the pecan-flecked butter cookies you shape like a half-moon, bake, and dredge in powdered sugar while they're still warm. It was my mother's recipe, and before that, her mother's. If my grown children are coming home for Christmas, they expect crescent cookies. And if they're not traveling back to Tennessee for the holidays, they bake their own.

For you, it might be a specific recipe, or possibly an ingredient such as benne seeds, ginger, or dates, that reminds you of a person in the past who once made cookies for you.

This chapter is full of both grandmothers and children who love cookies. When my granddaughter was here while I was testing the tea cakes—soft sugar cookies—for this chapter, she stood on her tippy-toes to reach the cooling rack to grab another one, thinking all the while I didn't notice.

Children love tea cakes because they fit in their hands. Some are soft and pillowy, almost like cake, and others crispy like a sugar cookie. And nothing is more evocative of childhood than sugar cookies, especially when rolled in colorful sprinkles before baking. From these basic cookie recipes, I move into fragrant cookies—ginger cookies and something called a Demopolis Turtleback, a soft spice cookie masquerading as a tea cake—and then comes chocolate and pecan. Some of my favorite cookies are

the glossy chocolate "chewies" baked like they used to at Gottlieb's in Savannah, Laura Bush's cowboy cookies—loaded with Texas-size heaps of chocolate, nuts, and coconut—and Kate's Pecan Tassies.

If you don't have all the right spices and add-ins, bake these cookies with what you do have. Cookies are forgiving and have adapted well to what we've had on hand—pecans instead of almonds, oats instead of nuts, raisins and not currants, nutmeg in place of cloves—and then they magically become our own.

We might not even bake individual cookies at all, opting instead to turn the dough into the easiest of all cookies— bars and squares. Who can resist gooey lemon squares? And no one I know passes on my mother's chess cake, which is what happens when you turn the deliciousness of chess pie into finger food. I also share a seriously fudgy brownie recipe, which, for one North Carolina family, is the tie that binds.

To help you bake like your grandmother, I've seasoned the chapter with plenty of tips, such as making the chocolate chip dough ahead to let it hydrate, dropping the pecan lace cookie dough onto the pan with the smallest spoon because they spread as they bake, and creating your own slice-and-bake cookies in waxed paper for busy days ahead.

Southern cookies are not only exceptionally delicious, but they have stories as interesting as their flavors.

8 TIPS FOR COOKIE-BAKING *Bliss*

1. **READ THE RECIPE BEFORE YOU BEGIN AND ALLOW TIME FOR THE DOUGH TO REST IF NECESSARY.** A rest in the fridge, for at least an hour and often overnight, allows the dough to hydrate, so the flour soaks up the moisture and the cookies are more shapely and less likely to fall or dip when they bake.

2. **IF YOU WANT TO ADD YOUR OWN TOUCHES TO A COOKIE, TWEAK IT WITH YOUR FAVORITE SPICES.** But make sure to keep the basics—flour, sugar, eggs, and the fat—the same.

3. **IF YOU HAVE A CONVENTIONAL OVEN, BAKE ONE PAN AT A TIME ON THE MIDDLE RACK.** If you have a convection oven, you can bake multiple pans on all the racks at once. Decrease the oven temperature by 25 degrees and also decrease the baking time by 25 percent. For example, if the cookies bake at 350°F for 12 minutes in a conventional oven, you should bake them at 325°F for 9 minutes in a convection oven.

4. **BUTTER SHOULD BE AT ROOM TEMPERATURE.** A couple hours ahead of baking, place the butter on the kitchen counter to soften. Or, if you are working with cold butter, place it in the microwave on high power for 8 to 10 seconds, or until soft.

5. **CHOOSE THE RIGHT PAN.** Shiny aluminum pans are the best, as they bake cookies that are crisp and evenly browned. Darker tin pans are fine for oatmeal and chocolate chip cookies where you want more browning, caramelizing, and flavor. But beware of dark nonstick pans when baking sugar cookies and other light-colored doughs, because they will quickly brown your cookies. If in doubt about your pan, line it first with parchment paper to keep the cookies baking evenly and also to make cookie removal a snap. Either restaurant-style half-sheet pans with 1-inch sides or the completely flat cookie sheets are fine for baking these recipes.

6. **CHECK FOR COOKIE DONENESS AT THE FIRST BAKING TIME LISTED IN THE RECIPE.** Turn on the oven light to watch for signs of doneness, such as browning around the edges. With chocolate cookies, watch for a change in the appearance, from shiny to opaque.

7. **FOR PERFECT COOKIES, BAKE A TEST COOKIE.** You can always adjust the salt or cinnamon if you bake a cookie first and try it.

8. **LET COOKIES COOL COMPLETELY BEFORE STORING.** To keep cookies crisp, store them in metal containers with tight-fitting lids. To keep them soft, store in ceramic, wooden, glass, or plastic containers. Cookies freeze well stored in zipper-top bags.

Alice Jo's Sugar Cookies

Alice Jo Lane Giddens was a child of the Depression who knew how to stretch a dollar and made the best sugar cookies ever. No family vacation, holiday party, or family reunion was complete without them. While divorced and raising four children in Valdosta, Georgia, she ran Alice in Wonderland Kindergarten from her converted backyard carport for thirty-five years, launching countless preschoolers and tutoring struggling students. Her daughter, Martha Nesbit, said when Giddens joined her children and grandchildren for vacation, she would arrive with tins of these cookies—"The crispiest sugar cookies ever produced." And they are. The combination of butter and oil is unusual and contributes to their shortbread-like consistency; they melt in your mouth. I bake them for family holiday parties. Rolled in colored sugars, they are a big hit with young children, just the right size for their hands. This recipe makes a lot, about 10 dozen. Nesbit keeps them baked and ready in the freezer, always a reminder of her mom.

Makes 10 dozen (2-inch) cookies | Prep: 15 to 20 minutes | Chill: 4 hours or overnight | Bake: 10 to 15 minutes per batch

4 cups (480 grams) all-purpose flour

1 teaspoon salt

1 teaspoon baking soda

1 teaspoon cream of tartar

16 tablespoons (2 sticks/227 grams) unsalted butter, at room temperature

1 cup vegetable oil

1 cup (108 grams) confectioners' sugar

1 cup (200 grams) granulated sugar

2 large eggs

1 teaspoon vanilla extract

3/4 to 1 teaspoon almond extract

Colored coarse sugars for rolling

1. Whisk together the flour, salt, baking soda, and cream of tartar in a medium bowl and set aside.

2. Place the butter, oil, and both sugars in a large bowl and beat with an electric mixer on medium speed until smooth and satiny, 1 to 2 minutes. Smooth out any lumps in the butter by beating at a little higher speed for less than a minute. Add the eggs, vanilla, and almond extract and beat until smooth, 1 to 2 minutes. Scrape down the sides of the bowl with a rubber spatula and add the flour mixture, 1 cup at a time, beating on low until just combined. Cover the bowl with plastic wrap and place in the refrigerator until firm, at least 4 hours or preferably overnight.

3. When you're ready to bake, heat the oven to 350ºF, with a rack in the middle. Pour the decorating sugars into small bowls.

4. With a melon baller or two teaspoons, drop 1/2-inch balls of dough into the sugar and roll them in it to cover, then place the

balls on 12-by-17-inch ungreased baking sheets, spacing them 2 inches apart. Press down lightly on the balls twice with a fork to flatten them. Bake, one pan at a time, until the cookies just begin to brown around the edges, 10 to 15 minutes. Remove from the oven, let rest on the pan for 30 seconds, then transfer to a wire rack to cool completely, 15 minutes. Repeat with the remaining dough, cooling the pans between batches. Store in an airtight container for up to a week or freeze for up to a month.

NOTE:

For 4-inch cookies, drop 1-inch balls into the sugar, press, and bake for 15 to 18 minutes.

Tea Cakes Like Grandma Made

If the South had a version of the French madeleine, it would be the tea cake—a soft and spongy round more cake than cookie and small enough to tuck in your pocket. Tea cakes were the emblematic food of the Great Migration, a period of time from 1910 to 1970 when six million Blacks moved out of the rural South to cities in the Northeast and Midwest and all the way to California. They took their memories and tea cakes with them.

This recipe is adapted from the cookbook *Pound Cakes & More*, written by the late Clarice Clardy-White, who was raised in Clarksville, Tennessee. She wrote about traveling to her Grandma Pink's house and looking forward to her grandmother's soft and spongy tea cakes. For a cakey tea cake, use all vegetable shortening or half shortening and half butter. The parchment keeps tea cakes from browning too much on the bottom of the pan.

Makes about 28 (2 1/2–inch) tea cakes Prep: 20 to 25 minutes Bake: 18 to 22 minutes per batch

Parchment paper for lining the pan

8 tablespoons (1 stick/114 grams) unsalted butter, lard, or vegetable shortening or a combination, at room temperature

3/4 cup (150 grams) granulated sugar

1 large egg

1 teaspoon vanilla extract

1/4 teaspoon almond extract

2 cups (224 grams) cake flour

1/2 teaspoon baking soda

1/2 teaspoon salt (if using unsalted butter or shortening)

1/4 cup whole buttermilk

GLAZE

1 cup (108 grams) confectioners' sugar, sifted

2 tablespoons whole milk

1/2 teaspoon vanilla extract

1. Heat the oven to 325ºF, with a rack in the middle. Line a 12-by-17-inch baking sheet with parchment paper.

2. Place the butter, lard, or vegetable shortening, or combination of them, in a large bowl. Add the sugar. With an electric mixer, beat on medium speed until creamy, about 2 minutes. Add the egg, vanilla, and almond extract and beat until well combined, 1 minute. Scrape down the sides of the bowl with a rubber spatula.

3. In a separate bowl, whisk together the flour, baking soda, and salt. Add the flour mixture alternately with the buttermilk to the butter mixture, beginning and ending with the flour mixture, and beating on low until just combined.

4. Scoop generous 1-inch balls of the dough onto the prepared baking sheet, spacing them 2 inches apart. Bake, one pan at a time, until they spring back when lightly pressed in the center and just begin to turn lightly browned around the bottom edges, 18 to 22 minutes. Remove to a wire rack to cool completely. Repeat with the remaining dough, cooling the pan between batches.

5. Serve the tea cakes warm or let them cool and glaze them.

6. **Make the glaze:** Sift the confectioners' sugar into a small bowl and whisk in the milk and vanilla until smooth.

7. Spoon over the tea cakes, letting the glaze dribble down the sides and set for 20 minutes before serving. Store in a loosely covered container or on a plate draped with waxed paper for several days.

CLARICE CLARDY-WHITE, BLACK HISTORIAN AND TEA CAKE BAKER

In the late summer, while I was working on this book, my husband and I drove to Tuscaloosa, Alabama. At the University of Alabama, in the David Walker Lupton Cookbook Collection of African American cookbooks in the W. S. Hoole Special Collections Library, I found Clarice Clardy-White's *Pound Cakes & More*, published in 1997. Clardy-White, who was born in 1933 in Montgomery County, Tennessee, earned the nickname "Miss President," because she led whatever organization she became a part of. In college she pursued music education, then her master of music, and finally did postgraduate work at Austin Peay State University. She married, raised three children, was a music specialist in the public school system, and was known as Clarksville's Black historian. After her husband's death, Clardy-White moved to Atlanta to be near her children and found her place at Ebenezer Baptist Church, singing in the choir, serving as president of the book club, and learning to play bridge. She died in 2022 at eighty-nine, just two months before I tried to find her and ask her about these tea cakes.

1877 Virginia Tea Cakes

Crispy tea cakes became popular in the South after a group of women in Edenton, North Carolina, protesting the British tax on imported tea, staged a tea party without tea, in 1775. Tea cakes were simply crispy sugar cookies, which would get softer and cakier through the years as baking soda and buttermilk entered the recipe. But this old recipe, adapted from one first published in Marion Cabell Tyree's *Housekeeping in Old Virginia* cookbook in 1877 and then in *Food to Die For: A Book of Funeral Food, Tips and Tales* by Jessica Bemis Ward in 2004, reflects tea cakes as they were first baked. Tyree, of Lynchburg, Virginia, was a granddaughter of "Give me liberty, or give me death!" patriot Patrick Henry. Ward's book was a fundraiser for the Lynchburg cemetery.

These tea cakes are flecked with freshly grated nutmeg, but depending on what was in your pantry, they might have been flavored with lemon zest or rose water.

Makes about 5 dozen tea cakes	Prep: 25 to 30 minutes	Chill: 3 hours or overnight	Bake: 6 to 8 minutes per batch

1 1/2 cups (300 grams) granulated sugar, plus 1/4 cup (50 grams) for sprinkling on the cookies before baking

12 tablespoons (1 1/2 sticks/170 grams) unsalted butter, at room temperature

1 large egg

1/3 cup sour cream

3 1/4 cups (390 grams) all-purpose flour, plus more for rolling the dough

1 scant teaspoon (7/8 teaspoon) baking soda

1 to 1 1/2 teaspoons freshly ground nutmeg

1. Place the 1 1/2 cups sugar and butter in a large bowl and beat with an electric mixer on medium speed until fluffy, 2 to 3 minutes. Scrape the sides of the bowl with a rubber spatula and add the egg and sour cream, beating until just combined.

2. Whisk together the 3 1/4 cups flour, baking soda, and nutmeg in a medium bowl. Add the flour mixture, 1 cup at a time, to the sugar and butter mixture, beating on low until just combined. Cover with plastic wrap and chill until firm, at least 3 hours or preferably overnight.

3. When you're ready to bake, heat the oven to 400°F, with a rack in the middle.

4. Working with a third of the dough at a time, roll it out on a lightly floured surface to 1/4-inch thickness. Cut into rounds with a 2-inch cutter and transfer to 12-by-17-inch ungreased baking sheets, placing them 2 inches apart. Sprinkle with some of the 1/4 cup sugar. Bake, one pan at a time, until the tea cakes just begin to brown, 6 to 8 minutes. Remove from the oven and let rest on the cookie sheet for 1 minute, then remove with a metal spatula to wire racks to cool completely, 15 minutes. Repeat with the remaining dough, cooling the pans between batches. Store in an airtight container for up to 2 weeks or freeze for up to 1 month.

Dark Chocolate and Walnut Wafers

What do you do when you can't find thin dark-chocolate wafer cookies at the supermarket and need to make a chocolate cookie crust? Make your own. This recipe was born out of imitating those black cookies that are more chocolaty than sweet, and this version is more delicious and versatile. Fold in nuts, if desired. Serve with scoops of vanilla or homemade buttermilk ice cream (page 459).

Makes about 3 dozen cookies Prep: 15 to 20 minutes Chill: Overnight Bake: 10 to 15 minutes per batch

1 cup (120 grams) unbleached all-purpose flour

1/2 cup (50 grams) Dutch-process or regular unsweetened cocoa powder

2/3 cup (120 grams) lightly packed light brown sugar

1/2 cup (100 grams) granulated sugar

1/4 teaspoon baking soda

1/4 teaspoon salt

8 tablespoons (1 stick/114 grams) unsalted butter, melted and slightly cooled

1 teaspoon vanilla extract

1 large egg

1/2 cup (4 ounces/57 grams) finely chopped black or English walnuts (see Note)

1/4 cup coarse sugar for sprinkling

NOTE:

If you have been raised on black walnuts, you know their sweet-bitter flavor and how they meld with chocolate. They are native to America, and the trees grow prolifically in limestone-rich soil across the eastern United States.

1. Place the flour and cocoa in a food processor. Pulse to combine. Add both sugars and the baking soda and salt and pulse to combine. Pour in the melted butter, vanilla, and egg. Pulse until the mixture comes together into a ball. Add the walnuts and process until just combined. Set aside or wrap the dough in plastic wrap and place in the fridge overnight.

2. When you're ready to bake, heat the oven to 350°F, with a rack in the middle.

3. Pinch off 1-inch pieces of dough and roll them into balls in your palms. Place 12 on a 12-by-17-inch ungreased baking sheet about 2 inches apart. Sprinkle with a little of the coarse sugar and press down on the balls with a glass to flatten them to 1/3 inch. Bake until they are nearly firm, 10 to 15 minutes. (If you bake them less, they are more chewy, and if you bake them more, they are crispy.)

4. With a metal spatula, remove the cookies to a wire rack to cool. Repeat twice with the remaining dough, cooling the pan between batches.

5. Let the cookies cool completely, about 1 hour. Store in an airtight tin for up to a week.

Justines

These buttery date, oat, and pecan cookies are supposedly named for a Memphis restaurant called Justine's that opened its doors in a pink-stuccoed Victorian mansion in 1958, and for the next thirty-seven years delighted the South with its polished silver, crabmeat, and hollandaise. And this cookie recipe had been a favorite of a Mississippi cook who lost it in Hurricane Katrina's floodwater in 2005. A *Times-Picayune* newspaper reader, the late Barbara Wedemeyer, came to the rescue and shared the recipe.

Sometimes you just have to take recipe stories with a grain of salt, or in this case, sugar. After checking with multiple Memphis cooks and reading old Justine's menus, I was unable to place these cookies at the famous restaurant where owner Justine Smith and cook Wilma Madison served up French cuisine with a refined New Orleans twist. But it doesn't matter, because the cookies, adapted from *Cooking Up a Storm*, by Marcelle Bienvenu and Judy Walker, are absolutely delicious!

Makes 6 dozen 2-inch cookies Prep: 30 to 35 minutes Bake: 10 to 15 minutes per batch

12 dates (about 7 ounces)

Parchment paper for lining the
 pans

16 tablespoons (2 sticks/227
 grams) unsalted butter, at
 room temperature

2/3 cup (133 grams) granulated
 sugar, plus 1 cup (200
 grams) for rolling

1 cup (192 grams) lightly
 packed light brown sugar

1 large egg

1 teaspoon vanilla extract

2 1/2 cups (300 grams) all-
 purpose flour

2 teaspoons baking soda

1/8 teaspoon salt

1 cup (80 grams) old-fashioned
 oats

1 cup (4 ounces/114 grams)
 chopped pecans

1. Slice the dates in half, removing the stem end and the pit. Chop to make 1 cup. Set aside.

2. Heat the oven to 350°F, with a rack in the middle. Line two 12-by-17-inch baking sheets with parchment paper.

3. Place the butter, the 2/3 cup granulated sugar, and the brown sugar in a large bowl and beat with an electric mixer on medium speed until fluffy, 2 to 3 minutes. Scrape down the sides of the bowl with a rubber spatula. Add the egg and vanilla and beat until just combined.

4. In a separate bowl, whisk together the flour, baking soda, and salt and add to the butter and sugar mixture a cupful at a time, beating on low until just blended. Fold in the dates, oats, and pecans. The dough will be stiff.

5. Place the 1 cup sugar in a shallow bowl. Shape the dough into 1 1/2–inch balls and roll in the sugar, then place on the prepared baking sheets about 2 inches apart. Bake, one pan at a time, until lightly browned, 8 to 10 minutes. Remove to a wire rack to cool completely. Repeat with the remaining dough, cooling the pans between batches. Store for up to 2 weeks in an airtight container.

LACE COOKIE *Secrets*

In this deeply nostalgic recipe, which Lee Barnes included in her 1977 *Lee Barnes' Cooking* cookbook, she instructs you to line the baking pans with foil or parchment and drop the dough by "small ice teaspoons" on the pan. Ice or iced teaspoons, those long and slender spoons for stirring sugar into a tall glass of tea, aren't used much anymore. But the idea is to drop just a bit of the dough onto the pan because these cookies have so little flour, they spread while baking. I use the smaller end of a melon ball scoop. I also add a sprinkling of kosher salt once the cookies are cooling, to cut the sweetness of the sugar.

Lee Barnes' Creole Lace Cookies

Lace cookies are as much a part of Louisiana and Mississippi as the magnolia. With a praline-like flavor, they bake up thin and see-through, like lace. This recipe comes from the files of the late Lee Barnes, who taught cooking in New Orleans from 1974 to 1989 and was a native of Natchez, Mississippi. At first she taught cooking classes out of her apartment, then opened a school, advertising her classes on the sides of streetcars. She taught mostly Creole and French cooking and invited guest chefs Leah Chase, Jacques Pépin, and Paul Prudhomme to teach as well. When she was remembered at a tribute in 2002 by her alma mater, Newcomb College, and Slow Food New Orleans, it was said her greatest gift was helping New Orleans to remember its very own recipes. Barnes died of a brain tumor at forty-one in 1992.

Makes 5 to 6 dozen (2 1/2–inch) cookies Prep: 25 to 30 minutes Bake: 10 to 15 minutes per batch

Parchment paper for lining the pans

1 1/3 cups (4 1/2 to 5 ounces/128 to 142 grams) finely chopped pecans

1 cup (200 grams) granulated sugar

1/4 cup (30 grams) all-purpose flour

1/3 teaspoon baking powder

1/4 teaspoon salt

8 tablespoons (1 stick/114 grams) unsalted butter, melted

2 teaspoons vanilla extract

1 large egg, lightly beaten

Kosher salt or flaky sea salt for sprinkling (optional)

1. Heat the oven to 325°F, with a rack in the middle. Line two 12-by-17-inch baking sheets with parchment paper.

2. Place the pecans, sugar, flour, baking powder, and salt in a large bowl and stir to combine. Add the melted butter, vanilla, and lightly beaten egg and stir until smooth. Drop the dough by teaspoonfuls onto the prepared pans 3 inches apart, 10 to 12 to a pan.

3. Bake, one pan at a time, until golden brown, 10 to 15 minutes. Let cool on the pan for 3 minutes. Run a metal spatula under them and transfer to a wire rack to cool. Sprinkle with kosher or sea salt, if desired. Repeat with the remaining dough, cooling the pans between batches.

4. After the cookies cool completely, store in an airtight container between sheets of waxed paper for up to 2 weeks.

Ginger Cemetery Cookies

Food to Die For, a 2004 cookbook compiled by Jessica Bemis Ward, was part of an ongoing fundraising effort to keep up the Old City Cemetery in Lynchburg, Virginia, where more than 20,000 people have been buried for the last two centuries. When the ladies of Lynchburg started the ambitious project to restore the twenty-six-acre cemetery, it was overgrown and unappreciated. Today, it is a landmark where Civil War soldiers from fourteen states are interred alongside enslaved Black people.

This ginger cookie recipe submitted to the cookbook by Ann Richards has been served at so many cemetery fundraisers, they are called "cemetery cookies." Even if you don't bake them for a funeral, their bright ginger flavor will please any crowd. Place small balls of dough on the pan, because these cookies spread as they bake. How long to bake is up to you. More time in the oven and they are crispy; less time and they are chewy.

Makes 7 to 8 dozen cookies Prep: 30 to 35 minutes Chill: 3 hours or overnight Bake: 10 to 14 minutes

12 tablespoons (1 1/2 sticks/170 grams) unsalted butter, at room temperature

1 cup (200 grams) granulated sugar, plus 1/4 cup (50 grams) for rolling

1 large egg

1/4 cup molasses

2 cups (240 grams) all-purpose flour

2 teaspoons baking soda

1 teaspoon ground cinnamon

1 teaspoon ground cloves

1/2 teaspoon ground ginger

1/2 teaspoon salt

1. Place the butter and the 1 cup sugar in a large bowl and beat with an electric mixer on medium speed until light and fluffy, 2 to 3 minutes. Scrape down the sides of the bowl with a rubber spatula. Add the egg and molasses and beat until just combined, 30 seconds. Scrape down the bowl and set aside.

2. Sift together the flour, baking soda, cinnamon, cloves, ginger, and salt in a medium bowl. Add half of the flour mixture to the butter and sugar mixture, beating on low speed until just combined. Add the remaining flour mixture and beat until just combined. Scrape down the sides of the bowl and stir until smooth. Cover the bowl with plastic wrap and chill for at least 3 hours or preferably overnight.

3. When you're ready to bake, heat the oven to 325°F, with a rack in the middle. Put the 1/4 cup sugar in a small bowl. Roll the dough into 1-inch balls (8 to 10 grams each) and roll in the sugar. Place 2 to 3 inches apart on 12-by-17-inch ungreased baking sheets and flatten to 1/4-inch thickness with the bottom of a glass.

4. Bake, one pan at a time, until firm and crisp, 10 to 14 minutes. Immediately remove from the pan to cool on a wire rack. Repeat with the remaining dough, cooling the pan between batches. Let the cookies cool to room temperature, 15 minutes, before serving. Store in an airtight container for up to 2 weeks.

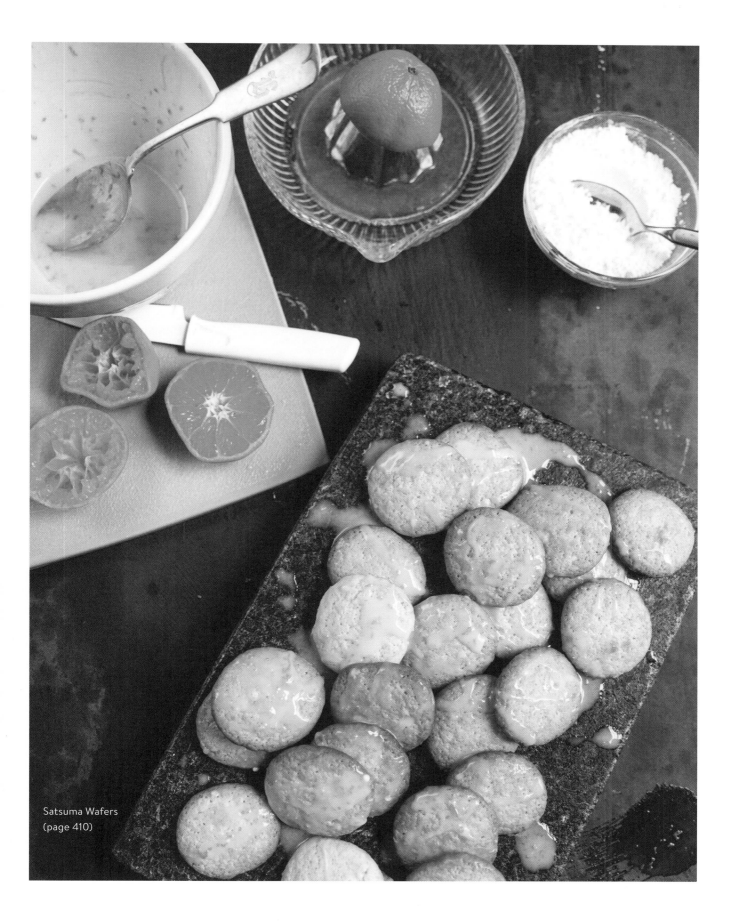

Satsuma Wafers
(page 410)

Satsuma Wafers

Satsuma oranges have grown in the South since the early 1900s, when a million Japanese Owari satsuma mandarin trees were planted along the Gulf of Mexico coast from Florida to Texas. The small, sweet satsumas can't tolerate temperatures below 15 degrees. Their brightly colored orange flesh and a leathery rind that is easy to peel, make them a favorite of schoolchildren. I adapted this icebox cookie recipe from one in the 1920 *Selma Times-Journal*, when satsumas were very much in vogue.

| Makes 3 to 4 dozen 2-inch cookies | Prep: 15 to 20 minutes | Chill: 4 hours or overnight | Bake: 10 to 13 minutes per batch |

2/3 cup (133 grams) granulated sugar

4 tablespoons (1/2 stick/57 grams) unsalted butter, at room temperature

1 large egg

1 satsuma or tangerine

1 1/2 cups (180 grams) all-purpose flour

1 1/2 teaspoons baking powder

1/4 teaspoon salt

Waxed paper or parchment paper for rolling up the dough

NOTE:

To glaze these satsuma cookies, after cooling them, drizzle with a little glaze made by whisking together 1/2 cup sifted confectioners' sugar with 1 to 2 tablespoons satsuma juice.

1. Place the sugar and butter in a large bowl and beat with an electric mixer on medium speed until fluffy and light, 2 to 3 minutes. Add the egg and beat until just combined.

2. Grate the satsuma or tangerine zest to yield 1 heaping teaspoon and add to the bowl. Cut the fruit in half and squeeze the juice into a small bowl. Whisk together the flour, baking powder, and salt in a small bowl. Add 2 tablespoons of the juice and the flour mixture to the butter and sugar mixture. Beat on low speed until just incorporated, about 1 minute.

3. Tear off a 16-inch piece of waxed or parchment paper. Spoon the dough in a line running lengthwise down the center. Wrap the paper up around the dough to secure, and roll gently on the counter with your palms until the log is 14 to 15 inches in length and 1 1/4 inches in diameter. Twist the ends to seal. Chill for at least 4 hours or preferably overnight.

4. When ready to bake, heat the oven to 350°F, with a rack in the middle. Remove the dough from the fridge and unwrap it. Slice into 1/3-inch-thick slices and place on 12-by-17-inch ungreased baking sheets 2 inches apart. Bake until lightly browned, 10 to 13 minutes. Remove to a wire rack to cool completely. Repeat with the remaining dough, cooling the pans between batches. Store in a tightly covered container for up to 2 weeks.

Demopolis Turtleback Cookies

William Henry Traeger was changing trains on his way to Meridian, Mississippi, in 1926 when he saw a bakery for sale in Demopolis, Alabama. He came back to Demopolis, bought the bakery, and introduced the river town to a soft spiced cookie with a cinnamon glaze that glistened like a turtle's shell. The Turtleback resembled the German Lebkuchen (gingerbread) and soon became a part of the town's culture. I adapted this recipe from one shared in the April 2015 *Saveur* magazine.

| Makes about 3 dozen 2-inch cookies | Prep: 40 to 45 minutes | Chill: 6 hours or overnight | Bake: 10 to 13 minutes per batch |

1 1/2 cups (180 grams) all-purpose flour

1/2 cup (2 ounces/57 grams) chopped pecans

1 teaspoon ground cinnamon

1/2 teaspoon baking soda

1/2 teaspoon ground cardamom

1/4 teaspoon kosher salt

1/2 cup (96 grams) firmly packed light brown sugar

1/2 cup (100 grams) granulated sugar

16 tablespoons (2 sticks/227 grams) unsalted butter, at room temperature

1 teaspoon vanilla extract

2 large eggs

Parchment paper for lining the pans

Cinnamon Glaze (page 446)

1. Place the flour, the pecans, the cinnamon, the baking soda, the cardamom, and the salt in a medium bowl and set aside.

2. Place the brown sugar, granulated sugar, butter, and vanilla in a large bowl and beat with an electric mixer on medium speed until fluffy and light, 2 to 3 minutes. Scrape down the sides of the bowl with a rubber spatula. Add the eggs, one at a time, beating well after each addition. Add the flour mixture in 2 additions, beating on low. Scrape down the sides of the bowl. Cover with plastic wrap and chill for at least 6 hours or preferably overnight.

3. When ready to bake, heat the oven to 350°F. Line two 12-by-17-inch baking sheets with parchment paper.

4. Remove the dough from the fridge and roll into 1 1/2–inch balls (about 3/4 ounce each). Place on the prepared pans 2 to 3 inches apart, pressing down to about 1/2-inch thickness with a small piece of parchment or the back of a spatula. Bake, one pan at a time, until slightly browned around the edges, 10 to 13 minutes. Remove from the oven and slide the parchment off the pan. Let the cookies cool for 1 minute, then transfer to a wire rack to cool completely, 30 minutes, before frosting. Repeat with the remaining dough, cooling the pans between batches.

5. Prepare the Cinnamon Glaze. With a small spatula, spread 1 teaspoon on each cookie. Let set 30 minutes. Store in one layer.

Mama Allie's Pecan Icebox Cookies

I was searching for a copy of a cookbook called *Mama Allie's Recipes* when I drove into Plains, Georgia, a few years back. Frances Allethea Murray Smith, known as Mama Allie by her family, or Miss Allie if you were being more formal, was former First Lady Rosalynn Carter's mother. Left a widow, Mama Allie raised children, sewed, dairy farmed, and worked in the grocery store, the school cafeteria, and the Plains Post Office, where she was employed for twenty-nine years. According to her granddaughter LeAnne Smith, Mama Allie picked up pecans in the yard and shelled and froze them for these do-ahead cookies, which I have adapted slightly. There was always a tin of these crisp and buttery cookies brimming with pecan flavor during the holidays, Smith recalls, and for "Stitch and Chat" meetings where everyone sewed, crocheted, or knitted their own pieces and sometimes worked on a big quilt together. Icebox cookies appeal to busy people like Mama Allie who made the dough ahead and baked off fresh cookies when she needed them.

Makes 4 dozen 2-inch cookies	Prep: 15 to 20 minutes	Chill: 3 hours or overnight	Bake: 8 to 10 minutes per batch

1/2 cup (2 ounces/57 grams) chopped pecans

8 tablespoons (1 stick/114 grams) unsalted butter, at room temperature

3/4 cup (144 grams) lightly packed light brown sugar

1 large egg

1 teaspoon vanilla extract

1 1/4 cups (150 grams) all-purpose flour

1/2 teaspoon salt

1/4 teaspoon baking soda

Parchment or waxed paper for wrapping the dough

Pecan halves (optional)

1. Place the chopped pecans in a food processor and pulse until finely chopped. Add the butter and brown sugar and pulse to combine. Add the egg and vanilla and pulse until combined. In a small bowl, stir together the flour, salt, and baking soda. Turn the flour mixture into the food processor and pulse until smooth.

2. Tear off a sheet of waxed or parchment paper about 15 inches long. Spoon the dough onto the paper and roll into a log about 12 inches long. Wrap the paper up around the dough and chill for 4 hours or preferably overnight. You can store the log in the freezer in a zipper-top bag for up to 3 months.

3. When you're ready to bake, remove the dough from the refrigerator and roll it back and forth on the counter until it is about 1 1/2 inches in diameter. Place in the freezer while the oven preheats. Heat the oven to 375ºF, with a rack in the middle.

4. Remove the dough from the freezer and from the paper and slice into 1/4-inch-thick rounds. Arrange 1 inch apart on 12-by-17-inch ungreased baking sheets. If desired, press a pecan half into each round. Bake, one pan at a time, until the cookies are golden brown and crispy around the edges, 8 to 10 minutes. Transfer to a wire rack to cool. Repeat with the remaining dough, cooling the pans between batches. Store the cookies for up to a week in an airtight container.

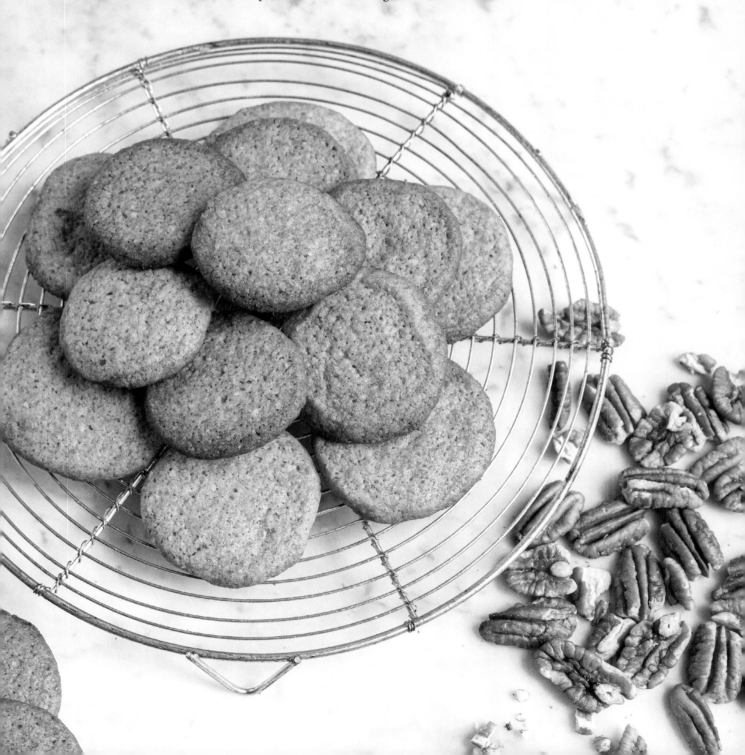

CHARLESTON: A COSMOPOLITAN CITY

Lowcountry food historian John Martin Taylor says Charleston was the first place where a unique cuisine emerged that was indicative of the melting pot that America was becoming. In 1750 no other place in the South had this level of cuisine, not even New Orleans. Charleston was the richest city in the new world, with almost as large a population as New York and Boston. It boasted a bookstore with 50,000 volumes. Its people had a variety of cultural backgrounds; its ingredients came from both land and sea; and its recipes remained intact in spite of the Civil War and Reconstruction. Bananas, pineapple, spices, and olive oil arrived into its port from all over the world.

Benne Seed Wafers

A year after the *Charleston Receipts* cookbook was published in 1950, Clementine Paddleford, the food writer for the *New York Herald Tribune*, was invited by the women who wrote the cookbook to come visit. And that's how Paddleford was introduced to benne wafers, paper-thin, almost caramel-flavored cookies with a delightful crunch from local benne (similar to sesame) seeds. Benne (or beni) is the word for "sesame" in the language of the Gullah Geechee people, descendants of enslaved West Africans who live in South Carolina's Lowcountry. Benne has grown along the South Carolina coastline and barrier sea islands, and its roots are in Africa. The seeds impart a deep burnt-honey flavor, almost woodsy, to these wafers, and the recipe is adapted from *Charleston Receipts* and the late Savannah caterer Sally Sullivan. My friend Martha Nesbit shared that recipe in her cookbook *Nibbles & Scribbles* (2019). You can order benne seeds from Anson Mills in Columbia, South Carolina, or buy sesame seeds to substitute. What's important is that the seeds must be toasted before adding to the dough, so watch them closely to avoid burning them.

Makes about 7 dozen 2-inch wafers	Prep: 30 to 35 minutes	Bake: 15 to 18 minutes per batch

3/4 cup (3.5 ounces/101 grams) benne or white sesame seeds

12 tablespoons (1 1/2 sticks/170 grams) unsalted butter, at room temperature

1 cup plus 2 tablespoons (219 grams) lightly packed light brown sugar

1 large egg

1 cup (120 grams) all-purpose flour

1/2 teaspoon baking powder

1/4 teaspoon salt

1 teaspoon vanilla extract

Parchment paper to line the pans

1. Heat the oven to 350°F, with a rack in the middle.

2. Spread out the seeds on a 12-by-17-inch rimmed baking sheet. Place in the oven and turn on the oven light. Bake until the seeds turn golden brown, 12 to 15 minutes. Remove from the oven and reduce the temperature to 300°F. Let the seeds cool, about 15 minutes.

3. Place the butter and brown sugar in a large bowl and beat with an electric mixer on medium speed until creamy and light, 2 to 3 minutes. Add the egg and beat until just combined. Scrape down the sides of the bowl with a rubber spatula. Whisk together the flour, baking powder, and salt in a small bowl and add to the butter mixture, along with the vanilla. Beat on low until just combined. When the benne seeds have cooled, add them to the dough and beat on low to incorporate, 10 seconds.

4. Line two 12-by-17-inch baking sheets with parchment paper. Drop the dough by rounded teaspoons onto the prepared pans, spacing the cookies 2 to 3 inches apart. You will be able to fit 9 to 12 cookies per pan. Bake one pan at a time, until deeply golden brown, 15 to 18 minutes. Let the cookies rest on the pan for 10 minutes, then carefully run a metal spatula under them and place on a wire rack to cool completely, 1 hour. Repeat with the remaining dough, cooling the pans between batches. Store in an airtight container for up to a week.

Kate's Pecan Tassies

In the play and movie *Steel Magnolias* (1989), Clairee Belcher, played by the late actress Olympia Dukakis, is known for gossip—"If you don't have anything nice to say about anybody, come sit by me!"—as well as for her pecan tassies, which she proudly carries into the beauty shop to share. These small bites of pecan pie have been baked for baby showers and debutante teas, synagogue luncheons and funeral wakes, following us literally from birth to the grave. Nathalie Dupree, coauthor of *Mastering the Art of Southern Cooking*, has loved the cookies ever since her assistant, Kate Almand, shared this family recipe with her. It's my favorite version of this Southern classic. The cream cheese dough is easy to pull together and work with, the gooey pecan filling includes ingredients you probably already have on hand, and the recipe makes a big plateful for sharing.

You'll need enough mini muffin pans to make the 30 tassies.

Makes about 30 pecan tassies	Prep: 30 to 35 minutes	Freeze and chill: 45 to 50 minutes	Bake: 28 to 32 minutes per batch

CRUST

8 tablespoons (1 stick/114 grams) unsalted butter

1 cup (120 grams) all-purpose flour

3 ounces cream cheese, chilled

FILLING

1 large egg

1/2 cup (96 grams) lightly packed light brown sugar

1 tablespoon unsalted butter, melted

1 teaspoon vanilla extract

Pinch of salt

2/3 cup (2.5 ounces/71 grams) finely chopped pecans

1. **Make the crust:** Cut the butter into 1/2-inch cubes and place in a bowl in the freezer until firm, 15 to 20 minutes.

2. Place the flour in a food processor. Add the frozen butter cubes and pulse until the texture of oatmeal, about 30 times. Cut the cream cheese into 4 pieces and distribute them on top of the butter and flour. Pulse until the dough begins to pull together, about 15 pulses. With your hands, gather the dough and press it together into a ball. It may seem dry at first, but keep pressing and it will come together. Wrap the dough in plastic wrap and place it in the fridge to chill for at least 30 minutes and up to 5 days.

3. When you're ready to bake, remove the dough from the fridge. Pinch off pieces of dough that are about 1/2 tablespoon in size. Press these into the ungreased 2-inch cups of a mini muffin or cupcake pan. You will fill about 30 cups with dough. Press the dough so that it covers the bottoms and sides of the cups to form miniature crusts. Place the pans in the fridge while you prepare the filling.

4. **Make the filling:** Heat the oven to 325ºF, with a rack in the middle. Place the egg, brown sugar, melted butter, vanilla, and salt in a medium bowl and whisk until smooth. Set aside.

5. Remove the crusts from the refrigerator. Scatter half of the pecans evenly into the bottom of the crusts, using about 1/2 teaspoon for each. With a small spoon, portion the filling over the nuts, evenly filling the crusts a little more than halfway and not allowing the filling to get between the pan and the shell. Sprinkle the remaining pecans on top of the filling. Wipe any drops of filling off the pans and place in the oven.

6. Bake the pans side by side until the crusts are lightly golden brown, 28 to 32 minutes. Let the tassies cool in the pans for about 10 minutes, then run a knife around the crusts and transfer them to a wire rack to cool completely or to a plate to serve slightly warm. These keep well in an airtight container at room temperature for up to 5 days. Or you can freeze them airtight for up to 1 month.

NOTE:

This recipe was developed back when 3-ounce packages of cream cheese were easy to find. If you have an 8-ounce block of cream cheese, the amount needed for this recipe will be slightly less than half. Or use a kitchen scale to weigh out the exact 3 ounces.

Crescent Tea Cookies

When I was a girl, pecan crescent cookies were my mother's Christmas specialty, and now they are mine. What makes this recipe so popular is that the dough has just a few ingredients and can be made a day ahead. You form the dough into the half-moon crescent shapes and then dust them with confectioners' sugar while the cookies are still a little warm, so the sugar will stick. It's likely the European almond crescent cookie found its way into Southern baking through bakeries and then into homes in Louisiana and Texas. One of the first recipes for crescent tea cookies with pecans appeared in Eleanor Howe's "Household News" column in newspapers in Port Allen and Shreveport, Louisiana, in 1939. With cinnamon added, and baked in round balls, these are a Texas favorite, Mexican Wedding Cookies.

Makes 4 dozen cookies Prep: 20 to 25 minutes Bake: 18 to 22 minutes per batch

16 tablespoons (2 sticks/227 grams) salted butter, at room temperature

2 teaspoons pure vanilla extract

1/2 cup (58 grams) confectioners' sugar, plus 2 cups (216 grams) for dusting the cookies (see Notes)

2 cups (240 grams) all-purpose flour (see Notes)

1 full cup (5 ounces/140 grams) very finely chopped pecans

NOTES:

Sift the confectioners' sugar if necessary to remove the lumps.

I always use a soft low-protein flour in this recipe because I want the cookies crumbly and tender; White Lily works well. If you use a flour with more gluten (protein), reduce the flour to 1 3/4 cups.

1. Heat the oven to 325ºF, with a rack in the middle.

2. Place the butter and vanilla in a large bowl and beat with an electric mixer on low speed until creamy, 1 minute. Add the 1/2 cup confectioners' sugar and beat until just combined. Add the flour and pecans and beat just until blended, 30 seconds. The dough will be stiff.

3. Pinch off 1/2-inch pieces of dough and shape into crescents. Place on 12-by-17-inch ungreased baking sheets about 2 inches apart. Bake, one pan at a time, until the cookies turn light brown, 18 to 22 minutes. Remove the pan from the oven, let the cookies rest for 2 minutes on the pan, then remove with a metal spatula to a wire rack to cool partially, 3 to 4 minutes.

4. Place the 2 cups confectioners' sugar in a shallow bowl and carefully roll the warm cookies in the sugar, dusting off the excess. Place them on the rack to cool completely, 1 hour. Repeat with the remaining cookie dough, cooling the pans between batches. Store in a tightly covered tin for up to 2 weeks.

Carolyn's Chocolate Chip Cookies

Every year Carolyn Guerry of Chattanooga walks into her July 4 family reunion carrying a tin of home-baked cookies, and her relatives follow her like she's the Pied Piper. Her moist, chewy, chocolate-filled cookies are bliss. Raised on a farm in Benton, Tennessee, in the southeastern corner of the state, Guerry has been baking since she was a teenager, learning from her mother, who baked a pie or cake each day. The secret to great chocolate chip cookies, she says, is to not overbake them. "You've got to stay right with them. Every oven bakes differently." Guerry prefers to bake the cookies at 350ºF, but I like the flavor you get from 375ºF, so I've given both temperatures. Guerry bakes with a mix of butter and vegetable shortening, but I prefer the flavor of all butter and a little extra salt.

Makes 4 dozen (2 1/2–inch) cookies Prep: 20 to 25 minutes Bake: 12 to 15 minutes at 350ºF or 9 to 12 minutes at 375ºF

2 cups (240 grams) all-purpose flour

1 teaspoon baking soda

1/2 to 3/4 teaspoon salt

8 tablespoons (1 stick/114 grams) unsalted butter or margarine, at room temperature

1/2 cup (3.5 ounces) vegetable shortening or another 4 ounces (1 stick) butter

3/4 cup (144 grams) lightly packed light or dark brown sugar

1/2 cup (100 grams) granulated sugar

1 teaspoon vanilla extract

1 large egg

2 cups (12 ounces/342 grams) semisweet chocolate chunks

1/2 cup (2 ounces/57 grams) chopped pecans or walnuts

NOTES:

If heating the oven to 375ºF, bake the cookies for 9 to 12 minutes. Store in zipper-top bags for up to a week or freeze up to 3 months.

1. Heat the oven to 350ºF, with a rack in the middle (see Notes).

2. Whisk together the flour, baking soda, and salt in a small bowl.

3. Place the butter or margarine, shortening (or more butter), and both sugars in a large bowl and beat with an electric mixer on medium speed until creamy, 2 to 3 minutes. Add vanilla and egg and beat until well combined, about 1 minute. Scrape down the sides of the bowl with a rubber spatula. Add the flour mixture and beat on low until just combined. Add chocolate and nuts, beating just enough to mix, or fold them in by hand.

4. Drop by about 1-inch tablespoons onto 12-by-17-inch ungreased baking sheets, spacing 2 inches apart. Bake, one pan at a time, until the cookies are lightly browned around the edges but soft in the center, 12 to 15 minutes. Rest on the pan for 1 minute, then remove to a rack to cool. Repeat with the remaining dough.

A CHOCOLATE CHIP COOKIE CHECKLIST

FAT. Butter brings flavor and crispness, but shortening makes the cookies chewy and soft.

SUGAR. Brown sugar adds chewiness and deeper flavor, and white sugar makes the cookies crispy. A mix of the two is best, and dark brown sugar brings more intensity than light.

FLOUR. I've tried them all. High-protein unbleached flours offer shape, and lower-protein bleached flours give tenderness. I've baked them with rye flour for spiciness, and I recommend it. If you are like me and keep a variety of flours in your cupboard for baking, use half of a King Arthur-type flour and half of a lower protein like White Lily for the best of both worlds.

EGGS. One egg is best for most recipes. Too much egg makes cookies cakey.

SALT. You need it to balance the sugar. And it partners well with dark chocolate. If you're watching your sodium, reduce the salt as needed. I like 3/4 teaspoon. Or you could use 1/2 teaspoon and then top the cookies with a little flaked sea salt after baking, if you like.

CHOCOLATE. Use semisweet chunks or 60 percent cacao chocolate chips.

Baltimore Berger Cookies

If you're not from Baltimore, you've probably never tasted a Berger cookie. This soft sugar cookie iced with a thick layer of chocolate fudge was born in the mid-1800s, when German Henry Berger opened a bakery in East Baltimore. The original Berger was oblong in shape and shortbread-like in texture, wrote Robert Moss in the March 2016 issue of *Saveur* magazine. Berger's cookies in their distinctive red boxes are still found in groceries across the Baltimore area. This recipe was created by PJ Hamel at King Arthur Baking Company.

Makes about 2 dozen cookies Prep: 50 to 55 minutes Bake: 7 to 9 minutes per batch

COOKIES

Parchment paper for pan
5 tablespoons plus 1 teaspoon
 (74 grams) unsalted butter,
 at room temperature
1/2 teaspoon salt
1 teaspoon vanilla extract
1 teaspoon baking powder
1/2 cup granulated sugar
1 large egg
1 1/2 cups (180 grams) unbleached
 all-purpose flour, divided
1/3 cup whole milk, at room
 temperature

ICING

2 cups (12 ounces/342 grams)
 semisweet chocolate chips
1 1/2 tablespoons light corn syrup
3/4 cup heavy cream
1 teaspoon vanilla extract
Generous 1 1/2 cups (172 grams)
 confectioners' sugar, sifted
Dash of salt

1. Heat the oven to 400°F, with a rack in the middle. Line a 12-by-17-inch baking sheet with parchment paper.

2. **Make the cookies:** Place the butter, salt, vanilla, and baking powder in a large bowl and beat with an electric mixer on medium speed until creamy, 1 minute. Scrape down the sides of the bowl with a rubber spatula, and with the mixer still running, beat in sugar until fluffy, 1 minute. Add egg and mix until combined. Scrape down the sides of the bowl. Add half of the flour and beat until combined. Add the milk, then add the remaining flour and beat, about 20 seconds. The dough will be soft and loose.

3. Dollop rounded tablespoons onto the prepared pan, about 2 inches apart. Place the pan in the oven and bake until cookies spring back and the bottoms are lightly mottled brown, 7 to 9 minutes. Remove from the oven before there is any browning on the top, or the cookies will be overbaked. Repeat with the remaining dough. Let the cookies cool before icing.

4. **Make the icing:** Place chocolate chips, corn syrup, and cream in a saucepan over low heat. Whisk until melted, 7 to 8 minutes. Remove from heat and whisk in the vanilla, confectioners' sugar, and salt until smooth. Dip tops of cookies twice in the icing. Let cool 1 hour.

Laura Bush's Cowboy Cookies

Cookies that use up the last bits of dried fruit, chocolate, oats, and nuts in your pantry have been called "rocks," "billy goats," or "kitchen-sink cookies." In Texas, a chocolate chip cookie loaded with all the goodies is a Cowboy Cookie and was shared in the 1976 *Dallas Junior League Cookbook* and in *Family Circle* magazine by then future First Lady Laura Bush during the 2000 presidential election. You can find these cookies on the menu at Cafe 43 in the George W. Bush Presidential Center on the campus of Southern Methodist University (SMU) in Dallas, Laura Bush's alma mater, or you can bake my adaptation of them at home. I use a little less flour than Bush's recipe does and add a teaspoon of salt to balance the sugar. Feel free to create your own combination of add-ins as long as it's about 6 cups—chopped chocolate, nuts, oats, and dried fruit. For best results, make the dough a day ahead and refrigerate so the flour absorbs the moisture and the cookies bake up beautifully. They are wonderful!

Makes about 3 dozen 3-inch cookies Prep: 20 to 25 minutes Bake: 16 to 20 minutes per batch

16 tablespoons (2 sticks/227 grams) unsalted
 butter, at room temperature

1 1/2 cups (288 grams) lightly packed light brown
 sugar

1/2 cup (100 grams) granulated sugar

2 large eggs

1 1/2 teaspoons vanilla extract

2 cups (240 grams) all-purpose flour

1 teaspoon baking soda

1 teaspoon salt

1/2 teaspoon ground cinnamon (optional)

2 cups (160 grams) old-fashioned oats

2 cups (12 ounces/342 grams) semisweet or bittersweet
 chocolate chips

1 cup (45 grams) unsweetened shredded coconut

1 cup (4 ounces/114 grams) chopped pecans

1. Heat the oven to 350ºF, with a rack in the upper middle.

2. Place the butter and both sugars in a large bowl and beat with an electric mixer on medium-low speed until creamy, about 2 minutes. Add the eggs and vanilla and beat until combined, 1 minute more. Set aside.

3. Place the flour, baking soda, salt, and cinnamon (if desired) in a medium bowl and whisk to combine.

Pour the flour mixture over the butter and sugar mixture. Add the oats. Beat on low until just combined, about 30 seconds. Turn off the mixer and scrape down the sides of the bowl. Fold in the chocolate chips, coconut, and pecans by hand. (If your mixer is heavy-duty, you can add the oats, chocolate chips, coconut, and pecans all at one time and mix on low to combine.)

4. Scoop the dough onto 12-by-17-inch ungreased baking sheets, using a scoop that is about 1 3/4 inches wide. Place 6 scoops onto each baking sheet. Bake one pan at a time. For chewy cookies, bake until they have browned around the edges but are still a little soft in the center, 16 to 18 minutes. For crispier cookies, bake for 18 to 20 minutes, so they are lightly browned all over. Remove the pan from the oven and let the cookies rest on the pan for 1 minute. Remove with a metal spatula to a wire rack to cool completely, 20 minutes. Repeat with the remaining dough, cooling the pans between batches. Store in zipper-top bags for up to a week or freeze for up to 3 months.

Nora's "Medium-Rare" Brownies

"Medium-rare" is how Elliott Mackle, then the dining critic of *The Atlanta Journal-Constitution*, described the fudgy, rich brownies that were the signature of Kay Goldstein's gourmet shop Proof of the Pudding in 1979. Proof catered to Atlanta's indulgences not only with brownies but with fresh croissants and a velvety cold pimento soup at a time when the stock market was running high and there could never be too much cream or chocolate. The recipe is "family," and Goldstein was married to her husband, Buck, for a good while before his mother, Grace, entrusted her with a copy of the recipe created by "Aunt Nora" Wolfson. Goldstein's children always asked her to bake Nora's brownies when they brought someone special home to meet the parents.

Goldstein uses two 9-inch square metal baking pans, but since not everyone has these, I call for a 9-by-13-inch metal pan. I've reduced the 3 3/4 cups chopped walnuts in the original recipe a bit, and you have the option to place the nuts on top so they toast and brown. Goldstein admits the brownies taste sweet to her today, and I concur, and I have reduced the sugar. But the most important detail is the baking time. I use an instant-read thermometer to make sure I don't overcook the brownies, taking them out of the oven when they are around 165ºF in the center. The temperature will jump about 30 degrees while they rest. As Goldstein's mother-in-law said when she handed her the recipe: "Never, never overbake them!"

Makes 32 brownies (1 1/2 by 2 1/4 inches if baked in a 9-by-13-inch pan or 2 1/4-inch squares if baked in two 9-inch square pans)

Prep: 20 to 25 minutes

Bake: 30 to 35 minutes for the 9-inch pans and 45 to 50 minutes for the 9-by-13-inch pan

Soft butter and flour for prepping the pan

28 tablespoons (3 1/2 sticks/400 grams) unsalted butter

5 ounces bittersweet chocolate (60 to 72 percent cacao; see Note)

5 ounces semisweet chocolate

8 large eggs

3 1/4 to 3 1/2 cups (650 to 700 grams) granulated sugar

1 tablespoon vanilla extract

1 teaspoon sea salt

1 3/4 cups (210 grams) all-purpose flour or gluten-free flour blend

2 to 3 3/4 cups (8 to 13 ounces/228 to 369 grams) roughly chopped walnuts

1. Heat the oven to 325ºF, with a rack in the middle. Grease and flour a 9-by-13-inch metal baking pan or two 9-inch square baking pans.

2. Place the butter and both chocolates in a medium saucepan over low heat and stir until melted, 3 to 4 minutes. Place the eggs in a large bowl and beat with an electric mixer on medium speed, adding the sugar a bit at a time until light and fluffy. Add the butter and chocolate mixture, vanilla, and sea salt and beat until smooth. Fold in the flour and

walnuts (unless you want to sprinkle them on top). Pour the batter into the prepared pan or pans and place them in the oven.

3. Bake until the top is glossy and jiggles when you shake it, 45 to 50 minutes for the 9-by-13-inch pans and 30 to 35 minutes for the 9-inch pans. The internal temperature should be 165ºF on an instant-read thermometer. Let the brownies cool in the pan on a wire rack for several hours. For best slicing, freeze first, then slice into squares. Store covered with plastic wrap for up to a week or freeze in heavy-duty foil or zipper-top bags for up to 3 months.

NOTE:

Goldstein suggests a high-quality bittersweet chocolate such as Valrhona, Guittard, Callebaut, or Scharffenberger.

From the top: Nora's "Medium-Rare" Brownies (page 425), First Saturday in May Bourbon Bars (page 434), Shortnin' Bread (page 429), and My Mother's Chess Cake (page 430)

Shortnin' Bread

Shortbread was called "shortnin'" bread in parts of the South, and just as in its native Scotland, it was a buttery treat to be savored on special days such as New Year's. (According to the *Oxford English Dictionary*, *short* means "friable, easily crumbled.") The term surfaced in the first half of the eighteenth century, about the time Scottish settlers were bringing their shortbread recipes to America.

This utterly delicious version with Scottish roots comes from *North Carolina & Old Salem Cookery* (1992) by the late Beth Tartan, who was the food editor of the *Winston-Salem Journal* for forty-four years. I have altered the recipe only slightly, adding a little salt and a little vanilla.

Makes 16 pieces, 2 inches each	Prep: 10 to 15 minutes	Bake: 25 to 30 minutes

1 3/4 cups (210 grams) all-
 purpose flour
1/2 cup (96 grams) lightly
 packed light brown sugar
16 tablespoons (2 sticks/227
 grams) unsalted butter, soft
 but cool to the touch, cut
 into tablespoons
1/2 teaspoon salt
2 teaspoons vanilla extract

1. Heat the oven to 350°F, with a rack in the middle.

2. Place the flour and brown sugar in a food processor. Pulse 10 to 12 times until well mixed. Distribute the butter pieces around the bowl. Add the salt and vanilla. Process until the mixture pulls together into a ball, 20 to 25 seconds.

3. Turn into an 8-inch ungreased square pan, spreading the dough evenly with a small metal spatula or butter knife to reach the corners. Bake until lightly browned and firm, 25 to 30 minutes.

4. Remove from the oven and let rest for 30 minutes, then cut into squares or bars. Store in an airtight container for up to 2 weeks.

THE SCOTS OF NORTH CAROLINA

Immigrants from the Highlands of Scotland were encouraged to settle in North Carolina in the early 1700s. They were farmers and had been offered a ten-year exemption from paying taxes in this new warm, swampy land of pine trees. While they came from a cold country with a short growing season and thin and rocky soil in which only oats and barley might survive, they farmed corn and wheat all year in their new surroundings and integrated well into North Carolina.

My Mother's Chess Cake

My mother, Emily Ann Carr, but known all her life as Bebe, was an outstanding self-taught cook. She could not cook when she and my father were married in March 1949. Her mother was widowed and working full-time when my mother would have wanted to learn how to bake. Through the years of raising three daughters and cooking for a large extended family and many friends, she made cooking and baking look effortless. These bars are similar to blondies and, like chess pie, they have a soft and creamy interior texture. I love that they use what's on hand—flour, brown sugar, butter, pecans—which makes me think the recipe came out of the 1930s, when that's the way people baked. While my mother baked these gooey, wonderful bars with bleached all-purpose flour, I bake them with unbleached for a more chewy texture. She dusted the top with powdered sugar, but I prefer them plain and simple.

Makes 32 bars, about 3 1/4 by 1 inch Prep: 20 minutes Bake: 30 to 35 minutes

Vegetable oil spray and flour for prepping the pan

2 cups (384 grams) lightly packed light brown sugar

1/2 cup (100 grams) granulated sugar

16 tablespoons (2 sticks/227 grams) unsalted butter, melted

4 large eggs, separated

1 3/4 cups (210 grams) unbleached all-purpose flour

2 teaspoons baking powder

1/2 teaspoon salt

1 teaspoon vanilla extract

1 cup (4 ounces/114 grams) finely chopped pecans

1 tablespoon confectioners' sugar for dusting (optional)

1. Heat the oven to 325°F, with a rack in the middle. Lightly mist a 9-by-13-inch metal baking pan with vegetable oil spray and dust with flour.

2. Place both sugars and the melted butter in a large bowl. Beat with an electric mixer on low speed until combined, 1 to 2 minutes. Add the egg yolks and beat on medium until the dough is creamy, 2 minutes.

3. Whisk together the flour, baking powder, and salt in a small bowl and add to the sugar and butter mixture, beating on low until just combined. Add the vanilla and beat just to combine.

4. With clean beaters, beat the egg whites on high speed until they come to stiff peaks, about 3 minutes. Fold the egg whites into the dough with a rubber spatula by turning the dough up and over the whites. Turn the bowl a quarter turn with your other hand every time you fold. Scatter the pecans over the top and fold them in. Turn the batter into the prepared pan and smooth the top with the spatula.

5. Bake until the cake is well browned around the edges but still soft in the center, 30 to 35 minutes. Remove the pan from the oven and let the cake cool for 30 minutes. If you like, dust with confectioners' sugar. Slice and serve. Store in an airtight container at room temperature for about a week or frozen for up to 3 months.

Chess Cake

1 box light brown sugar
1 cup white sugar
2 sticks of butter
4 eggs separated
2 cups sifted flour
2 t Royal Baking Powder
1/4 t salt
1 Cup pecans
1 t vanilla.

over

Junior League Lemon Squares

What do you get when you spread shortbread with lemon curd? Lemon squares, a Junior League institution and a do-ahead sweet for summer bridge games and garden parties, as well as for church suppers and bake sales. They are heaven in a puckery lemon bite! This recipe is a blend of one shared by *Fort Worth Star-Telegram* columnist Mary Meade in the 1950s and a recipe my mother often used. Sometimes I scatter small fresh blueberries over the top about halfway through baking or on top just before serving. The bars are easier to slice if you make them a day ahead.

Makes 24 squares, each about 2 inches Prep: 30 to 35 minutes Bake: 40 to 46 minutes

CRUST

16 tablespoons (2 sticks/227
 grams) unsalted butter, at
 room temperature
1/2 cup (54 grams)
 confectioners' sugar
1/2 teaspoon salt
2 cups (240 grams) all-purpose
 flour, divided

FILLING

3 cups (600 grams) granulated
 sugar
1/2 cup (60 grams) plus
 1 tablespoon all-purpose
 flour
2 large or 3 medium lemons
6 large eggs
1 cup (170 grams) small fresh
 blueberries (optional)
2 teaspoons confectioners'
 sugar for dusting

1. Heat the oven to 350°F, with a rack in the middle.

2. **Make the crust:** Place the butter in a large bowl and beat with an electric mixer on low speed until creamy, about 1 minute. Add the confectioners' sugar and salt and blend until fluffy, 30 seconds. Turn off the mixer and scrape down the sides of the bowl. Add half of the flour to the bowl and blend on low until incorporated. Add the remaining flour and blend until just combined, 15 to 20 seconds. Turn the dough into a 9-by-13-inch ungreased metal pan and, with floured fingertips, press the dough evenly across the bottom of the pan. Prick the dough with a fork so steam can escape and so the dough won't bubble during baking. Bake until lightly golden, 12 to 14 minutes. Remove from the oven.

3. **Meanwhile, make the filling:** Whisk together the sugar and flour in a medium bowl. Set aside. Grate enough zest from the lemons to yield 1 tablespoon. Cut the lemons in half and juice them to yield 1/2 cup plus 1 tablespoon lemon juice. Add the zest, lemon juice, and eggs to the sugar and flour mixture and beat on low until just combined, about 1 minute. Pour the filling over the baked crust and return to the oven.

4. If you want to add blueberries to the filling, after the lemon squares have baked for 20 minutes, open the oven and carefully scatter the berries evenly on top of the filling. Press down gently onto the berries to anchor them. Close the oven door and

continue baking for another 8 to 12 minutes. Or, to make plain lemon squares, bake the lemon squares for 28 to 32 minutes. If you like, you can garnish the top with the berries after the squares have been removed from the oven and placed on a wire rack to cool to room temperature, or chilled for best slicing. Dust with confectioners' sugar, slice, and serve. Store in the pan, covered with plastic wrap, for up to a week in the refrigerator or freeze in the pan for up to 3 months.

First Saturday in May Bourbon Bars

Redolent of bourbon, these chocolate-nut bars are named after the renowned horse race that runs the first Saturday in May and the pie often baked for it. After turning this pie into bars to take to a friend's bourbon-tasting party, I never looked back and have since only baked these as bars, because they're more fun to eat with your fingers and you get more of the wickedly rich inside goo. They are adapted from a recipe that won the 1985 Kentucky State Fair for favorite pie, and created by Donna Richardson. To keep the chocolate chips and pecans from sinking to the bottom, sprinkle them on the top just before baking.

Makes about 30 bars Prep: 15 to 20 minutes Bake: 35 to 40 minutes

2 (9-inch) piecrusts (pages 306
 to 313)
1 cup (200 grams) granulated sugar
1/2 cup (60 grams) all-purpose flour
2 large eggs
8 tablespoons (1 stick/114 grams)
 unsalted butter, melted and
 cooled
1/2 teaspoon kosher salt
3 to 4 tablespoons bourbon
1 teaspoon vanilla extract
1 cup (6 ounces/171 grams) semisweet
 chocolate chips
1 cup (4 ounces/114 grams) coarsely
 chopped pecans or walnuts

1. Line a 10-by-15-inch jellyroll pan with the piecrusts, pressing with your fingers to spread the crusts evenly into the corners. Place in the fridge. Heat the oven to 350ºF, with a rack in the lower middle.

2. For the filling, place the sugar, flour, and eggs in a large bowl and whisk to combine well. Add the melted butter, salt, bourbon, and vanilla and whisk until smooth. Pour into the prepared crust. Scatter the chocolate chips on top of the batter. Scatter the nuts on top of the chocolate chips.

3. Bake until the crust and top are golden brown, 35 to 40 minutes.

4. Remove the pan from the oven and let cool for at least 1 hour before slicing into bars. Store in zipper-top bags for up to a week or freeze for up to 3 months.

FIRST SATURDAY IN MAY PIE

The whole pie baked from this recipe has been the subject of much litigation. Its customary name, "Derby Pie," was trademarked in 1969 by Kern's Kitchen of Louisville, which bakes, boxes, and sells the pie in airports and grocery stores and to local restaurants. The company sued the *Courier-Journal*, Louisville's long-standing newspaper, for one million dollars a few years back for sharing a pie recipe with that name. The lawsuit was dismissed by the judge, who said there was no confusion between what the newspaper printed and the pie sold by Kern's Kitchen.

If you want to bake a whole pie and not bars, use one piecrust and crimp the edges or just press down on the edges of the crust with a fork to form decorative lines. Heat the oven to 350°F, with a rack in the lower middle. Pour the filling into the crust, scatter the chocolate chips on top, then the nuts on top of the chocolate chips. Bake until the crust and the filling are golden brown, 40 to 45 minutes. Let cool for 1 hour before slicing.

Just don't call it Derby, although you can get close with names like Winner's Circle and Louisville Hospitality.

GINGER COOKIES

Ginger cookies have perennial appeal, from the large Creole Stage Planks of New Orleans to small round Cry Babies of Virginia, Maryland, and Delaware, to the thin ginger cookies of the Moravians in North Carolina, to Salzburger gingersnaps. The Salzburgers were German-speaking Protestant refugees expelled from their home in what is now Austria by the Catholic archbishop in 1731. A large group settled along the Atlantic coast in Ebenezer, Georgia, and after yellow fever and other hardships, resettled to a better location they called New Ebenezer, where they were millers and bakers. Today their descendants gather in Effingham County at the Jerusalem Lutheran Church for reunions of lemonade and Salzburger ginger cookies, a recipe that goes something like this: "Boil 1 cup molasses or cane syrup, stir in 2 tablespoons hog's lard or butter, 1 tablespoon ginger, 1 teaspoon baking soda, plain flour as needed to make a good dough. Roll out thinly, cut into shapes and bake until lightly browned."

Gottlieb's Chocolate Chewies

When the Russian Jewish immigrant Isadore Gottlieb opened Gottlieb's Bakery in 1884 on Bull Street in downtown Savannah, he began a baking dynasty. For generations, his cinnamon rolls, rye and challah breads, and these chocolate meringue cookies were an important part of being Jewish in Savannah. The cookies have an intense chocolaty-ness and an irresistible chewiness that seems to amplify if you freeze them briefly. The pecans toast magically as the cookies bake. The cookies can be gluten-free if you bake them with cornstarch or a gluten-free flour blend, and they may have been baked and sold during Passover. At the Central Markets grocery stores in Texas, cookies like these are known as "forgotten" cookies, because after baking, they were left in a turned-off oven to crisp (thus forgotten). Gottlieb's closed in 1994, but now you can bake the cookies at home.

Makes 2 to 3 dozen (2-inch) cookies · Prep: 10 minutes · Bake: 12 to 15 minutes per batch

Parchment paper for lining the pans

2 3/4 cups (294 grams) confectioners' sugar

Generous 1/2 cup (60 grams) unsweetened cocoa powder

1 tablespoon cornstarch or 2 tablespoons all-purpose flour or a gluten-free flour blend

Pinch of salt

3 large egg whites

1/2 teaspoon vanilla extract

2 cups (8 ounces/228 grams) finely chopped pecans

1. Heat the oven to 350°F, with a rack in the middle. Line two 12-by-17-inch baking sheets with parchment paper.

2. Place the confectioners' sugar, cocoa, cornstarch (or flour or gluten-free mix), and salt in a large bowl and beat with an electric mixer on low speed until just combined. Add the egg whites and beat to incorporate the whites, then increase the speed to high and beat for 1 minute, or until very well combined. Stir in the vanilla and pecans.

3. Scoop or drop heaping tablespoonfuls of dough 2 inches apart onto the prepared baking sheets. Bake, one pan at a time, until the cookies are shiny and firm on the outside, but inside they are still a little soft, 12 to 15 minutes. (Gauge the baking time by the size of the cookie. Smaller cookies bake in about 12 minutes and larger ones need more baking time.) Remove the pan from the oven and let the cookies rest for 2 minutes on the pan.

4. With a metal spatula, remove the cookies to a wire rack to cool. Repeat with the remaining dough, cooling the pans between batches.

5. If desired, place the cooled cookies in a zipper-top bag in the freezer for 1 hour, which makes them even more fudgy. Store in an airtight container at room temperature for 1 week. Freeze for up to 3 months.

FROSTINGS AND
FLOURISHES ———

It is the icing that makes a cake popular.

—HELEN CORBITT, *HELEN CORBITT'S COOKBOOK*, 1957

Jimmy, I'm not going to tell you again to quit eating that icing. . . . If you keep that up, there's not going to be enough left for Paw Paw's birthday cake—and you're gonna be sick as a dog.

—MARTHA PEARL VILLAS, *MY MOTHER'S SOUTHERN DESSERTS*, BY JAMES VILLAS, 1998

*W*hat baking all my life and interviewing talented cooks for this book have taught me is that you don't always need to frost a cake or make a glaze or special sauce. Often the pie or cake can stand on its own and needs no adornment. In fact, most of the desserts in this book have just a dusting of powdered sugar, a dollop of whipped cream, or a drizzle of glaze.

The secret to baking well is to finish dessert with a flourish, not drown it. Thus the name for this last chapter.

I've boiled down my favorites so any one of these recipes will send your dessert over the top, and I've offered enough variety, so you have some choices. Basics are essential, like whipped cream, boiled custard, and chocolate icing.

But adding the lemon to the caramel glaze, buttermilk to the ice cream, or peppermint to the buttercream—that's when things get interesting and everyone gets talking. Don't be afraid to jazz up a cream cheese frosting with a little cinnamon, lemon zest, or orange zest.

And just because I say a frosting pairs with a cake doesn't mean you have to agree with me. Use this chapter as a way of creating your own great Southern desserts, and that would be the greatest compliment I could receive.

Cream Cheese Frosting (page 454)

Boiled Custard

I grew up with boiled custard on Christmas Eve, served in punch cups with fruitcake and pound cake. It was a Tennessee holiday tradition, a gentler version of eggnog, and you can make it without any alcohol, as I am sure my Presbyterian grandmother did. You're not going to find it in every Southern cookbook because it is so regional. But you will find it in Tennessee and Mississippi cookbooks, and the recipe I settled on is from *Being Dead Is No Excuse* (2005), by Gayden Metcalfe and Charlotte Hays. They call it Bourbon Boiled Custard, but as I said, not everyone puts bourbon in it. But if they do, it's gonna be good, especially with Mrs. Mosal's White Fruitcake, Baba au Rhum, Christmas Black Cake, and festive cookies such as Justines and Crescent Tea Cookies.

Serves 8	Prep: 20 to 25 minutes	Cook: 10 to 14 minutes	Chill: At least 4 hours

1 cup (200 grams) granulated sugar

2 tablespoons all-purpose flour

4 large eggs

Big pinch of salt

3 cups whole milk

1 cup heavy cream

2 teaspoons vanilla extract

1/4 cup bourbon (optional)

1. Place the sugar and flour in a large heavy saucepan or in the top of a double boiler (see Note). Whisk in the eggs and salt until smooth.

2. Place the milk in a separate saucepan and bring to a simmer over medium heat, letting bubbles form around the edges of the pan, 3 to 4 minutes. Remove from the heat and stir in the cream.

3. Ladle 1/2 cup at a time of the warm milk mixture into the egg mixture and whisk to combine. Place the pan with the eggs over low heat or over simmering water in the double boiler. Stir with a flat spatula until the mixture creates steam and thickens enough to coat a spoon, 10 to 14 minutes, or 170°F to 175°F on an instant-read thermometer.

4. Remove the pan from the heat and pour the custard into a glass bowl. Stir in the vanilla and bourbon, if desired. Place in the refrigerator to chill for at least 4 hours. Serve as a beverage in small cups or as a sauce.

NOTE:

If you have a heavy copper pan for making sauces, it's perfect for this recipe, because it's thick and will protect the eggs from heating too quickly. But if you do not, use a double boiler—or what's known as a bain-marie—where you place a bowl or insert on top of a saucepan filled with simmering water. The trick is to keep the water at a simmer, not a boil, and to make sure the water is not touching the bottom of the bowl or the insert holding the custard. It takes a little longer to thicken with the double boiler, but every pan and stove is different. You are looking for a just-thickened custard that coats the spoon. It will thicken more as it cools.

Boiled White Icing

The most famous fluffy white icing may be the seven minute, but it can be temperamental and weep on rainy days. For a more durable icing, I like this one better. The trick is to keep beating the egg whites as the temperature on the candy thermometer climbs.

Makes 3 cups, enough to frost a two- or three-layer cake Prep: 20 to 25 minutes

1 cup (200 grams) granulated sugar, plus 1 tablespoon for the egg whites

1/4 cup water

Dash of cream of tartar

Dash of salt

2 large egg whites, at room temperature

2 tablespoons confectioners' sugar

1/2 teaspoon vanilla extract

1. Place the 1 cup granulated sugar, water, cream of tartar, and salt in a small saucepan over medium-high heat. Stir to combine, then cover and bring to a boil. Once the mixture is boiling, remove the cover and reduce the heat to medium-low to keep the mixture at a low boil. Attach a candy thermometer to the side of the pan.

2. Meanwhile, place the egg whites in a large bowl and beat them with an electric mixer on high speed until they are almost stiff peaks, about 4 minutes. Add the 1 tablespoon granulated sugar gradually while beating, until the whites come to stiff peaks. Set aside.

3. Check the mixture on the stove and let the candy thermometer reach 238°F, or soft-ball stage. The syrup will slowly drop from a metal spoon. While beating the egg whites on medium-high speed, slowly drizzle about a third of the syrup into the whites. Place the pan back on the burner and let the syrup come back to a low boil. Let the syrup reach 244°F on the thermometer, when a thin hair of syrup drops from the metal spoon. Slowly drizzle half of this syrup into the whites while beating on medium-high speed. Place the pan back on the burner, let the syrup come to a low boil, and let the temperature reach 250°F. This happens quickly. About two thin hairs will drop from the spoon. Slowly drizzle the remaining syrup into the whites, beating at medium-high speed. Immediately beat in the confectioners' sugar and vanilla until just incorporated. The icing should be thick, smooth, and spreadable. Spread at once onto cooled cake layers.

Warm Lemon Sauce

For Grandmother Bailey's Soft Gingerbread (pages 319–320) or for pound cake.

Makes 1 1/2 cups Prep: 15 to 20 minutes

8 tablespoons (1 stick/114 grams) salted butter (if using unsalted, add 1/4 teaspoon salt)

1 cup (200 grams) granulated sugar

1 large egg, lightly beaten

1/4 cup water

1 teaspoon grated lemon zest

3 tablespoons lemon juice (from 1 extra-large lemon or 2 medium lemons)

1. Place the butter in a medium heavy saucepan and let it melt over low heat. Remove the pan from the heat and stir in the sugar, lightly beaten egg, water, lemon zest, and lemon juice.

2. Return the pan to low heat and cook, whisking constantly, until the mixture thickens and bubbles appear around the edges of the pan, 7 to 8 minutes. Serve at once.

Cinnamon Glaze

Use this glaze to spread over tea cakes and the Demopolis Turtleback Cookies (page 411).

Makes about 1 ½ cups, enough to glaze 3 dozen cookies

1 1/2 cups (162 grams) confectioners' sugar, sifted

1/4 teaspoon ground cinnamon

1/4 teaspoon kosher salt

4 tablespoons (1/2 stick/57 grams) unsalted butter

1/4 cup (48 grams) lightly packed brown sugar

1/2 teaspoon vanilla extract

3 tablespoons heavy cream

1. Whisk together the confectioners' sugar, cinnamon, and salt in a bowl.

2. Melt the butter in a medium saucepan over low heat and whisk in the brown sugar and let cook until it bubbles up, 2 to 3 minutes. Remove from the heat and whisk in the vanilla and cream. Whisk in the confectioners' sugar mixture until smooth.

Buttermilk Glaze

I love this old-fashioned glaze over any spice cake or pudding, especially Mrs. Kitching's Smith Island Fig Cake (pages 339–340).

Enough for a 9-by-13-inch cake Prep: 10 to 15 minutes

1/2 cup (100 grams) granulated sugar

1/4 cup whole buttermilk

2 teaspoons light corn syrup

2 tablespoons unsalted butter

1/4 teaspoon salt

1 teaspoon vanilla extract

1. Place the sugar, buttermilk, corn syrup, butter, and salt in a medium saucepan over medium heat and bring to a boil, stirring. Reduce the heat to low and let the mixture simmer until smooth and thickened, 2 to 3 minutes. Remove the pan from the heat and stir in the vanilla.

2. Drizzle the glaze over a warm cake and smooth the top with a small metal spatula so the cake absorbs the glaze. Let the cake sit for 30 minutes so the glaze sets slightly (it is still sticky), then slice and serve.

Chocolate Glaze

Indispensable, this glaze goes over any cake or ice cream. Add a teaspoon of espresso powder to crank up the flavor.

Makes about 1 cup, enough to top a Bundt cake Prep: 10 to 15 minutes

2 tablespoons unsalted butter

1 tablespoon unsweetened cocoa powder

Pinch of salt

1 1/2 tablespoons whole milk, half-and-half, or coconut milk, or as needed

3/4 cup (78 grams) confectioners' sugar, sifted

1. Melt the butter in a small saucepan over low heat, 2 minutes. Stir in the cocoa, salt, and milk, half-and-half, or coconut milk. Cook, stirring, until the mixture thickens and just begins to come to a boil, 1 minute longer. Remove the pan from the heat. Whisk in the confectioners' sugar until smooth.

2. Pour over the top of a cake. Let sit for 15 minutes so the glaze can set before slicing and serving.

Quick Caramel Icing

Here is the icing recipe my mother handed down to me many years ago. It is a lot easier to prepare than the old-fashioned method of caramelizing the sugar. (That recipe is on page 451.) This frosting has great flavor, dirties few pans in the kitchen, and is ready in a snap.

Makes 3 to 4 cups icing, enough for a three-layer cake Prep: 10 to 15 minutes

12 tablespoons (1 1/2 sticks/170 grams)
 unsalted butter, cut into tablespoons
3/4 cup (144 grams) lightly packed light
 brown sugar
3/4 cup (144 grams) lightly packed dark
 brown sugar
1/3 cup whole milk
2 1/2 to 3 cups (270 to 324 grams)
 confectioners' sugar, sifted
2 teaspoons vanilla extract
1/4 teaspoon salt, or to taste

1. Place the butter and both brown sugars in a medium saucepan over medium heat and stir until the butter melts and the mixture begins to boil, 2 to 3 minutes. Add the milk, stir, and let the mixture come back to a boil.

2. Remove the pan from the heat and whisk in 2 1/2 cups of the confectioners' sugar, the vanilla, and the salt. Whisk until smooth. If the icing is too runny, add another 1/2 cup confectioners' sugar. Do not add so much sugar that the frosting thickens and hardens. It needs to be smooth enough to spread. It will set as it cools.

Caramel Glaze

This is just the right amount for pouring over the top of a Bundt or pound cake.

Makes about 1 cup Prep: 10 to 15 minutes

4 tablespoons (1/2 stick/57 grams) unsalted
 butter
1/4 cup (48 grams) lightly packed light brown
 sugar
1/4 cup (48 grams) lightly packed dark brown
 sugar
3 tablespoons whole milk
3/4 to 1 cup (78 to 108 grams) confectioners'
 sugar, sifted
1/4 teaspoon sea or kosher salt

1. Place the butter and both brown sugars in
 a small saucepan over medium heat and
 stir until the butter melts and the mixture
 begins to boil, 2 to 3 minutes. Add the milk,
 stir, and let the mixture come back to a boil.

2. Remove the pan from the heat and whisk in
 3/4 cup of the confectioners' sugar and the
 salt. Whisk until smooth. The glaze should
 coat a spoon but still be pourable. If it's too
 thin, whisk in a little more confectioners'
 sugar. Pour over the top of a cake and let it
 sit for 15 minutes to set.

Old-Fashioned Caramel Icing

This is the real-deal icing for caramel cake. You need two pans and some patience.

Makes 4 cups, enough to frost a three-layer cake Prep: 40 to 45 minutes

3 cups (600 grams) granulated
 sugar, divided
1 cup canned evaporated milk
1/4 teaspoon salt
8 tablespoons (1 stick/114 grams)
 cold unsalted butter
1 teaspoon vanilla extract

1. Place 2 1/2 cups of the sugar, the evaporated milk, and the salt in a large heavy saucepan over medium heat. Stir constantly until the mixture boils and the sugar has dissolved. Continue stirring and let the mixture boil for 3 minutes. Remove the pan from the heat.

2. Place the remaining 1/2 cup sugar in an 8- to 10-inch cast-iron skillet over medium heat. Let the sugar caramelize—turn from granulated into a deep golden brown—without stirring, 4 to 5 minutes. When the mixture is just deep golden, but not dark brown, remove it from the heat. The heat in the skillet continues to cook the sugar, so if you let it get dark, it will burn. (If this happens, remove the skillet from the heat, let it cool completely, and clean the skillet. Repeat the process with a clean skillet and 1/2 cup granulated sugar.)

3. Stir about 1/2 cup of the sugar–evaporated milk mixture into the hot caramelized sugar to bring the heat down. Then pour the contents of the skillet back into the saucepan with the remaining sugar–evaporated milk mixture. Stir until incorporated. Add the butter and vanilla and stir until the butter melts and the mixture is smooth.

4. Place the saucepan in a large bowl filled with 2 inches of ice water. Stir the icing with a wooden spoon until it is cool and thick, 4 to 5 minutes. You don't want the icing to thicken too much or it will be difficult to spread. When it is of a spreadable consistency, remove the pan from the ice water bath. Frost quickly; the icing will harden as it cools.

Chocolate Fudge Icing

When I was a child, my mother made chocolate icing the old-fashioned way, by standing over the stove and stirring until it reached just the right temperature, which she tested by dropping a teaspoon into a glass of cold water to see if it had formed a "soft ball." This recipe is much, much simpler. My family puts it over everything.

Makes 3 cups, enough for a two-layer cake, a 13-by-9-inch cake, or 20 cupcakes

Prep: 10 to 15 minutes

8 tablespoons (1 stick/114 grams) unsalted butter

1/4 cup (25 grams) unsweetened cocoa powder

Pinch of kosher or sea salt

1/3 cup whole milk, half-and-half, or coconut milk, or more as needed

2 to 3 cups (216 to 324 grams) confectioners' sugar, sifted

1. Melt the butter in a medium saucepan over low heat, 2 to 3 minutes. Stir in the cocoa, salt, and milk, half-and-half, or coconut milk. Cook, stirring, until the mixture thickens and just begins to come to a boil, 1 minute longer. Remove the pan from the heat. Stir in 2 cups of the confectioners' sugar, a bit at a time, adding up to 1 cup more sugar or more milk (or half-and-half or coconut milk) if needed, until the frosting is smooth and just begins to thicken. It will set once it gets on a cake.

2. Pour the frosting over the tops of cooled cake layers, then spread the sides of the cake with more frosting, smoothing it out with a long metal spatula as you go. For 9-by-13-inch cakes, pour the frosting onto the cake in the pan. Let it set for 20 minutes before slicing. For cupcakes, spoon the frosting on top while it is warm or dunk the tops of cupcakes into the pan of frosting.

Three-Minute Chocolate Icing

For when you don't have confectioners' sugar or a lot of time.

Frosts 12 to 18 cupcakes or glazes a Bundt cake Prep: 10 minutes

1 cup (200 grams) granulated sugar

1/4 cup (25 grams) unsweetened cocoa powder

4 tablespoons (1/2 stick/57 grams) unsalted butter

1/4 teaspoon salt

1/4 cup whole milk

1. Place the sugar, cocoa, butter, salt, and milk in a small saucepan over medium heat. Bring to a boil, stirring, and once the mixture comes to a boil, let it boil for 3 minutes, stirring in the center of the pan, trying not to scrape the sides of the pan.

2. Remove the pan from the heat and place it in a medium stainless-steel bowl half-filled with ice water. Stir the icing until thick enough to spread, 1 to 2 minutes.

Cream Cheese Frosting

It's the frosting we spread on our favorite cakes—red velvet, carrot cake, and hummingbird cake. Make sure your cream cheese and butter are at room temperature before beginning. If necessary, place them in a glass bowl in the microwave on high power for 20 seconds to soften. If you make the frosting ahead, let it come to room temperature before icing the cake. Adding the little bit of milk is our family trick to make the frosting lighter and more spreadable so it won't tear the cake.

Prep time: 10 to 15 minutes

FOR A THREE-LAYER CAKE WITH PLENTY OF FROSTING:

12 ounces cream cheese, at room temperature

8 tablespoons (1 stick/114 grams) unsalted butter, at room temperature

Pinch of salt

5 cups (540 grams) confectioners' sugar, sifted, divided

1 1/2 teaspoons vanilla extract

2 tablespoons whole milk, or as needed to make the frosting more spreadable

FOR A TWO-LAYER CAKE OR A THREE-LAYER CAKE WITH A MODERATE AMOUNT OF FROSTING:

8 ounces cream cheese, at room temperature

8 tablespoons (1 stick/114 grams) unsalted butter, at room temperature

Pinch of salt

3 1/2 cups (378 grams) confectioners' sugar, sifted, divided

1 teaspoon vanilla extract

1 tablespoon whole milk, or as needed to make the frosting more spreadable

1. Place the cream cheese and butter in a large bowl and beat with an electric mixer on low speed until combined, 30 seconds. Add the salt and half of the confectioners' sugar. Beat until smooth.

2. Add the vanilla and the remaining half of the confectioners' sugar and beat until smooth. Add the milk, increase the mixer speed to medium, and beat the frosting until fluffy and spreadable, about 1 minute more.

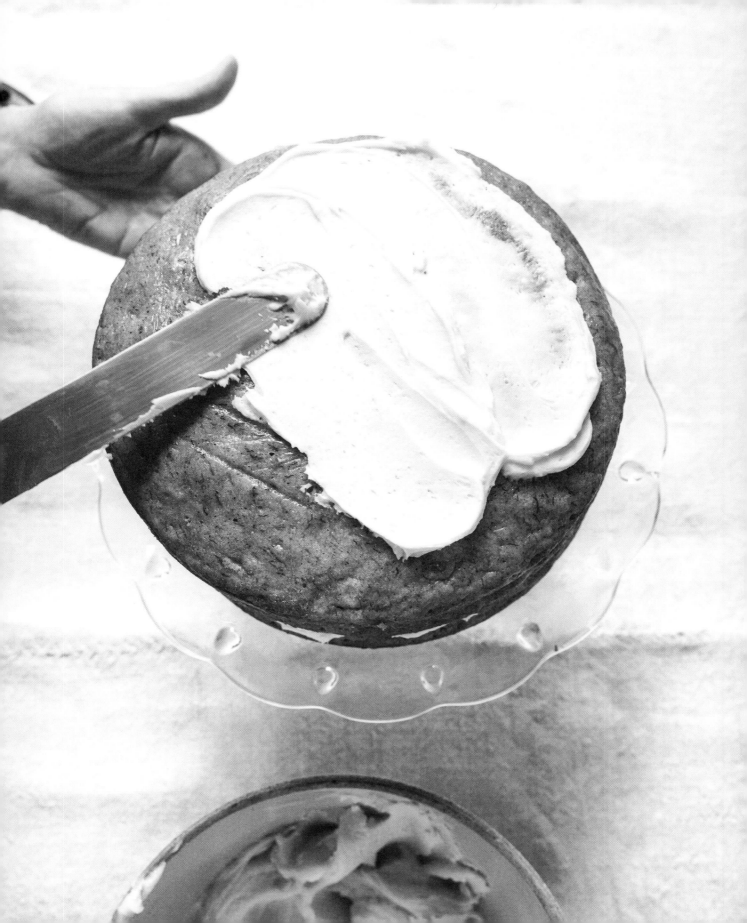

Vanilla Buttercream Frosting

The trick for great buttercream frosting is to add only as much sugar as needed to pull the frosting together and make it spreadable. If you use unsalted butter, add a big pinch of salt to balance the sugar, and if you use salted butter, omit the salt. Sift the powdered sugar before adding it, because a lumpy frosting is not a good frosting!

Makes 3 1/2 cups, enough to frost a two- or three-layer cake or 20 cupcakes

Prep: 15 minutes

8 tablespoons (1 stick/114 grams) unsalted butter, at room temperature

3 1/2 cups (378 grams) confectioners' sugar, sifted

3 tablespoons whole milk, or more as needed

1 to 2 teaspoons vanilla extract

Pinch of salt

1. Place the butter in a medium bowl and beat with an electric mixer on low speed until smooth, 30 seconds. Add 3 cups of the confectioners' sugar, 2 tablespoons of the milk, the vanilla, and the salt and beat on low speed until the sugar is incorporated. Add the remaining 1/2 cup sugar and the remaining tablespoon milk and beat until smooth.

2. Increase the mixer speed to medium and beat until the frosting is light and fluffy, 1 minute more. If the frosting is too thick to spread, beat in a little more milk.

FOR CRUSHED PEPPERMINT BUTTERCREAM FROSTING: Fold in 1/4 cup finely crushed peppermint candy and 1/2 teaspoon peppermint extract.

FOR CHOCOLATE BUTTERCREAM FROSTING: Add 2/3 cup unsweetened cocoa powder to the butter and reduce the confectioners' sugar to 2 1/2 cups. You may need 1 to 2 tablespoons more milk to make it spreadable.

Peanut Butter Frosting

The easiest and most delicious frosting for chocolate cake and cupcakes.

Makes 3 cups, enough to frost a two-layer cake or 24 cupcakes Prep: 10 minutes

1 cup creamy peanut butter

8 tablespoons (1 stick/114 grams) unsalted butter, at room temperature

2 to 2 1/2 cups (216 to 270 grams) confectioners' sugar, sifted

2 to 3 tablespoons whole milk

2 teaspoons vanilla extract

1/2 teaspoon kosher salt

1. Place the peanut butter and butter in a medium bowl and beat with an electric mixer on low speed until fluffy, 30 seconds. Add the 2 cups confectioners' sugar and 2 tablespoons milk, a little at a time. Add the vanilla and salt. Beat on low, 1 minute.

2. Increase the mixer speed to medium and beat until fluffy, 1 minute, adding up to 1/2 cup more confectioners' sugar if the frosting is too thin or up to 1 tablespoon more milk if it is too stiff.

Ermine Frosting

Use for Mother Farr's Red Devil's Food Cake (pages 356–357) or when you have no confectioners' sugar.

Enough to frost a two-layer cake Prep: 20 to 25 minutes Chill: 1 hour

5 tablespoons all-purpose flour

1 cup cold whole milk

1 teaspoon vanilla extract

Pinch of salt

16 tablespoons (2 sticks/227 grams) unsalted butter, at room temperature

1 cup (200 grams) granulated sugar

1. Whisk together the flour and milk in a small saucepan and cook over medium heat until thick and pudding-like, 4 to 5 minutes. Remove the pan from the heat and whisk in the vanilla and salt. Pour the mixture into a small heatproof bowl. Cover the surface with plastic wrap and chill for 1 hour.

2. Place the butter and sugar in a large bowl and beat with an electric mixer on medium speed until light and fluffy, 4 minutes. Remove the milk and flour mixture from the refrigerator and slowly add it to the butter and sugar while beating on medium. Continue to beat until the mixture is light and fluffy and resembles whipped cream, about 2 minutes.

Barely Sweet Whipped Cream

It takes minutes to whip a bowlful of cream to stiff peaks, and it takes far longer than that to thaw a container of frozen whipped topping. So just from a time perspective, it pays to whip real cream. Plus, the flavor is so good. Customize the sweetness based on what cake it goes with and your own taste. I like barely sweet whipped cream—it tastes real to me.

Makes 2 cups, enough to lightly frost a two-layer cake Prep: 5 minutes

1 cup heavy whipping cream

2 tablespoons confectioners'
 sugar, or to taste

1/2 teaspoon vanilla extract

1. Chill a large mixing bowl and electric mixer beaters in the freezer for a few minutes or in the refrigerator for 15 minutes while you measure the ingredients.

2. Pour the cream into the chilled bowl and beat with an electric mixer on high speed until it thickens, 1 1/2 minutes. Stop the machine and add the confectioners' sugar and vanilla. Beat on high speed until stiff peaks form, 1 to 2 minutes more.

FOR A HALF RECIPE: Use 1/2 cup heavy whipping cream, 1 tablespoon confectioners' sugar, and a dash of vanilla extract.

FOR A DOUBLE RECIPE TO FROST A THREE-LAYER CAKE: Use 2 cups cream, 1/4 cup confectioners' sugar, and 1 teaspoon vanilla extract.

FOR UNSWEETENED WHIPPED CREAM: Omit the sugar and vanilla and just whip the cream.

45

The Lee Brothers' Buttermilk Ice Cream

Born in Manhattan but raised in Charleston, South Carolina, brothers Matt and Ted Lee grew accustomed to buttermilk in cornbread, but not ice cream. Yet writers influence each other, and Mississippi author and caterer Kathy Starr wrote of pouring buttermilk over crumbled cornbread with sugar, and that got the brothers thinking they could turn buttermilk into ice cream. Now they have influenced me, and this has become my basic ice cream formula, made with whole buttermilk or whole milk, and it is out of this world with pureed sweetened peaches added. It's true what the Lee Brothers say in their 2006 *The Lee Bros. Southern Cookbook*, that this ice cream "goes with just about any cake or pie you can imagine."

Serves 6 to 8, about 1 quart	Prep: 15 to 20 minutes	Chill: At least 4 hours, or overnight	Churn: About 1 hour, depending on your ice cream freezer	Freeze: 2 hours

4 large egg yolks

1/2 cup (100 grams) granulated sugar

2 cups heavy cream

1 1/2 cups whole buttermilk, divided

1 tablespoon vanilla extract or 1 teaspoon grated lemon zest

1 bag (5 to 7 pounds) ice

1/2 cup (100 grams) rock salt

FOR PEACH ICE CREAM

Turn 2 cups sliced peaches in saucepan with 1 cup plus 2 tablespoons sugar. Cook until soft, 15 minutes. Puree and cool. Omit sugar in the recipe. Use just 1 cup buttermilk. Add the peach puree when you add the vanilla.

1. Place the egg yolks in a large mixing bowl or the large bowl of a stand mixer. Whisk or beat on high for 30 seconds, then gradually add the sugar, beating until the mixture is thickened and is lemon yellow in color, about 2 minutes. Set aside.

2. Pour the cream and 1 cup of the buttermilk into a medium saucepan over medium heat. When steam rises and bubbles begin to form around the pan edges, when it's about 160°F but the milk does not boil, gradually pour the hot mixture into the egg mixture and whisk or beat until blended. Whisk in the vanilla or lemon zest. Pour into a glass jar or bowl and chill at least 4 hours or preferably overnight.

3. When you're ready to make ice cream, remove the container from the refrigerator. Stir in the remaining 1/2 cup buttermilk. Pour the mixture into an ice cream maker and churn according to the manufacturer's instructions. If using an old-fashioned ice cream maker, you will need 1 bag of ice layered with the rock salt.

4. When the machine stops, about 1 hour for old-fashioned ice cream makers, transfer to a container with a tight-fitting lid. Freeze for at least 2 hours, so the ice cream hardens. Scoop into bowls and serve.

ACKNOWLEDGMENTS

*B*aking is a vital part of Southern culture, and you don't have to sit long at Sunday dinner or curled up in a chair with a copy of *Southern Sideboards* or any other spiral-bound community cookbook to find recipes that stir memories and curiosity. That's how I felt going into this book, and to better understand the recipes, ingredients, methods, people, locations, and history, I searched cookbooks, library private collections, old diaries, newspapers, and historical journals and spoke to many people in and outside the South.

The following were most helpful with my research:

Constance Carter of the Library of Congress

Archivist James Thweatt and curator Christopher Ryland with the Elizabeth Neige Todhunter
 Papers in Vanderbilt University's History of Medicine Collections

Michael Pearce and Jessica Kincaid at the David Walker Lupton Cookbook Collection in the W. S.
 Hoole Special Collections Library at the University of Alabama–Tuscaloosa

Chloe Raub, Head of Archives and Special Collections with the Newcomb Institute of Tulane
 University

Serena McCracken of the Kenan Research Center at the Atlanta History Center

Liz Williams, author and founder of the New Orleans Food & Beverage Museum

Leni Sorensen, a Mary Randolph scholar in Virginia

Marcie Cohen Ferris, North Carolina author and Jewish foodways scholar

Jessica B. Harris, culinary historian and author

John Martin Taylor, Lowcountry historian

David Shields, Carolina Distinguished Professor at the University of South Carolina

Glenn Roberts, founder of Anson Mills, Columbia, South Carolina

Linda Carman, of Cullman, Alabama, retired home economist for Martha White Foods

Alice Randall, Nashville author and professor at Vanderbilt University

Nellah McGough and editor-in-chief Sid Evans at *Southern Living*

Erin Napier at Laurel Mercantile Co., Laurel, Mississippi

Tennessee historian Carole Bucy

Daniel Ackermann, curator of Old Salem (North Carolina) Museums and Gardens

Kate Rauhauser-Smith, director of Mount Airy Museum of Regional History, Mount Airy, North Carolina

Shelby Jones, Billy Rankin, and Amanda Beverly at Shaker Village, Kentucky

Ann Campbell of the Cathedral Church of the Advent, Birmingham, Alabama, for assistance with the Ewing Steele research

Bill Short of the Rhodes College library, Memphis, Tennessee

Lynette Calhoun Wagster, Weakley County (Tennessee) Press

Feeding America: The Historic American Cookbook Project, Michigan State University digital archives

Project Gutenberg digital cookbooks

The Margaret Cook Cookbook Collection, Texas Woman's University

Newspapers.com

The University of Florida's Digital Collections, George A. Smathers Libraries.

I am grateful to these producers, makers, and chefs:

Greg Bailey, Tampa, Florida

Sharon and Allan Benton, Madisonville, Tennessee

Scott Elder, Sevierville, Tennessee

Laurie Faulkner, Jimmy Proffitt, and the team at The Old Mill, Pigeon Forge, Tennessee

Kevin Gillespie, Atlanta, Georgia

Tom Gray, Jacksonville, Florida

Jennifer Lapidus, Hendersonville, North Carolina

Ouita Michel, Midway, Kentucky

Dolester Miles, Birmingham, Alabama

Brian Noyes, Warrenton, Virginia

Anthony Petrochko, Columbia, Tennessee

Chrysta Poulos, Atlanta, Georgia

Gloria Smiley, Atlanta, Georgia

Bill Smith, Chapel Hill, North Carolina

Frank Stitt, Birmingham, Alabama

Allison Vaughan, Jacksonville, Florida

Lisa Marie White, Nashville, Tennessee

Bob Woods, Murfreesboro, Tennessee

Many thanks to these writers and authors:

Hugh Acheson
Jim Auchmutey
Connie Bailey-Kitts
Rachel Barnett
Vishwesh Bhatt
Jennifer Biggs
Kelly Brant
Sheri Castle
Regina Charboneau
Shirley Corriher
Crescent Dragonwagon
Fred DuBose
Nathalie Dupree

John T. Edge
Tenney Flynn
Damon Lee Fowler
Christine Gardner
Jane Garvey
Kay Goldstein
Lyssa Harvey
Eddie Hernandez
Emily Hilliard
Sonya Jones
Kate McDermott
Nancie McDermott
Adrian Miller

Carrie Morey
Martha Nesbit
Stella Parks
Scott Peacock
Susan Puckett
Rona Roberts
Kat Robinson
Dori Sanders
Clara Silverstein
Lauren Titus
Poppy Tooker
Joyce White

A sincere thanks to the following people for sharing recipes, reflections, and even their oven:

Lucy Allen
Laurene Bach
The family of Lee
 Barnes
Ella Beesley
Helen Bird
Beth Carpenter
Jamie Dietrich
Jackie Drake and
 Beth Meador

Lisa Dunn
The family of
 Marion Flexner
Curtis Flowers
Patti and Jim Greek
Carolyn Guerry
Sarah Halcomb
The family of
 Duncan Hines
Dina Jennings

Kyle Tibbs Jones
Alfred Kennedy
Thornton Kennedy
Kathleen Livingston
Sarah Augusta
 Lodge
Debbie Lowenthal
Haile McCollum
Lucy Mercer
Lee Hedges Pierce

Lane Mathis Price
Katharine Shilcutt
LeAnne Smith
Marcia Thompson
Lee Threadgill and
 her family

And a special thanks to the people who made this book possible in so many ways:

My family, for understanding that once this book was done, I'd be home again: my husband, John, and my children, John, Litton, Kathleen and Hugh, and Gray. My sisters, Ginger and Susan, and her family, my in-laws, and my cousins. We do have a lot of cousins in and out of the South, and you know who you are!

Thanks to my friends, and many of you are already mentioned because you, too, dove into this project with me, and I so appreciate.

Thanks to the readers of my newsletter *Between the Layers* and everyone who bakes my recipes.

Books like this one aren't possible without a lot of other people helping out. I am grateful to my agent, David Black, and his team for leading me through this whale of a project. And my editor, Rux Martin, has been a miracle worker, guiding me, consoling, laughing, and bringing her lifetime of experience and perspective to Southern baking. Thank you, Rux! Also many thanks to Marilyn Jansen and Michael Aulisio at Harper Celebrate and their teams, including Kristen Parrish, Jen Showalter Greenwalt, Candace Floyd, and Emily Ghattas for producing this beautiful book. Thank you to my publicists, MacKenzie Collier and Carrie Bachman, for letting the world know about it. Thank you to Jeanine Strock for helping me locate historical photos and illustrations that added context to this book.

My photographer, Rinne Allen, deserves an award for patience as well as for her gifted eye. Rinne, I have loved working on this book with you. Also, I appreciate Tami Hardeman, food stylist, and her assistant, Angela Hinkel, for making sure our photos were gorgeous. Jo Nichol, thank you for helping us bake cookies for the shoot; Hugh Acheson and team, thank you for helping us find fresh figs in the middle of winter; and Laurene Bach, thank you for letting this perfect stranger bake a pound cake in your kitchen. A cover pound cake, no less! To Athens, Georgia, farmer Richard Hill, who gave us beautiful eggs; to the children of Arrow preschool, who came for tiny cinnamon rolls; to Heidi and Sam Stabler, for their hospitality; and to Allison and Aziz Coleman and their daughters, Mila and Cora, who beautifully decorated cupcakes, thank you for your enthusiasm as this book came to life in Rinne's studio. And long before that, thanks to Martha Bowden in Nashville for helping me test many of these recipes, as she has always done. I so appreciate!

Many hands do make light work, but nothing about this book has been light. For every single one of those hands, thank you. And for people I spoke with but never met, I hope to have that opportunity soon.

Lastly, I would like to acknowledge five authors who are no longer alive but whose works greatly influenced my book: Mildred Council, John Egerton, Edna Lewis, Bill Neal, and Beth Tartan. You informed and inspired me through your words, recipes, and documentation. Thank you.

And I'd like to thank my parents, who are no longer with us, for giving me a life in the South. It has been a wonderful life and a most curious one, and I wish they were here to read this book on how things have played out, and how my first futile attempts at baking when I was young grew into something larger than I ever knew possible.

With much appreciation to all,
Anne

BIBLIOGRAPHY

Anderson, Jean. *A Love Affair with Southern Cooking.* New York: William Morrow, 2007. Print.

Bhatt, Vishwesh. *I Am From Here.* New York: W. W. Norton, 2022. Print.

Bivins, S. Thomas. *The Southern Cookbook: A Manual of Cooking and List of Menus.* Hampton, Virginia: Press of the Hampton Institute, 1912. Digital.

Boyd, Valerie. *Wrapped in Rainbows: The Life of Zora Neale Hurston.* New York: Scribner, 2003. Print.

Bragg, Rick. *The Best Cook in the World: Tales from My Momma's Table.* New York: Knopf, 2019. Print.

Brown, Marion. *Marion Brown's Southern Cookbook.* Chapel Hill: University of North Carolina Press, 1968. Print.

Butler, Cleora. *Cleora's Kitchens: The Memoir of a Cook & Eight Decades of Great American Food.* San Francisco: Council Oak Books, 2003. Print.

Byrn, Anne. *American Cake.* New York: Rodale Books, 2016. Print.

———, *American Cookie.* New York: Rodale Books, 2018. Print.

———, *Cooking in the New South.* Atlanta: Peachtree Publishers, Ltd., 1994. Print.

———, *What Can I Bring? Cookbook.* New York: Workman, 2007. Print.

Castle, Sheri. *The Southern Living Community Cookbook: Celebrating Food & Fellowship in the American South.* Birmingham: Oxmoor House, 2014. Print.

Cheney, Winifred Green. *The Southern Hospitality Cookbook.* Birmingham: Oxmoor House, 1976. Print.

Claiborne, Craig. *Craig Claiborne's Southern Cooking.* New York: Times Books, 1987. Print.

A Collection of Recipes: Campbell Chapel A.M.E. Church. Denver. 1977. Print.

Confederate Receipt Book: A Compilation of Over One Hundred Receipts, Adapted to the Times. Athens: University of Georgia Press, 1960. Print.

Cook, Margaret. *American's Charitable Cooks: A Bibliography of Fund-Raising Cook Books Published in the United States (1861–1915).* Kent, Ohio. 1971. Print.

Cookies: Food Writers' Favorites. Edited by Barbara Gibbs Ostmann and Jane Baker. New York: Dial Publishing Company, 1991. Print.

Corriher, Shirley O. *BakeWise.* New York: Scribner, 2008. Print.

———, *CookWise.* New York: William Morrow, 1997. Print.

Dabney, Joseph E. *Smokehouse Ham, Spoon Bread, & Scuppernong Wine: The Folklore and Art of Southern Appalachian Cooking.* Nashville: Cumberland House, 1998. Print.

Darden, Norma Jean and Carole Darden. *Spoonbread and Strawberry Wine.* Garden City, NY: Doubleday, 1978. Print.

Davis, Jack E. *The Gulf: The Making of an American Sea.* New York: W. W. Norton, 2017. Print.

Day, Cheryl. *Cheryl Day's Treasury of Southern Baking.* New York: Artisan, 2021. Print.

Day, Cheryl and Griffith Day. *The Back in the Day Bakery Cookbook.* New York: Artisan, 2012. Print.

Denier, Joel. *The World on a Plate: A Tour through the History of America's Ethnic Cuisine.* Lincoln: University of Nebraska Press, 2007. Print.

Dull, Mrs. S. R. *Southern Cooking.* New York: Grosset & Dunlap, 1941. Print.

Dupree, Nathalie and Cynthia Graubart. *Mastering the Art of Southern Cooking.* Layton, Utah: Gibbs Smith, 2012. Print.

———. *Southern Biscuits.* Layton, Utah: Gibbs Smith, 2001. Print.

Edge, John T. *The Potlikker Papers: A Food History of the Modern South.* New York: Penguin Press, 2017. Print.

Egerton, John. *Side Orders: Small Helpings of Southern Cookery & Culture.* Atlanta: Peachtree Publishers, 1990. Print.

———. *Southern Food: At Home, on the Road, in History.* New York: Knopf, 1987. Print.

Estes, Rufus. *Good Things to Eat, as Suggested by Rufus.* Chicago. 1911. Digital.

Farr, Sidney Saylor. *More Than Moonshine.* Pittsburgh: University of Pittsburgh Press, 1983. Print.

Ferris, Marcie Cohen. *The Edible South: The Power of Food and the Making of an American Region.* Chapel Hill: University of North Carolina Press, 2014. Print.

———. *Matzoh Ball Gumbo: Culinary Tales of the Jewish South.* Chapel Hill: University of North Carolina Press, 2005. Print.

Fischer, David Hackett. *Albion's Seed: Four British Folkways in America.* New York: Oxford University Press, 1989. Print.

Fisher, Abby. *What Mrs. Fisher Knows About Old Southern Cooking, Soups, Pickles, Preserves, Etc.* San Francisco. 1881. Digital.

Four Great Southern Cooks. Atlanta: DuBose Publishing. 1980. Print.

Fowler, Damon Lee. *Classical Southern Cooking.* New York: Crown, 1995. Print.

A Foxfire Christmas. Edited by Eliot Wigginton and His Students. Chapel Hill: University of North Carolina Press, 1996. Print.

Frey, Valerie J. *Preserving Family Recipes.* Athens: University of Georgia Press, 2015. Print.

Fussell, Betty. *The Story of Corn.* Albuquerque: University of New Mexico Press, 1992. Print.

Gill, Tiffany M. *Beauty Shop Politics: African American Women's Activism in the Beauty Industry.* Champaign, Illinois: University of Illinois Press, 2010. Print.

Goldstein, Kay and Liza Nelson. *A Book of Feasts: Recipes and Stories from American Celebrations.* Atlanta: Longstreet Press, 1993. Print.

Gray, Lewis Cecil. *History of Agriculture in the Southern United States to 1860,* Volumes 1 and 2. Washington, DC: Carnegie Institution of Washington, 1933. Print.

The Happy Table of Eugene Walter. Edited by Donald Goodman and Thomas Head. Chapel Hill: University of North Carolina Press, 2011. Print.

Harris, Jessica B. *High on the Hog: A Culinary Journey from Africa to America.* New York: Bloomsbury, 2011. Print.

———. *Iron Pots and Wooden Spoons.* New York: Ballantine Books, 1991. Print.

Hernandez, Eddie and Susan Puckett. *Turnip Greens & Tortillas.* New York: Houghton Mifflin Harcourt, 2018. Print.

Hess, John and Karen Hess. *The Taste of America.* Urbana: University of Illinois Press, 2000. Print.

Hess, Karen, and Louisa Cheves Smythe Stoney. *The Carolina Rice Kitchen: The African Connection.* Columbia: University of South Carolina Press, 1992. Print.

Hilburn, Prudence. *A Treasury of Southern Baking*. New York: HarperCollins, 1993. Print.

The Historical Cookbook of the American Negro. National Council of Negro Women, Inc. Boston: Beacon Press, 2000. Print.

Jewish Roots in Southern Soil: A New History. Edited by Marcie Cohen Ferris and Mark I. Greenberg. Waltham, Massachusetts: Brandeis University Press, 2006. Print.

Kurlansky, Mark. *The Food of a Younger Land*. New York: Riverhead Books, 2009. Print.

Lee, Matt and Ted Lee. *The Lee Bros. Southern Cookbook*. New York: W. W. Norton, 2006. Print.

Lewis, Edna. *In Pursuit of Flavor*. New York: Knopf, 1988. Print.

———. *The Taste of Country Cooking*. New York: Knopf, 1976. Print.

Lewis, Edna, and Scott Peacock. *The Gift of Southern Cooking*. New York: Knopf, 2003. Print.

Lukas, Albert G. and Jessica B. Harris. *Sweet Home Cafe Cookbook: A Celebration of African American Cooking*. Washington, DC: Smithsonian Books, 2018. Print.

McDermott, Nancie. *Southern Pies: A Gracious Plenty of Pie Recipes, from Lemon Chess to Chocolate Pecan*. San Francisco: Chronicle Books, 2010. Print.

Miller, Adrian. *The President's Kitchen Cabinet: The Story of the African Americans Who Have Fed Our First Families, from the Washingtons to the Obamas*. Chapel Hill: University of North Carolina Press, 2017. Print.

———. *Soul Food: The Surprising Story of an American Cuisine, One Plate at a Time*. Chapel Hill: University of North Carolina Press, 2013. Print.

Mickler, Ernest Matthew. *White Trash Cooking*. Berkeley: Ten Speed Press, 1986. Print.

Montgomery, Miss Robbie with Ramin Ganeshram. *Sweetie Pie's Cookbook: Soulful Southern Recipes, From My Family to Yours*. New York: Amistad, 2015. Print.

Moritz, Mrs. C. F., and Miss Adele Kahn. *The Twentieth Century Cook Book*. New York: G. W. Dillingham Co., 1898. Digital.

Neal, Bill. *Bill Neal's Southern Cooking*. Chapel Hill: University of North Carolina Press, 1985. Print.

———. *Biscuits, Spoonbread & Sweet Potato Pie*. Chapel Hill: University of North Carolina Press, 1990. Print.

Opie, Frederick Douglass. *Hog and Hominy: Soul Food from Africa to America*. New York: Columbia University Press, 2008. Print.

Porter, Mrs. M. E. *Mrs. Porter's New Southern Cookery Book*. New York: Promontory Press, 1974. Print.

Porterfield, James D. *Dining by Rail*. New York: St. Martin's Press, 1993. Print.

Rawlings, Marjorie Kinnan. *Cross Creek Cookery*. New York: Simon & Schuster, 1942. Print.

Ray, Jeanne. *Eat Cake*. New York: Shaye Areheart Books, 2003. Print.

Reed, Julia. *Ham Biscuits, Hostess Gowns, and Other Southern Specialties*. New York: St. Martin's Press, 2008. Print.

Rombauer, Irma S. *The Joy of Cooking*. Philadelphia: Blakiston Company, 1943. Print.

Russell, Mrs. Malinda. *A Domestic Cook Book*. Paw Paw, Michigan: T. O. Ward, 1866. A facsimile printed by Inland Press, Detroit, 2007. Print.

Sauceman, Fred W. *The Place Setting*. Macon: Mercer University Press, 2006. Print.

Sax, Richard. *Classic Home Desserts*. Boston: Houghton Mifflin, 1994. Print.

Sharpless, Rebecca. *Cooking in Other Women's Kitchens: Domestic Workers in the South, 1865–1960*. Chapel Hill: University of North Carolina Press, 2010. Print.

———. *Fertile Ground, Narrow Choices*. Chapel Hill: University of North Carolina Press, 1999. Print.

Shields, David S. *Southern Provisions: The Creation & Revival of a Cuisine*. Chicago: University of Chicago Press, 2015. Print.

Smart-Grosvenor, Vertamae. *Vertamae Cooks in the Americas' Family Kitchen*. San Francisco: KQED Books, 1996. Print.

————. *Vibration Cooking, or The Travel Notes of a Geechie Girl.* Garden City, New York: Doubleday, 1970. Print.

Sohn, Mark F. *Mountain Country Cooking: A Gathering of the Best Recipes from the Smokies to the Blue Ridge.* New York: St. Martin's Press, 1996. Print.

The Southern Foodways Alliance Community Cookbook. Edited by Sara Roahen and John T. Edge. Athens: University of Georgia Press, 2010. Print.

Stallworth, Lyn and Rod Kennedy Jr. *The County Fair Cookbook.* New York: Hyperion, 1994. Print.

Stitt, Frank. *Frank Stitt's Southern Table.* New York: Artisan, 2005. Print.

Stockett, Kathryn. *The Help.* New York: Amy Einhorn Books, 2009. Print.

Strobel, Pamela. *Princess Pamela's Soul Food Cookbook.* New York: New American Library, 1969. Print.

Taylor, John Martin. *Charleston to Phnom Penh: A Cook's Journal.* Columbia: University of South Carolina Press, 2022. Print.

————. *The Fearless Frying Cookbook.* New York: Workman Publishing, 1997. Print.

————. *Hoppin' John's Lowcountry Cooking: Recipes and Ruminations from Charleston & the Carolina Coastal Plain.* Chapel Hill: University of North Carolina Press, 2000. Print.

————. *The New Southern Cook.* New York: Bantam Books, 1995. Print.

Tillery, Carolyn Quick. *The African American Heritage Cookbook.* New York: Kensington Publishing, 1996. Print.

Tipton-Martin, Toni. *The Jemima Code: Two Centuries of African American Cookbooks.* Austin: University of Texas Press, 2015. Print.

————. *Jubilee: Recipes from Two Centuries of African American Cooking.* New York: Clarkson Potter, 2019. Print.

Trager, James. *The Food Chronology.* New York: Henry Holt and Company, 1995. Print.

Twitty, Michael W. *The Cooking Gene: A Journey Through African American Culinary History in the Old South.* New York: Amistad/HarperCollins, 2017. Print.

Welty, Eudora. *Delta Wedding.* New York: Harcourt, Brace and Co., 1946. Print.

Wilkerson, Isabel. *The Warmth of Other Suns: The Epic Story of America's Great Migration.* New York: Vintage, 2010. Print.

Willard, Pat. *America Eats!* New York: Bloomsbury, 2008. Print.

Woods, Sylvia. *Sylvia's Family Soul Food Cookbook.* New York: Morrow, 1999. Print.

Zanger, Mark H. *The American History Cookbook.* Westport: Greenwood Press, 2003. Print.

ALABAMA

Blejwas, Emily. *The Story of Alabama in Fourteen Foods.* Tuscaloosa: University of Alabama Press, 2019. Print.

Duncan, Martie. *Alabama Cravings: The Most Requested Recipes from Alabama Restaurants Past & Present.* Birmingham: Advance Local, 2018. Print.

More Secrets of Cooking. Cathedral Church of the Advent Lenten Lunch Committee. Birmingham, 1990. Print.

Rudisill, Marie. *Fruitcake: Heirloom Recipes and Memories of Truman Capote and Cousin Sook.* Chapel Hill: University of North Carolina Press, 2010. Print.

Tapper, Monica. *A Culinary Tour Through Alabama History.* Charleston: The History Press, 2021. Print.

ARKANSAS

Ashley, Liza with Carolyn Huber. *Thirty Years at the Mansion: The Classic Cookbook Combining Recipes, Recollections and Photographs from the Arkansas Governor's Mansion.* Little Rock: August House, 1985. Print.

Dragonwagon, Crescent. *The Cornbread Gospels.* New York: Workman, 2015. Print.

Grisham, Cindy. *A Savory History of Arkansas Delta Food.* Charleston: The History Press, 2013. Print.

Our African American Heritage Cookbook: Old and New Recipes for Neighbors and Friends in Ft. Smith, Arkansas. African American Heritage Group, 1999. Print.

Robinson, Kat. *Another Slice of Arkansas Pie.* Little Rock: Tonti Press, 2018. Print.

FLORIDA

Florida Agriculturalist. 1878–1892. Digital.

Key West Cook Book. Woman's Club Key West, Florida, 1949. Print.

Opie, Fred. *Zora Neale Hurston on Florida Food: Recipes, Remedies & Simple Pleasures.* Charleston: The History Press, 2015. Print.

Shearer, Victoria. *The Florida Keys Cookbook.* Guilford, Connecticut: Globe Pequot, 2013. Print.

Spear, Jeffrey. *The First Coast Heritage Cookbook.* Jacksonville: In Good Taste Press, 2013. Print.

Voltz, Jeanne and Caroline Stuart. *The Florida Cookbook: From Gulf Coast Gumbo to Key Lime Pie.* New York: Knopf, 1996. Print.

Wickham, Joan Adams. *Food Favorites of St. Augustine.* St. Augustine: C. F. Hamblen, Inc. 1973. Print.

GEORGIA

Atlanta Cooknotes. The Junior League of Atlanta, Inc., 1982. Print.

The Atlanta Exposition Cookbook, compiled by Mrs. Henry Lumpkin Wilson. Athens: University of Georgia Press, 1984. Print.

Atlanta Natives' Favorite Recipes. Compiled by Frances Arrington Elyea. Atlanta: Superior Printing Company, 1975. Print.

Brown, Fred and Sherri M. L. Smith. *The Best of Georgia Farms Cookbook and Tour Book.* Atlanta: CI Publishing, 1998. Print.

Christ Church Frederica Cookbook. Episcopal Churchwomen of Christ Church, Frederica. St. Simons Island, 1992. Print.

Colquitt, Harriet Ross. *Savannah Cook Book.* New York: Farrah, 1933. Print.

DeBolt, Margaret Wayt with Emma Rylander Law and Carter Olive. *Georgia Sampler Cookbook.* Norfolk, Virginia: Donning Publishers, 1983. Print.

Food for My Household: Recipes by Members of Ebenezer Baptist Church. Edited by Mary Nell Hollis Glenn. Atlanta, 1986. Print.

Hartley, Grace. *Grace Hartley's Southern Cookbook.* Secaucus, New Jersey: Castle, 1976. Print.

Hill, Annabella P. *Mrs. Hill's Southern Practical Cookery and Receipt Book.* (Originally published in 1872.) Columbia: The University of South Carolina Press, 1995. Print.

Jackson, Ruth. *Ruth Jackson's Soulfood Cookbook.* Memphis: Wimmer Brothers, 1978. Print.

Jones, Sonya. *Sweet Auburn Desserts.* Gretna: Pelican Publishing Company, 2012. Print.

Lang, Rebecca. *Y'all Come Over.* New York: Rizzoli, 2021. Print.

Lupo, Margaret. *Southern Cooking from Mary Mac's Tea Room.* Atlanta, 1982. Print.

Mama Allie's Recipes. Compiled by Frances Irlbeck. Plains, Georgia, 2001. Print.

Nesbit, Martha Giddens. *Nibbles & Scribbles: Cooking and Writing in the Deep South.* Savannah, 2019. Print.

Otawka, Whitney. *The Saltwater Table: Recipes from the Coastal South.* New York: Abrams, 2019. Print.

Pines and Plantations. The Vashti Auxiliary. Thomasville, Georgia, 1976. Print.

Quatrano, Anne Stiles. *Summerland.* New York: Rizzoli, 2013. Print.

Terry, Elizabeth with Alexis Terry. *Savannah Seasons.* New York: Doubleday, 1996. Print.

Wilkes, Mrs. L. H. *Famous Recipes from Mrs. Wilkes' Boarding House in Historic Savannah.* Memphis: Wimmer Brothers, 1976. Print.

KENTUCKY

Baird, Sarah C. *Kentucky Sweets: Bourbon Balls, Spoonbread & Mile High Pie.* Charleston: The History Press, 2014. Print.

Brown, Fiona Young. *A Culinary History of Kentucky.* Charleston: The History Press, 2014. Print.

Bryan, Lettice. *The Kentucky Housewife.* 1839, reprinted by Applewood Books. Print.

Hatchett, Louis. *Duncan Hines: How a Traveling Salesman Became the Most Trusted Name in Food.* Lexington: University Press of Kentucky, 2014. Print.

Heritage Cookbook: A Collection of Recipes. Heritage Center Inc. of Simpson County. Franklin, Kentucky, 1998. Print.

Fox, Minnie C. *The Blue Grass Cook Book.* 1904, reprinted by Applewood Books. Print.

Flexner, Marion. *Out of Kentucky Kitchens.* New York: Franklin Watts, Inc., 1949. Print.

Michel, Ouita, Sara Gibbs, and Genie Graf. *Just a Few Miles South: Timeless Recipes from our Favorite Places.* Lexington: University Press of Kentucky, 2021. Print.

Skaggs, Deirdre A. and Andrew W. McGraw. *The Historic Kentucky Kitchen.* Lexington: University Press of Kentucky, 2013. Print.

Special Recipes of Hugh Emma Eird. Garrard County, Kentucky, 1998. Print.

Van Willigen, John. *Kentucky's Cookbook Heritage: Two Hundred Years of Southern Cuisine and Culture.* Lexington: University Press of Kentucky, 2014. Print.

LOUISIANA

Barnes, Lee. *Lee Barnes Cooking.* New Orleans, 1977. Print.

Chase, Leah. *The Dooky Chase Cookbook.* Gretna: Pelican Publishing Company, 1990. Print.

Clark, Emily. *Masterless Mistresses.* Chapel Hill: University of North Carolina Press, 2007. Print.

Collin, Rima and Richard Collin. *The New Orleans Cookbook.* New York: Knopf, 1977. Print.

Cooking from Across the Tracks. Black Heritage Festival of Louisiana, 1991. Print.

Cooking Up a Storm. Edited by Marcelle Bienvenu and Judy Walker. San Francisco: Chronicle Books, 2008. Print.

Covert, Mildred L. and Sylvia P. Gerson. *Kosher Creole Cookbook.* Gretna: Pelican Publishing Company, 1982. Print.

The Creole Cookery Book. Christian Woman's Exchange, 1937. Reprinted by Franklin Classics Trade Press, 2018. Print.

Eustis, Celestine. *Cooking in Old Creole Days.* New York: R. H. Russell, 1904. Print.

Flynn, Tenney. *The Deep End of Flavor.* Layton, Utah: Gibbs Smith, 2019. Print.

Lagasse, Emeril and Marcelle Bienvenu. *Louisiana Real & Rustic.* New York: William Morrow, 1996. Print.

Land, Mary. *Louisiana Cookery.* Jackson: University Press of Mississippi, 2005. Print.

The Picayune's Creole Cook Book. New Orleans: The Picayune, 1900. Print.

Recipes and Reminiscences of New Orleans. Parents Club of Ursuline Academy Inc., 1971. Print.

Richard, Lena. *Lena Richard's Cook Book.* New Orleans: Rogers Printing Co., 1939. Print.

River Road Recipes. The Junior League of Baton Rouge, Inc., 2012. Print.

Tooker, Poppy. *Drag Queen Brunch.* New Orleans: Rainbow Road Press, 2020. Print.

———. *Louisiana Eats! The People, the Food, and Their Stories.* Gretna: Pelican Publishing Company, 2013. Print.

Williams, Elizabeth M. *Nana's Creole Italian Table: Recipes and Stories from Sicilian New Orleans.* Baton Rouge: Louisiana State University Press, 2022. Print.

———. *New Orleans: A Food Biography.* Lanham, Maryland: AltaMira Press, 2013.

MARYLAND

Howard, Jane Gilmor (Mrs. B. C.). *Fifty Years in a Maryland Kitchen*. Philadelphia: J. B. Lippincott & Co., 1881. Digital.

Shields, John. *Chesapeake Bay Cooking with John Shields*. Baltimore: John Hopkins University Press, 2015. Print.

300 Years of Black Cooking in St. Mary's County, Maryland. St. Mary's County Community Affairs Committee, 1983. Print.

Weaver, William Woys. *A Quaker Woman's Cookbook: The Domestic Cookery of Elizabeth Ellicott Lea*. Mechanicsburg, Pennsylvania: Stackpole Books, 2004. Print.

MISSISSIPPI

Bayou Cuisine: Its Tradition and Transition. St. Stephen's Episcopal Church, Indianola, Mississippi, 1970. Print.

Foose, Martha. *Screen Doors and Sweet Tea: Recipes and Tales from a Southern Cook*. New York: Clarkson Potter, 2008. Print.

The Jackson Cookbook. Compiled by the Symphony League of Jackson, Mississippi, 1971. Print.

Laurel Mercantile Family Recipes & Stories, Volume 1. Laurel, Mississippi, 2016. Print.

Metcalfe, Gayden and Charlotte Hays. *Being Dead Is No Excuse*. New York: Hachette, 2015. Print.

Puckett, Susan. *A Cook's Tour of Mississippi*. Jackson: Clarion-Ledger, 1980. Print.

———. *Eat Drink Delta: A Hungry Traveler's Journey Through the Soul of the South*. Athens: University of Georgia Press, 2013. Print.

Southern Sideboards. Junior League of Jackson, Mississippi, 1978. Print.

Starr, Kathy. *The Soul of Southern Cooking*. Jackson: University Press of Mississippi, 1989. Print.

A Taste in Time. Marshall County Historical Society, Holly Springs, Mississippi, 1975. Print.

NORTH CAROLINA

Council, Mildred. *Mama Dip's Kitchen*. Chapel Hill: University of North Carolina Press, 1999. Print.

Fitch, Jenny. *The Fearrington House Cookbook*. 1987. Print.

McKee, Lily Byrd. *High Hampton Hospitality*. Chapel Hill, 1970. Print.

Lapidus, Jennifer. *Southern Ground*. Berkeley: Ten Speed Press, 2021. Print.

The Old Salem Museums & Gardens Cookbook. Old Salem, Inc., Winston-Salem, North Carolina, 2008. Print.

Smith, Bill. *Seasoned in the South*. Chapel Hill: Algonquin Books, 2006. Print.

St. Joseph's A.M.E. Church Favorite Recipes and Household Hints. Durham, North Carolina, 1982. Print.

Tartan, Beth. *North Carolina & Old Salem Cookery*. Chapel Hill: University of North Carolina Press, 1992. Print.

Villas, James with Martha Pearl Villas. *My Mother's Southern Desserts*. New York: William Morrow, 1998. Print.

SOUTH CAROLINA

Burn, Billie. *Stirrin' the Pots on Daufuskie*. Daufuskie Island, South Carolina, 1985. Print.

Charleston Receipts. The Junior League of Charleston, 1950. Print.

A Colonial Plantation Cookbook: The Receipt Book of Harriet Pinckney Horry, 1770. Edited by Richard J. Hooker. Columbia: University of South Carolina Press, 1984. Print.

Hess, Karen. *The Carolina Rice Kitchen: The African Connection*. Columbia: University of South Carolina Press, 1992. Print.

LeClercq, Anne Sinkler Whaley. *An Antebellum Plantation Household*. Columbia: University of South Carolina Press, 2006. Print.

Mercer, Johnny with Harris Lewis and Al Nichols. *The Geechee Cook Book.* Savannah, 1956. Print.

Meggett, Emily. *Gullah Geechee Home Cooking.* New York: Abrams, 2022. Print.

Pregnall, Teresa. *Treasured Recipes from the Charleston Cake Lady.* New York: Hearst Books, 1996. Print.

Rhett, Blanche S. *Two Hundred Years of Charleston Cooking.* New York: Random House, 1934. Print.

Robinson, Sallie Ann. *Gullah Home Cooking the Daufuskie Way.* Chapel Hill: University of North Carolina Press, 2003. Print.

Rutledge, Sarah. *The Carolina Housewife.* (Originally published in 1847.) Columbia: University of South Carolina Press, 1979. Print.

Sanders, Dori. *Dori Sanders' Country Cooking: Recipes and Stories from the Family Farm Stand.* Chapel Hill: Algonquin Books, 1995. Print.

Schulze, Richard. *Carolina Gold Rice.* Charleston: The History Press, 2005. Print.

The Way It Was in Charleston. Edited by Thomas R. Waring Jr. Old Greenwich, Connecticut: Devin-Adair Company, 1980. Print.

TENNESSEE

Brown, Katherine Panky. *Panky's Pantry Secrets: 100 Years of Cherished Family Recipes.* Lookout Mountain, Tennessee, 1976. Print.

Clardy-White, Clarice. *Pound Cakes & More.* Woodlawn, Tennessee, 1997. Print.

Dalsass, Diana. *Miss Mary's Down-Home Cooking: Traditional Recipes from Lynchburg, Tennessee.* New York: New American Library, 1984. Print.

Dinner on the Diner. Junior League of Chattanooga, 1983. Print.

Favorite Recipes Collected by United Methodist Women Pleasant View, Tennessee. Kansas City, Kansas: Bev-Ron Publishing, 1975. Print.

Fisk Club Cookbook. Nashville: Publishing House M.E. Church, South, 1912. Print.

Hach, Carter. *The Hachland Hill Cookbook.* Nashville: Blue Hills Press, 2022. Print.

Hach, Phila. *Global Feasting Tennessee Style.* Clarksville, Tennessee, 1996. Print.

The Housekeeper's Manual: A Collection of Valuable Receipts, Carefully Selected and Arranged. Moore Memorial Presbyterian Church. Nashville: Publishing House of the Methodist Episcopal Church South, 1875. Print.

LeSueur, Sadie. *Recipes and Party Plans.* Nashville: Parthenon Press, 1958. Print.

The Memphis Cook Book. The Junior League of Memphis, Inc., 1952. Print.

The Nashville Cookbook. Nashville Area Home Economics Association, 1977. Print.

Nashville Seasons. The Junior League of Nashville, Inc., 1964. Print.

Naturally Good! Stone Ground—Whole Grain Recipes from The Old Mill. Compiled by Gene Aiken. Gatlinburg, Tennessee: Buckhorn Press, 1980. Print.

A Skillet Full of Traditional Southern Memories & Recipes. South Pittsburg Historic Preservation Society, Inc., South Pittsburg, Tennessee, 2003. Print.

Tennessee Tables. The Junior League of Knoxville, Inc., 1982. Print.

20th Anniversary National Corn Bread Festival Winning Recipes 1997–2016. Lodge Manufacturing Company, South Pittsburg, Tennessee, 2016. Print.

Woman's Exchange Cook Book Volume 1. The Woman's Exchange of Memphis, Inc., 1964. Print.

Ziegler, Arlene. *Satsuma: Fun for the Cook.* Nashville, 1963. Print.

———. *Satsuma: More Fun for the Cook.* Nashville, 1965. Print.

TEXAS

Black Dallas Remembered: Family Heritage Cookbook. Dallas, 1998. Print.

Corbitt, Helen. *Helen Corbitt's Cookbook.* Boston: Houghton Mifflin, 1957. Print.

———. *Helen Corbitt Cooks for Company.* Boston: Houghton Mifflin, 1974. Print.

The Dallas Junior League Cookbook. The Junior League of Dallas, 1976. Print.

Gee, Denise. *Sweet on Texas: Lovable Confections From the Lone Star State.* San Francisco: Chronicle Books, 2012. Print.

Koock, Mary Faulk. *The Texas Cookbook.* Denton: University of North Texas Press, 1965. Print.

Lagniappe. The Junior League of Beaumont, Texas, Inc., 1982. Print.

Linck, Ernestine Sewell and Joyce Gibson Roach. *Eats: A Folk History of Texas Foods.* Fort Worth: Texas Christian University Press, 1989. Print.

McDuff, Marihelen. *A Taste of Texas.* New York: Random House, 1949. Print.

Shepherd, Chris and Kaitlyn Goalen. *Cook Like a Local.* New York: Clarkson Potter, 2019. Print.

VIRGINIA

Cooking with Tidewater's Own: From the pages of The Journal and Guide. Norfolk, 1987. Print.

Dining at Monticello. Edited by Damon Lee Fowler. Thomas Jefferson Foundation, Inc., 2005. Print.

Food to Die For: A Book of Funeral Food, Tips and Tales. Compiled by Jessica Bemis Ward. Southern Memorial Association, Lynchburg, Virginia, 2004. Print.

Harbury, Katharine E. *Colonial Virginia's Cooking Dynasty.* Columbia: University of South Carolina Press, 2004. Print.

Montpelier Hospitality: History, Traditions and Recipes. Montpelier Foundation, Montpelier Station, Virginia, 2002. Print.

Noyes, Brian. *The Red Truck Bakery Farmhouse Cookbook.* New York: Clarkson Potter, 2022. Print.

Randolph, Mary. *The Virginia Housewife Or, Methodical Cook: A Facsimile of an Authentic Early American Cookbook.* New York: Dover Publications, Inc., 1993. Print.

Recipes from Old Virginia. Compiled by Virginia Association for Family & Community Education, Inc. Richmond: The Dietz Press, 2014. Print.

Tyree, Marion Cabell. *Housekeeping in Old Virginia.* New York: G. W. Carleton & Co, 1877. Print.

The Williamsburg Cookbook. The Colonial Williamsburg Foundation, Williamsburg, Virginia, 1971. Print.

WEST VIRGINIA

Hilliard, Emily. *Making Our Future.* Chapel Hill: University of North Carolina Press, 2022. Print.

Tinnell, Shannon Colaianni. *A Culinary History of West Virginia.* Charleston: The History Press, 2020. Print.

INDEX

C

Q

R

CREDITS

INTRODUCTION

Peach shed: From the Federal Writer's Project, WPA, 1936–1940, the South Caroliniana Library, University of South Carolina, Columbia, South Carolina.

Zephyr Wright: Courtesy of the LBJ Presidential Library. National Archives and Records Administration.

Map of the South illustration: Mat Edwards.

SIZZLING CORNBREAD

Church in cornfield: From the Federal Writer's Project, WPA, 1939, the South Caroliniana Library, University of South Carolina, Columbia, South Carolina.

Hatch Show Print of Lester Flatt and Earl Scruggs: Reproduction courtesy of the Country Music Hall of Fame® and Museum/Hatch Show Print.

Zora Neale Hurston: Publicity photo for *Seraph on the Suwannee* (contemporary print and later enlargement). Wearing dark dress with white accents, white leaf earrings. Zora Neale Hurston Papers, Special and Area Studies Collections, University of Florida.

Heirloom corn courtesy of Anson Mills.

Jimmy Carter: Courtesy of the Jimmy Carter Presidential Library and Museum.

Minnie Pearl (Sarah Cannon): Courtesy of the Country Music Hall of Fame® and Museum.

Virginia Robinson Byrn and William Allen Byrn, Jr: Courtesy of the family.

HOT BISCUITS

Virginia Housewife Cookbook: 1836 edition. Public domain.

Mrs. Wilkes Boarding House: Photographer Rinne Allen.

Nathalie Dupree: From the Nathalie Dupree archive, Irvin Department of Rare Books and Special Collections, University of South Carolina Libraries, Columbia, South Carolina.

John Egerton: From Special Collections, Nashville Public Library.

Scott Peacock: Photographer Rinne Allen.

Old White Lily sign in Knoxville, Tennessee: Courtesy of Hometown Food Company.

Dori Sanders: Photographer Peter Taylor.

Arrowroot drawing: From the State Archives of Florida.

QUICK LOAVES, GRIDDLE CAKES, WAFFLES, AND FRITTERS

Royal Baking Powder Cookbook: Back cover of the 1922 *Royal Baking Powder Cookbook*. Courtesy of the
 History of Medicine Collections, Vanderbilt University.

Helen Corbitt: Courtesy of The University of Dallas.

Woman with rice basket: Courtesy of Georgetown County Library.

Edna Lewis: Photographer John T. Hill.

Rosa Parks: Washington, DC, 1968. From the Prints and Photographs Division, Library of Congress.

Café du Monde: Photographer Rinne Allen.

ROLLS, BREADS, AND YEAST-RAISED CAKES

Sarah ("Pat") Kirkwood Lodge: Courtesy of her family.

Charlie Moore: From the 1973 Martin Elementary School Annual, courtesy of the Laura and David Spencer family.

Duncan Hines: From the Special Collections Library, Western Kentucky University.

Old Charleston, South Carolina, bakery photo: Courtesy of the Collis Family Papers, Special Collections,
 College of Charleston Libraries.

Moravian woman in costume: Courtesy of Sister Deborah, used by permission.

COMFORTING PUDDINGS

Eddie Hernandez: Photographer Angie Mosier.

Persimmon: Diospyros virginiana (Persimmon). Tessie K. Frank watercolors, circa 1895–1935. gra00006.
 Archives of the Gray Herbarium, Harvard University.

Bill Neal: Photo courtesy of his family.

Lena Richard: Lena Richard, left, with her daughter, Paula Rhodes. From the Lena Richard papers (NA-071).
 Newcomb Archives and Nadine Robbert Vorhoff Collection, Newcomb Institute, Tulane University.

Jane Grant Gilmor Howard: Circa 1820 portrait by Thomas Sully. Bequest of Benjamin Chew Howard.
 Courtesy of the Maryland Center for History and Culture, Museum Collection.

"His Daughter," a cartoon by W. E. Hill, appearing in the Nashville *Tennessean*, January 11, 1948. Courtesy of
 the Tennessee State Library & Archives.

PIES PLAIN AND FANCY

Maggie Cox: Courtesy of Lee Buford Threadgill.

1940s Key West postcard: From the State Archives of Florida.

Johnetta Miller: Courtesy of her family.

Shaker Village at Pleasant Hill: Photographer Rinne Allen.

Ma Hoyle (Beulah Hinton Hoyle): Courtesy of her family.

Frank Stitt: Photographed by Caleb Chancey at Chez Fonfon, one of his Birmingham restaurants. Courtesy of the Stitt Restaurant Group.

Marion Flexner: From the Flexner Family Collection. History of Medicine Collections, Vanderbilt University.

Dr. George Washington Carver: From the Frances Benjamin Johnston Collection, Prints & Photographs Division, Library of Congress, LC-J601–302.

BAKE ME A CAKE

Henrietta Dull: Courtesy of her family.

Alice Shutt Bailey: Circa 1940s, Rock, West Virginia. Courtesy of Connie Bailey Kitts.

Eliza Jane Ashley: From the Eliza Jane Ashley Papers. Butler Center for Arkansas Studies, Central Arkansas Library System.

Elizabeth Cate Collins: Courtesy of her family.

Eudora Welty: From the Eudora Welty Collection, Mississippi Department of Archives and History. Photographer: Kay Bell.

Sonya Jones: Photographer Rinne Allen.

Dolester Miles: Photographer Rinne Allen.

Old Crisco Cookbook: Tested Crisco Recipes: The Absolutely New Product For Frying, For Shortening, For Cake Making. From the Alan and Shirley Brocker Sliker Collection, MSS 314, Special Collections, Michigan State University Libraries.

Buck's One Stop: Photographer Rinne Allen.

COOKIES AND BARS BY THE DOZEN

Alice Jo Lane Giddens: Courtesy of her family.

Lee Barnes: From the Lee Barnes papers (NA-178) Newcomb Archives and Nadine Robbert Vorhoff Collection, Newcomb Institute, Tulane University.

Laura Bush: Courtesy of the George W. Bush Presidential Library, National Archives and Records Administration.

Recipe card for Nora's Brownies: Courtesy of Kay Goldstein.

Gottlieb's Bakery: From left, Elliot, Irving, Buster, and Isser Gottlieb at the old Gottlieb's Bakery in downtown Savannah, Georgia: Courtesy of the Gottlieb's Bakery family.

ABOUT THE AUTHOR

Anne Byrn is a *New York Times* bestselling food writer and cookbook author based in Nashville, Tennessee, where she learned to cook and bake as a child alongside her mother, Bebe. Every holiday shared with her large extended family of cousins offered infinite opportunities to bake. For fifteen years she was the food editor of *The Atlanta Journal-Constitution*, and she attended La Varenne École de Cuisine in Paris, receiving an advanced certificate. But while raising three children and cooking for a busy family, she embraced some shortcuts and wrote the bestseller *The Cake Mix Doctor*, one of *Southern Living* magazine's top 100 cookbooks of all time. She is also the author of *American Cake* and *Skillet Love*. When she isn't baking and gardening, Anne writes a weekly newsletter called *Between the Layers* on Substack.

Photo by EMILY DORIO